Philosophy Looks at the Arts

Philosophy Looks at the Arts

Contemporary Readings in Aesthetics Revised edition

> Edited by Joseph Margolis

Temple University Press Philadelphia

Library of Congress Cataloging in Publication Data

Margolis, Joseph Zalman, 1924– ed. Philosophy looks at the arts.

Includes bibliographies. 1. Aesthetics—Addresses, essays, lectures. 2. Art—Philosophy—Addresses, essays, lectures. 3. Analysis (Philosophy)—Addresses, essays, lectures. I. Title. BH21.M3 1977 111.8'5 77-95028 ISBN 0-87722-123-5 ISBN 0-87722-134-0 pbk.

Temple University Press, Philadelphia 19122 © copyright 1978 by Temple University. All rights reserved Published 1978 Printed in the United States of America

CONCORDIA UNIVERSITY LIBRARY PORTLAND, OR 97211

Contents

Prejace	vii
Part One The Nature of Aesthetic Interests	1
1. The Aesthetic Point of View Monroe	C. Beardsley 6
2. Piece: Contra Aesthetics Tin	nothy Binkley 25
3. Aesthetic Theory	
and the Experience of Art	R. K. Elliott 45
Bibliography	58
Part Two Aesthetic Qualities	61
4. Aesthetic Concepts	F. N. Sibley 64
5. Categories of Art Kend	lall L. Walton 88
Bibliography	115
Part Three The Definition of Art	117
6. The Role of Theory in Aesthetics	Morris Weitz 121
	Arthur Danto 132
8. Creativity in the Arts J	ack Glickman 145
Bibliography	162
Part Four The Ontology of Art	165
	ard Wollheim 169
	as Wolterstorff 189
of Works of Art Jo.	seph Margolis 213
Bibliography	221

	vi	NUNIVERSITY LIBRARY	VGROOMOO Con	ntents
	Part	Five Representation in Art		223
	12.	Reality Remade	Nelson Goodman	225
	13.	On Drawing an Object	Richard Wollheim	249
_	14.	Depiction, Vision, and Convention	Patrick Maynard	273
	Bibli	ography		287
2	Part	Six The Intentional Fallacy and Exp	ressive Qualities	289
	15.	The Intentional Fallacy		
		W. K. Wimsatt, Jr., a	and Monroe C. Beardsley	293
	16.	Intention and Interpretation		
		in Criticism	Frank Cioffi	307
	17.	Expressive Properties of Art	Guy Sircello	325
	18.	Art and Expression: A Critique	Alan Tormey	346
	Bibli	ography		362
		Seven The Objectivity of Criticism		365
4	19.	The Testability of an Interpretation	Monroe C. Beardsley	370
	20.	Robust Relativism	Joseph Margolis	387
	21.	Critical Communication	Arnold Isenberg	403
	Bibli	ography		416
	Part	Eight Fiction and Metaphor		419
	22.	The Language of Fiction	Margaret Macdonald	424
	23.	Possible but Unactual Objects:		
		On What There Isn't	Alvin Plantinga	438
	24.	Metaphor	Max Black	451
	Bibli	ography		468
	Note	s on the Contributors		471
	Index	¢		473

Preface

I have received a great many inquiries about why the first edition of *Philosophy Looks at the Arts* went out of print and whether it was to be reissued. Drawn by the compliment and the interest of several publishing companies, I began to recast the collection under circumstances oddly similar to those under which the first edition took form. Then as now, I was at work completing a volume of my own essays in aesthetics. I had, I may say, some difficulty finding a publisher for that other book, *The Language of Art and Art Criticism*, which Wayne State University Press finally brought out in 1965, three years after the appearance of the anthology. It pursued a rather different philosophical conviction from the one favored by the then-establishment forces in aesthetics: I believe its perceived change of direction discouraged a prompt appearance. The anthology, on the other hand, was surprisingly successful and served in a small way to strengthen the quality of analytic aesthetics.

Now, of course, the philosophical atmosphere is entirely altered. The work produced in aesthetics at present compares quite favorably with what is being done elsewhere in philosophy. In fact, there is reason to think that the conceptual puzzles of aesthetics—centered as they are on the activities of human persons and the peculiar properties of culture, language, intention, history and tradition—may yet be discovered to hold the most promising clue to an adequate philosophical synthesis. I sincerely believe it will.

The vigor of contemporary work has, however, made it impossible either to reissue the old anthology or to substitute another as short as the first. Not only have the topics of aesthetics changed and expanded significantly in the last fifteen years; there is a new sense of the density of each topic's alternatives. At the time of the first anthology, most instructors in aesthetics and the philosophy of art wanted a small set of choice selections from analytic aesthetics to fit into their larger, divergent pro-

grams. Now, the convergent orientation of Anglo-American aesthetics is so decidedly analytic that the supporting materials wanted are more usually drawn from the arts themselves, the various critical and historical literatures, technical discussions of features of the crafts involved, the psychology of perception and affect-in short, from a body of work that could not possibly be sampled in any meaningful way in a compendious collection. The first anthology favored a new unity; now, we may assume that a fair working unity already obtains. The result is that this edition of Philosophy Looks at the Arts must serve an entirely different purpose. What is wanted is a good sample of the diverging currents within a broadly analytic approach to the arts, one that catches up a reasonable number of the most active and influential contributors and provides a sense of the conceptual antagonisms of the greatest promise and interest. To attempt to satisfy these considerations is, inevitably, to omit the work of a good many who played a more important role at an earlier stage of analytic aesthetics or who have contributed more recently important papers not so easily construed as representing threads of thought that need to be brought together now. In fact, in collecting the papers finally included, I was repeatedly struck by the interlocking nature of the themes, by the inevitability of certain choices once certain other papers had been selected.

So the collection cannot but have a touch of idiosyncrasy about it. It reflects, I cannot deny, the picture of the unity of aesthetics that I have been trying to capture in the second version of my own essays. That volume, now called Art and Philosophy, is about to appear after some odd and completely extraneous vicissitudes. But, to me at least, its postponement has reminded me both of the postponement of the first volume and of the dependence of the earlier anthology on the way in which I had first focused my own perception of the field. The result is, to make a long story short, that I should like to think the collection offered here is not merely a teaching instrument but an accurate and compendious sample of the principal strands of thought across the range of contemporary aesthetics. It is structured in such a way as to include the key papers standing close to the beginning of a rich controversy (for instance, Sibley's, Weitz's, Wimsatt and Beardsley's) or the most polarized discussions of a given set of topics. I have also tried to include papers that scan a share of the pertinent literature-both those included elsewhere in the collection as well as those that could not be included at all.

I believe there is no anthology of this sort in the current literature. Most collections are rather blunderbuss affairs. Some are collections from special sources, for instance from *The Journal of Aesthetics and Art Criticism* and from the *British Journal of Aesthetics*. There is only one recent attempt that I know of to put together a collection on the salient theme of con-

Preface

temporary analytic aesthetics: Lars Aagaard-Mogensen's Culture and Art (1976). I am pleased to make mention of it.

I must thank a number of friends whom I have canvassed about what should be considered for inclusion: Monroe Beardsley, Ted Cohen, John Fisher, Jack Glickman, Beryl Lang, Catherine Lord, Francis Sparshott, Jerome Stolnitz, Alan Tormey. Their suggestions have converged considerably with my own preferences.

Part One The Nature of Aesthetic Interests

It is notoriously difficult to define the boundaries of such large and lively interests as the scientific, the moral, and the aesthetic. At least since Immanuel Kant, philosophers have hoped to be able to mark out nice logical distinctions among the kinds of judgments corresponding to such interests. In fact, Kant imposed one of the great obstacles to modern philosophy in this respect: enormous effort has been required to show that the demarcation lines Kant favored—or other similarly construed distinctions—actually falsify or distort the uniformities and differences favored among our conceptual networks. This is not to say that questions that belong to the very heart of empirical science, moral judgment, the appreciation and criticism of fine art are not easily identified. They are, of course. But since Kant, philosophers have been inclined to hope that when they are sorted, such questions will lead to neat categorical differences justifying their having been distinguished in the ways in which they have. Hence, there is a certain embarrassment at stake in failing to discover the required distinctions.

On the other hand, one may very well question the notion of *discovering* the difference between the scientific, the moral, and the aesthetic. What would such a discovery be like? It seems fairly clear that the distinctions would prove to be some philosopher's proposal, not a discovery at all. One need not deny that there are certain hard-core questions that belong unquestionably to each of these domains. But that hardly means that the boundaries of each are open to inspection. Criticism shades into science, and moral considerations into appreciation. In the moral domain, for instance, it is often maintained that moral judgments are inherently action-guiding, that there is no point to a moral judgment if it is not intended to direct another or oneself to act appropriately in a relevant situation. But if that is so, then how are we to understand valid moral judgments in situations in which the required action is impossible ("you ought to, or are obliged to, pay that loan today though you've squandered the money

at the racetrack") or in which the action appraised or appreciated is beyond the capacity of normal persons to perform at will ("St. Francis acted as a saint")?

Even after it develops that no simple logical differences exist among scientific, moral, and aesthetic judgments, philosophers may enthusiastically continue their attempt to distinguish the aesthetic domain. Inquiry then turns to another sort of distinction—for instance, the controlling interest of each of these domains. So one may argue that distinctive sets of reasons are regularly put forward to defend those sorts of judgments we call aesthetic, economic, or moral. The judgments themselves need not differ in their logical properties; it may be only that there are clusters or classes of reasons that would be relevant to each. And the question arises whether these are overlapping for the sorts of judgment distinguished, whether they may be sharply defined, or whether they may be exhibited only by way of admissible samples.

Beneath all this lurks the question of the nature of such large categoryterms as the aesthetic, the moral, the scientific. It may be asked, for instance, whether philosophers are primarily explicating the meaning of "aesthetic" or whether, by an ellipsis, they are really generalizing about the properties of certain sorts of judgments or remarks that are taken without dispute (though they are not infrequently disputed) to belong within the scope of aesthetic interest. That is, one may ask whether an analysis of the meaning of "aesthetic" will be fruitful independently of the second sort of issue, whether in fact it can even be undertaken. The point is not without some interest (given the professional literature), because it is well known that philosophers have quite regularly disputed among themselves whether this or that is *really* appropriate to the aesthetic point of view. It may then be that statements about the aesthetic point of view are actually elliptical summaries of findings upon this or that set of favored data-which some philosophers at least will have thought to be related in an important way to our concern with fine art; other philosophers, appearing to dispute the very meaning of the aesthetic, may either be disputing those findings or providing alternative findings for other sets of data.

J. O. Urmson's contribution, some years ago, to the Aristotelian Society's symposium on "What makes a situation aesthetic?" (1957) threads through this sort of consideration. His method is in accord both with some traditional conceptions of the central features of aesthetic interest and with a certain powerful theme in recent Anglo-American philosophy (associated originally with the name of Wittgenstein): that the use of terms in actual currency in our language need not, and may not be able to, be defined by means of necessary and sufficient conditions. There are, however, certain telltale features of Urmson's account. Urmson adopts the cautious approach of distinguishing between the "simpler cases" and the more difficult

The Nature of Aesthetic Interests

cases of aesthetic evaluation. He favors the view—associated with the original sense of the "aesthetic"—that the aesthetic aspects of things are concerned with how objects or phenomena appear to, or are discriminated by, the senses. He saves the thesis by admitting both that non-perceptual properties may be included "by courtesy" and by conceding that the more complex cases of aesthetic concern cannot be satisfactorily reduced to the formula for the simpler cases. He also distinguishes between the merit of things as being good things of a kind and the aesthetic merit of things, that is, their merit judged from a certain point of view. It is, in his view, merely contingent that the criteria for judging the goodness of a thing of a kind may well be the same as the criteria for being aesthetically meritorious (dining room tables, for instance). But the combination of these two concessions forces us to request a more detailed account of what it is, precisely, that makes a situation aesthetic.

Here, the difficulties encountered are of the greatest importance. For one thing, the extension of the terms "aesthetic" and "work of art" are clearly not the same, though it is often supposed that the point of aesthetics is to clarify the nature of our appreciation of fine art: natural phenomena and objects not designated artworks are ordinarily admitted to be aesthetically eligible. But then, the very range of artworks changes in rather surprising ways (see Part Three) and, with that, the range of what might be viewed as aesthetically relevant changes as well. The principal pressure points regarding the meaning of aesthetic interest, however, are all centered, in one way or another, on the aesthetic relevance of the imperceptible or the non-perceptual. But the guarrelsome nature of the non-perceivable cannot be denied. For instance, the distinction of forgeries and fakes in art suggests a consideration that cannot normally be restricted to what is perceptually accessible. Sometimes, as in print-making, it may merely be that the intention to produce a print from an authentic plate contrary to the original artist's authorization makes a particular print a forgery. If that consideration is aesthetically relevant, then the aesthetic cannot be confined to the perceptible. But the question remains whether that consideration is actually relevant aesthetically-rather than in some other way. Commentators disagree. Again, it is extremely difficult to see how the literary arts can be subsumed under the formula for the "simpler cases." Clive Bell had already admitted this in pressing the general thesis that Urmson's view approaches: it occasioned the most acrobatic adjustments imaginable; some theorists were led to hold that reading texts in order to understand the meaning of what was written was simply not essential to (though it was needed to occasion) one's aesthetic appreciation of a poem or novel. A third difficulty concerns the relevance of background information—cultural, biographical, intentional factors (see Part Six). If one must grasp something of the context in which a work of art is produced in order

to appreciate *it* aesthetically, then even if one centers one's interest on what is perceivable, non-perceptual factors will and must relevantly inform what is perceivable. For example, to understand a style, a genre, a representation, a symbol, an historical tradition, a personal intention, is to understand what cannot be explicated solely in perceptual terms. Finally, if these difficulties be conceded, then one must concede as well that the appreciation of works of art may entail the exercise of capacities other than perceptual—for instance, imagination or conceptual understanding. The point is that the properties of a work of art may not be such as either to invite perceptual inspection at all or to invite perception primarily or exclusively. So-called conceptual art is often not perceptually accessible at all, though for that reason some will dispute whether conceptual art is not a contradiction in terms. And much art, not only literature but painting and music as well, seems to be appreciated only when certain imagining abilities are called into play. The empathists had pressed the thesis in a certain restricted way, but there seems to be a larger range of abilities at stake. The perception of physiognomic aspects of the lines in a painting, discrimination of the "movement" of a musical line, the appreciation of scenes depicted in novels or of the motivation of characters in a play all suggest our reliance on abilities that may inform sensory perception but that cannot be characterized merely as such.

Monroe Beardsley's comparatively recent effort (1970) to isolate the aesthetic point of view and the nature of aesthetic qualities is cognizant of all these difficulties. Beardsley attempts nevertheless to salvage a thesis, associated with his well-known effort to construe aesthetic appreciation as an objective undertaking, in which aesthetic properties or values are actually possessed by objects, objects that may be examined for them in certain assignably correct ways by normally endowed percipients. He shifts here from earlier formulations, in speaking of the experiencing rather than the *perceiving* of artworks (or other suitable objects); and he holds that aesthetic gratification is primarily obtained by attending to the "formal unity" and "regional qualities" of an object or phenomenon. This raises questions about whether such properties can be shown actually to obtain in a given object, to be somehow discernible in it, to preclude the tenability of alternative and incompatible ascriptions of such properties (see Part Seven); it also imposes on us the problem of specifying how to give "correct" and "complete" instructions about experiencing the actual aesthetic values that an object may be supposed to have. Whatever the difficulties Beardsley's account generates, it constitutes the most forthright and informed effort we have to recover the objectivity of aesthetic discourse as such from the pressures of the sort already adduced.

Timothy Binkley's very recent paper (1977) is a witty, iconoclastic piece—one of a number he has written in the same spirit—in which the

The Nature of Aesthetic Interests

more received and conventional views about the aesthetic appreciation of works of art are threatened by attention to implications drawn from bolder, more recent, and more extreme efforts in the arts themselves. Here, relying on certain novel developments in so-called conceptual art, Binkley shows effectively that there are actually works of art (if such they may be called) that *cannot* be explicated in perceptual terms. Even if one contests his specimens—though the dubious force of doing so is clear enough— Binkley does oblige us to see that, even in more conventional settings, intentional, contextual, background considerations are all but impossible to eliminate (see Parts Five and Six). So construed, his account challenges not only the more straightforward presumption of Urmson's discussion but also the prospect of sustaining the kind of objective discovery that Beardsley favors.

Perhaps the most important implication of Binkley's account is that it is guite impossible to separate the characterization of the aesthetic from one's sense of the range of what constitutes art. This is not to say that definitions, here, isolate essential properties (see Part Three) but only that the point of defining the aesthetic is to throw into relief the kinds of properties prized in the context of appreciating art. R. K. Elliott (1966-67), reflecting on this very consideration within the range of more standard objects of art than Binkley favors, notes that the usual perceptioncentered theories of aesthetic experience tend to impoverish our actual appreciation of art. In order to accommodate the full range of what we savor, Elliott proposes an expression theory. What is distinctive about it is, precisely, that it is not an expression theory of art or of artistic creation but of what is appreciated in properly attending to art (see Part Six) and that, in that regard, the objectivism to which a perception-centered account pretends is found deficient. Here, then, we see the potential opposition between speaking of the nature of art (the actual properties of which can be discriminated) and speaking of the nature of aesthetic experience, which leads us to speak of experiencing a work of art "from within" and hence, to hold that objective contemplation is simply an inadequate characterization of aesthetic engagement. It forces us to see, therefore, the import of counterpart tendencies in defining the nature of art itself (see Part Three).

MONROE C. BEARDSLEY

There has been a persistent effort to discover the uniquely aesthetic component, aspect, or ingredient in whatever is or is experienced. Unlike some other philosophical quarries, the object of this chase has not proved as elusive as the snark, the Holy Grail, or Judge Crater—the hunters have returned not empty-handed, but overburdened. For they have found a rich array of candidates for the basically and essentially aesthetic:

aesthetic experience	aest
aesthetic value	aest
aesthetic enjoyment	aest
aesthetic satisfaction	

aesthetic objects aesthetic concepts aesthetic situations.

Confronted with such trophies, we cannot easily doubt that there *is* something peculiarly aesthetic to be found in our world or our experience; yet its exact location and its categorial status remain in question. This is my justification for conducting yet another raid on the ineffable, with the help of a different concept, one in the contemporary philosophical style.

I

When the conservationist and the attorney for Con Edison argue their conflicting cases before a state commission that is deciding whether a nuclear power plant shall be built beside the Hudson River, we can say they do not merely disagree; they regard that power plant from different points of view. When the head of the Histadrut Publishing House refused to publish the novel *Exodus* in Israel, he said: "If it is to be read as history, it is

Reprinted from *Contemporary Philosophic Thought*, Volume 3, edited by Howard E. Kiefer and Milton K. Munitz (Albany: State University of New York Press, 1970), pp. 219–237, by permission of the State University of New York Press.

inaccurate. If it is to be read as literature, it is vulgar."¹ And Maxim Gorky reports a remark that Lenin once made to him:

'I know nothing that is greater than [Beethoven's] Appassionata. I would like to listen to it every day. A marvelous, superhuman music. I always say with pride—a naive pride perhaps: What miracles human beings can perform!' Then screwing his eyes [Lenin] added, smiling sadly, 'But I can't listen to music too often; it affects your nerves. One wants to say stupid nice things and stroke on the head the people who can create such beauty while living in this vile hell. And now you must not stroke anyone on the head: you'll have your hands beaten off. You have to hit them on the head without mercy, though our ideal is not to use violence against anyone. Hmm, hmm, —an infernally cruel job we have.'²

In each of these examples, it seems plausible to say that one of the conflicting points of view is a peculiarly aesthetic one: that of the conservationist troubled by threats to the Hudson's scenic beauty; that of the publisher who refers to reading *Exodus* "as literature"; that of Lenin, who appears to hold that we ought to adopt the political (rather than the aesthetic) point of view toward Beethoven's sonata, because of the unfortunate political consequences of adopting the aesthetic point of view.

If the notion of the aesthetic point of view can be made clear, it should be useful from the philosophical point of view. The first philosophical use is in mediating certain kinds of dispute. To understand a particular point of view, we must envision its alternatives. Unless there can be more than one point of view toward something the concept breaks down. Consider, for example, the case of architecture. The classic criteria of Vitruvius were stated tersely by Sir Henry Wotton in these words: "Well-building hath three conditions: Commodity, Firmness, and Delight." Commodity is function: that it makes a good church or house or school. Firmness is construction: that the building holds itself up. Suppose we were comparing a number of buildings to see how well built they are, according to these "conditions." We would find some that are functionally effective, structurally sound, and visually attractive. We would find others-old wornout buildings or new suburban shacks-that are pretty poor in each of these departments. But also we would find that the characteristics vary independently over a wide range; that some extremely solid old bank buildings have Firmness (they are knocked down at great cost) without much Commodity or Delight, that some highly delightful buildings are functionally hopeless, that some convenient bridges collapse.

Now suppose we are faced with one of these mixed structures, and invited to say whether it is a good building, or how good it is. Someone might say the bank is very well built, because it is strong; another might reply that nevertheless its ugliness and inconvenience make it a very poor building. Someone might say that the bridge couldn't have been much good if it collapsed; but another might reply that it was a most excellent bridge, while it lasted—that encomium cannot be taken from it merely because it did not last long.

Such disputes may well make us wonder—as Geoffrey Scott wonders in his book on *The Architecture of Humanism*³—whether these "conditions" belong in the same discussion. Scott says that to lump them together is confusing: it is to "force on architecture an unreal unity of aim," since they are "incommensurable virtues." For clarity in architectual discussion, then, we might separate the three criteria, and say that they arise in connection with three different points of view—the practical, the engineering, and the aesthetic. In this way, the notion of a point of view is introduced to break up a dispute into segments that seem likely to be more manageable. Instead of asking one question—whether this is a good building we divide it into three. Considering the building from the aesthetic point of view, we ask whether it is a good work of architecture; from the engineering point of view, whether it is a good structure; and from the practical point of view, whether it is a good machine for living.

Thus one way of clarifying the notion of a point of view would be in terms of the notion of being good of a kind.⁴ We might say that to adopt the aesthetic point of view toward a building is to classify it as belonging to a species of aesthetic objects-namely, works of architecture-and then to take an interest in whether or not it is a good work of architecture. Of course, when an object belongs to one obvious and notable kind, and we judge it in relation to that kind, the "point of view" terminology is unnecessary. We wouldn't ordinarily speak of considering music from a musical point of view, because it wouldn't occur to us that someone might regard it from a political point of view. In the same way, it would be natural to speak of considering whiskey from a medical point of view but not of considering penicillin from a medical point of view. This shows that the "point of view" terminology is implicitly rejective: it is a device for setting aside considerations advanced by others (such as that the bridge will fall) in order to focus attention on the set of considerations that we wish to emphasize (such as that the sweep and soar of the bridge are a joy to behold).

The "point of view" terminology, however, is more elastic than the "good of its kind" terminology. To consider a bridge or music or sculpture as an aesthetic object is to consider it from the aesthetic point of view. But what about a mountain, a sea shell, or a tiger? These are neither musical compositions, paintings, poems, nor sculptures. A sea shell cannot be *good* sculpture if it is not sculpture at all. But evidently we can adopt

the aesthetic point of view toward these things. In fact, some aesthetic athletes (or athletic aesthetes) have claimed the ability to adopt the aesthetic point of view toward anything at all—toward *The Story of O* (this is what Elliot Fremont-Smith has called "beyond pornography"), toward a garbage dump, toward the murders of three civil-rights workers in Philadelphia, Mississippi. (This claim has been put to a severe test by some of our more far-out sculptors.) Perhaps even more remarkable is the feat recently performed by those who viewed the solemn installation of an "invisible sculpture" behind the Metropolitan Museum of Art. The installation consisted in digging a grave-size hole and filling it in again. "It is really an underground sculpture," said its conceiver, Claes Oldenburg, "I think of it as the dirt being loosened from the sides in a certain section of Central Park."⁵ The city's architectural consultant, Sam Green, commented on the proceedings:

This is a conceptual work of art and is as much valid as something you can actually see. Everything is art if it is chosen by the artist to be art. You can say it is good art or bad art, but you can't say it isn't art. Just because you can't see a statue doesn't mean that it isn't there.

This, of course, is but one of countless examples of the current tendency to stretch the boundaries of the concept of "art."

The second philosophical use of the notion of the aesthetic point of view is to provide a broad concept of art that might be helpful for certain purposes. We might say:

A work of art (in the broad sense) is any perceptual or intentional object that is deliberately regarded from the aesthetic point of view.⁶

Here, "regarding" would have to include looking, listening, reading, and similar acts of attention, and also what I call "exhibiting"—picking up an object and placing it where it readily permits such attention, or presenting the object to persons acting as spectators.

Π

What, then, is the aesthetic point of view? I propose the following:

To adopt the aesthetic point of view with regard to X is to take an interest in whatever aesthetic value X may possess.

I ask myself what I am doing in adopting a particular point of view, and acting toward an object in a way that is appropriate to that point of view;

and, so far as I can see, it consists in searching out a corresponding value in the object, to discover whether any of it is present. Sometimes it is to go farther: to cash in on that value, to realize it, to avail myself of it. All this searching, seeking and, if possible, realizing, I subsume under the general phrase "taking an interest in." To listen to Beethoven's *Appassionata* with pleasure and a sense that it is "marvelous, superhuman music," is to seek—and find—aesthetic value in it. To read the novel *Exodus* "as literature," and be repelled because it is "vulgar," is (I take it) to seek aesthetic value in it, but not find very much of it. And when Geoffrey Scott makes his distinction between different ways of regarding a building, and between that "constructive integrity in fact" which belongs under Firmness, and that "constructive vividness in appearance" which is a source of architectural Delight, he adds that "their value in the building is of a wholly disparate kind"⁷; in short, the two points of view, the engineering and the aesthetic, involve two kinds of value.

This proposed definition of "aesthetic point of view" will not, as it stands, fit all of the ordinary uses of this phrase. There is a further complication. I am thinking of a remark by John Hightower, Executive Director of the New York State Council on the Arts, about the Council's aim to "encourage some sort of aesthetic standards." He said, "There are lots of laws that unconsciously inhibit the arts. Architecture is the most dramatic example. Nobody has looked at the laws from an aesthetic point of view."8 And I am thinking of a statement in the Yale Alumni Magazine9 that the Yale City Planning Department was undertaking "a pioneering two-year research project to study highway environment from an aesthetic point of view." I suppose the attention in these cases was not on the supposed aesthetic value of the laws or of the present "highway environment," but rather in the aesthetic value that might be achieved by changes in these things. Perhaps that is why these examples speak of "an aesthetic point of view," rather than "the aesthetic point of view." And we could, if we wish, make use of this verbal distinction in our broadened definition.

To adopt an aesthetic point of view with regard to X is to take an interest in whatever aesthetic value that X may possess or that is obtainable by means of X.

I have allowed the phrase "adopting the aesthetic point of view" to cover a variety of activities. One of them is judging:

To judge X from the aesthetic point of view is to estimate the aesthetic value of X.

Those who are familiar with Paul Taylor's treatment of points of view in his book *Normative Discourse* will note how the order I find in these concepts differs from the one he finds. His account applies only to judging, which makes it too narrow to suit me. It also has, I think, another flaw. He holds that:

Taking a certain point of view is nothing but adopting certain canons of reasoning as the framework within which value judgments are to be justified; the canons of reasoning define the point of view. . . . We have already said that a value judgment is a moral judgment if it is made from the moral point of view.¹⁰

Thus we could ask of Taylor, What is an aesthetic value judgment? He would reply, It is one made from the aesthetic point of view. And which are those? They are the ones justified by appeal to certain "canons of reasoning," and more particularly the "rules of relevance." But which are the aesthetic rules of relevance? These are the rules "implicitly or explicitly followed by people" in using the aesthetic value-language—that is, in making judgments of aesthetic value. Perhaps I have misunderstood Taylor's line of thought here, but the path it seems to trace is circular. I hope to escape this trap by breaking into the chain at a different point.

I define "aesthetic point of view" in terms of "aesthetic value." And while I think this step is by no means a trivial one, it is not very enlightening unless it is accompanied by some account of aesthetic value. I don't propose to present a detailed theory on this occasion, but I shall extend my chain of definitions to a few more links, and provide some defense against suspected weaknesses. What, then, is aesthetic value?

The aesthetic value of an object is the value it possesses in virtue of its capacity to provide aesthetic gratification.

There are three points about this definition that require some attention.

First, it will be noted that this is not a definition of "value." It purports to distinguish *aesthetic* value from other kinds of value in terms of a particular capacity. It says that in judging the total value of an object we must include that part of its value which is due to its capacity to provide aesthetic gratification.

The second point concerns "aesthetic gratification." My earliest version of this capacity-definition of "aesthetic value" employed the concept of aesthetic experience.¹¹ I am still not persuaded that this concept must be abandoned as hopeless, but it needs further elaboration in the face of the criticism coming from George Dickie, whose relentless attack on unnecessarily multiplied entities in aesthetics has led him to skepticism about whether there is such a thing as aesthetic experience.¹² I have tried working with the concept of aesthetic enjoyment instead,¹³ and that may be on the right track. For the present occasion, I have chosen a term that I think is somewhat broader in scope, and perhaps therefore slightly less misleading.

Again, however, the term "aesthetic gratification" is not self-explanatory. It seems clear that one kind of gratification can be distinguished from another only in terms of its intentional object: that is, of the properties that the pleasure is taken *in*, or the enjoyment is enjoyment *of*. To discriminate aesthetic gratification—and consequently aesthetic value and the aesthetic point of view—we must specify what it is obtained from. I offer the following:

Gratification is aesthetic when it is obtained primarily from attention to the formal unity and/or the regional qualities of a complex whole, and when its magnitude is a function of the degree of formal unity and/or the intensity of regional quality.

The defense of such a proposal would have to answer two questions. First, is there such a type of gratification? I think there is, and I think that it can be distinguished from other types of gratification, though it is often commingled with them. Second, what is the justification for calling this type of gratification "aesthetic"? The answer to this question would be more complicated. Essentially, I would argue that there are certain clear-cut exemplary cases of works of art—that is, poems, plays, musical compositions, etc.—that must be counted as works of art if anything is. There is a type of gratification characteristically and preeminently provided by such works, and this type of gratification (once distinguished above. Finally, this type of gratification (once distinguished) has a paramount claim to be denominated "aesthetic"—even though there are many other things that works of art can do to you, such as inspire you, startle you, or give you a headache.

If this line of argument can be made convincing, we find ourselves with what might be called primary *marks* of the aesthetic: It is the presence in the object of some notable degree of unity and/or the presence of some notable intensity of regional quality that indicates that the enjoyments or satisfactions it affords are aesthetic—insofar as those enjoyments or satisfactions are afforded by these properties. I shall return to these marks a little later, and show the sort of use I think can be made of them.

Ш

But before we come to that, we must consider the third point about the capacity-definition of "aesthetic value"—and this is the most troublesome of them all.

The term "capacity" has been chosen with care. My view is that the aesthetic value of an object is not a function of the actual degree of gratification obtained from it. It is not an average, or the mean degree of gratification obtained from it by various perceivers. It is not a sum, or the total gratification obtained from it in the course of its existence. All these depend in part on external considerations, including the qualifications of those who happen to resort to libraries, museums, and concerts, and the circumstances of their visits. I am thinking in terms of particular exposures to the work—a particular experience of the music, of the poem, of the painting—and of the degree of aesthetic gratification obtained on each occasion. Aesthetic value depends on the highest degree obtainable under optimal circumstances. Thus my last definition should be supplemented by another one:

The amount of aesthetic value possessed by an object is a function of the degree of aesthetic gratification it is capable of providing in a particular experience of it.

My reason for holding this view is that I want to say that a critical evaluation is a judgment of aesthetic value, and it seems clear to me that estimating capacities is both the least and the most we can ask of the critical evaluator. I take it that when a literary critic, for example, judges the goodness of a poem (from the aesthetic point of view), and is prepared to back up his judgment with reasons, he must be saying something about the relationship of the poem to the experiences of actual or potential readers. The question is, What is this relationship? When a critic says that a poem is good, he is hardly ever in a position to predict the gratification that particular readers or groups of readers will receive from it. Moreover, he is usually not in a position to generalize about tendencies, to say, for instance, that readers of such-and-such propensities, preferences, or preparations will probably be delighted by the poem. If the critic has at his disposal the information required to support such statements, he is of course at liberty to say such things as: "This would have appealed to President Kennedy," or "This is an ideal Christmas gift for your friends who love mountain climbing." But when he simply says, "This is a good poem," we must interpret him as saying something weaker (though still significant) about the capacity of the work to provide a notable degree of aesthetic gratification. For that is a judgment he should be able to support, if he understands the poem.

The question, however, is whether the capacity-definition of "aesthetic value" is too weak, as a report of what actually happens in art criticism. I can think of three difficulties that have been or could be raised. They might be called (1) the unrecognized masterpiece problem, (2) the LSD problem, and (3) the Edgar Rice Burroughs problem. Or, to give them

more abstract names, they are (1) the problem of falsification, (2) the problem of illusion, and (3) the problem of devaluation.

(1) Some people are troubled by one consequence of the capacitydefinition-that objects can possess aesthetic value that never has been and never will be realized, such as the "gems of purest ray serene the dark unfathomed caves of ocean bear." This ought not to trouble us, I think. It is no real paradox that many objects worth looking at can never be looked at. But there is another kind of aesthetic inaccessibility in the highly complicated and obscure work that no critic can find substantial value in, though it may still be there. In Balzac's short story, "Le Chefd'oeuvre inconnu," the master painter works in solitude for years, striving for the perfection of his greatest work; but in his dedication and delusion he overlays the canvas with so many brush strokes that the work is ruined. When his fellow artists finally see the painting, they are appalled by it. But how can they be sure that the painting doesn't have aesthetic value, merely because they have not found any? The capacity to provide aesthetic gratification of a high order may still be there, though they are not sharp or sensitive enough to take advantage of it.

If my proposed definition entailed that negative judgments of aesthetic value cannot even in principle be justified, then we would naturally mistrust it. But of course this consequence is not necessary. What does follow is that there is a certain asymmetry between negative and affirmative judgments, with respect to their degree of confirmation; but this is so between negative and affirmative existential statements in general. The experienced critic may have good reason in many cases not only for confessing that he finds little value in a painting, but for adding that very probably no one ever will find great value in it.

(2) If aesthetic value involves a capacity, then its presence can no doubt be sufficiently attested by a single realization. What a work *does* provide, it clearly *can* provide. And if my definition simply refers to the capacity, without qualification, then it makes no difference under what conditions that realization occurs. Now take any object you like, no matter how plain or ugly—say a heap of street sweepings awaiting the return of the street cleaner. Certainly we want to say that it is lacking in aesthetic value. But suppose someone whose consciousness is rapidly expanding under the influence of LSD or some other hallucinogenic drug happens to look at this heap and it gives him exquisite aesthetic gratification. Then it has the capacity to do so, and so it has high aesthetic value. But then perhaps every visual object has high aesthetic value, and all to about the same degree—if the reports may be trusted.

I cannot speak authoritatively of the LSD experience, but I gather that when a trip is successful, the object, however humble, may glow with un-

wonted intensity of color and its shapes assume an unexpected order and harmony. In short, the experience is illusory. This is certainly suggested by the most recent report I have run across.¹⁴ Dr. Lloyd A. Grumbles, a Philadelphia psychiatrist,

said that while listening to Beethoven's *Eroica*, particularly the third movement, he felt simultaneously "insatiable longing and total gratification." . . Dr. Grumbles said he also looked at prints of Picasso and Renoir paintings and realized, for the first time, "they were striving for the same goal."

Now you know he was under the influence of LSD.

This example suggests a modification of the definition given earlier:

The aesthetic value of X is the value that X possesses in virtue of its capacity to provide aesthetic gratification when *correctly experienced*.

(3) The problem of devaluation can perhaps be regarded as a generalization of the LSD problem.¹⁵ When I was young I was for a time an avid reader of the Martian novels of Edgar Rice Burroughs. Recently when I bought the Dover paperback edition and looked at them again, I found that I could hardly read them. Their style alone is enough to repel you, if you really pay attention to it.

The problem is this: if on Monday I enjoy a novel very much, and thus know that it has the capacity to provide gratification, then how can I ever reverse that judgment and say the novel lacks that capacity? If the judgment that the novel is a good one is a capacity-judgment, it would seem that downward reevaluations (that is, devaluations) are always false —assuming that the original higher judgment was based on direct experience. There is no problem about upward reevaluations: when I say on Tuesday that the novel is better than I thought on Monday, this means that I have discovered the novel to have a greater capacity than I had realized. But how can we explain the lowering of an aesthetic evaluation and still maintain that these evaluations are capacity-judgments?

Some cases of devaluation can no doubt be taken care of without modifying the definition of "aesthetic value." The devaluation may be due to a shift in our value grades caused by enlargement of our range of experience. I might think that *Gone with the Wind* is a great novel, because it is the best I have read, but later I might take away that encomium and give it to *War and Peace*. Or the devaluation may be due to the belated recognition that my previous satisfaction in the work was a response to extraaesthetic features. I now realize that my earlier enjoyment of detective stories was probably caused only in small part by their literary qualities, and was much more of a game-type pleasure.

But setting these cases aside, there remain cases where on perfectly sound and legitimate grounds I decide that the work, though it has provided a certain level of aesthetic gratification, is in fact not really that good. I have over-estimated it. Evidently the definition of "aesthetic value" must be modified again. One thing we might do is insert a stipulation that the work be a reliable or dependable source of gratification: flukes don't count. We need not change the judgment into a straight tendency-statement. But we might insist that the enjoyment of the novel must at least be a repeatable experience. Something like this notion seems to underlie the frequent claim that our first reactions to a new work of art are not wholly to be trusted, that we should wait awhile and try it again; that we should see whether we can find at least one other person to corroborate our judgment; or that only posterity will be in a position to know whether the work is great.

I grant that all these precautions are helpful—indeed, they enable us to avoid the two sources of error mentioned a moment ago: having an inadequately formulated set of grading terms, and confusing aesthetic with nonaesthetic gratification. But I think it ought to be possible for a person, after a single experience of a work, to have excellent grounds for thinking it good and for commending it to others. And I think he would be justified in pointing out that he has found a potential source of aesthetic gratification that lies ready to be taken advantage of—even though he does not yet know how readily, how easily, how conveniently, or how frequently recourse may be had to it. Thus my escape from the difficulty is to revise the definition of "aesthetic value" again so as to stipulate that it is the value of the whole work that is in question:

The aesthetic value of X is the value that X possesses in virtue of its capacity to provide aesthetic gratification when correctly and completely experienced.

The youth who was carried away by the adventures of Thuvia and the green men of Mars and the other denizens of that strange planet may well have gotten greater aesthetic gratification than the elderly person who returned to them after so many years. For the youth was fairly oblivious to the faults of style, and he filled in the flat characterizations with his own imagination, giving himself up unselfconsciously to the dramatic events and exotic scenery. But, though he was lucky in a way, his judgment of the *whole* work was not to be trusted.

IV

We saw earlier that the notion of a point of view plays a particular role in focusing or forwarding certain disputes by limiting the range of relevant considerations. We invoke the aesthetic point of view when we want to set aside certain considerations that others have advanced—as that a poem is pornographic, or that a painting is a forgery—or that (as Jacques Maritain remarks) "A splendid house without a door is not a good work of architecture."¹⁶ But the person whose considerations are thus rejected may feel that the decision is arbitrary, and enter an appeal, in the hope that a higher philosophical tribunal will rule that the lower court erred in its exclusions. How do we know whether being pornographic, or being a forgery, or lacking a door, is irrelevant from the aesthetic point of view? I propose this answer:

A consideration about an object is relevant to the aesthetic point of view if and only if it is a fact about the object that affects the degree to which the marks of aesthetic gratification (formal unity and intensity of regional quality) are present in the object.

Thus: Is the fact that a painting is a forgery relevant to a judgment of it from the aesthetic point of view? No; because it has no bearing on its form or quality. Is the fact that a painting is a seascape relevant? Sometimes. It is when the subject contributes to, or detracts from, its degree of unity or its qualitative intensity. Is the biography of the composer relevant? According to a writer in *The Music Review*:

It is a well-known fact that knowledge of the circumstances surrounding the composition of a work enhances the audience's appreciation. . . It is because of this that programme notes, radio comments, and music appreciation courses are in such demand. To secure such knowledge is one of the important tasks of musical research.¹⁷

Now, I'm not sure that this "well-known fact" is really a fact, but let us assume that it is. Does it follow that information about the circumstances of composition is relevant to consideration of the work from an aesthetic point of view? We can imagine this sort of thing:

It was a cold rainy day in Vienna, and Schubert was down to his last crust of bread. As he looked about his dingy garret, listening to the rain that beat down, he reflected that he could not even afford to feed his mice. He recalled a sad poem by Goethe, and suddenly a melody sprang into his head. He seized an old piece of paper, and began to write feverishly. Thus was "Death and the Maiden" born.

Now even if everyone, or *nearly* everyone, who reads this program note finds that it increases his appreciation of the song, a condition of appreciation is not necessarily a condition of value. From this information—say, that it was raining—nothing can be inferred about the specifically aesthetic character of the song. (It is relevant, of course, that the words and music match each other in certain ways; however, we know that not by biographical investigation but by listening to the song itself.)

Here is one more example. In a very interesting article "On the Aesthetic Attitude in Romanesque Art," Meyer Schapiro has argued that:

Contrary to the general belief that in the Middle Ages the work of art was considered mainly as a vehicle of religious teaching or as a piece of craftsmanship serving a useful end, and that beauty of form and color was no object of contemplation in itself, these texts abound in aesthetic judgments and in statements about the qualities and structure of the work. They speak of the fascination of the image, its marvelous likeness to physical reality, and the artist's wonderful skill, often in complete abstraction from the content of the object of art.¹⁸

Schapiro is inquiring whether medieval people were capable of taking the aesthetic point of view in some independence of the religious and technological points of view. He studies various texts in which aesthetic objects are described and praised, to elicit the grounds on which this admiration is based, and to discover whether these grounds are relevant to the aesthetic point of view. Form and color, for example, are clearly relevant, and so to praise a work for its form or color is to adopt the aesthetic point of view. And I should think the same can be said for "the fascination of the image"—by which Schapiro refers to the extraordinary interest in the grotesque figures freely carved by the stonecutters in Romanesque buildings. These centaurs, chimeras, two-headed animals, creatures with feet and the tail of a serpent, etc., are the images deplored by St. Bernard with an ambivalence like that in Lenin's remark about Beethoven:

In the cloister, under the eyes of the brethren who read there, what profit is there in those ridiculous monsters, in that marvelous and deformed beauty, in that beautiful deformity?¹⁹

But what of Schapiro's other points—the image's "marvelous likeness to physical reality, and the artist's wonderful skill"?

If a person admires skill in depiction, he is certainly not taking a religious point of view—but is he taking the aesthetic point of view? I should think not. No doubt when he notices the accuracy of depiction, reflects on the skill required to achieve it, and thus admires the artist, he may be placed in a more favorable psychological posture toward the work itself. But this contributes to the conditions of the experience; it does not enter into the experience directly, as does the perception of form and color, or the recognition of the represented objects as saints or serpents. So I would say that the fact that the medieval writer admired the skill in depiction is *not* evidence that he took the aesthetic point of view, though it is evidence that he took *an* aesthetic point of view, since skill was involved in the production of the work.

V

There is one final problem that may be worth raising and commenting upon briefly—although it is not at all clear to me how the problem should even be formulated. It concerns the justification of adopting the aesthetic point of view, and its potential conflicts with other points of view. On one hand, it is interesting to note that much effort has been spent (especially during recent decades) in getting people to adopt the aesthetic point of view much more firmly and continuously than has been common in our country. The conservationists are trying to arouse us to concern for the preservation of natural beauties, instead of automatically assuming that they have a lower priority than any other interest that happens to come up-such as installing power lines, or slaughtering deer, or advertising beer. And those who are concerned with "education of the eye," or "visual education," are always developing new methods of teaching the theory and practice of good design; the aim being to produce people who are aware of the growing hideousness of our cities and towns, and who are troubled enough to work for changes.

But the effort to broaden the adoption of the aesthetic point of view sometimes takes another form. According to its leading theoretician, the "Camp sensibility" is characterized by the great range of material to which it can respond: "Camp is the consistently aesthetic experience of the world," writes Susan Sontag. "It incarnates a victory of style over content, of aesthetics over morality, of irony over tragedy."²⁰

Here is an extreme consequence of trying to increase the amount of aesthetic value of which we can take advantage. But it also gives rise to an interesting problem, which might be called "the dilemma of aesthetic education." The problem is pointed up by a cartoon I saw not long ago (by David Gerard), showing the proprietor of a junkyard named "Sam's Salvage" standing by a huge pile of junked cars, and saying to two other men: "Whattya mean it's an ugly eyesore? If I'd paid Picasso to pile it up, you'd call it a work of art."

The central task of aesthetic education, as traditionally conceived, is the improvement of taste, involving the development of two dispositions: (1) the capacity to obtain aesthetic gratification from increasingly subtle and complex aesthetic objects that are characterized by various forms of unity-in short, the response to beauty in one main sense; and (2) an increasing dependence on objects beautiful in this way (having harmony, order, balance, proportion) as sources of aesthetic satisfaction. It is this impulse that is behind the usual concept of "beautification"-shielding the highways from junkyards and billboards, and providing more trees and flowers and grass. As long as the individual's aesthetic development in this sense is accompanied by increasing access to beautiful sights and sounds, it is all to the good. His taste improves: his aesthetic pleasures are keener; and when he encounters unavoidable ugliness, he may be moved to eliminate it by labor or by law. On the other hand, suppose he finds that his environment grows uglier, as the economy progresses, and that the ugliness becomes harder to escape. Second, suppose he comes to enjoy another kind of aesthetic value, one that derives from intensity of regional quality more than formal fitness. And third, suppose he comes to realize that his aesthetic gratification is affected by the demands he makes upon an object-especially because the intensity of its regional qualities partly depends on its symbolic import. For example, the plain ordinary object may be seen as a kind of symbol, and become expressive (i.e., assume a noteworthy quality) if the individual attends to it in a way that invites these features to emerge. Suddenly, a whole new field of aesthetic gratification opens up. Trivial objects, the accidental, the neglected, the meretricious and vulgar, all take on new excitement. The automobile graveyard and the weed-filled garden are seen to have their own wild and grotesque expressiveness as well as symbolic import. The kewpie doll, the Christmas card, the Tiffany lampshade, can be enjoyed aesthetically, not for their beauty but for their bizarre qualities and their implicit reflection of social attitudes. This is a way of transfiguring reality, and though not everything can be transfigured, perhaps, it turns out that much can.

What I mean by the dilemma of aesthetic education is this: that we are torn between conflicting ways of redirecting taste. One is the way of love of beauty, which is limited in its range of enjoyment, but is reformist by implication, since it seeks a world that conforms to its ideal. The other is the way of aestheticizing everything—of taking the aesthetic point of view wherever possible—and this widens enjoyment, but is defeatist, since instead of eliminating the junkyard and the slum it tries to see them as expressive and symbolic. The conflict here is analogous to that between the social gospel and personal salvation in some of our churches—though no

doubt its consequences are not equally momentous. I don't suppose this dilemma is ultimately unresolvable, though I cannot consider it further at the moment. I point it out as one of the implications of the tendency (which I have been briefly exploring) to extend the aesthetic point of view as widely as possible.

But there is another weighty tradition opposed to this expansion. Lenin and St. Bernard stand witness to the possibility that there may be situations in which it is morally objectionable to adopt the aesthetic point of view. A man who had escaped from Auschwitz commented on Rolf Hochmuth's play: "The Deputy should not be considered as a historical work or even as a work of art, but as a moral lesson."21 Perhaps he only meant that looking for historical truth or artistic merit in The Deputy is a waste of time. But he may also have meant that there is something blameworthy about anyone who is capable of contemplating those terrible events from a purely historical or purely aesthetic point of view. Renata Adler, reporting in The New Yorker²² on the New Politics Convention that took place in Chicago on Labor Day weekend, 1967, listed various types of self-styled "revolutionaries" who attended, including "the aesthetic-analogy revolutionaries, who discussed riots as though they were folk songs or pieces of local theatre, subject to appraisal in literary terms ('authentic,' 'beautiful')." That is carrying the aesthetic point of view pretty far.

This possibility has not gone unnoticed by imaginative writers-notably Henry James and Henrik Ibsen.23 The tragedy of Mrs. Gereth, in The Spoils of Poynton, is that of a woman who could not escape the aesthetic point of view. She had a "passion for the exquisite" that made her prone "to be rendered unhappy by the presence of the dreadful [and] she was condemned to wince wherever she turned." In fact, the things that troubled her most-and she encountered them everywhere, but nowhere in more abundance than the country house known as Waterbath-were just the campy items featured by Miss Sontag: "trumpery ornament and scrapbook art, with strange excrescences and bunchy draperies, with gimcracks that might have been keepsakes for maid-servants [and even] a souvenir from some centennial or other Exhibition." The tragedy of the sculptor, Professor Rubek, in When We Dead Awaken, is that he so utterly aestheticized the woman who loved him and who was his model that she was not a person to him. As she says, "The work of art first-then the human being." It may even be-and I say this with the utmost hesitation, since I have no wish to sink in these muddy waters-that this is the theme of Antonioni's film, Blow-Up: the emptiness that comes from utter absorption in an aesthetic point of view of a photographer to whom every person and every event seems to represent only the possibility of a new photographic image. In that respect, Antonioni's photographer is certainly worse than Professor Rubek.

The mere confrontation of these two vague and general social philosophies of art will not, of course, take us very far in understanding the possibilities and the limitations of the aesthetic point of view. I leave matters unresolved, with questions hanging in the air. Whatever resolution we ultimately find, however, will surely incorporate two observations that may serve as a pair of conclusions.

First, there are occasions on which it would be wrong to adopt the aesthetic point of view, because there is a conflict of values and the values that are in peril are, in that particular case, clearly higher. Once in a while you see a striking photograph or film sequence in which someone is (for example) lying in the street after an accident, in need of immediate attention. And it is a shock to think suddenly that the photographer must have been on hand. I don't want to argue ethics of news photography, but if someone, out of the highest aesthetic motives, withheld first-aid to a bleeding victim in order to record the scene, with careful attention to lighting and camera speed, then it is doubtful that that picture could be so splendid a work of art as to justify neglecting so stringent a moral obligation.

The second conclusion is that there is nothing—no object or event that is *per se* wrong to consider from the aesthetic point of view. This, I think, is part of the truth in the art-for-art's-sake doctrine. To adopt the aesthetic point of view is simply to seek out a source of value. And it can never be a moral error to realize value—barring conflict with other values. Some people seem to fear that a serious and persistent aesthetic interest will become an enervating hyperaestheticism, a paralysis of will like that reported in advanced cases of psychedelic dependence. But the objects of aesthetic interest—such as harmonious design, good proportions, intense expressiveness—are not drugs, but part of the breath of life. Their cumulative effect is increased sensitization, fuller awareness, a closer touch with the environment and concern for what it is and might be. It seems to me very doubtful that we could have too much of these good things, or that they have inherent defects that prevent them from being an integral part of a good life.

Notes

1. New Republic (Jan. 16, 1961), p. 23. Cf. Brendan Gill, in The New Yorker (March 5, 1966): "It is a lot easier to recommend attendance at "The Gospel According to St. Matthew' as an act of penitential piety during the Lenten season than it is to praise the movie as a movie. Whether or not the life and death of Our Lord is the greatest story ever told, it is so far from being merely a story that we cannot deal with it in literary terms (if we could, I think we would have to begin by saying that in respect to construction and motivation it leaves much to be desired); our difficulty is enormously increased when we

try to pass judgment on the story itself once it has been turned into a screenplay."

2. From Gorky's essay on Lenin, *Collected Works*, XVII (Moscow, 1950), 39–40. My colleague Professor Olga Lang called my attention to this passage and translated it for me. Cf. *Days with Lenin* (New York: International Publishers, 1932), p. 52. *Time* (April 30, 1965, p. 50) reported that the Chinese Communists had forbidden the performance of Beethoven's works because they "paralyze one's revolutionary fighting will." A Chinese bacteriologist, in a letter to a Peking newspaper, wrote after listening to Beethoven, "I began to have strange illusions about a world filled with friendly love."

3. New York: Doubleday Anchor Books, 1954, p. 15, where he quotes Wotton.

4. In this discussion, I have been stimulated by an unpublished paper by J. O. Urmson on "Good of a Kind and Good from a Point of View," which I saw in manuscript in 1961. I should also like to thank him for comments on an earlier version of this paper. Cf. his note added to "What Makes a Situation Aesthetic?" in Joseph Margolis, ed., *Philosophy Looks at the Arts* [first edition] (New York: Charles Scribner's Sons, 1962), p. 26. I also note that John Hospers has some interesting remarks on the aesthetic point of view in "The Ideal Aesthetic Observer," *British Journal of Aesthetics*, II (1962), 99–111.

5. The New York Times, Oct. 2, 1967, p. 55.

6. Cf. my "Comments" on Stanley Cavell's paper, in W. H. Capitan and D. D. Merrill, eds., *Art, Mind, and Religion* (Pittsburgh: University of Pittsburgh Press, 1967), esp. pp. 107–109.

7. Op. cit., p. 89; cf. pp. 90–91, 95. In case it may be thought that architects who have the highest respect for their materials might repudiate my distinction, I quote Pier Luigi Nervi (in his Charles Eliot Norton lectures): "There does not exist, either in the past or in the present, a work of architecture which is accepted and recognized as excellent from the aesthetic point of view which is not also excellent from a technical point of view." From *Aesthetics and Technology in Building* (Cambridge: Harvard University Press, 1965), p. 2. Though arguing that one kind of value is a necessary (but not a sufficient) condition of the other, Nervi clearly assumes that there is a distinguishable aesthetic point of view.

8. The New York Times, April 2, 1967, p. 94.

9. Dec. 1966, p. 20.

10. Paul Taylor, Normative Discourse (Englewood Cliffs, N.J.: Prentice-Hall, Inc., 1961), p. 109.

11. See Aesthetics: Problems in the Philosophy of Criticism (New York: Harcourt, Brace & World, Inc., 1958), ch. 11.

12. See "Beardsley's Phantom Aesthetic Experience," Journal of Philosophy, LXII (1965), 129–136, and my "Aesthetic Experience Regained," Journal of Aesthetics and Art Criticism, XXVII (1969), 3–11.

13. "The Discrimination of Aesthetic Enjoyment," British Journal of Aesthetics, III (1963), 291-300.

14. In the Delaware County Daily Times (Chester, Pa.), Feb. 10, 1967.

15. It was discussed briefly in my *Aesthetics* (New York: Harcourt, Brace, & World, 1958), pp. 534–535, but has since been called to my attention more sharply and forcefully by Professor Thomas Regan.

16. L'Intuition Créatrice dans l'Art et dans la Poésie (Paris: Desclée de Brouwer, 1966), p. 53.

17. Hans Tischler, "The Aesthetic Experience," Music Review, XVII (1956), 200.

18. In K. Bharatha Iyer, ed., Art and Thought (London: Luzac, 1947), p. 138. I thank my colleague John Williams for calling my attention to this essay.

19. Ibid., p. 133.

20. Susan Sontag, "Notes on Camp," Partisan Review, XXXI (Fall 1964), 526.

21. The New York Times, May 4, 1966.

22. Sept. 23, 1967.

23. I set aside the somewhat indelicate verse by W. H. Auden, called "The Aesthetic Point of View."

Piece: Contra Aesthetics

TIMOTHY BINKLEY

I. What Is This Piece?

1. The term "aesthetics" has a general meaning in which it refers to the philosophy of art. In this sense, any theoretical writing about art falls within the realm of aesthetics. There is also a more specific and more important sense of the term in which it refers to a particular type of theoretical inquiry which emerged in the eighteenth century when the "Faculty of Taste" was invented. In this latter sense, "aesthetics" is the study of a specific human activity involving the perception of aesthetic qualities such as beauty, repose, expressiveness, unity, liveliness. Although frequently purporting to be a (or even the) philosophy of art, aesthetics so understood is not exclusively about art: it investigates a type of human experience (aesthetic experience) which is elicited by artworks, but also by nature and by non-artistic artifacts. The discrepancy is generally thought to be unimportant and is brushed aside with the assumption that if aesthetics is not exclusively about art, at least art is primarily about the aesthetic. This assumption, however, also proves to be false, and it is the purpose of this piece to show why. Falling within the subject matter of aesthetics (in the second sense) is neither a necessary nor a sufficient condition for being art.

2. Robert Rauschenberg erases a DeKooning drawing and exhibits it as his own work, "Erased DeKooning Drawing." The aesthetic properties of the original work are wiped away, and the result is not a nonwork, but another work. No important information about Rauschenberg's piece is presented in the way it *looks*, except perhaps *this* fact, that looking at it is artistically inconsequential. It would be a mistake to search for aestheti-

From The Journal of Aesthetics and Art Criticism, XXXV (1977), 265–277. Reprinted with the permission of the author and The Journal of Aesthetics and Art Criticism.

2.

The Nature of Aesthetic Interests

cally interesting smudges on the paper. The object may be bought and sold like an aesthetically lush Rubens, but unlike the Rubens it is only a souvenir or relic of its artistic meaning. The owner of the Rauschenberg has no privileged access to its artistic content in the way the owner of the Rubens does who hides the painting away in a private study. Yet the Rauschenberg piece is a work of art. Art in the twentieth century has emerged as a strongly self-critical discipline. It has freed itself of aesthetic parameters and sometimes creates directly with ideas unmediated by aesthetic qualities. An artwork is a piece: and a piece need not be an aesthetic object, or even an object at all.

3. This piece is occasioned by two works of art by Marcel Duchamp, *L.H.O.O.Q.* and *L.H.O.O.Q.* Shaved. How do I know they are works of art? For one thing, they are listed in catalogues. So I assume they are works of art. If you deny that they are, it is up to you to explain why the listings in a Renoir catalogue are artworks, but the listings in a Duchamp catalogue are not. And why the Renoir show is an exhibition of artworks, while the Duchamp show is not, and so forth. Anyway, whether the Duchamp pieces are works of art is ultimately inconsequential, as we shall see.

This piece is also, shall we say, about the philosophical significance of Duchamp's art. This piece is primarily about the concept "piece" in art; and its purpose is to reformulate our understanding of what a "work of art" is.

II. What Is L.H.O.O.Q.?

These are Duchamp's words:

This Mona Lisa with a moustache and a goatee is a combination readymade and iconoclastic Dadaism. The original, I mean the original readymade is a cheap chromo 8x5 on which I inscribed at the bottom four letters which pronounced like initials in French, made a very risque joke on the Gioconda.¹

Imagine a similar description of the *Mona Lisa* itself. Leonardo took a canvas and some paint and put the paint on the canvas in such-and-such a way so that—presto—we have the renowned face and its environs. There is a big difference between this description and Duchamp's description. The difference is marked by the unspecified "such-and-such" left hanging in the description of Leonardo's painting. I could, of course, go on indefinitely describing the look of the *Mona Lisa*, and the fidelity with which your imagination reproduced this look would depend upon such things as how good my description is, how good your imagination is, and chance. Yet regardless of how precise and vivid my description is, one

thing it will never do is acquaint you with the painting. You cannot claim to know that work of art on the basis of reading the most exquisite description of it, even though you may learn many interesting things *about* it. The way you come to know the *Mona Lisa* is by looking at it or by looking at a decent reproduction of it. The reason reproductions count is not that they faithfully reproduce the work of art, but rather because what the work of art is depends fundamentally upon how it looks. And reproductions can do a more or less acceptable job of duplicating (or replicating) the salient features of the appearance of a painting. This does not mean that a person is entitled to limit his or her aesthetic judgments to reproductions. What it means is that you can't say much about a painting until you know how it looks.

Now reconsider the description of Duchamp's piece: *L.H.O.O.Q.* is a reproduction of the Mona Lisa with a moustache, goatee, and letters added. There is no amorphous "such-and-such" standing for the most important thing. The description tells you what the work of art is; you now know the piece without actually having seen it (or a reproduction of it). When you do see the artwork there are no surprises: Yes, there is the reproduction of the *Mona Lisa*; there is the moustache, the goatee; there are the five letters. When you look at the artwork you learn nothing of artistic consequence which you don't already know from the description Duchamp gives, and for this reason it would be pointless to spend time attending to the piece as a connoisseur would savor a Rembrandt. Just the opposite is true of the *Mona Lisa*. If I tell you it is a painting of a woman with an enigmatic smile, I have told you little about the work of art since the important thing is how it *looks*; and that I can only *show* you, I cannot tell you.

This difference can be elucidated by contrasting ideas and appearances. Some art (a great deal of what is considered traditional art) creates primarily with appearances. To know the art is to know the look of it; and to know that is to experience the look, to perceive the appearance. On the other hand, some art creates primarily with ideas.² To know the art is to know the idea; and to know an idea is not necessarily to experience a particular sensation, or even to have some particular experience. This is why you can know L.H.O.O.Q. either by looking at it or by having it described to you. (In fact, the piece might be better or more easily known by description than by perception.) The critical analysis of appearance, which is so useful in helping you come to know the Mona Lisa, bears little value in explaining L.H.O.O.Q. Excursions into the beauty with which the moustache was drawn or the delicacy with which the goatee was made to fit the contours of the face are fatuous attempts to say something meaningful about the work of art. If we do look at the piece, what is important to notice is that there is a reproduction of the Mona Lisa, that a moustache

has been added, etc. It hardly matters exactly *how* this was done, how it looks. One views the *Mona Lisa* to see what it looks like, but one approaches Duchamp's piece to obtain information, to gain access to the thought being expressed.

III. What Is L.H.O.O.Q. Shaved?

Duchamp sent out invitations to preview the show called "Not Seen and/ or Less Seen of/by Marcel Duchamp/Rrose Selavy 1904-64: Mary Sisler Collection." On the front of the invitation he pasted a playing card which bears a reproduction of the *Mona Lisa*. Below the card is inscribed, in French, "L.H.O.O.Q. Shaved." This piece looks like the *Mona Lisa* and the *Mona Lisa* looks like it: since one is a reproduction of the other, their aesthetic qualities are basically identical.³ Differences in how they look have little, if any, artistic relevance. We do not establish the identity of one by pointing out where it looks different from the other. This is due to the fact that Duchamp's piece does not articulate its artistic statement in the language of aesthetic qualities. Hence, its aesthetic properties are as much a part of *L.H.O.O.Q. Shaved* as a picture of a mathematician in an algebra book is part of the mathematics.

Appearances are insufficient for establishing the identity of a work of art if the point is not in the appearance. And if the point is in the appearance, how do we establish that? What is to keep a Duchamp from stealing the look for ulterior purposes? Here occurs the limit of the ability of aesthetics to cope with art, since aesthetics seeks out appearances. To see why and how, we need to examine the nature of aesthetics.

IV. What Is Aesthetics?

1. *The Word.* The term "aesthetics" has come to denote that branch of philosophy which deals with art. The word originated in the eighteenth century when Alexander Gottlieb Baumgarten adopted a Greek word for perception to name what he defined to be "the science of perception."⁴ Relying upon a distinction familiar to "the Greek philosophers and the Church fathers," he contrasted things perceived (aesthetic entities) with things known (noetic entities), delegating to "aesthetics" the investigation of the former. Baumgarten then gathered the study of the arts under the aegis of aesthetics. The two were quickly identified and "aesthetics" became "the philosophy of art" in much the way "ethics" is the philosophy of morality.

2. Aesthetics and Perception. From the outset aesthetics has been devoted to the study of "things perceived," whether reasoning from the "aesthetic attitude" which defines a unique way of perceiving, or from the "aesthetic object" of perception. The commitment to perceptual experience was deepened with the invention of the Faculty of Taste by

eighteenth-century philosophers anxious to account for the human response to Beauty and to other aesthetic qualities. The Faculty of Taste exercises powers of discrimination in aesthetic experiences. A refined person with highly developed taste is enabled to perceive and recognize sophisticated and subtle artistic expressions which are closed to the uncultured person with poorly developed taste. This new faculty was characterized by its operation in the context of a special "disinterested" perception, a perception severed from self interest and dissociated from so-called "practical concerns." The development of the concept of disinterestedness reinforced the perceptual focus of aesthetics, since removing "interest" from experience divests it of utility and invests its value in immediate awareness. An aesthetic experience is something pursued "for its own sake." Eventually aesthetics came to treat the object of aesthetic perception as a kind of illusion since its "reality"-i.e., the reality of disinterested perceptionstands disconnected from the reality of practical interest. The two realities are incommensurable: The cows in Turner's paintings can be seen, but not milked or heard.

It is important to note that aesthetics is an outgrowth of the ancient tradition of the philosophy of the Beautiful. Beauty is a property found in both art and nature. A man is beautiful; so is his house and the tapestries hung inside. Aesthetics has continued the tradition of investigating a type of experience which can be had in the presence of both natural and created objects. As a result, aesthetics has never been strictly a study of artistic phenomena. The scope of its inquiry is broader than art since aesthetic experience is not an experience unique to art. This fact has not always been sufficiently emphasized, and as a result aesthetics frequently appears in the guise of philosophy-of-art-in-general.

As aesthetics and the philosophy of art have become more closely identified, a much more serious confusion has arisen. The work of art has come to be construed as an aesthetic object, an object of perception. Hence the meaning and essence of all art is thought to inhere in appearances, in the looks and sounds of direct (though not necessarily unreflective) awareness. The first principle of philosophy of art has become: all art possesses aesthetic qualities, and the core of a work is its nest of aesthetic qualities. This is why "aesthetics" has become just another name for the philosophy of art. Although it is sometimes recognized that aesthetics is not identical to the philosophy of art, but rather a complementary study, it is still commonly assumed that all art is aesthetic in the sense that falling within the subject matter of aesthetics is at least a necessary (if not a sufficient) condition for being art.⁵ Yet as we shall see, being aesthetic is neither a necessary nor a sufficient condition for being art.

Devotees of modern aesthetics may believe that Baumgarten's "science of perception" is a moribund enterprise befitting only pre-Modern aesthetics rapt in pursuit of ideal Beauty. Yet a survey of contemporary aesthetic theory will prove that this part of philosophy still accepts its *raison d'être* to be a perceptual entity—an appearance—and fails to recognize sufficiently the distinction between "aesthetics" in the narrow sense and the philosophy of art. In his essay "Aesthetic and Non-Aesthetic," Frank Sibley has articulated this commitment to perception:

It is of importance to note first that, broadly speaking, aesthetics deals with a kind of perception. People have to *see* the grace of unity of a work, *hear* the plaintiveness or frenzy in the music, *notice* the gaudiness of a color scheme, *feel* the power of a novel, its mood, or its uncertainty of tone . . . the crucial thing is to see, hear, or feel. To suppose indeed that one can make aesthetic judgements without aesthetic perception . . . is to misunderstand aesthetic judgement.⁶

Despite the many new directions taken by the philosophy of art in the twentieth century, it is still practised under the guidance of aesthetic inquiry, which assumes that the work of art is a thing perceived.

The reason aesthetic qualities must be perceived in order to be judged is that they inhere in what Monroe Beardsley has called the "perceptual object": "A perceptual object is an object some of whose qualities, at least, are open to direct sensory awareness."⁷ This he contrasts with the "physical basis" of aesthetic qualities, which "consists of things and events describable in the vocabulary of physics."⁸ Hence the work of art turns out to be an entity possessed of two radically different aspects, one aesthetic and the other physical:

When a critic . . . says that Titian's later paintings have a strong atmospheric quality and vividness of color, he is talking about aesthetic objects. But when he says that Titian used a dark reddish underpainting over the whole canvas, and added transparent glazes to the painting after he laid down the pigment, he is talking about physical objects.⁹

This "aesthetic object" is taken by the philosophy of art to be its subject of study. Appearances are paramount, from expressionist theories which construe the artwork as an "imaginary object" through which the artist has articulated his or her "intuition," to formalist theories which venerate perceptual form.¹⁰ Clive Bell's "significant form" is clearly a perceptual form since it must be perceived and arouse the "aesthetic emotion" before it functions artistically.¹¹ Susanne Langer has christened aesthetic appearances "semblances," and has undertaken what is probably the most exten-

sive investigation of artistic semblance in her book *Feeling and Form*. Aesthetics perceives all the arts to be engaged in the creation of some kind of semblance or artistic "illusion" which presents itself to us for the sake of its appearance.

It has been difficult, however, to maintain a strictly perceptual interpretation of the aesthetic "appearance." Literature is the one major art form which does not easily accommodate the perceptual model of arthood. Although we perceive the printed words in a book, we do not actually perceive the literary work which is composed with intangible linguistic elements. Yet as Sibley points out, the reader will "feel the power of a novel, its mood, or its uncertainty of tone," so that its aesthetic qualities are at least *experienced* through reading if not actually perceived by one of the senses. There are various things we experience without perceiving them. Like an emotion, the power of a novel is "felt" without its being touched or heard or seen. Thus, although it will not be quite correct to say that one cannot know the aesthetic qualities of a novel without "direct perceptual access," it is true that one cannot know them without directly experiencing the novel by reading it. This rules out the possibility of coming to know a literary work by having it described to you (as one may very well come to know L.H.O.O.Q.). Just as you must look at the particular object constituting a painting, you must read the particular words comprising a novel in order to judge it aesthetically. Hence, although perception is the paradigm of aesthetic experience, an accurate aesthetic theory will locate aesthetic qualities more generally in a particular type of experience (aesthetic experience) so that literature can be included.

3. The Theory of Media. What does it mean to have the requisite "direct experience" of an aesthetic object? How do you specify what it is that one must experience in order to know a particular artwork? Here we encounter a problem. Aesthetic qualities cannot be communicated except through direct experience of them. So there is no way of saying just what the aesthetic qualities of a work are independently of experiencing them. As Isabel Hungerland puts it, there are no intersubjective criteria for testing the presence of aesthetic qualities.¹² This is why one cannot communicate the Mona Lisa by describing it. It is impossible to establish criteria for identifying artworks which are based on their aesthetic qualities. And this is the point where aesthetics needs the concept of a medium. Media are the basic categories of art for aesthetics, and each work is identified through its medium. Let's see how this is done.

In recent aesthetics, the problem of the relationship between the aesthetic and the non-aesthetic properties of an object has been much discussed. Whatever the particular analysis given, it is generally conceded that aesthetic qualities *depend* in some way upon non-aesthetic qualities.¹³ There is no guarantee that a slight change in color or shape will leave the aesthetic qualities of a painting unaffected, and this is why reproductions often have aesthetic qualities different from those of the original.¹⁴ Changing what Beardsley calls the "physical" properties, however slightly, can alter those features of a work of art which are experienced in the "aesthetic experience" of the object. Aesthetic objects are vulnerable and fragile, and this is another reason why it is important to have identity criteria for them.

Since aesthetic qualities depend on non-aesthetic qualities, the identity of an aesthetic artwork can be located through conventions governing its non-aesthetic qualities. These conventions determine the non-aesthetic parameters which must remain invariant in identifying particular works. A medium is not simply a physical material, but rather a network of such conventions which delimits a realm over which physical materials and aesthetic qualities are mediated. For example, in the medium of painting there is a convention which says that the paint, but not the canvas, stretcher, or frame, must remain invariant in order to preserve the identity of the artwork. On the other hand, paint is not a conventional invariant in the art of architecture but is applied to buildings (at least on the inside) according to another art, interior decorating. The same architectural work could have white walls or pink walls, but a painting could not have its white clouds changed to pink and still remain the same painting. Similarly, the medium of painting is invariant through modifications of the frame holding a painting, while a building is not invariant through modifications in, say, the woodwork. Moving a Rubens from an elaborate Baroque frame into a modern Bauhaus frame will not change the work of art, but making a similar change in the woodwork of a building will change, however slightly, the architectural work.

In its network of conventions, each artistic medium establishes nonaesthetic criteria for identifying works of art. By being told which medium a work is in, we are given the parameters within which to search for and experience its aesthetic qualities. As we watch a dance, we heed how the dancers move their bodies. As we watch a play on the same stage, we concentrate instead on what is being acted out. Treating a piece of writing as a poem will make us focus on different non-aesthetic features than if we approach it as a short story: when the type is set for a poem the individual lines are preserved, as they are not in a short story. Thus Susanne Langer's characterization of media in terms of the particular type of semblance they create is pointed in the wrong direction. She holds that painting creates the illusion of space, music the illusion of the passage of time, etc. Yet it is not the "content" of an aesthetic illusion which determines the medium. Before we can tell whether something presents a semblance

of space, we have to know where to look for the semblance; and this we know by understanding the conventions, i.e., the medium, within which the thing is proffered for aesthetic experience. Anything that can be seen can be seen aesthetically, i.e., it can be viewed for the sake of discerning its aesthetic qualities. The reason we know to look at the aesthetic qualities on the front of a painting is not because the back lacks aesthetic qualities, but rather because the conventions of painting tell us to look there. Even if the back of a painting looks more interesting than the front, the museum director is nevertheless required to hang the painting in the conventional way with the front out. The medium tells you what to experience in order to know the aesthetic artwork.

In the twentieth century we have witnessed a proliferation of new media. A medium seems to emerge when new conventions are instituted for isolating aesthetic qualities differently on the basis of new materials or machines. Film became an artistic medium when its unique physical structure was utilized to identify aesthetic qualities in a new way. The film maker became an artist when he or she stopped recording the creation of the playwright and discovered that film has resources for creation which theater lacks. The aesthetic qualities that can be presented by a film photographed from the orchestra and obedient to the temporal structure of the play are, basically, the aesthetic properties of the play itself. But when the camera photographs two different actions in two different places at two different times, and the images end up being seen at the same time and place, aesthetic properties can be realized which are inaccessible to theater. A new convention for specifying aesthetic properties has emerged. We say "See this film" instead of "See this play." In each case, what you look for is determined by the conventions of the medium.

The aesthetic theory of media has given rise to an analogy which seems to be gaining acceptance: a work of art is like a person. The dependence of aesthetic qualities on non-aesthetic ones is similar to the dependence of character traits on the bodily dispositions of persons. As Joseph Margolis has put it, works of art are *embodied* in a physical object (or physical event) in much the way a person is embodied in a human body:

To say that a work of art is embodied in a physical object is to say that its identity is necessarily linked to the identity of the physical object in which it is embodied, though to identify the one is not to identify the other; it is also to say that, *qua* embodied, a work of art must possess properties other than those ascribed to the physical object in which it is embodied, though it may be said to possess (where relevant) the properties of that physical object as well. Also, *if* in being embodied, works of art are, specifically, *emergent entities*, then the properties that a work of art possesses will include properties of a kind that cannot appropriately be ascribed to the object in which it is embodied.¹⁵

The "emergent" entities of aesthetic art are aesthetic qualities which are accessible only through direct experience. The aesthetic and physical properties of the artwork fuse into a person-like whole, the former constituting the "mind," the latter the "body" of the work. When we want to locate a person we look for his or her body—likewise, when we want to locate an artwork we look for its "body," namely the physical material in which it is embodied, as delimited by the conventions of media.

Although not universally accepted, this person analogy appears frequently in aesthetic theory because it provides a suitable model for understanding the artwork as a single entity appealing to two markedly different types of interest. It explains, for example, the basis of the connection between Beauty and Money.

The analogy has recently been carried to the extent of claiming that works of art, like persons, have rights.¹⁶ To deface a canvas by Picasso or a sculpture by Michelangelo is not only to violate the rights of its owner, but also to violate certain rights of the work itself. The work is a person; to mar the canvas or marble is to harm this person. So we see that aesthetic works of art are also mortal. Like people, they age and are vulnerable to physical deterioration.

4. Art and Works. Aesthetics has used the conventions of media to classify and identify artworks, but its vision of the nature of art does not adequately recognize the thoroughly conventional structure within which artworks appear. This is because aesthetics tends to view a medium as a kind of substance (paint, wood, stone, sound, etc.) instead of as a network of conventions.

Its preoccupation with perceptual entities leads aesthetics to extol and examine the "work of art," while averting its attention almost entirely from the myriad other aspects of that complex cultural activity we call "art." In other words, art for aesthetics is fundamentally a class of things called works of art which are the sources of aesthetic experience. To talk about art is to talk about a set of objects. To define art is to explain membership in this class. Thus we frequently find aesthetic discussions of the question "What is art?" immediately turning to the question "What is a work of art?" as though the two questions are unquestionably identical. Yet they are not the same.

What counts as a work of art must be discovered by examining the practice of art. Art, like philosophy, is a cultural phenomenon, and any particular work of art must rely heavily upon its artistic and cultural context in communicating its meaning. *L.H.O.O.Q. Shaved* looks as much like

the *Mona Lisa* as any reproduction of it does, but their artistic meanings could hardly be more different. Just as I cannot tell you what the word "rot" means unless you say whether it is English or German, I cannot explain the meaning of a painting without viewing it immersed in an artistic milieu. The shock value of Manet's *Olympia*, for example, is largely lost on modern audiences, although it can be recovered by studying the society in which the painting emerged. Even so simple a question as what a painting represents cannot be answered without some reference to the conventions of depiction which have been adopted. Whether a smaller patch of paint on the canvas is a smaller person or a person farther away—or something else—is determined by conventions of representation. The moribund prejudice against much of the "unrealistic" art of the past comes from misjudging it according to standards which are part of the alien culture of the present.

Thus trying to define "art" by defining "work of art" is a bit like trying to define philosophy by saying what constitutes a philosophy book. A work of art cannot stand alone as a member of a set. Set membership is not the structure of that human activity called art. To suppose we can examine the problem of defining art by trying to explain membership in a class of entities is simply a prejudice of aesthetics, which underplays the cultural structure of art for the sake of pursuing perceptual objects. Yet even as paradigmatic an aesthetic work as the *Mona Lisa* is a thoroughly cultural entity whose artistic and aesthetic meanings adhere to the painting by cultural forces, not by the chemical forces which keep the paint intact for a period of time.

As media proliferated, the aesthetic imperatives implied in their conventions weakened. Art has become increasingly non-aesthetic in the twentieth century, straining the conventions of media to the point where lines between them blur. Some works of art are presented in "multi-media," others (such as Duchamp's) cannot be placed within a medium at all. The concept of a medium was invented by aesthetics in order to explain the identity of artworks which articulate with aesthetic qualities. As art questions the dictates of aesthetics, it abandons the conventions of media. Let us see why.

V. Art Outside Aesthetics

Art need not be aesthetic. L.H.O.O.Q. Shaved makes the point graphic by duplicating the appearance of the Mona Lisa while depriving it of its aesthetic import. The two works look exactly the same but are completely different. As the risque joke is compounded by L.H.O.O.Q. Shaved, the Mona Lisa is humiliated. Though restored to its original appearance, it is not restored to its original state. Duchamp added only the moustache and goatee, but when he removed them the sacred aura of aesthetic qualities

vanished as well-it had been a conventional artistic covering which adhered to the moustache and goatee when they were removed, like paint stuck to tape. The original image is intact but literalized; its function in Duchamp's piece is just to denote the Mona Lisa. L.H.O.O.Q. looked naughty, graffiti on a masterpiece. It relies upon our seeing both the aesthetic aura and its impudent violation. But as its successor reinstates the appearance, the masterpiece is ironically ridiculed a second time with the disappearance of the dignity which made L.H.O.O.Q. a transgression. The first piece makes fun of the Gioconda, the second piece destroys it in the process of "restoring" it. L.H.O.O.Q. Shaved re-indexes Leonardo's artwork as a derivative of L.H.O.O.O., reversing the temporal sequence while literalizing the image, i.e., discharging its aesthetic delights. Seen as "L.H.O.O.Q. shaved," the image is sapped of its artistic/aesthetic strength -it seems almost vulgar as it tours the world defiled. This is because it is placed in a context where its aesthetic properties have no meaning and its artistic "person" is reduced to just another piece of painted canvas.

It has already been pointed out that one can know the work *L.H.O.O.Q.* without having any direct experience of it, and instead by having it described. This it shares with a great deal of recent art which eschews media. When Mel Bochner puts lines on a gallery wall to measure off the degrees of an arc, their purpose is to convey information, not to proffer aesthetic delights. The same is true of On Kawara's "I GOT UP" postcards, which simply note his time of rising each day.¹⁷ What you need to see, to experience, in order to know this art is subject to intersubjective tests—unlike aesthetic art—and this is why description will sometimes be adequate in communicating the artwork.

When Duchamp wrote "L.H.O.O.Q." beneath the image of the Mona Lisa, he was not demonstrating his penmanship. The beauty of a script depends upon aesthetic properties of its line. The meaning of a sentence written in the script, however, is a function of how the lines fit into the structure of an alphabet. Aesthetics assumes that artistic meaning must be construed according to the first type of relation between meaning and line, but not the second. It mistakes the experience of aesthetic qualities for the substance of art. Yet the remarkable thing about even aesthetic art is not its beauty (or any other of its aesthetic qualities), but the fact that it is human-created beauty articulated in a medium.

The flaw in aesthetics is this: how something looks is partly a function of what we bring to it, and art is too culturally dependent to survive in the mere look of things. The importance of Duchamp's titles is that they call attention to the cultural environment which can either sustain or suffocate the aesthetic demeanor of an object. Duchamp's titles do not name objects; they put handles on things. They call attention to the artistic

framework within which works of art are indexed by their titles and by other means. The culture infects the work.

A great deal of art has chosen to articulate in the medium of an aesthetic space, but there is no a priori reason why art must confine itself to the creation of aesthetic objects. It might opt for articulation in a semantic space instead of an aesthetic one so that artistic meaning is not embodied in a physical object or event according to the conventions of a medium. Duchamp has proven this by creating non-aesthetic art, i.e., art whose meaning is not borne by the appearance of an object. In particular, the role of line in L.H.O.O.Q. is more like its role in a sentence than in a drawing or painting.¹⁸ This is why the appearance of the moustache and goatee are insignificant to the art. The first version of L.H.O.O.Q. was executed not by Duchamp, but by Picabia on Duchamp's instructions, and the goatee was left off. It would be an idle curiosity to speculate about whose version is better or more interesting on the basis of how each looks. The point of the artwork cannot be ascertained by scrutinizing its appearance. It is not a person-like union of physical and perceptual qualities. Its salient artistic features do not depend upon non-aesthetic qualities in the sense of being embodied in them. The aesthetic qualities of L.H.O.O.Q., like the aesthetic qualities of Rauschenberg's erased DeKooning, are not offered up by the artist for aesthetic delectation, but rather are incidental features of the work like its weight or its age. Line is perceived in Duchamp's piece just as it is in a sentence in a book, and in both cases we can descry the presence of aesthetic qualities. But the point of neither can be read off its physiognomy. The lines are used to convey information, not to conjure up appearances; consequently the relationship of meaning to material is similar to what it is in a drawing of a triangle in a geometry book.

If an artwork is a person, Duchamp has stripped her bare of aesthetic aura. *L.H.O.O.Q.* treats a person as an object by means of the joke produced by reading the letters in French. It also treats an artwork as a "mere thing." The presence of the moustache violates the *Mona Lisa*'s aesthetic rights and hence violates the artwork "person." In making fun of these persons, Duchamp's piece denies its own personhood.

Aesthetics is limited by reading the artwork on the model of a person. Some person-like entities are works of art, but not all artworks are persons. If not a person, what is an artwork?

VI. What Is an Artwork?

An artwork is a piece. The concept "work of art" does not isolate a class of peculiar aesthetic personages. The concept marks an indexical function in the artworld. To be a piece of art, an item need only be indexed as an artwork by an artist. Simply recategorizing an unsuspecting

entity will suffice. Thus "Is it art?" is a question of little interest. The question is "So what if it is?" Art is an epiphenomenon over the class of its works.¹⁹

The conventions of titling works of art and publishing catalogues facilitate the practice of indexing art. However, it is important to distinguish between the artist's act of indexing by creating and the curator's act of indexing by publishing the catalogue. It is the former act which makes art; the latter act usually indexes what is already art under more specific headings, such as works by a certain artist, works in a particular show, works owned by a person or a museum, etc. To make art is, basically, to isolate something (an object, an idea, . . .) and say of it, "This is a work of art," thereby cataloguing it under "Artworks." This may seem to devolve responsibility for arthood upon the official creators of art called artists, and the question of determining arthood turns into a question of determining who the artists are. But this wrongly places emphasis upon entities again, overshadowing the practice of art. Anyone can be an artist. To be an artist is to utilize (or perhaps invent) artistic conventions to index a piece. These might be the conventions of a medium which provide for the indexing of an aesthetic piece by means of non-aesthetic materials. But even the aesthetic artist has to stand back from the painting or play at a certain point and say "That's it. It's done." This is the point where the artist relies upon the basic indexing conventions of art. The fundamental art-making (piece-making) act is the specification of a piece: "The piece is _____ Putting paint on canvas-or making any kind of product-is just one way of specifying what the work of art is. When Duchamp wrote "L.H.O.O.Q." below the reproduction, or when Rauschenberg erased the DeKooning, it was not the work (the labor) they did which made the art. A work of art is not necessarily something worked on; it is basically something conceived. To be an artist is not always to make something, but rather to engage in a cultural enterprise in which artistic pieces are proffered for consideration. Robert Barry once had an exhibition in which nothing was exhibited:

My exhibition at the Art & Project Gallery in Amsterdam in December, '69, will last two weeks. I asked them to lock the door and nail my announcement to it, reading: "For the exhibition the gallery will be closed."²⁰

The fact that someone could be an artist by just christening his or her radio or anxiety to be an artwork may seem preposterous. However, the case of the Sunday Painter who rarely shows his or her paintings to anyone is not substantially different. We need to beware of confusing issues about arthood with issues about good or recognized arthood. The amateur

indexer may index trivially, and the effortlessness of the task will only seem to compound the artistic inconsequence. But things are not so different when the Sunday Painter produces a few terrible watercolors which are artistically uninteresting. Despite their artistic failures, both the casual indexer and the casual painter are still artists, and the pieces they produce are works of art, just as the economics student's term paper is a piece of economics, however naive or poorly done. Simply by making a piece, a person makes an artistic "statement"; good art is distinguished by the interest or significance of what it says. Of course, interesting art, like interesting economics, is usually produced by people who, in some sense, are considered "professionals." Thus there are senses of "artist" and "economist" which refer to people who pursue their disciplines with special dedication. But what these "professionals" do is no different from what the amateurs do; it is just a difference in whether the activity is selected as a vocation. This shows that the question "Is that person an artist?" like the question "Is that thing an artwork?" is not a question with great artistic import.

A useful analogy is suggested. Art is a practised discipline of thought and action, like mathematics, economics, philosophy, or history. The major difference between art and the others is that doing art is simply employing indexing conventions defined by the practice. The reason for this is that the general focus of art is creation and conception for the sake of creation and conception, and consequently the discipline of art has devised a piecemaking convention which places no limits on the content of what is created. In other words, art, unlike economics, has no general subject matter. The artworld develops and evolves through a complex network of interrelated interests, so it does have the general structure of a "discipline." But part of the recent history of art includes the loosening of conventions on what can be art until they are purely "formal." The wider use of the term "piece" instead of "work" reflects this liberalization, as does the decreasing importance of media. "Work of art" suggests an object. "Piece" suggests an item indexed within a practice. There are many kinds of "pieces," differing according to the practices they are indexed within. A "piece" could be a piece of mathematics or economics or art; and some pieces may be addressed to several disciplines. An artwork is just a piece (of art), an entity specified by conventions of the practice of art.

This view of art has one very important point of difference with aesthetics. Media are set up to identify works extensionally. Joseph Margolis relies on this idea when he argues that the identity of an artwork depends upon the identity of the physical object in which it is embodied:

So works of art are said to be the particular objects they are, in *intensional contexts*, although they may be identified, by the linkage

of embodiment, through the identity of what may be identified *in* extensional contexts. That is, works of art are identified extensionally, in the sense that their identity (whatever they are) is controlled by the identity of what they are embodied in. \dots^{21}

Some difficulties for this view are already suggested by Duchamp's "double painting," a single stretcher with Paradise painted on one side and The King and Queen Surrounded by Swift Nudes on the other. The decisive cases, however, are found among artworks which are produced merely by indexing, such as Duchamp's readymades. Indexes index their items intensionally: from the fact that "the morning star" occurs in an index, one cannot infer that "the evening star" occurs there also, even though the two expressions denote the same object. L.H.O.O.Q. Shaved could, for the sake of argument, be construed as residing in the same physical object as the Mona Lisa itself. Then there is one extensionally specified object, but two intensionally specified artworks. Rauschenberg has suggested this possibility since the only things of substance he changed by erasing the DeKooning drawing were aesthetic qualities. To complete the cycle in the way Duchamp did, Rauschenberg should buy a DeKooning painting and exhibit it in his next show: "Unerased DeKooning." The point is that artworks are identified intensionally, not extensionally. The reason L.H.O.O.Q. Shaved and the Mona Lisa are different artworks is not that they are different objects, but rather that they are different ideas. They are specified as different pieces in the art practice.

That an artwork is a piece and not a person was established by the Readymade. Duchamp selected several common objects and converted them into art simply by indexing them as artworks. Sometimes this was accomplished in conjunction with explicit indexing ceremonies, such as signing and dating a work, giving it a title, entering it in a show. But always what separates the readymade artwork from the "readymade" object it was ready-made from is a simple act of indexing. Duchamp says, "A point I want very much to establish is that the choice of these Readymades was never dictated by aesthetic delectation. The choice was based on a reaction of visual indifference with a total absence of good or bad taste."22 The Readymade demonstrates the indexical nature of the concept "work of art" by showing that whether something is an artwork is not determined by its appearance but by how it is regarded in the artworld. The same shovel can be a mere hardware item at one time and an artwork at another depending upon how the artworld stands in relation to it. Even an old work of art can be converted into a new one without changing the appearance of the old work, but only "creating a new idea for it," as Duchamp has said of the urinal readymade called Fountain. The significance of the title of this piece has not been fully appreciated. A urinal is a fountain;

that is, it is an object designed for discharging a stream of water. The reason most urinals are *not* fountains, despite their designs, is that their locations and use differ from similar devices we do consider fountains. The objects are structurally similar, but their cultural roles are very different. Putting a urinal in a gallery makes it visible as a "fountain" and as a work of art because the context has been changed. Cultural contexts endow objects with special meanings; and they determine arthood.²³

It has been pointed out that Fountain was accepted as a work of art only because Duchamp had already established his status as an artist by producing works in traditional forms. This is probably true: not just anyone could have carried it off. You cannot revolutionize the accepted conventions for indexing unless you have some recognition in the artworld already. However, this does not mean that Duchamp's piece is only marginal art and that anyone desiring to follow his act of indexing has to become a painter first. When Duchamp made his first non-aesthetic work, the conventions for indexing artworks were more or less the media of aesthetics: to make an artwork was to articulate in a medium. Duchamp did not simply make an exception to these conventions, he instituted a new convention, the indexing convention which countenances non-aesthetic art, though perhaps it should be said rather that Duchamp uncovered the convention, since it lies behind even the use of media, which are specialized ways of indexing aesthetic qualities. In any event, once the new convention is instituted anyone can follow it as easily as he or she can follow the indexing conventions of aesthetics. The Sunday Indexer can have just as good a time as the Sunday Painter.

VII. Duchamp's Legacy

Because of Duchamp's wit and humor, it was easy at first to dismiss his art, or maybe just to be confused by it. Yet it is not trivial because it is funny. With the art of Duchamp, art emerged openly as a practice. His *Large Glass*, whose meaning is inaccessible to anyone who merely examines the physical object, stands as the first monument to an art of the mind.

This kind of art developed historically; it is not an anomaly. Probably it originates in what Clement Greenberg calls "Modernism," whose characteristic feature is self-criticism. Like philosophy, art developed to the point where a critical act about the discipline (or part of it) could be part of the discipline itself. Once embarked on self-scrutiny, art came to realize that its scope could include much more than making aesthetic objects. It is a practice, which is why jokes about art can be art in the way jokes about philosophy can be philosophy. Art is a practice which can be characterized about as well and as usefully as philosophy can be. Defining art is not likely to be a very interesting pursuit. An artwork is a piece indexed within conventions of this practice, and its being an artwork is determined not by its properties, but by its location in the artworld. Its properties are used to say *what* the particular work is.

If art must be aesthetic, the tools of the art-indexer must be media, whether mixed or pure. To make a work of art is to use a medium to join together literal physical qualities and created aesthetic qualities. An aesthetic person is born in the intercourse.

Aesthetics treats aesthetic experience, not art. Anything, from music to mathematics, can be seen aesthetically. This is the basis for the traditional preoccupation of aesthetics with Beauty, a quality found in both art and nature. Aesthetics deals with art and other things under the heading of aesthetic experience. Conversely, not all art is aesthetic. Seeing its marriage to aesthetics as a forced union, art reaches out to find meaning beyond skin-deep looks. The indexers create with ideas. The tools of indexing are the languages of ideas, even when the ideas are aesthetic.

Notes

1. Quoted from *Marcel Duchamp*, catalogue for the show organized by the Museum of Modern Art and the Philadelphia Museum of Art, edited by Anne d'Harnoncourt and Kynaston McShine (New York: Museum of Modern Art; Philadelphia, Philadelphia Museum of Art, 1973), p. 289. When pronounced in French, the letters produce a sentence meaning "She has a hot ass."

2. For numerous examples see Lucy Lippard, Six Years: The Dematerialization of the Art Object from 1966 to 1972 (New York, 1973). There is no sharp dichotomy between idea art and appearance art. Most traditional art is concerned with ideas, even though they may be expressed visually.

3. One might even consider the *Mona Lisa* an instance of L.H.O.O.Q.Shaved. Duchamp refers to the earlier piece L.H.O.O.Q as "this Mona Lisa with a moustache and goatee. . . ."

4. See Alexander Gottlieb Baumgarten, *Reflections on Poetry*, trans. Karl Aschenbrenner and William B. Holther (Berkeley, 1954), p. 78. The translators translate *scientia cognitionis sensitivae* as "the science of perception." Monroe Beardsley gives a somewhat more precise translation: "the science of sensory cognition." See his *Aesthetics from Classical Greece to the Present* (New York, 1966), p. 157. For useful discussions of the emergence of "aesthetics" in eighteenth-century philosophy, see Beardsley's history and also George Dickie, *Aesthetics: An Introduction* (New York, 1971).

5. George Dickie expresses what is occasionally realized: "The concept of art is certainly related in important ways to the concept of the aesthetic, but the aesthetic cannot completely absorb art." (See *Aesthetics: An Introduction*, p. 2.) However, it turns out that one way art is related to aesthetics is that both the philosophy of art and the philosophy of criticism, like aesthetics itself, are grounded in what Dickie calls "aesthetic experience." (See the diagram on p. 45 of *Aesthetics*.) It seems that for Dickie, what differentiates aesthetics

from the other two is simply the manner in which each studies aesthetic experience. See also his *Art and the Aesthetic* (Ithaca, 1974). Dickie takes a very important first step in distinguishing the concepts "art" and "aesthetics," but his search for a definition of "work of art" seems to me to follow an aesthetic development based upon the notion of "appreciation." Dickie's views are discussed at greater length in my essay "Deciding about Art: A Polemic against Aesthetics," in *Culture and Art*, ed. Lars Aagaard-Mogensen (Atlantic Highlands, N.J., 1976).

6. Frank Sibley, "Aesthetic and Non-Aesthetic," pp. 135–159, *The Philosophical Review*, LXXIV (1965), reprinted in Matthew Lipman, ed., *Contemporary Aesthetics* (Boston, 1973), p. 434. See also Sibley's "Aesthetic Concepts," *The Philosophical Review*, LXVIII (1959), 421–450.

7. Monroe Beardsley, Aesthetics: Problems in the Philosophy of Criticism (New York, 1958), p. 31.

8. Ibid., p. 31.

9. *Ibid.*, p. 33. George Dickie presents arguments against Beardsley's notion of the aesthetic object, but I do not find them very persuasive. See Dickie's *Art and the Aesthetic*, pp. 148 ff.

10. See Benedetto Croce, *Aesthetic* (New York, 1929), and R. G. Collingwood, *The Principles of Art* (New York, 1938). In the expression theory developed by Croce and Collingwood, it is not the concept of expression itself which is aesthetic, but rather the concept of intuition.

11. See Clive Bell, Art (New York, 1959). Formalist criticism has maintained its commitment to aesthetics. See for example, Clement Greenberg, Art and Culture (Boston, 1961), and "Modernist Painting," Art and Literature, Vol. IX (1965).

12. See Isabel Creed Hungerland, "The Logic of Aesthetic Concepts," The Proceedings and Addresses of the American Philosophical Association, Vol. XL (1963), and "Once Again, Aesthetic and Non-Aesthetic," The Journal of Aesthetics and Art Criticism, XXVI (1968), 285–295.

13. See Sibley, "Aesthetic and Non-Aesthetic," for a discussion of the dependency of aesthetic qualities on non-aesthetic qualities.

14. E. H. Gombrich, in *Art and Illusion* (New York, 1960), demonstrates how a simple change in contrast in a photograph can change its aesthetic properties.

15. Joseph Margolis, "Works of Art as Physically Embodied and Culturally Emergent Entities," *The British Journal of Aesthetics*, XV (1975), 189.

16. See Alan Tormey, "Aesthetic Rights," The Journal of Aesthetics and Art Criticism, XXXII (1973), 163–170.

17. See Ursula Meyer, Conceptual Art (New York, 1972).

18. It is interesting that Duchamp says there are *four* letters in the title "L.H.O.O.Q." There are five letter tokens, each with its own particular appearance. But there are only four letter types, and a letter type does not have any particular appearance.

19. George Dickie develops a related notion in his "Institutional Theory of Art." See especially Art and the Aesthetic. His basic idea is that something is

art which has been christened art. One difficulty with this view is that it does not provide for the intensional specification of a work of art. This point is discussed later on. The notion of indexing introduced here is discussed further in "Deciding about Art" (see above).

20. In Meyer, Conceptual Art, p. 41.

21. Margolis, "Works of Art as Physically Embodied and Culturally Emergent Entities," p. 191. An extensional context is one in which expressions denoting the same entity can replace one another without altering the truth of what is said.

George Dickie holds that making art involves a kind of status-conferral. This theory has insights to offer, but it does have the shortcoming that statusconferral is basically extensional. If it is true that Cicero has had the status of statesman conferred on him, the same is true of Tully, since the two names belong to the same person.

22. Marcel Duchamp, p. 89.

23. Cf. Arthur Danto, "The Artworld," *The Journal of Philosophy*, Vol. LXI (1964), where a similar point is made, pp. 571–584.

I am grateful to Lars Aagaard-Mogensen, Linda Ashley, and Monroe Beardsley for their helpful comments on earlier drafts of this paper.

Aesthetic Theory and the Experience of Art R. K. ELLIOTT

I wish to maintain that in some important respects a version of Expression Theory provides a better account of our experience of art and of the nature of a work of art than does an aesthetic theory outlined by the following five points. (i) The work of art, qua aesthetic object or object of criticism, is a complex of phenomenally objective qualities, including aesthetic qualities. (ii) Aesthetic perception is understood chiefly as the perception of aesthetic qualities, but 'perception' is here used in an extended sense, so that an aesthetic quality may be a content of thought or imagination rather than of sight of hearing. (iii) Emotional qualities like joy or sadness are phenomenally objective qualities of the form or gestalt character of a work or of a part of a work, and since in order to appreciate the work it is necessary only to sense or recognize these qualities, not to feel them, they are not treated as logically distinct from the other qualities commonly attributed to works of art. (iv) But since a work may be exciting, soothing or disgusting, it must be allowed that arousal of emotion has some aesthetic significance. (v) In aesthetic experience attention is firmly directed upon the aesthetic object or upon some part of it, and it is always possible to distinguish this object from our response to it.1 For Expression Theory, in its classical or 'refined' form, the arousal of emotion as by the operation of a cause was a sign either of bad art or lack of taste. Aesthetic experience was not a matter of recognizing that the object possesses emotional (and other) qualities, but required the reader to transfer himself into the poet's mind, re-enact his creative expression and thereby allow his clarified emotion to be manifested in him. According to Gentile, in aesthetic experience every duality between ourselves and the

From *Proceedings of the Aristotelian Society*, n.s., LXVII (1966–1967), 111–126. Copyright © 1967 The Aristotelian Society. Reprinted by courtesy of the Editor of The Aristotelian Society.

3.

poet is transcended; when we have entered into the poet's feeling we feel ourselves to be looking upon the same world as he looked upon, with the same heart and eyes.²

The exaggerations of Expression Theory, especially the belief that in experiencing a poem aesthetically we reproduce in ourselves the creative activity of the poet, may have obscured its less spectacular but more genuine insight, namely, that some works of art are capable of being experienced as if they were human expression and that we do not experience expression exactly as we perceive objects or ordinary objective qualities. By 'expression' I mean only that expression which is perceived as qualifying or issuing from the person, especially gesture, speech and such internal activities as thinking and imagining. I do not intend the term to cover any object perceived as made by a person and existing independently of him. The Expression Theorists recognized that a poem can be perceived not as an object bearing an impersonal meaning but as if it were the speech or thought of another person and that it is possible for us to make this expression our own. A work may be experienced 'from within' or 'from without.' I cannot define these terms but hope that this paper will elucidate their meaning. So far as poetry and painting are concerned, experiencing a work from within is, roughly speaking, experiencing it as if one were the poet or the artist. If a work is experienced as expression, experiencing it from within involves experiencing this expression after a certain imaginative manner as one's own. Experiencing it from without is experiencing it as expression, but not experiencing this expression as if it were one's own. When I say that a work 'expresses emotion' I mean that if it is perceived as or as if it were expression, it may be perceived as or as if it were the expression of an emotion.

In so far as experiencing a lyric poem differs from hearing someone actually speaking to us, in general these differences make it easier rather than more difficult for us to experience the poem from within. The poet is not visibly before us as another individual; the poem itself may rapidly and lucidly acquaint us with all that is necessary for us to understand the situation in which the poet (qua 'speaker' of the poem) is represented as experiencing an emotion; and to experience the poem at all we have to give it a real or virtual reading in which we embody the poet's expression in our own voice. Consequently, the lyric 'I' functions as an invitation to the reader to place himself, in imagination, at the point from which the poet is related to the situation given in the poem. Qua maker, the poet may employ devices which tend to inhibit this communion, but in many cases the reader is able, eventually if not immediately, to take up the lyric 'I,' invest himself imaginatively with the poet's situation, and experience the poet's expression and the emotion expressed from the place of the expres-

Aesthetic Theory and the Experience of Art

sing subject rather than from the place of one who hears and understands the expression from without.

When we experience an emotion in this way, through an imaginative assumption of the expression and situation of another person (real or imaginary) we need not and commonly do not experience it as we would if the situation were unequivocally our own. In the Lysis Plato distinguishes between the ignorance which is both present in and predicable of a man and that which though it is present in him is not predicable of him.³ Emotion is subject to a similar distinction: the emotion that I feel in experiencing a work of art from within (and that which I feel as another person's in real life) may be present in me without being predicable of me. It is present in me because I do not merely recognize that the poet is expressing, for example, sadness, but actually feel this sadness; yet the emotion I feel is not predicable of me, i.e., it would be false to say that I am sad or even, unqualifiedly, that I feel sad. Edith Stein describes emotion felt in this way (in our experience of other persons) as 'primordial' for the other subject, 'non-primordial' for me: it is 'there for me in him'.4 The emotion expressed in a lyric poem may be 'there for me in the speaker of the poem', even if the speaker is a fiction and even if the motion was never experienced by the historical poet.

In experiencing a poem from within, the reader keeps more or less explicit contact with the poet. Sometimes he seems to be there together with the poet, as if they inhabited the same body and as if the poet were speaking or thinking with the reader's voice; sometimes the reader seems to be there in place of the poet, expressing and experiencing the poet's emotion as it were on the poet's behalf; sometimes the reader seems even to have supplanted the poet, but still without experiencing the expressed emotion as the product of his own fantasy. On occasions, as Longinus recognized, the experience is so vivid that it seems almost as if the reader were actually in the poet's situation. He has to return to himself, rather as if he were waking from a dream. As a rule, however, the reader is aware of his ability to relinquish the imagined situation and break off his communion with the poet immediately and without effort. We rarely experience a poem entirely from within, but are drawn into the world of the poem at certain points and later once more experience it from without, usually without noticing these changes in our point of view.

I have spoken of 'experiencing' a poem from within and from without, but these are very like alternative manners of performing a work as well as alternative modes of experiencing it. The word 'poem' is correctly applied not only to the text but also to that which may be constructed and experienced on the basis of the text, rather as the musical work is both the score and that which is present for perception when the work is performed. A

poem is 'realized' by a process in which understanding and imagination supplement and progressively correct each other. An initial understanding of the words of the text enables us to begin to represent the work in imagination, and these same words appear also in the imaginative representation. Through the representation which at this stage is the partial intuitive fulfillment of a meaning as yet only tentatively grasped, we become aware of new significances which lead in turn to the modification of the representation. This process continues indefinitely. Not every poem need be represented according to either of the modes that I have described, but where it is possible to experience a work according to these modes (i.e., when it can be experienced as expression) it is not immaterial which of them we adopt, for the perception of aesthetic qualities begins almost as soon as we begin to realize the poem and these qualities will differ according to the mode of representation. Two critics may find the same poem to be vivid and unified, but for one it has the vividness and unity of an observed event, for the other a vividness and unity more like those of an experience in which he actively participates. Even the aesthetic qualities of the rhythm and word-music will differ in some degree. Although for a particular poem one mode of representation may be more appropriate than the other, there is no ground for declaring either mode to be in general 'unaesthetic'. In so far as psychical distance is taken to be the absence of merely personal feeling and practical concern, it may be maintained or lost whichever mode is adopted. Each is a way of making the work available to aesthetic awareness. In one case the poem arises as a complex content entirely at the objective pole of consciousness; in the other it is realized as an experience the description of which involves a reference not simply to an objective content but also to the subject. In the first case aesthetic perception is awareness of certain qualities of an objective content; in the second it also includes a reflexive awareness of certain aspects of the experience as such.

It is difficult not to experience Donne's first *Holy Sonnet* ('Thou hast made me') from within. If after having experienced the poem in this way the reader were asked what his attention had been fixed upon, he could only answer that it had been fixed upon death and damnation—not upon death and damnation in general, however, nor his own, nor yet the poet's. He could not say exactly what it had been fixed upon unless he could describe his own situation relative to the poet and the world of the poem. If he is a person of critical temperament, the poem *qua* experience will become more and more comprehensively an object of reflection, so that at some stage it will be appropriate to say that he is related to the poem as to an objective content. But the object so contemplated is one which cannot be described without reference to the subject. So long as the full extent of the equivocality of 'work of art' and of all its specifications is not clearly recognized, such assertions as 'Aesthetic experience is experience of the

Aesthetic Theory and the Experience of Art

work' and 'The critic's task is to talk about the work, not about himself' have the sort of ambivalence which allows them to be misused as instruments of persuasion. Except in so far as he reflects upon his own experience, a person who experiences a poem from within does not concentrate his attention on any objective content which can be identified with the poem *qua* aesthetic object. He does not even fix his attention on the words of the poem, for when we speak or think from deep feelings, although we are aware of our words, of their adequacy or the lack of it, and even of the quality of their sound, it is scarcely correct to say that our attention is concentrated upon them. When experiencing a poem from within we do not fix our attention upon it but live it according to a certain imaginative mode. This is not sufficient from the aesthetic point of view, but it is not in any way aesthetically improper.

Hölderlin's elegy Homecoming shows the development of the poet's mood from serene expectation to loving reflection on the homeland, from this to the flowering of his joy in actual perception, then to serenity once more in an attitude of benediction. This much may be understood, after a fashion, through experiencing the poem from without, but the emotion experienced is of an extreme kind, and if we experience it only from without we can understand it only in its peculiarity as Hölderlin's-as the particular state of a decidedly unusual person. This, together with the idiosyncrasy of some of the poet's ideas, his generalized vocabulary and fastidious craftsmanship, makes the poem seem for us a strange though extremely beautiful object. Once we are able to experience it from within, however, it retains this character only as an inessential and misleading aspect. It appears instead as a sublime expression of a great human emotion which it enables us to experience eminently, though non-primordially. At the same time we know the emotion to be one which we have felt in real life in a more ordinary fashion. The difference in what the poem means to us could hardly be greater, yet it would not be wrong to say that we understood its meaning when we experienced it only from without. The inability to experience such a poem from within is a deprivation for which no exquisiteness of taste can compensate. When we experience Donne's poem The Sunne Rising from without, we hear the poet, represented as lying in bed with his mistress, address the sun with good-humoured but violently expressed contempt. We are shocked by his impiety and impressed by the brilliance of his wit. When we experience the poem from within, the poet's expression is reproduced in us at a level which is prior to the distinction between what is spoken aloud and what is merely thought. As a result the dramatic character of the poem is appreciably softened, and what appeared from without as aggressively clever conceit now seems at once more playful and more serious. The lyrical aspect of the poem is experienced more convincingly, and we feel a sense of the power and glory of sensual love-

The Nature of Aesthetic Interests

the same emotion which is experienced with such splendour in the *Song* of *Solomon*. Now it seems to us that the poet diminished the sun only to glorify a greater god, one whose power we ourselves feel in experiencing the poem from within. But in this case the understanding obtained through experiencing the poem from within does not establish its authority absolutely. This poem has two faces, and the critic must experience it according to both modes if he is to evaluate it justly.

There is a sense in which a poem can be said to provide an adequate 'objective correlative' of an emotion if the poem is experienced from within. It does this to the extent that it displays or 'imitates' the emotion, and to the extent to which it enables us to experience it when we realize the poem from within. A poem like Hölderin's elegy *Homecoming* or Donne's *The Sunne Rising* accomplishes this by deploying a situation around the reader as he realizes the poem, by representing the structure of a developing mood, and by enabling him to reproduce in imagination, from the place of the experiencing subject, modes of speech, changes in the direction, tempo and pressure of thought, movements of fancy, and even the modifications of perception through which the emotion manifests itself. The reader must himself contribute the appropriate feelings and emotional tone, but his feeling will be appropriate not only to the imagined situation but also to the expression he has made his own. Under this guidance the emotion comes into being in him.

In his article 'The Expression Theory of Art'⁵ Professor Bouwsma argues that we can perceive or sense the sadness of sad music without feeling sad ourselves, and that to attempt to elucidate the application of 'emotional' predicates to music by reference to expression is only to invite confusion. When we say 'The music is sad' we may mean that it makes us sad, but for the good critic, at least, 'The music is sad' means that the form or gestalt character of the music has a certain audible quality which we call 'sad' because the music has some of the characteristics of sad persons. 'The sadness is to the music rather like the redness to the apple, than it is like the burp to the cider.' We do apply emotional predicates to sounds according to the two criteria Bouwsma mentions, but we also apply them because we perceive sounds as or as if they were expressing emotion. Bouwsma maintains that once a poem is born it has its character as surely as a cry in the night, but a cry in the night, because it is so unexpected, can at first be heard not as human expression but as pure sound. It may have an emotional quality: not grief or fear but eeriness, the power through strangeness to cause fear. An intermediate stage would be hearing that the cry has a certain emotional quality, judging it to be a sad sound, but still not perceiving it as an expression of sadness. We call some sounds 'happy' or 'merry' in this way, because they have some of the characteristics of

Aesthetic Theory and the Experience of Art

happy persons, and we perceive these emotional qualities as gestalt characters without hearing the sounds as if they were expression. But in such cases we have to judge that it is appropriate to apply the emotional predicate. To perceive music as expressing emotion we have to perceive the sounds as if they were expression. When I watch the foliage of a tree blown hither and thither in a strong wind, at first I see only a multiplicity of movements. Then this multitude becomes a unity, and I see a restless and fearful agitation on the brink of frenzy. But to see the foliage in this way is to see it as if it were a person and to grasp its movement as if it were expression. If I am to continue perceiving this vividly explicit fearfulness I must remain under the spell. As soon as I concentrate upon the movements simply as movements, I cease to see the tree as if it were a person and drop back into a more ordinary mode of perception. Similarly, the humming of telegraph wires may be heard as the contented murmuring of a number of 'voices', but if one concentrates upon the sound the voices disappear and the inhuman noise of the wire returns. If I listen to a passage of 'sad' music to discover whether I perceive an emotional quality or an expression of sadness, I hear sounds with an emotional quality. But the conditions of the experiment preclude me from hearing anything else. Music is eminently expressive but the musical sounds are very different from the sound of the human voice. Consequently, when attention is fixed on the sounds, one hears something inhuman having an intense emotional quality. For it to be possible for us to hear the music as expressing emotion, we must not be concentrating too keenly upon the qualities of the sounds themselves but listening to the music in a more relaxed and 'natural' way. Then we find ourselves hearing some passage as if someone were expressing his emotion in and through the sounds as a person does in and through his voice; but although we hear the sounds rather as if they were a voice, in listening to pure music we seldom if ever hear them as the ordinary human voice. But there is a different manner in which we may hear the music as if it were expressing emotion, namely, by hearing it as our own expression. We value these experiences because the emotion in the music is realized most definitely and most vividly in these ways. Hearing the music as expressing emotion, whether from without or from within, is an instance of imaginatively enriched perception, one of many which we encounter in the experience of art.

That the expression and the emotion it expresses 'belong' to nobody is no more a hindrance to our understanding the expression and experiencing the emotion than it is with poetry. We sometimes attribute the expressed emotion to the composer, but very often we do not attribute it to anyone definite: it is merely 'his' emotion which is being expressed. On occasions, perhaps, although we hear the music as expression we do not attribute the expression to anyone at all, perceiving expression without an expressor, as

no doubt we once did in early childhood. The emotion expressed in a song or aria is usually referred to the character the singer is personating. Perceiving anything as if it were expression of emotion involves a reference to feeling, but we can perceive the music as expressing sadness without being made sad by it. Whether we are made sad by it or not, experiencing it simply as the expression of someone else's sadness is experiencing it from without. Often, however, we are able to experience the music from within, in which case we experience it as if it were our own expression and may feel the expressed emotion non-primordially. The hearer does not have to perform the music as the reader has to perform the poem, but in a certain way he can appropriate the stream of musical sound as his own expression. An extreme experience of emotionally expressive music from within is very like a real-life experience of, say, joy, when the emotion has no definite object and when we express it by voice or gesture. In this case we begin by directing an ordinary attention on the musical sounds, but, as if in a single movement, the music is received by us and, as it were, reissues from us as if it were our own expression, not exactly as if it were our own voice but as a mode of expression sui generis. Once the mood or emotion is present in us the experience is usually extremely pleasing, for to the extent that emotion is not tied to any external state of affairs or dependent in any other way upon the subject's representing anything to himself by means of concepts, music is an incomparably lucid and powerful means of expression.⁶ It is as if in feeling joy or sadness we were at the same time conscious of an adequacy of expression far beyond anything we could have imagined.

Coming to understand a musical work is not simply a matter of frequently exercising concentration upon an object for the purpose of discerning its aesthetic qualities. In experiencing a work for the first time it appears to us chiefly, perhaps, as a sonorous object, but in places as someone else's expression. As we grow more familiar with it, however, some phrases and melodies no longer seem to be directed at us from a source outside us. We may not experience them as if they were issuing from us, on an analogy with the voice, but as coming into being in us, an analogy with a process of thought. We may become aware of this when at some time we feel ourselves to be inwardly articulating or 'containing' a passage which we remember had previously seemed to be directed at us from without. Slow reflective passages lend themselves readily to an appropriation of this sort; vehement passages may seem to be 'thought' by us or to issue from us as external expression. This is not mere familiarity with the work, for instead of causing our interest in the music to slacken it enables us to experience the mood or emotional tone rather than merely recognize its emotional quality. That is, having made the expression our own, we contribute the element of feeling, as we do in experiencing a lyric poem from within.

Aesthetic Theory and the Experience of Art

When we seem to be expressing the music externally, it seems as if it is flowing forth from the mood, though often the mood seems inadequate to the expression-it may seem as if the expression were sustaining the mood, rather than vice versa. When we seem to be 'thinking' the music, it often seems as if we are at the same time feeling it. In many cases hearing the music from within is feeling the emotion or feeling expressed. Sometimes we find ourselves not only 'thinking' or otherwise 'expressing' the music, but thinking or expressing it powerfully, as if our own resources were equal to the music. It is firmly appropriated and we are expressing it as if from the heart. This is feeling the expressed emotion. On other occasions, feeling the emotion involves more than this. For example, there is a difference between recognizing the intense and narrow concentration of extremely sad music and living in this concentration in experiencing the music from within. Sometimes, feeling the emotion amounts to accompanying the music with internal gestures. In hearing the conclusion of the first movement of La Mer from within, we may enjoy a glorious expansion of spirit, assuming in imagination something of the stature, zest and majesty of a sea-god. From without, some such being seems to tower over us, regal and threatening. Both tendencies can be inhibited by concentrating on the music as pure sound. We may feel an expressed emotion, however, without feeling it primordially. Joyful music tends to make us joyful when we experience it from within, but often we know that the joy we are feeling is only present in us and does not qualify the self. The passage from La Mer is exhilarating, but does not induce the state it expresses. Nevertheless, in so far as hearing music from within involves the appropriation of the musical expression the musical work is an experience, not an object. We cannot, by reflecting on our experience, discover a content exactly like that which we would have had if we had experienced the work from without. We discover instead 'sounds suffused with feeling.'

Whether we experience some passages from within or from without or as pure sound may well make a difference to our evaluation of a musical work. Sometimes, when we fail to experience them as expression we regard the hearing as abortive and consider that the work's aesthetic qualities have not been properly experienced. In other cases we may value a work without having experienced certain passages from within, and one day be surprised to find that someone else values it, as we think, excessively, but gives very much the same reasons for its merit as we do. In extreme cases, there is complete aesthetic disagreement. This is understandable, since a passage which seems banal if it and other passages have been experienced as pure sound may seem almost unbearably poignant if it and certain earlier passages have been experienced as expression. A case in point is the 'hurdy gurdy' passage in the finale of Bartok's 5th String Quartet. Some critics value it for its expressiveness, others can see it only as an appalling error of judgement. Some passages in some of Wordsworth's poems present criticism with a similar problem, seeming on one reading wholly banal, on another wholly sublime. Where emotionally expressive music is found within a literary context, as in opera, the significance of the music may differ very considerably according to the mode of perception we adopt. There is a passage of presentation music in Bartok's opera Bluebeard's Castle which occurs when Bluebeard is showing Judith his vast domain, and we naturally experience this music as Bluebeard's expression. When we experience it from without, it gives an impression of vanity, even pomposity, in a character of great force; but we can hardly avoid experiencing it also from within, whereupon it seems to express a somewhat naïve pride and strength with which it is easy to sympathize. This ambivalence is in keeping with Bluebeard's character as we know it from the rest of the opera. The music is complex, and I suspect that some features are more prominent when it is experienced from without, others when it is experienced from within, and that this is enough to change the significance of the music as delineating Bluebeard's character. But like Donne's poem, this passage must be experienced according to both modes if one is to grasp its full significance.

There are many pictures before which ordinary aesthetic contemplation can be transformed into a mode of perception in which the percipient seems to see the reality of what is represented in the representation. A picture like Rouault's Flight into Egypt would be quite insignificant if it did not have the power suddenly to make it seem that we are actually there, in an unbounded landscape, with the sky extending over us in a chill dawn. Our point of view shifts spontaneously from a point outside the world of the work to a point within it. If we value a work because it offers us such an experience we may be inclined, for want of a better word, to call it 'vivid' or 'realistic', but the relevant aesthetic property cannot be adequately described except by reference to the shift in the subject's point of view. The movement from seeing the picture as representing a chill dawn to the imaginative experience of such a dawn as if real, is of the same kind as the movement from experiencing a lyric poem from without to experiencing it from within, for it is the assumption of 'the painter's' point of . view and of his relation to his world. The historical painter may not have painted from life, as the historical poet may not have actually experienced the events he describes in his poem, but as the poem is given as verbal expression, so the representational picture is given as a visual field—that of an 'observer' who is analogous with the poet qua 'speaker' of the poem, and as it is possible to make the poet's expression one's own, so the picture may cease to be an object in the percipient's visual field, become itself the visual field, and be experienced as if the objects in it were real. Ordinarily

Aesthetic Theory and the Experience of Art

we see the represented dawn as such, either simply as a represented dawn or as the representation of a dawn seen by Rouault. In the experience I am describing we are shifted suddenly from one of these more ordinary modes of perception to a mode which is like the extreme kind of poetic experience of which Longinus writes.⁷ Both in the experience of a poem and of a picture from within, an emotional character is realized through an imaginative response to the work, but in the experience of the picture this realization is accomplished rather through an imaginative extension and modification of what is actually seen than through what is merely imagined, so that the experience of the picture from within has an aspect of illusion. Nevertheless the difference between the poetic and pictural experiences is chiefly that between what activates imagination in each case, whether words or things seen. In neither case is what activates imagination transcended: the words are not superseded in the poetic experience, nor is perception supplanted by imagination in the experience of the picture. Words or things seen are taken up into a more comprehensive experience in the constitution of which imagination plays a vital part.

A perfect analogy between the experience of a picture and that of a lyric poem from within, has not vet been established, however, for it has not been shown that a picture, when experienced from within, can be an adequate 'objective correlative' of an emotion. Before Rouault's Flight into Egypt we experience 'the dawn-feeling,' but the picture relies upon our providing a general human response and does little to determine this response any further. Here the painter is at a disadvantage. In experiencing a lyric poem it is normally quite easy to distinguish the objects of the poet's world from his attitude towards them: if he speaks of the sun as an officious court dignitary we do not have to imagine it as wearing a ruff or as appropriately grey-bearded. But whatever means the painter adopts to determine our attitude must be visible in the picture. If he distorts the image of the object of the emotion he wishes to communicate, it is this distorted image which we experience as if real when we experience the work from within its world, so that we respond not to the object of the emotion but rather to the emotion itself as objectified in the image. If on contemplating a picture of Rouault's I feel myself to be in the real presence of one of his monstrous judges, this experience will not directly deliver either the emotion that the artist intended to convey or its object. But if the painter does not obviously distort the image the percipient is left free to adopt what attitude he pleases: it is a matter of temperament whether he feels pity or contempt for the unattractive elder members of Goya's royal family. Yet in some pictures even this difficulty has been surmounted. One's first impressions of Bonnard's Nude before a Mirror are of its brilliant colour and of its decorative character. The nude is the

centre of the picture-space and is more sharply and emphatically drawn than anything at the sides of the picture or in the background. All the rest is an extravagant décor for the central figure. The mirror, which occupies much of the left margin of the picture, reflects a curtain as a long narrow area of brilliantly coloured patches and spots. The window glistens. The corner of the bedspread in the right foreground is richly coloured and formally pleasing. One recognizes almost immediately that this is a good picture, but the judgement is made with reservations. The central figure seems a little awkwardly related to the background, the sensuous charm of which is perhaps excessive. But even while he is contemplating the picture in this way, the percipient's mode of perception may be transformed, and it is as if he were in the very room, looking at a real woman standing before a mirror, not with the neutral attitude of someone looking at something in a picture but with an affectionate, even a loving glance. It is as if he has assumed not only the artist's visual field but his very glance, and is gazing upon the same world with the same heart and eyes. He is no longer aware of the exaggerated colour or of the decorative aspect of the picture. It is as if these features had helped to create the attitude appropriate for the perception of the central figure—a technique common in religious painting-and in accomplishing this had given up their own prominence. I do not maintain that it is the function of painting to produce experiences of this kind, but it is in such experiences that Expression Theory's dream of a communion which is temporarily an identity seems most nearly to be realized. Less intense or less complete experiences of pictures from within, involving only a part of a picture or a momentary sense of the real presence of the object represented, are not uncommon. Imaginatively enhanced perception of these and other kinds have nothing to do with skill or taste, but this does not suffice to establish their irrelevance from the aesthetic point of view.

A somewhat clearer indication of what it means, in general, to experience a work 'from within' can now be given. Music is perceived as expression, but does not deliver a situation. Painting delivers a situation but is not perceived as expression. Poetry both delivers a situation and is perceived as expression. In each case there is the possibility of an imaginative movement whereby the percipient enters into a more intimate relation with the work, either by appropriating the musical expression, or by allowing the world of the picture to become as if it were his world instead of contemplating it as an object in his world, or by taking up the poetic expression and constructing the world of the poem as if it were his world. But expression and world are relative to a subject, and the percipient is often explicitly aware that the expression or world that he has made or allowed to become his is not in fact his own. Hence he may well feel a sense of

Aesthetic Theory and the Experience of Art

identity or close communion with someone else, whom he is likely to identify as the artist. These, I believe, are the features of our experience of art which provide a certain limited justification for Expression Theory. At the same time they cast doubt on the adequacy of any exclusively objectivist aesthetic theory.

The theory I have been criticizing restricts the application of 'aesthetic' to one aspect or region of our experience of art, perhaps in the belief that this is necessary if aesthetic judgement is to have objective validity. By this improverishment of the concept of aesthetic experience Aesthetics becomes the philosophy of a scarcely practicable aestheticism which it has itself created. Yet even the problem of the objectivity of aesthetic judgement could be clarified by a more catholic understanding of our actual experience of art, in particular of the creative contribution made by the subject. Our experience of art, like our religious or moral experience, has its own character but is not yet transparent to us. It is this, in all its variety and complexity and with all the problems it presents, that Aesthetics should exhibit and examine, not only for the sake of remaining in contact with ordinary lovers of art but in order that through Aesthetics we may attain a better understanding of ourselves. A version of aesthetic experience adapted in a comparatively simple manner to our intellectualist preferences is not an acceptable substitute.

Notes

1. This composite 'theory' does not do justice to the views of any of the philosophers who advanced any of the theses contained in it, but is meant as a statement of a set of opinions which are currently sometimes expressed or presupposed. I have taken the components of the theory from the work of Professors Beardsley, Bouwsma, Dickie and Margolis, and from that of Professor Hepburn.

2. See Merle E. Brown, Neo-Idealist Aesthetics: Croce-Gentile-Collingwood (Detroit, 1966), pp. 168–169.

3. 217C-218B.

4. On the Problem of Empathy, trans. W. Stein (The Hague, 1964), pp. 11, 16. Edith Stein distinguishes three grades of 'empathic' experience (i.e., experience of the consciousness of another person): (1) recognition that the other is, e.g., joyful, (2) living in his joy, (3) objectification of this experience.

5. In W. Elton, ed., Aesthetics and Language (Oxford, 1954), pp. 73-99.

6. See Kierkegaard, *Either/Or*, trans. David and Lillian Swenson (London, 1946), pp. 35–110.

7. See Ruby Meager, "The Sublime and the Obscene," *The British Journal of Aesthetics* (July 1964).

Bibliography to Part One

A comparatively recent summary of the historical development of aesthetics is provided in:

Ruth Saw and Harold Osborne, "Aesthetics as a Branch of Philosophy," British Journal of Aesthetics, I (1960), 8-20.

A fuller survey is provided in:

Monroe C. Beardsley, Aesthetics from Classical Greece to the Present (New York, 1966);

and a sense of the changing status of the fine arts is conveyed in:

Paul O. Kristeller, "The Modern System of the Arts," Journal of the History of Ideas, XII (1951), 469–527; and XIII (1952), 17–46.

General doubts about the fruitfulness of aesthetics may be found in:

William E. Kennick, "Does Traditional Aesthetics Rest on a Mistake?," Mind, XVII (1958), 317–334;

J. A. Passmore, "The Dreariness of Aesthetics," reprinted in William Elton (ed.), *Aesthetics and Language* (Oxford, 1954).

One of the early symposia of an analytic sort, with contributions by J. O. Urmson and David Pole, appears in:

"What Makes a Situation Aesthetic?," *Proceedings of the Aristotelian Society*, Supplementary Vol. XXXI (1957), 75-106.

Various other attempts to explicate aspects of the aesthetic point of view are to be found in:

Henry Aiken, "The Aesthetic Relevance of Belief," Journal of Aesthetics and Art Criticism, IX (1951), 301-315;

Virgil Aldrich, "Picture Space," Philosophical Review, LXVII (1958), 342-352;

Monroe C. Beardsley, Aesthetics (New York, 1958), Ch. 1;

George Dickie, Art and the Aesthetic (Ithaca, 1974);

W. B. Gallie, "The Function of Philosophical Aesthetics," reprinted in William Elton (ed.), Aesthetics and Language (Oxford, 1954);

Joseph Margolis, Art and Philosophy (New York, 1978), Chs. 2-3;

Bibliography

- I. A. Richards, Principles of Literary Criticism (London, 1925), Ch. 2;
- Jerome Stolnitz, Aesthetics and Philosophy of Art Criticism (Boston, 1960); Vincent Tomas, "Aesthetic Vision," Philosophical Review, LXVIII (1959), 52-67:
- Eliseo Vivas, "A Definition of the Esthetic Experience," reprinted in his Creation and Discovery (New York, 1955);
- Roman Ingarden, "Artistic and Aesthetic Values," British Journal of Aesthetics, IV (1964), 198-213;
- A fairly recent exchange on the meaning of the aesthetic appears in:
 - George Dickie, "The Myth of the Aesthetic Attitude," American Philosophical Quarterly, I (1964), 56-66.
 - George Dickie, "Beardsley's Phantom Aesthetic Experience," Journal of Philosophy, LXII (1965), 129-136.
 - Monroe C. Beardsley, "Aesthetic Experience Regained," Journal of Aesthetics and Art Criticism, XXVIII (1969), 3-11.

Of particular interest is the dispute about Frank Sibley's view of aesthetic qualities (see Part Two, Bibliography).

Part Two Aesthetic Qualities

Contemporary linguistic analysis has benefited aesthetics, in a very noticeable way, by subjecting to detailed scrutiny large lists of the familiar terms we use to characterize works of art. The truth is that this examination has never been attempted before in a fully systematic way or with the advantage of a powerful and well-developed philosophical method. The result has been some discoveries of considerable importance.

The pivotal question for all such analysis is, what are the conditions on which we correctly apply a characterizing term to a given work of art? The finding has been that these vary strikingly with different sets of terms. The question is obviously important, since only by means of the analysis indicated could we hope to describe the logical nature of disputes about works of art. Is, for example, this Rembrandt *somber*? Are those colors *garish*? Would you say she has a *regal* manner? Clearly, the issue spreads far beyond the narrow confines of art to the appreciative remarks we make in general conversation.

There is, of course, an extraordinarily large number of respects in which all of our characterizing terms may be classified. Can we state necessary conditions for their use? sufficient conditions? necessary and sufficient conditions? Are there terms for which we can supply neither necessary nor sufficient conditions? If there are, how is their use supported? Are there purely descriptive terms? purely evaluative terms? terms that are mixed in this regard? Are there descriptive and evaluative terms whose proper use depends on affective responses on our part? on dispositions to respond? Are there terms for which one can provide paradigm cases? terms for which one cannot? And if the latter (think of epithets like "He's the Michelangelo of poetry"), can and how can they be supported?

From the vantage of a large perspective, one can see that the sort of analysis indicated is simply the application, to a range of terms having a somewhat local interest for specialists in aesthetics and the arts, of a general method of working. The main force of this strategy has already been marked out very clearly in the philosophical contributions of such authors as Wittgenstein, John Wisdom, and J. L. Austin. But what is fascinating to observe is the correspondence among findings made in the most disparate fields of philosophical analysis.

The point can be made in either of two ways. We have been made to notice that a large number of expressions central to talk in different domains are readily but informally associated with paradigm instances, without, however, permitting us to formulate either necessary or sufficient conditions for their use. Otherwise stated, we have been made to notice that arguments supporting certain sorts of judgment central in different domains cannot be classified as deductive or inductive but depend on some "intermediate" logic in accord with which we may specify only "characteristically" favorable or unfavorable evidence. There are cases, that is, in which we argue more from instance to instance than from principle or rule to application. And this, it turns out, is particularly worth emphasizing in the domain of aesthetics.

Frank Sibley's discussion (1959) of qualities prominent in aesthetic discourse is probably the most thoroughgoing effort made to date to fix the "intermediate" logic of the bulk of the expressions employed there. It has actually provoked an immense number of responses and counterresponses. And in doing so, it has led us to sort out a good number of central distinctions that any comprehensive theory of aesthetic interest, aesthetic perception, aesthetic qualities would need to consider. Sibley is quite explicit about aesthetic discrimination's being a perceptual ability, but a perceptual ability involving the exercise of taste. He has also pressed as uncompromisingly as possible the thesis that aesthetic qualities are not condition-governed in any way that bears on the confirmation or disconfirmation of relevant aesthetic claims: they are, apparently, emergent qualities of some sort, dependent on non-aesthetic properties, possessed by the objects in question, and discriminable by percipients having the requisite taste. These details of his theory fix the sense in which it would be a mistake to construe his thesis as intuitionistic.

But it has invited a variety of challenges. For one thing, it raises a question about how to decide—as well as what the theoretical ground may be for deciding—between whether a candidate object actually has or merely seems to have the aesthetic quality assigned. These—graceful, delicate, dainty, handsome, comely, elegant, garish, to take one troublesome array of terms that Sibley himself provides—are supposed to enter into valid, objective judgments about matters of fact. But there can be no matters of fact where the is/seems contrast is not assigned a critical epistemic function. This thesis is clearly advanced for instance by Isabel Hungerland. For another, it raises a question about whether aesthetic appreciation and perception—in any generous sense of those notions—can be confined to

Aesthetic Qualities

perceptual considerations (see Part One). Sometimes, it seems that aesthetic appreciation may well be non-perceptual; sometimes, it seems that aesthetic perception itself can only function as such when properly informed by relevant background considerations, as of history, biography, intention (see Parts Five and Six). If so, then aesthetic perception must be an ability that cannot be adequately characterized as a merely *percep*tual ability. This is the theme of the strong objection that Kendall Walton advances (1970). The very categories of art, Walton argues, in terms of which works of art are properly perceived, require that our perception be appropriately oriented in terms of a wide variety of factors bearing on the origin of a given work, factors not normally construed as being of aesthetic relevance. Here, Walton opposes the views of both Sibley and Beardsley (see Part One). Walton also manages to draw attention to the variety of aesthetically relevant features of works of art that are either not directly considered by Sibley or that would appear to be anomalous from the point of view of either Sibley or Beardsley-in particular, conceptual art and representational art. His reflections, here, tend to confirm the distinctively cultural nature of art (see Parts Three and Four)-hence, of the culturally informed nature of pertinent perceptions.

The enlargement of the range of aesthetically relevant qualities and features suggests both the inescapability of a mixed array of distinctions and the unlikelihood of any thesis like Sibley's holding without exception. The mere mention of representational qualities (see Part Five), for instance, signifies the implausibility of construing certain sorts of discriminations as being not condition-governed in Sibley's sense. Some authors, notably Peter Kivy and Ted Cohen, have persuasively shown that either relevant aesthetic properties (for instance, unity in music) may be taken to be condition-governed or else the putative demarcation between aesthetic and non-aesthetic perception is merely a question-begging version of the original thesis. Cohen (1973) in fact mounts a direct attack-a pragmatic attack, he calls it-on the very distinction between aesthetic and nonaesthetic perception. To the extent that we favor the challenge, emphasizing the intrusion of taste and appreciation in putatively perceptual discrimination, we are inexorably led to consider the possible defensibility of alternative, non-convergent ways of "seeing" a work of art (see Part Seven); and, correspondingly, of the need to replace a narrowly perceptual thesis with one that accommodates the relevance (a) of background information; (b) of non-perceptual discrimination; (c) of interpretation; (d) of taste and appreciative orientation. Kivy (1973) attempts to show, more directly, that among the very concepts that Sibley had supposed to be not condition-governed we must admit salient predicates that actually are condition-governed. Cohen, therefore, challenges the entire distinction between the aesthetic and the non-aesthetic; Kivy, the logical uniformity of just those distinctions that Sibley regards as involving aesthetic concepts.

Aesthetic Concepts FRANK SIBLEY

The remarks we make about works of art are of many kinds. For the purpose of this paper I wish to indicate two broad groups. I shall do this by examples. We say that a novel has a great number of characters and deals with life in a manufacturing town; that a painting uses pale colors, predominantly blues and greens, and has kneeling figures in the foreground; that the theme in a fugue is inverted at such a point and that there is a stretto at the close; that the action of a play takes place in the span of one day and that there is a reconciliation scene in the fifth act. Such remarks may be made by, and such features pointed out to, anyone with normal eyes, ears, and intelligence. On the other hand, we also say that a poem is tightly-knit or deeply moving; that a picture lacks balance, or has a certain serenity and repose, or that the grouping of the figures sets up an exciting tension; that the characters in a novel never really come to life, or that a certain episode strikes a false note. It would be neutral enough to say that the making of such judgments as these requires the exercise of taste, perceptiveness, or sensitivity, of aesthetic discrimination or appreciation; one would not say this of my first group. Accordingly, when a word or expression is such that taste or perceptiveness is required in order to apply it, I shall call it an aesthetic term or expression, and I shall, correspondingly, speak of aesthetic concepts or taste concepts.1

Aesthetic terms span a great range of types and could be grouped into various kinds of sub-species. But it is not my present purpose to attempt any such grouping; I am interested in what they all have in common. Their almost endless variety is adequately displayed in the following list: *unified*, *balanced*, *integrated*, *lifeless*, *serene*, *somber*, *dynamic*, *powerful*, *vivid*, *delicate*, *moving*, *trite*, *sentimental*, *tragic*. The list of course is not limited

From *The Philosophical Review*, LXVIII (1959), 421–450 (now with extensive minor revisions). Reprinted with the permission of the author and *The Philosophical Review*.

to adjectives; expressions in artistic contexts like *telling contrast, sets up a tension, conveys a sense of*, or *holds it together* are equally good illustrations. It includes terms used by both layman and critic alike, as well as some which are mainly the property of professional critics and specialists.

I have gone for my examples of aesthetic expressions in the first place to critical and evaluative discourse about works of art because it is there particularly that they abound. But now I wish to widen the topic; we employ terms the use of which requires an exercise of taste not only when discussing the arts but quite liberally throughout discourse in everyday life. The examples given above are expressions which, appearing in critical contexts, most usually, if not invariably, have an aesthetic use; outside critical discourse the majority of them more frequently have some other use unconnected with taste. But many expressions do double duty even in everyday discourse, sometimes being used as aesthetic expressions and sometimes not. Other words again, whether in artistic or daily discourse, function only or predominantly as aesthetic terms; of this kind are graceful, delicate, dainty, handsome, comely, elegant, garish. Finally, to make the contrast with all the preceding examples, there are many words which are seldom used as aesthetic terms at all: red, noisy, brackish, clammy, square, docile, curved, evanescent, intelligent, faithful, derelict, tardy, freakish.

Clearly, when we employ words as aesthetic terms we are often making and using metaphors, pressing into service words which do not primarily function in this manner. Certainly also, many words have come to be aesthetic terms by some kind of metaphorical transference. This is so with those like "dynamic," "melancholy," "balanced," "tightly-knit" which, except in artistic and critical writings, are not normally aesthetic terms. But the aesthetic vocabulary must not be thought wholly metaphorical. Many words, including the most common (lovely, pretty, beautiful, dainty, graceful, elegant), are certainly not being used metaphorically when employed as aesthetic terms, the very good reason being that this is their primary or only use, some of them having no current non-aesthetic use. And though expressions like "dynamic," "balanced," and so forth have come by a metaphorical shift to be aesthetic terms, their employment in criticism can scarcely be said to be more than quasi-metaphorical. Having entered the language of art description and criticism as metaphors they are now standard vocabulary in that language.²

The expressions I am calling aesthetic terms form no small segment of our discourse. Often, it is true, people with normal intelligence and good eyesight and hearing lack, at least in some measure, the sensitivity required to apply them; a man need not be stupid or have poor eyesight to fail to see that something is graceful. Thus taste or sensitivity is somewhat more rare than certain other human capacities; people who exhibit a sensitivity both wide-ranging and refined are a minority. It is over the application of aesthetic terms too that, notoriously, disputes and differences sometimes go helplessly unsettled. But almost everybody is able to exercise taste to some degree and in some matters. It is surprising therefore that aesthetic terms have been so largely neglected. They have received glancing treatment in the course of other aesthetic discussions; but as a broad category they have not received the direct attention they merit.

The foregoing has marked out the area I wish to discuss. One warning should perhaps be given. When I speak of taste in this paper, I shall not be dealing with questions which center upon expressions like "a matter of taste" (meaning, roughly, a matter of personal preference or liking). It is with an ability to *notice* or *see* or *tell* that things have certain qualities that I am concerned.

I

In order to support our application of an aesthetic term, we often refer to features the mention of which involves other aesthetic terms: "it has an extraordinary vitality because of its free and vigorous style of drawing," "graceful in the smooth flow of its lines," "dainty because of the delicacy and harmony of its coloring." It is as normal to do this as it is to justify one mental epithet by other epithets of the same general type, intelligent by ingenious, inventive, acute, and so on. But often when we apply aesthetic terms, we explain why by referring to features which do not depend for their recognition upon an exercise of taste: "delicate because of its pastel shades and curving lines," or "it lacks balance because one group of figures is so far off to the left and is so brightly illuminated." When no explanation of this latter kind is offered, it is legitimate to ask or search for one. Finding a satisfactory answer may sometimes be difficult, but one cannot ordinarily reject the question. When we cannot ourselves quite say what nonaesthetic features make something delicate or unbalanced or powerful or moving, the good critic often puts his finger on something which strikes us as the right explanation. In short, aesthetic terms always ultimately apply because of, and aesthetic qualities always ultimately depend upon, the presence of features which, like curving or angular lines, color contrasts, placing of masses, or speed of movement, are visible, audible, or otherwise discernible without any exercise of taste or sensibility. Whatever kind of dependence this is, and there are various relationships between aesthetic qualities and non-aesthetic features, what I want to make clear in this paper is that there are no non-aesthetic features which serve in any circumstances as logically sufficient conditions for applying aesthetic terms. Aesthetic or taste concepts are not in this respect condition-governed at all.

There is little temptation to suppose that aesthetic terms resemble words which, like "square," are applied in accordance with a set of necessary and sufficient conditions. For whereas each square is square in virtue of the

same set of conditions, four equal sides and four right angles, aesthetic terms apply to widely varied objects; one thing is graceful because of these features, another because of those, and so on almost endlessly. In recent times philosophers have broken the spell of the strict necessary-and-sufficient model by showing that many everyday concepts are not of that type. Instead, they have described various other types of concepts which are governed only in a much looser way by conditions. However, since these newer models provide satisfactory accounts of many familiar concepts, it might plausibly be thought that aesthetic concepts are of some such kind and that they similarly are governed in some looser way by conditions. I want to argue that aesthetic concepts differ radically from any of these other concepts.

Amongst these concepts to which attention has recently been paid are those for which no *necessary-and-sufficient* conditions can be provided, but for which there are a number of relevant features, A, B, C, D, E, such that the presence of some groups or combinations of these features is *sufficient* for the application of the concept. The list of relevant features may be an open one; that is, given A, B, C, D, E, we may not wish to close off the possible relevance of other unlisted features beyond E. Examples of such concepts might be "dilatory," "discourteous," "possessive," "capricious," "prosperous," "intelligent" (but see below). If we begin a list of features relevant to "intelligent" with, for example, ability to grasp and follow various kinds of instructions, ability to master facts and marshall evidence, ability to solve mathematical or chess problems, we might go on adding to this list almost indefinitely.

However, with concepts of this sort, although decisions may have to be made and judgment exercised, it is always possible to extract and state, from cases which have already clearly been decided, the sets of features or conditions which were regarded as sufficient in those cases. These relevant features which I am calling conditions are, it should be noted, features which, though not sufficient alone and needing to be combined with other similar features, nevertheless carry some weight and can count only in one direction. Being a good chess player can count only towards and not against intelligence. Whereas mention of it may enter sensibly along with other remarks in expressions like "I say he is intelligent because . . ." or "the reason I call him intelligent is that . . . "; it cannot be used to complete such negative expressions as "I say he is unintelligent because. . . ." But what I want particularly to emphasize about features which function as conditions for a term is that some group or set of them is sufficient fully to ensure or warrant the application of that term. An individual characterized by some of these features may not yet qualify to be called lazy or intelligent, and so on, beyond all question, but all that is needed is to add some further (indefinite) number of such characterizations and a point is reached where we have enough. There are individuals possessing a number of such features of whom one cannot deny, cannot but admit, that they are intelligent. We have left necessary-and-sufficient conditions behind, but we are still in the realm of sufficient conditions.

But aesthetic concepts are not condition-governed even in this way. There are no sufficient conditions, no non-aesthetic features such that the presence of some set or number of them will beyond question logically justify or warrant the application of an aesthetic term. It is impossible (barring certain limited exceptions, see below) to make any statements corresponding to those we can make for condition-governed words. We are able to say "If it is true he can do this, and that, and the other, then one just cannot deny that he is intelligent," or "if he does A, B, and C, I don't see how it can be denied that he is lazy," but we cannot make any general statement of the form "If the vase is pale pink, somewhat curving, lightly mottled, and so forth, it will be delicate, cannot but be delicate." Nor again can one say any such things here as "Being tall and thin is not enough alone to ensure that a vase is delicate, but if it is, for example, slightly curving and pale colored (and so forth) as well, it cannot be denied that it is." Things may be described to us in non-aesthetic terms as fully as we please but we are not thereby put in the position of having to admit (or being unable to deny) that they are delicate or graceful or garish or exquisitely balanced.3

No doubt there are some respects in which aesthetic terms are governed by conditions or rules. For instance, it may be impossible that a thing should be garish if all its colors are pale pastels, or flamboyant if all its lines are straight. There may be, that is, descriptions using only nonaesthetic terms which are incompatible with descriptions employing certain aesthetic terms. If I am told that a painting in the next room consists solely of one or two bars of very pale blue and very pale grey set at right angles on a pale fawn ground, I can be sure that it cannot be fiery or garish or gaudy or flamboyant. A description of this sort may make certain aesthetic terms inapplicable or inappropriate; and if from this description I inferred that the picture was, or even might be, fiery or gaudy or flamboyant, this might be taken as showing a failure to understand these words. I do not wish to deny therefore that taste concepts may be governed negatively by conditions.4 What I am emphasizing is that they quite lack governing conditions of a sort many other concepts possess. Though on seeing the picture we might say, and rightly, that it is delicate or serene or restful or sickly or insipid, no description in non-aesthetic terms permits us to claim that these or any other aesthetic terms must undeniably apply to it.

I have said that if an object is characterized *solely* by certain sorts of features this may count decisively against the possibility of applying to it certain aesthetic terms. But of course the presence of *some* such features

need not count decisively; other features may be enough to outweigh those which, on their own, would render the aesthetic term inapplicable. A painting might be garish even though much of its color is pale. These facts call attention to a further feature of taste concepts. One can find general features or descriptions which in some sense count in one direction only, only for or only against the application of certain aesthetic terms. Angularity, fatness, brightness, or intensity of color are typically not associated with delicacy or grace. Slimness, lightness, gentle curves, lack of intensity of color are associated with delicacy, but not with flamboyance, majesty, grandeur, splendor or garishness. This is shown by the naturalness of saying, for example, that someone is graceful because she's so light, but in spite of being quite angular or heavily built; and by the corresponding oddity of saying that something is graceful because it is so heavy or angular, or delicate because of its bright and intense coloring. This may therefore sound quite similar to what I have said already about conditions in discussing terms like "intelligent." There are nevertheless very significant differences. Although there is this sense in which slimness, lightness, lack of intensity of color, and so on, count only towards, not against, delicacy, these features, I shall say, at best count only typically or characteristically towards delicacy; they do not count towards in the same sense as condition-features count towards laziness or intelligence; that is, no group of them is ever logically sufficient.

One way of reinforcing this is to notice how features which are characteristically associated with one aesthetic term may also be similarly associated with other and rather different aesthetic terms. "Graceful" and "delicate" may be on the one hand sharply contrasted with terms like "violent," "grand," "fiery," "garish," or "massive" which have characteristic non-aesthetic features quite unlike those for "delicate" and "graceful." But on the other hand "graceful" and "delicate" may also be contrasted with aesthetic terms which stand much closer to them, like "flaccid," "weakly," "washed out," "lanky," "anaemic," "wan," "insipid"; and the range of features characteristic of these qualities, pale color, slimness, lightness, lack of angularity and sharp contrast, is virtually identical with the range for "delicate" and "graceful." Similarly many of the features typically associated with "joyous," "fiery," "robust," or "dynamic" are identical with those associated with "garish," "strident," "turbulent," "gaudy," or "chaotic." Thus an object which is described very fully, but exclusively in terms of qualities characteristic of delicacy, may turn out on inspection to be not delicate at all, but anaemic or insipid. The failures of novices and the artistically inept prove that quite close similarity in point of line, color, or technique gives no assurance of gracefulness or delicacy. A failure and a success in the manner of Degas may be generally more alike, so far as their non-aesthetic features go, than either is like a successful Fragonard. But it is not necessary to go even this far to make my main point. A painting which has only the kind of features one would associate with vigor and energy but which even so fails to be vigorous and energetic *need* not have some other character, need not be instead, say, strident or chaotic. It may fail to have any particular character whatever. It may employ bright colors, and the like, without being particularly lively and vigorous at all; but one may feel unable to describe it as chaotic or strident or garish either. It is, rather, simply lacking in character (though of course this too is an aesthetic judgment; taste is exercised also in seeing that the painting has no character).

There are of course many features which do not in these ways characteristically count for (or against) particular aesthetic qualities. One poem has strength and power because of the regularity of its meter and rhyme; another is monotonous and lacks drive and strength because of its regular meter and rhyme. We do not feel the need to switch from "because of" to "in spite of." However, I have concentrated upon features which are characteristically associated with aesthetic qualities because, if a case could be made for the view that taste concepts are in any way governed by sufficient conditions, these would seem to be the most promising candidates for governing conditions. But to say that features are associated only *characteristically* with an aesthetic term *is* to say that they can never amount to sufficient conditions; no description however full, even in terms characteristic of gracefulness, puts it beyond question that something is graceful in the way a description may put it beyond question that someone is lazy or intelligent.

It is important to observe, however, that in this paper I am not merely claiming that no sufficient conditions can be stated for taste concepts. For if this were all, taste concepts might not be after all really different from one kind of concept recently discussed. They could be accommodated perhaps with those concepts which Professor H. L. A. Hart has called "defeasible"; it is a characteristic of defeasible concepts that we cannot state sufficient conditions for them because, for any sets we offer, there is always an (open) list of defeating conditions any of which might rule out the application of the concept. The most we can say schematically for a defeasible concept is that, for example, A, B, and C together are sufficient for the concept to apply unless some feature is present which overrides or voids them. But, I want to emphasize, the very fact that we can say this sort of thing shows that we are still to that extent in the realm of conditions.⁵ The features governing defeasible concepts can ordinarily count only one way, either for or against. To take Hart's example, "offer" and "acceptance" can count only towards the existence of a valid contract, and fraudulent misrepresentation, duress, and lunacy can count only against. And even with defeasible concepts, if we are told that there are no voiding features present, we can know that some set of conditions or features, A, B,

 C, \ldots , is enough, in this absence of voiding features, to ensure, for example, that there is a contract. The very notion of a defeasible concept seems to require that some group of features *would* be sufficient *in certain circumstances*, that is, in the absence of overriding or voiding features. In a certain way defeasible concepts lack sufficient conditions then, but they are still, in the sense described, condition-governed. My claim about taste concepts is stronger; that they are not, except negatively, governed by conditions at all. We could not conclude even in certain circumstances, e.g., if we were told of the absence of all "voiding" or uncharacteristic features (no angularities, and the like), that an object *must* certainly be graceful, no matter how fully it was described to us as possessing features characteristic of gracefulness.

My arguments and illustrations so far have been rather simply schematic. Many concepts, including most of the examples I have used (intelligent, and so on, above), are much more thoroughly open and complex than my illustrations suggest. Not only may there be an open list of relevant conditions; it may be impossible to give precise rules telling how many features from the list are needed for a sufficient set or in which combinations; impossible similarly to give precise rules covering the extent or degree to which such features need to be present in those combinations. Indeed, we may have to abandon as futile any attempt to describe or formulate anything like a complete set of precise conditions or rules, and content ourselves with giving only some general account of the concept, making reference to samples or cases or precedents. We cannot fully master or employ these concepts therefore simply by being equipped with lists of conditions, readily applicable procedures or sets of rules, however complex. For to exhibit a mastery of one of these concepts we must be able to go ahead and apply the word correctly to new individual cases, at least to central ones; and each new case may be a uniquely different object, just as each intelligent child or student may differ from others in relevant features and exhibit a unique combination of kinds and degrees of achievement and ability. In dealing with these new cases mechanical rules and procedures would be useless; we have to exercise our judgment, guided by a complex set of examples and precedents. Here then there is a marked superficial similarity to aesthetic concepts. For in using aesthetic terms too we learn from samples and examples, not rules, and we have to apply them, likewise, without guidance by rules or readily applicable procedures, to new and unique instances. Neither kind of concept admits of a simply "mechanical" employment.

But this is *only* a superficial similarity. It is at least noteworthy that in applying words like "lazy" or "intelligent" to new and unique instances we say that we are required to exercise *judgment;* it would be indeed odd to say that we are exercising *taste*. In exercising judgment we are called upon

to weigh the pros and cons against each other, and perhaps sometimes to decide whether a quite new feature is to be counted as weighing on one side or on the other. But this goes to show that, though we may learn from and rely upon samples and precedents rather than a set of stated conditions, we are not out of the realm of general conditions and guiding principles. These precedents necessarily embody, and are used by us to illustrate, a complex web of governing and relevant conditions which it is impossible to formulate completely. To profit by precedents we have to understand them; and we must argue consistently from case to case. This is the very function of precedents. Thus it is possible, even with these very loosely condition-governed concepts, to take clear or paradigm cases of X and to say "this is X because . . .," and follow it up with an account of features which logically clinch the matter.

Nothing like this is possible with aesthetic terms. Examples undoubtedly play a crucial role in giving us a grasp of these concepts; but we do not and cannot derive from these examples conditions and principles, however complex, which will enable us, if we are consistent, to apply the terms even to some new cases. When, with a clear case of something which is in fact graceful or balanced or tightly-knit, someone tells me why it is, what features make it so, it is always possible for me to wonder whether, in spite of these features, it really is graceful, balanced, and so on. No such features logically clinch the matter.

The point I have argued may be reinforced in the following way. A man who failed to realize the nature of aesthetic concepts, or someone who, knowing he lacked sensitivity in aesthetic matters, did not want to reveal this lack might by assiduous application and shrewd observation provide himself with some rules and generalizations; and by inductive procedures and intelligent guessing, he might frequently say the right things. But he could have no great confidence or certainty; a slight change in an object might at any time unpredictably ruin his calculations, and he might as easily have been wrong as right. No matter how careful he has been about working out a set of consistent principles and conditions, he is only in a position to think that the object is very possibly delicate. With concepts like lazy, intelligent, or contract, someone who intelligently formulated rules that led him aright appreciably often *would* thereby show the beginning of a grasp of those concepts; but the person we are considering is not even beginning to show an awareness of what delicacy is. Though he sometimes says the right thing, he has not seen, but guessed, that the object is delicate. However intelligent he might be, we could easily tell him wrongly that something was delicate and "explain" why without his being able to detect the deception. (I am ignoring complications now about negative conditions.) But if we did the same with, say, "intelligent" he could at least often uncover some incompatibility or other which would need explaining. In a world of beings like himself he would have no use for concepts like deli-

cacy. As it is, these concepts would play a quite different role in his life. He would, for himself, have no more reason to choose tasteful objects, pictures, and so on, than a deaf man would to avoid noisy places. He could not be praised for exercising taste; at best his ingenuity and intelligence might come in for mention. In "appraising" pictures, statuettes, poems, he would be doing something quite different from what other people do when they exercise taste.

At this point I want to notice in passing that there are times when it may look as if an aesthetic word could be applied according to a rule. These cases vary in type; I shall mention only one. One might say, in using "delicate" of glassware perhaps, that the thinner the glass, other things being equal, the more delicate it is. Similarly, with fabrics, furniture, and so on, there are perhaps times when the thinner or more smoothly finished or more highly polished something is, the more certainly some aesthetic term or other applies. On such occasions someone might formulate a rule and follow it in applying the word to a given range of articles. Now it may be that sometimes when this is so, the word being used is not really an aesthetic term at all; "delicate" applied to glass in this way may at times really mean no more than "thin" or "fragile." But this is certainly not always the case; people often are exercising taste even when they say that glass is very delicate because it is so thin, and know that it would be less so if thicker and more so if thinner. These instances where there appear to be rules are peripheral cases of the use of aesthetic terms. If someone did merely follow a rule we should not say he was exercising taste, and we should hesitate to admit that he had any real notion of delicacy until he satisfied us that he could discern it in other instances where no rule was available. In any event, these occasions when aesthetic words can be applied by rule are exceptional, not central or typical, and there is still no reason to think we are dealing with a logical entailment.⁶

It must not be thought that the impossibility of stating any conditions (other than negative) for the application of aesthetic terms results from an accidental poverty or lack of precision in language, or that it is simply a question of extreme complexity. It is true that words like "pink," "bluish," "curving," "mottled" do not permit of anything like a specific naming of each and every varied shade, curve, mottling, and blending. But if we were to give special names much more liberally than either we or even the specialists do (and no doubt there are limits beyond which we could not go), or even if, instead of names, we were to use vast numbers of specimens and samples of particular shades, shapes, mottlings, lines, and configurations, it would still be impossible, and for the same reasons, to supply any conditions.

We do indeed, in talking about a work of art, concern ourselves with its individual and specific features. We say that it is delicate not simply because it is in pale colors but because of *those* pale colors, that it is graceful

not because its outline curves slightly but because of that particular curve. We use expressions like "because of its pale coloring," "because of the flecks of bright blue," "because of the way the lines converge" where it is clear we are referring not to the presence of general features but to very specific and particular ones. But it is obvious that even with the help of precise names, or even samples and illustrations, of particular shades of color, contours and lines, any attempt to state conditions would be futile. After all, the very same feature, say a color or shape or line of a particular sort, which helps make one work may quite spoil another. "It would be quite delicate if it were not for that pale color there" may be said about the very color which is singled out in another picture as being largely responsible for its delicate quality. No doubt one way of putting this is to say that the features which make something delicate or graceful, and so on, are combined in a peculiar and unique way; that the aesthetic quality depends upon exactly this individual or unique combination of just these specific colors and shapes so that even a slight change might make all the difference. Nothing is to be achieved by trying to single out or separate features and generalizing about them.

I have now argued that in certain ways aesthetic concepts are not and cannot be condition- or rule-governed.⁷ Not to be so governed is one of their essential characteristics. In arguing this I first claimed in a general way that no non-aesthetic features are possible candidates for conditions, and then considered more particularly both the "characteristic" general features associated with aesthetic terms and the individual or specific features found in particular objects. I have not attempted to examine what relationship these specific features of a work do bear to its aesthetic qualities. An examination of the locutions we use when we refer to them in the course of explaining or supporting our application of an aesthetic term reinforces with linguistic evidence the fact that we are certainly not offering them as explanatory or justifying conditions. When we are asked why we say a certain person is lazy or intelligent or courageous, we are being asked in virtue of what do we call him this; we reply with "because of the way he regularly leaves his work unfinished," or "because of the ease with which he handles such and such problems," and so on. But when we are asked to say why, in our opinion, a picture lacks balance or is somber in tone, or why a poem is moving or tightly organized, we are doing a different kind of thing. We may use similar locutions: "his verse has strength and variety because of the way he handles the meter and employs the caesura," or "it is nobly austere because of the lack of detail and the restricted palette." But we can also express what we want to by using quite other expressions: "it is the handling of meter and caesura which is responsible for its strength and variety," "its nobly austere quality is *due to* the lack of detail and the use of a restricted palette," "its lack of balance results from the high-

lighting of the figures on the left," "those minor chords *make it* extremely moving," "those converging lines *give it* an extraordinary unity." These are locutions we cannot switch to with "lazy" or "intelligent"; to say what *makes* him lazy, what is *responsible for* his laziness, what it is *due to*, is to broach another question entirely.

One after another, in recent discussions, writers have insisted that aesthetic judgments are not "mechanical": "Critics do not formulate general standards and apply these mechanically to all, or to classes of, works of art." "Technical points can be settled rapidly, by the application of rules," but aesthetic questions "cannot be settled by any mechanical method." Instead, these writers on aesthetics have emphasized that there is no "substitute for individual judgment" with its "spontaneity and speculation" and that "The final standard . . . [is] the judgment of personal taste."8 What is surprising is that, though such things have been repeated again and again, no one seems to have said what is meant by "taste" or by the word "mechanical." There are many judgments besides those requiring taste which demand "spontaneity" and "individual judgment" and are not "mechanical." Without a detailed comparison we cannot see in what particular way aesthetic judgments are not "mechanical," or how they differ from those other judgments, nor can we begin to specify what taste is. This I have attempted. It is a characteristic and essential feature of judgments which employ an aesthetic term that they cannot be made by appealing, in the sense explained, to non-aesthetic conditions.9 This, I believe, is a logical feature of aesthetic or taste judgments in general, though I have argued it here only as regards the more restricted range of judgments which employ aesthetic terms. It is part of what "taste" means.

Π

A great deal of work remains to be done on aesthetic concepts. In the remainder of this paper I shall offer some further suggestions which may help towards an understanding of them.

The realization that aesthetic concepts are governed only negatively by conditions is likely to give rise to puzzlement over how we manage to apply the words in our aesthetic vocabulary. If we are not following rules and there are no conditions to appeal to, how are we to know when they are applicable? One very natural way to counter this question is to point out that some other sorts of concepts also are not condition-governed. We do not apply simple color words by following rules or in accordance with principles. We see that the book is red by looking, just as we tell that the tea is sweet by tasting it. So too, it might be said, we just see (or fail to see) that things are delicate, balanced, and the like. This kind of comparison between the exercise of taste and the use of the five senses is indeed familiar; our use of the word "taste" itself shows that the comparison is age-old and very natural. Yet whatever the similarities, there are great dissimilarities too. A careful comparison cannot be attempted here though it would be valuable; but certain differences stand out, and writers who have emphasized that aesthetic judgments are not "mechanical" have sometimes dwelt on and been puzzled by them.

In the first place, while our ability to discern aesthetic features is dependent upon our possession of good eyesight, hearing, and so on, people normally endowed with senses and understanding may nevertheless fail to discern them. "Those who listen to a concert, walk round a gallery, read a poem may have roughly similar sense perceptions, but some get a great deal more than others," Miss Macdonald says; but she adds that she is "puzzled by this feature 'in the object' which can be seen only by a specially qualified observer" and asks, "What is this 'something more'?"¹⁰

It is this difference between aesthetic and perceptual qualities which in part leads to the view that "works of art are esoteric objects . . . not simple objects of sense perception."11 But there is no good reason for calling an object esoteric simply because we discern aesthetic qualities in it. The objects to which we apply aesthetic words are of the most diverse kinds and by no means esoteric: people and buildings, flowers and gardens, vases and furniture, as well as poems and music. Nor does there seem any good reason for calling the qualities themselves esoteric. It is true that someone with perfect eves or ears might miss them, but we do after all say we observe or notice them ("Did you notice how very graceful she was?," "Did you observe the exquisite balance in all his pictures?"). In fact, they are very familiar indeed. We learn while quite young to use many aesthetic words, though they are, as one might expect from their dependence upon our ability to see, hear, distinguish colors, and the like, not the earliest words we learn; and our mastery and sophistication in using them develop along with the rest of our vocabulary. They are not rarities; some ranges of them are in regular use in everyday discourse.

The second notable difference between the exercise of taste and the use of the five senses lies in the way we support those judgments in which aesthetic concepts are employed. Although we use these concepts without rules or conditions, we do defend or support our judgments, and convince others of their rightness, by talking; "disputation about art is not futile," as Miss Macdonald says, for critics do "attempt a certain kind of explanation of works of art with the object of establishing correct judgments."¹² Thus even though this disputation does not consist in "deductive or inductive inference" or "reasoning," its occurrence is enough to show how very different these judgments are from those of a simple perceptual sort.

Now the critic's talk, it is clear, frequently consists in mentioning or pointing out the features, including easily discernible non-aesthetic ones, upon which the aesthetic qualities depend. But the puzzling question re-

mains how, by mentioning these features, the critic is thereby justifying or supporting his judgments. To this question a number of recent writers have given an answer. Stuart Hampshire, for example, says that "One engages in aesthetic discussion for the sake of what one might see on the way. . . . If one has been brought to see what there is to be seen in the object, the purpose of discussion is achieved. . . . The point is to bring people to see these features."¹³ The critic's talk, that is, often serves to support his judgments in a special way; it helps us to *see* what he has seen, namely, the aesthetic qualities of the object. But even when it is agreed that this is one of the main things that critics do, puzzlement tends to break out again over *how* they do it. How is it that by talking about features of the work (largely non-aesthetic ones) we can manage to bring others to see what they had not seen? "What sort of endowment is this which *talking* can modify? . . . Discussion does not improve eyesight and hearing" (my italics).¹⁴

Yet of course we do succeed in applying aesthetic terms, and we frequently do succeed by talking (and pointing and gesturing in certain ways) in bringing others to see what we see. One begins to suspect that puzzlement over how we can possibly do this, and puzzlement over the "esoteric" character of aesthetic qualities too, arises from bearing in mind inappropriate philosophical models. When someone is unable to see that the book on the table is brown, we cannot get him to see that it is by talking; consequently it seems puzzling that we might get someone to see that the vase is graceful by talking. If we are to dispel this puzzlement and recognize aesthetic concepts and qualities for what they are, we must abandon unsuitable models and investigate how we actually employ these concepts. With so much interest in and agreement about *what* the critic does, one might expect descriptions of *how* he does it to have been given. But little has been said about this, and what has been said is unsatisfactory.

Miss Macdonald,¹⁵ for example, subscribes to this view of the critic's task as presenting "what is not obvious to casual or uninstructed inspection," and she does ask the question "What sort of considerations are involved, *and how*, to justify a critical verdict?" (my italics). But she does not in fact go on to answer it. She addresses herself instead to the different, though related, question of the interpretation of art works. In complex works different critics claim, often justifiably, to discern different features; hence Miss Macdonald suggests that in critical discourse the critic is bringing us to see what he sees by offering new interpretations. But if the question is "what (the critic) does and how he does it," he cannot be represented either wholly or even mainly as providing new interpretations. His task quite as often is simply to help us appreciate qualities which other critics have regularly found in the works he discusses. To put the stress upon *new* interpretations is to leave untouched the question how, by talking, he can help us to see *either* the newly appreciated aesthetic qualities *or* the old. In any case, besides complex poems or plays which may bear many interpretations, there are also relatively simple ones. There are also vases, buildings, and furniture, not to mention faces, sunsets, and scenery, about which no questions of "interpretation" arise but about which we talk in similar ways and make similar judgments. So the "puzzling" questions remain: how do we support these judgments and how do we bring others to see what we see?

Hampshire,¹⁶ who likewise believes that the critic brings us "to see what there is to be seen in the object," does give some account of how the critic does this. "The greatest service of the critic" is to point out, isolate, and place in a frame of attention the "particular features of the particular object which *make* it ugly or beautiful"; for it is "difficult to see and hear all that there is to see and hear," and simply a prejudice to suppose that while "things really do have colors and shapes . . . there do not exist literally and objectively, concordances of colors and perceived rhythms and balances of shapes." However, these "extraordinary qualities" which the critic "may have seen (in the wider sense of 'see')" are "qualities which are of no direct practical interest." Consequently, to bring us to see them the critic employs "an unnatural use of words in description"; "the common vocabulary, being created for practical purposes, obstructs any disinterested perception of things"; and so these qualities "are normally described metaphorically by some transference of terms from the common vocabulary."

Much of what Hampshire says is right. But there is also something quite wrong in the view that the "common" vocabulary "obstructs" our aesthetic purposes, that it is "unnatural" to take it over and use it metaphorically, and that the critic "is under the necessity of building . . . a vocabulary in opposition to the main tendency of his language" (my italics). First, while we do often coin new metaphors in order to describe aesthetic qualities, we are by no means always under the necessity of wresting the "common vocabulary" from its "natural" uses to serve our purposes. There does exist, as I observed earlier, a large and accepted vocabulary of aesthetic terms some of which, whatever their metaphorical origins, are now not metaphors at all, others of which are at most quasi-metaphorical. Second, this view that our use of metaphor and quasi-metaphor for aesthetic purposes is unnatural or a makeshift into which we are forced by a language designed for other purposes misrepresents fundamentally the character of aesthetic qualities and aesthetic language. There is nothing unnatural about using words like "forceful," "dynamic," or "tightly-knit" in criticism; they do their work perfectly and are exactly the words needed for the purposes they serve. We do not want or need to replace them by words which lack the metaphorical element. In using them to describe works of art, the very point is that we are noticing aesthetic qualities related to their literal or common meanings. If we possessed a quite different word from "dynamic," one we could use to point out an aesthetic quality unrelated to the common

meaning of "dynamic," it could not be used to describe that quality which "dynamic" does serve to point out. Hampshire pictures "a colony of aesthetes, disengaged from practical needs and manipulations" and says that "descriptions of aesthetic qualities, which for us are metaphorical, might seem to them to have an altogether literal and familiar sense"; they might use "a more directly descriptive vocabulary." But if they had a new and "directly descriptive" vocabulary lacking the links with non-aesthetic properties and interests which our vocabulary possesses, they would have to remain silent about many of the aesthetic qualities we can describe; further, if they were more completely "disengaged from practical needs" and other non-aesthetic awarenesses and interests, they would perforce be blind to many aesthetic qualities we can appreciate. The links between aesthetic qualities and non-aesthetic ones are both obvious and vital. Aesthetic concepts, all of them, carry with them attachments and in one way or another are tethered to or parasitic upon non-aesthetic features. The fact that many aesthetic terms are metaphorical or quasi-metaphorical in no way means that common language is an ill-adapted tool with which we have to struggle. When someone writes as Hampshire does, one suspects again that critical language is being judged against other models. To use language which is frequently metaphorical might be strange for some other purpose or from the standpoint of doing something else, but for the purpose and from the standpoint of making aesthetic observations it is not. To say it is an unnatural use of language for doing this is to imply there is or could be for this purpose some other and "natural" use. But these are natural ways of talking about aesthetic matters.

To help understand what the critic does, then, how he supports his judgments and gets his audience to see what he sees, I shall attempt a brief description of the methods we use as critics.¹⁷

(1) We may simply mention or point out non-aesthetic features: "Notice these flecks of color, that dark mass there, those lines." By merely drawing attention to those easily discernible features which make the painting luminous or warm or dynamic, we often succeed in bringing someone to see these aesthetic qualities. We get him to see B by mentioning something different, A. Sometimes in doing this we are drawing attention to features which may have gone unnoticed by an untrained or insufficiently attentive eye or ear: "Just listen for the repeated figure in the left hand," "Did you notice the figure of Icarus in the Breughel? It is very small." Sometimes they are features which have been seen or heard but of which the significance or purpose has been missed in any of a variety of ways: "Notice how much darker he has made the central figure, how much brighter these colors are than the adjacent ones," "Of course, you've observed the ploughman in the foreground; but had you considered how he, like everyone else in the picture, is going about his business without noticing the fall of Icarus?" In mentioning features which may be discerned by anyone with normal eyes, ears, and intelligence, we are singling out what may serve as a kind of key to grasping or seeing something else (and the key may not be the same for each person).

(2) On the other hand we often simply mention the very qualities we want people to see. We point to a painting and say, "Notice how nervous and delicate the drawing is," or "See what energy and vitality it has." The use of the aesthetic term itself may do the trick; we say what the quality or character is, and people who had not seen it before see it.

(3) Most often, there is a linking of remarks about aesthetic and nonaesthetic features: "Have you noticed this line and that, and the points of bright color here and there . . . don't they give it vitality, energy?"

(4) We do, in addition, often make extensive and helpful use of similes and genuine metaphors: "It's as if there were small points of light burning," "as though he had thrown on the paint violently and in anger," "the light shimmers, the lines dance, everything is air, lightness and gaiety," "his canvasses are fires, they crackle, burn, and blaze, even at their most subdued always restlessly flickering, but often bursting into flame, great pyrotechnic displays," and so on.

(5) We make use of contrasts, comparisons, and reminiscences: "Suppose he had made that a lighter yellow, moved it to the right, how flat it would have been," "Don't you think it has something of the quality of a Rembrandt?," "Hasn't it the same serenity, peace, and quality of light of those summer evenings in Norfolk?" We use what keys we have to the known sensitivity, susceptibilities, and experience of our audience.

Critics and commentators may range, in their methods, from one extreme to the other, from painstaking concentration on points of detail, line and color, vowels and rhymes, to more or less flowery and luxuriant metaphor. Even the enthusiastic biographical sketch decorated with suitable epithet and metaphor may serve. What is best depends on both the audience and the work under discussion. But this would not be a complete sketch unless certain other notes were added.

(6) Repetition and reiteration often play an important role. When we are in front of a canvas we may come back time and again to the same points, drawing attention to the same lines and shapes, repeating the same words, "swirling," "balance," "luminosity," or the same similes and metaphors, as if time and familiarity, looking harder, listening more carefully, paying closer attention may help. So again with variation; it often helps to talk round what we have said, to build up, supplement with more talk of the same kind. When someone misses the swirling quality, when one epithet or one metaphor does not work, we throw in related ones; we speak of its wild movement, how it twists and turns, writhes and whirls, as though, failing to score a direct hit, we may succeed with a barrage of near-synonyms.

(7) Finally, besides our verbal performances, the rest of our behavior is important. We accompany our talk with appropriate tones of voice, expression, nods, looks, and gestures. A critic may sometimes do more with a sweep of the arm than by talking. An appropriate gesture may make us see the violence in a painting or the character of a melodic line.

These ways of acting and talking are not significantly different whether we are dealing with a particular work, paragraph, or line, or speaking of an artist's work as a whole, or even drawing attention to a sunset or scenery. But even with the speaker doing all this, we may fail to see what he sees. There may be a point, though there need be no limit except that imposed by time and patience, at which he gives up and sets us (or himself) down as lacking in some way, defective in sensitivity. He may tell us to look or read again, or to read or look at other things and then come back again to this; he may suspect there are experiences in life we have missed. But these are the things he does. This is what succeeds if anything does; indeed it is all that can be done.

By realizing clearly that, whether we are dealing with art or scenery or people or natural objects, this is how we operate with aesthetic concepts, we may recognize this sphere of human activity for what it is. We operate with different kinds of concepts in different ways. If we want someone to agree that a color is red we may take it into a good light and ask him to look; if it is viridian we may fetch a color chart and make him compare; if we want him to agree that a figure is fourteen-sided we get him to count; and to bring him to agree that something is dilapidated or that someone is intelligent or lazy we may do other things, citing features, reasoning and arguing about them, weighing and balancing. These are the methods appropriate to these various concepts. But the ways we get someone to see aesthetic qualities are different; they are of the kind I have described. With each kind of concept we can describe what we do and how we do it. But the methods suited to these other concepts will not do for aesthetic ones, or vice versa. We cannot prove by argument or by assembling a sufficiency of conditions that something is graceful; but this is no more puzzling than our inability to prove, by using the methods, metaphors, and gestures of the art critic, that it will be mate in ten moves. The questions raised admit of no answer beyond the sort of description I have given. To go on to ask, with puzzlement, how it is that when we do these things people come to see, is like asking how is it that, when we take the book into a good light, our companion agrees with us that it is red. There is no place for this kind of question or puzzlement. Aesthetic concepts are as natural, as little esoteric, as any others. It is against the background of different and philosophically more familiar models that they seem queer or puzzling.

I have described how people justify aesthetic judgments and bring others to see aesthetic qualities in things. I shall end by showing that the methods I have outlined are the ones natural for and characteristic of taste concepts from the start. When someone tries to make me see that a painting is delicate or balanced, I have some understanding of these terms already and know in a sense what I am looking for. But if there is puzzlement over how, by talking, he can bring me to see these qualities in this picture, there should be a corresponding puzzlement over how I learned to use aesthetic terms and discern aesthetic qualities in the first place. We may ask, therefore, how we learn to do these things; and this is to inquire (1) what natural potentialities and tendencies people have and (2) how we develop and take advantage of these capacities in training and teaching. Now for the second of these, there is no doubt that our ability to notice and respond to aesthetic qualities is cultivated and developed by our contacts with parents and teachers from quite an early age. What is interesting for my present purpose is that, while we are being taught in the presence of examples what grace, delicacy, and so on are, the methods used, the language and behavior, are of a piece with those of the critic as I have already described them.

To pursue these two questions, consider first those words like "dynamic," "melancholy," "balanced," "taut," or "gay" the aesthetic use of which is quasi-metaphorical. It has already been emphasized that we could not use them thus without some experience of situations where they are used literally. The present inquiry is how we shift from literal to aesthetic uses of them. For this it is required that there be certain abilities and tendencies to link experiences, to regard certain things as similar, and to see, explore, and be interested in these similarities. It is a feature of human intelligence and sensitivity that we do spontaneously do these things and that the tendency can be encouraged and developed. It is no more baffling that we should employ aesthetic terms of this sort than that we should make metaphors at all. Easy and smooth transitions by which we shift to the use of these aesthetic terms are not hard to find. We suggest to children that simple pieces of music are hurrying or running or skipping or dawdling, from there we move to lively, gay, jolly, happy, smiling, or sad, and, as their experiences and vocabulary broaden, to solemn, dynamic, or melancholy. But the child also discovers for himself many of these parallels and takes interest or delight in them. He is likely on his own to skip, march, clap, or laugh with the music, and without this natural tendency our training would get nowhere. Insofar, however, as we do take advantage of this tendency and help him by training, we do just what the critic does. We may merely need to persuade the child to pay attention, to look or listen; or we may simply call the music jolly. But we are also likely to use, as the critic does, reiteration, synonyms, parallels, contrasts, similes, metaphors, gestures, and other expressive behavior.

Of course the recognition of similarities and simple metaphorical extensions are not the only transitions to the aesthetic use of language. Others

are made in different ways; for instance, by the kind of peripheral cases I mentioned earlier. When our admiration is for something as simple as the thinness of a glass or the smoothness of a fabric, it is not difficult to call attention to such things, evoke a similar delight, and introduce suitable aesthetic terms. These transitions are only the beginnings; it may often be questionable whether a term is yet being used aesthetically or not. Many of the terms I have mentioned may be used in ways which are not straightforwardly literal but of which we should hesitate to say that they demanded much yet by way of aesthetic sensitivity. We speak of warm and cool colors, and we may say of a brightly colored picture that at least it is gay and lively. When we have brought someone to make this sort of metaphorical extension of terms, he has made one of the transitional steps from which he may move on to uses which more obviously deserve to be called aesthetic and demand more aesthetic appreciation. When I said at the outset that aesthetic sensitivity was rarer than some other natural endowments. I was not denying that it varies in degree from the rudimentary to the refined. Most people learn easily to make the kinds of remarks I am now considering. But when someone can call bright canvasses gay and lively without being able to spot the one which is really vibrant, or can recognize the obvious outward vigor and energy of a student composition played con fuoco while failing to see that it lacks inner fire and drive, we do not regard his aesthetic sensitivity in these areas as particularly developed. However, once these transitions from common to aesthetic uses are begun in the more obvious cases, the domain of aesthetic concepts may broaden out, and they may become more subtle and even partly autonomous. The initial steps, however varied the metaphorical shifts and however varied the experiences upon which they are parasitic, are natural and easy.

Much the same is true when we turn to those words which have no standard non-aesthetic use, "lovely," "pretty," "dainty," "graceful," "elegant." We cannot say that these are learned by a metaphorical shift. But they still are linked to non-aesthetic features in many ways and the learning of them also is made possible by certain kinds of natural response, reaction, and ability. We learn them not so much by noticing similarities, but by our attention being caught and focussed in other ways. Certain phenomena which are outstanding or remarkable or unusual catch the eye or ear, seize our attention and interest, and move us to surprise, admiration, delight, fear, or distaste. Children begin by reacting in these ways to spectacular sunsets, woods in autumn, roses, dandelions, and other striking and colorful objects, and it is in these circumstances that we find ourselves introducing general aesthetic words to them, like "lovely," "pretty," and "ugly." It is not an accident that the first lessons in aesthetic appreciation

consist in drawing the child's attention to roses rather than to grass; nor is it surprising that we remark to him on the autumn colors rather than on the subdued tints of winter. We all of us, not only children, pay aesthetic attention more readily and easily to such outstanding and easily noticeable things. We notice with pleasure early spring grass or the first snow, hills of notably marked and varied contours, scenery flecked with a great variety of color or dappled variously with sun and shadow. We are struck and impressed by great size or mass, as with mountains or cathedrals. We are similarly responsive to unusual precision or minuteness or remarkable feats of skill, as with complex and elaborate filigree, or intricate wood carving and fan-vaulting. It is at these times, taking advantage of these natural interests and admirations, that we first teach the simpler aesthetic words. People of moderate aesthetic sensitivity and sophistication continue to exhibit aesthetic interest mainly on such occasions and to use only the more general words ("pretty," "lovely," and the like). But these situations may serve as a beginning from which we extend our aesthetic interests to wider and less obvious fields, mastering as we go the more subtle and specific vocabulary of taste. The principles do not change; the basis for learning more specific terms like "graceful," "delicate," and "elegant" is also our interest in and admiration for various non-aesthetic natural properties ("She seems to move effortlessly, as if floating," "So very thin and fragile, as if a breeze might destroy it," "So small and yet so intricate," "So economical and perfectly adapted").18 And even with these aesthetic terms which are not metaphorical themselves ("graceful," "delicate," "elegant"), we rely in the same way upon the critic's methods, including comparison, illustration, and metaphor, to teach or make clear what they mean.

I have wished to emphasize in the latter part of this paper the natural basis of responses of various kinds without which aesthetic terms could not be learned. I have also outlined what some of the features are to which we naturally respond: similarities of various sorts, notable colors, shapes, scents, size, intricacy, and much else besides. Even the non-metaphorical aesthetic terms have significant links with all kinds of natural features by which our interest, wonder, admiration, delight, or distaste is aroused. But in particular I have wanted to urge that it should not strike us as puzzling that the critic supports his judgments and brings us to see aesthetic qualities by pointing out key features and talking about them in the way he does. It is by the very same methods that people helped us develop our aesthetic sense and master its vocabulary from the beginning. If we responded to those methods then, it is not surprising that we respond to the critic's discourse now. It would be surprising if, by using this language and behavior, people could *not* sometimes bring us to see the aesthetic qualities of things; for this would prove us lacking in one characteristically human kind of awareness and activity.

Notes

1. I shall speak loosely of an "aesthetic term," even when, because the word sometimes has other uses, it would be more correct to speak of its *use* as an aesthetic term. I shall also speak of "nonaesthetic" words, concepts, features, and so on. None of the terms other writers use, "natural," "observable," "perceptual," "physical," "objective" (qualities), "neutral," "descriptive" (language), when they approach the distinction I am making, is really apt for my purpose.

2. A contrast will reinforce this. If a critic were to describe a passage of music as chattering, carbonated, or gritty, a painter's coloring as vitreous, farinaceous, or effervescent, or a writer's style as glutinous, or abrasive, he *would* be using live metaphors rather than drawing on the more normal language of criticism. Words like "athletic," "vertiginous," "silken" may fall somewhere between.

3. In a paper reprinted in *Aesthetics and Language*, ed. W. Elton (Oxford, 1954), pp. 131–146, Arnold Isenberg discusses certain problems about aesthetic concepts and qualities. Like others who approach these problems, he does not isolate them, as I do, from questions about verdicts on the *merits* of works of art, or from questions about *likings* and *preferences*. He says something parallel to my remarks above: "There is not in all the world's criticism a single purely descriptive statement concerning which one is prepared to say beforehand, 'if it is true, I shall *like* that work so much the better' " (p. 139, my italics). I should think *this* is highly questionable.

4. Isenberg (op. cit., p. 132) makes a somewhat similar but mistaken point: "If we had been told that the colors of a certain painting are garish, it would be *astonishing* to find that they are *all* very pale and unsaturated" (my italics). But if we say "all" rather than "predominantly," then "astonishing" is the wrong word. The word that goes with "all" is "impossible"; "astonishing" might go with "predominantly."

5. H. L. A. Hart, "The Ascription of Responsibility and Rights" in *Logic and Language*, 1st ser., ed. A. G. N. Flew (Oxford, 1951). Hart indeed speaks of "conditions" throughout, see p. 148.

6. I cannot in the compass of this paper discuss the other types of apparent exceptions to my thesis. Cases where a man *lacking* in sensitivity might learn and follow a rule, as above, ought to be distinguished from cases where someone who *possesses* sensitivity might know, from a non-aesthetic description, that an aesthetic term applies. I have stated my thesis as though this latter kind of case never occurs because I have had my eye on the logical features of *typical* aesthetic judgments and have preferred to over- rather than understate my view. But with certain aesthetic terms, especially negative ones, there may perhaps be some rare genuine exceptions when a description enables us to visualize very fully, and when what is described belongs to certain restricted classes of things, say human faces or animal forms. Perhaps a description like "One eye red and rheumy, the other missing, a wart-covered nose, a twisted mouth, a greenish pallor" may justify in a strong sense ("must be," "cannot but be,") the judgments "ugly" or "hideous." If so, such cases are marginal, form a very small minority, and are uncharacteristic or atypical of aesthetic judgments in general. Usually when, on hearing a description, we say "it *must* be very beautiful (graceful, or the like)," we mean no more than "it surely must be, it's only remotely possible that it isn't." Different again are situations, and these are very numerous, where we can move quite simply from "bright colors" to "gay," or from "reds and yellows" to "warm," but where we are as yet only on the borderline of anything that could be called an expression of taste or aesthetic sensibility. I have stressed the importance of this transitional and border area between non-aesthetic and obviously aesthetic judgments in Section II.

7. Helen Knight says (Elton, op. cit., p. 152) that "piquant" (one of my "aesthetic" terms) "depends on" various features (a retroussé nose, a pointed chin, and the like), and that these features are criteria for it; this second claim is what I am denying. She also maintains that "good," when applied to works of art, depends on criteria like balance, solidity, depth, profundity (my aesthetic terms again; I should place piquancy in this list). I would deny this too, though I regard it as a different question and do not consider it in this paper. The two questions need separating: the relation of non-aesthetic features (retroussé, pointed) to aesthetic qualities, and the relation of aesthetic qualities to "aesthetically good" (verdicts). Most writings which touch on the nature of aesthetic concepts have this other (verdict) question mainly in mind. Mrs. Knight blurs this difference when she says, for example, "'piquant' is the same kind of world as 'good.'"

8. See articles by Margaret Macdonald and J. A. Passmore in Elton, op. cit., pp. 118, 41, 40, 119.

9. As I indicated, above, I have dealt only with the relation of *non-aesthetic* to aesthetic features. Perhaps a description in *aesthetic* terms may occasionally suffice for applying another aesthetic term. Johnson's Dictionary gives "hand-some" as "beautiful with dignity"; Shorter O. E. D. gives "pretty" as "beautiful in a slight, dainty, or diminutive way."

10. Macdonald in Elton, op. cit., pp. 114, 119. See also pp. 120, 122.

11. Macdonald, *ibid.*, pp. 114, 120–123. She speaks of non-aesthetic properties here as "physical" or "observable" qualities, and distinguishes between "physical object" and "work of art."

12. Ibid., 115-116; cf. also John Holloway, Proceedings of the Aristotelian Society, Supp. Vol. XXIII (1949), pp. 175-176.

13. Stuart Hampshire in Elton, op. cit., p. 165. Cf. also remarks in Elton by Isenberg (pp. 142, 145), Passmore (p. 38), in *Philosophy and Psychoanalysis* by John Wisdom (Oxford, 1953), pp. 223-224, and in Holloway, op. cit., p. 175.

14. Macdonald, op. cit., pp. 119-120.

15. Ibid., see pp. 127, 122, 125, 115. Other writers also place the stress on interpretation, cf. Holloway, op. cit., p. 173 ff.

16. Op. cit., pp. 165-168.

17. Holloway, op. cit., pp. 173-174, lists some of these very briefly.

18. It is worth noticing that most of the words which in current usage are

primarily or exclusively aesthetic terms had earlier non-aesthetic uses and gained their present use by some kind of metaphorical shift. Without reposing too great weight on these etymological facts, it can be seen that their history reflects connections with the responses, interests, and natural features I have mentioned as underlying the learning and use of aesthetic terms. These transitions suggest both the dependence of aesthetic upon other interests, and what some of these interests are. Connected with liking, delight, affection, regard, estimation, or choice—beautiful, graceful, delicate, lovely, exquisite, elegant, dainty; with fear or repulsion—ugly; with what notably catches the eye or attention—garish, splendid, gaudy; with what attracts by notable rarity, precision, skill, ingenuity, elaboration—dainty, nice, pretty, exquisite; with adaptation to function, suitability to ease of handling—handsome.

Categories of Art KENDALL L. WALTON

I. Introduction

False judgments enter art history if we judge from the impression which pictures of different epochs, placed side by side, make on us. . . . They speak a different language.¹

Paintings and sculptures are to be looked at; sonatas and songs are to be heard. What is important about these works of art, as works of art, is what can be seen or heard in them.² Inspired partly by apparent commonplaces such as these, many recent aesthetic theorists have attempted to purge from criticism of works of art supposedly extraneous excursions into matters not (or not "directly") available to inspection of the works, and to focus attention on the works themselves. Circumstances connected with a work's origin, in particular, are frequently held to have no essential bearing on an assessment of its aesthetic nature—for example, who created the work, how, and when; the artist's intentions and expectations concerning it, his philosophical views, psychological state, and love life; the artistic traditions and intellectual atmosphere of his society. Once produced (it is argued) the work must stand or fall on its own; it must be judged for what it is, regardless of how it came to be as it is.

Arguments for the irrelevance of such nistorical circumstances to aesthetic judgments about works of art may, but need not, involve the claim that these circumstances are not of "aesthetic" interest or importance, though obviously they are often important in biographical, historical, psychological, or sociological researches. One might consider an artist's action in producing a work to be aesthetically interesting, an "aesthetic object" in its own right, while vehemently maintaining its irrelevance to an aesthetic

From The Philosophical Review, LXXIX (1970), 334-367. Reprinted with the permission of the author and The Philosophical Review.

Categories of Art

investigation of the work. Robert Rauschenberg once carefully obliterated a drawing by de Kooning, titled the bare canvas "Erased De Kooning Drawing," framed it, and exhibited it.³ His doing this might be taken as symbolic or expressive (of an attitude toward art, or toward life in general, or whatever) in an "aesthetically" significant manner, perhaps somewhat as an action of a character in a play might be, and yet thought to have no bearing whatever on the aesthetic nature of the finished product. The issue I am here concerned with is how far critical questions about works of art can be *separated* from questions about their histories.⁴

One who wants to make this separation quite sharp may regard the basic facts of art along the following lines. Works of art are simply objects with various properties, of which we are primarily interested in perceptual onesvisual properties of paintings, audible properties of music, and so forth.5 A work's perceptual properties include "aesthetic" as well as "nonaesthetic" ones-the sense of mystery and tension of a painting as well as its dark coloring and diagonal composition; the energy, exuberance, and coherence of a sonata, as well as its meters, rhythms, pitches, timbres, and so forth; the balance and serenity of a Gothic cathedral as well as its dimensions, lines, and symmetries.⁶ Aesthetic properties are features or characteristics of works of art just as much as nonaesthetic ones are.7 They are in the works, to be seen, heard, or otherwise perceived there. Seeing a painting's sense of mystery or hearing a sonata's coherence might require looking or listening longer or harder than does perceiving colors and shapes, rhythms and pitches; it may even require special training or a special kind of sensitivity. But these qualities must be discoverable simply by examining the works themselves if they are discoverable at all. It is never even partly in virtue of the circumstances of a work's origin that it has a sense of mystery or is coherent or serene. Such circumstances sometimes provide hints concerning what to look for in a work, what we might reasonably expect to find by examining it. But these hints are always theoretically dispensable; a work's aesthetic properties must "in principle" be ascertainable without their help. Surely (it seems) a Rembrandt portrait does not have (or lack) a sense of mystery in virtue of the fact that Rembrandt intended it to have (or to lack) that quality, any more than a contractor's intention to make a roof leakproof makes it so; nor is the portrait mysterious in virtue of any other facts about what Rembrandt thought or how he went about painting the portrait or what his society happened to be like. Such circumstances are important to the result only in so far as they had an effect on the pattern of paint splotches that became attached to the canvas, and the canvas can be examined without in any way considering how the splotches got there. It would not matter in the least to the aesthetic properties of the portrait if the paint had been applied to the canvas not by Rembrandt at all, but by a chimpanzee or a cyclone in a paint shop.

The view sketched above can easily seem very persuasive. But the tendency of critics to discuss the histories of works of art in the course of justifying aesthetic judgments about them has been remarkably persistent. This is partly because hints derived from facts about a work's history, however dispensable they may be "in principle," are often crucially important in practice. (One might simply not think to listen for a recurring series of intervals in a piece of music, until he learns that the composer meant the work to be structured around it.) No doubt it is partly due also to genuine confusions on the part of critics. But I will argue that (some) facts about the origins of works of art have an *essential* role in criticism, that aesthetic judgments rest on them in an absolutely fundamental way. For this reason, and for another as well, the view that works of art should be judged simply by what can be perceived in them is seriously misleading, though there is something right in the idea that what matters aesthetically about a painting or a sonata is just how it looks or sounds.

II. Standard, Variable, and Contra-Standard Properties

I will continue to call tension, mystery, energy, coherence, balance, serenity, sentimentality, pallidness, disunity, grotesqueness, and so forth, as well as colors and shapes, pitches and timbres properties of works of art, though "property" is to be construed broadly enough not to beg any important questions. I will also, following Sibley, call properties of the former sort "aesthetic" properties, but purely for reasons of convenience I will include in this category "representational" and "resemblance" properties, which Sibley excludes-for example, the property of representing or being a picture of Napoleon, that of depicting an old man (as) stooping over a fire, that of resembling, or merely suggesting, a human face, claws (the petals of Van Gogh's sunflowers), or (in music) footsteps or conversation. It is not essential for my purposes to delimit with any exactness the class of aesthetic properties (if indeed any such delimitation is possible), for I am more interested in discussing particular examples of such properties than in making generalizations about the class as a whole. It will be obvious, however, that what I say about the examples I deal with is also applicable to a great many other properties we would want to call aesthetic.

Sibley points out that a work's aesthetic properties depend on its nonaesthetic properties; the former are "emergent" or "*Gestalt*" properties based on the latter.⁸ I take this to be true of all the examples of aesthetic properties we will be dealing with, including representational and resemblance ones. It is because of the configuration of colors and shapes on a painting, perhaps in particular its dark colors and diagonal composition, that it has a sense of mystery and tension, if it does. The colors and shapes of a portrait are responsible for its resembling an old man and (perhaps

Categories of Art

with its title) its depicting an old man. The coherence or unity of a piece of music (for example, Beethoven's *Fifth Symphony*) may be largely due to the frequent recurrence of a rhythmic motive, and the regular meter of a song plus the absence of harmonic modulation and of large intervals in the voice part may make it serene or peaceful.

Moreover, a work *seems* or *appears* to us to have certain aesthetic properties because we observe in it, or it appears to us to have, certain nonaesthetic features (though it may not be necessary to notice consciously all the relevant nonaesthetic features). A painting depicting an old man may not look like an old man to someone who is color-blind, or when it is seen from an extreme angle or in bad lighting conditions so that its colors or shapes are distorted or obscured. Beethoven's *Fifth Symphony* performed in such a sloppy manner that many occurrences of the four-note rhythmic motive do not sound similar may seem incoherent or disunified.

I will argue, however, that a work's aesthetic properties depend not only on its nonaesthetic ones, but also on which of its nonaesthetic properties are "standard," which "variable," and which "contra-standard," in senses to be explained. I will approach this thesis by way of the psychological point that what aesthetic properties a work seems to us to have depends not only on what nonaesthetic features we perceive in it, but also on which of them are standard, which variable, and which contra-standard *for us* (in a sense also to be explained).

It is necessary to introduce first a distinction between standard, variable, and contra-standard properties relative to perceptually distinguishable categories of works of art. Such categories include media, genre, styles, forms, and so forth-for example, the categories of paintings, cubist paintings, Gothic architecture, classical sonatas, paintings in the style of Cézanne, and music in the style of late Beethoven-if they are interpreted in such a way that membership is determined solely by features that can be perceived in a work when it is experienced in the normal manner. Thus whether or not a piece of music was written in the eighteenth century is irrelevant to whether it belongs to the category of classical sonatas (interpreted in this way), and whether a work was produced by Cézanne or Beethoven has nothing essential to do with whether it is in the style of Cézanne or late Beethoven. The category of etchings as normally construed is not perceptually distinguishable in the requisite sense, for to be an etching is, I take it, simply to have been produced in a particular manner. But the category of apparent etchings, works which look like etchings from the quality of their lines, whether they are etchings or not, is perceptually distinguishable. A category will not count as "perceptually distinguishable" in my sense if in order to determine perceptually whether something belongs to it, it is necessary (in some or all cases) to determine which categories it is correctly perceived in partly or wholly on the basis of nonperceptual considerations. (See Section IV below.) This prevents, for example, the category of serene things from being perceptually distinguishable in this sense.

A feature of a work of art is standard with respect to a (perceptually distinguishable) category just in case it is among those in virtue of which works in that category belong to that category-that is, just in case the lack of that feature would disqualify, or tend to disqualify, a work from that category. A feature is variable with respect to a category just in case it has nothing to do with works' belonging to that category; the possession or lack of the feature is irrelevant to whether a work qualifies for the category. Finally, a contra-standard feature with respect to a category is the absence of a standard feature with respect to that category-that is, a feature whose presence tends to disqualify works as members of the category. Needless to say, it will not be clear in all cases whether a feature of a work is standard, variable, or contra-standard relative to a given category, since the criteria for classifying works of art are far from precise. But clear examples are abundant. The flatness of a painting and the motionlessness of its markings are standard, and its particular shapes and colors are variable, relative to the category of painting. A protruding threedimensional object or an electrically driven twitching of the canvas would be contra-standard relative to this category. The straight lines in stickfigure drawings and squarish shapes in cubist paintings are standard with respect to those categories respectively, though they are variable with respect to the categories of drawing and painting. The exposition-development-recapitulation form of a classical sonata is standard, and its thematic material is variable, relative to the category of sonatas.

In order to explain what I mean by features being standard, variable, or contra-standard for a person on a particular occasion, I must introduce the notion of perceiving a work in, or as belonging to, a certain (perceptually distinguishable) category.9 To perceive a work in a certain category is to perceive the "Gestalt" of that category in the work. This needs some explanation. People familiar with Brahmsian music-that is, music in the style of Brahms (notably, works of Johannes Brahms)-or impressionist paintings can frequently recognize members of these categories by recognizing the Brahmsian or impressionist Gestalt qualities. Such recognition is dependent on perception of particular features that are standard relative to these categories, but it is not a matter of inferring from the presence of such features that a work is Brahmsian or impressionist. One may not notice many of the relevant features, and he may be very vague about which ones are relevant. If I recognize a work as Brahmsian by first noting its lush textures, its basically traditional harmonic and formal structure, its superimposition and alternation of duple and triple meters, and so forth, and recalling that these characteristics are typical of Brahmsian works. I have

Categories of Art

not recognized it by hearing the Brahmsian *Gestalt*. To do that is simply to recognize it by its Brahmsian *sound*, without necessarily paying attention to the features ("cues") responsible for it. Similarly, recognizing an impressionist painting by its impressionist *Gestalt*, is recognizing the impressionist *look* about it, which we are familiar with from other impressionist paintings; not applying a rule we have learned for recognizing it from its features.

To *perceive* a *Gestalt* quality in a work—that is, to perceive it in a certain category—is not, or not merely, to *recognize* that *Gestalt* quality. Recognition is a momentary occurrence, whereas perceiving a quality is a continuous state which may last for a short or long time. (For the same reason, seeing the ambiguous duck-rabbit figure as a duck is not, or not merely, recognizing a property of it.) We perceive the Brahmsian or impressionist *Gestalt* in a work when, and as long as, it *sounds* (*looks*) Brahmsian or impressionist to us. This involves perceiving (not necessarily being aware of) features standard relative to that category. But it is not *just* this, nor this plus the intellectual realization that these features make the work Brahmsian, or impressionist. These features are perceived combined into a single *Gestalt* quality.

We can of course perceive a work in several or many different categories at once. A Brahms sonata might be heard simultaneously as a piece of music, a sonata, a romantic work, and a Brahmsian work. Some pairs of categories, however, seem to be such that one cannot perceive a work as belonging to both at once, much as one cannot see the duck-rabbit both as a duck and as a rabbit simultaneously. One cannot see a photographic image simultaneously as a still photograph and as (part of) a film, nor can one see something both in the category of paintings and at the same time in the category (to be explained shortly) of *guernicas*.

It will be useful to point out some of the *causes* of our perceiving works in certain categories. (a) In which categories we perceive a work depends in part, of course, on what other works we are familiar with. The more works of a certain sort we have experienced, the more likely it is that we will perceive a particular work in that category. (b) What we have heard critics and others say about works we have experienced, how they have categorized them, and what resemblances they have pointed out to us is also important. If no one has ever explained to me what is distinctive about Schubert's style (as opposed to the styles of, say, Schumann, Mendelssohn, Beethoven, Brahms, Hugo Wolf), or even pointed out that there is such a distinctive style, I may never have learned to hear the Schubertian *Gestalt* quality, even if I have heard many of Schubert's works, and so I may not hear his works as Schubertian. (c) How we are introduced to the particular work in question may be involved. If a Cézanne painting is exhibited in a collection of French Impressionist works, or if before seeing it we are told that it is French Impressionist, we are more likely to see it as French Impressionist than if it is exhibited in a random collection and we are not told anything about it beforehand.

I will say that a feature of a work is standard for a particular person on a particular occasion when, and only when, it is standard relative to some category in which he perceives it, and is not contra-standard relative to any category in which he perceives it. A feature is variable for a person on an occasion just when it is variable relative to *all* of the categories in which he perceives it. And a feature is contra-standard for a person on an occasion just when it is contra-standard relative to *any* of the categories in which he perceives it.¹⁰

III. A Point About Perception

I turn now to my psychological thesis that what aesthetic properties a work seems to have, what aesthetic effect it has on us, how it strikes us aesthetically often depends (in part) on which of its features are standard, which variable, and which contra-standard for us. I offer a series of examples in support of this thesis.

(a) Representational and resemblance properties provide perhaps the most obvious illustration of this thesis. Many works of art look like or resemble other objects—people, buildings, mountains, bowls of fruit, and so forth. Rembrandt's "Titus Reading" looks like a boy, and in particular like Rembrandt's son; Picasso's "Les Demoiselles d'Avignon" looks like five women, four standing and one sitting (though not *especially* like any particular women). A portrait may even be said to be a *perfect* likeness of the sitter, or to capture his image *exactly*.

An important consideration in determining whether a work *depicts* or *represents* a particular object, or an object of a certain sort (for example, Rembrandt's son, or simply *a* boy), in the sense of being a picture, sculpture, or whatever of it¹¹ is whether the work resembles that object, or objects of that kind. A significant degree of resemblance is, I suggest, a necessary condition in most contexts for such representation or depiction,¹² though the resemblance need not be obvious at first glance. If we are unable to see a similarity between a painting purportedly of a woman and women, I think we would have to suppose either that there is such a similarity which we have not yet discovered (as one might fail to see a face in a maze of lines), or that it simply is not a picture of a woman. Resemblance is of course not a *sufficient* condition for representation, since a portrait (containing only one figure) might resemble both the sitter and his twin brother equally but is not a portrait of both of them. (The title might determine which of them it depicts.)¹³

It takes only a touch of perversity, however, to find much of our talk about resemblances between works of art and other things preposterous.

Categories of Art

Paintings and people are *very* different sorts of things. Paintings are pieces of canvas supporting splotches of paint, while people are live, three-dimensional, flesh-and-blood animals. Moreover, except rarely and under special conditions of observation (probably including bad lighting) paintings and people *look* very different. Paintings look like pieces of canvas (or anyway flat surfaces) covered with paint and people look like flesh-and-blood animals. There is practically no danger of confusing them. How, then, can anyone seriously hold that a portrait resembles the sitter to any significant extent, let alone that it is a perfect likeness of him? Yet it remains true that many paintings strike us as resembling people, sometimes very much or even exactly—despite the fact that they look so very different!

To resolve this paradox we must recognize that the resemblances we perceive between, for example, portraits and people, those that are relevant in determining what works of art depict or represent, are resemblances of a somewhat special sort, tied up with the categories in which we perceive such works. The properties of a work which are standard for us are ordinarily irrelevant to what we take it to look like or resemble in the relevant sense, and hence to what we take it to depict or represent. The properties of a portrait which make it *so* different from, so easily distinguishable from, a person—such as its flatness and its *painted* look—are standard for us. Hence these properties just do not count with regard to what (or whom) it looks like. It is only the properties which are variable for us, the colors and shapes on the work's surface, that make it look to us like what it does. And these are the ones which are taken as relevant in determining what (if anything) the work represents.¹⁴

Other examples will reinforce this point. A marble bust of a Roman emperor seems to us to resemble a man with, say, an aquiline nose, a wrinkled brow, and an expression of grim determination, and we take it to represent a man with, or as having, those characteristics. But why don't we say that it resembles and represents a perpetually motionless man, of uniform (marble) color, who is severed at the chest? It is similar to such a man, it seems, and much more so than to a normally colored, mobile, and whole man. But we are not struck by the former similarity when we see the bust, obvious though it is on reflection. The bust's uniform color, motionlessness, and abrupt ending at the chest are standard properties relative to the category of busts, and since we see it as a bust they are standard for us. Similarly, black-and-white drawings do not look to us like colorless scenes and we do not take them to depict things as being colorless, nor do we regard stick-figure drawings as resembling and depicting only very thin people. A cubist work might look like a person with a cubical head to someone not familiar with the cubist style. But the standardness of such cubical shapes for people who see it as a cubist work prevents them from making that comparison.

The shapes of a painting or a still photograph of a high jumper in action are motionless, but these pictures do not look to us like a high jumper frozen in mid-air. Indeed, depending on features of the pictures which are variable for us (for example, the exact positions of the figures, swirling brush strokes in the painting, slight blurrings of the photograhic image) the athlete may seem in a frenzy of activity; the pictures may convey a vivid sense of movement. But if static images exactly like those of the two pictures occur in a motion picture, and we see it as a motion picture, they probably would strike us as resembling a static athlete. This is because the immobility of the images is standard relative to the category of still pictures and variable relative to that of motion pictures. (Since we are so familiar with still pictures it might be difficult to see the static images as motion pictures for very long, rather than as [filmed] still pictures. But we could not help seeing them that way if we had no acquaintance at all with the medium of still pictures.) My point here is brought out by the tremendous aesthetic difference we are likely to experience between a film of a dancer moving very slowly and a still picture of him, even if "objectively" the two images are very nearly identical. We might well find the former studied, calm, deliberate, laborious, and the latter dynamic, energetic, flowing, or frenzied.

In general, then, what we regard a work as resembling, and as representing, depends on the properties of the work which are variable, and not on those which are standard for us.¹⁵ The latter properties serve to determine what *kind* of a representation the work is, rather than what it represents or resembles. We take them for granted, as it were, in representations of that kind. This principle helps to explain also how clouds can look like elephants, how diatonic orchestral music can suggest a conversation or a person crying or laughing, and how a twelve-year-old boy can look like his middle-aged father.

We can now see how a portrait can be an *exact* likeness of the sitter, despite the huge differences between the two. The differences, in so far as they involve properties standard for us, simply do not count against likeness, and hence not against exact likeness. Similarly, a boy not only can resemble his father but can be his "spitting image," despite the boy's relative youthfulness. It is clear that the notions of resemblance and exact resemblance that we are concerned with are not even cousins of the notion of perceptual indistinguishability.

(b) The importance of the distinction between standard and variable properties is by no means limited to cases involving representation or resemblance. Imagine a society which does not have an established medium of painting, but does produce a kind of work of art called *guernicas*. *Guernicas* are like versions of Picasso's "Guernica" done in various basrelief dimensions. All of them are surfaces with the colors and shapes of

Categories of Art

Picasso's "Guernica," but the surfaces are molded to protrude from the wall like relief maps of different kinds of terrain. Some guernicas have rolling surfaces, others are sharp and jagged, still others contain several relatively flat planes at various angles to each other, and so forth. Picasso's "Guernica" would be counted as a guernica in this society-a perfectly flat one—rather than as a painting. Its flatness is variable and the figures on its surface are standard relative to the category of guernicas. Thus the flatness, which is standard for us, would be variable for members of the other society (if they should come across "Guernica") and the figures on the surface, which are variable for us, would be standard for them. This would make for a profound difference between our aesthetic reaction to "Guernica" and theirs. It seems violent, dynamic, vital, disturbing to us. But I imagine it would strike them as cold, stark, lifeless, or serene and restful, or perhaps bland, dull, boring—but in any case not violent, dynamic, and vital. We do not pay attention to or take note of "Guernica"'s flatness; this is a feature we take for granted in paintings, as it were. But for the other society this is "Guernica"'s most striking and noteworthy characteristic-what is expressive about it. Conversely, "Guernica"'s color patches, which we find noteworthy and expressive, are insignificant to them.

It is important to notice that this difference in aesthetic response is not due *solely* to the fact that we are much more familiar with flat works of art than they are, and they are more familiar with "Guernica" 's colors and shapes. Someone equally familiar with paintings and *guernicas* might, I think, see Picasso's "Guernica" as a painting on some occasions, and as a *guernica* on others. On the former occasion it will probably look dynamic, violent, and so forth to him, and on the latter cold, serene, bland, or lifeless. Whether he sees the work in a museum of paintings or a museum of *guernicas*, or whether he has been told that it is a painting or a *guernica*, may influence how he sees it. But I think he might be able to shift at will from one way of seeing it to the other, somewhat as one shifts between seeing the duck-rabbit as a duck and seeing it as a rabbit.

This example and the previous ones might give the impression that in general only features of a work that are variable for us are aesthetically important—that these are the expressive, aesthetically active properties, as far as we are concerned, whereas features standard for us are aesthetically inert. But this notion is quite mistaken, as the following examples will demonstrate. Properties standard for us are not aesthetically lifeless, though the life that they have, the aesthetic effect they have on us, is typically very different from what it would be if they were variable for us.

(c) Because of the very fact that features standard for us do not seem striking or noteworthy, that they are somehow expected or taken for granted, they can contribute to a work a sense of order, inevitability, stability, correctness. This is perhaps most notably true of large-scale structural

properties in the time arts. The exposition-development-recapitulation form (including the typical key and thematic relationships) of the first movements of classical sonatas, symphonies, and string quartets is standard with respect to the category of works in sonata-allegro form, and standard for listeners, including most of us, who hear them as belonging to that category. So proceeding along the lines of sonata-allegro form seems right to us; to our ears that is how sonatas are supposed to behave. We feel that we know where we are and where we are going throughout the work-more so, I suggest, than we would if we were not familiar with sonata-allegro form, if following the strictures of that form were variable rather than standard for us.¹⁶ Properties standard for us do not always have this sort of unifying effect, however. The fact that a piano sonata contains only piano sounds, or uses the Western system of harmony throughout, does not make it seem unified to us. The reason, I think, is that these properties are too standard for us in a sense that needs explicating (see note 10). Nevertheless, sonata form is unifying partly because it is standard rather than variable for us.

(d) That a work (or part of it) has a certain determinate characteristic (for example, of size, speed, length, volume) is often variable relative to a particular category, when it is nevertheless standard for that category that the variable characteristic falls within a certain range. In such cases the aesthetic effect of the determinate variable property may be colored by the standard limits of the range. Hence these limits function as an aesthetic catalyst, even if not as an active ingredient.

Piano music is frequently marked sostenuto, cantabile, legato, or lyrical. But how can the pianist possibly carry out such instructions? Piano tones diminish in volume drastically immediately after the key is struck, becoming inaudible relatively promptly, and there is no way the player can prevent this. If a singer or violinist should produce sounds even approaching a piano's in suddenness of demise, they would be nerve-wrackingly sharp and percussive-anything but cantabile or lyrical! Yet piano music can be cantabile, legato, or lyrical nevertheless; sometimes it is extraordinarily so (for example, a good performance of the Adagio Cantabile movement of Beethoven's *Pathétique* sonata). What makes this possible is the very fact that the drastic diminution of piano tones cannot be prevented, and hence never is. It is a standard feature for piano music. A pianist can, however, by a variety of devices, control a tone's rate of diminution and length within the limits dictated by the nature of the instrument.¹⁷ Piano tones may thus be more or less sustained within these limits, and how sustained they are, how quickly or slowly they diminish and how long they last, within the range of possibilities, is variable for piano music. A piano passage that sounds lyrical or cantabile to us is one in which the individual tones are relatively sustained, given the capabilities of the instrument. Such a passage

sounds lyrical only because piano music is limited as it is, and we hear it as piano music; that is, the limitations are standard properties for us. The character of the passage is determined not merely by the "absolute" nature of the sounds, but by that in relation to the standard property of what piano tones can be like.¹⁸

This principle helps to explain the lack of energy and brilliance that we sometimes find even in very fast passages of electronic music. The energy and brilliance of a fast violin or piano passage derives not merely from the absolute speed of the music (together with accents, rhythmic characteristics, and so forth), but from the fact that it is fast *for that particular medium*. In electronic music different pitches can succeed one another at any frequency up to and including that at which they are no longer separately distinguishable. Because of this it is difficult to make electronic music *sound* fast (energetic, violent). For when we have heard enough electronic music to be aware of the possibilities we do not feel that the speed of a passage approaches a limit, no matter how fast it is.¹⁹

There are also visual correlates of these musical examples. A small elephant, one which is smaller than most elephants with which we are familiar, might impress us as charming, cute, delicate, or puny. This is not simply because of its (absolute) size, but because it is small *for an elephant*. To people who are familiar not with our elephants but with a race of minielephants, the same animal may look massive, strong, dominant, threatening, lumbering, if it is large for a mini-elephant. The size of elephants is variable relative to the class of elephants, but it varies only within a certain (not precisely specifiable) range. It is a standard property of elephants that they do fall within this range. How an elephant's size affects us aesthetically depends, since we see it as an elephant, on whether it falls in the upper, middle, or lower part of the range.

(e) Properties standard for a certain category which do not derive from physical limitations of the medium can be regarded as results of more or less conventional "rules" for producing works in the given category (for example, the "rules" of sixteenth-century counterpoint, or those for twelvetone music). These rules may combine to create a dilemma for the artist which, if he is talented, he may resolve ingeniously and gracefully. The result may be a work with an aesthetic character very different from what it would have had if it had not been for those rules. Suppose that the first movement of a sonata in G major modulates to C-sharp major by the end of the development section. A rule of sonata form decrees that it must return to G for the recapitulation. But the keys of G and C-sharp are as unrelated as any two keys can be; it is difficult to modulate smoothly and quickly from one to the other. Suppose also that while the sonata is in C-sharp there are signs that, given other rules of sonata form, indicate that the recapitulation is imminent (for example, motivic hints of the return, an emotional climax, or a cadenza). Listeners who hear it as a work in sonata form are likely to have a distinct feeling of unease, tension, uncertainty, as the time for the recapitulation approaches. If the composer with a stroke of ingenuity accomplishes the necessary modulation quickly, efficiently, and naturally, this will give them a feeling of relief—one might say of deliverance. The movement to C-sharp (which may have seemed alien and brashly adventurous) will have proven to be quite appropriate, and the entire sequence will in retrospect have a sense of correctness and perfection about it. Our impression of it is likely, I think, to be very much like our impression of a "beautiful" or "elegant" proof in mathematics. (Indeed the composer's task in this example is not unlike that of producing such a proof.)

But suppose that the rule for sonatas were that the recapitulation must be *either* in the original key *or* in the key one half-step below it. Thus in the example above the recapitulation could have been in F-sharp major rather than G major. This possibility removes the sense of tension from the occurrence of C-sharp major in the development section, for a modulation from C-sharp to F-sharp is as easy as any modulation is (since C-sharp is the dominant of F-sharp). Of course, there would also be no special *release* of tension when the modulation to G is effected, there being no tension to be released. In fact, that modulation probably would be rather surprising, since the permissible modulation to F-sharp would be much more natural.

Thus the effect that the sonata has on us depends on which of its properties are dictated by "rules," which ones are standard relative to the category of sonatas and hence standard for us.

(f) I turn now to features which are contra-standard for us—that is, ones which have a tendency to disqualify a work from a category in which we nevertheless perceive it. We are likely to find such features shocking, or disconcerting, or startling, or upsetting, just because they are contra-standard for us. Their presence may be so obtrusive that they obscure the work's variable properties. Three-dimensional objects protruding from a canvas and movement in a sculpture are contra-standard relative to the categories of painting and (traditional) sculpture respectively. These features are contra-standard for us, and probably shocking, if despite them we perceive the works possessing them in the mentioned categories. The monochromatic paintings of Yves Klein are disturbing to us (at least at first) for this reason: we see them as paintings, though they contain the feature contra-standard for paintings of being one solid color. Notice that we find other similarly monochromatic surfaces—for example, walls of living rooms—not in the least disturbing, and indeed quite unnoteworthy.

If we are exposed frequently to works containing a certain kind of feature which is contra-standard for us, we ordinarily adjust our categories to

accommodate it, making it contra-standard for us no longer. The first painting with a three-dimensional object glued to it was no doubt shocking. But now that the technique has become commonplace we are not shocked. This is because we no longer see these works as *paintings*, but rather as members of either (a) a new category—*collages*—in which case the offending feature has become standard rather than contra-standard for us, or (b) an expanded category which includes paintings both with and without attached objects, in which case that feature is variable for us.

But it is not just the rarity, unusualness, or unexpectedness of a feature that makes it shocking. If a work differs too significantly from the norms of a certain category we do not perceive it in that category and hence the difference is not contra-standard for us, even if we have not previously experienced works differing from that category in that way. A sculpture which is constantly and vigorously in motion would be so obviously and radically different from traditional sculptures that we probably would not perceive it as one even if it is the first moving sculpture we have come across. We would either perceive it as a kinetic sculpture, or simply remain confused. In contrast, a sculptured bust which is traditional in every respect except that one ear twitches slightly every thirty seconds would be perceived as an ordinary sculpture. So the twitching ear would be contrastandard for us and would be considerably more unsettling than the much greater movement of the other kinetic sculpture. Similarly, a very small colored area of an otherwise entirely black-and-white drawing would be very disconcerting. But if enough additional color is added to it we will see it as a colored rather than a black-and-white drawing, and the shock will vanish.

This point helps to explain a difference between the harmonic aberrations of Wagner's *Tristan and Isolde* on the one hand and on the other Debussy's *Pelléas et Mélisande* and *Feux* and Schoenberg's *Pierrot Lunaire* as well as his later twelve-tone works. The latter are not merely *more* aberrant, *less* tonal, than *Tristan*. They differ from traditional tonal music in such respects and to such an extent that they are not heard as tonal at all. *Tristan*, however, retains enough of the apparatus of tonality, despite its deviations, to be heard as a tonal work. For this reason its lesser deviations are often the more shocking.²⁰ *Tristan* plays on harmonic traditions by selectively following and flaunting them, while *Pierrot Lunaire* and the others simply ignore them.

Shock then arises from features that are not just rare or unique, but ones that are contra-standard relative to categories in which objects possessing them are perceived. But it must be emphasized that to be contra-standard relative to a certain category is not merely to be rare or unique *among things of that category*. The melodic line of Schubert's song, "*Im Walde*," is probably unique; it probably does not occur in any other songs, or other works of any sort. But it is not contra-standard relative to the category of songs, because it does not tend to disqualify the work from that category. Nor is it contra-standard relative to any other category to which we hear the work as belonging. And clearly we do not find this melodic line at all upsetting. What is important is not the rarity of a feature, but its connection with the classification of the work. Features contra-standard for us are perceived as being misfits in a category which the work strikes us as belonging to, as doing *violence* to such a category, and being rare in a category is not the same thing as being a misfit in it.

It should be clear from the above examples that how a work affects us aesthetically—what aesthetic properties it seems to us to have and what ones we are inclined to attribute to it—depends in a variety of important ways on which of its features are standard, which variable, and which contra-standard for us. Moreover, this is obviously not an isolated or exceptional phenomenon, but a pervasive characteristic of aesthetic perception. I should emphasize that my purpose has not been to establish general principles about how each of the three sorts of properties affects us. How any particular feature affects us depends also on many variables I have not discussed. The important point is that in many cases whether a feature is standard, variable, or contra-standard for us has a great deal to do with what effect it has on us. We must now begin to assess the theoretical consequence of this.

IV. Truth and Falsity

The fact that what aesthetic properties a thing seems to have may depend on what categories it is perceived in raises a question about how to determine what aesthetic properties it really does have. If "Guernica" appears dynamic when seen as a painting, and not dynamic when seen as a *guernica*, is it dynamic or not? Can one way of seeing it be ruled correct, and the other incorrect? One way of approaching this problem is to deny that the apparently conflicting aesthetic judgments of people who perceive a work in different categories actually do conflict.²¹

Judgments that works of art have certain aesthetic properties, it might be suggested, implicitly involve reference to some particular set of categories. Thus our claim that "Guernica" is dynamic really amounts to the claim that it is (as we might say) dynamic *as a painting*, or for people who see it as a painting. The judgment that it is not dynamic made by people who see it as a *guernica* amounts simply to the judgment that it is not dynamic *as a guernica*. Interpreted in these ways, the two judgments are of course quite compatible. Terms like "large" and "small" provide a convenient model for this interpretation. An elephant might be both small as an elephant and large as a mini-elephant, and hence it might be called

truly either "large" or "small," depending on which category is implicitly referred to.

I think that aesthetic judgments are in *some* contexts amenable to such category-relative interpretations, especially aesthetic judgments about natural objects (clouds, mountains, sunsets) rather than works of art. (It will be evident that the alternative account suggested below is not readily applicable to most judgments about natural objects.) But most of our aesthetic judgments can be forced into this mold only at the cost of distorting them beyond recognition.

My main objection is that category-relative interpretations do not allow aesthetic judgments to be mistaken often enough. It would certainly be natural to consider a person who calls "Guernica" stark, cold, or dull, because he sees it as a guernica, to be mistaken: he misunderstands the work because he is looking at it in the wrong way. Similarly, one who asserts that a good performance of the Adagio Cantabile of Beethoven's Pathétique is percussive, or that a Roman bust looks like a unicolored, immobile man severed at the chest and depicts him as such, is simply wrong, even if his judgment is a result of his perceiving the work in different categories from those in which we perceive it. Moreover, we do not accord a status any more privileged to our own aesthetic judgments. We are likely to regard, for example, cubist paintings, serial music, or Chinese music as formless, incoherent, or disturbing on our first contact with these forms largely because, I suggest, we would not be perceiving the works as cubist paintings, serial music, or Chinese music. But after becoming familiar with these kinds of art we would probably retract our previous judgments, admit that they were mistaken. It would be quite inappropriate to protest that what we meant previously was merely that the works were formless or disturbing for the categories in which we then perceived them, while admitting that they are not for the categories of cubist paintings, or serial, or Chinese music. The conflict between apparently incompatible aesthetic judgments made while perceiving a work in different categories does not simply evaporate when the difference of categories is pointed out, as does the conflict between the claims that an animal is large and that it is small, when it is made clear that the person making the first claim regarded it as a minielephant and the one making the second regarded it as an elephant. The latter judgments do not (necessarily) reflect a real disagreement about the size of the animal, but the former do reflect a real disagreement about the aesthetic nature of the work.

Thus it seems that, at least in some cases, it is *correct* to perceive a work in certain categories, and *incorrect* to perceive it in certain others; that is, our judgments of it when we perceive it in the former are likely to be true, and those we make when perceiving it in the latter false. This pro-

vides us with absolute senses of "standard," "variable," and "contrastandard": features of a work are standard, variable, or contra-standard absolutely just in case they are standard, variable, or contra-standard (respectively) for people who perceive the work correctly. (Thus an absolutely standard feature is standard relative to some category in which the work is correctly perceived and contra-standard relative to none, an absolutely variable feature is variable relative to all such categories, and an absolutely contra-standard feature is contra-standard relative to at least one such category.)

How is it to be determined in which categories a work is correctly perceived? There is certainly no very precise or well-defined procedure to be followed. Different criteria are emphasized by different people and in different situations. But there are several fairly definite considerations which typically figure in critical discussions and fit our intuitions reasonably well. I suggest that the following circumstances count toward its being correct to perceive a work, W, in a given category, C:

(i) The presence in W of a relatively large number of features standard with respect to C. The correct way of perceiving a work is likely to be that in which it has a minimum of contra-standard features for us. I take the relevance of this consideration to be obvious. It cannot be correct to perceive Rembrandt's "Titus Reading" as a kinetic sculpture, if this is possible, just because that work has too few of the features which make kinetic sculptures kinetic sculptures. But of course this does not get us very far, for "Guernica," for example, qualifies equally well on this count for being perceived as a painting and as a guernica.

(*ii*) The fact, if it is one, that W is better, or more interesting or pleasing aesthetically, or more worth experiencing when perceived in C than it is when perceived in alternative ways. The correct way of perceiving a work is likely to be the way in which it comes off best.

(*iii*) The fact, if it is one, that the artist who produced W intended or expected it to be perceived in C, or thought of it as a C.

(iv) The fact, if it is one, that C is well established in and recognized by the society in which W was produced. A category is well established in and recognized by a society if the members of the society are familiar with works in that category, consider a work's membership in it a fact worth mentioning, exhibit works of that category together, and so forth—that is, roughly if that category figures importantly in their way of classifying works of art. The categories of impressionist painting and Brahmsian music are well established and recognized in our society; those of *guernicas*, paintings with diagonal composition containing green crosses, and pieces of music containing between four and eight F-sharps and at least seventeen quarter notes every eight bars are not. The categories in which a work is

correctly perceived, according to this condition, are generally the ones in which the artist's contemporaries did perceive or would have perceived it.

In certain cases I think the mechanical process by which a work was produced, or (for example, in architecture) the non-perceptible physical characteristics or internal structure of a work, is relevant. A work is probably correctly perceived as an apparent etching²² rather than, say, an apparent woodcut or line drawing, if it was produced by the etching process. The strength of materials in a building, or the presence of steel girders inside wooden or plaster columns counts toward (not necessarily conclusively) the correctness of perceiving it in the category of buildings with visual characteristics typical of buildings constructed in that manner. Because of their limited applicability I will not discuss these considerations further here.

What can be said in support of the relevance of conditions (ii), (iii), and (iv)? In the examples mentioned above, the categories in which we consider a work correctly perceived seem to meet (to the best of our knowledge) each of these three conditions. I would suppose that "Guernica" is better seen as a painting than it would be seen as a guernica (though this would be hard to prove). In any case, Picasso certainly intended it to be seen as a painting rather than a guernica, and the category of paintings is, and that of guernicas is not, well established in his (that is, our) society. But this of course does not show that (ii), (iii), and (iv) each is relevant. It tends to indicate only that one or other of them, or some combination, is relevant. The difficulty of assessing each of the three conditions individually is complicated by the fact that by and large they can be expected to coincide, to yield identical conclusions. Since an artist usually intends his works for his contemporaries he is likely to intend them to be perceived in categories established in and recognized by his society. Moreover, it is reasonable to expect works to come off better when perceived in the intended categories than when perceived in others. An artist tries to produce works which are well worth experiencing when perceived in the intended way and, unless we have reason to think he is totally incompetent, there is some presumption that he succeeded at least to some extent. But it is more or less a matter of chance whether the work comes off well when perceived in some unintended way. The convergence of the three conditions, however, at the same time diminishes the practical importance of justifying them individually, since in most cases we can decide how to judge particular works of art without doing so. But the theoretical question remains.

I will begin with (ii). If we are faced with a choice between two ways of perceiving a work, and the work is very much better perceived in one way than it is perceived in the other, I think that, at least in the absence of contrary considerations, we would be strongly inclined to settle on the

former way of perceiving it as the *correct* way. The process of trying to determine what is in a work consists partly in casting around among otherwise plausible ways of perceiving it for one in which the work is good. We feel we are coming to a correct understanding of a work when we begin to like or enjoy it; we are finding what is really there when it seems to be worth experiencing.

But if (ii) is relevant, it is quite clearly not the only relevant consideration. Take any work of art we can agree is of fourth- or fifth- or tenth-rate quality. It is quite possible that if this work were perceived in some farfetched set of categories that someone might dream up, it would appear to be first-rate, a masterpiece. Finding such ad hoc categories obviously would require talent and ingenuity on the order of that necessary to produce a masterpiece in the first place. But we can sketch how one might begin searching for them. (a) If the mediocre work suffers from some disturbingly prominent feature that distracts from whatever merits the work has, this feature might be toned down by choosing categories with respect to which it is standard, rather than variable or contra-standard. When the work is perceived in the new way the offending feature may be no more distracting than the flatness of a painting is to us. (b) If the work suffers from an overabundance of clichés it might be livened up by choosing categories with respect to which the clichés are variable or contra-standard rather than standard. (c) If it needs ingenuity we might devise a set of rules in terms of which the work finds itself in a dilemma and then ingeniously escapes from it, and build these rules into a set of categories. Surely, however, if there are categories waiting to be discovered which would transform a mediocre work into a masterpiece, it does not follow that the work really is a hitherto unrecognized masterpiece. The fact that when perceived in such categories it would appear exciting, ingenious, and so forth, rather than grating, cliché-ridden, pedestrian, does not make it so. It cannot be correct, I suggest, to perceive a work in categories which are totally foreign to the artist and his society, even if it comes across as a masterpiece in them.23

This brings us to the historical conditions (iii) and (iv). I see no way of avoiding the conclusion that one or the other of them at least is relevant in determining in what categories a work is correctly perceived. I consider both relevant, but will not argue here for the independent relevance of (iv). (iii) merits special attention in light of the recent prevalence of disputes about the importance of artists' intentions. To test the relevance of (iii)we must consider a case in which (iii) and (iv) diverge. One such instance occurred during the early days of the twelve-tone movement in music. Schoenberg no doubt intended even his earliest twelve-tone works to be heard as such. But this category was certainly not then well established or recognized in his society: virtually none of his contemporaries (except

close associates such as Berg and Webern), even musically sophisticated ones, would have (or could have) heard these works in that category. But it seems to me that even the very first twelve-tone compositions are correctly heard as such, that the judgments one who hears them otherwise would make of them (for example, that they are chaotic, formless) are mistaken. I think this would be so even if Schoenberg had been working entirely alone, if *none* of his contemporaries had any inkling of the twelvetone system. No doubt the first twelve-tone compositions are much better when heard in the category of twelve-tone works than when they are heard in any other way people might be likely to hear them. But as we have seen this cannot *by itself* account for the correctness of hearing them in the former way. The only other feature of the situation which could be relevant, so far as I can see, is Schoenberg's intention.

The above example is unusual in that Schoenberg was extraordinarily self-conscious about what he was doing, having explicitly formulated rules—that is, specified standard properties—for twelve-tone composition. Artists are of course not often so self-conscious, even when producing revolutionary works of art. Their intentions as to which categories their works are to be perceived in are not nearly as clear as Schoenberg's were, and often they change their minds considerably during the process of creation. In such cases (as well as ones in which the artists' intentions are unknown) the question of what categories a work is correctly perceived in is, I think, left by default to condition (iv), together with (i) and (ii). But it seems to me that in almost all cases at least one of the historical conditions, (iii) and (iv), is of crucial importance.

My account of the rules governing decisions about what categories works are correctly perceived in leaves a lot undone. There are bound to be a large number of undecidable cases on my criteria. Artists' intentions are frequently unclear, variable, or undiscoverable. Many works belong to categories which are borderline cases of being well established in the artists' societies (perhaps, for example, the categories of rococo music—for instance, C. P. E. Bach—of music in the style of early Mozart, and of very thin metal sculptured figures of the kind that Giacometti made). Many works fall between well-established categories (for example, between impressionist and cubist paintings), possessing *some* of the standard features relative to each, and so neither clearly qualify nor clearly fail to qualify on the basis of condition (i) to be perceived in either. There is, in addition, the question of what relative weights to accord the various conditions when they conflict.

It would be a mistake, however, to try to tighten up much further the rules for deciding how works are correctly perceived. To do so would be simply to legislate gratuitously, since the intuitions and precedents we have to go on are highly variable and often confused. But it is important to notice just where these intuitions and precedents are inconclusive, for doing so will expose the sources of many critical disputes. One such dispute might well arise concerning Giacometti's thin metal sculptures. To a critic who sees them simply as sculptures, or sculptures of people, they look frail, emaciated, wispy, or wiry. But that is not how they would strike a critic who sees them in the category of thin metal sculptures of that sort (just as stick figures do not strike us as wispy or emaciated). He would be impressed not by the thinness of the sculptures, but by the expressive nature of the positions of their limbs, and so forth, and so no doubt would attribute very different aesthetic properties to them. Which of the two ways of seeing these works is correct is, I suspect, undecidable. It is not clear whether enough such works have been made and have been regarded sufficiently often as constituting a category for that category to be deemed well established in Giacometti's society. And I doubt whether any of the other conditions settle the issue conclusively. So perhaps the dispute between the two critics is essentially unresolvable. The most that we can do is to point out just what sort of a difference of perception underlies the dispute, and why it is unresolvable.

The occurrence of such impasses is by no means something to be regretted. Works may be fascinating precisely because of shifts between equally permissible ways of perceiving them. And the enormous richness of some works is due in part to the variety of permissible, and worthwhile, ways of perceiving them. But it should be emphasized that even when my criteria do not clearly specify a *single* set of categories in which a work is correctly perceived, there are bound to be possible ways of perceiving it (which we may or may not have thought of) that they definitely rule out.

The question posed at the outset of this section was how to determine what aesthetic properties a work has, given that which ones it seems to have depend on what categories it is perceived in, on which of its properties are standard, which variable, and which contra-standard for us. I have sketched in rough outline rules for deciding in what categories a work is *correctly* perceived (and hence which of its features are absolutely standard, variable, and contra-standard). The aesthetic properties it actually possesses are those that are to be found in it when it is perceived correctly.²⁴

V. Conclusion

I return now to the issues raised in Section I. (I will adopt for the remainder of this paper the simplifying assumption that there is only one correct way of perceiving any work. Nothing important depends on this.) If a work's aesthetic properties are those that are to be found in it when it is perceived correctly, and the correct way to perceive it is determined partly by historical facts about the artist's intention and/or his society, no

examination of the work itself, however thorough, will by itself reveal those properties.²⁵ If we are confronted by a work about whose origins we know absolutely nothing (for example, one lifted from the dust at an as yet unexcavated archaeological site on Mars), we would simply not be in a position to judge it aesthetically. We could not possibly tell by staring at it, no matter how intently and intelligently, whether it is coherent, or serene, or dynamic, for by staring we cannot tell whether it is to be seen as a sculpture, a *guernica*, or some other exotic or mundane kind of work of art. (We could attribute aesthetic properties to it in the way we do to natural objects, which of course does not involve consideration of historical facts about artists or their societies. [Cf. Section IV.] But to do this would not be to treat the object as a *work* of art.)

It should be emphasized that the relevant historical facts are not merely useful aids to aesthetic judgment; they do not simply provide hints concerning what might be found in the work. Rather they help to determine what aesthetic properties a work has; they, together with the work's nonaesthetic features, make it coherent, serene, or whatever. If the origin of a work which is coherent and serene had been different in crucial respects, the work would not have had these qualities; we would not merely have lacked a means for discovering them. And of two works which differ only in respect of their origins-that is, which are perceptually indistinguishable -one might be coherent or serene, and the other not. Thus, since artists' intentions are among the relevant historical considerations, the "intentional fallacy" is not a fallacy at all. I have of course made no claims about the relevance of artists' intentions as to the aesthetic properties that their works should have, and these intentions are among those most discussed in writings on aesthetics. I am willing to agree that whether an artist intended his work to be coherent or serene has nothing essential to do with whether it is coherent or serene. But this must not be allowed to seduce us into thinking that no intentions are relevant.

Aesthetic properties, then, are not to be found in works themselves in the straightforward way that colors and shapes or pitches and rhythms are. But I do not mean to deny that we perceive aesthetic properties in works of art. I see the serenity of a painting, and hear the coherence of a sonata, despite the fact that the presence of these qualities in the works depends partly on circumstances of their origin, which I cannot (now) perceive. Jones's marital status is part of what makes him a bachelor, if he is one, and we cannot tell his marital status just by looking at him, though we can thus ascertain his sex. Hence, I suppose, his bachelorhood is not a property we can be said to perceive in him. But the aesthetic properties of a work do not depend on historical facts about it in anything like the way Jones's bachelorhood depends on his marital status. The point is not that the historical facts (or in what categories the work is correctly perceived, or which of its properties are absolutely standard, variable, and contra-standard) function as *grounds* in any ordinary sense for aesthetic judgments. By themselves they do not, in general, count either for or against the presence of any particular aesthetic property. And they are not part of a larger body of information (also including data about the work derived from an examination of it) from which conclusions about the work's aesthetic properties are to be deduced or inferred. We must learn to *perceive* the work in the correct categories, as determined in part by the historical facts, and judge it by what we then perceive in it. The historical facts help to determine whether a painting is, for example, serene *only* (as far as my arguments go) by affecting what way of perceiving the painting must reveal this quality if it is truly attributable to the work.

We must not, however, expect to judge a work simply by setting ourselves to perceive it correctly, once it is determined what the correct way of perceiving it is. For one cannot, in general, perceive a work in a given set of categories simply by setting himself to do it. I could not possibly, merely by an act of will, see "Guernica" as a guernica rather than a painting, or hear a succession of street sounds in any arbitrary category one might dream up, even if the category has been explained to me in detail. (Nor can I imagine except in a rather vague way what it would be like, for example, to see "Guernica" as a guernica.) One cannot merely decide to respond appropriately to a work-to be shocked or unnerved or surprised by its (absolutely) contra-standard features, to find its standard features familiar or mundane, and to react to its variable features in other waysonce he knows the correct categories. Perceiving a work in a certain category or set of categories is a skill that must be acquired by training, and exposure to a great many other works of the category or categories in question is ordinarily, I believe, an essential part of this training. (But an effort of will may facilitate the training, and once the skill is acquired one may be able to decide at will whether or not to perceive it in that or those categories.) This has important consequences concerning how best to approach works of art of kinds that are new to us-contemporary works in new idioms, works from foreign cultures, or newly resurrected works from the ancient past. It is no use just immersing ourselves in a particular work, even with the knowledge of what categories it is correctly perceived in, for that alone will not enable us to perceive it in those categories. We must become familiar with a considerable variety of works of similar sorts.

When dealing with works of more familiar kinds it is not generally necessary to undertake deliberately the task of training ourselves to be able to perceive them in the correct categories (except perhaps when those categories include relatively subtle ones). But this is almost always, I think, only because we have been trained unwittingly. Even the ability to see paintings as paintings had to be acquired, it seems to me, by repeated ex-

posure to a great many paintings. The critic must thus go beyond the work before him in order to judge it aesthetically, not only to discover what the correct categories are, but also to be able to perceive it in them. The latter does not require consideration of historical facts, or consideration of facts at all, but it requires directing one's attention nonetheless to things other than the work in question.

Probably no one would deny that some sort of perceptual training is necessary, in many if not all instances, for apprehending a work's serenity or coherence, or other aesthetic properties. And of course it is not only aesthetic properties whose apprehension by the senses requires training. But the kind of training required in the aesthetic cases (and perhaps some others as well) has not been properly appreciated. In order to learn how to recognize gulls of various kinds, or the sex of chicks, or a certain person's handwriting, one must usually have gulls of those kinds, or chicks of the two sexes, or examples of that person's handwriting pointed out to him, practice recognizing them himself, and be corrected when he makes mistakes. But the training important for discovering the serenity or coherence of a work of art that I have been discussing is not of this sort (though this sort of training might be important as well). Acquiring the ability to perceive a serene or coherent work in the correct categories is not a matter of having had serene or coherent things pointed out to one, or having practiced recognizing them. What is important is not (or not merely) experience with other serene and coherent things, but experience with other things of the appropriate categories.

Much of the argument in this paper has been directed against the seemingly common-sense notion that aesthetic judgments about works of art are to be based solely on what can be perceived in them, how they look or sound. That notion is seriously misleading, I claim, on two quite different counts. I do not deny that paintings and sonatas are to be judged solely on what can be seen or heard in them—when they are perceived correctly. But examining a work with the senses can by itself reveal neither how it is correct to perceive it, nor how to perceive it that way.

Notes

1. Heinrich Wölfflin, Principles of Art History, trans. M. D. Hottinger (7th ed.; New York, 1929), p. 228.

2.[W]e should all agree, I think, . . . that any quality that cannot even in principle be heard in it [a musical composition] does not belong to it as music." Monroe Beardsley, *Aesthetics: Problems in the Philosophy of Criticism* (New York, 1958), pp. 31-32.

3. Cf. Calvin Tompkins, The Bride and the Bachelors (New York, 1965), pp. 210-211.

4. Monroe Beardsley argues for a relatively strict separation (*op. cit.*, pp. 17-34). Some of the strongest recent attempts to enforce this separation are to be found in discussions of the so-called "intentional fallacy," beginning with William Wimsatt and Beardsley, "The Intentional Fallacy," *Sewanee Review*, Vol. LIV (1946), which has been widely cited and reprinted. Despite the name of the "fallacy" these discussions are not limited to consideration of the relevance of artists' *intentions*.

5. The aesthetic properties of works of literature are not happily called "perceptual." For reasons connected with this it is sometimes awkward to treat literature together with the visual arts and music. (The notion of perceiving a work in a category, to be introduced shortly, is not straightforwardly applicable to literary works.) Hence in this paper I will concentrate on visual and musical works, though I believe that the central points I make concerning them hold, with suitable modifications, for novels, plays, and poems as well.

6. Frank Sibley distinguishes between "aesthetic" and "nonaesthetic" terms and concepts in "Aesthetic Concepts," *Philosophical Review*, Vol. LXVIII (1959).

7. Cf. Paul Ziff, "Art and the 'Object of Art," in Ziff, *Philosophic Turnings* (Ithaca, N.Y., 1966), pp. 12–16 (originally published in *Mind*, N. S. Vol. LX [1951]).

8. "Aesthetic and Nonaesthetic," Philosophical Review, Vol. LXXII (1965).

9. This is a very difficult notion to make precise, and I do not claim to have succeeded entirely. But the following comments seem to me to go in the right direction, and, together with the examples in the next section, they should clarify it sufficiently for my present purposes.

10. In order to avoid excessive complexity and length, I am ignoring some considerations that might be important at a later stage of investigation. In particular, I think it would be important at some point to distinguish between different *degrees* or *levels* of standardness, variableness, and contra-standardness for a person; to speak, e.g., of features being *more* or *less* standard for him. At least two distinct sorts of grounds for such differences of degree should be recognized. (a) Distinctions between perceiving a work in a certain category to a greater and lesser extent should be allowed for, with corresponding differences of degree in the standardness for the perceiver of properties relative to that category. (b) A feature which is standard relative to more, and/or more specific, categories in which a person perceives the work should thereby count as more standard for him. Thus, if we see something as a painting and also as a French Impressionist painting, features standard relative only to the latter.

11. This excludes, e.g., the sense of "represent" in which a picture might represent justice or courage, and probably other senses as well.

12. This does not hold for the special case of photography. A photograph is a photograph of a woman no matter what it looks like, I take it, if a woman was in front of the lens when it was produced.

13. Nelson Goodman denies that resemblance is necessary for representation —and obviously not merely because of isolated or marginal examples of non-

resembling representations (p. 5). I cannot treat his arguments here, but rather than reject *en masse* the common-sense beliefs that pictures do resemble significantly what they depict and that they depict what they do partly because of such resemblances, if Goodman advocates rejecting them, I prefer to recognize a sense of "resemblance" in which these beliefs are true. My disagreement with him is perhaps less sharp than it appears since, as will be evident, I am quite willing to grant that the relevant resemblances are "conventional." Cf. Goodman, *Languages of Art* (Indianapolis, 1968), p. 39, n. 31.

14. The connection between features variable for us and what the work looks like is by no means a straightforward or simple one, however. It may involve "rules" which are more or less "conventional" (e.g., the "laws" of perspective). Cf. E. H. Gombrich, *Art and Illusion* (New York, 1960), and Nelson Goodman, *op. cit.*

15. There is at least one group of exceptions to this. Obviously features of a work which are standard for us because they are standard relative to some *representational* category which we see it in—e.g., the category of nudes, still lifes, or landscapes—do help determine what the work looks like to us and what we take it to depict.

16. The presence of clichés in a work sometimes allows it to contain drastically disorderly elements without becoming chaotic or incoherent. Cf. Anton Ehrenzweig, *The Hidden Order of Art* (London, 1967), pp. 114–116.

17. The timing of the release of the key affects the tone's length. Use of the sustaining pedal can lessen slightly a tone's diminuendo by reinforcing its overtones with sympathetic vibrations from other strings. The rate of diminuendo is affected somewhat more drastically by the force with which the key is struck. The more forcefully it is struck the greater is the tone's relative diminuendo. (Obviously the rate of diminuendo cannot be controlled in this way independently of the tone's initial volume.) The successive tones of a melody can be made to overlap so that each tone's sharp attack is partially obscured by the lingering end of the preceding tone. A melodic tone may also be reinforced after it begins by sympathetic vibrations from harmonically related accompanying figures, contributed by the composer.

18. "[T]he musical media we know thus far derive their whole character and their usefulness as musical media precisely from their limitations." Roger Sessions, "Problems and Issues Facing the Composer Today," in Paul Henry Lang, *Problems of Modern Music* (New York, 1960), p. 31.

19. One way to make electronic music sound fast would be to make it sound like some traditional instrument, thereby trading on the limitations of that instrument.

20. Cf. William W. Austin, *Music in the 20th Century* (New York, 1966), pp. 205–206; and Eric Salzman, *Twentieth-Century Music: An Introduction* (Englewood Cliffs, N.J., 1967), pp. 5, 8, 19.

21. I am ruling out the view that the notions of truth and falsity are not applicable to aesthetic judgments, on the ground that it would force us to reject so much of our normal discourse and common-sense intuitions about art that theoretical aesthetics, conceived as attempting to understand the institution

of art, would hardly have left a recognizable subject matter to investigate. (Cf. the quotation from Wölfflin, above.)

22. Cf. p. 339.

23. To say that it is incorrect (in my sense) to perceive a work in certain categories is not necessarily to claim that one *ought not* to perceive it that way. I heartily recommend perceiving mediocre works in categories that make perceiving them worthwhile whenever possible. The point is that one is not likely to *judge* the work correctly when he perceives it incorrectly.

24. This is a considerable oversimplification. If there are two equally correct ways of perceiving a work, and it appears to have a certain aesthetic property perceived in one but not the other of them, does it actually possess this property or not? There is no easy general answer. Probably in some such cases the question is undecidable. But I think we would sometimes be willing to say that a work is, e.g., touching or serene if it seems so when perceived in one correct way (or, more hesitantly, that there is "something very touching, or serene, about it"), while allowing that it does not seem so when perceived in another way which we do not want to rule incorrect. In some cases works have aesthetic properties (e.g., intriguing, subtle, alive, interesting, deep) which are not apparent on perceiving it in any single acceptable way, but which depend on the multiplicity of acceptable ways of perceiving it and relations between them. None of these complications relieves the critic of the responsibility for determining in what way or ways it is correct to perceive a work.

25. But this, plus a general knowledge of what sorts of works were produced when and by whom, might.

[Ed.—Walton wishes to add the following note: "Since the original publication of this paper I have changed my views concerning resemblance in representational art. Cf. my 'Pictures and Make-Believe,' *Philosophical Review*, Vol. LXXXII (1973)."]

Bibliography to Part Two

Frank Sibley's essay has generated a rather large industry. Among his own related papers may be mentioned:

- "Aesthetic and Non-Aesthetic," *Philosophical Review*, LXXIV (1965), 135-159;
- "Aesthetic Concepts: A Rejoinder," Philosophical Review, LXXII (1963), 79-83;
- "Objectivity and Aesthetics," *Proceedings of the Aristotelian Society*, Suppl. Vol. XLII (1968), 31-54.

Reviews by various hands of the principal issues may be found in:

- Ted Cohen, "Aesthetic/Non-aesthetic and the Concept of Taste: A Critique of Sibley's Position," *Theoria*, XXXIX (1973), 113-152;
- Isabel Hungerland, "Once Again, Aesthetic and Non-Aesthetic," Journal of Aesthetics and Art Criticism, XXVI (1968), 285-295;
- Peter Kivy, Speaking of Art (The Hague, 1973);
- H. R. G. Schwyzer, "Sibley's 'Aesthetic Concepts,'" Philosophical Review, LXXII (1963), 72-78;
- Gary Stahl, "Sibley's 'Aesthetic Concepts': An Ontological Mistake," Journal of Aesthetics and Art Criticism, XXIX (1971), 385-389.
- The relevance of forgery, intentional considerations, and imagination is aired in: Virgil C. Aldrich, *Philosophy of Art* (Englewood Cliffs, 1963);

Timothy Binkley, "Deciding about Art," in Lars Aagaard-Mogensen (ed.), Culture and Art (Nyborg and Atlantic Highlands, 1976);

Nelson Goodman, Languages of Art (Indianapolis, 1969);

Nelson Goodman, "The Status of Style," Critical Inquiry, I (1974), 799-811;

- Alfred Lessing, "What Is Wrong with a Forgery?" Journal of Aesthetics and Art Criticism, XXIII (1965), 464-471;
- Leonard B. Meyer, "Forgery and the Anthropology of Art," in Lars Aagaard-Mogensen (ed.), *Culture and Art* (Nyborg and Atlantic Highlands);

Aesthetic Qualities

Arthur C. Danto, "Artworks and Real Things," Theoria, XXXIX (1973), 1–17;

Melvin Rader, "The Imaginative Mode of Awareness," Journal of Aesthetics and Art Criticism, XXXIII (1974), 411-429;

Richard Rudner, "On Seeing What We Shall See," in Richard Rudner and Israel Scheffler (eds.), Logic & Art (Indianapolis, 1972);

Mark Sagoff, "The Aesthetic Status of Forgeries," Journal of Aesthetics and Art Criticism, XXXV (1976), 169–180.

Background views against which to fix the distinction of Sibley's thesis may be found in:

P. H. Nowell-Smith, Ethics (London, 1954), Chapters 5-6;

John Wisdom, "Gods," reprinted in his *Philosophy and Psycho-Analysis* (Oxford, 1953);

Ludwig Wittgenstein, *The Blue and Brown Books* (Oxford, 1958). None of these is narrowly concerned with aesthetics.

A general review of aesthetic issues appears in Part One; additional references appear in the bibliography, Part One.

Part Three The Definition of Art

Aestheticians are perennially trying to define what a work of art is. The variety of answers advanced is itself worth noting, because it suggests that the question may be irregular in some way. Still, there is perhaps no quicker introduction to classical discussions of art than to summarize the master definitions that have been provided, say, from Plato to Clive Bell.

It should be noticed that "work of art" is used in two entirely different ways, at the very least. For one, it is a value-laden term applied to things in virtue of certain alleged excellences. And for a second, it is one of the most basic category-terms in aesthetics, designating the principal objects that are to be examined from a certain point of view—objects possibly, though not necessarily, entitled to be characterized as "works of art" on the first use of the phrase. This distinction is often overlooked, though it would appear to affect decisively the nature of any effort to define "work of art."

The trouble with any effort to fix the basic category-term, "work of art," is that it will depend on what counts as an aesthetic point of view. But what counts as an aesthetic point of view cannot itself be decided by some simple inspection of actual usage. Philosophers seem to decide, more than to find, what the boundaries of aesthetic interest are (see Part One). And the definition of "work of art" may vary according to the varying boundaries assigned to the aesthetic. This means that at least some apparent incompatibilities in definition may reflect the shifting decisions of philosophers regarding the definition of the aesthetic.

Comparatively recently, the question had been raised whether (following the lead of Wittgenstein) it is at all possible to isolate the essential and distinctive properties of works of art. It has been argued, for instance, that works of art exhibit only "family resemblances" or "strands of similarities" but not essential and distinctive properties common to all admitted instances. The question is a vexed one, because it is not entirely clear what sort of initial restrictions may properly be placed on the collection of things for which this claim, or the counterclaim, could be confirmed. Hence, if no restriction is allowed, it would seem trivially true that no definition of the required sort could be put forward, since an expression like "work of art" is probably used in a great variety of somewhat unrelated ways (Is a sunset a work of art, for instance? Is life a work of art? Is driftwood art?). And if an initial restriction is allowed, will it be a logical or an empirical matter that a definition of the required sort cannot be found? The question at stake is not, specifically, *the* definition of art but the eligibility of the effort to define art. Though if "art" be definable, we surely would want to know what the best formulation is.

Still, if "work of art" is a basic category-term, its importance probably is to be located elsewhere than in the presumed effort to discover its essential conditions (which may, nevertheless, remain legitimate). Because to identify such essential conditions is to summarize the findings of other primary investigations—for instance, the nature and orientation of criticism upon the fine arts. That is, the definition probably serves to indicate the focus of a systematic account of other questions of aesthetics more directly concerned with the professional and amateur examination of works of art themselves.

Morris Weitz's Matchette Prize essay (1955) has undoubtedly been responsible for a lively reconsideration of what are perhaps the best-known theories in aesthetics, which have regularly been advanced in the form of definitions of art. It represents a turning-point in aesthetic theory precisely by raising a "meta-aesthetic" question. But as with so many parallel efforts in other fields, it proves to be extremely difficult to separate sharply "object"-level questions and "meta"-level questions, that is, questions about the status of "object"-level questions—in particular, the question, What is art? In effect an entire industry has developed canvassing the force of Weitz's challenge.

Intuitively, it seems preposterous to deny that it is possible to say, and worth saying, what fine art is. The nature of Weitz's demurrer is rather less obvious than may at first appear. Weitz seems to press the point that if it is to be provided, a definition of art should identify what is really essential to it, what its necessary and sufficient conditions are. Apparently, a definition can be provided "for a special purpose," but this, Weitz believes, is not the same thing.

We are bound to raise several questions here. Are there any definitions that do not serve a special purpose? Do definitions, if they serve a special purpose—for instance, facilitating reference and focus for a set of competing theories about art—fail for that reason to capture the essence of art? And is it the case that serviceable definitions must, and must be supposed to, capture the real essence of what they characterize? It is in fact a feature

The Definition of Art

of the more recent, changed reception of definitional requests (for instance, in the account provided by Hilary Putnam) that we may characterize the distinctive traits or conditions of art without pretending to fix its essence or without insisting that empirical definitions be addressed to real essences. One of the most notable recent discussions of the peculiar nature of works of art is Arthur Danto's paper "The Artworld" (1964). In effect, Danto does not disgualify definitions but rather shows why it is that, particularly with regard to art, the inventive possibilities oblige us to keep adjusting our antecedently stabilized characterizations. In doing so, Danto clearly links the treatment of the definition of art with the deeper question of the metaphysical status of a work of art. He hints at a difference between physical nature and human culture and he introduces, without development, what he calls the "'is' of artistic identification." What we may suggest, here, without pursuing that issue (see Part Four) is that definitions may serve only to fix the properties of what, in accord with the prevailing current of competing theories, are thought to be the normal or central instances. In this sense, as we say, definitions fix only the nominal, not the real, essences of things; that is, definitions are practical and alterable instruments servicing developing theories that cover at least certain undeniable specimens. It is entirely possible, therefore, that works of art that are somewhat deviant relative to the standard cases can be admitted as works of art and can be admitted to have properties quite different from those focused by our definition, without contradiction at all. It is only when such discrepancies begin to take on a systematic importance that earlier serviceable definitions will have to give way: then, the meaning of "art" will have to change, whereas it need not have changed in accommodating our changing beliefs about what a work of art could be like. This explains in a sense the tolerance that is possible in speaking of driftwood, readymades, l'art trouvé, machine art, the art of chimpanzees, and so-called conceptual or idea art. It also suggests the sense in which we may proceed by genus and difference, by necessary and sufficient conditions, or by characteristic conditions, without in the least violating any logical constraints on the formulation of empirical definitions. The definitions of empirical terms in the sciences are intended to facilitate discourse that is primarily explanatory (in the causal sense) and predictive. Where art is concerned, no such constraints obtain, though there is a clear sense in which definitions must be brought into fair agreement with the general sorts of theories and activities that characterize our aesthetic concern with the arts themselves. The concession, it may be admitted, points as well to the possible vacuity of definitional disputes. But, more important, it signifies a refinement in the theory of definition and a sense of the function and validity of particular definitions of art.

Nelson Goodman (1977) has, for reasons rather different from Danto's, eschewed the definition of art. In speaking of the "symptoms" of art as opposed to its "defining properties," however, he does actually consider a set of disjunctively necessary and conjunctively sufficient conditions that tempt us—against his demurrer—to view his thesis as definitional. These are linked to symbolic functioning; to features of symbols, to features symbolized, and to functioning at least by way of exemplification. The theory that works of art are symbols or symbolic forms is perennially of interest. of course. Goodman introduces a particularly subtle version of it, by means of which he is able to expose certain anomalies in formalist theories of art. But in doing so, he obliges us to consider once again how minimal the basis may be on which to construe an object as functioning symbolicallyhence, the vulnerability of the theory that art exhibits in some strong sense a symbolic function. The key to Goodman's entire theory of art rests with the concept of exemplification. Granted that to exemplify is to symbolize; the question remains whether in possessing whatever properties it does possess (nonsymbolic properties), a work of art must be said to refer to or symbolize any or all such properties. Goodman's account, therefore, suggests a possible asymmetry between validating and invalidating definitions of art or, more informally, characterizations of what serves as strong (or even decisive) evidence of the presence of art. It also suggests the variety of strategies by which we may recover some of the purposes of definition without conceding that the specification of "salient," "characteristic," "symptomatic," and similar traits are to count as actually definitional in nature.

Jack Glickman (1976) adopts another strategy. Instead of challenging what is normally thought to be a defining property of art, namely, being an artifact, Glickman attempts to show that being an artifact does not entail having been made by anyone. He explores, in passing, the notion of creativity and centers on the kind of art that is thought to be creative in nature. By this strategy, Glickman shows the possibility of dispute even about what is entailed by admittedly defining properties. And his claim that "particulars are made, types created" draws us on to the profound ontological problem of how a work of art can be a particular and combine concrete and abstract properties (see Part Four).

The Role of Theory in Aesthetics MORRIS WEITZ

Theory has been central in aesthetics and is still the preoccupation of the philosophy of art. Its main avowed concern remains the determination of the nature of art which can be formulated into a definition of it. It construes definition as the statement of the necessary and sufficient properties of what is being defined, where the statement purports to be a true or false claim about the essence of art, what characterizes and distinguishes it from everything else. Each of the great theories of art-Formalism, Voluntarism, Emotionalism, Intellectualism, Intuitionism, Organicism-converges on the attempt to state the defining properties of art. Each claims that it is the true theory because it has formulated correctly into a real definition the nature of art; and that the others are false because they have left out some necessary or sufficient property. Many theorists contend that their enterprise is no mere intellectual exercise but an absolute necessity for any understanding of art and our proper evaluation of it. Unless we know what art is, they say, what are its necessary and sufficient properties, we cannot begin to respond to it adequately or to say why one work is good or better than another. Aesthetic theory, thus, is important not only in itself but for the foundations of both appreciation and criticism. Philosophers, critics, and even artists who have written on art, agree that what is primary in aesthetics is a theory about the nature of art.

Is aesthetic theory, in the sense of a true definition or set of necessary and sufficient properties of art, possible? If nothing else does, the history of aesthetics itself should give one enormous pause here. For, in spite of the many theories, we seem no nearer our goal today than we were in Plato's time. Each age, each art-movement, each philosophy of art, tries over and over again to establish the stated ideal only to be succeeded by a new or

From The Journal of Aesthetics and Art Criticism, XV (1956), 27-35. Reprinted by permission of the author and the editor of The Journal of Aesthetics and Art Criticism.

revised theory, rooted, at least in part, in the repudiation of preceding ones. Even today, almost everyone interested in aesthetic matters is still deeply wedded to the hope that the correct theory of art is forthcoming. We need only examine the numerous new books on art in which new definitions are proffered; or, in our own country especially, the basic textbooks and anthologies to recognize how strong the priority of a theory of art is.

In this essay I want to plead for the rejection of this problem. I want to show that theory-in the requisite classical sense-is never forthcoming in aesthetics, and that we would do much better as philosophers to supplant the question, "What is the nature of art?," by other questions, the answers to which will provide us with all the understanding of the arts there can be. I want to show that the inadequacies of the theories are not primarily occasioned by any legitimate difficulty such, e.g., as the vast complexity of art, which might be corrected by further probing and research. Their basic inadequacies reside instead in a fundamental misconception of art. Aesthetic theory-all of it-is wrong in principle in thinking that a correct theory is possible because it radically misconstrues the logic of the concept of art. Its main contention that "art" is amenable to real or any kind of true definition is false. Its attempt to discover the necessary and sufficient properties of art is logically misbegotten for the very simple reason that such a set and, consequently, such a formula about it, is never forthcoming. Art, as the logic of the concept shows, has no set of necessary and sufficient properties; hence a theory of it is logically impossible and not merely factually difficult. Aesthetic theory tries to define what cannot be defined in its requisite sense. But in recommending the repudiation of aesthetic theory I shall not argue from this, as too many others have done, that its logical confusions render it meaningless or worthless. On the contrary, I wish to reassess its role and its contribution primarily in order to show that it is of the greatest importance to our understanding of the arts.

Let us now survey briefly some of the more famous extant aesthetic theories in order to see if they do incorporate correct and adequate statements about the nature of art. In each of these there is the assumption that it is the true enumeration of the defining properties of art, with the implication that previous theories have stressed wrong definitions. Thus, to begin with, consider a famous version of Formalist theory, that propounded by Bell and Fry. It is true that they speak mostly of painting in their writings but both assert that what they find in that art can be generalized for what is "art" in the others as well. The essence of painting, they maintain, are the plastic elements in relation. Its defining property is significant form, i.e., certain combinations of lines, colors, shapes, volumes—everything on the canvas except the representational elements—which evoke a unique response to such combinations. Painting is definable as plastic organization. The nature of art, what it *really* is, so their theory goes, is a unique com-

Role of Theory in Aesthetics

bination of certain elements (the specifiable plastic ones) in their relations. Anything which is art is an instance of significant form; and anything which is not art has no such form.

To this the Emotionalist replies that the truly essential property of art has been left out. Tolstoy, Ducasse, or any of the advocates of this theory, find that the requisite defining property is not significant form but rather the expression of emotion in some sensuous public medium. Without projection of emotion into some piece of stone or words or sounds, etc., there can be no art. Art is really such embodiment. It is this that uniquely characterizes art, and any true, real definition of it, contained in some adequate theory of art, must so state it.

The Intuitionist disclaims both emotion and form as defining properties. In Croce's version, for example, art is identified not with some physical, public object but with a specific creative, cognitive and spiritual art. Art is really a first stage of knowledge in which certain human beings (artists) bring their images and intuitions into lyrical clarification or expression. As such, it is an awareness, non-conceptual in character, of the unique individuality of things; and since it exists below the level of conceptualization or action, it is without scientific or moral content. Croce singles out as the defining essence of art this first stage of spiritual life and advances its identification with art as a philosophically true theory or definition.

The Organicist says to all of this that art is really a class of organic wholes consisting of distinguishable, albeit inseparable, elements in their causally efficacious relations which are presented in some sensuous medium. In A. C. Bradley, in piece-meal versions of it in literary criticism, or in my own generalized adaptation of it in my *Philosophy of the Arts*, what is claimed is that anything which is a work of art is in its nature a unique complex of interrelated parts—in painting, for example, lines, colors, volumes, subjects, etc., all interacting upon one another on a paint surface of some sort. Certainly, at one time at least it seemed to me that this organic theory constituted the one true and real definition of art.

My final example is the most interesting of all, logically speaking. This is the Voluntarist theory of Parker. In his writings on art, Parker persistently calls into question the traditional simple-minded definitions of aesthetics. "The assumption underlying every philosophy of art is the existence of some common nature present in all the arts."¹ "All the so popular brief definitions of art—'significant form,' 'expression,' 'intuition,' 'objectified pleasure'—are fallacious, either because, while true of art, they are also true of much that is not art, and hence fail to differentiate art from other things; or else because they neglect some essential aspect of art."² But instead of inveighing against the attempt at definition of art itself, Parker insists that what is needed is a complex definition rather than a simple one. "The definition of art must therefore be in terms of a complex of characteristics. Failure to recognize this has been the fault of all the well-known definitions."³ His own version of Voluntarism is the theory that art is essentially three things: embodiment of wishes and desires imaginatively satisfied, language, which characterizes the public medium of art, and harmony, which unifies the language with the layers of imaginative projections. Thus, for Parker, it is a true definition to say of art that it is ". . . the provision of satisfaction through the imagination, social significance, and harmony. I am claiming that nothing except works of art possesses all three of these marks."⁴

Now, all of these sample theories are inadequate in many different ways. Each purports to be a complete statement about the defining features of all works of art and yet each of them leaves out something which the others take to be central. Some are circular, e.g., the Bell-Fry theory of art as significant form which is defined in part in terms of our response to significant form. Some of them, in their search for necessary and sufficient properties, emphasize too few properties, like (again) the Bell-Fry definition, which leaves out subject-representation in painting, or the Croce theory, which omits inclusion of the very important feature of the public, physical character, say, of architecture. Others are too general and cover objects that are not art as well as works of art. Organicism is surely such a view since it can be applied to any causal unity in the natural world as well as to art.⁵ Still others rest on dubious principles, e.g., Parker's claim that art embodies imaginative satisfactions, rather than real ones; or Croce's assertion that there is nonconceptual knowledge. Consequently, even if art has one set of necessary and sufficient properties, none of the theories we have noted, or, for that matter, no aesthetic theory yet proposed, has enumerated that set to the satisfaction of all concerned.

Then there is a different sort of difficulty. As real definitions, these theories are supposed to be factual reports on art. If they are, may we not ask, Are they empirical and open to verification or falsification? For example, what would confirm or disconfirm the theory that art is significant form or embodiment of emotion or creative synthesis of images? There does not even seem to be a hint of the kind of evidence which might be forthcoming to test these theories; and indeed one wonders if they are perhaps honorific definitions of "art," that is, proposed redefinitions in terms of some *chosen* conditions for applying the concept of art, and not true or false reports on the essential properties of art at all.

But all these criticisms of traditional aesthetic theories—that they are circular, incomplete, untestable, pseudo-factual, disguised proposals to change the meaning of concepts—have been made before. My intention is to go beyond these to make a much more fundamental criticism, namely, that aesthetic theory is a logically vain attempt to define what cannot be

Role of Theory in Aesthetics

defined, to state the necessary and sufficient properties of that which has no necessary and sufficient properties, to conceive the concept of art as closed when its very use reveals and demands its openness.

The problem with which we must begin is not "What is art?," but "What sort of concept is 'art'?" Indeed, the root problem of philosophy itself is to explain the relation between the employment of certain kinds of concepts and the conditions under which they can be correctly applied. If I may paraphrase Wittgenstein, we must not ask, What is the nature of any philosophical x?, or even, according to the semanticist, What does "x" mean?, a transformation that leads to the disastrous interpretation of "art" as a name for some specifiable class of objects; but rather, What is the use or employment of "x"? What does "x" do in the language? This, I take it, is the initial question, the begin-all if not the end-all of any philosophical problem and solution. Thus, in aesthetics, our first problem is the elucidation of the actual employment of the concept of art, to give a logical description of the actual functioning of the concept, including a description of the conditions under which we correctly use it or its correlates.

My model in this type of logical description or philosophy derives from Wittgenstein. It is also he who, in his refutation of philosophical theorizing in the sense of constructing definitions of philosophical entities, has furnished contemporary aesthetics with a starting point for any future progress. In his new work, *Philosophical Investigations*,⁶ Wittgenstein raises as an illustrative question, What is a game? The traditional philosophical, theoretical answer would be in terms of some exhaustive set of properties common to all games. To this Wittgenstein says, let us consider what we call "games": "I mean board-games, card-games, ball-games, Olympic games, and so on. What is common to them all?—Don't say: 'there *must* be something common, or they would not be called "games"' but *look and see* whether there is anything common to all, but similarities, relationships, and a whole series of them at that. . . "

Card games are like board games in some respects but not in others. Not all games are amusing, nor is there always winning or losing or competition. Some games resemble others in some respects—that is all. What we find are no necessary and sufficient properties, only "a complicated network of similarities overlapping and crisscrossing," such that we can say of games that they form a family with family resemblances and no common trait. If one asks what a game is, we pick out sample games, describe these, and add, "This and *similar things* are called 'games.'" This is all we need to say and indeed all any of us knows about games. Knowing what a game is is not knowing some real definition or theory but being able to recognize and explain games and to decide which among imaginary and new examples would or would not be called "games."

The problem of the nature of art is like that of the nature of games, at least in these respects: If we actually look and see what it is that we call "art," we will also find no common properties—only strands of similarities. Knowing what art is is not apprehending some manifest or latent essence but being able to recognize, describe, and explain those things we call "art" in virtue of these similarities.

But the basic resemblance between these concepts is their open texture. In elucidating them, certain (paradigm) cases can be given, about which there can be no question as to their being correctly described as "art" or "game," but no exhaustive set of cases can be given. I can list some cases and some conditions under which I can apply correctly the concept of art but I cannot list all of them, for the all-important reason that unforeseeable or novel conditions are always forthcoming or envisageable.

A concept is open if its conditions of application are emendable and corrigible; i.e., if a situation or case can be imagined or secured which would call for some sort of *decision* on our part to extend the use of the concept to cover this, or to close the concept and invent a new one to deal with the new case and its new property. If necessary and sufficient conditions for the application of a concept can be stated, the concept is a closed one. But this can happen only in logic or mathematics where concepts are constructed and completely defined. It cannot occur with empirically-descriptive and normative concepts unless we arbitrarily close them by stipulating the ranges of their uses.

I can illustrate this open character of "art" best by examples drawn from its sub-concepts. Consider questions like "Is Dos Passos' U.S.A. a novel?," "Is V. Woolf's To the Lighthouse a novel?" "Is Joyce's Finnegan's Wake a novel?" On the traditional view, these are construed as factual problems to be answered yes or no in accordance with the presence or absence of defining properties. But certainly this is not how any of these questions is answered. Once it arises, as it has many times in the development of the novel from Richardson to Joyce (e.g., "Is Gide's The School for Wives a novel or a diary?"), what is at stake is no factual analysis concerning necessary and sufficient properties but a decision as to whether the work under examination is similar in certain respects to other works, already called "novels," and consequently warrants the extension of the concept to cover the new case. The new work is narrative, fictional, contains character delineation and dialogue but (say) it has no regular time-sequence in the plot or is interspersed with actual newspaper reports. It is like recognized novels, A, B, C . . . , in some respects but not like them in others. But then neither were B and C like A in some respects when it was decided to extend the concept applied to A to B and C. Because work N + 1 (the

Role of Theory in Aesthetics

brand new work) is like A, B, C, . . . N in certain respects—has strands of similarity to them—the concept is extended and a new phase of the novel engendered. "Is N + 1 a novel?," then, is no factual, but rather a decision problem, where the verdict turns on whether or not we enlarge our set of conditions for applying the concept.

What is true of the novel is, I think, true of every sub-concept of art: "tragedy," "comedy," "painting," "opera," etc., of "art" itself. No "Is X a novel, painting, opera, work of art, etc.?" question allows of a definitive answer in the sense of a factual yes or no report. "Is this *collage* a painting or not?" does not rest on any set of necessary and sufficient properties of painting but on whether we decide—as we did!—to extend "painting" to cover this case.

"Art," itself, is an open concept. New conditions (cases) have constantly arisen and will undoubtedly constantly arise; new art forms, new movements will emerge, which will demand decisions on the part of those interested, usually professional critics, as to whether the concept should be extended or not. Aestheticians may lay down similarity conditions but never necessary and sufficient ones for the correct application of the concept. With "art" its conditions of application can never be exhaustively enumerated since new cases can always be envisaged or created by artists, or even nature, which would call for a decision on someone's part to extend or to close the old or to invent a new concept. (E.g., "It's not a sculpture, it's a mobile.")

What I am arguing, then, is that the very expansive, adventurous character of art, its ever-present changes and novel creations, makes it logically impossible to ensure any set of defining properties. We can, of course, choose to close the concept. But to do this with "art" or "tragedy" or "portraiture," etc., is ludicrous since it forecloses on the very conditions of creativity in the arts.

Of course there are legitimate and serviceable closed concepts in art. But these are always those whose boundaries of conditions have been drawn for a *special* purpose. Consider the difference, for example, between "tragedy" and "(extant) Greek tragedy." The first is open and must remain so to allow for the possibility of new conditions, e.g., a play in which the hero is not noble or fallen or in which there is no hero but other elements that are like those of plays we already call "tragedy." The second is closed. The plays it can be applied to, the conditions under which it can be correctly used are all in, once the boundary, "Greek," is drawn. Here the critic can work out a theory or real definition in which he lists the common properties at least of the extant Greek tragedies. Aristotle's definition, false as it is as a theory of all the plays of Aeschylus, Sophocles, and Euripides, since it does not cover some of them,⁷ properly called "tragedies," can be interpreted as a real (albeit incorrect) definition of this closed concept; although it can also be, as it unfortunately has been, conceived as a purported real definition of "tragedy," in which case it suffers from the logical mistake of trying to define what cannot be defined—of trying to squeeze what is an open concept into an honorific formula for a closed concept.

What is supremely important, if the critic is not to become muddled, is to get absolutely clear about the way in which he conceives his concepts; otherwise he goes from the problem of trying to define "tragedy," etc., to an arbitrary closing of the concept in terms of certain preferred conditions or characteristics which he sums up in some linguistic recommendation that he mistakenly thinks is a real definition of the open concept. Thus, many critics and aestheticians ask, "What is tragedy?," choose a class of samples for which they may give a true account of its common properties, and then go on to construe this account of the chosen closed class as a true definition or theory of the whole open class of tragedy. This, I think, is the logical mechanism of most of the so-called theories of the sub-concepts of art: "tragedy," "comedy," "novel," etc. In effect, this whole procedure, subtly deceptive as it is, amounts to a transformation of correct criteria for *recognizing* members of certain legitimately closed classes of works of art into recommended criteria for *evaluating* any putative member of the class.

The primary task of aesthetics is not to seek a theory but to elucidate the concept of art. Specifically, it is to describe the conditions under which we employ the concept correctly. Definition, reconstruction, patterns of analysis are out of place here since they distort and add nothing to our understanding of art. What, then, is the logic of "X is a work of art"?

As we actually use the concept, "Art" is both descriptive (like "chair") and evaluative (like "good"); i.e., we sometimes say, "This is a work of art," to describe something and we sometimes say it to evaluate something. Neither use surprises anyone.

What, first, is the logic of "X is a work of art," when it is a descriptive utterance? What are the conditions under which we would be making such an utterance correctly? There are no necessary and sufficient conditions but there are the strands of similarity conditions, i.e., bundles of properties, none of which need be present but most of which are, when we describe things as works of art. I shall call these the "criteria of recognition" of works of art. All of these have served as the defining criteria of the individual traditional theories of art; so we are already familiar with them. Thus, mostly, when we describe something as a work of art, we do so under the conditions of there being present some sort of artifact, made by human skill, ingenuity, and imagination, which embodies in its sensuous, public medium—stone, wood, sounds, words, etc.—certain distinguishable elements and relations. Special theorists would add conditions like satisfaction of wishes, objectification or expression of emotion, some act of em-

Role of Theory in Aesthetics

pathy, and so on: but these latter conditions seem to be quite adventitious, present to some but not to other spectators when things are described as works of art. "X is a work of art and contains no emotion, expression, act of empathy, satisfaction, etc.," is perfectly good sense and may frequently be true. "X is a work of art and . . . was made by no one," or ". . . exists only in the mind and not in any publicly observable thing," or ". . . was made by accident when he spilled the paint on the canvas," in each case of which a normal condition is denied, are also sensible and capable of being true in certain circumstances. None of the criteria of recognition is a defining one, either necessary or sufficient, because we can sometimes assert of something that it is a work of art and go on to deny any one of these conditions, even the one which has traditionally been taken to be basic, namely, that of being an artifact: Consider, "This piece of driftwood is a lovely piece of sculpture." Thus, to say of anything that it is a work of art is to commit oneself to the presence of some of these conditions. One would scarcely describe X as a work of art if X were not an artifact, or a collection of elements sensuously presented in a medium, or a product of human skill, and so on. If none of the conditions were present, if there were no criteria present for recognizing something as a work of art, we would not describe it as one. But, even so, no one of these or any collection of them is either necessary or sufficient.

The elucidation of the descriptive use of "Art" creates little difficulty. But the elucidation of the evaluative use does. For many, especially theorists, "This is a work of art" does more than describe; it also praises. Its conditions of utterance, therefore, include certain preferred properties or characteristics of art. I shall call these "criteria of evaluation." Consider a typical example of this evaluative use, the view according to which to say of something that it is a work of art is to imply that it is a successful harmonization of elements. Many of the honorific definitions of art and its sub-concepts are of this form. What is at stake here is that "Art" is construed as an evaluative term which is either identified with its criterion or justified in terms of it. "Art" is defined in terms of its evaluative property, e.g., successful harmonization. On such a view, to say "X is a work of art" is (1) to say something which is taken to mean "X is a successful harmonization" (e.g., "Art is significant form") or (2) to say something praiseworthy on the basis of its successful harmonization. Theorists are never clear whether it is (1) or (2) which is being put forward. Most of them, concerned as they are with this evaluative use, formulate (2), i.e., that feature of art that makes it art in the praise-sense, and then go on to state (1), i.e., the definition of "Art" in terms of its art-making feature. And this is clearly to confuse the conditions under which we say something evaluatively with the meaning of what we say. "This is a work of art," said evaluatively, cannot mean "This is a successful harmonization of elements"

—except by stipulation—but at most is said in virtue of the art-making property, which is taken as a (the) criterion of "Art," when "Art" is employed to assess. "This is a work of art," used evaluatively, serves to praise and not to affirm the reason why it is said.

The evaluative use of "Art," although distinct from the conditions of its use, relates in a very intimate way to these conditions. For, in every instance of "This is a work of art" (used to praise), what happens is that the criterion of evaluation (e.g., successful harmonization) for the employment of the concept of art is converted into a criterion of recognition. This is why, on its evaluative use, "This is a work of art" implies "This has P," where "P" is some chosen art-making property. Thus, if one chooses to employ "Art" evaluatively, as many do, so that "This is a work of art and not (aesthetically) good" makes no sense, he uses "Art" in such a way that he refuses to *call* anything a work of art unless it embodies his criterion of excellence.

There is nothing wrong with the evaluative use; in fact, there is good reason for using "Art" to praise. But what cannot be maintained is that theories of the evaluative use of "Art" are true and real definitions of the necessary and sufficient properties of art. Instead they are honorific definitions, pure and simple, in which "Art" has been redefined in terms of chosen criteria.

But what makes them-these honorific definitions-so supremely valuable is not their disguised linguistic recommendations; rather it is the debates over the reasons for changing the criteria of the concept of art which are built into the definitions. In each of the great theories of art, whether correctly understood as honorific definitions or incorrectly accepted as real definitions, what is of the utmost importance are the reasons proffered in the argument for the respective theory, that is, the reasons given for the chosen or preferred criterion of excellence and evaluation. It is this perennial debate over these criteria of evaluation which makes the history of aesthetic theory the important study it is. The value of each of the theories resides in its attempt to state and to justify certain criteria which are either neglected or distorted by previous theories. Look at the Bell-Fry theory again. Of course, "Art is significant form" cannot be accepted as a true, real definition of art; and most certainly it actually functions in their aesthetics as a redefinition of art in terms of the chosen condition of significant form. But what gives it its aesthetic importance is what lies behind the formula: In an age in which literary and representational elements have become paramount in painting, return to the plastic ones since these are indigenous to painting. Thus, the role of the theory is not to define anything but to use the definitional form, almost epigrammatically, to pin-point a crucial recommendation to turn our attention once again to the plastic elements in painting.

Role of Theory in Aesthetics

Once we, as philosophers, understand this distinction between the formula and what lies behind it, it behooves us to deal generously with the traditional theories of art; because incorporated in every one of them is a debate over and argument for emphasizing or centering upon some particular feature of art which has been neglected or perverted. If we take the aesthetic theories literally, as we have seen, they all fail; but if we reconstrue them, in terms of their function and point, as serious and argued-for recommendations to concentrate on certain criteria of excellence in art, we shall see that aesthetic theory is far from worthless. Indeed, it becomes as central as anything in aesthetics, in our understanding of art, for it teaches us what to look for and how to look at it in art. What is central and must be articulated in all the theories are their debates over the reasons for excellence in art-debates over emotional depth, profound truths, natural beauty, exactitude, freshness of treatment, and so on, as criteria of evaluationthe whole of which converges on the perennial problem of what makes a work of art good. To understand the role of aesthetic theory is not to conceive it as definition, logically doomed to failure, but to read it as summaries of seriously made recommendations to attend in certain ways to certain features of art.

Notes

1. D. Parker, "The Nature of Art," reprinted in E. Vivas and M. Krieger, *The Problems of Aesthetics* (N.Y., 1953), p. 90.

- 2. Ibid., pp. 93-94.
- 3. Ibid., p. 94.
- 4. Ibid., p. 104.

5. See M. Macdonald's review of my *Philosophy of the Arts, Mind*, Oct. 1951, pp. 561–564, for a brilliant discussion of this objection to the Organic theory.

6. L. Wittgenstein, *Philosophical Investigations* (Oxford, 1953), tr. E. Anscombe; see esp. Part I, Sec. 65-75. All quotations are from these sections.

7. See H. D. F. Kitto, Greek Tragedy (London, 1939), on this point.

The Artworld ARTHUR DANTO

Hamlet:

Do you see nothing there? The Queen: Nothing at all; yet all that is I see. Shakespeare: Hamlet, Act III, Scene IV

Hamlet and Socrates, though in praise and deprecation respectively, spoke of art as a mirror held up to nature. As with many disagreements in attitude, this one has a factual basis. Socrates saw mirrors as but reflecting what we can already see; so art, insofar as mirrorlike, yields idle accurate duplications of the appearances of things, and is of no cognitive benefit whatever. Hamlet, more acutely, recognized a remarkable feature of reflecting surfaces, namely that they show us what we could not otherwise perceive-our own face and form-and so art, insofar as it is mirrorlike, reveals us to ourselves, and is, even by socratic criteria, of some cognitive utility after all. As a philosopher, however, I find Socrates' discussion defective on other, perhaps less profound grounds than these. If a mirrorimage of o is indeed an imitation of o, then, if art is imitation, mirrorimages are art. But in fact mirroring objects no more is art than returning weapons to a madman is justice; and reference to mirrorings would be just the sly sort of counterinstance we would expect Socrates to bring forward in rebuttal of the theory he instead uses them to illustrate. If that theory requires us to class these as art, it thereby shows its inadequacy: "is an imitation" will not do as a sufficient condition for "is art." Yet, perhaps because artists were engaged in imitation, in Socrates' time and after, the insufficiency of the theory was not noticed until the invention of photog-

From *The Journal of Philosophy*, LXI (1964), 571–584. Reprinted by permission of the author and *The Journal of Philosophy*.

7.

The Artworld

raphy. Once rejected as a sufficient condition, mimesis was quickly discarded as even a necessary one; and since the achievement of Kandinsky, mimetic features have been relegated to the periphery of critical concern, so much so that some works survive in spite of possessing those virtues, excellence in which was once celebrated as the essence of art, narrowly escaping demotion to mere illustrations.

It is, of course, indispensable in socratic discussion that all participants be masters of the concept up for analysis, since the aim is to match a real defining expression to a term in active use, and the test for adequacy presumably consists in showing that the former analyzes and applies to all and only those things of which the latter is true. The popular disclaimer notwithstanding, then, Socrates' auditors purportedly knew what art was as well as what they liked; and a theory of art, regarded here as a real definition of 'Art,' is accordingly not to be of great use in helping men to recognize instances of its application. Their antecedent ability to do this is precisely what the adequacy of the theory is to be tested against, the problem being only to make explicit what they already know. It is our use of the term that the theory allegedly means to capture, but we are supposed able, in the words of a recent writer, "to separate those objects which are works of art from those which are not, because . . . we know how correctly to use the word 'art' and to apply the phrase 'work of art.' " Theories, on this account, are somewhat like mirror-images on Socrates' account, showing forth what we already know, wordy reflections of the actual linguistic practice we are masters in.

But telling artworks from other things is not so simple a matter, even for native speakers, and these days one might not be aware he was on artistic terrain without an artistic theory to tell him so. And part of the reason for this lies in the fact that terrain is constituted artistic in virtue of artistic theories, so that one use of theories, in addition to helping us discriminate art from the rest, consists in making art possible. Glaucon and the others could hardly have known what was art and what not: otherwise they would never have been taken in by mirror-images.

I

Suppose one thinks of the discovery of a whole new class of artworks as something analogous to the discovery of a whole new class of facts anywhere, viz., as something for theoreticians to explain. In science, as elsewhere, we often accommodate new facts to old theories via auxiliary hypotheses, a pardonable enough conservatism when the theory in question is deemed too valuable to be jettisoned all at once. Now the Imitation Theory of Art (IT) is, if one but thinks it through, an exceedingly powerful theory, explaining a great many phenomena connected with the causation and evaluation of artworks, bringing a surprising unity into a complex domain. Moreover, it is a simple matter to shore it up against many purported counterinstances by such auxiliary hypotheses as that the artist who deviates from mimeticity is perverse, inept, or mad. Ineptitude, chicanery, or folly are, in fact, testable predications. Suppose, then, tests reveal that these hypotheses fail to hold, that the theory, now beyond repair, must be replaced. And a new theory is worked out, capturing what it can of the old theory's competence, together with the heretofore recalcitrant facts. One might, thinking along these lines, represent certain episodes in the history of art as not dissimilar to certain episodes in the history of science, where a conceptual revolution is being effected and where refusal to countenance certain facts, while in part due to prejudice, inertia, and self-interest, is due also to the fact that a well-established, or at least widely credited theory is being threatened in such a way that all coherence goes.

Some such episode transpired with the advent of post-impressionist paintings. In terms of the prevailing artistic theory (IT), it was impossible to accept these as art unless inept art: otherwise they could be discounted as hoaxes. self-advertisements, or the visual counterparts of madmen's ravings. So to get them accepted as art, on a footing with the Transfiguration (not to speak of a Landseer stag), required not so much a revolution in taste as a theoretical revision of rather considerable proportions, involving not only the artistic enfranchisement of these objects, but an emphasis upon newly significant features of accepted artworks, so that quite different accounts of their status an artworks would now have to be given. As a result of the new theory's acceptance, not only were post-impressionist paintings taken up as art, but numbers of objects (masks, weapons, etc.) were transferred from anthropological museums (and heterogeneous other places) to musées des beaux arts, though, as we would expect from the fact that a criterion for the acceptance of a new theory is that it account for whatever the older one did, nothing had to be transferred out of the musée des beaux arts-even if there were internal rearrangements as between storage rooms and exhibition space. Countless native speakers hung upon suburban mantelpieces innumerable replicas of paradigm cases for teaching the expression 'work of art' that would have sent their Edwardian forebears into linguistic apoplexy.

To be sure, I distort by speaking of a theory: historically, there were several, all, interestingly enough, more or less defined in terms of the IT. Art-historical complexities must yield before the exigencies of logical exposition, and I shall speak as though there were one replacing theory, partially compensating for historical falsity by choosing one which was actually enunciated. According to it, the artists in question were to be understood not as unsuccessfully imitating real forms but as successfully creating new ones, quite as real as the forms which the older art had been thought,

The Artworld

in its best examples, to be creditably imitating. Art, after all, had long since been thought of as creative (Vasari says that God was the first artist), and the post-impressionists were to be explained as genuinely creative, aiming, in Roger Fry's words, "not at illusion but reality." This theory (RT) furnished a whole new mode of looking at painting, old and new. Indeed, one might almost interpret the crude drawing in Van Gogh and Cézanne, the dislocation of form from contour in Rouault and Dufy, the arbitrary use of color planes in Gauguin and the Fauves, as so many ways of drawing attention to the fact that these were non-imitations, specifically intended not to deceive. Logically, this would be roughly like printing "Not Legal Tender" across a brilliantly counterfeited dollar bill, the resulting object (counterfeit cum inscription) rendered incapable of deceiving anyone. It is not an illusory dollar bill, but then, just because it is non-illusory it does not automatically become a real dollar bill either. It rather occupies a freshly opened area between real objects and real facsimiles of real objects: it is a non-facsimile, if one requires a word, and a new contribution to the world. Thus, Van Gogh's Potato Eaters, as a consequence of certain unmistakable distortions, turns out to be a non-facsimile of real-life potato eaters; and inasmuch as these are not facsimiles of potato eaters, Van Gogh's picture, as a non-imitation, had as much right to be called a real object as did its putative subjects. By means of this theory (RT), artworks re-entered the thick of things from which socratic theory (IT) had sought to evict them: if no more real than what carpenters wrought, they were at least no less real. The Post-Impressionist won a victory in ontology.

It is in terms of RT that we must understand the artworks around us today. Thus Roy Lichtenstein paints comic-strip panels, though ten or twelve feet high. These are reasonably faithful projections onto a gigantesque scale of the homely frames from the daily tabloid, but it is precisely the scale that counts. A skilled engraver might incise The Virgin and the Chancellor Rollin on a pinhead, and it would be recognizable as such to the keen of sight, but an engraving of a Barnett Newman on a similar scale would be a blob, disappearing in the reduction. A photograph of a Lichtenstein is indiscernible from a photograph of a counterpart panel from Steve Canyon; but the photograph fails to capture the scale, and hence is as inaccurate a reproduction as a black-and-white engraving of Botticelli, scale being essential here as color there. Lichtensteins, then, are not imitations but new entities, as giant whelks would be. Jasper Johns, by contrast, paints objects with respect to which questions of scale are irrelevant. Yet his objects cannot be imitations, for they have the remarkable property that any intended copy of a member of this class of objects is automatically a member of the class itself, so that these objects are logically inimitable. Thus, a copy of a numeral just is that numeral: a painting of 3 is a 3 made of paint. Johns, in addition, paints targets, flags, and maps. Finally, in what I hope are not unwitting footnotes to Plato, two of our pioneers—Robert Rauschenberg and Claes Oldenburg—have made genuine beds.

Rauschenberg's bed hangs on a wall, and is streaked with some desultory housepaint. Oldenburg's bed is a rhomboid, narrower at one end than the other, with what one might speak of as a built-in perspective: ideal for small bedrooms. As beds, these sell at singularly inflated prices, but one could sleep in either of them: Rauschenberg has expressed the fear that someone might just climb into his bed and fall asleep. Imagine, now, a certain Testadura-a plain speaker and noted philistine-who is not aware that these are art, and who takes them to be reality simple and pure. He attributes the paintstreaks on Rauschenberg's bed to the slovenliness of the owner, and the bias in the Oldenburg bed to the ineptitude of the builder or the whimsy, perhaps, of whoever had it "custom-made." These would be mistakes, but mistakes of rather an odd kind, and not terribly different from that made by the stunned birds who pecked the sham grapes of Zeuxis. They mistook art for reality, and so has Testadura. But it was meant to be reality, according to RT. Can one have mistaken reality for reality? How shall we describe Testadura's error? What, after all, prevents Oldenburg's creation from being a misshapen bed? This is equivalent to asking what makes it art, and with this query we enter a domain of conceptual inquiry where native speakers are poor guides: they are lost themselves.

Π

To mistake an artwork for a real object is no great feat when an artwork is the real object one mistakes it for. The problem is how to avoid such errors, or to remove them once they are made. The artwork is a bed, and not a bed-illusion; so there is nothing like the traumatic encounter against a flat surface that brought it home to the birds of Zeuxis that they had been duped. Except for the guard cautioning Testadura not to sleep on the artworks, he might never have discovered that this was an artwork and not a bed; and since, after all, one cannot discover that a bed is not a bed, how is Testadura to realize that he has made an error? A certain sort of explanation is required, for the error here is a curiously philosophical one, rather like, if we may assume as correct some well-known views of P. F. Strawson, mistaking a person for a material body when the truth is that a person is a material body in the sense that a whole class of predicates, sensibly applicable to material bodies, are sensibly, and by appeal to no different criteria, applicable to persons. So you cannot discover that a person is not a material body.

We begin by explaining, perhaps, that the paintstreaks are not to be explained away, that they are *part* of the object, so the object is not a mere

The Artworld

bed with—as it happens—streaks of paint spilled over it, but a complex object fabricated out of a bed and some paintstreaks: a paint-bed. Similarly, a person is not a material body with—as it happens—some thoughts superadded, but is a complex entity made up of a body and some conscious states: a conscious-body. Persons, like artworks, must then be taken as irreducible to *parts* of themselves, and are in that sense primitive. Or, more accurately, the paintstreaks are not part of the real object—the bed—which happens to be part of the artwork, but are, *like* the bed, part of the artwork as such. And this might be generalized into a rough characterization of artworks that happen to contain real objects as parts of themselves: not every part of an artwork A is part of a real object R when R is part of A and can, moreover, be detached from A and seen *merely* as R. The mistake thus far will have been to mistake A for *part* of itself, namely R, even though it would not be incorrect to say that A is R, that the artwork is a bed. It is the 'is' which requires clarification here.

There is an *is* that figures prominently in statements concerning artworks which is not the is of either identity or predication; nor is it the is of existence, of identification, or some special is made up to serve a philosophic end. Nevertheless, it is in common usage, and is readily mastered by children. It is the sense of *is* in accordance with which a child, shown a circle and a triangle and asked which is him and which his sister, will point to the triangle saying "That is me"; or, in response to my question, the person next to me points to the man in purple and says "That one is Lear"; or in the gallery I point, for my companion's benefit, to a spot in the painting before us and say "That white dab is Icarus." We do not mean, in these instances, that whatever is pointed to stands for, or represents, what it is said to be, for the word 'Icarus' stands for or represents Icarus: yet I would not in the same sense of is point to the word and say "That is Icarus." The sentence "That a is b" is perfectly compatible with "That a is not b" when the first employs this sense of *is* and the second employs some other, though a and b are used nonambiguously throughout. Often, indeed, the truth of the first *requires* the truth of the second. The first, in fact, is incompatible with "That a is not b" only when the is used nonambiguously throughout. For want of a word I shall designate this the is of artistic identification; in each case in which it is used, the *a* stands for some specific physical property of, or physical part of, an object; and, finally, it is a necessary condition for something to be an artwork that some part or property of it be designable by the subject of a sentence that employs this special is. It is an is, incidentally, which has near-relatives in marginal and mythical pronouncements. (Thus, one is Quetzalcoatl; those are the Pillars of Hercules.)

Let me illustrate. Two painters are asked to decorate the east and west walls of a science library with frescoes to be respectively called *Newton's* *First Law* and *Newton's Third Law*. These paintings, when finally unveiled, look, scale apart, as follows:

As objects I shall suppose the works to be indiscernible: a black, horizontal line on a white ground, equally large in each dimension and element. *B* explains his work as follows: a mass, pressing downward, is met by a mass pressing upward: the lower mass reacts equally and oppositely to the upper one. *A* explains his work as follows: the line through the space is the path of an isolated particle. The path goes from edge to edge, to give the sense of its *going beyond*. If it ended or began within the space, the line would be curved: and it is parallel to the top and bottom edges, for if it were closer to one than to another, there would have to be a force accounting for it, and this is inconsistent with its being the path of an *isolated* particle.

Much follows from these artistic identifications. To regard the middle line as an edge (mass meeting mass) imposes the need to identify the top and bottom half of the picture as rectangles, and as two distinct parts (not necessarily as two masses, for the line could be the edge of one mass jutting up-or down-into empty space). If it is an edge, we cannot thus take the entire area of the painting as a single space: it is rather composed of two forms, or one form and a non-form. We could take the entire area as a single space only by taking the middle horizontal as a *line* which is not an edge. But this almost requires a three-dimensional identification of the whole picture: the area can be a flat surface which the line is above (Jetflight), or below (Submarine-path), or on (Line), or in (Fissure), or through (Newton's First Law)-though in this last case the area is not a flat surface but a transparent cross section of absolute space. We could make all these prepositional qualifications clear by imagining perpendicular cross sections to the picture plane. Then, depending upon the applicable prepositional clause, the area is (artistically) interrupted or not by the

The Artworld

horizontal element. If we take the line as *through* space, the edges of the picture are not really the edges of the space: the space goes beyond the picture if the line itself does; and we are in the same space as the line is. As B, the edges of the picture can be part of the picture in case the masses go right to the edges, so that the edges of the picture are their edges. In that case, the vertices of the picture would be the vertices of the masses, except that the masses have four vertices more than the picture itself does: here four vertices would be part of the art work which were not part of the real object. Again, the faces of the masses could be the face of the picture, and in looking at the picture, we are looking at these faces: but space has no face, and on the reading of A the work has to be read as faceless, and the face of the physical object would not be part of the artwork. Notice here how one artistic identification engenders another artistic identification, and how, consistently with a given identification, we are required to give others and *precluded* from still others: indeed, a given identification determines how many elements the work is to contain. These different identifications are incompatible with one another, or generally so, and each might be said to make a different artwork, even though each artwork contains the identical real object as part of itself-or at least parts of the identical real object as parts of itself. There are, of course, senseless identifications: no one could, I think, sensibly read the middle horizontal as Love's Labour's Lost or The Ascendency of St. Erasmus. Finally, notice how acceptance of one identification rather than another is in effect to exchange one world for another. We could, indeed, enter a quiet poetic world by identifying the upper area with a clear and cloudless sky, reflected in the still surface of the water below, whiteness kept from whiteness only by the unreal boundary of the horizon.

And now Testadura, having hovered in the wings throughout this discussion, protests that all he sees is paint: a white painted oblong with a black line painted across it. And how right he really is: that is all he sees or that anybody can, we aesthetes included. So, if he asks us to show him what there is further to see, to demonstrate through pointing that this is an artwork (Sea and Sky), we cannot comply, for he has overlooked nothing (and it would be absurd to suppose he had, that there was something tiny we could point to and he, peering closely, say "So it is! A work of art after all!"). We cannot help him until he has mastered the *is of artistic identification* and so *constitutes* it a work of art. If he cannot achieve this, he will never look upon artworks: he will be like a child who sees sticks as sticks.

But what about pure abstractions, say something that looks just like A but is entitled No. 7? The 10th Street abstractionist blankly insists that there is nothing here but white paint and black, and none of our literary identifications need apply. What then distinguishes him from Testadura,

whose philistine utterances are indiscernible from his? And how can it be an artwork for him and not for Testadura, when they agree that there is nothing that does not meet the eye? The answer, unpopular as it is likely to be to purists of every variety, lies in the fact that this artist has returned to the physicality of paint through an atmosphere compounded of artistic theories and the history of recent and remote painting, elements of which he is trying to refine out of his own work; and as a consequence of this his work belongs in this atmosphere and is part of this history. He has achieved abstraction through rejection of artistic identifications, returning to the real world from which such identifications remove us (he thinks), somewhat in the mode of Ch'ing Yuan, who wrote:

Before I had studied Zen for thirty years, I saw mountains as mountains and waters as waters. When I arrived at a more intimate knowledge, I came to the point where I saw that mountains are not mountains, and waters are not waters. But now that I have got the very substance I am at rest. For it is just that I see mountains once again as mountains, and waters once again as waters.

His identification of what he has made is logically dependent upon the theories and history he rejects. The difference between his utterance and Testadura's "This is black paint and white paint and nothing more" lies in the fact that he is still using the *is* of artistic identification, so that his use of "That black paint is black paint" is not a tautology. Testadura is not at that stage. To see something as art requires something the eye cannot decry—an atmosphere of artistic theory, a knowledge of the history of art: an artworld.

III

Mr. Andy Warhol, the Pop artist, displays facsimiles of Brillo cartons, piled high, in neat stacks, as in the stockroom of the supermarket. They happen to be of wood, painted to look like cardboard, and why not? To paraphrase the critic of the *Times*, if one may make the facsimile of a human being out of bronze, why not the facsimile of a Brillo carton out of plywood? The cost of these boxes happens to be 2×10^3 that of their homely counterparts in real life—a differential hardly ascribable to their advantage in durability. In fact the Brillo people might, at some slight increase in cost, make their boxes out of plywood without these becoming artworks, and Warhol might make *his* out of cardboard without their ceasing to be art. So we may forget questions of intrinsic value, and ask why the Brillo people cannot manufacture art and why Warhol cannot *but* make artworks. Well, his are made by hand, to be sure. Which is like an insane reversal of Picasso's strategy in pasting the label from a bottle of Suze onto a drawing,

The Artworld

saying as it were that the academic artist, concerned with exact imitation, must always fall short of the real thing: so why not just use the real thing? The Pop artist laboriously reproduces machine-made objects by hand, e.g., painting the labels on coffee cans (one can hear the familiar commendation "Entirely made by hand" falling painfully out of the guide's vocabulary when confronted by these objects). But the difference cannot consist in craft: a man who carved pebbles out of stones and carefully constructed a work called Gravel Pile might invoke the labor theory of value to account for the price he demands; but the question is, What makes it art? And why need Warhol make these things anyway? Why not just scrawl his signature across one? Or crush one up and display it as Crushed Brillo Box ("A protest against mechanization . . .") or simply display a Brillo carton as Uncrushed Brillo Box ("A bold affirmation of the plastic authenticity of industrial . . .")? Is this man a kind of Midas, turning whatever he touches into the gold of pure art? And the whole world consisting of latent artworks waiting, like the bread and wine of reality, to be transfigured, through some dark mystery, into the indiscernible flesh and blood of the sacrament? Never mind that the Brillo box may not be good, much less great art. The impressive thing is that it is art at all. But if it is, why are not the indiscernible Brillo boxes that are in the stockroom? Or has the whole distinction between art and reality broken down?

Suppose a man collects objects (ready-mades), including a Brillo carton; we praise the exhibit for variety, ingenuity, what you will. Next he exhibits nothing but Brillo cartons, and we criticize it as dull, repetitive, self-plagiarizing—or (more profoundly) claim that he is obsessed by regularity and repetition, as in Marienbad. Or he piles them high, leaving a narrow path; we tread our way through the smooth opaque stacks and find it an unsettling experience, and write it up as the closing in of consumer products, confining us as prisoners: or we say he is a modern pyramid builder. True, we don't say these things about the stockboy. But then a stockroom is not an art gallery, and we cannot readily separate the Brillo cartons from the gallery they are in, any more than we can separate the Rauschenberg bed from the paint upon it. Outside the gallery, they are pasteboard cartons. But then, scoured clean of paint, Rauschenberg's bed is a bed, just what it was before it was transformed into art. But then if we think this matter through, we discover that the artist has failed, really and of necessity, to produce a mere real object. He has produced an artwork. his use of real Brillo cartons being but an expansion of the resources available to artists, a contribution to artists' materials, as oil paint was, or tuche.

What in the end makes the difference between a Brillo box and a work of art consisting of a Brillo Box is a certain theory of art. It is the theory that takes it up into the world of art, and keeps it from collapsing into the real object which it is (in a sense of *is* other than that of artistic identification). Of course, without the theory, one is unlikely to see it as art, and in order to see it as part of the artworld, one must have mastered a good deal of artistic theory as well as a considerable amount of the history of recent New York painting. It could not have been art fifty years ago. But then there could not have been, everything being equal, flight insurance in the Middle Ages, or Etruscan typewriter erasers. The world has to be ready for certain things, the artworld no less than the real one. It is the role of artistic theories, these days as always, to make the artworld, and art, possible. It would, I should think, never have occurred to the painters of Lascaux that they were producing *art* on those walls. Not unless there were neolithic aestheticians.

IV

The artworld stands to the real world in something like the relationship in which the City of God stands to the Earthly City. Certain objects, like certain individuals, enjoy a double citizenship, but there remains, the RT notwithstanding, a fundamental contrast between artworks and real objects. Perhaps this was already dimly sensed by the early framers of the IT who, inchoately realizing the nonreality of art, were perhaps limited only in supposing that the sole way objects had of being other than real is to be sham, so that artworks necessarily had to be imitations of real objects. This was too narrow. So Yeats saw in writing "Once out of nature I shall never take / My bodily form from any natural thing." It is but a matter of choice: and the Brillo box of the artworld may be just the Brillo box of the real one, separated and united by the *is* of artistic identification. But I should like to say some final words about the theories that make artworks possible, and their relationship to one another. In so doing, I shall beg some of the hardest philosophical questions I know.

I shall now think of pairs of predicates related to each other as "opposites," conceding straight off the vagueness of this *demodé* term. Contradictory predicates are not opposites, since one of each of them must apply to every object in the universe, and neither of a pair of opposites need apply to some objects in the universe. An object must first be of a certain kind before either of a pair of opposites applies to it, and then at most and at least one of the opposites must apply to it. So opposites are not contraries, for contraries may both be false of some objects in the universe, but opposites cannot both be false; for of some objects, neither of a pair of opposites *sensibly* applies, unless the object is of the right sort. Then, if the object is of the required kind, the opposites behave as contradictories. If F and non-F are opposites, an object o must be of a certain kind K before either of these sensibly applies; but if o is a member of K, then o either is F or non-F, to the exclusion of the other. The class of pairs

The Artworld

of opposites that sensibly apply to the $(\hat{o})Ko$ I shall designate as the class of *K*-relevant predicates. And a necessary condition for an object to be of a kind K is that at least one pair of K-relevant opposites be sensibly applicable to it. But, in fact, if an object is of kind K, at least and at most one of each K-relevant pair of opposites applies to it.

I am now interested in the K-relevant predicates for the class K of artworks. And let F and non-F be an opposite pair of such predicates. Now it might happen that, throughout an entire period of time, every artwork is non-F. But since nothing thus far is both an artwork and F, it might never occur to anyone that non-F is an artistically relevant predicate. The non-F-ness of artworks goes unmarked. By contrast, all works up to a given time might be G, it never occurring to anyone until that time that something might both be an artwork and non-G; indeed, it might have been thought that G was a *defining trait* of artworks when in fact something might first have to be an artwork before G is sensibly predicable of it—in which case non-G might also be predicable of artworks, and G itself then could not have been a defining trait of this class.

Let G be 'is representational' and let F be 'is expressionist.' At a given time, these and their opposites are perhaps the only art-relevant predicates in critical use. Now letting '+' stand for a given predicate P and '-' for its opposite non-P, we may construct a style matrix more or less as follows:

F	G
+	+
+	
	+
_	

The rows determine available styles, given the active critical vocabulary: representational expressionistic (e.g., Fauvism); representational nonexpressionistic (Ingres); nonrepresentational expressionistic (Abstract Expressionism); nonrepresentational nonexpressionist (hard-edge abstraction). Plainly, as we add art-relevant predicates, we increase the number of available styles at the rate of 2^n . It is, of course, not easy to see in advance which predicates are going to be added or replaced by their opposites, but suppose an artist determines that H shall henceforth be artistically relevant for his paintings. Then, in fact, both H and non-H become artistically relevant for *all* painting, and if his is the first and only painting that is H, every other painting in existence becomes non-H, and the entire community of paintings is enriched, together with a doubling of the available style opportunities. It is this retroactive enrichment of the entities in the artworld that makes it possible to discuss Raphael and De Kooning together, or Lichtenstein and Michelangelo. The greater the variety of artistically relevant predicates, the more complex the individual members of the artworld become; and the more one knows of the entire population of the artworld, the richer one's experience with any of its members.

In this regard, notice that, if there are m artistically relevant predicates, there is always a bottom row with m minuses. This row is apt to be occupied by purists. Having scoured their canvasses clear of what they regard as inessential, they credit themselves with having distilled out the essence of art. But this is just their fallacy: exactly as many artistically relevant predicates stand true of their square monochromes as stand true of any member of the Artworld, and they can *exist* as artworks only insofar as "impure" paintings exist. Strictly speaking, a black square by Reinhardt is artistically as rich as Titian's *Sacred and Profane Love*. This explains how less is more.

Fashion, as it happens, favors certain rows of the style matrix: museums, connoisseurs, and others are makeweights in the Artworld. To insist, or seek to, that all artists become representational, perhaps to gain entry into a specially prestigious exhibition, cuts the available style matrix in half: there are then $2^n / 2$ ways of satisfying the requirement, and museums then can exhibit all these "approaches" to the topic they have set. But this is a matter of almost purely sociological interest: one row in the matrix is as legitimate as another. An artistic breakthrough consists, I suppose, in adding the possibility of a column to the matrix. Artists then, with greater or less alacrity, occupy the positions thus opened up: this is a remarkable feature of contemporary art, and for those unfamiliar with the matrix, it is hard, and perhaps impossible, to recognize certain positions as occupied by artworks. Nor would these things be artworks without the theories and the histories of the Artworld.

Brillo boxes enter the artworld with that same tonic incongruity the *commedia dell'arte* characters bring into *Ariadne auf Naxos*. Whatever is the artistically relevant predicate in virtue of which they gain their entry, the rest of the Artworld becomes that much the richer in having the opposite predicate available and applicable to its members. And, to return to the views of Hamlet with which we began this discussion, Brillo boxes may reveal us to ourselves as well as anything might: as a mirror held up to nature, they might serve to catch the conscience of our kings.

Creativity in the Arts JACK GLICKMAN

I. What is it to be creative? The answer usually given is that there is a "creative process," and most writers on creativity have taken their task to be a description of the kind of activity that takes place when one is acting creatively. In the first part of this paper I will argue that that is the wrong way to go about characterizing creativity, that one must attend to the artistic product rather than to the process. In Part II, I argue that their failure to properly distinguish creating from making has led some to suppose, erroneously, that some recent trends in art have celebrated the end of artistic creation.

Douglas Morgan, in reviewing a large number of writers on creativity, provides a convenient account of what I'll call the Creative-Process Theory. He finds that

the "classic" theory of the creative process breaks it down into various stages. From two to five stages are usually thought necessary to describe the process, but the various descriptions bear a revealing community, and I think we may take the "four-step" interpretation as reflecting the consensus:

1. A period of "preparation" during which the creator becomes aware of a problem or difficulty, goes through trial-and-error random movement in unsuccessful attempts to resolve a felt conflict . . .

2. A period of "incubation," renunciation or recession, during which the difficulty drops out of consciousness. The attention is totally redirected . . .

3. A period or event of "inspiration" or "insight" . . . the "aha!" phenomenon, characterized by a flood of vivid imagery, an emotional release, a feeling of exultation, adequacy, finality . . .

Reprinted from *Culture and Art.* Copyright © 1976 by Lars Aagaard-Mogensen. Used by permission of the author and of Eclipse Books.

4. A period of "elaboration" or "verification" during which the "idea" is worked out in detail, fully developed.²

According to Morgan, not only is it "complacently assumed by nearly all investigators that there is such a thing as the creative process—or a class of processes sharing important sets of characteristics, [it is assumed also] that creative processes in art and in science are identical or very nearly so."³

The theory has serious inadequacies. It excludes many instances of creative activity—improvizations in the performing arts, for example, and other instances in which the creating has taken place in a single unreflective burst of energy, as when poets have had a poem come to them all at once. The most objectionable inadequacy of the Creative-Process theory, though, is that what it describes is not at all limited to creative activity. The pattern described fits equally well many instances of genuine creativity and many instances of inept, bungling attempts at creativity. It also fits activities that are not even attempts at creativity: Suppose someone mentions a name that sounds familiar, and I try to recall the person mentioned. Someone asks me, "Do you remember George Spelvin?" "George Spelvin, George Spelvin," I repeat, mulling over the name (step 1-aware of a problem). I can't remember, so I put the problem aside, no longer consciously concerned with it (step 2-incubation). After a while it suddenly comes to me, "Sure, I remember George Spelvin; he's an actor!" (step 3-the "aha"! phenomenon). Then I begin to remember more, "I saw him as the Chorus in Romeo and Juliet" (step 4-filling in details). Recalling who a person is, given his name, hardly seems an instance of creative activity; yet it fits the description of the creative process.

In criticizing the Creative-Process theory, I might be accused of flogging a dead horse. Most psychologists seem to have abandoned this sort of account of creativity, as have many philosophers. Yet, as I will argue, in many subsequent accounts of creativity the same crucial error persists—the assumption that creativity consists in some distinctive pattern of thought and/or activity. It persists, for example, in Vincent Tomas's theory of creativity in the arts.

Tomas puts the problem this way: when one asks what's meant in saying that an artist is creative or that something is a work of creative art, "one is asking for a clarification or analysis of the concept of creativity as applied to art. One wants to know explicitly the nature of artistic creation—to be given a description of the conditions an activity must satisfy if it is to be an instance of artistic creation rather than of something else."⁴ This last sentence quoted makes it clear that he wants a set of conditions that are not only necessary but also sufficient for an instance of artistic activity to be creative activity.

Tomas begins with the example of a rifleman aiming and firing at a target: the rifleman knows what he wants to do—hit the bull's-eye—and he knows that if a hole appears in the bull's-eye after he fires, he has succeeded. The rifleman knows what he should do to hit the bull's-eye—what position to assume and how to hold the rifle, get the correct sight picture, and squeeze off the shot. If the rifleman fails, Tomas says, he has not obeyed all the rules, and if he succeeds and is congratulated, he is congratulated for being able to learn and obey all the rules.

But when we congratulate an artist for being creative, Tomas says, it is not because he was able to obey rules and thereby do what had been done before. "We congratulate him because he embodied in colors or in language something the like of which did not exist before."⁵ Unlike the rifleman, "the creative artist does not initially know what his target is Creative activity in art . . . is not . . . activity engaged in and consciously controlled so as to produce a desired result."⁶

Yet, Tomas says,

the creative artist has a sense that his activity is directed—that it is heading somewhere . . . Despite the fact that he cannot say precisely where he is going . . . he *can* say that certain directions are not right. After writing a couplet or drawing a line, he will erase it because it is "wrong" and try again

Creative activity in art, then, is activity subject to critical control by the artist, although not by virtue of the fact that he foresees the final result of the activity. That this way of construing creativity reflects part of what we have in mind when we speak of creative art can be shown if we contrast what results from creative activity so construed with what results from other activities that we do not call creative.

Thus we do not judge a painting, poem, or other work to be a work of creative art unless we believe it to be original. If it strikes us as being a repetition of other paintings or poems, if it seems to be the result of a mechanical application of a borrowed technique or style to novel subject matter, to the degree that we apprehend it as such, to the same degree we deny that it is creative.⁷

It is fairly clear, then, how Tomas relates the following three questions: (1) What characterizes an artist as a creative artist? (2) What characterizes a poem, painting, or other work as a creative work of art? (3) What characterizes an activity as artistic creation? Tomas would answer the first two of these questions in terms of his answer to the third: artists, when they work in the manner described, are engaged in artistic creation; a creative artist is one who is able to achieve artistic creation, and a creative work of art is one that results from artistic creation. Tomas claims that although we judge a poem or painting to be a creative work on the basis of qualities of the work itself, such a judgment is possible because the work reveals features of the activity that produced it.

So far, then, Tomas has set forth two conditions an activity must satisfy to be artistic creation: (1) the artist does not envisage the final result of his work, but (2) the artist exercises "critical control." The first condition, I think, contains a conceptual truth-that if someone knows just what the product of his labors will be, then that product is, in a sense, already created. I'll have more to say about this later. For the present, though, I want to point out only that this first condition does not distinguish the artist who is creative from the one who is not. Tomas allows that a sculptor might know exactly what his sculpture will look like before he begins to work his material, and might even hire someone else to execute his plan. Tomas says that in such a case the creative act is finished: it is the production of the idea, and all that remains is to "objectify the idea" in some material-a matter of skill or work. But for any artist at work, either he does not envisage the result, in which case his activity fulfills one of the conditions of artistic creation, or else he does envisage the result, in which case he may be objectifying an idea that is the product of a creative act, and so in this case too he may have been creative.

Tomas's second condition raises difficulties, for artists at times produce a work in a single unreflective outpouring of energy. Tomas considers what is supposedly such a case—Nietzsche's writing of *Thus Spake Zarathustra*.

Even if Nietzsche didn't deliberately change a thing, even if all came out just right from the very first line, was there not a relatively cool hour when Nietzsche (and the same goes for Coleridge and *Kubla Khan*) read what he had written and judged it to be an adequate expression of his thought? . . . If there was such a cool hour and such a critical judgment in Nietzsche's case, this is all that is needed to have made him create *Zarathustra* on the view of creation presented above.⁸

Undoubtedly there was a cool moment when Nietzsche and Coleridge looked over their work, but that was after the work was created. According to Tomas, had either Nietzsche or Coleridge not looked over his work after it was finished it would not be a creative work, but since he did look it over it is a creative work. This is paradoxical: the work is the same in either case. And think of a jazz musician improvizing a performance; whether he later happens to judge it adequate after listening to a recording seems totally irrelevant to whether his performance was creative. At any rate, if critical control can amount to no more than looking over the work,

it is certainly an easy condition for any artist, creative or not, to fulfill, but it hardly seems necessary.

Tomas sees one other essential factor in artistic creation-inspiration.

In the creative process, two moments may be distinguished, the moment of inspiration, when the new suggestion appears in consciousness, and the moment of development or elaboration. The moment of inspiration is sometimes accompanied by exalted feelings.⁹

Inspiration seems to be the sort of thing Morgan called the "aha!" phenomenon; in fact, it becomes quite clear at this point that Tomas's theory is simply a more elaborate version of the Creative-Process theory. Tomas introduces the notion of inspiration to explain the "critical control" in creative activity.

Whenever the artist goes wrong, he feels himself being kicked, and tries another way which, he surmises, trusts, or hopes, will not be followed by a kick. What is kicking him is "inspiration," which is already there. What he makes must be adequate to his inspiration. If it isn't, he feels a kick.¹⁰

Tomas comments: "admittedly, the concept of inspiration we have been making use of is in need of clarification."¹¹ I agree. Ordinarily there is no distinction between a good inspiration and a poor one: to say an idea is an inspiration is to say it is a good idea or the right idea; if the idea is a poor one, it is not called an inspiration. But then there can be no characterization of inspiration in terms of the agent's feelings, for on that basis alone one cannot differentiate having an inspiration and having what *seems* to be an inspiration. It is likely that an artist might think he is being creative when he is not. Tomas says that "whenever the artist goes wrong, he feels himself being kicked." Maybe some artists feel such a kick when they *think* they have gone wrong, but surely there have been a lot of kickless goings wrong in the history of artistic activity. Each of two artists may work in the way Tomas describes, each having feelings of inspiration, each critically controlling his work according to the "kicks" he feels, yet one artist may be creative and the other not be creative at all.

The three conditions of artistic creation that Tomas lays down—not envisaging the result, exercising critical control, and undergoing feelings of inspiration—do not help to distinguish the creative artist from the uncreative one. In what follows, I will try to show that the Creative-Process theory rests on a fundamental misconception about creating.

Tomas realizes that "in discourse about art, we use 'creative' in an honorific sense, in a sense in which creative activity always issues in something that is different in an interesting, important, fruitful, or other *valuable* way."¹² This I think is correct and crucially important. It is precisely because we do not call an activity creative unless its product is new and valuable that no characterization of creating simply in terms of the artist's actions, thoughts, and feelings can be adequate, for such a characterization cannot distinguish activity that results in a valuably new product from that which does not. Let's take a closer look, then, at what it is that one "does" when one is creative.

In the arts one might create by composing music, writing, painting—i.e. we might say that someone was not only painting but also creating, or not only writing but also creating. It is not that he is doing two things at the same time. If we say that someone is doing two things at the same time riding a bicycle and viewing the countryside, for example, or reading and drinking coffee—we can imagine our subject doing one of these things without the other. Creating, however, is not an isolable activity. The creator cannot be just creating; he has to be doing something we could describe as writing, painting, composing, or whatever. One does not always create when one paints, writes, or composes; these are means by which one might create. A number of activities sometimes qualify as "creating."

To know whether someone has created, we have to see (or be told about) the results of his work. And the creator himself knows he has created only by seeing what he has done. It is unusual to say "I am creating"; "create" is seldom used in the continuous present tense. I suppose we can imagine a painter, say, who after a bit of especially satisfying work exclaims "I am creating!" but in such a case the creating is not something he is doing at the moment, it is something he has done. If we ask "How do you know you're creating?" he might answer "Just look at what I've painted." Notice that it makes sense to ask "How do you know you're creating?" whereas it would be silly to ask "How do you know you're painting?" Similarly one might be surprised that he has created, but not surprised that he has painted. We say an activity such as painting, writing, or composing is creating if it achieves new and valuable results; no specific isolable activity *creating* corresponds to the verb "create" as painting corresponds to the verb

These considerations suggest that "create" is one of that class of verbs Gilbert Ryle has labeled "achievement verbs." The verb "win," for example, signifies not an activity but an achievement. Winning a race requires some sort of activity, such as running, but winning is itself not an activity.

One big difference between the logical force of a task verb and that of a corresponding achievement verb is that in applying an achievement verb we are asserting that some state of affairs obtains over and above that which consists in the performance, if any, of the subservient task

activity. For a runner to win, not only must he run but also his rivals must be at the tape later than he; for a doctor to effect a cure, his patient must both be treated and be well again . . . An autobiographical account of the agent's exertions and feelings does not by itself tell whether he has brought off what he was trying to bring off.¹³

For a painter, composer or writer to create, not only must he paint, compose or write, he also must achieve new and valuable results; therefore, no description of just the artist's "exertions and feelings" will tell us whether he has created.

If creating were a specific process or activity we would expect that one could decide to create. But artists often try unsuccessfully to create. Given the technical knowledge, one can decide to write, paint or compose, but not create.

If creating were a specific process or activity we would expect the possibility of error. It is easy to *make* something *wrong*. But one cannot create something wrong; either one creates or one does not. But just as winning is not an infallible kind of running, creating is not an infallible kind of making; it is an achievement.

To say that someone created x is often to say that x was, upon being produced, absolutely new-i.e. new to everyone. To say that someone has been creative, though, is to say that the product is new to the agent. Someone may be creative in solving a math problem, for example, if he devises a solution more elegant and ingenious than the standard way of solving such a problem, even though others may have devised the same solution before. I do not think, though, that ordinary usage supports a hard and fast distinction between creating, implying the product is new to everyone, and being creative, implying the product is new to the agent. One might say, "Horticulturist A thought he had created a new hybrid, but B had developed the same hybrid years before." But one might as well say, "A and B, independently, both created the same hybrid." In neither case, though, is there any implication that A was less creative than B. To say, then, that someone created x, or that in producing x someone was being creative, is to imply that x was new to the agent. As Kennick points out, if a contemporary of Cézanne working in Siberia and wholly unacquainted with what was going on elsewhere in the art world, produced canvases just like the late canvases of Cézanne, we would have no reason not to describe his work as creative.

Judgments of creativity are implicitly comparative, like saying that a man is tall or short. But the comparison is not unrestricted. A work of art is creative only in comparison with works with which it is properly comparable, i.e. with what the artist might reasonably be expected to have been acquainted with.¹⁴

Although whether we ascribe the verb "create" depends on the product, not on the activity that produced it, it does not follow that the praise conferred by "create" and "creative" applies only to the product; but in saying that the agent is creative, one is praising him for what he has accomplished, not for having gone through some special process in accomplishing it. This brings us to a crucial difference between the consequences of my view and those of a theory such as Tomas's for answering the following three questions: (1) What characterizes an artist as creative? (2) What characterizes a poem, painting or other work as a creative work? and (3) What characterizes an activity as artistic creation? For Tomas, the third question is primary, and the first two are answered in terms of its answer. On my view the answer to all three depends on the product; it is the product that determines whether we call the activity creating, and also whether we call the agent and the work creative.

The Creative-Process theory has been the dominant theory of creativity during the last half century, and it is hardly surprising that it has been the dominant theory of *artistic* creation, since as such it is a variation on a main theme in the expression theory of art, which because of the influence of Croce, Collingwood, Dewey, and others, has been the dominant theory of art. As the expression theory is usually formulated, good art, or "art proper," comes about only as the result of a certain sort of process—"artistic expression." But as critics of the expression theory have emphasized, an examination of the process is irrelevant to an evaluation of the product.¹⁵ This, essentially, has been my criticism of the Creative-Process theory. "Creative" is a term of praise, but there is no specific sort of activity necessary or sufficient for producing things of value.

Tomas argued that we judge a work of art to be creative on the basis of properties of the work itself, but only because we take those properties as evidence that the creator went through a certain sort of process. I think Kennick is correct, though, in insisting that we do nothing of the kind. Rather,

we determine whether a work of art is creative by looking at the work and by comparing it with previously produced works of art in the same or in the nearest comparable medium or genre . . .

Anyone can tell at a glance whether two paintings or two poems are different, but not just anyone can tell at a glance which of two paintings or poems is the more creative. To tell this, one must be acquainted with properly comparable works of art and be able to appreciate the aesthetic significance of any artistic innovation, see how it enlarges the range of viable artistic alternatives and thereby "places" what has already been done by putting it, so to speak, in a new light.¹⁶

It might be objected that Kennick's view, which I am endorsing, confuses *evidence* of creativity with what it *means* to say that someone is creative. But the answer to this objection is clear, I think, when we realize that "create" is an achievement verb and so applies only when something besides the performance of some action is the case. Although a patient's recovering his health is evidence that the doctor cured him, it is also the criterion for ascribing the verb "cure" to what the doctor did. To cure someone *means* to make him well as a result of treatment. I suppose that in some sense a valuably new artwork is "evidence" of creativity, but more than that, we apply the verb "create" only when the results are new and valuable, since creating *means* producing what is valuably new.

Tomas considers the possibility that being creative is simply producing what is valuably new, but he dismisses that possibility with the following argument.

Do we want to mean by creation in art *merely* the production of a work that not only is different but is different in a valuable way? In that case, it would follow that a computer would be no less creative than Beethoven was, if it produced a symphony as original and as great as one of his, or that a monkey could conceivably paint pictures which were no less works of creative art than Picasso's . . . So conceived, artistic creation is not necessarily an action, in the sense of this word that involves intention and critical control, and the traditional distinction between action and mere movement is obliterated.¹⁷

Concerning Tomas's claim that if monkeys and machines create works of art, then "[1] artistic creation is not necessarily an action . . . and [2] the traditional distinction between action and mere movement is obliterated," the first conjunct of the conclusion seems to follow from the premise, but the second one does not. If machines can create artworks then it seems true that artistic creation is not necessarily an action, but it does not follow that there is no distinction between action and mere movement.

But more to the point, to say that someone is creative is to say that he is creative in some specific way. There are creative painters, creative teachers, creative businessmen, creative mathematicians. We might say of someone creative in a number of ways that he is a creative person, or creative in general, but we can in such instances enumerate the various ways in which he is creative.

Now can a monkey be as creative as Picasso? The proper reply is "As creative a *what* as Picasso?" As creative an *artist*? Only if it is allowed that a monkey can be an artist. Similarly, if we are to make any sense of the question "Is a monkey at a typewriter who produces a sonnet identical with

one of Shakespeare's as creative as Shakespeare?" it must mean "Is the monkey as creative a *poet* as Shakespeare?" and the answer is clearly No unless it is allowed that a monkey can be a poet. I would think that being a poet at least encompasses (1) knowing a language, and (2) producing and/or selecting an arrangement of "sentences" of that language as meant to be taken in a certain way: hence a monkey cannot be a poet.¹⁸ I am not concerned to argue this point here however. I am concerned only to make clear that on the view I am advancing *if* one allows that a monkey can be an artist or poet, then it is in principle possible for a monkey to be as creative an artists or poets, then neither can they be creative artists or creative poets, no matter what they produce. The same argument applies *mutatis mutandis* to machine behavior.

I think the problem that Tomas raises here is not so much a problem about creativity as about art—whether what is produced by monkey or machine can properly be called art. If it can, then no doubt some such artworks and "artists" are more creative than others. Even if monkeys are not creative *artists*, however, it doesn't follow that it would never make sense to say that a monkey was creative. After all, ascriptions of creativity implicitly compare what's been created to other things of similar kind and provenance. To say that little Johnny is creative is perhaps to say that *for a five-year-old* he is creative, and it is not to compare him with Picasso. Similarly one might want to say that Bonzo is more creative than the other chimps if he does paintings with a far greater variety of colors and configurations. But to say this would be only to say that he is a more creative *chimp;* it is not to put him in a class with Picasso, or even with little Johnny.

II. To construe creating, as many have, as a kind of making, is to overlook crucial differences between the concepts *making* and *creating*. Consider the following examples of "make" and "create" in sentences with the same direct object.

> The chef made a new soup today. The chef created a new soup today.

The seamstress made a new dress. The fashion designer created a new dress.

Although the same noun occurs as direct object in both sentences of each pair, with "make" the noun designates a particular thing, but with "create" the noun is generic. If the chef created a new soup, he created a new kind of soup, a new recipe; he may not have made the soup. But if we say "He made a new soup today," "soup" refers to some particular pot of soup he

prepared. The seamstress made some particular dress, but the fashion designer created a new design.¹⁹ Particulars are made, types created.

Suppose a potter makes a vase and creates a new design on the surface. It may seem that the design is a particular thing, but what was created is a particular design only in that it is a particular type of design. If I say he created a new design. I do not mean that what he created are just those lines he put on the surface of the vase. Suppose I make a thousand copies of that vase; I could then show the potter any of the copies and ask, "Did you create the design on this vase?" The answer in all cases would be Yes. The answer would be No if I asked, "Did you make the design on this vase?" With "make," "design" refers to an individual; with "create," "design" refers to a type. The use of "create" or "make"-one word rather than the other-does not indicate a different sort of process, but a different sort of product (individual or type). Someone might in the same process both make a design (individual) and also thereby create a design (type). When we talk about what is created we are not primarily concerned with some particular individual object and its fabrication, rather we are concerned primarily with the idea, conception, or design that that individual object embodies. If I serve you a dish and say it was created by Brillat-Savarin, I do not mean that he has been resurrected and put to work in my kitchen; he developed the recipe.

At this point it might be objected that the choice between "create" and "make" does not always indicate a different sort of object: we do not distinguish the kind of "product" (individual or type) when, for example, we say, "He created a disturbance" rather than, "He made a disturbance." True, but I am concerned only with creating that is creative. One can create all sorts of things; before lighting a fire in the fireplace, we heat the chimney to create a draft: we can create a disturbance, or create a nuisance; we create difficulties, impressions, opinion. If someone creates a certain impression, it is no reason to call him creative; he may create the impression of himself that he is uncreative. If someone creates a draft, or a menace, or difficulties, or a stir, it is usually no reason to call him creative. But if a chef creates a new dish, a businessman creates a new way of merchandising, or a painter creates a work of art, these often are reasons to call that person creative. My remarks about the verb "create" (here and elsewhere in this paper) apply only to cases in which the adjective form "creative" is also applicable; this is the use of "create" which, like "creative," is honorific. The object of "create" when the creating is non-creative is some specific state of affairs rather than some new conception.

I said earlier that there is a conceptual truth contained in Tomas's claim that in creative activity the artist does not envisage the final result of his work. I have argued similarly that creating is producing what is new to the agent. Also when we consider that what is of primary importance in talk of creativity is not the fabrication of some particular object but rather the idea or conception it embodies, this explains Tomas's example of the sculptor. It is now commonplace for sculptors to send the plans for their sculptures to foundries to be executed; in such a case, the sculptor is clearly the creator of the artwork though the foundry makes the work. In the analogous case of an artist who is executing his work himself from a finished plan, the creative part of the work is done, as Tomas says, and what remains is to objectify the idea. (But of course it is not *only* in being creative that one does not forsee the product of one's efforts.)

An issue that's been debated recently is whether natural objects, such as pieces of driftwood, can be works of art. If they can, a curious question arises: who is the creator of such artworks? When Morris Weitz argued in an oft-quoted passage that a piece of driftwood could be a sculpture, and Joseph Margolis vigorously denied this, they put the issue this way: is being an artifact a necessary condition of something's being a work of art?²⁰ But what really seems at issue in their dispute is whether a work of art must have been made by someone and that is another matter. I will now argue that although (1) being an artifact *is* a necessary condition of something's being a work of art, (2) there is no conclusive reason to insist that a work of art must have been made by someone, and so (3) an artist may create a work of art that no one has made.

Most often the term "artifact" is used to refer to an object of archeological or historical interest, such as an ornament, weapon or utensil; obviously something need not be an artifact in this sense, a relic of some defunct culture, before it can be considered a work of art. But "artifact" is used also to refer to contemporary objects; without stretching the term one can speak of automobile hubcaps and plastic dishes as artifacts of our present-day culture. Practically any sort of alteration of the material environment might count as an artifact-a pile of rocks serving as a marker, for example, or a circle of trees planted to demarcate a certain area. Also a single natural object can be an artifact if it has been invested with some important function. Suppose that a stick-one that has not been materially altered, has not been carved or smoothed by any one-takes on magical significance in some culture. The stick, let's suppose, is believed by everyone in the culture to have certain magical properties; it may be handled only by the high priest, and by him only in accordance with certain rituals. Surely such a stick would count as an artifact of that culture; one can easily imagine it, if its use were known, on display centuries later along with the bowls, spears and jewelry of that culture.

Now let's take a hypothetical case. Suppose an artist exhibits pieces of driftwood; perhaps the gallery announces a new conception *Beach Art*. The pieces of driftwood are materially unaltered—i.e. they have not been sanded, smoothed, carved, or re-shaped by anyone. Suppose further that

this exhibit is warmly accepted by the artworld, and so the pieces of driftwood acquire the status of artworks. The very fact that the pieces of driftwood would have acquired the status of artworks in our culture would qualify them as artifacts of our culture; i.e. any object accepted as a work of art in our culture would thereby automatically qualify as an artifact of our culture. And since being a work of art of a culture is a *sufficient* condition of something's being an artifact of that culture, it follows that being an artifact is a *necessary* condition of something's being a work of art, a *logically* necessary condition though. Just as the stick's being a magic wand would qualify it as an artifact of its culture. The argument so far, then, is that being an artifact is a *logically* necessary condition of something's being a work of art. The question that remains is: can a piece of driftwood (or some other natural object) qualify as an artwork?

As was mentioned earlier, an artist need not *make* the work of art he creates. A sculptor might send the plans for a steel sculpture to a foundry there to be fabricated, and in various other ways an artist may have other craftsmen execute the work of art he creates. What is central to the notion of creating something is the new design, idea, or conception, not fabrication; most often one creates a work of art in the process of executing it, but this is not necessary.

But the artist need not even design the art object. Duchamp displayed as art a urinal and entitled it *Fountain:* he did not make the object nor did he design it, yet he created the artwork *Fountain*. Among Duchamp's other "readymades" was a bottlerack, which became an artwork appropriately entitled *Bottlerack;* it is acknowledged by many as an artwork, and as one *created* by Duchamp. So in many cases the creator of a work of art has not fabricated the art object, and in other cases the artist has not only not made the art object, he has not designed it either. And if the artist need not have made and need not even have designed the art object, then I see no conclusive conceptual block to allowing that the artwork be a natural object.

As far as I know, neither pieces of driftwood nor other natural objects are now universally accepted as artworks. So besides separating the question of artifactuality from that of whether an artwork need have been made, what I have been arguing is that there is no conceptual absurdity in the idea of a work of art created by someone but made by no one. There are not sufficient grounds for ruling *a priori* that pieces of driftwood or other natural objects cannot be works of art, and if they are accepted as such, they would not be that much different from objects already widely accepted as artworks. Already we have artworks that were neither made nor designed by the artist who created them.

The direction of the present argument has been influenced by Arthur Danto's paper "The Artworld." Also influenced by Danto's argument that

"to see something as art requires something the eye cannot decry—an atmosphere of artistic theory, a knowledge of the history of art: an artworld,"²¹ George Dickie has argued that art's institutional setting makes possible a definition of art in terms of necessary and sufficient conditions. Dickie argues that a work of art can be defined as "1) an artifact 2) upon which some person or persons acting on behalf of a certain social institution (the artworld) has conferred the status of candidate for appreciation."²² This is not the place to discuss Dickie's theory in detail, but in order to raise some pertinent issues I'll briefly register some doubts about it.

First, for the reasons given above the condition of artifactuality seems to me superfluous. Also, it is doubtful that the definition sets forth conditions sufficient for something's being a work of art. Consider the tools, tableware, textiles, office equipment, and other functional objects in the Museum of Modern Art's Design Collection. Arthur Drexler, director of the department, says that "an object is chosen for its quality because it is thought to achieve, or to have originated, those formal ideals of beauty which have become the major stylistic concepts of our time. . . . It applies to objects not necessarily works of art but which, nevertheless, have contributed importantly to the development of design."23 Here we have objects -not necessarily works of art-upon which someone acting in behalf of the artworld has conferred the status of candidate for appreciation. And granting what Danto says, that to see something as a work of art-or, at least, that to see some things as works of art-requires an atmosphere of artistic theory, it doesn't follow, given such an atmosphere, that even in the artworld everyone will see it as art. The artworld is not monolithic. Some painters and sculptors still balk at calling pieces of driftwood works of art. Their hesitation to call such objects works of art does not stem from a reluctance to value such objects: no matter how exquisite such objects may be, they would say, they are no more works of art than is a magnificent sunset. They know, moreover, the intent with which such objects have been proffered as art, they understand fully the theory of *objets trouvés*; their reluctance to call such objects works of art is their reluctance to accept that theory. For them the theory does not establish a sufficiently strong link between found natural objects and the body of acknowledged works of art so that they are willing to classify the natural objects as artworks. I do not wish to discuss the question how widely accepted as art an object must be before it can be said unequivocally to be art. I am not even sure that that is the right question to raise. I want only to register a doubt about Dickie's claim that anything proffered as art is to be classified unequivocally as art no matter the extent of its acceptance. Nowadays it would be simply false to claim that a Jackson Pollock painting is not a work of art; similarly, I think, with Duchamp's readymades. And perhaps not even pieces of driftwood are a borderline case, although I think they are. In any case,

the driftwood dispute is illuminating because it shows that although on Danto's view anything might become a work of art, that doesn't mean *any*-*thing goes:* rational argument has a place in formulating and assessing the theory that would extend the concept of art to some new kind of object.

In mentioning Duchamp's readymades I claimed that although Duchamp did not make or design the bottlerack, he created the artwork Bottlerack. He brought into existence a new work of art (although he did not make a new object). It might be objected that if an art museum director decides to put on display a collection of, say, bottles, or doorknobs or shopping bags, objects not generally considered works of art, and they come to be generally considered artworks, it is not the museum director who is credited as the artist who created them, rather it is the person who designed the objects. And if, in general, the person responsible for bringing about acceptance of x as an artwork is not considered the artist who created x, why should we say it is Duchamp, and not the person who designed the bottlerack, who created Bottlerack? But there is a difference between the two cases: Duchamp is creating art and the museum director is only displaying it. Presumably when the museum director decides to put on display doorknobs, shopping bags, or whatever, his gesture is one of calling attention to objects he considers to be already works of art, but ones that have gone unrecognized. But Duchamp and subsequent artists who have transformed mere objects into artworks by signing their names to them have not supposed that there were all these objects, already artworks, lying around unnoticed; they have created those objects artworks. (I purposely choose this locution to parallel the locution "The Monarch created him an Earl.") (I am not, by the way, assuming that all such creatings are creative.)

The Duchamp case I think supports Danto's contention that "it is the role of artistic theories, these days as always, to make the artworld, and art, possible."²⁴ It is not the case, as I take Dickie to be saying, that it is simply the right institutional setting that confers the status "work of art," but rather it is, as Danto emphasizes, the artistic theory which relates the new object to the existing body of acknowledged artworks. And, I would think, it is because of the specific theory in the context of which Duchamp's readymades appeared that they are artworks.

In writing about the Museum of Modern Art's mammoth Duchamp retrospective, Harold Rosenberg points out that "since their first public appearance, [Duchamp's] creations have possessed an inherent capacity to stir up conflict. Sixty years ago, he entered the art world by splitting it, and he still stands in the cleft."²⁵ "[H]e remains the primary target to those critics and artists whose interest lies in restoring art to a 'normal' continuity with the masterpieces of the past."²⁶ Rosenberg then sketches the case against Duchamp, one argument of which is the following. In adopting the ready-made, Duchamp has introduced the deadly rival of artistic creation—an object fabricated by machine and available everywhere, an object chosen, as he put it, on the basis of pure "visual indifference," in order to "reduce the idea of aesthetic consideration to the choice of the mind, not the ability of cleverness of the hand." In the world of the ready-made, anything can become a work of art through being signed by an artist . . . The title "artist," no longer conferred in recognition of skill in conception and execution, is achieved by means of publicity.²⁷

To repeat a point I've already belabored, skill in execution cannot be considered necessary for artistic creation since works of art are so often not executed by their creators. To exclude readymades on that account would entail excluding too much else. And ingenuity, wit, and insight of conception are not necessarily excluded either. Just as some artworks of great technical skill embody the most banal conceptions and others, brilliant conceptions, is there not a range of conceptual skill exhibited in readymades, *objets trovés*, and works of conceptual art? Such art does exclude "ability or cleverness of the hand," but it does not on that account preclude artistic creation.

Notes

1. A shorter version of this paper was read at the 8th National Conference of the British Society of Aesthetics, Sept. 22, 1973. The present essay contains portions of my "Art and Artifactuality," *Proceedings* of the VIIth International Congress of Aesthetics; it also contains portions of "On Creating,"—some comments on W. E. Kennick's "Creative Acts," that were both printed in Kiefer & Munitz, eds., *Perspectives in Education, Religion, and the Arts* (Albany 1970). The argument of the present essay parallels to some extent the argument of D. Henze's "Logic, Creativity and Arts," *Australasian Journal of Philosophy*, Vol. XL (1962). See also D. Brook and M. Wright, "Henze on Logic, Creativity and Art," *Australasian Journal of Philosophy*, Vol. XLI (1963), and Henze's rejoinder in that journal, Vol. XLII (1964). So many people have given me helpful criticisms and advice on successive drafts of this paper that I cannot hope to list them all. I am very grateful for their help; I hope they will forgive my not trying to name them all here.

2. D. N. Morgan, "Creativity Today," Journal of Aesthetics and Art Criticism, Vol. XII (1953), 14.

3. Ibid., p. 12.

4. In his Introduction to V. Tomas, ed., *Creativity in the Arts* (Englewood Cliffs, 1964), p. 2.

5. V. Tomas, "Creativity in Art," ibid., p. 98.

6. Ibid., p. 98.

7. Ibid., p. 99f.

8. Ibid., p. 106.

9. Ibid., p. 104.

10. Ibid., p. 108.

11. *Ibid.* The sort of thing that Tomas is talking about is clarified by Beardsley in his development of Tomas's theory. See M. C. Beardsley "On the Creation of Art," *Journal of Aesthetics and Art Criticism* (1965).

12. Tomas, "Creativity in Art," p. 100.

13. G. Ryle, The Concept of Mind (New York, 1950), p. 150.

14. In W. E. Kennick, ed., Art and Philosophy (New York, 1964), p. 376.

15. See, e.g., J. Hospers "The Croce-Collingwood Theory of Art," *Philosophy*, Vol. XXXI (1956).

16. W. E. Kennick, "Creative Acts," op. cit., p. 225.

17. Tomas, Introduction, p. 3.

18. Whether a monkey can do these things is of course an empirical question. Current experiments in teaching language to chimps may, for all we know, result in some chimp poetry.

19. This distinction is nicely observed in a recent television commercial for sewing machines. The camera takes us to the workroom of a fashion designer who tells us: "I depend on my machines to make the things I create."

20. "None of the criteria of recognition is a defining one, either necessary or sufficient, because we can sometimes assert of something that it is a work of art and go on to deny one of these conditions, even the one which has traditionally been taken to be basic, namely that of being an artifact: Consider, 'This piece of driftwood is a lovely piece of sculpture.'" [M. Weitz, "The Role of Theory in Aesthetics," repr. in J. Margolis, *Philosophy Looks at the Arts* (New York, 1962), p. 57]. What he says is surely *false*. If anyone were pressed to explain the remark, he would of course say that the driftwood looks very much like a sculpture, that it is as if nature were a sculpture, that we could imagine the driftwood actually fashioned by a human sculptor. In making such a remark, we hardly wish to deny what *is* a necessary condition for an object's being an artifact." J. Margolis, *The Language of Art and Art Criticism* (Detroit, 1965), p. 40.

21. A. Danto, "The Artworld." [Ed.—"The Artworld" originally appeared in *The Journal of Philosophy*, LXI (1964), 571–584.]

22. G. Dickie, Aesthetics (Pegasus, 1971), p. 101.

23. Quoted by A. L. Huxtable in "Moma's Immortal Pots and Pans," New York Times Magazine, Oct. 6, 1974, p. 74.

24. Danto, loc. cit.

25. H. Rosenberg, "The Art World," The New Yorker, Feb. 18, 1974, p. 86.

26. Ibid., p. 88.

27. Ibid.

Bibliography to Part Three

Some relatively early discussions of the definition of a work of art include:

- Monroe C. Beardsley, "The Definition of the Arts," Journal of Aesthetics and Art Criticism, XX (1961), 175-187;
- Margaret Macdonald, "Art and Imagination," Proceedings of the Aristotelian Society, LIII (1952-1953);
- Joseph Margolis, "Mr. Weitz and the Definition of Art," *Philosophical Studies*, IX (1958), 88–94;
- Douglas N. Morgan, "Art Pure and Simple," Journal of Aesthetics and Art Criticism, XX (1961), 187-195;
- Mary Mothersill, "Critical Comments," Journal of Aesthetics and Art Criticism, XX (1961), 195–198; comments on Beardsley and Morgan (above) in a joint symposium;
- C. L. Stevenson, "On 'What is a Poem?,' " Philosophical Review, LXVI (1957), 329-362;
- Paul Ziff, "The Task of Defining a Work of Art," *Philosophical Review*, LXIII (1953), 68-78.

Some more recent discussions of the definition of a work of art moving along rather different lines, include:

Monroe C. Beardsley, "Is Art Essentially Institutional?," in Lars Aagaard-Mogensen (ed.), Culture and Art (Nyborg and Atlantic Highlands, 1976);

James D. Carney, "Defining Art," British Journal of Aesthetics, XV (1975), 191-207;

- Ted Cohen, "The Possibility of Art: Remarks on a Proposal by Dickie," *Philosophical Review*, LXXXII (1973), 69-82;
- George Dickie, "Defining Art II," in Matthew Lipman (ed.), Contemporary Aesthetics (Boston, 1973);
- George Dickie, Art and the Aesthetic; An Institutional Analysis (Ithaca: 1974);
- Gary Iseminger, "Appreciation, the Artworld, and the Aesthetic," in Lars Aagaard-Mogensen (ed.), *Culture and Art* (Nyborg and Atlantic Highlands, 1976);

Bibliography

- Colin Lyas, "Danto and Dickie on Art," in Lars Aagaard-Mogensen (ed.), Culture and Art (Nyborg and Atlantic Highlands, 1976);
- M. H. Mitias, "Art as a Social Institution," Personalist, LVI (1975), 330-335;
- Richard J. Sclafani, "Art as a Social Institution: Dickie's New Definition," Journal of Aesthetics and Art Criticism, XXXII (1973), 111-114;
- Richard J. Sclafani, "The Logical Primitiveness of the Concept of a Work of Art," British Journal of Aesthetics, XV (1975), 14-28;
- Jeanne Wacker, "Particular Works of Art," Mind, LIX (1960), 223-233;
- Morris Weitz, "Can 'Art' Be Defined?" in Morris Weitz (ed.), Problems In Aesthetics (New York, 1970).
- Paul Ziff, "Art and the 'Object of Art,' " reprinted in William Elton (ed.), Aesthetics and Language (Oxford, 1954).

Some of these papers bear more on characterizing art institutionally than on definition in the narrow sense.

Reference may also be made, for the general philosophical setting for all these papers (including Weitz's), to:

- Ludwig Wittgenstein, *Philosophical Investigations*, trans. by G. E. M. Anscombe (New York, 1953), I, pars. 65-67.
- A much-discussed account of Wittgenstein's thesis may be found in: Maurice Mandelbaum, "Family Resemblances and Generalization Concerning the Arts," American Philosophical Quarterly, II (1965), 219-228.

Other related discussions include:

- Haig Khatchadourian, "Family Resemblances and the Classification of Works of Art," *Journal of Aesthetics and Art Criticism*, XXVIII (1969), 79–90;
 Haig Khatchadourian, *The Concept of Art* (New York, 1971);
 - Anthony R. Manser, "Games and Family Resemblances," *Philosophy*, XLII (1967), 210-225;
 - Richard Sclafani, "'Art,' Wittgenstein, and Open-textured Concepts," Journal of Aesthetics and Art Criticism, XXIX (1970), 333-341.

An entirely different but increasingly influential account of definition, applicable to art but not focused on it, is provided in:

Hilary Putnam, Collected Papers, Vol. 2 (Cambridge, 1975), particularly. "Is Semantics Possible?" and "The Meaning of 'Meaning."

- Related papers, concerned with the individuation of works of art, include: Monroe C. Beardsley, *Aesthetics* (New York, 1958), Ch. 1;
 - Donald Henze, "Is the Work of Art a Construct?" Journal of Philosophy, LII (1955), 433-439;
 - Margaret Macdonald, "Some Distinctive Features of Arguments Used in Criticism of the Arts," reprinted (revised) in William Elton (ed.), Aesthetics and Language (Oxford, 1954);

Joseph Margolis, "The Identity of a Work of Art," Mind, LXVII (1959), 34-50;

Stephen Pepper, "Further Considerations on the Aesthetic Work of Art," Journal of Philosophy, XLIX (1952), 274-279.

On issues particularly concerned with Nelson Goodman's views about the identity and individuation of works of art, see:

Joseph Margolis, "Art as Language," *The Monist*, LVIII (1974), 175–186; Alan Tormey, "Interdeterminacy and Identity in Art," *The Monist*, LVIII (1974), 203–213;

William E. Webster, "Music is Not a 'Notational System'", Journal of Aesthetics and Art Criticism, XXIX (1970), 489-497.

Clearly, the issue of the definition and individuation of art cannot be easily separated from the ontology of art. The bibliography and selections for Part Four, therefore, are particularly pertinent.

Part Four The Ontology of Art

Theorizing about what kind of entity a work of art is cannot but be initially baffling. If, on the one hand, we insist that it is some sort of selfcontained entity that exists independently of being appreciated, we have difficulty accommodating literature at least. If, on the other, we insist that a work of art exists only insofar as an aesthetic percipient interacts with some other object-an object less than the work of art that emerges from the putative interaction-we have difficulty fixing a work of art as a public object that may attract critical exchange capable of a measure of objectivity (see Part One). Some works of art, notably in the plastic arts, either are or are quite closely linked to physical objects-or so it seems; and other art works-notably where notations are readily accessible, as in music, literature, drama-seem hardly to be physical objects at all. In some of the arts, we are inclined to think that particular works are uniquely manifested, paintings for instance, or medieval cathedrals-though the qualification suggests a mere contingency. In other of the arts, etchings and music for instance, we are quite prepared to speak of particular printings of the same etching and particular performances of the same sonata. Hence, we are tempted to think that some works of art are particular objects and that some are not particulars of any sort at all. Finally, in this regard, there is good reason to think that the metaphysical peculiarities of art are bound to be matched by every other kind of entity that can be distinguished in the context of human culture-persons, for instance, or words and sentences, even actions of an institutionalized sort. So the ontology of art promises to be a peculiarly strategic inquiry, in terms of which, briefly, the relationship between human culture and physical nature may be perspicuously sketched.

Broadly speaking, the central issues tend to cluster around the question of how to identify and reidentify a particular work of art and around the question of how to specify the nature of the entity thus identified. These questions are not entirely separable, of course, because a favored answer to one will affect the eligibility of answers to the other. And the answers to either are bound to reflect larger strategies concerning a comprehensive philosophy. Thus, for example, an adherence to materialism is likely to encourage the view that works of art are physical objects or at least intimately "associated" in some way with physical objects. The difficulty of maintaining that thesis may incline one toward a form of idealism or at least to an idealistically skewed account; and with that may come support for the claim that works of art are actually not particulars at all, but universals.

There is no tightly linear history of the theory of art. Nevertheless, one can excerpt the views of a number of leading contemporary discussants about the ontology of art that yield a strong sense of continuity and of the pointed and deliberate refinement of the central questions. In this regard, though he cannot rightly be said to have written in the analytic style favored by the Anglo-American tradition, Roman Ingarden (1964) has, perhaps uniquely, provided a clear picture of the phenomenological aspects of our aesthetic interest in art and of the inescapable ontological complexities that that engenders. Ingarden appreciated the dependence of aesthetically relevant remarks on the public identification of a work of art, but he also wished to accommodate the variety of sensitive discriminations that different percipients differently placed might defensibly be led to make, on the basis (he supposed) of the somewhat schematic structure of actual art works. Ingarden was led, therefore, to think of a work of art as, somehow, the developing construction of an historically changing community of sensitive respondents. In order to fix the identity of particular works, he was attracted to the view that, although a work of art was comprised of a number of "levels" of elements, some were more fundamental than others (relative to identity) and perhaps also less amenable to the variable flowering of interpretive and appreciative responses. There is a sense in which Ingarden fixes the field to be analyzed without providing an entirely explicit and coherent analysis of the entities of the field. For we are left with the problem of the precise conditions under which works of art are actually identified and of the precise sense in which a work of art is an object of some particular kind. What one wants to know is, how can the variety of properties attributed to works of art actually be the properties of some particular thing? Ingarden indicates well enough what the range of such properties are that must be accounted for; but he does not tell us how to collect them in the ontologically relevant sense.

The papers included in Part Four attempt to sort the different kinds of art—given the rather different properties that poems, paintings, sonatas, etchings and the like exhibit—in a way that will permit us to say whether there is some general rubric that could cover all the arts and, if so, what it might be. Richard Wollheim (1968), for example, is inclined to contrast

The Ontology of Art

those arts that either involve performance or depend on notation (the two being quite closely linked, as in music, or, more ambiguously, as in literature) with those arts (chiefly, the plastic arts) that directly involve composition with physical materials. His conclusions are somewhat tentative. He cannot altogether reject a physicalist account of certain of the arts, since on his view, expressive and representational properties may be ascribed to physical objects (see Parts Five and Six); but, on the other hand, he cannot fit such a view to other of the arts and is therefore attracted to the possibility that (some) works of art are universals. What Wollheim makes clear is that the type/token distinction, explored earlier in the literature, is absolutely central to the clarification of the ontology of art. In this regard he attempts to sort out the differences between the class/member distinction, the kind/instance distinction and the type/token distinction. Ironically, it is his adherence to the phenomenological aspects of aesthetic appreciation that complicates his ontology, for it is his attention to the complexities of performance and interpretation that lead him to theorize about art works as universals. We are, however, bound to raise questions about how particular (token) works could conceivably share properties with abstract entities (types) thought somehow to be the works of art. For example, if music uses sound, then how is it that an abstract entity, a sonata, could possibly have temporal or spatial or sensory properties? And if the entities favored fail to exhibit such properties, then how can they be the works we attend to in the usual way?

Nicholas Wolterstorff (1975), in effect, presses these difficulties against Wollheim, preserving the latter's distinction between "objects" and "performances." Wolterstorff rejects the view that types and tokens can share properties, opting instead for the ingenious view that they share predicates. He therefore finds no difficulty in viewing works of art as universals, in conformity with a more general defense of his, favoring the reality of universals (in On Universals [1970]). But Wolterstorff's solution raises difficulties of its own: first of all because it is not clear how types and tokens can "share" predicates or what that entails; secondly because the special difficulties confronting Wollheim's view confront Wolterstorff's as well. In particular, Wolterstorff must face the problem of explaining how it is that works of art can be created and destroyed-even if that involves destroying a notation—as well as the problem of explaining how an abstract entity can be said to have sensory or physical properties of any sort. The puzzle persists, therefore, that, say, a sonata can be heard but heard in different performances in different places at different or the same times. How to interpret the type/token relationship still presents difficulties.

Joseph Margolis (1977) has attempted to link the problems of numerical identity and of metaphysical nature together. By insisting on the ontological distinction of culturally emergent entities—in particular, works of art—he interprets tokens as tokens-of-types and construes what is thus individuated as an "embodied" entity of a certain complex sort. There are, therefore, no types distinct from tokens that could be compared or that could be said to share either properties or predicates. Tokens simply are tokens-of-types; and reference to types is heuristically introduced solely for the purpose of facilitating the individuation of particular objects as tokens of one and the same type. Correspondingly, the notion of an embodied entity is intended to facilitate the collection of the entire range of relevant properties—both physical and intentional—that Ingarden and others have insisted may be ascribed to works of art. The solution offered is characterized as a form of non-reductive materialism and suggests something of the ontological oddity of works of art in particular and of cultural entities in general.

All of these papers, however, force us to consider whether an adequate ontology can be formulated that declines to take into consideration the special products of human culture. In this respect, the philosophy of art serves strategically as an introduction to the largest conceptual issue that confronts us all, namely, that of the relationship between physical nature and human culture. What, we want to know, must be added to our account of nature in order to accommodate the existence of persons, of works of art, of language itself?

Art and Its Objects RICHARD WOLLHEIM

4

Let us begin with the hypothesis that works of art are physical objects. I shall call this for the sake of brevity the "physical-object hypothesis." Such a hypothesis is a natural starting point: if only for the reason that it is plausible to assume that things are physical objects unless they very obviously aren't. Certain things very obviously aren't physical objects. Now though it may not be obvious that works of art are physical objects, they don't seem to belong among these other things. They don't, that is, immediately group themselves along with thoughts, or periods of history, or numbers, or mirages. Furthermore, and more substantively, this hypothesis accords with many traditional conceptions of Art and its objects and what they are.

5

Nevertheless the hypothesis that all works of art are physical objects can be challenged. For our purposes it will be useful, and instructive, to divide this challenge into two parts: the division conveniently corresponding to a division within the arts themselves. For in the case of certain arts the argument is that there is no physical object that can with any plausibility be identified as the work of art: there is no object existing in space and time (as physical objects must) that can be picked out and thought of as a piece of music or a novel. In the case of other arts—most notably painting and sculpture—the argument is that, though there are physical objects of a standard and acceptable kind that could be, indeed generally are, identified as works of art, such identifications are wrong.

From Richard Wollheim, Art and Its Objects (New York: Harper and Row, 1968), sections 4–10, 15–16, 18–20, 35–38. Reprinted by permission of the author and Harper and Row.

The first part of this challenge is, as we shall see, by far the harder to meet. However it is, fortunately, not it, but the second part of the challenge, that potentially raises such difficulties for aesthetics.

That there is a physical object that can be identified as *Ulysses* or *Der Rosenkavalier* is not a view that can long survive the demand that we should pick out or point to that object. There is, of course, the copy of *Ulysses* that is on my table before me now, there is the performance of *Der Rosenkavalier* that I will go to tonight, and both these two things may (with some latitude, it is true, in the case of the performance) be regarded as physical objects. Furthermore, a common way of referring to these objects is by saying things like "*Ulysses* is on my table," "I shall see *Rosenkavalier* tonight": from which it would be tempting (but erroneous) to conclude that *Ulysses* just is my copy of it, *Rosenkavalier* just is tonight's performance.

Tempting, but erroneous; and there are a number of very succinct ways of bringing out the error involved. For instance, it would follow that if I lost my copy of *Ulysses*, *Ulysses* would become a lost work. Again, it would follow that if the critics disliked tonight's performance of *Rosenkavalier*, then they dislike *Rosenkavalier*. Clearly neither of these inferences is acceptable.

We have here two locutions or ways of describing the facts: one in terms of works of art, the other in terms of copies, performances, etc. of works of art. Just because there are contexts in which these two locutions are interchangeable, this does not mean that there are no contexts, moreover no contexts of a substantive kind, in which they are not interchangeable. There very evidently are such contexts, and the physical-object hypothesis would seem to overlook them to its utter detriment.

7

But, it might now be maintained, of course it is absurd to identify *Ulysses* with my copy of it or *Der Rosenkavalier* with tonight's performance, but nothing follows from this of a general character about the wrongness of identifying works of art with physical objects. For what was wrong in these two cases was the actual physical object that was picked out and with which the identification was then made. The validity of the physical-object hypothesis, like that of any other hypothesis, is quite unaffected by the consequences of misapplying it.

For instance, it is obviously wrong to say that *Ulysses* is my copy of it. Nevertheless, there is a physical object, of precisely the same order of being as my copy, though significantly not called a "copy" with which such an identification would be quite correct. This object is the author's manuscript: that, in other words, which Joyce wrote when he wrote *Ulysses*.

6

On the intimate connection, which undoubtedly does exist, between a novel or a poem on the one hand and the author's manuscript on the other, I shall have something to add later. But the connection does not justify us in asserting that one just is the other. Indeed, to do so seems open to objections not all that dissimilar from those we have just been considering. The critic, for instance, who admires *Ulysses* does not necessarily admire the manuscript. Nor is the critic who has seen or handled the manuscript in a privileged position as such when it comes to judgment on the novel. And—here we have come to an objection directly parallel to that which seemed fatal to identifying *Ulysses* with my copy of it—it would be possible for the manuscript to be lost and *Ulysses* to survive. None of this can be admitted by the person who thinks that *Ulysses* and the manuscript are one and the same thing.

To this last objection someone might retort that there are cases (e.g., *Love's Labour Won*, Kleist's *Robert Guiscard*) where the manuscript is lost and the work is lost, and moreover the work is lost because the manuscript is lost. Of course there is no real argument here, since nothing more is claimed than that there are *some* cases like this. Nevertheless the retort is worth pursuing, for the significance of such cases is precisely the opposite of that intended. Instead of reinforcing, they actually diminish, the status of the manuscript is lost?, the answer is, When and only when the manuscript is unique: but then this would be true for any copy of the work were it unique.

Moreover, it is significant that in the case of *Rosenkavalier* it is not even possible to construct an argument corresponding to the one about *Ulysses*. To identify an opera or any other piece of music with the composer's holograph, which looks the corresponding thing to do, is implausible because (for instance), whereas an opera can be heard, a holograph cannot be. In consequence it is common at this stage of the argument, when music is considered, to introduce a new notion, that of the ideal performance, and then to identify the piece of music with this. There are many difficulties here: in the present context it is enough to point out that this step could not conceivably satisfy the purpose for which it was intended; that is, that of saving the physical-object hypothesis. For an ideal performance cannot be, even in the attenuated sense in which we have extended the term to ordinary performances, a physical object.

8

A final and desperate expedient to save the physical-object hypothesis is to suggest that all those works of art which cannot plausibly be identified with physical objects are identical with classes of such objects. A novel, of which there are copies, is not my or your copy but is the class of all its copies. An opera, of which there are performances, is not tonight's or last night's performance, nor even the ideal performance, but is the class of all its performances. (Of course, strictly speaking, this suggestion doesn't save the hypothesis at all: since a class of physical objects isn't necessarily, indeed is most unlikely to be, a physical object itself. But it saves something like the spirit of the hypothesis.)

However, it is not difficult to think of objections to this suggestion. Ordinarily we conceive of a novelist as writing a novel, or a composer as finishing an opera. But both these ideas imply some moment in time at which the work is complete. Now suppose (which is not unlikely) that the copies of a novel or the performances of an opera go on being produced for an indefinite period: then, on the present suggestion, there is no such moment, let alone one in their creator's lifetime. So we cannot say that *Ulysses* was written by Joyce, or that Strauss composed *Der Rosenkavalier*. Or, again, there is the problem of the unperformed symphony, or the poem of which there is not even a manuscript: in what sense can we now say that these things even *exist*?

But perhaps a more serious, certainly a more interesting, objection is that in this suggestion what is totally unexplained is why the various copies of *Ulysses* are all said to be copies of *Ulysses* and nothing else, why all the performances of *Der Rosenkavalier* are reckoned performances of that one opera. For the ordinary explanation of how we come to group copies or performances as being of this book or of that opera is by reference to something else, something other than themselves, to which they stand in some special relation. (Exactly what this other thing is, or what is the special relation in which they stand to it is, of course, something we are as yet totally unable to say.) But the effect, indeed precisely the point, of the present suggestion is to eliminate the possibility of any such reference: if a novel or opera just is its copies or its performances, then we cannot, for purposes of identification, refer from the latter to the former.

The possibility that remains is that the various particular objects, the copies or performances, are grouped as they are, not by reference to some other thing to which they are related, but in virtue of some relation that holds between them: more specifically, in virtue of resemblance.

But, in the first place, all copies of *Ulysses*, and certainly all performances of *Der Rosenkavalier*, are not perfect matches. And if it is now said that the differences do not matter, either because the various copies or performance resemble each other in all relevant respects, or because they resemble each other more than they resemble the copies or performances of any other novel or opera, neither answer is adequate. The first answer begs the issue, in that to talk of relevant respects presupposes that we know how, say, copies of *Ulysses* are grouped together: the second answer evades the issue, in that though it may tell us why we do not, say, reckon any of the performances of *Der Rosenkavalier* as performances of *Arabella*, it

gives us no indication why we do not set some of them up separately, as performances of some third opera.

Secondly, it seems strange to refer to the resemblance between the copies of *Ulysses* or the performances of *Rosenkavalier* as though this were a brute fact: a fact, moreover, which could be used to explain why they were copies or performances of what they are. It would be more natural to think of this so-called "fact" as something that itself stood in need of explanation: and, moreover, as finding its explanation in just that which it is here invoked to explain. In other words, to say that certain copies or performances are of *Ulysses* or *Rosenkavalier* because they resemble one another seems precisely to reverse the natural order of thought: the resemblance, we would think, follows from, or is to be understood in terms of, the fact that they are of the same novel or opera.

9

However, those who are ready to concede that some kinds of works of art are not physical objects will yet insist that others are. *Ulysses* and *Der Rosenkavalier* may not be physical objects, but the *Donna Velata* and Donatello's *St. George* most certainly are.

I have already suggested (section 5) that the challenge to the physicalobject hypothesis can be divided into two parts. It will be clear that I am now about to embark on the second part of the challenge: namely, that which allows that there are (some) physical objects that could conceivably be identified as works of art, but insists that it would be quite erroneous to make the identification.

(To some, such a course of action may seem superfluous. For enough has been said to disprove the physical-object hypothesis. That is true; but the argument that is to come has its intrinsic interest, and for that reason is worth developing. Those for whom the interest of all philosophical argument is essentially polemical, and who have been convinced by the preceding argument, may choose to think of that which is to follow as bearing upon a revised or weakened version of the physical-object hypothesis: namely, that some works of art are physical objects.)

10

In the Pitti there is a canvas (No. 245) 85 cm x 64 cm: in the Museo Nazionale, Florence, there is a piece of marble 209 cm high. It is with these physical objects that those who claim that the *Donna Velata* and the *St. George* are physical objects would naturally identify them.

This identification can be disputed in (roughly) one or other of two ways. It can be argued that the work of art has properties which are incompatible with certain properties that the physical object has, alternatively it can be argued that the work of art has properties which no physical object could have: in neither case could the work of art be the physical object.

An argument of the first kind would run: We say of the *St. George* that it moves with life (Vasari). Yet the block of marble is inanimate. Therefore the *St. George* cannot be that block of marble. An argument of the second kind would run: We say of the *Donna Velata* that it is exalted and dignified (Wölfflin). Yet a piece of canvas in the Pitti cannot conceivably have these qualities. Therefore the *Donna Velata* cannot be that piece of canvas.

These two arguments, I suggest, are not merely instances of these two ways of arguing, they are characteristic instances. For the argument that there is an incompatibility of property between works of art and physical objects characteristically concentrates on the representational properties of works of art. The argument that works of art have properties that physical objects could not have characteristically concentrates on the expressive properties of works of art. The terms "representational" and "expressive" are used here in a very wide fashion, which, it is hoped, will become clear as the discussion proceeds.

15

We might begin by considering two false views of how works of art acquire their expressiveness: not simply so as to put them behind us, but because each is in its way a pointer to the truth. Neither view requires us to suppose that works of art are anything other than physical objects.

The first view is that works of art are expressive because they have been produced in a certain state of mind or feeling on the part of the artist: and to this the rider is often attached, that it is this mental or emotional condition that they express. But if we take the view first of all with the rider attached, its falsehood is apparent. For it is a common happening that a painter or sculptor modifies or even rejects a work of his because he finds that it fails to correspond to what he experienced at the time. If, however, we drop the rider, the view now seems arbitrary or perhaps incomplete. For there seems to be no reason why a work should be expressive simply because it was produced in some heightened condition if it is also admitted that the work and the condition need not have the same character. (It would be like trying to explain why a man who has measles is ill by citing the fact that he was in contact with someone else who was also ill when that other person was not ill with measles or anything related to measles.) It must be understood that I am not criticising the view because it allows an artist to express in his work a condition other than that which he was in at the time: my case is rather that the view does wrong both to allow this fact and to insist that the expressiveness of the work can be accounted for exclusively in terms of the artist's condition.

However, what is probably the more fundamental objection to this view, and is the point that has been emphasized by many recent philosophers, is that the work's expressiveness now becomes a purely external feature of it. It is no longer something that we can or might observe, it is something that we infer from what we observe: it has been detached from the object as it manifests itself to us, and placed in its history, so that it now belongs more to the biography of the artist than to criticism of the work. And this seems wrong. For the qualities of gravity, sweetness, fear, that we invoke in describing works of art seem essential to our understanding of them; and if they are, they cannot be extrinsic to the works themselves. They cannot be, that is, mere attributes of the experiences or activities of Masaccio, of Raphael, of Grünewald—they inhere rather in the Brancacci frescoes, in the Granduca Madonna, in the Isenheim Altarpiece.

The second view is that works of art are expressive because they produce or are able to produce a certain state of mind or feeling in the spectator: moreover (and in the case of this view it is difficult to imagine the rider ever detached), it is this mental or emotional condition that they express. This view is open to objections that closely parallel those we have just considered.

For, in the first place, it seems clearly false. Before works even of the most extreme emotional intensity, like Bernini's St. Teresa or the black paintings of Goya, it is possible to remain more or less unexcited to the emotion that it would be agreed they express. Indeed, there are many theories that make it a distinguishing or defining feature of art that it should be viewed with detachment, that there should be a distancing on the part of the spectator between what the work expresses and what he experiences: although it is worth noting, in passing, that those theorists who have been most certain that works of art do not arouse emotion, have also been uncertain, in some cases confused, as to how this comes about: sometimes attributing it to the artist, sometimes to the spectator; sometimes, that is, saying that the artist refrains from giving the work the necessary causal power, sometimes saying that the spectator holds himself back from reacting to this power.

However, the main objection to this view, as to the previous one, is that it removes what we ordinarily think of as one of the essential characteristics of the work of art from among its manifest properties, locating it this time not in its past but in its hidden or dispositional endowment. And if it is now argued that this is a very pertinent difference, in that the latter is, in principle at least, susceptible to our personal verification in a way in which the former never could be, this misses the point. Certainly we can actualize the disposition, by bringing it about that the work produces in us the condition it is supposed to express: and there is clearly no corresponding way in which we can actualize the past. But though this is so, this still does not make the disposition itself—and it is with this, after all, that the work's expressiveness is equated—any the more a property that we can observe.

16

And yet there seems to be something to both these views: as an examination of some hypothetical cases might bring out.

For let us imagine that we are presented with a physical object—we shall not for the moment assume that it either is or is supposed to be a work of art—and the claim is made on its behalf, in a way that commands our serious attention, that it is expressive of a certain emotion: say, grief. We then learn that it had been produced quite casually, as a diversion or as part of a game: and we must further suppose that it arouses neither in us nor in anyone else anything more than mild pleasure. Can we, in the light of these facts, accept the claim? It is conceivable that we might; having certain special reasons.

But now let us imagine that the claim is made on behalf not of a single or isolated object, but of a whole class of objects of which our original example would be a fair specimen, and it turns out that what was true of it is true of all of them both as to how they were produced and as to what they produce in us. Surely it is impossible to imagine any circumstances in which we would allow *this* claim.

But what are we to conclude from this? Are we to say that the two views are true in a general way, and that error arises only when we think of them as applying in each and every case? The argument appears to point in this direction, but at the same time it seems an unsatisfactory state in which to leave the matter. (Certain contemporary moral philosophers, it is true, seem to find a parallel situation in their own area perfectly congenial, when they say that an individual action can be right even though it does not satisfy the utilitarian criterion, provided that that sort of action, or that that action in general, satisfies the criterion: the utilitarian criterion, in other words, applies on the whole, though not in each and every case.)

The difficulty here is this: Suppose we relax the necessary condition in the particular case because it is satisfied in general, with what right do we continue to regard the condition that is satisfied in general as necessary? Ordinarily the argument for regarding a condition as necessary is that there could not be, or at any rate is not, anything of the requisite kind that does not satisfy it. But this argument is not open to us here. Accordingly, at the lowest, we must be prepared to give some account of how the exceptions arise: or, alternatively, why we are so insistent on the condition in general. To return to the example: it seems unacceptable to say that a single object can express grief though it was not produced in, nor is it productive of, that emotion, but that a class of objects cannot express grief unless most

of them, or some of them, or a fair sample of them, satisfy these conditions—unless we can explain why we discriminate in this way.

At this point what we might do is to turn back and look at the special reasons, as I called them, which we might have for allowing an individual object to be expressive of grief though it did not satisfy the conditions that hold generally. There seem to be roughly two lines of thought which if followed might allow us to concede expressiveness. We might think, "Though the person who made this object didn't feel grief when he made it, yet this is the sort of thing I would make if I felt grief. . . ." Alternatively we might think, "Though I don't feel grief when I look at this here and now, yet I am sure that in other circumstances I would. . . ." Now, if I am right in thinking that these are the relevant considerations, we can begin to see some reason for our discrimination between the particular and the general case. For there is an evident difficulty in seeing how these considerations could apply to a whole class of objects: given, that is, that the class is reasonably large. For our confidence that a certain kind of object was what we would produce if we experienced grief would be shaken by the fact that not one (or very few) had actually been produced in grief: equally, our confidence that in other circumstances we should feel grief in looking at them could hardly survive the fact that no one (or scarcely anyone) ever had. The special reasons no longer operating, the necessary conditions reassert themselves.

18

The question, however, might now be raised, Suppose the two criteria, which hitherto have been taken so closely together, should diverge: for they might: how could we settle the issue? And the difficulty here is not just that there is no simple answer to the question, but that it looks as though any answer given to it would be arbitrary. Does this, therefore, mean that the two criteria are quite independent, and that the whole concept of expression, if, that is, it is constituted as I have suggested, is a contingent conjunction of two elements, which could as easily fall apart as together?

I shall argue that the concept of expression, at any rate as this applies to the arts, is indeed complex, in that it lies at the intersection of two constituent notions of expression. We can gain some guidance as to these notions from the two views of expression we have been considering, for they are both reflected in, though also distorted by, these views. But, whereas the two views seem quite contingently connected, and have no clear point of union, once we understand what these notions are we can see how and why they interact. Through them we can gain a better insight into the concept of expression as a whole.

In the first place, and perhaps most primitively, we think of a work of art as expressive: that is to say, we conceive of it as coming so directly and immediately out of some particular emotional or mental state that it bears unmistakeable marks of that state upon it. In this sense the word remains very close to its etymology: ex-primere, to squeeze out or press out. An expression is a secretion of an inner state. I shall refer to this as "natural expression." Alongside this notion is another, which we apply when we think of an object as expressive of a certain condition because, when we are in that condition, it seems to us to match, or correspond with, what we experience inwardly: and perhaps when the condition passes, the object is also good for reminding us of it in some special poignant way, or for reviving it for us. For an object to be expressive in this sense, there is no requirement that it should originate in the condition that it expresses, nor indeed is there any stipulation about its genesis: for these purposes it is simply a piece of the environment which we appropriate on account of the way it seems to reiterate something in us. Expression in this sense I shall (following a famous nineteenth-century usage) call "correspondence."

We may now link this with the preceding discussion by saying that the preoccupation with what the artist felt, or might have felt, reflects a concern with the work of art as a piece of natural expression: whereas the preoccupation with what the spectator feels, or might feel, reflects a concern with the work of art as an example of correspondence.

But though these two notions are logically distinct, in practice they are bound to interact: indeed, it is arguable that it goes beyond the limit of legitimate abstraction to imagine one without the other. We can see this by considering the notion of appropriateness, or fittingness, conceived as a relation holding between expression and expressed. We might think that such a relation has a place only in connection with correspondences. For in the case of natural expression, the link between inner and outer is surely too powerful or too intimate to allow its mediation. It is not because tears seem like grief that we regard them as an expression of grief: nor does a man when he resorts to tears do so because they match his condition. So we might think. But in reality, at any level above the most primitive, natural expression will always be coloured or influenced by some sense of what is appropriate; there will be a feedback from judgment, however inchoate or unconscious this may be, to gesture or exclamation. Again, when we turn to correspondence, it might seem that here we are guided entirely by appropriateness or the fit: that is to say, we appeal uniquely to the appearances or characteristics of objects, which hold for us, in some quite unanalyzed way, an emotional significance. We do not (we might think) check these reactions against observed correlations. But once again this is a simplification. Apart from a few primitive cases, no physiognomic perception will be independent of what is for us the supreme example of the

relationship between inner and outer: that is, the human body as the expression of the psyche. When we endow a natural object or an artifact with expressive meaning, we tend to see it corporeally: that is, we tend to credit it with a particular look which bears a marked analogy to some look that the human body wears and that is constantly conjoined with an inner state.

19

To the question, Can a work of art be a physical object if it is also expressive?, it now looks as though we can, on the basis of the preceding account of expression, give an affirmative answer. For that account was elaborated with specifically in mind those arts where it is most plausible to think of a work of art as a physical object. But it may seem that with both the two notions of expression that I have tried to formulate, there remains an unexamined or problematic residue. And in the two cases the problem is much the same.

It may be stated like this: Granted that in each case the process I have described is perfectly comprehensible, how do we come at the end of it to attribute a human emotion to an object? In both cases the object has certain characteristics. In one case these characteristics mirror, in the other case they are caused by, certain inner states of ours. Why, on the basis of this, do the names of the inner states get transposed to the objects?

The difficulty with this objection might be put by saying that it treats a philosophical reconstruction of a part of our language as though it were a historical account. For it is not at all clear that, in the cases where we attribute emotions to objects in the ways that I have tried to describe, we have any other way of talking about the objects themselves. There is not necessarily a prior description in nonemotive terms, on which we superimpose the emotive description. Or, to put the same point in nonlinguistic terms, it is not always the case that things that we see as expressive, we can or could see in any other way. In such cases what we need is not a justification, but an explanation, of our language. That I hope to have given.

20

We have now completed our discussion of the physical-object hypothesis, and this would be a good moment at which to pause and review the situation.

The hypothesis, taken literally, has been clearly shown to be false: in that there are arts where it is impossible to find physical objects that are even candidates for being identified with works of art (sections 6-8). However, as far as those other arts are concerned where such physical objects can be found, the arguments against the identification—namely, those based on the fact that works of art have properties not predicable of physical objects—seemed less cogent (sections 9-19). I have now to justify the

assertion that I made at the very beginning of the discussion (section 5), that it was only in so far as it related to these latter arts that the challenge to this hypothesis had any fundamental significance for aesthetics.

The general issue raised, whether works of art are physical objects, seems to compress two questions: the difference between which can be brought out by accenting first one, then the other, constituent word in the operative phrase. Are works of art *physical* objects? Are works of art physical *objects*? The first question would be a question about the stuff or constitution of works of art, what in the broadest sense they are made of: more specifically, Are they mental? or physical? are they constructs of the mind? The second question would be a question about the category to which works of art belong, about the criteria of identity and individuation applicable to them: more specifically, Are they universals, of which there are instances?, or classes, of which there are members?, are they particulars? Roughly speaking, the first question might be regarded as metaphysical, the second as logical. And, confusingly enough, both can be put in the form of a question about what kind of thing a work of art is.

Applying this distinction to the preceding discussion, we can now see that the method of falsifying the hypothesis that all works of art are physical objects has been to establish that there are some works of art that are not objects (or particulars) at all: whereas the further part of the case, which depends upon establishing that those works of art which are objects are nevertheless not physical, has not been made good. If my original assertion is to be vindicated, I am now required to show that what is of moment in aesthetics is the physicality of works of art rather than their particularity.

. .

35

... [I want to] go back and take up an undischarged commitment: which is that of considering the consequences of rejecting the hypothesis that works of art are physical objects, in so far as those arts are concerned where there is no physical object with which the work of art could be plausibly identified. This will, of course, be in pursuance of my general aim—which has also directed the preceding discussion—of establishing that the rejection of the hypothesis has serious consequences for the philosophy of art only in so far as those arts are concerned where there *is* such an object.

I have already stated (sections 5, 20) that, once it is conceded that certain works of art are not physical *objects*, the subsequent problem that arises, which can be put by asking, What sort of thing are they?, is essentially a logical problem. It is that of determining the criteria of identity and individuation appropriate to, say, a piece of music or a novel. I shall char-

acterise the status of such things by saying that they are (to employ a term introduced by Peirce) *types*. Correlative to the term "type" is the term "token." Those physical objects which (as we have seen) can out of desperation be thought to be works of art in cases where there are no physical objects that can plausibly be thought of in this way, are *tokens*. In other words, *Ulysses* and *Der Rosenkavalier* are types; my copy of *Ulysses* and tonight's performance of *Rosenkavalier* are tokens of those types. The question now arises, What is a type?

The question is very difficult, and, unfortunately, to treat it with the care and attention to detail that it deserves is beyond the scope of this essay.

We might begin by contrasting a type with other sorts of thing that it is not. Most obviously we could contrast a type with a *particular*: this I shall take as done. Then we could contrast it with other various kinds of nonparticulars: with a *class* (of which we say that it has *members*), and a *universal* (of which we say that it has *instances*). An example of a class would be the class of red things: an example of a universal would be redness: and examples of a type would be the word "red" and the Red Flag—where this latter phrase is taken to mean not this or that piece of material, kept in a chest or taken out and flown at a masthead, but the flag of revolution, raised for the first time in 1830 and that which many would willingly follow to their death.

Let us introduce as a blanket expression for types, classes, universals, the term generic entity, and, as a blanket expression for those things which fall under them, the term *element*. Now we can say that the various generic entities can be distinguished according to the different ways or relationships in which they stand to their elements. These relationships can be arranged on a scale of intimacy or intrinsicality. At one end of the scale we find classes, where the relationship is at its most external or extrinsic: for a class is merely made of, or constituted by, its members which are extensionally conjoined to form it. The class of red things is simply a construct out of all those things which are (timelessly) red. In the case of universals the relation is more intimate: in that a universal is present in all its instances. Redness is in all red things. With types we find the relationship between the generic entity and its elements at its most intimate: for not merely is the type present in all its tokens like the universal in all its instances, but for much of the time we think and talk of the type as though it were itself a kind of token, though a peculiarly important or pre-eminent one. In many ways we treat the Red Flag as though it were a red flag (cf. "We'll keep the Red Flag flying high").

These varying relations in which the different generic entities stand to their elements are also reflected (if, that is, this is *another* fact) in the degree to which both the generic entities and their elements can satisfy the same predicates. Here we need to make a distinction between sharing properties and properties being transmitted. I shall say that when A and B are both f, f is shared by A and B. I shall further say that when A is f because B is f, or B is f because A is f, f is transmitted between A and B. (I shall ignore the sense or direction of the transmission, i.e. I shall not trouble, even where it is possible, to discriminate between the two sorts of situation I have mentioned as instances of transmission.)

First, we must obviously exclude from consideration properties that can pertain only to tokens (e.g. properties of location in space and time) and equally those which pertain only to types (e.g. "was invented by"). When we have done this, the situation looks roughly as follows: Classes can share properties with their members (e.g. the class of big things is big), but this is very rare: moreover, where it occurs it will be a purely contingent or fortuitous affair, i.e. there will be no transmitted properties. In the cases of both universals and types, there will be shared properties. Red things may be said to be exhilarating, and so also redness. Every red flag is rectangular, and so is the Red Flag itself. Moreover, many, if not all, the shared properties will be transmitted.

Let us now confine our attention to transmitted properties because it is only they which are relevant to the difference in relationship between, on the one hand, universals and types and, on the other hand, their elements. Now there would seem to be two differences in respect of transmitted properties which distinguish universals from types. In the first place, there is likely to be a far larger range of transmitted properties in the case of types than there is with universals. The second difference is this: that in the case of universals no property that an instance of a certain universal has necessarily, i.e. that it has in virtue of being an instance of that universal, can be transmitted to the universal. In the case of types, on the other hand, all and only those properties that a token of a certain type has necessarily, i.e. that it has in virtue of being a token of that type, will be transmitted to the type. Examples would be: Redness, as we have seen, may be exhilarating, and, if it is, it is so for the same reason that its instances are, i.e. the property is transmitted. But redness cannot be red or coloured, which its instances are necessarily. On the other hand, the Union Jack is coloured and rectangular, properties which all its tokens have necessarily: but even if all its tokens happened to be made of linen, this would not mean that the Union Jack itself was made of linen.

To this somewhat negative account of a type—concentrated largely on what a type is not—we now need to append something of a more positive kind, which would say what it is for various particulars to be gathered together as tokens of the same type. For it will be appreciated that there corresponds to every universal and to every type a class: to redness the class of red things, to the Red Flag the class of red flags. But the converse

it not true. The question therefore arises, What are the characteristic circumstances in which we postulate a type? The question, we must appreciate, is entirely conceptual: it is a question about the structure of our language.

A very important set of circumstances in which we postulate types-perhaps a central set, in the sense that it may be possible to explain the remaining circumstances by reference to them-is where we can correlate a class of particulars with a piece of human invention: these particulars may then be regarded as tokens of a certain type. This characterization is vague, and deliberately so: for it is intended to comprehend a considerable spectrum of cases. At one end we have the case where a particular is produced, and is then copied: at the other end, we have the case where a set of instructions is drawn up which, if followed, give rise to an indefinite number of particulars. An example of the former would be the Brigitte Bardot looks: an example of the latter would be the Minuet. Intervening cases are constituted by the production of a particular which was made in order to be copied, e.g. the Boeing 707, or the construction of a mould or matrix which generates further particulars, e.g. the Penny Black. There are many ways of arranging the cases-according, say, to the degree of human intention that enters into the proliferation of the type, or according to the degree of match that exists between the original piece of invention and the tokens that flow from it. But there are certain resemblances between all the cases: and with ingenuity one can see a natural extension of the original characterization to cover cases where the invention is more classificatory than constructive in nature, e.g. the Red Admiral.

36

It will be clear that the preceding characterization of a type and its tokens offers us a framework within which we can (at any rate roughly) understand the logical status of things like operas, ballets, poems, etchings, etc.: that is to say, account for their principles of identity and individuation. To show exactly where these various kinds of things lie within this framework would involve a great deal of detailed analysis, more than can be attempted here, and probably of little intrinsic interest. I shall touch very briefly upon two general sets of problems, both of which concern the feasibility of the project. In this section I shall deal with the question of how the type is identified or (what is much the same thing) how the tokens of a given type are generated. In the next section I shall deal with the question of what properties we are entitled to ascribe to a type. These two sets of questions are not entirely distinct: as we can see from the fact that there is a third set of questions intermediate between the other two, concerning how we determine whether two particulars are or are not tokens of the same type. These latter questions, which arise for instance sharply in connection with translation, I shall pass over. I mention them solely to place those which I shall deal with in perspective.

First, then, as to how the type is identified. In the case of any work of art that it is plausible to think of as a type, there is what I have called a piece of human invention: and these pieces of invention fall along the whole spectrum of cases as I characterized it. At one end of the scale, there is the case of a poem, which comes into being when certain words are set down on paper or perhaps, earlier still, when they are said over in the poet's head (cf. the Croce-Collingwood theory). At the other end of the scale is an opera which comes into being when a certain set of instructions, i.e. the score, is written down, in accordance with which performances can be produced. As an intervening case we might note a film, of which different copies are made: or an etching or engraving, where different sheets are pulled from the same matrix, i.e. the plate.

There is little difficulty in all this, so long as we bear in mind from the beginning the variety of ways in which the different types can be identified, or (to put it another way) in which the tokens can be generated from the initial piece of invention. It is if we begin with too limited a range of examples that distortions can occur. For instance, it might be argued that, if the tokens of a certain poem are the many different inscriptions that occur in books reproducing the word order of the poet's manuscript, then "strictly speaking" the tokens of an opera must be the various pieces of sheet music or printed scores that reproduce the marks on the composer's holograph. Alternatively, if we insist that it is the performances of the opera that are the tokens, then, it is argued, it must be the many readings or "voicings" of the poem that are *its* tokens.

Such arguments might seem to be unduly barren or pedantic, if it were not that they revealed something about the divergent media of art: moreover, if they did not bear upon the issues to be discussed in the next section.

37

It is, we have seen, a feature of types and their tokens, not merely that they may share properties, but that when they do, these properties may be transmitted. The question we have now to ask is whether a limit can be set upon the properties that may be transmitted: more specifically, since it is the type that is the work of art and therefore that with which we are expressly concerned, whether there are any properties—always of course excluding those properties which can be predicated only of particulars—that belong to tokens and cannot be said *ipso facto* to belong to their types.

It might be thought that we have an answer, or at least a partial answer, to this question in the suggestion already made, that the properties transmitted between token and type are only those which the tokens possess

necessarily. But a moment's reflection will show that any answer along these lines is bound to be trivial. For there is no way of determining the properties that a token of a given type has necessarily, independently of determining the properties of that type: accordingly, we cannot use the former in order to ascertain the latter. We cannot hope to discover what the properties of the Red Flag are by finding out what properties the various red flags have necessarily: for how can we come to know that e.g. this red flag is necessarily red, prior to knowing that the Red Flag itself is red?

There are, however, three observations that can be made here on the basis of our most general intuitions. The first is that there are no properties or sets of properties that cannot pass from token to type. With the usual reservations, there is nothing that can be predicated of a performance of a piece of music that could not also be predicated of that piece of music itself. This point is vital. For it is this that ensures what I have called the harmlessness of denying the physical-object hypothesis in the domain of those arts where the denial consists in saying that works of art are not physical *objects*. For though they may not be objects but types, this does not prevent them from having physical properties. There is nothing that Dürer's engraving of St. Anthony has a very differentiated texture, or that the conclusion of "Celeste Aida" is pianissimo.

The second observation is that, though any single property may be transmitted from token to type, it does not follow that all will be: or to put it another way, a token will have some of its properties necessarily, but it need not have all of them necessarily. The full significance of this point will emerge later.

Thirdly, in the case of *some* arts it is necessary that not all properties should be transmitted from token to type: though it remains true that for any single property it might be transmitted. The reference here is, of course, to the performing arts—to operas, plays, symphonies, ballet. It follows from what was said above that anything that can be predicated of a performance of a piece of music can also be predicated of the piece of music itself: to this we must now add that not every property that can be predicated of the former *ipso facto* belongs to the latter. This point is generally covered by saying that in such cases there is essentially an element of *interpretation*, where for these purposes interpretation may be regarded as the production of a token that has properties in excess of those of the type.

"Essentially" is a word that needs to be taken very seriously here. For, in the first place, there are certain factors that might disguise from us the fact that every performance of a work of art involves, or is, an interpretation. One such factor would be antiquarianism. We could—certainly if the evidence were available—imagine a *Richard III* produced just as Burbage played it, or *Das Klagende Lied* performed just as Mahler conducted it.

But though it would be possible to bring about in this way a replica of Burbage's playing or Mahler's conducting, we should none the less have interpretations of Richard III and Das Klagende Lied, for this is what Burbage's playing and Mahler's conducting were, though admittedly the first. Secondly, it would be wrong to think of the element of interpretationassuming that this is now conceded to be present in the case of all performances-as showing something defective. Suzanne Langer, for instance, has characterized the situation in the performing arts by saying that e.g. the piece of music the composer writes is "an incomplete work": "the performance" she says "is the completion of a musical work." But this suggests that the point to which the composer carries the work is one which he could, or even should, have gone beyond. To see how radical a reconstruction this involves of the ways in which we conceive the performing arts. we need to envisage what would be involved if it were to be even possible to eliminate interpretation. For instance, one requirement would be that we should have for each performing art what might be called, in some very strong sense, a universal notation: such that we could designate in it every characteristic that now originates at the point of performance. Can we imagine across the full range of the arts what such a notation would be like? With such a notation there would no longer be any executant arts: the whole of the execution would have been anticipated in the notation. What assurance can we have that the reduction of these arts to mere mechanical skills would not in turn have crucial repercussions upon the way in which we regard or assess the performing arts?

38

However, if we no longer regard it as a defect in certain arts that they require interpretation, it might still seem unsatisfactory that there should be this discrepancy within the arts: that, for instance, the composer or the dramatist should be denied the kind of control over his work that the poet or the painter enjoys.

In part, there just *is* a discrepancy within the arts. And this discrepancy is grounded in very simple facts of very high generality, which anyhow lie outside art: such as that words are different from pigments; or that it is human beings we employ to act and human beings are not all exactly alike. If this is the source of dissatisfaction, the only remedy would be to limit art very strictly to a set of processes or stuffs that were absolutely homogeneous in kind.

In part, however, the dissatisfaction comes from exaggerating the discrepancy, and from overlooking the fact that in the nonperforming arts there is a range of ways in which the spectator or audience can take the work of art. It is, I suggest, no coincidence that *this* activity, of taking the poem or painting or novel in one way rather than another, is also called

"interpretation." For the effect in the two cases is the same, in that the control of the artist over his work is relaxed.

Against this parallelism between the two kinds of interpretation, two objections can be raised. The first is that the two kinds of interpretations differ in order or level. For whereas performative interpretation occurs only within certain arts, critical interpretation pertains to all: more specifically a critical interpretation can be placed upon any given performative interpretation-so the point of the parallelism vanishes, in that the performing arts still remain in a peculiar or discrepant situation. Now I do not want to deny that any performance of a piece of music or a play can give rise to a critical interpretation: the question, however, is, When this happens, is this on the same level as a performative interpretation? I want to maintain that we can fruitfully regard it as being so. For in so far as we remain concerned with the play or the piece of music, what we are doing is in the nature of suggesting or arguing for alternative performances, which would have presented the original work differently: we are not suggesting or arguing for alternative ways in which the actual performance might be taken. Our interpretation is on the occasion of a performance, not about it. The situation is, of course, complicated to a degree that cannot be unravelled here by the fact that acting and playing music are also arts, and in criticising individual performances we are sometimes conversant about those arts: which is why I qualified my remark by saving "in so far as we remain concerned with the play or piece of music."

The second and more serious objection to the parallelism between the two kinds of interpretation is that they differ as to necessity. For whereas a tragedy or a string quartet has to be interpreted, a poem or a painting need not be. At any given moment it may be necessary to interpret them, but that will be only because of the historical incompleteness of our comprehension of the work. Once we have really grasped it, further interpretation will no longer be called for. In other words, critical interpretation ultimately eliminates itself: whereas a piece of music or a play cannot be performed once and for all.

On this last argument I wish to make two preliminary observations: First, the argument must not draw any support (as the formulation here would seem to) from the indubitable but irrelevant fact that a performance is a transient not an enduring phenomenon. The relevant fact is not that a piece of music or a play must always be performed anew but that it can always be performed afresh, i.e. that every new performance can involve a new interpretation. The question then is, Is there not in the case of the non-performing arts the same permanent possibility of new interpretations? Secondly, the argument seems to be ambiguous between two formulations, which are not clearly, though in fact they may be, equivalent: the ostensibly stronger one, that in the case of a poem or painting all interpretations can ultimately be eliminated; and the ostensibly weaker one, that in these cases all interpretations save one can ultimately be eliminated.

Against the eliminability of interpretation, the only decisive argument is one drawn from our actual experience of art. There are, however, supplementary considerations, the full force of which can be assessed only as this essay progresses, which relate to the value of art. Allusions to both can be found in a brilliant and suggestive work, Valéry's "Réflexions sur l'Art."

In the first place the value of art, as has been traditionally recognized, does not exist exclusively, or even primarily, for the artist. It is shared equally between the artist and his audience. One view of how this sharing is effected, which is prevalent but implausible, is that the artist makes something of value, which he then hands on to the audience, which is thereby enriched. Another view is that in art there is a characteristic ambiguity, or perhaps better plasticity, introduced into the roles of activity and passivity: the artist is active, but so also is the spectator, and the spectator's activity consists in interpretation. "A creator," Valéry puts it, "is one who makes others create."

Secondly-and this point too has received some recognition-the value of art is not exhausted by what the artist, or even by what the artist and the spectator, gain from it: it is not contained by the transaction between them. The work of art itself has a residual value. In certain "subjectivist" views-as e.g. in the critical theory of I. A. Richards-the value of art is made to seem contingent: contingent, that is, upon there being found no better or more effective way in which certain experiences assessed to be valuable can be aroused in, or transmitted between, the minds of the artist and his audience. Now it is difficult to see how such a conclusion can be avoided if the work of art is held to be inherently exhaustible in interpretation. [Earlier] the view was considered that works of art are translucent; the view we are now asked to consider would seem to suggest that they are transparent, and as such ultimately expendable or "throw-away." It is against such a view that Valéry argued that we should regard works of art as constituting "a new and impenetrable element" which is interposed between the artist and the spectator. The ineliminability of interpretation he characterises, provocatively, as "the creative misunderstanding."

10. Toward an Ontology of Art Works NICHOLAS WOLTERSTORFF

What sort of entity is a symphony? A drama? A dance? A graphic art print? A sculpture? A poem? A film? A painting?

Are works of art all fundamentally alike in their ontological status? These are the questions to be discussed in this paper.

I. A Phenomenology of the Distinctions among Works of Art

In several of the arts there is application for the distinction between a performance of something and that which is performed. In music, for example, one can distinguish between a performance of *Verklaerte Nacht* and that which is thereby performed, namely, Arnold Schoenberg's work *Verklaerte Nacht*. Similarly, in dance one can distinguish between a performance of *Swan Lake* and that which is thereby performed, namely, the ballet *Swan Lake*.

Some people will be skeptical as to whether, in the cases cited and others of the same sort, we really do have two distinct entities—a performance and that which is performed. But assuming it to be true that the concept of a performance of something and the concept of something performed both have application to the arts, there are two sorts of considerations which force one to the conclusion that that which is performed on a given occasion is distinct from the performance of it.

In the first place, a thing performed and a performance thereof will always diverge in certain of their properties. For example, *having been composed by Schoenberg* is a property of *Verklaerte Nacht* but not of any performance of *Verklaerte Nacht*. On the other hand, *taking place at a certain time and place* is a property of every performance of *Verklaerte Nacht* but not of *Verklaerte Nacht* itself. It is worth noting that a work performed

Reprinted by permission of the author and of the editor of NOÛS, Vol. IX (1975), 115-142.

may diverge from performances thereof not only in 'ontological' properties but also in 'aesthetic' properties. For example, it may be that *having the voice part begin on A natural* is not a property of any performance of Schoenberg's *Pierrot Lunaire*, though it is a property of the work itself, indeed, an *essential* one.

A second sort of consideration, one which is actually a specific application of the first, also leads to the conclusion that in certain of the arts one must distinguish between those entities which are performances and those entities which are works performed. This second sort of consideration hinges on applications of the concepts of identity and diversity. That which is performed on one occasion may be identical with that which is performed on another; George Szell, for example, may twice over have conducted a performance of Verklaerte Nacht. Thus, there may be two distinct performances of one single musical work. But two distinct things cannot each be identical with some one thing. Thus, the two distinct performances cannot both be identical with the work performed. But if one of them, call it A, was identified with the work performed, then the other, call it B, would, by virtue of being a performance of the work performed, be a performance of performance A. Not only that, but performance A would be capable of being performed on many other occasions as well. Both of these consequences, however, seem impossible.

Let us henceforth call a work of art which can be performed, a *per-formance-work*. Most if not all performance-works are universals, in that they can be multiply performed.

It would seem that performances in the arts are as correctly called "works of art" as are performance-works. The ontological status of performances is relatively clear, however, while that of performance-works is immensely perplexing. Performances are occurrences or events. They take place at a certain time and place, begin at a certain time and end at a certain time, last for a certain stretch of time, and have temporal parts in the sense that each performance is half over at a certain time, three-quarters over at a certain time, one-eighth over at a certain time, etc. But what sort of entity is a performance-work? That is something which we shall have to discuss in considerable detail. What should already be clear, though, is that performance-works are not occurrences (events). Thus, already we can answer one of our opening questions. Works of art are not all alike in their ontological status.

In certain of the non-performing arts distinctions similar to the performance/performance-work distinction have application. Consider, for example, graphic-art prints. Here, a commonly applied distinction is that between a particular impression and the work of which it is an impression; between, for example, the tenth impression of *Obedient unto Death* and the print of which it is an impression, namely, George Rouault's *Obedient*

unto Death. And consider those cases in which sculpture is produced from a mold. Here, a commonly applied distinction is that between a particular casting of, say, *The Thinker* and the sculptural work of which it is a casting, namely, Rodin's *The Thinker*. And consider thirdly those cases in the field of architecture in which many different buildings are produced according to one set of specifications. Here, a commonly applied distinction is that between a given example of, say, the Tech-Bilt House No. 1 and that of which it is an example, namely, the Tech-Bilt House No. 1.

It may be noticed that an impression of a work of graphic art, a casting of a work of sculptural art, and an example of a work of architectural art are all enduring physical objects. This is why we have grouped these particular arts together. In order to have a convenient terminology, let us call the entities of which there can be impressions, castings, or examples, *objectworks*. And let us say that impressions, castings, and examples are *objects* of object-works. Thus, as a counterpart to the performance/performancework distinction, we have the distinction between impressions, castings, and examples on the one hand and object-works on the other.

The considerations which impel us to distinguish between an objectwork and those entities which are objects thereof are parallel to those which impel us to distinguish between an entity which is a performance-work and those entities which are performances thereof. One consideration is again that of divergence in properties. For example, having a thumb-print in the lower left corner may be a property of a given impression of Rouault's print Obedient unto Death, or even of all impressions thereof, though it is not a property of the print Obedient unto Death. A second consideration is again to be derived from applications of the concepts of identity and diversity. For example, there can be two different castings of the same sculptural work; and neither both of these castings together nor either one singly can be identified with the work. In the case of object-works there is vet a third sort of consideration which may be adduced, one hinging on applications of the concepts of existence and non-existence. Any one of the several objects of an object-work can be destroyed without the object-work thereby being destroyed. I could, for example, perform the horrifying operation of burning my impression of Rouault's Obedient unto Death, but I would not thereby put the print itself out of existence. Nor could I put the print out of existence by destroying any one of the other impressions, nor even by destroying the original etched plate.

It would seem that both object-works and the objects thereof are entitled to being called "works of art." Further, the ontological status of the latter is relatively unproblematic: They are physical objects. Of course, plenty of things about the nature of physical objects remains unclear. Yet we know what they are, and it is clear that impressions, castings, and examples are to be numbered among them. But what is an object-work? What is *its* ontological status? That is something which we shall have to discuss in detail.

There remain literary works, films, and paintings to consider. A literary work can be both written down and 'sounded out'. There can be both copies of it and utterances of it. Now, a copy is a physical object, whereas an uttering of something is a certain sort of event. Further, the *copy of* relation seems closely similar to the *example of*, *the impression of*, and the *casting of* relations. Accordingly, I shall say that a copy of a literary work is an object of it; and I shall add literary works to the group of entities to be called object-works. Furthermore, an utterance of a literary work is an event, very much like a performance. Accordingly, in the class of things to be called performance-works I shall include also literary works. Literary works, then, are both performance-works and object-works.

Saving this, however, makes one want to look back to see whether we do not have good ground for saying that works of music and drama are also both performance-works and object-works. In the case of dramatic works I think it is clear that we must say "No." A dramatic performance is a pattern of actions. The actions will in all but the most unusual cases include speech actions. But in all but the most unusual cases they will include other sorts of actions as well. More importantly, that pattern of actions which is a dramatic performance will always include actions of role-playing. For these reasons, a reading aloud or a recitation of the script of a drama is not yet a performance of the drama. A copy of the script for a drama is not a copy of the drama but instructions for proper performances thereof. The script may of course be a literary work in its own right. And that work can have both readings aloud and copies. But the drama is not the script. And a copy of the script is not a copy of the drama. The drama has no copies. All it has is performances. Dramas are only performance-works.

Music presents a somewhat less clear situation. The crucial question is this: Does a copy of the score stand to a work of music in a relationship similar enough to that in which a copy stands to a work of literature to justify us in calling the score-copy an object of the work? It seems to me not decisively clear one way or the other. What does seem clear is that a word can be both written down and uttered aloud, whereas a sound cannot be written down but only sounded out. The marks in a copy of a score are not instances of sounds but rather instructions for producing sounds. Of course, an instance of some sequence of words can also be treated as instructions for the utterance of that sequence; yet at the same time it is genuinely an instance of those words. Some words, especially those in primitive cultures, are never written down; some, especially those in technical languages, are never sounded out. Yet most words have a dual manifestation. The same is not true of sounds. But suppose someone suggests that

music should be thought of as being composed of *notes* rather than sounds, and then goes on to argue that notes, like words, can be both sounded out and written down. Obviously, this is a suggestion worthy of further investigation. Whether it is true or false is not at once clear. But nothing that is said hereafter will depend essentially on whether or not it is true. So I shall continue to suppose that music consists of sounds.

The film seems to have a dual status similar to that of words. One and the same film may have many copies, a copy being a physical object; and it may also have many showings, a showing being an occurrence (event). Thus, a film, like a literary work, has claim to being regarded as both an object-work and a performance-work. There is this difference worth noting though: A showing of a film will always occur by way of the showing of a certain copy of the film, whereas the utterance of a literary work need not occur by way of the reading of some copy of the work. One can recite it from memory.

As for paintings, it seems that neither the object/object-work distinction nor the performance/performance-work distinction has application, nor does it seem that any close counterpart to these distinctions has application. There is, of course, the distinction between the work and reproductions of the work. But this is a quite different distinction, as can be seen from the fact that one can also have reproductions of each of the various impressions of a print. What is lacking in painting is any counterpart to the print/impression distinction. All one has is a counterpart to the impression/reproduction distinction. The point may be put by saying that all the impressions of a print are originals, none is a reproduction. The conclusion must be that a painting is a physical object. But more will be said on this matter later in our discussion.

To say this is not, of course, to deny that reproductions of paintings along with reproductions of sculpture are, in some cases at least, entitled to being called "works of art" in their own right. So too are films, though they are for the most part 'reproductive' of performances and of visible events and objects. And so too are recordings, though most recordings are 'reproductive' of sounds and of audible performances. It is interesting to note, however, that in the case of visual-art reproductions and sculpture reproductions one again often has application for the print/impression or the work/casting distinction, and that in the case of recordings (records) one can distinguish between the recording on the one hand and the various discs of the recording on the other and, in turn, between a given disc on the one hand and various playings of the disc on the other.

Though I have called what we have done thus far *phenomenology*, what I have said is of course not free from ontological commitment. In saying that the distinction between performances and that which is performed can be applied to the arts, I said something which entails that there are per-

formance-works. And I said that of most if not all of these it is true that they can be multiply performed. A thorough nominalist would deny that there are any multiply performable entities. Similarly, he would deny the existence of 'multiply-objectible' entities. I think it would be worthwhile to consider how the nominalist conviction that there are no such entities might most plausibly be developed; and I also think it would be worthwhile to consider whether any decisive arguments against such nominalism can be offered. But I shall not on this occasion attempt either of these. Rather, the question which I wish to discuss in detail is this: What is the ontological status of performance-works and object-works?

To simplify our terminology, I shall henceforth in this paper call only performance-works and object-works *art works*. And both performances of art works and objects of art works will be called examples of art works. I shall continue to use "work of art" to cover both art works and their examples, along with such things as paintings which are neither. Perhaps here is also a good place to remark that the fact that the performance/performance-work distinction or the object/object-work distinction applies to a certain art does not imply that it applies *throughout* that art. There may be works of that art which are neither. Those works of music, for example, which are *total* improvisations (as distinguished from those which are improvisations on a theme) are neither performances nor performance-works.¹

II. The Sharing of Predicates and Properties Between Art Works and Examples

We cannot here discuss all competitors to the theory proposed in the following pages. But for an understanding of the theory, it will be useful briefly to consider and put behind us the view that performance-works and object-works are *sets* of their examples. The untenability of this suggestion can be seen by noticing that whatever members a set has it has necessarily, whereas a performance-work or object-work might always have had different and more or fewer performances or objects than it does have; and by noticing that if set α has no members and set β has no members, then α is identical with β , whereas it is not the case that if art work γ has no instances and art work δ has no instances, then γ is identical with δ .

That there is but one null set is clear enough. But that a set cannot have had a different membership from what it does have is a fact apt to be confused with related but different facts. The property, *having been a disciple of St. Francis*, is a property shared in common by all and only the members of a certain set, that one, namely, whose members are all and only the disciples of St. Francis. Let us for convenience name this set D. Now, whoever has the property of *having been a disciple of St. Francis* has it only contingently. Accordingly, that set which is D might have been such that some of its members lacked this property; indeed, all might have lacked

it. Alternatively, persons who are not members of D might have had this property. Thus, some other set than D might have been such that all and only its members have the property of *having been a disciple of St. Francis*. But all of these facts pertaining to what might have been in place of what is, are thoroughly compatible with the fact that D has its membership essentially.

To begin, consider some logical predicate which in normal usage can be predicated of two different things in such a way as to assert something true in both cases. Let us say that in such a case those two things *share that predicate*. One striking feature of the relationship between an art work and its examples is the pervasive sharing of predicates between the art work on the one hand and its examples on the other. "Is in the key of C minor" can be predicated truly of Beethoven's *Opus 111* and also of most if not all performances of Beethoven's *Opus 111*. "Has the figure slightly off-center to the right" can be predicated truly of Rouault's *Obedient unto Death* and likewise of most if not all impressions of *Obedient unto Death*. And so on, and on.

Of course, not every predicate which can be predicated truly of an art work, or which can be predicated truly of examples of some art work, is shared by the work and its examples. "Is a performance" and "is an occurrence" are never shared, nor are "can be repeatedly performed" and "can repeatedly occur." Nor is "composed by Hindemith" ever shared. "Is thought about by me" is in some cases shared between a certain art work and all of its examples, in other cases it is shared between a certain art work and only some of its examples, while in yet other cases it is not shared between an art work and any of its examples. And "has 'no' as its third word" is unshared between the poem *Sailing to Byzantium* and my particular copy of it, whereas it is shared between the poem and *most* copies of it.

One naturally wonders, at this point, whether when a predicate is shared between an art work and some one or more of its examples, there is normally also a sharing of some property for which the predicate stands. If so, then the predicate is used *univocally*. On the other hand, if the predicate stands for two different properties but if there is some systematic relation between these, then the predicate is used *analogically*. If not even this is true, the predicate is used *equivocally*. Shortly, we shall discuss this issue pertaining to properties. Meanwhile, without yet committing ourselves on it, let us see whether we can find some pattern in this pervasive sharing of predicates. (See also Wolterstorff [9]: 250–254.)

From the start, one feels that there is some connection between a predicate's being true of the examples of an art work and its being true of the work. Can this feeling be substantiated? The example we have already used provides us with evidence for concluding that the following formula will not do: A predicate P is true of some art work W if P is true of every example of W. For "is a performance" is true of all the examples of performance-works but cannot be true, in its normal sense, of any of those art works themselves.

So suppose that from here on we discard from consideration those predicates which are true of one or more of the examples of some art work but which, in their normal meaning, *cannot* be true of the work itself. (When a predicate P used with normal meaning cannot be true of W, P will be said to be *excluded by* W. Likewise, when a property P cannot be possessed by W, P will be said to be *excluded by* W.) What then about the formula: For any predicate P which is not excluded by W, P is true of W if P is true of every example of W? One objection to this formula is that it is far more constricted in its application than what we were looking for. For we saw that "has a G sharp in its seventh measure" may be true of Bartok's *First Quartet* even though of many of its performances it is not true. Indeed, it may be true of none of the performances.

A clue to a better formula can be gotten by looking more closely at this example. Is it not the case that "has a G sharp in its seventh measure" is true of Bartok's *First Quartet* in case it is *impossible* that something should be a *correct* performance of Bartok's *First* and lack the property of having a G sharp in its seventh measure? Is it not the case that "has 'no' as its third word" is true of *Sailing to Byzantium* in case it is *impossible* that something should be a *correct* copy of *Sailing to Byzantium* and lack the property of having "no" as its third word?

These examples naturally suggest to us the following formula: For any predicate P which is not excluded by W, if there is some property being P which P expresses in normal usage and is such that it is impossible that something should be a correctly formed example of W and lack being P, then P is true of W.

But to this general formula as well, there are counterexamples. Consider for instance the predicate "is a performance or was highly thought of by Beethoven." There will be many works such that this predicate used in its normal sense will not be excluded by the work. Likewise, it is impossible that something should be a correctly formed example of some such work and lack the property of *being either a performance or highly thought of by Beethoven*; for it is impossible that that thing should lack the property of being a performance. Yet the predicate in question may very well not be true of the work. For the work cannot be a performance, and it may not have been highly thought of by Beethoven. And in general, take a predicate of the form "is either A or anti-W," where "is anti-W" represents a predicate such that (i) it is excluded by W and (ii) when predicated of examples of W it stands for a property such that necessarily if something is an example of W, then it has that property, and where "is A" represents any predicate whatsoever which is not excluded by W. Then the 'disjunc-

tive predicate' represented by "is either A or anti-W" is itself not excluded by W and is itself such that when predicated of some example of W, it stands for a property such that it is impossible that something should be a correct example of W and lack it. Yet obviously the predicate may very well not be true of W.

The essence of the difficulty here would seem to be that some predicates stand for properties such that it is impossible that something should be an example of W at all, correct or incorrect, and lack the property. Such properties might be said to be *necessary to* examples of W. If we could eliminate from consideration predicates standing for such properties, then counterexamples of the sort suggested will be forestalled. So let us say that a predicate P is *acceptable with respect to* W if and only if P is neither excluded by W nor is such that any property for which it stands when truly predicated of examples of W is one which is necessary to examples of W. Then our proposed formula becomes this: For any predicate P which is acceptable with respect to W, if there is some property *being* P which P expresses in normal usage and is such that it is impossible that something should be a correctly formed example of W and lack *being* P, then P is true of W. (It should be noticed that the claim here is not *if and only if*, but just *if*.)

The core feature of this proposal is the suggestion that what is true of correctly formed examples of an art work plays a decisive role in determining what can be predicated truly of the work. Or, to put it yet more indefinitely, the core feature is the suggestion that the concept of an art work is intimately connected with the concept of a correctly formed example of the work.

Perhaps if we considered the matter in detail, we could find still more pattern to the sharing of predicates between art works and examples than what we have thus far uncovered. But enough has been uncovered for our subsequent purposes. So let us now move from the level of language to the level of ontology and consider whether, when predicates are shared according to the general pattern uncovered, there is also a sharing of properties designated by those predicates.

One is naturally inclined to think that there is. Our dictionaries do not, after all, tell us that a certain word standardly means one thing when truly predicated of an art work and something else when truly predicated of an example of the work. Yet I think that we must in fact come to the conclusion that predicates shared between art works and their examples do not function univocally when the sharing follows the general pattern we have uncovered. For what one means, in truthfully predicating "has 'no' as its third word" of some copy of *Sailing to Byzantium* is that the third word-*occurrence* is "no." But when one truthfully predicates "has 'no' as its third word" of *Sailing to Byzantium* itself, one cannot mean this. For the

poem does not consist of word-occurrences. Similarly, what one means in truthfully predicating "has a G sharp in its seventh measure" of some performance of Bartok's *Fifth* is that in its seventh measure there was an *occurrence* of the G-sharp pitch. But the *Quartet* itself does not consist of sound-occurrences. So I think it must be admitted that we have not discovered a systematic identity but only a systematic relation between the property designated by some predicate when it is truthfully predicated of some art examples and the property designated by that same predicate when truthfully predicated of the art work. Our conclusion must be that the sharing of predicates between art works and their examples pervasively exhibits *analogical* predication.

The situation is as follows. Suppose that P is a predicate which can be shared between an art work W and its examples, and suppose further that a property for which P stands when truthfully predicated of examples of W is *being* P. Then for those cases in which the sharing of P fits the general pattern which we formulated, P when truthfully predicated of W stands for the property of *being such that something cannot be a correct example of it without having the property of being* P.

III. Art Works are Kinds

We have seen some of the fundamental relations which hold between an art work and its examples. But we have not yet gained much insight into the ontological status of art works. We are left so far without any satisfying answer to our question: What *is* an art work? We must take a next step.

The proposal I wish to make is that performance-works and objectworks are *kinds* (*types, sorts*)—kinds whose examples are the performances or objects of those works. A performance-work is a certain kind of performance; an object-work is a certain kind of object.

A phenomenon which tends at once to confirm us in the suggestion that art works are kinds whose examples are the examples of those works is the fact that kinds which are not art works are like art works in just the ways that (as we saw earlier) sets of their examples are unlike art works. Just as an art work might have had different and more or fewer performances and objects than it does have, so too the kind Man, for example, might have had different and more or fewer examples than it does have. If Napoleon had not existed, it would not then have been the case that Man did not exist. Rather, Man would then have lacked one of the examples which in fact it had. And secondly, just as there may be two distinct unperformed symphonies, so too may there be two distinct unexampled kinds —e.g., the Unicorn and the Hippogriff.

Not only does it seem that art works are *kinds*. What is even more striking is their many close similarities to those special kinds of kinds familiarly known as *natural* kinds.

It has long been noticed by philosophers that in the case of natural kinds there is a pervasive sharing of predicates and/or properties between kinds and their examples. Let us look at the pattern of such sharing, beginning with a proposal made by Richard Wollheim. Having excluded from consideration those properties which cannot be shared between kinds and examples, his suggestion is that the following is necessarily true: The K shares a certain property with all Ks if and only if it is impossible that something should be an example of the K and lack the property ([8]:64–65).

What must be clearly perceived about this formula is that it speaks of properties, not of predicates. And in many if not most cases, a sharing of a predicate does not have, underlying it, a sharing of a property for which the predicate stands. That property which a grizzly possesses, of being something that growls, is not a property which the Grizzly could possess. Once one sees this, it becomes clear that the formula has an extremely limited application. Cases of shared predicates are common. Cases in which those predicates stand for properties which can be shared are relatively uncommon. Thus, the formula gives very little insight into the relation between kinds and their examples. Perhaps it's true that all grizzlies growl. And certainly it is true that the Grizzly growls (though at the same time it's true that something can be an example of the Grizzly while being mute). Yet this is not a counterexample to the formula; because what the Grizzly's growling consists of cannot be identical with what a grizzly's growling consists of. The tenability of the formula with respect to such cases is bought at the price of giving us no illumination with respect to them.

Even so, however, there are rather obvious counterexamples of other sorts to the formula. It could happen that a certain kind would share with all its examples the property of *having been referred to by someone or other*. Yet most kinds are such that something *could* be an example of them and still lack this property.

But now consider once again the sentence "The Grizzly growls." Is it not the case that "growls" is true of the Grizzly if it is impossible that something should be a *properly* formed grizzly and not growl? A grizzly muted is a malformed grizzly, and so also is a grizzly born without a growl. What makes "growls" true of the Grizzly is that something cannot be a properly formed grizzly unless it growls. In botanical and zoological taxonomy books, one is not told about the features shared by all examples of a certain kind, nor about the features which a thing cannot lack if it is to be a properly formed example of the kind. So already we have for natural kinds the same pattern which we earlier uncovered for art works: For any predicate P which is acceptable with respect to the K, if there is some property being P which P expresses in normal usage and which is such that it is impossible that something should be a properly formed example of the K and lack *being P*, then *P* is true of the K.

As in the case of art works, we must raise the question whether when we have a sharing of some predicate between a kind and its examples, we also have a sharing of some property for which that predicate stands. With respect to those cases which fit our general formula, I think the answer must be, "No, we do not." Predications in such cases are not univocal. But neither are they equivocal. They are analogical. When grizzlies growl, they emit from their throats certain characteristic sound-patterns which we English-speaking people call "growling." But the kind, Grizzly, does not do that. Its sound-emission cannot be caught on some record. Yet-the Grizzly growls. "Growls," when truly predicated of the Grizzly, would seem to stand for the property of being such that something cannot be a properly formed example of it unless it growls. Thus, there is a systematic non-univocality about "growls." The predicate "growls" stands naturally for two quite different properties, one holding of the Grizzly and one holding of at least every properly formed example thereof. In general, for those cases in which the sharing of predicates between a kind and its examples follows the general pattern which we have formulated, the predicates are used analogically in exactly the way in which they were seen to be used analogically in the corresponding cases for art works.

In concluding this section of our discussion, let us articulate an important assumption which we have been making throughout. Consider the kind: Red Thing. This does seem to be a genuine kind; it differs from the class of all red things in that it might have had different and more or fewer members than it does have. But now notice that there cannot be a distinction, among examples of this kind, between improperly formed examples and properly formed examples of the kind. For it is not possible that some of the examples of the Red Thing should be improperly formed examples of this kind (i.e., things improperly red), nor is it possible that some should be properly formed examples of the kind (i.e., things properly red). Or consider the two kinds: Properly Formed Orchid and Malformed Orchid. There seems no reason to doubt that there are such kinds as these. But neither of these can have properly formed examples, nor can either have improperly formed examples.

When a kind, the K, is such that it is possible that it should have properly formed examples and also possible that it should have improperly formed examples, let us say that the K is a *norm-kind*. We have assumed throughout our discussion that art works and natural kinds are both norm-kinds.

IV. What Kind of Kinds Are Art Works?

Having suggested that art works are kinds, we must now take the next step of considering which kind a given art work is to be identified with. For the

sake of convenience, I shall conduct the discussion by referring exclusively to music. But I shall have an eye throughout on the application to art works generally.

In performing a musical work, one produces an occurrence of a certain sound-sequence, the sound-sequence itself being capable of multiple occurrences. Accordingly, that particular kind which is some musical work has as its examples various occurrences of sound-sequences. It is a kind whose examples are sound-sequence-occurrences.

But now more specifically, with which of those many kinds whose examples are sound-sequence-occurrences is a given musical work to be identified? An answer which comes immediately to mind is this:

(1) A musical work W is identical with that kind whose examples are occurrences of that sound-sequence which correct performances of W are occurrences of.²

About this it must be said, however, that for most if not all musical works there is no such sound-sequence. This is so, for one reason, because standards of correctness by no means wholly determine which sound-sequence must occur if W is to be performed correctly. Performances of a given work can all be correct in every detail—yet differ significantly. The musical works which come closest to permitting no divergence among their correct performances are those 'totally serialized' works of the last quarter century. Yet even these permit some divergence.

So (1) must be discarded. And the revised suggestion we should consider is this:

(2) A musical work W is identical with that kind whose examples are occurrences of members of that set of sound-sequences which correct performances of W are occurrences of.

But this suggestion, though it is better than (1), is also not satisfactory. On this view, an incorrect performance of some work W would not be an example thereof. Yet an incorrect performance of some work is, in spite of its incorrectness, a performance thereof. And is it not on that account an example of the work? Are not all performances of W to be counted among the examples of the kind with which W is identical?

So (2) must be revised by dropping the reference to *correct* performance, thus:

(3) A musical work W is identical with that kind whose examples are occurrences of members of that set of sound-sequences which performances of W are occurrences of.³

But now we must in turn raise a question concerning the satisfactoriness of (3), a question which plunges us into a whole nest of subtle matters. In performing a musical work one produces an occurrence of a certain sound-sequence. It is clear, however, that that very same sound-sequence can in principle occur in other ways than by way of someone performing that work—or indeed, *any* work. It can be made to occur, for example, by the blowing of the wind, or by someone's doodling on a piano, or by an electronic organ's going berserk. Performing is one way of producing occurrences of sound-sequences. But the very same sound-sequence which can be produced by the activity of performing can be produced in other ways as well. So a performance is not merely an occurrence of a certain sound-sequence. It is an occurrence produced by the activity of performing.

The question to consider now is whether a musical work is just a certain kind of sound-sequence-occurrence, no matter how produced, or whether a musical work is a certain kind of performance. Is (3) the formula we want, or the following:

(4) A musical work W is identical with that kind whose examples are performances of W (or, more simply stated, with the kind: Performance of W)?

To answer this question we shall have to look a bit into the nature of performing.

Performing is clearly an intentional act. But what is the nature of the intention involved? When someone performs Beethoven's *Opus 111*, what is it that he intends? Does he perhaps intend to follow the directions of the score in producing a sound-sequence-occurrence? Well, often he does indeed have this intent. But even success in this intent is seldom a sufficient condition for having performed the work. For though scores do, among their other functions, provide specifications for producing examples of the work, seldom are all the matters pertaining to correct performance specified in a score. Normally, many are simply presupposed by the composer as part of the style and tradition in which he is working, and others are suggested without ever being specified. If the performer limits himself to following the specifications in the score, not even attempting in other respects to produce a correct example of the work, it is at the very least doubtful that he has performed the work.

An even more decisive objection is that one can perform some work without at all intending to follow the specifications of the score for the work. For there may be no score. If Beethoven had composed his *Opus 111* before scoring it, it would have been possible for him to perform the work without being guided by the score for that or any other work. That is, it would have been possible for him not merely to produce an occurrence of a sound-sequence which could also occur as a performance of *Opus 111*,

but actually to perform the work. In fact, of course, there now is a score for *Opus 111*. But the vast bulk of indigenous folk music remains unscored. So in that case performers are never guided by the scores for the works. Yet those works can be performed.

It is true that specifications can be laid down to performers by means other than scores. The folk-music performer can be told verbally how some passage is to be performed. Or the rhythm can be stomped out for him by foot. But quite clearly it is no significant improvement over our first thought to say that the intention involved in performing a work is the intention to follow the specifications for producing examples of that work. For of most works it is true that even when we include all specifications, whether expressed in score notation or otherwise, these specifications are woefully insufficient for determining correct examples. Bartok, in his early career, set about scoring various Hungarian folk songs. His work did not consist of taking specifications which were expressed in something other than the Western scoring system and expressing them in score notation. On the contrary, his work consisted of providing those works, for the first time in their careers, with specifications for performance. And by and large our Western scores contain all the specifications we have for our musical works. But these are not enough. Correct performance requires knowledge of more matters than these.4

What emerges from all this is that to perform a work one must have knowledge of what is required for a correct example of the work; and one must then try to act on such knowledge in producing an occurrence of a sound-sequence. It is the producer's acting on his knowledge of the requirements that makes of some sound-sequence-occurrences a performance of the work, instead of merely an occurrence of a sound-sequence that *might also* have occurred in a performance of the work. Such knowledge may be gained in many ways—for example, from scores or other specifications. But seldom will it be gained wholly from specifications which have been expressed. And sometimes it may not be gained from these at all.

It is not necessary, though, if one is to perform a work, that one *succeed* in one's attempt to act on one's knowledge of what is required of a sound-sequence-occurrence if it is to be a correct example of the work. Even if one makes mistakes and so does not actually produce a correct example, still one may have performed the work. Of course there are limits, albeit rather indefinite ones, on how seriously one can fail and still have performed the work.

So my suggestion concerning the nature of performing is this: To perform a musical work W is to aim to produce a sound-sequence-occurrence in accord with one's knowledge of what is required of something if it is to be a correct example of W, and to succeed at least to the extent of producing an example of W.⁵ An implication of this understanding of the nature of performing is that when a performer deliberately departs from the requirements for a correct performance of some work W, he is then not performing W. Sometimes such departures are motivated by the performer's inability to negotiate some passage. In other cases they are motivated by the performer's belief that he can thereby produce an aesthetically better performance. But whatever the motive, if Anthony Newman, say, deliberately departs from what is necessary for a correct example of Bach's *Prelude and Fugue in D minor*, then (strictly speaking) he is not performing that work. He is probably instead performing Newman's variation on Bach's *Prelude and Fugue in D minor*.

We have been discussing at some length the concept of *performing*. It is time now to return to the question which led us into this discussion, namely, which is the correct view as to the nature of the musical work, (3) or (4)? Is a musical work just a certain kind of sound-sequence-occurrence, or is it a certain kind of performance?

What is worth noticing first is that on both (3) and (4), art works can be viewed as norm-kinds. That is evident in (4), but probably not so on (3). For on (3), W is just a kind whose examples are the occurrences of a certain set of sound-sequences. And sound-sequence-occurrences just are or are not occurrences of that sequence of which they are occurrences. It makes no sense to speak of some as correct occurrences thereof and some as incorrect occurrences. However, there seems to be nothing against thinking of certain of the 'member' sound-sequences as correct ones, and the rest as incorrect ones. Then correct examples of the work will be those which are occurrences of the former; incorrect examples will be those which are occurrences of the latter. Thus, the fact that art works are normkinds is as compatible with (3) as with (4).

What is also worth noting is that on both (3) and (4) those properties which a work has by virtue of what counts as correctness in examples belong to it essentially. A work which has a G natural in its seventh measure cannot fail to have had a G natural there, on pain of not being that work.

But in addition to the similarities, there are significant differences between the kinds which (3) proposes to identify with art works and those which (4) proposes to identify with them. So let us contrast some of the implications of each of these views. If (3) were true, then one would have to distinguish between examples and performances of works. As a matter of contingent fact, it might be that only performances of W were examples of W. But there would be no necessity in this. And as a corollary, on (3) one could hear Bartok's *Second Sonata* without anyone performing it. For, presumably, by hearing an example of the work one can hear the work; and on (3) a work can have non-performance examples. Also, on (3) one could hear a work W without hearing a performance of W, by hearing a

performance (correct or incorrect) of a distinct work W'. Further, one could hear several different musical works by listening to a performance of just one work. On (4), however, none of these results obtain.

Furthermore, if (3) were true, it would be possible for W to have among its examples sound-occurrences which are also examples of W'. For a sound-sequence which could occur as a correct (or indeed incorrect) performance of W might also occur as an incorrect performance of W'. One's first inclination is to say that on this point too, (3) and (4) differ. On (4), it would seem, distinct works cannot share any examples. But in fact this is false. On either view, musical works W and W' are identical if and only if whatever is necessary for something to be a correct example of W is also necessary for something to be a correct example of W', and vice versa. And on either view, something is a performance of a work W only if its production is guided by W's requirements for correct examples. But it seems clear that a given performance can be a performance of two distinct works; and so also it seems clear that the production of a given performance can be guided by the requirements for correct examples of two works at once. This can happen in two sorts of ways. If works W and W' are related in such a way that whatever W requires for correct performance W' also does, but not vice versa (there being matters which Wsettles in terms of correctness but which W' leaves optional), then, though W and W' are distinct works, whatever is a performance of W will also be one of W'. But even when works do not 'overlap' in this way, a group of performers, or even a single performer, can perform two works at once. This indeed is required by some of the works of Charles Ives. To perform them, hymns, folk songs, and patriotic songs must all be performed concurrently. Thus, on (4) as well as on (3), distinct works can share some, and even all, examples. However, on (4) the only cases of shared examples between two works W and W' will be those in which a performance is guided both by the criteria for correct examples of W and by those for correct examples of W'. And this limitation does not hold on (3).

But though there are a number of significant differences between the conception of a musical work offered us by (3) and that offered us by (4), none of the differences thus far pointed out seem to provide a solid reason for preferring either of (3) or (4) to the other. On some issues, (3) may give us a more 'natural' understanding; on others, (4). But on none of these issues does either seem to give us a clearly mistaken understanding. And though the implications of the two views diverge on more issues than we have cited, I do not think that these other divergent implications yield any more decisive reason for preferring one view to the other. Though the kinds with which each view proposes to identify a given musical work both exist and are definitely distinct from each other, yet it is simply not clear which of these different kinds is identical with the work. The situation

seems to be that when we refer to and speak of what we regard as art works, we, in all likelihood, do not with definiteness mean to pick out entities of either sort as opposed to those of the other. For on most matters entities of these two sorts do not differ. And the matters where they do differ are so far off on the edge of our normal concern in the arts that we have never had to make up our minds as to which of these sorts of entities we intend to be dealing with.

It is possible, of course, that future developments in the arts will force us to make up our minds. And perhaps those developments are already upon us. For example, John Cage's work 4 feet 33 inches requires no particular sorts of sounds or sound-sequences whatsoever. There are requirements for a correct performance of the work; namely that the pianist keep his hands poised above a piano keyboard for 4 minutes and 33 seconds. And there are sounds to be listened to, namely, the sounds produced by the audience as they gradually realize what is being perpetrated. But the requirements include no specifications concerning sounds whatsoever. Thus, it is obvious that (3) simply lacks application to this case. (4), though, is still relevant. And if works such as this are eventually regarded as works of music, a decisive shift away from (3) toward (4) will have occurred.⁶

V. What Is It to Compose?

On either of the two views we have been considering, a composer of a musical work can be thought of as one who determines what constitutes correctness of performances of the work. And such determination of correctness has in turn two phases. The composer must think of, or consider, the correctness-conditions in question. And in addition, since in the course of composing a work he normally considers a great many more such than he actually settles on, he must certify these as those he wants. This much is essential to being a composer.

But normally a composer does more than determine what constitutes correctness of performance. Normally he also produces a score. Now, as we remarked earlier, a typical function of a score is to provide specifications for producing (correct) examples of the work associated with the score. Yet it does seem possible for a composer to determine a set of correctness-conditions which he knows to be impossible of being followed by any present performers on any extant or anticipated instruments. And it does seem possible for the composer to score such a work. Of course, he would not expect to hear it, and neither would he think of his score as providing specifications for performances. The score would just be the composer's *record* of his determination. It seems in fact that this is what every score is. Most scores function and are meant to function to guide performances. But what is true of every score is that it is a record of the

Toward an Ontology

artist's determination of correctness-conditions. If the record is in addition publicly legible, then it can also serve to communicate to others a knowledge of the conditions, and thus of the work. Musical afficionados can then become acquainted with the work by reading the score, and some may even thereby get some enjoyment from it.

Typically, then, there are at least these two activities involved in composing a work of music: The artist determines what constitutes correctness of performance, and he makes a record of his determination. Normally, of course, these two activities do not take place in neat separation. But sometimes they do. Mozart said that he imagined whole symphonies in his head. Housman said that he imagined poems while shaving. And concerning such cases, a question to consider is whether thereby an art work has been composed. Can one compose "in one's head"? Well, one can determine correctness-conditions in one's head, but one cannot in one's head *record* the determination. Thus, depending on whether one regards recording one's determination as necessary for composing a musical or literary work, different answers will be given.

A consequence of what we have been saying is that two people can compose the same work. For surely it is possible for two people to determine and record the same correctness-conditions. Thus, Beethoven's *Opus 111* is not necessarily just an opus of Beethoven. Indeed, it is not necessarily an opus of Beethoven at all. So also, the same musical work can in principle be known and performed in two different and independent cultures.

Does the artist, by composing his musical work, thereby also *create* it? That is, does he bring it into existence? If (4) is the correct theory as to the nature of the musical work, so that a musical work is a performance-kind, then it certainly seems plausible to hold that he does, at least if composing is understood as consisting just in the determination of correctness-conditions. For on (4) there can be no examples of a work which are not performances thereof. And to perform the work, one must know what is required of something if it is to be a correct example. But no one can know what these correctness-conditions are until they have been determined by someone or other. And for someone to determine the correctness-conditions is just to compose the work. On the other hand, composing the work would seem sufficient for bringing it into existence. Certainly it does not seem necessary that it also be performed. For there seems nothing contradictory in the notion of unperformed musical works.

But if (3) is the correct theory as to the nature of a musical work, it is not plausible to hold that in composing one creates. For on (3) a work may have examples which are not performances. And so there is nothing to prevent its having examples before performances have been made possible by the determination of correctness-conditions. But, surely, if there are examples of a work at a given time, then the work exists at that time. Thus, if (3) is correct, composing a work cannot in general be viewed as bringing it into existence.

But what, then, on (3), are the existence criteria for musical works? One possible view is that there exists such a work as W at time t if and only if W is being exemplified at t. But this view has the implausible consequence that musical works not only come into existence and go out, but that most of them exist intermittently. For on this view, the work exists when and only when it is being exemplified. And rare is the musical work which has no pair of exemplifications such that there is some time, between the occurrence of members of the pair, when the work is not being exemplified.

An alternative view would be that there exists such a work as W if and only if W is being exemplified or has been exemplified. But this view has the consequence that there cannot be a musical work which has not been exemplified. In fact, however, the contemporary literature concerning music is filled with the laments of composers whose works go unexemplified.

So perhaps the best view is that a musical work W exists just in case it is *possible* that there be an exemplification of W. For this view has none of the untoward consequences of the other views. On this view, it would not be possible for a work to be composed but not exist; on this view, a work would not cease to exist when all exemplifications ceased; and on this view, there could be unexemplified works.

It should be noticed, though, that on this view musical works exist everlastingly. For if it is ever possible that there be something which is an example of *Opus 111*, then it is always possible. Neither by composing nor by any other activity on his part does a composer bring his work into existence. Rather, if (3) is correct, the composer should be thought of as a selector rather than as a creator. To compose would be to select a certain kind of sound-occurrence. The only thing a composer would normally bring into existence would be a token (copy) of his score. Creation would be confined to token creation. Furthermore, since the selection of the work occurs in the process of determining its correctness-conditions, such determination would have to be viewed as consisting in *discovering* the conditions. By contrast, on the view that the artist brings his work into existence by composing it, determination of the conditions for correctness can best be thought of as consisting in *devising* the conditions.

It must be admitted that there is something odd in thinking of musical works as existing everlastingly, waiting to be selected and recorded. But perhaps the correct view is that though the entity which is a musical work *exists* everlastingly, it is not a *musical work* until some composer does something to it. If so, then in answer to the question, "What must be done to a kind in order to make it a musical work?", one can take one's stand

Toward an Ontology

at at least two different points. One can hold that it is not a musical work until someone has determined its correctness-conditions, or one can hold that it is not a musical work until its correctness-conditions have been recorded as well as determined.

VI. How to Tell Correctness

Our discussion concerning the ontological status of art works has concentrated on music. The detailed application to the other arts of the points we have made can be left to the reader. But two final matters must be considered. One is this: Why can paintings and sculptures not be viewed as single-exampled kinds rather than as physical objects, thereby giving us a "unified theory" of art works? P. F. Strawson, after saying that "in a certain sense, paintings and works of sculpture" are types, adds this footnote:

The mention of paintings and works of sculpture may seem absurd. Are they not particulars? But this is a superficial point. The things the dealers buy and sell are particulars. But it is only because of the empirical deficiencies of reproductive techniques that we identify these with the works of art. Were it not for these deficiencies, the original of a painting would have only the interest which belongs to the original manuscript of a poem. Different people could look at exactly the same painting in different places at the same time, just as different people can listen to exactly the same quartet at different times in the same place. ([6]:231.)

The situation is not quite as Strawson represents it, however. Of course there is nothing impossible in a certain object-work's having but one object. But object-works are norm-kinds, and being such they have associated with them certain requirements for something's being a correct example of the work. What is different in the case of paintings is that there are no such associated requirements. There simply are no requirements for something's being a correct example of some kind of which *The Odalesque* is the premier example. Of course, one can pick out things which to a certain close degree *resemble* this painting. There is a kind corresponding to them, and the painting is an example of it. But this is not a norm-kind, and none of our names of paintings are names of such entities.

Secondly, a question which has been pressing for a long time is this: How do we tell what constitutes a correct example of some art work? By now, however, the question has almost answered itself. In the case of works produced by some artist, the answer is that we try to discover the relevant features of that artifact which the artist produced (or which he arranged to have produced) as a record of his selection and as a guide or production-item for the making of examples. Of course, we will often discover that we cannot find out with any surety what the relevant features of that artifact were (are). We may no longer have the poet's original copy of the poem nor any very reliable evidence as to what it was like in crucial respects. Or we may have several copies from the poet's hand and not know which he authenticated. Or we may have an original authenticated copy but it may contain mistakes made by the poet, and we may find it impossible to determine which of various possibilities he had in mind. Or we may have an original, authenticated, and correct copy, but we may no longer know how to interpret all the symbols. In all such cases and many others we simply have to acknowledge that we are to some extent uncertain as to what constitutes a correct example. To that extent, we are also uncertain as to the character of the work. Yet it is clear what we must look for: the features of that original artifact.

In the case of those art works sustained in the memory of a culture and for which there is no artifact functioning as guide or production-item, we simply have to find out what the culture would regard as a correct and what it would regard as an incorrect example of the work—which is the same as finding out what the culture takes the art work to be like in those respects.⁷

References

- [1] Collingwood, R. G., *The Principles of Art* (Oxford: Oxford University Press, 1938).
- [2] Harrison, Andrew, "Works of Art and Other Cultural Objects," *Proceedings* of the Aristotelian Society, XVIII (1967–1968), 105–128.
- [3] MacDonald, Margaret, "Art and Imagination," Proceedings of the Aristotelian Society LIII (1952-53), 205-226.
- [4] Margolis, Joseph, *The Language of Art and Art Criticism* (Detroit: Wayne State University Press, 1965).
- [5] Stevenson, C. L., "On 'What Is a Poem?," Philosophical Review, LXVI (1957): 329-362.
- [6] Strawson, P. F., Individuals (London: Methuen, 1959).
- [7] Wellek, R., and A. Warren, *Theory of Literature* (New York: Harcourt, Brace and World, 1956).
- [8] Wollheim, Richard, Art and Its Objects (New York: Harper and Row, 1968).
- [9] Wolterstorff, Nicholas, On Universals (Chicago: University of Chicago Press, 1970).

Notes

1. The general drift of the distinctions made above has been acquiring something of a consensus in recent years among those who have concerned them-

Toward an Ontology

selves with the nature of works of art. See Harrison [2], MacDonald [3], Margolis [4], Stevenson [5], Wellek and Warren [7], and Wollheim [8].

2. The circular reference to W, in (1) and all that follows, is harmless. For we are not discussing how to identify (pick out) art works. Instead, assuming that we are acquainted with art works and that we can identify them, we are discussing their ontological status. Also, this formula and the following ones are not meant to be restricted to works which *actually have* examples. Strictly, it should read "whose examples are or would be occurrences," and "are or would be occurrences of."

3. A question to consider is whether or not this kind is identical with the set of those sound-sequences. Of course the *kind* in question here, a kind whose examples are certain sound-sequence-occurrences, is not identical with the *set* of those same sound-sequence-occurrences—for reasons already rehearsed. But that is not what we are considering. Rather, the question is this: Might a certain set of sound-sequences be identical with the kind whose examples are the occurrences of the members of that set?

A view concerning the nature of a work of music which has a great deal of initial plausibility is that it is a certain sound-sequence. When one notices, however, that among correct performances there is often wide variation in the sound-sequences instantiated, then it is clear that this initial view must be modified. The least modification would seem to be that a work of music is a *set* of sound-sequences, namely, that set whose members can occur as a correct performance. Now this line of thought concerning the nature of the work of music is different from the line pursued in the paper. There, the line pursued is that a work of music is a certain sound-sequence or set of sound-sequence. The question posed, however, is whether these two lines of thought are incompatible.

I see no reason for thinking that they are. So far as I can see, a set of soundsequences is identical with the kind whose examples are occurrences of the members of the set. If this is correct, then the proposal made by (3) is identical with this:

(3a) W is identical with the set of those sound-sequences which performances of W are occurrences of.

4. Throughout, in speaking of specifications I have been thinking of specifications for *correct* performances. Possibly some of the specifications to be found in scores are not such but are instead specifications for *excellent* performances. This may be true, for example, for the registrations suggested in the scores for certain organ works. I suspect that in the case of works of folk art for which no scores exist, it is often difficult or even impossible to distinguish between what is *correct* and what is *excellent*.

5. It should be remarked that what is required of something if it is to be a correct performance of some work of music is often not just that the performance *sound* a certain way. It may be required, for example, that the sounds be produced by certain specific instruments, whether or not other instruments could make the same sounds. Is this the case for electronic music? For a correct performance of some work for magnetic tape, must the sounds be produced by

playing a tape (a tape, furthermore, which is either the original or genetically derived therefrom)?

6. More than just such a shift would be involved in such a change of concept. In addition, the claim that we made in beginning this discussion, 'In performing a musical work one produces an occurrence of a certain sound-sequence', would then have become false.

7. In thinking through the issues discussed in this paper, I have received a great deal of assistance from my colleagues in the Philosophy Department at Calvin College. I have also received valuable advice from the editor of $No\hat{u}s$, from a reader for $No\hat{u}s$, and from Kendall Walton.

The Ontological Peculiarity of Works of Art

JOSEPH MARGOLIS

In the context of discussing the nature of artistic creativity, Jack Glickman offers the intriguing comment, "Particulars are made, types created."¹ The remark is a strategic one, but it is either false or misleading; and its recovery illuminates in a most economical way some of the complexities of the creative process and of the ontology of art. Glickman offers as an instance of the distinction he has in mind, the following: "If the chef created a new soup, he created a new kind of soup, a new recipe; he may not have made the soup [that is, some particular pot of soup]."² If, by 'kind,' Glickman means to signify a universal of some sort, then, since universals are not created (or destroyed), it could not be the case that the chef "created" a new soup, a new kind of soup.³ It must be the case that the chef, in making a particular (new) soup, created (to use Glickman's idiom) a kind of soup; otherwise, of course, that the chef created a new (kind of) soup may be evidenced by his having formulated a relevant recipe (which locution, in its own turn, shows the same ambiguity between type and token).

What is important, here, may not meet the eye at once. But if he can be said to create (to invent) a (new kind of) soup and if universals cannot be created or destroyed, then, in creating a kind of soup, a chef must be creating something other than a universal. The odd thing is that a kind of soup thus created is thought to be individuated among related creations; hence, it appears to be a particular of some sort. But it also seems to be an abstract entity if it is a particular at all. Hence, although it may be possible to admit abstract particulars in principle,⁴ it is difficult to concede that what the chef created is an abstract particular *if* one may be said to have *tasted* what the chef created. The analogy with art is plain. If Picasso

From The Journal of Aesthetics and Art Criticism, XXXVI (1977), 45-50. Reprinted by permission of the author and The Journal of Aesthetics and Art Criticism.

11.

created a new kind of painting, in painting Les Demoiselles d'Avignon, it would appear that he could not have done so by using oils.

There is only one solution if we mean to speak in this way. It must be possible to instantiate particulars (of a certain kind or of certain kinds) as well as to instantiate universals or properties. I suggest that the term 'type' -in all contexts in which the type/token ambiguity arises-signifies abstract particulars of a kind that can be instantiated. Let me offer a specimen instance. Printings properly pulled from Dürer's etching plate for Melancholia I are instances of that etching; but bona fide instances of Melancholia I need not have all their relevant properties in common, since later printings and printings that follow a touching up of the plate or printings that are themselves touched up may be genuine instances of Melancholia I and still differ markedly from one another-at least to the sensitive eye. Nothing, however, can instantiate a property without actually instantiating that property.⁵ So to think of types as particulars (of a distinctive kind) accommodates the fact that we individuate works of art in unusual ways-performances of the same music, printings of the same etching, copies of the same novel-and that works of art may be created and destroyed. If, further, we grant that, in creating a new soup, a chef stirred the ingredients in his pot and that, in creating a new kind of painting, in painting Les Demoiselles, Picasso applied paint to canvas, we see that it is at least normally the case that one does not create a new kind of soup or a new kind of painting without (in Glickman's words) making a particular soup or a particular painting.

A great many questions intrude at this point. But we may bring this much at least to bear on an ingenious thesis of Glickman's. Glickman wishes to say that, though driftwood may be construed as a creation of "beach art," it remains true that driftwood was made by no one, is in fact a natural object, and hence that "the condition of artifactuality" so often claimed to be a necessary condition of being a work of art, is simply "superfluous."6 "I see no conclusive conceptual block," says Glickman, "to allowing that the artwork [may] be a natural object."7 Correspondingly, Duchamp's "readymades" are created out of artifacts, but the artist who created them did not actually make them. Glickman's thesis depends on the tenability of his distinction between making and creating; and as we have just seen, one does not, in the normal case at least, create a new kind of art (type) without making a particular work of that kind (that is, an instance of that particular, the type, not merely an instance of that kind, the universal). In other words, when an artist creates (allowing Glickman's terms) "beach art," a new kind of art, the artist makes a particular instance (or token) of a particular type-much as with wood sculpture, this unique token of this driftwood composition. He cannot create the universals that are newly instantiated since universals cannot be created. He can create a

The Ontological Peculiarity

new type-particular, a particular of the kind "beach art" but he can do so only by making a token-particular of that type. What this shows is that we were unnecessarily tenative about the relation between types and tokens. We may credit an artist with having created a new type of art; but there are no types of art that are not instantiated by some token-instances or for which we lack a notation by reference to which (as in the performing arts) admissible token-instances of the particular type-work may be generated.

The reason for this strengthened conclusion has already been given. When an artist creates his work using the materials of his craft, the work he produces must have some perceptible physical properties at least; but it could not have such properties if the work were merely an abstract particular (or, of course, a universal). Hence, wherever an artist produces his work directly, even a new kind of work, he cannot be producing an abstract particular. Alternatively put, to credit an artist with having created a new type of art-a particular art-type-we must (normally) be thus crediting him in virtue of the particular (token) work he has made. In wood sculpture, the particular piece an artist makes is normally the unique instance of his work; in bronzes, it is more usually true that, as in Rodin's peculiarly industrious way, there are several or numerous tokens of the very same (type) sculpture. But though we may credit the artist with having created the type, the type does not exist except instantiated in its proper tokens. We may, by a kind of courtesy, say that an artist who has produced the cast for a set of bronzes has created an artwork-type; but the fact is: (i) he has made a particular cast, and (ii) the cast he's made is not the work *created*. Similar considerations apply to an artist's preparing a musical notation for the sonata he has created: (i) the artist makes a token instance of a type notation; and (ii) all admissible instances of his sonata are so identified by reference to the notation. The result is that, insofar as he creates a type, an artist must make a token. A chef's assistant may actually make the first pot of soup-of the soup the chef has created, but the actual soup exists only when the pot is made. Credit to the chef in virtue of his recipe is partly an assurance that his authorship is to be acknowledged in each and every pot of soup that is properly an instance of his creation, whether he makes it or not; and it is partly a device for individuating proper token instances of particular type objects. But only the token instances of a type actually exist and aesthetic interest in the type is given point only in virtue of one's aesthetic interest in actual or possible tokens-as in actual or contemplated performances of a particular sonata.

But if these distinctions be granted, then, normally, an artist makes a token of the type he has created. He could not create the type unless he made a proper token or, by the courtesy intended in notations and the like, he provided a schema *for* making proper tokens of a particular type. Hence, what is normally made, in the relevant sense, is a token of a type. It must

be the case, then, that when Duchamp created his *Bottlerack*, although he did not make a bottlerack—that is, although he did not manufacture a bottlerack, although he did not first bring it about that an object instantiate being a bottlerack—nevertheless, *he did make a token of the Bottlerack*. Similarly, although driftwood is not a manufactured thing, when an artist creates (if an artist can create) a piece of "beach art," *he makes a token of that piece of "beach art.*" He need not have made the driftwood. But that shows (i) that artifactuality is not superfluous, though it is indeed puzzling (when displaying otherwise untouched driftwood in accord with the developed sensibilities of a society can count as the creation of an artwork); and (ii) it is not the case (contrary to Glickman's claims) that a natural object can *be* a work of art or that a work can be created though *nothing* be made.

We may summarize the ontological peculiarities of the type/token distinction in the following way: (i) types and tokens are individuated as particulars; (ii) types and tokens are not separable and cannot exist separately from one another; (iii) types are instantiated by tokens and 'token' is an ellipsis for 'token-of-a-type'; (iv) types and tokens may be generated and destroyed in the sense that actual tokens of a novel type may be generated, the actual tokens of a given type may be destroyed, and whatever contingencies may be necessary to the generation of actual tokens may be destroyed or disabled; (v) types are actual abstract particulars in the sense only that a set of actual entities may be individuated as tokens of a particular type: (vi) it is incoherent to speak of comparing the properties of actual token- and type-particulars as opposed to comparing the properties of actual particular tokens-of-a-type; (vii) reference to types as particulars serves exclusively to facilitate reference to actual and possible tokens-of-atype. These distinctions are sufficient to mark the type/token concept as different from the kind/instance concept and the set/member concept.

Here, a second ontological oddity must be conceded. The driftwood that is made by no one is not the (unique) token that is made of the "beach art" creation; and the artifact, the bottlerack, that Duchamp did not make is not identical with the (probably but not necessarily unique) token that Duchamp did make of the creation called *Bottlerack*. What Duchamp made was a token of *Bottlerack*; and what the manufacturer of bottleracks made was a particular bottlerack that served as the material out of which Duchamp created *Bottlerack* by making a (probably unique) instance of *Bottlerack*. For, consider that Duchamp made something when he created *Bottlerack* but he did not make a bottlerack; also, that no one made the driftwood though someone (on the thesis) made a particular composition of art using the driftwood. If the bottlerack were said to be identical with Duchamp's *Bottlerack* (the token or the type), we should be contradicting ourselves; the same would be true of the driftwood case. Hence, in spite of

The Ontological Peculiarity

appearances, there must be an ontological difference between tokens of artwork-types and such physical objects as bottleracks and driftwood that can serve as the materials out of which they are made.

My own suggestion is that (token) works of art are embodied in physical objects, not identical with them. I should argue, though this is not the place for it, that persons, similarly, are embodied in physical bodies but not identical with them.8 The idea is that not only can one particular instantiate another particular in a certain way (tokens of types) but one particular can embody or be embodied in another particular with which it is (necessarily) not identical. The important point is that identity cannot work in the anomalous cases here considered (nor in the usual cases of art) and that what would otherwise be related by way of identity are, obviously, particulars. Furthermore, the embodiment relationship does not invite dualism though it does require a distinction among kinds of things and among the kinds of properties of things of such kinds. For example, a particular printing of Dürer's Melancholia I has the property of being a particular token of Melancholia I (the artwork type), but the physical paper and physical print do not, on any familiar view, have the property of being a token of a type. Only objects having such intentional properties as that of "being created" or, as with words, having meaning or the like can have the property of being a token of a type.⁹

What is meant in saying that one particular is embodied in another is: (i) that the two particulars are not identical; (ii) that the existence of the embodied particular presupposes the existence of the embodying particular; (iii) that the embodied particular possesses some of the properties of the embodying particular; (iv) that the embodied particular possesses properties that the embodying particular does not possess; (v) that the embodied particular possesses properties of a kind that the embodying particular cannot possess; (vi) that the individuation of the embodied particular presupposes the individuation of the embodying particular. The 'is' of embodiment, then, like the 'is' of identity and the 'is' of composition¹⁰ is a logically distinctive use. On a theory, for instance a theory about the nature of a work of art, a particular physical object will be taken to embody a particular object of another kind in such a way that a certain systematic relationship will hold between them. Thus, for instance, a sculptor will be said to make a particular sculpture by cutting a block of marble: Michelangelo's Pietà will exhibit certain of the physical properties of the marble and certain representational and purposive properties as well; it will also have the property of being a unique token of the creation Pietà. The reason for theorizing thus is, quite simply, that works of art are the products of culturally informed labor and that physical objects are not. So seen, they must possess properties that physical objects, qua physical objects, do not and cannot possess. Hence, an identity thesis leads to palpable contradictions. Furthermore, the conception of embodiment promises to facilitate a non-reductive account of the relationship between physical nature and human culture, without dualistic assumptions. What this suggests is that the so-called mind/body problem is essentially a special form of a more general culture/nature problem. But that is another story.

A work of art, then, is a particular. It cannot be a universal because it is created and can be destroyed; also, because it possesses physical and perceptual properties. But it is a peculiar sort of particular, unlike physical bodies, because (i) it can instantiate another particular; and (ii) it can be embodied in another particular. The suggestion here is that all and only culturally emergent or culturally produced entities exhibit these traits. So the ontological characteristics assigned are no more than the most generic characteristics of art: its distinctive nature remains unanalyzed. Nevertheless, we can discern an important difference between these two properties, as far as art is concerned. For, the first property, that of being able to instantiate another particular, has only to do with individuating works of art and whatever may, contingently, depend upon that; while the second property has to do with the ontologically dependent nature of actual works of art. This is the reason we may speak of type artworks as particulars. They are heuristically introduced for purposes of individuation, though they cannot exist except in the sense in which particular tokens of particular type artworks exist. So we can never properly compare the properties of a token work and a type work.¹¹ What we may compare are alternative tokens of the same type-different printings of the same etching or different performances of the same sonata. In short, every work of art is a token-of-atype; there are no tokens or types tout court. Again, this is not to say that there are no types or that an artist cannot create a new kind of painting. It is only to say that so speaking is an ellipsis for saying that a certain set of particulars are tokens of a type and that the artist is credited with so working with the properties of things, instantiated by the members of that set, that they are construed as tokens of a particular type.

So the dependencies of the two ontological traits mentioned are quite different. There are no types that are separable from tokens because there are no tokens except tokens-of-a-type. The very process for individuating tokens entails individuating types, that is, entails individuating different sets of particulars as the alternative tokens of this or that type. There is nothing left over to discuss. What may mislead is this: the concept of different tokens of the same type is intended, in the arts, to accommodate the fact that the aesthetically often decisive differences among tokens of the same type (alternative performances of a sonata, for instance) need not matter as far as the individuation of the (type) work is concerned.¹² But particular works of art cannot exist except as embodied in physical objects. This is simply another way of saying that works of art are culturally emergent

The Ontological Peculiarity

entities; that is, that works of art exhibit properties that physical objects cannot exhibit, but do so in a way that does not depend on the presence of any substance other than what may be ascribed to purely physical objects. Broadly speaking, those properties are what may be characterized as functional or intentional properties and include design, expressiveness, symbolism, representation, meaning, style, and the like. Without prejudice to the nature of either art or persons, this way of viewing art suggests a very convenient linkup with the functional theory of mental traits.¹³ Be that as it may, a reasonable theory of art could hold that when physical materials are worked in accord with a certain artistic craft then there emerges, culturally, an object embodied in the former that possesses a certain orderly array of functional properties of the kind just mentioned. Any object so produced may be treated as an artifact. Hence, works of art exist as fully as physical objects but the condition on which they do so depends on the independent existence of some physical object itself. Works of art, then, are culturally emergent entities, tokens-of-a-type that exist embodied in physical objects.

Notes

1. Jack Glickman, "Creativity in the Arts," in Lars Aagaard-Mogensen, ed., *Culture and Art* (Nyborg and Atlantic Highlands, N.J.: F. Løkkes Forlag and Humanities Press, 1976), p. 140.

2. Loc. cit.

3. Difficulties of this sort undermine the recent thesis of Nicholas Wolterstorff's, namely, that works of art are in fact kinds. Cf. Nicholas Wolterstorff, "Toward an Ontology of Art Works," *Nous*, IX (1975), 115–142. Also Joseph Margolis, *Art and Philosophy* (Atlantic Highlands, N.J.: Humanities Press, 1978), ch. 5.

4. Cf. Nelson Goodman, *The Structure of Appearance* (Indianapolis: Bobbs-Merrill, 2nd ed., 1966).

5. The subtleties of the type/token distinction are discussed at length in Margolis, *loc. cit.*

6. Op. cit., p. 144.

7. Ibid., p. 143.

8. A fuller account of the concept of embodiment with respect to art is given in *Art and Philosophy*, ch. 1. I have tried to apply the notion to all cultural entities—that is, persons, works of art, artifacts, words and sentences, machines, institutionalized actions, and the like—in *Persons and Minds* (Dordrecht: D. Reidel, 1977). Cf. also "On the Ontology of Persons," *New Scholasticism*, X (1976), 73-84.

9. This is very close in spirit to Peirce's original distinction between types and tokens. Cf. *Collected Papers of Charles Sanders Peirce*, ed. Charles Hartshorne and Paul Weiss (Cambridge: Harvard University Press, 1939), Vol. IV, par. 537.

10. Cf. David Wiggins, *Identity and Spatio-Temporal Continuity* (Oxford: Basil Blackwell, 1967).

11. This is one of the signal weaknesses of Wolterstorff's account, *loc. cit.*, as well as of Richard Wollheim's account; cf. *Art and Its Objects* (New York: Harper, 1968).

12. This counts against Nelson Goodman's strictures on the individuation of artworks. Cf. Languages of Art (Indianapolis: Bobbs-Merrill, 1968) and Joseph Margolis, "Numerical Identity and Reference in the Arts," British Journal of Aesthetics, X (1970), 138-146.

13. Cf. for instance Hilary Putnam, "Minds and Machines," in Sidney Hook, ed., *Dimensions of Mind* (Englewood Cliffs, N.J.: Prentice-Hall, 1960), and Jerry Fodor, *Psychological Explanation* (New York: Random House, 1968).

Bibliography to Part Four

The idealist theory of art, associated chiefly with the work of R. G. Collingwood and Benedetto Croce, is most clearly represented in:

R. G. Collingwood, Principles of Art (Oxford, 1935);

W. B. Gallie, "The Function of Philosophical Aesthetics," *Mind*, LVII (1948), 302-321;

John Hospers, "The Croce-Collingwood Theory of Art," *Philosophy*, XXXI (1956), 291–308.

The phenomenological account, which resists both the idealist and materialist alternatives, appears most forcefully in:

Roman Ingarden, "Aesthetic Experience and Aesthetic Object," Philosophy and Phenomenological Research, XXI (1961);

Roman Ingarden, "Artistic and Aesthetic Values," British Journal of Aesthetics, IV (1964), 198-213;

Roman Ingarden, *The Cognition of the Literary Work*, trans. Ruth Crowley and Kenneth R. Olson (Evanston, 1973);

See also, however:

Mikel Dufrenne, *The Phenomenology of Aesthetic Experience*, trans. Edward S. Casey *et al.* (Evanston, 1973), for critical adjustments in the theory;

and:

Henri Focillon, Life of Forms in Art, trans. Charles Beecher Hogan (New York, 1948);

Susanne Langer, Feeling and Form (New York, 1953);

J.-P. Sartre, *The Psychology of Imagination*, trans. (New York: 1948); which repay comparison.

- On the type/ token distinction and the treatment of works of art as universals, see: Jay E. Bachrach, "Type and Token and the Identification of the Work of Art," *Philosophy and Phenomenological Research*, XXXI (1971), 415–420;
 - A. Harrison, "Works of Art and Other Cultural Objects, Proceedings of the Aristotelian Society, LXVII (1968), 105-128;

Richard Rudner, "The Ontological Status of the Esthetic Object," Philosophy and Phenomenological Research, X (1949-50), 380-389;

Charles L. Stevenson, "On the Reasons That Can Be Given for the Interpretation of a Poem," in Joseph Margolis (ed.), *Philosophy Looks at the Arts* (New York, 1962, 1st ed.);

Jeanne Wacker, "Particular Works of Art," Mind, LIX (1960), 223-233.

These issues are closely linked to the cultural nature of art; hence, to the attempt to define or characterize art in terms of institutions or the contrast with "real things." On the latter issue, see particularly:

Gregory Battcock, The New Art (New York, 1966);

- Timothy Binkley, "Deciding about Art," in Lars Aagaard-Mogensen (ed.), Culture and Art (Nyborg and Atlantic Highlands, 1976);
- Arthur C. Danto, "Artworks and Real Things," *Theoria*, XXXIX (1973), 1–17;

Lucy Lippard, Six Years: The Dematerialization of the Art Object from 1966 to 1972 (New York, 1973);

Ursula Meyer, Conceptual Art (New York, 1972).

Part Five Representation in Art

The contemporary discussion of representational art is largely, though not entirely, associated with the appearance of Ernst Gombrich's Art and Illusion (1960). There, Gombrich insists that there is no innocent eye. Particularly in the visual arts, the temptation arises to construe representation in terms of given visual resemblances, to dwell on visual illusions, and to omit therefore the enormously complex background of beliefs, theories, assumptions and the like against which one "sees" visual objects as we do. But the attempt to develop a general account of representation ranging over all the arts and even beyond the arts suggests the inadequacythough not necessarily the irrelevance-of considerations of sensory similarity and perceptual illusion. Gombrich (1963) in fact links representation and (visual) illusion too closely. And if he may be taken to fix one pole of the current discussion of representation-emphasizing conditions of perception, Nelson Goodman (to some extent, in response to Gombrich's own claims) may be taken to fix the opposite pole-emphasizing rather the logical conditions of representation and, correspondingly, the conceptual and non-conceptual conditions of our appreciation of representation. In Goodman's hands (1976, 2nd ed.), the development leads to a larger view about the very nature of art (see Part Three) and adumbrates an even more comprehensive theory about the characteristic activities of man.

Goodman definitely shows that resemblance cannot in any independently operative way be said to be a necessary condition of representation (typically in painting), let alone a necessary and sufficient condition. He takes denotation to be "the core of representation" and to be "independent of resemblance." On the other hand, Gombrich's emphasis had been on illusion, and illusion suggests a disposition of some sort to construe certain visual displays in terms of resemblances—to some extent in spite of one's background beliefs or, at any rate, of variable and transient beliefs. Objections to the innocent eye need not entail that there are no favored resemblances, given the larger functioning of perception in survival, to which the human eye is prone; these may be due, on different theories, to the convergent features of all human cultures or to underlying biological regularities. In effect, the admission is the reverse side of Gombrich's thesis. Goodman will have none of this, however, for he believes that there are no favored relations at all of such a kind. The issue has enormous importance because Goodman is committed to an utterly uncompromising form of nominalism; the possibility of biologically grounded resemblances suggests a basis for the admission of universals—or, at any rate, a fuller reconciliation with realism. It is, however, in exploring representation as a classificatory procedure, involving one-term or two-term predicates, that Goodman excels.

Richard Wollheim (1965) pursues Gombrich's issue, partly in sympathy with Gombrich's distinctions, partly in opposition. He favors the view, to some extent convergent with both Gombrich's and Goodman's (though he does not discuss Goodman), that representation has an intentional aspect. But he also wishes, against Gombrich, to distinguish sharply between representation and illusion: the first concerns the way in which certain elements function intentionally without affecting our perceptual beliefs (or without regard to that); the second, as in *trompe l'oeil*, may even override our beliefs.

Patrick Maynard (1972) also pursues Gombrich's distinction but more in terms of explicating our sense of realism, fidelity, perceptual convincingness, without falling afoul of Goodman's criticism of Gombrich and yet without conceding a purely relativistic view of representational realism. So Maynard, too, avoids construing representation in terms of illusion; but he attempts to develop a conception of pictorial realism that is not illusionistic and is not merely controlled by representational conventions. In this regard, returning to the psychology—even the biology—of perception, he is inclined to resist Goodman's polar extreme at the same time that he avoids Gombrich's fatal linkage. But apart from quarrels about details, the admission of representational properties requires a counterpart admission of the complexity of the nature of aesthetic experience (see Part One) and of the nature of artworks (see Parts Three and Four).

12.

Reality Remade NELSON GOODMAN

Art is not a copy of the real world. One of the damn things is enough.*

1. Denotation

Whether a picture ought to be a representation or not is a question much less crucial than might appear from current bitter battles among artists, critics, and propagandists. Nevertheless, the nature of representation wants early study in any philosophical examination of the ways symbols function in and out of the arts. That representation is frequent in some arts, such as painting, and infrequent in others, such as music, threatens trouble for a unified aesthetics; and confusion over how pictorial representation as a mode of signification is allied to and distinguished from verbal description on the one hand and, say, facial expression on the other is fatal to any general theory of symbols.

The most naive view of representation might perhaps be put somewhat like this: "A represents B if and only if A appreciably resembles B," or "A represents B to the extent that A resembles B." Vestiges of this view, with assorted refinements, persist in most writing on representation. Yet more error could hardly be compressed into so short a formula.

Some of the faults are obvious enough. An object resembles itself to the maximum degree but rarely represents itself; resemblance, unlike representation, is reflexive. Again, unlike representation, resemblance is symmetric: B is as much like A as A is like B, but while a painting may represent the Duke of Wellington, the Duke doesn't represent the painting. Furthermore,

^{*}Reported as occurring in an essay on Virginia Woolf. I have been unable to locate the source.

Permission to reprint granted by Nelson Goodman. From Languages of Art, Chapter 1. © 1976, Hackett Publishing Company, Inc., Indianapolis.

in many cases neither one of a pair of very like objects represents the other: none of the automobiles off an assembly line is a picture of any of the rest; and a man is not normally a representation of another man, even his twin brother. Plainly, resemblance in any degree is no sufficient condition for representation.¹

Just what correction to make in the formula is not so obvious. We may attempt less, and prefix the condition "If A is a picture," Of course, if we then construe "picture" as "representation," we resign a large part of the question: namely, what constitutes a representation. But even if we construe "picture" broadly enough to cover all paintings, the formula is wide of the mark in other ways. A Constable painting of Marlborough Castle is more like any other picture than it is like the Castle, yet it represents the Castle and not another picture—not even the closest copy. To add the requirement that B must not be a picture would be desperate and futile; for a picture may represent another, and indeed each of the once popular paintings of art galleries represents many others.

The plain fact is that a picture, to represent an object,² must be a symbol for it, stand for it, refer to it; and that no degree of resemblance is sufficient to establish the requisite relationship of reference. Nor is resemblance *necessary* for reference; almost anything may stand for almost anything else. A picture that represents—like a passage that describes—an object refers to and, more particularly, *denotes*³ it. Denotation is the core of representation and is independent of resemblance.

If the relation between a picture and what it represents is thus assimilated to the relation between a predicate and what it applies to, we must examine the characteristics of representation as a special kind of denotation. What does pictorial denotation have in common with, and how does it differ from, verbal or diagrammatic denotation? One not implausible answer is that resemblance, while no sufficient condition for representation, is just the feature that distinguishes representation from denotation of other kinds. Is it perhaps the case that if A denotes B, then A represents B just to the extent that A resembles B? I think even this watered-down and innocuous-looking version of our initial formula betrays a grave misconception of the nature of representation.

2. Imitation

"To make a faithful picture, come as close as possible to copying the object just as it is." This simple-minded injunction baffles me; for the object before me is a man, a swarm of atoms, a complex of cells, a fiddler, a friend, a fool, and much more. If none of these constitute the object as it is, what else might? If all are ways the object is, then none is

the way the object is.⁴ I cannot copy all these at once; and the more nearly I succeeded, the less would the result be a realistic picture.

What I am to copy then, it seems, is one such aspect, one of the ways the object is or looks. But not, of course, any one of these at random not, for example, the Duke of Wellington as he looks to a drunk through a raindrop. Rather, we may suppose, the way the object looks to the normal eye, at proper range, from a favorable angle, in good light, without instrumentation, unprejudiced by affections or animosities or interests, and unembellished by thought or interpretation. In short, the object is to be copied as seen under aseptic conditions by the free and innocent eye.

The catch here, as Ernst Gombrich insists, is that there is no innocent eye.⁵ The eye comes always ancient to its work, obsessed by its own past and by old and new insinuations of the ear, nose, tongue, fingers, heart, and brain. It functions not as an instrument self-powered and alone, but as a dutiful member of a complex and capricious organism. Not only how but what it sees is regulated by need and prejudice.⁶ It selects, rejects, organizes, discriminates, associates, classifies, analyzes, constructs. It does not so much mirror as take and make; and what it takes and makes it sees not bare, as items without attributes, but as things, as food, as people, as enemies, as stars, as weapons. Nothing is seen nakedly or naked.

The myths of the innocent eye and of the absolute given are unholy accomplices. Both derive from and foster the idea of knowing as a processing of raw material received from the senses, and of this raw material as being discoverable either through purification rites or by methodical disinterpretation. But reception and interpretation are not separable operations; they are thoroughly interdependent. The Kantian dictum echoes here: the innocent eye is blind and the virgin mind empty. Moreover, what has been received and what has been done to it cannot be distinguished within the finished product. Content cannot be extracted by peeling off layers of comment.⁷

All the same, an artist may often do well to strive for innocence of eye. The effort sometimes rescues him from the tired patterns of everyday seeing, and results in fresh insight. The opposite effort, to give fullest rein to a personal reading, can be equally tonic—and for the same reason. But the most neutral eye and the most biased are merely sophisticated in different ways. The most ascetic vision and the most prodigal, like the sober portrait and the vitriolic caricature, differ not in how *much* but only in *how* they interpret.

The copy theory of representation, then, is stopped at the start by inability to specify what is to be copied. Not an object the way it is, nor all the ways it is, nor the way it looks to the mindless eye. Moreover, something is wrong with the very notion of copying any of the ways an object is, any aspect of it. For an aspect is not just the object-from-a-givendistance-and-angle-and-in-a-given-light; it is the object as we look upon or conceive it, a version or construal of the object. In representing an object, we do not copy such a construal or interpretation—we *achieve* it.⁸

In other words, nothing is ever represented either shorn of or in the fullness of its properties. A picture never merely represents x, but rather represents x as a man or represents x to be a mountain, or represents the fact that x is a melon. What could be meant by copying a fact would be hard to grasp even if there were any such things as facts; to ask me to copy x as a soandso is a little like asking me to sell something as a gift; and to speak of copying something to be a man is sheer nonsense. We shall presently have to look further into all this; but we hardly need look further to see how little is representation a matter of imitation.

The case for the relativity of vision and of representation has been so conclusively stated elsewhere that I am relieved of the need to argue it at any length here. Gombrich, in particular, has amassed overwhelming evidence to show how the way we see and depict depends upon and varies with experience, practice, interests, and attitudes. But on one matter Gombrich and others sometimes seem to me to take a position at odds with such relativity; and I must therefore discuss briefly the question of the conventionality of perspective.

3. Perspective

An artist may choose his means of rendering motion, intensity of light, quality of atmosphere, vibrancy of color, but if he wants to represent space correctly, he must—almost anyone will tell him—obey the laws of perspective. The adoption of perspective during the Renaissance is widely accepted as a long stride forward in realistic depiction. The laws of perspective are supposed to provide absolute standards of fidelity that override differences in style of seeing and picturing. Gombrich derides "the idea that perspective is merely a convention and does not represent the world as it looks," and he declares "One cannot insist enough that the art of perspective aims at a correct equation: It wants the image to appear like the object and the object like the image."⁹ And James J. Gibson writes: ". . . it does not seem reasonable to assert that the use of perspective in paintings is merely a convention, to be used or discarded by the painter as he chooses. . . When the artist transcribes what he sees upon a two-dimensional surface, he uses perspective geometry, of necessity."¹⁰

Obviously the laws of the behavior of light are no more conventional than any other scientific laws. Now suppose we have a motionless, monochromatic object, reflecting light of medium intensity only. The argument runs:¹¹—A picture drawn in correct perspective will, under specified conditions, deliver to the eye a bundle of light rays matching that delivered

by the object itself. This matching is a purely objective matter, measurable by instruments. And such matching constitutes fidelity of representation; for since light rays are all that the eye can receive from either picture or object, identity in pattern of light rays must constitute identity of appearance. Of course, the rays yielded by the picture under the specified conditions match not only those yielded by the object in question from a given distance and angle but also those yielded by any of a multitude of other objects from other distances and angles.¹² Identity in pattern of light rays, like resemblance of other kinds, is clearly no sufficient condition for representation. The claim is rather that such identity is a criterion of fidelity, of correct pictorial representation, where denotation is otherwise established.

If at first glance the argument as stated seems simple and persuasive, it becomes less so when we consider the conditions of observation that are prescribed. The picture must be viewed through a peephole, face on, from a certain distance, with one eye closed and the other motionless. The object also must be observed through a peephole, from a given (but not usually the same) angle and distance, and with a single unmoving eye. Otherwise, the light rays will not match.

Under these remarkable conditions, do we not have ultimately faithful representation? Hardly. Under these conditions, what we are looking at tends to disappear rather promptly. Experiment has shown that the eye cannot see normally without moving relative to what it sees;¹³ apparently, scanning is necessary for normal vision. The fixed eye is almost as blind as the innocent one. What can the matching of light rays delivered under conditions that make normal vision impossible have to do with fidelity of representation? To measure fidelity in terms of rays directed at a closed eye would be no more absurd. But this objection need not be stressed; perhaps enough eye motion could be allowed for scanning but not for seeing around the object.¹⁴ The basic trouble is that the specified conditions of observation are grossly abnormal. What can be the grounds for taking the matching of light rays delivered under such extraordinary conditions as a measure of fidelity? Under no more artificial conditions, such as the interposition of suitably contrived lenses, a picture far out of perspective could also be made to yield the same pattern of light rays as the object. That with clever enough stage-managing we can wring out of a picture drawn in perspective light rays that match those we can wring out of the object represented is an odd and futile argument for the fidelity of perspective.

Furthermore, the conditions of observation in question are in most cases not the same for picture and object. Both are to be viewed through a peephole with one transfixed eye; but the picture is to be viewed face on at a distance of six feet while the cathedral represented has to be looked at from, say, an angle of 45° to its facade and at a distance of two hundred feet. Now not only the light rays received but also the attendant conditions determine what and how we see; as psychologists are fond of saying, there is more to vision than meets the eye. Just as a red light says "stop" on the highway and "port" at sea, so the same stimulus gives rise to different visual experience under different circumstances. Even where both the light rays and the momentary external conditions are the same, the preceding train of visual experience, together with information gathered from all sources, can make a vast difference in what is seen. If not even the former conditions are the same, duplication of light rays is no more likely to result in identical perception than is duplication of the conditions if the light rays differ.

Pictures are normally viewed framed against a background by a person free to walk about and to move his eyes. To paint a picture that will under these conditions deliver the same light rays as the object, viewed under any conditions, would be pointless even if it were possible. Rather, the artist's task in representing an object before him is to decide what light rays, under gallery conditions, will succeed in rendering what he sees. This is not a matter of copying but of conveying. It is more a matter of 'catching a likeness' than of duplicating-in the sense that a likeness lost in a photograph may be caught in a caricature. Translation of a sort, compensating for differences in circumstances, is involved. How this is best carried out depends upon countless and variable factors, not least among them the particular habits of seeing and representing that are ingrained in the viewers. Pictures in perspective, like any others, have to be read; and the ability to read has to be acquired. The eye accustomed solely to Oriental painting does not immediately understand a picture in perspective. Yet with practice one can accommodate smoothly to distorting spectacles or to pictures drawn in warped or even reversed perspective.¹⁵ And even we who are most inured to perspective rendering do not always accept it as faithful representation: the photograph of a man with his feet thrust forward looks distorted, and Pike's Peak dwindles dismally in a snapshot. As the saying goes, there is nothing like a camera to make a molehill out of a mountain.

So far, I have been playing along with the idea that pictorial perspective obeys laws of geometrical optics, and that a picture drawn according to the standard pictorial rules will, under the very abnormal conditions outlined above, deliver a bundle of light rays matching that delivered by the scene portrayed. Only this assumption gives any plausibility at all to the argument from perspective; but the assumption is plainly false. By the pictorial rules, railroad tracks running outward from the eye are drawn converging, but telephone poles (or the edges of a façade) running upward from the eye are drawn parallel. By the 'laws of geometry' the poles should

also be drawn converging. But so drawn, they look as wrong as railroad tracks drawn parallel. Thus we have cameras with tilting backs and elevating lens-boards to 'correct distortion'—that is, to make vertical parallels come out parallel in our photographs; we do not likewise try to make the railroad tracks come out parallel. The rules of pictorial perspective no more follow from the laws of optics than would rules calling for drawing the tracks parallel and the poles converging. In diametric contradiction to what Gibson says, the artist who wants to produce a spatial representation that the present-day Western eye will accept as faithful must defy the 'laws of geometry.'

If all this seems quite evident, and neatly clinched by Klee,¹⁶ there is nevertheless impressive weight of authority on the other side,¹⁷ relying on the argument that all parallels in the plane of the façade project geometrically as parallels onto the parallel plane of the picture. The source of unending debate over perspective seems to lie in confusion concerning the pertinent conditions of observation. In Figure 1, an observer is on ground level with eye at a; at b,c is the facade of a tower atop a building; at d,eis a picture of the tower façade, drawn in standard perspective and to a scale such that at the indicated distances picture and façade subtend equal angles from a. The normal line of vision to the tower is the line a,f; looking much higher or lower will leave part of the tower facade out of sight or blurred. Likewise, the normal line of vision to the picture is a,g. Now although picture and facade are parallel, the line a,g is perpendicular to the picture, so that vertical parallels in the picture will be projected to the eve as parallel, while the line a.f is at an angle to the facade so that vertical parallels there will be projected to the eye as converging upward. We might try to make picture and facade deliver matching bundles of light rays to the eye by either (1) moving the picture upward to the position *h,i*, or (2) tilting it to the position *i,k*, or (3) looking at the picture from a but at the tower from m, some stories up. In the first two cases, since the picture must be also nearer the eye to subtend the same angle, the scale will be wrong for lateral (left-wing) dimensions. What is more important, none of these three conditions of observation is anywhere near normal. We do not usually hang pictures far above eye level, or tilt them drastically bottom toward us, or elevate ourselves at will to look squarely at towers.¹⁸ With eye and picture in normal position, the bundle of light rays delivered to the eye by the picture drawn in standard perspective is very different from the bundle delivered by the façade.

This argument by itself is conclusive, but my case does not rest upon it. The more fundamental arguments advanced earlier would apply with full force even had the choice of official rules of perspective been less whimsical and called for drawing as convergent all parallels receding in any

Figure 1

direction. Briefly, the behavior of light sanctions neither our usual nor any other way of rendering space; and perspective provides no absolute or independent standard of fidelity.

4. Sculpture

The troubles with the copy theory are sometimes attributed solely to the impossibility of depicting reality-in-the-round on a flat surface. But imitation is no better gauge of realism in sculpture than in painting. What is to be portrayed in a bronze bust is a mobile, many-faceted, and fluctuating person, encountered in ever-changing light and against miscellaneous backgrounds. Duplicating the form of the head at a given instant is unlikely to yield a notably faithful representation. The very fixation of such a momentary phase embalms the person much as a photograph taken at too short an exposure freezes a fountain or stops a racehorse. To portray faithfully

is to convey a person known and distilled from a variety of experiences. This elusive conceit is nothing that one can meaningfully try to duplicate or imitate in a static bronze on a pedestal in a museum. The sculptor undertakes, rather, a subtle and intricate problem of translation.

Even where the object represented is something simpler and more stable than a person, duplication seldom coincides with realistic representation. If in a tympanum over a tall Gothic portal, Eve's apple were the same size as a Winesap, it would not look big enough to tempt Adam. The distant or colossal sculpture has also to be *shaped* very differently from what it depicts in order to be realistic, in order to 'look right'. And the ways of making it 'look right' are not reducible to fixed and universal rules; for how an object looks depends not only upon its orientation, distance, and lighting, but upon all we know of it and upon our training, habits, and concerns.

One need hardly go further to see that the basic case against imitation as a test of realism is conclusive for sculpture as well as for painting.

5. Fictions

So far, I have been considering only the representation of a particular person or group or thing or scene; but a picture, like a predicate, may denote severally the members of a given class. A picture accompanying a definition in a dictionary is often such a representation, not denoting uniquely some one eagle, say, or collectively the class of eagles, but distributively eagles in general.

Other representations have neither unique nor multiple denotation. What, for example, do pictures of Pickwick or of a unicorn represent? They do not represent anything; they are representations with null denotation. Yet how can we say that a picture represents Pickwick, or a unicorn, and also say that it does not represent anything? Since there is no Pickwick and no unicorn, what a picture of Pickwick and a picture of a unicorn represent is the same. Yet surely to be a picture of Pickwick and to be a picture of a unicorn are not at all the same.

The simple fact is that much as most pieces of furniture are readily sorted out as desks, chairs, tables, etc., so most pictures are readily sorted out as pictures of Pickwick, of Pegasus, of a unicorn, etc., without reference to anything represented. What tends to mislead us is that such locutions as "picture of" and "represents" have the appearance of mannerly two-place predicates and can sometimes be so interpreted. But "picture of Pickwick" and "represents a unicorn" are better considered unbreakable one-place predicates, or class-terms, like "desk" and "table." We cannot reach inside any of these and quantify over parts of them. From the fact that P is a picture of or represents. Furthermore, a picture of

Pickwick is a picture of a man, even though there is no man it represents. Saying that a picture represents a soandso is thus highly ambiguous as between saying what the picture denotes and saying what kind of picture it is. Some confusion can be avoided if in the latter case we speak rather of a 'Pickwick-representing-picture' or a 'unicorn-representing-picture' or a 'man-representing-picture' or, for short, of a 'Pickwick-picture' or 'unicornpicture' or 'man-picture.' Obviously a picture cannot, barring equivocation, both represent Pickwick and represent nothing. But a picture may be of a certain kind—be a Pickwick-picture or a man-picture—without representing anything.¹⁹

The difference between a man-picture and a picture of a man has a close parallel in the difference between a man-description (or man-term) and a description of (or term for) a man. "Pickwick," "the Duke of Wellington," "the man who conquered Napoleon," "a man," "a fat man," "the man with three heads," are all man-descriptions, but not all describe a man. Some denote a particular man, some denote each of many men, and some denote nothing.²⁰ And although "Pickwick" and "the three-headed man" and "Pegasus" all have the same null extension, the second differs from the first in being, for example, a many-headed-man-description.

The way pictures and descriptions are thus classified into kinds, like most habitual ways of classifying, is far from sharp or stable, and resists codification. Borderlines shift and blur, new categories are always coming into prominence, and the canons of the classification are less clear than the practice. But this is only to say that we may have some trouble in telling whether certain pictures (in common parlance) 'represent a unicorn,' or in setting forth rules for deciding in every case whether a picture is a man-picture. Exact and general conditions under which something is a soandso-picture or a soandso-description would indeed be hard to formulate. We can cite examples: Van Gogh's Postman is a man-picture; and in English, "a man" is a man-description. And we may note, for instance, that to be a soandso-picture is to be a soandso-picture as a whole, so that a picture containing or contained in a man-picture need not itself be a man-picture. But to attempt much more is to become engulfed in a notorious philosophical morass; and the frustrating, if fascinating, problems involved are no part of our present task. All that directly matters here, I repeat, is that pictures are indeed sorted with varying degrees of ease into man-pictures, unicorn-pictures, Pickwick-pictures, winged-horse-pictures, etc., just as pieces of furniture are sorted into desks, tables, chairs, etc. And this fact is unaffected by the difficulty, in either case, of framing definitions for the several classes or eliciting a general principle of classification.

The possible objection that we must first understand what a man or a unicorn is in order to know how to apply "man-picture" or "unicornpicture" seems to me quite perverted. We can learn to apply "corncob pipe" or "staghorn" without first understanding, or knowing how to apply, "corn" or "cob" or "corncob" or "pipe" or "stag" or "horn" as separate terms. And we can learn, on the basis of samples, to apply "unicornpicture" not only without ever having seen any unicorns but without ever having seen or heard the word "unicorn" before. Indeed, largely by learning what are unicorn-pictures and unicorn-descriptions do we come to understand the word "unicorn"; and our ability to recognize a staghorn may help us to recognize a stag when we see one. We may begin to understand a term by learning how to apply either the term itself or some larger term containing it. Acquiring any of these skills may aid in acquiring, but does not imply possessing, any of the others. Understanding a term is not a precondition, and may often be a result, of learning how to apply the term and its compounds.²¹

Earlier I said that denotation is a necessary condition for representation, and then encountered representations without denotation. But the explanation is now clear. A picture must denote a man to represent him, but need not denote anything to be a man-representation. Incidentally, the copy theory of representation takes a further beating here; for where a representation does not represent anything there can be no question of resemblance to what it represents.

Use of such examples as Pickwick-pictures and unicorn-pictures may suggest that representations with null denotation are comparatively rare. Quite the contrary; the world of pictures teems with anonymous fictional persons, places, and things. The man in Rembrandt's Landscape with a Huntsman is presumably no actual person; he is just the man in Rembrandt's etching. In other words, the etching represents no man but is simply a man-picture, and more particularly a the-man-in-Rembrandt's Landscape-with-a-Huntsman-picture. And even if an actual man be depicted here, his identity matters as little as the artist's blood-type. Furthermore, the information needed to determine what if anything is denoted by a picture is not always accessible. We may, for example, be unable to tell whether a given representation is multiple, like an eagle-picture in the dictionary, or fictive, like a Pickwick-picture. But where we cannot determine whether a picture denotes anything or not, we can only proceed as if it did not-that is, confine ourselves to considering what kind of picture it is. Thus cases of indeterminate denotation are treated in the same way as cases of null denotation.

But not only where the denotation is null or indeterminate does the classification of a picture need to be considered. For the denotation of a

picture no more determines its kind than the kind of picture determines the denotation. Not every man-picture represents a man, and conversely not every picture that represents a man is a man-picture. And in the difference between being and not being a man-picture lies the difference, among pictures that represent a man, between those that do and those that do not represent him as a man.

6. Representation-as

The locution "represents . . . as" has two quite different uses. To say that a picture represents the Duke of Wellington as an infant, or as an adult, or as the victor at Waterloo is often merely to say that the picture represents the Duke at a given time or period—that it represents a certain (long or short, continuous or broken) temporal part or 'time-slice' of him. Here "as . . ." combines with the *noun* "the Duke of Wellington" to form a description of one portion of the whole extended individual.²² Such a description can always be replaced by another like "the infant Duke of Wellington" or "the Duke of Wellington upon the occasion of his victory at Waterloo." Thus these cases raise no difficulty; all that is being said is that the picture represents the object so described.

The second use is illustrated when we say that a given picture represents Winston Churchill as an infant, where the picture does not represent the infant Churchill but rather represents the adult Churchill as an infant. Here, as well as when we say that other pictures represent the adult Churchill as an adult, the "as . . ." combines with and modifies the *verb*; and we have genuine cases of *representation-as*. Such representation-as wants now to be distinguished from and related to representation.

A picture that represents a man denotes him; a picture that represents a fictional man is a man-picture; and a picture that represents a man as a man is a man-picture denoting him. Thus while the first case concerns only what the picture denotes, and the second only what kind of picture it is, the third concerns both the denotation and the classification.

More accurate formulation takes some care. What a picture is said to represent may be denoted by the picture as a whole or by a part of it. Likewise, a picture may be a soandso-picture as a whole or merely through containing a soandso-picture.²³ Consider an ordinary portrait of the Duke and Duchess of Wellington. The picture (as a whole) denotes the couple, and (in part) denotes the Duke. Furthermore, it is (as a whole) a two-person-picture, and (in part) a man-picture. The picture represents the Duke and Duchess as two persons, and represents the Duke as a man. But although it represents the Duke, and is a two-person-picture, it obviously does not represent the Duke as two persons; and although it represents two persons and is a man-picture, it does not represent the two as

a man. For the picture neither is nor contains any picture that as a whole both represents the Duke and is a two-man-picture, or that as a whole both represents two persons and is a man-picture.

In general, then, an object k is represented as a soundso by a picture p if and only if p is or contains a picture that as a whole both represents k and is a soundso-picture.²⁴ Many of the modifiers that have had to be included here may, however, be omitted as understood in what follows; for example, "is or contains a picture that as a whole both represents Churchill and is an adult-picture" may be shortened to "is an adult-picture representing Churchill."

Everyday usage is often careless about the distinction between representation and representation-as. Cases have already been cited where in saying that a picture represents a soandso we mean not that it denotes a soandso but that it is a soandso-picture. In other cases, we may mean both. If I tell you I have a picture of a certain black horse, and then I produce a snapshot in which he has come out a light speck in the distance, you can hardly convict me of lying; but you may well feel that I misled you. You understandably took me to mean a picture of the black horse as such; and you therefore expected the picture not only to denote the horse in question but to be a black-horse-picture. Not inconceivably, saying a picture represents the black horse might on other occasions mean that it represents the horse as black (i.e., that it is a black-thing-picture representing the horse) or that it represents the black thing in question as a horse (i.e., that it is a horse-picture representing the black thing).

The ambiguities of ordinary use do not end there. To say that the adult Churchill is represented as an infant (or as an adult) is to say that the picture in question is an infant-picture (or an adult-picture). But to say that Pickwick is represented as a clown (or as Don Quixote) cannot mean that the picture is a clown-picture (or Don-Quixote-picture) representing Pickwick; for there is no Pickwick. Rather, what is being said is that the picture belongs to a certain rather narrow class of pictures that may be described as Pickwick-as-clown-pictures (or Pickwick-as-Don-Quixotepictures).

Distinctions obscured in much informal discourse thus need to be carefully marked for our purposes here. Being a matter of monadic classification, representation-as differs drastically from dyadic denotative representation. If a picture represents k as a (or the) soandso, then it denotes kand is a soandso-picture. If k is identical with h, the picture also denotes and represents h. And if k is a suchandsuch, the picture also represents a (or the) suchandsuch, but not necessarily as a (or the) suchandsuch. To represent the first Duke of Wellington is to represent Arthur Wellesley and also to represent a soldier, but not necessarily to represent him as a soldier; for some pictures of him are civilian-pictures.

Representations, then, are pictures that function in somewhat the same way as descriptions.²⁵ Just as objects are classified by means of, or under, various verbal labels, so also are objects classified by or under various pictorial labels. And the labels themselves, verbal or pictorial, are in turn classified under labels, verbal or nonverbal. Objects are classified under "desk," "table," etc., and also under pictures representing them. Descriptions are classified under "desk-description," "centaur-description," "Ciceroname," etc.; and pictures under "desk-picture," "Pickwick-picture," etc. The labeling of labels does not depend upon what they are labels for. Some, like "unicorn," apply to nothing; and as we have noted, not all pictures of soldiers are soldier-pictures. Thus with a picture as with any other label, there are always two questions: what it represents (or describes) and the sort of representation (or description) it is. The first question asks what objects, if any, it applies to as a label; and the second asks about which among certain labels apply to it. In representing, a picture at once picks out a class of objects and belongs to a certain class or classes of pictures.26

7. Invention

If representing is a matter of classifying objects rather than of imitating them, of characterizing rather than of copying, it is not a matter of passive reporting. The object does not sit as a docile model with its attributes neatly separated and thrust out for us to admire and portray. It is one of countless objects, and may be grouped with any selection of them; and for every such grouping there is an attribute of the object. To admit all classifications on equal footing amounts to making no classification at all. Classification involves preferment; and application of a label (pictorial, verbal, etc.) as often *effects* as it records a classification. The 'natural' kinds are simply those we are in the habit of picking out for and by labeling. Moreover, the object itself is not ready-made but results from a way of taking the world. The making of a picture commonly participates in making what is to be pictured. The object and its aspects depend upon organization; and labels of all sorts are tools of organization.

Representation and description thus involve and are often involved in organization. A label associates together such objects as it applies to, and is associated with the other labels of a kind or kinds. Less directly, it associates its referents with these other labels and with their referents, and so on. Not all these associations have equal force; their strength varies with their directness, with the specificity of the classifications in question, and with the firmness of foothold these classifications and labelings have secured. But in all these ways a representation or description, by virtue of how it classifies and is classified, may make or mark connections, analyze objects, and organize the world.

Representation or description is apt, effective, illuminating, subtle, intriguing, to the extent that the artist or writer grasps fresh and significant relationships and devises means for making them manifest. Discourse or depiction that marks off familiar units and sorts them into standard sets under well-worn labels may sometimes be serviceable even if humdrum. The marking off of new elements or classes, or of familiar ones by labels of new kinds or by new combinations of old labels, may provide new insight. Gombrich stresses Constable's metaphor: "Painting is a science . . . of which pictures are but the experiments."27 In representation, the artist must make use of old habits when he wants to elicit novel objects and connections. If his picture is recognized as almost but not quite referring to the commonplace furniture of the everyday world, or if it calls for and yet resists assignment to a usual kind of picture, it may bring out neglected likenesses and differences, force unaccustomed associations, and in some measure remake our world. And if the point of the picture is not only successfully made but is also well-taken, if the realignments it directly and indirectly effects are interesting and important, the picture-like a crucial experiment-makes a genuine contribution to knowledge. To a complaint that his portrait of Gertrude Stein did not look like her, Picasso is said to have answered, "No matter; it will."

In sum, effective representation and description require invention. They are creative. They inform each other; and they form, relate, and distinguish objects. That nature imitates art is too timid a dictum. Nature is a product of art and discourse.

8. Realism

This leaves unanswered the minor question what constitutes realism of representation. Surely not, in view of the foregoing, any sort of resemblance to reality. Yet we do in fact compare representations with respect to their realism or naturalism or fidelity. If resemblance is not the criterion, what is?

One popular answer is that the test of fidelity is deception, that a picture is realistic just to the extent that it is a successful illusion, leading the viewer to suppose that it is, or has the characteristics of, what it represents. The proposed measure of realism, in other words, is the probability of confusing the representation with the represented. This is some improvement over the copy theory; for what counts here is not how closely the picture duplicates an object but how far the picture and object, under conditions of observation appropriate to each, give rise to the same responses and expectations. Furthermore, the theory is not immediately confounded by the fact that fictive representations differ in degree of realism; for even though there are no centaurs, a realistic picture might deceive me into taking it for a centaur.

Yet there are difficulties. What deceives depends upon what is observed, and what is observed varies with interests and habits. If the probability of confusion is 1, we no longer have representation-we have identity. Moreover, the probability seldom rises noticeably above zero for even the most guileful trompe-l'ail painting seen under ordinary gallery conditions. For seeing a picture as a picture precludes mistaking it for anything else; and the appropriate conditions of observation (e.g., framed, against a uniform background, etc.) are calculated to defeat deception. Deception enlists such mischief as a suggestive setting, or a peephole that occludes frame and background. And deception under such nonstandard conditions is no test of realism; for with enough staging, even the most unrealistic picture can deceive. Deception counts less as a measure of realism than as evidence of magicianship, and is a highly atypical mishap. In looking at the most realistic picture, I seldom suppose that I can literally reach into the distance, slice the tomato, or beat the drum. Rather, I recognize the images as signs for the objects and characteristics represented-signs that work instantly and unequivocally without being confused with what they denote. Of course, sometimes where deception does occur-say by a painted window in a mural—we may indeed call the picture realistic; but such cases provide no basis for the usual ordering of pictures in general as more or less realistic.

Thoughts along these lines have led to the suggestion that the most realistic picture is the one that provides the greatest amount of pertinent information. But this hypothesis can be quickly and completely refuted. Consider a realistic picture, painted in ordinary perspective and normal color, and a second picture just like the first except that the perspective is reversed and each color is replaced by its complementary. The second picture, appropriately interpreted, yields exactly the same information as the first. And any number of other drastic but information-preserving transformations are possible. Obviously, realistic and unrealistic pictures may be equally informative; informational yield is no test of realism.

So far, we have not needed to distinguish between fidelity and realism. The criteria considered earlier have been as unsatisfactory for the one as for the other. But we can no longer equate them. The two pictures just described are equally correct, equally faithful to what they represent, provide the same and hence equally true information; yet they are not equally realistic or literal. For a picture to be faithful is simply for the object represented to have the properties that the picture in effect ascribes to it. But such fidelity or correctness or truth is not a sufficient condition for literalism.

The alert absolutist will argue that for the second picture but not the first we need a key. Rather, the difference is that for the first the key is ready at hand. For proper reading of the second picture, we have to dis-

cover rules of interpretation and apply them deliberately. Reading of the first is by virtually automatic habit; practice has rendered the symbols so transparent that we are not aware of any effort, of any alternatives, or of making any interpretation at all.²⁸ Just here, I think, lies the touchstone of realism: not in quantity of information but in how easily it issues. And this depends upon how stereotyped the mode of representation is, upon how commonplace the labels and their uses have become.

Realism is relative, determined by the system of representation standard for a given culture or person at a given time. Newer or older or alien systems are accounted artificial or unskilled. For a Fifth-Dynasty Egyptian the straightforward way of representing something is not the same as for an eighteenth-century Japanese: and neither way is the same as for an early twentieth-century Englishman. Each would to some extent have to learn how to read a picture in either of the other styles. This relativity is obscured by our tendency to omit specifying a frame of reference when it is our own. "Realism" thus often comes to be used as the name for a particular style or system of representation. Just as on this planet we usually think of objects as fixed if they are at a constant position in relation to the earth, so in this period and place we usually think of paintings as literal or realistic if they are in a traditional²⁹ European style of representation. But such egocentric ellipsis must not tempt us to infer that these objects (or any others) are absolutely fixed, or that such pictures (or any others) are absolutely realistic.

Shifts in standard can occur rather rapidly. The very effectiveness that may attend judicious departure from a traditional system of representation sometimes inclines us at least temporarily to install the newer mode as standard. We then speak of an artist's having achieved a new degree of realism, or having found new means for the realistic rendering of (say) light or motion. What happens here is something like the 'discovery' that not the earth but the sun is 'really fixed.' Advantages of a new frame of reference, partly because of their novelty, encourage its enthronement on some occasions in place of the customary frame. Nevertheless, whether an object is 'really fixed' or a picture is realistic depends at any time entirely upon what frame or mode is then standard. Realism is a matter not of any constant or absolute relationship between a picture and its object but of a relationship between the system of representation employed in the picture and the standard system. Most of the time, of course, the traditional system is taken as standard; and the literal or realistic or naturalistic system of representation is simply the customary one.

Realistic representation, in brief, depends not upon imitation or illusion or information but upon inculcation. Almost any picture may represent almost anything; that is, given picture and object there is usually a system of representation, a plan of correlation, under which the picture represents the object.³⁰ How correct the picture is under that system depends upon how accurate is the information about the object that is obtained by reading the picture according to that system. But how literal or realistic the picture is depends upon how standard the system is. If representation is a matter of choice and correctness a matter of information, realism is a matter of habit.

Our addiction, in the face of overwhelming counterevidence, to thinking of resemblance as the measure of realism is easily understood in these terms. Representational customs, which govern realism, also tend to generate resemblance. That a picture looks like nature often means only that it looks the way nature is usually painted. Again, what will deceive me into supposing that an object of a given kind is before me depends upon what I have noticed about such objects, and this in turn is affected by the way I am used to seeing them depicted. Resemblance and deceptiveness, far from being constant and independent sources and criteria of representational practice are in some degree products of it.⁸¹

9. Depiction and Description

Throughout, I have stressed the analogy between pictorial representation and verbal description because it seems to me both corrective and suggestive. Reference to an object is a necessary condition for depiction or description of it, but no degree of resemblance is a necessary or sufficient condition for either. Both depiction and description participate in the formation and characterization of the world; and they interact with each other and with perception and knowledge. They are ways of classifying by means of labels having singular or multiple or null reference. The labels, pictorial or verbal, are themselves classified into kinds; and the interpretation of fictive labels, and of depiction-as and description-as, is in terms of such kinds. Application and classification of a label are relative to a system;32 and there are countless alternative systems of representation and description. Such systems are the products of stipulation and habituation in varying proportions. The choice among systems is free; but given a system, the question whether a newly encountered object is a desk or a unicorn-picture or is represented by a certain painting is a question of the propriety, under that system, of projecting the predicate "desk" or the predicate "unicorn-picture" or the painting over the thing in question, and the decision both is guided by and guides usage for that system.³³

The temptation is to call a system of depiction a language; but here I stop short. The question what distinguishes representational from linguistic systems needs close examination. One might suppose that the criterion of realism can be made to serve here, too; that symbols grade from the most realistic depictions through less and less realistic ones to descriptions. This is surely not the case; the measure of realism is habituation, but descrip-

Reality Remade

tions do not become depictions by habituation. The most commonplace nouns of English have not become pictures.

To say that depiction is by pictures while description is by passages is not only to beg a good part of the question but also to overlook the fact that denotation by a picture does not always constitute depiction; for example, if pictures in a commandeered museum are used by a briefing officer to stand for enemy emplacements, the pictures do not thereby represent these emplacements. To represent, a picture must function as a pictorial symbol; that is, function in a system such that what is denoted depends solely upon the pictorial properties of the symbol. The pictorial properties might be roughly delimited by a loose recursive specification.³⁴ An elementary pictorial characterization states what color a picture has at a given place on its face. Other pictorial characterizations in effect combine many such elementary ones by conjunction, alternation, quantification, etc. Thus a pictorial characterization may name the colors at several places, or state that the color at one place lies within a certain range, or state that the colors at two places are complementary, and so on. Briefly, a pictorial characterization says more or less completely and more or less specifically what colors the picture has at what places. And the properties correctly ascribed to a picture by pictorial characterization are its pictorial properties.

All this, though, is much too special. The formula can easily be broadened a little but resists generalization. Sculptures with denotation dependent upon such sculptural properties as shape do represent, but words with denotation dependent upon such verbal properties as spelling do not. We have not yet captured the crucial difference between pictorial and verbal properties, between nonlinguistic and linguistic symbols or systems, that makes the difference between representation in general and description.

What we have done so far is to subsume representation with description under denotation. Representation is thus disengaged from perverted ideas of it as an idiosyncratic physical process like mirroring, and is recognized as a symbolic relationship that is relative and variable. Furthermore, representation is thus contrasted with nondenotative modes of reference.

Notes

1. What I am considering here is pictorial representation, or depiction, and the comparable representation that may occur in other arts. Natural objects may represent in the same way: witness the man in the moon and the sheep-dog in the clouds. Some writers use "representation" as the general term for all varieties of what I call symbolization or reference, and use "symbolic" for the verbal and other nonpictorial signs I call nonrepresentational. "Represent" and its derivatives have many other uses, and while I shall mention some of these later,

others do not concern us here at all. Among the latter, for example, are the uses according to which an ambassador represents a nation and makes representations to a foreign government.

2. I use "object" indifferently for anything a picture represents, whether an apple or a battle. A quirk of language makes a represented object a subject.

3. Not until the next chapter will denotation be distinguished from other varieties of reference.

4. In "The Way the World Is," Review of Metaphysics, XIV (1960), 48-56, I have argued that the world is as many ways as it can be truly described, seen, pictured, etc., and that there is no such thing as the way the world is. Ryle takes a somewhat similar position (Dilemmas [Cambridge, England: Cambridge University Press, 1954], pp. 75-77) in comparing the relation between a table as a perceived solid object and the table as a swarm of atoms with the relation between a college library according to the catalogue and according to the accountant. Some have proposed that the way the world is could be arrived at by conjoining all the several ways. This overlooks the fact that conjunction itself is peculiar to certain systems; for example, we cannot conjoin a paragraph and a picture. And any attempted combination of all the ways would be itself only one-and a peculiarly indigestible one-of the ways the world is. But what is the world that is in so many ways? To speak of ways the world is, or ways of describing or picturing the world, is to speak of world-descriptions or worldpictures, and does not imply there is a unique thing-or indeed anything-that is described or pictured. Of course, none of this implies, either, that nothing is described or pictured. See further section 5 and note 19 below.

5. In Art and Illusion (New York: Pantheon Books, 1960), pp. 297–298 and elsewhere. On the general matter of the relativity of vision, see also such works as R. L. Gregory, Eye and Brain (New York: McGraw-Hill Book Co., 1966), and Marshall H. Segall, Donald Campbell, and Melville J. Herskovits, The Influence of Culture on Visual Perception (Indianapolis and New York: The Bobbs-Merrill Co., Inc., 1966).

6. For samples of psychological investigation of this point, see Jerome S. Bruner's "On Perceptual Readiness," *Psychological Review*, LXIV (1957), 123–152, and other articles there cited; also William P. Brown, "Conceptions of Perceptual Defense," *British Journal of Psychology Monograph Supplement* XXXV (Cambridge, England: Cambridge University Press, 1961).

7. On the emptiness of the notion of epistemological primacy and the futility of the search for the absolute given, see my *Structure of Appearance* (2nd ed.; Indianapolis and New York: The Bobbs-Merrill Co., Inc., 1966—hereinafter referred to as SA), pp. 132–145, and "Sense and Certainty," *Philosophical Review*, LXI (1952), 160–167.

8. And this is no less true when the instrument we use is a camera rather than a pen or brush. The choice and handling of the instrument participate in the construal. A photographer's work, like a painter's, can evince a personal style. Concerning the 'corrections' provided for in some cameras, see section 3 below.

9. Art and Illusion, pp. 254 and 257.

Reality Remade

10. From "Pictures, Perspective, and Perception," *Daedalus* (Winter 1960), p. 227. Gibson does not appear to have explicitly retracted these statements, though his interesting recent book, *The Senses Considered as Perceptual Systems* (Boston: Houghton Mifflin Co., 1966), deals at length with related problems.

11. Substantially this argument has, of course, been advanced by many other writers. For an interesting discussion see D. Gioseffi, *Prospettiva Artificialis* (Trieste: Universita degli studi di Trieste, Istituto di Storia dell'Arte Antica e Moderna, 1957), and a long review of the same by M. H. Pirenne in *The Art Bulletin*, XLI (1959), 213–217. I am indebted to Professor Meyer Schapiro for this reference.

12. Cf. Gombrich's discussion of 'gates' in Art and Illusion, pp. 250-251.

13. See L. A. Riggs, F. Ratliff, J. C. Cornsweet, and T. Cornsweet, "The Disappearance of Steadily Fixated Visual Objects," *Journal of the Optical Society of America*, XLIII (1953), 495–501. More recently, the drastic and rapid changes in perception that occur during fixation have been investigated in detail by R. M. Pritchard, W. Heron, and D. I. Hebb in "Visual Perception Approached by the Method of Stabilized Images," *Canadian Journal of Psychology*, XIV (1960), 67–77. According to this article, the image tends to regenerate, sometimes transformed into meaningful units not initially present.

14. But note that owing to the protuberance of the cornea, the eye when rotated, even with the head fixed, can often see slightly around the sides of an object.

15. Adaptation to spectacles of various kinds has been the subject of extensive experimentation. See, for example, J. E. Hochberg, "Effects of Gestalt Revolution: The Cornell Symposium on Perception," Psychological Review, LXIV (1959), 74-75; J. G. Taylor, The Behavioral Basis of Perception (New Haven: Yale University Press, 1962), pp. 166-185; and Irvin Rock, The Nature of Perceptual Adaptation (New York: Basic Books, Inc., 1966). Anyone can readily verify for himself how easy it is to learn to read pictures drawn in reversed or otherwise transformed perspective. Reversed perspective often occurs in Oriental, Byzantine, and mediaeval art; sometimes standard and reversed perspective are even used in different parts of one picture-see, for example, Leonid Ouspensky and Vladimir Lossky, The Meaning of Icons (Boston: Boston Book and Art Shop, 1952), p. 42 (note 1), p. 200. Concerning the fact that one has to learn to read pictures in standard perspective, Melville J. Herskovits writes in Man and His Works (New York: Alfred A. Knopf, 1948), p. 381: "More than one ethnographer has reported the experience of showing a clear photograph of a house, a person, a familiar landscape to people living in a culture innocent of any knowledge of photography, and to have the picture held at all possible angles, or turned over for an inspection of its blank back, as the native tried to interpret this meaningless arrangement of varying shades of grey on a piece of paper. For even the clearest photograph is only an interpretation of what the camera sees."

16. [Ed.—Goodman included a] frontispiece to this chapter. As Klee remarks, the drawing looks quite normal if taken as representing a floor but awry as representing a façade, even though in the two cases parallels in the object represented recede equally from the eye.

17. Indeed, this is the orthodox position, taken not only by Pirenne, Gibson, and Gombrich, but by most writers on the subject. Some exceptions, besides Klee, are Erwin Panofsky, "Die Perspektive als 'Symbolische Form,' "Vorträge der Bibliothek Warburg (1924–1925), pp. 258ff; Rudolf Arnheim, Art and Visual Perception (Berkeley: University of California Press, 1954), e.g., pp. 92ff, and elsewhere; and in an earlier day, one Arthur Parsey, who was taken to task for his heterodox views by Augustus de Morgan in Budget of Paradoxes (London, 1872), pp. 176–177. I am indebted to Mr. P. T. Geach for this last reference. Interesting discussions of perspective will be found in The Birth and Rebirth of Pictorial Space, by John White (New York: Thomas Yoseloff, 1958), chs. 8 and 13.

18. The optimal way of seeing the tower façade may be by looking straight at it from m; but then the optimal way of seeing the railroad tracks would be by looking down on them from directly above the midpoint of their length.

19. The substance of this and the following two paragraphs is contained in my paper, "On Likeness of Meaning," Analysis, I (1949), 1-7, and discussed further in the sequel, "On Some Differences about Meaning," Analysis XIII (1953), 90-96. See also the parallel treatment of the problem of statements 'about fictive entities' in "About," Mind, LXX (1961), esp. pp. 18-22. In a series of papers from 1939 on (many of them reworked and republished in From a Logical Point of View [Cambridge, Mass.: Harvard University Press, 1953]), W. V. Quine had sharpened the distinction between syncategorematic and other expressions, and had shown that careful observance of this distinction could dispel many philosophical problems.

I use the device of hyphenation (e.g., in "man-picture") as an aid in technical discourse only, not as a reform of everyday usage, where the context normally prevents confusion and where the impetus to fallacious existential inference is less compulsive, if not less consequential, than in philosophy. In what follows, "man-picture" will always be an abbreviation for the longer and more usual "picture representing a man," taken as an unbreakable one-place predicate that need not apply to all or only to pictures that represent an actual man. The same general principle will govern use of all compounds of the form "______picture." Thus, for example, I shall not use "Churchill-picture" as an abbreviation for "picture painted by Churchill" or for "picture belonging to Churchill." Note, furthermore, that a square-picture is not necessarily a square picture but a square-representing-picture.

20. Strictly, we should speak here of utterances and inscriptions; for different instances of the same term may differ in denotation. Indeed, classifying replicas together to constitute terms is only one, and a far from simple, way of classifying utterances and inscriptions into kinds. See further SA, pp. 359–363, and also Chapter IV [of Languages of Art].

21. To know how to apply all compounds of a term would entail knowing how to apply at least some compounds of all other terms in the language. We normally say we understand a term when we know reasonably well how to

Reality Remade

apply it and enough of its more usual compounds. If for a given "——picture" compound we are in doubt about how to apply it in a rather high percentage of cases, this is also true of the correlative "represents as a ——" predicate. Of course, understanding a term is not exclusively a matter of knowing how to apply it and its compounds; such other factors enter as knowing what inferences can be drawn from and to statements containing the term.

22. I am indebted to Mr. H. P. Grice and Mr. J. O. Urmson for comments leading to clarification of this point. Sometimes, the portion in question may be marked off along other than temporal lines. On the notion of a temporal part, see SA, pp. 127–129.

23. The contained picture may, nevertheless, denote given objects and be a soandso-picture *as a result* of its incorporation in the context of the containing picture, just as "triangle" through occurrence in "triangle and drums" may denote given musical instruments and be a musical-instrument-description.

24. This covers cases where k is represented as a soundso by either a whole picture or part of it. As remarked in the latter part of note 19 above, there are restrictions upon the admissible replacements for "soundso" in this definitional schema; an old or square picture or one belonging to Churchill does not thereby represent him as old or square or self-possessed.

25. The reader will already have noticed that "description" in the present text is not confined to what are called definite descriptions in logic but covers all predicates from proper names through purple passages, whether with singular, multiple, or null denotation.

26. The picture does not denote the class picked out, but denotes the no or one or several members of that class. A picture of course belongs to countless classes, but only certain of these (e.g., the class of square-pictures, the class of Churchill-pictures) and not others (e.g., the class of square pictures, the class of pictures belonging to Churchill) have to do with what the picture represents-as.

27. From Constable's fourth lecture at the Royal Institution in 1836; see C. R. Leslie, *Memoirs of the Life of John Constable*, ed. Jonathan Mayne (London: Phaidon Press, 1951), p. 323.

28. Cf. Descartes, *Meditations on the First Philosophy*, trans. E. S. Haldane and G. R. T. Ross (New York: Dover Publications, Inc., 1955), I, 155; also Berkeley, "Essay Towards a New Theory of Vision," in *Works on Vision*, ed. C. M. Turbayne (New York: The Bobbs-Merrill Co., Inc., 1963), p. 42.

29. Or conventional; but "conventional" is a dangerously ambiguous term: witness the contrast between "very conventional" (as "very ordinary") and "highly conventional" or "highly conventionalized" (as "very artificial").

30. Indeed, there are usually many such systems. A picture that under one (unfamiliar) system is a correct but highly unrealistic representation of an object may under another (the standard) system be a realistic but very incorrect representation of the same object. Only if accurate information is yielded under the standard system will the picture represent the object both correctly and literally.

31. Neither here nor elsewhere have I argued that there is no constant relation of resemblance; judgments of similarity in selected and familiar respects are, even though rough and fallible, as objective and categorical as any that are made in describing the world. But judgments of complex overall resemblance are another matter. In the first place, they depend upon the aspects or factors in terms of which the objects in question are compared; and this depends heavily on conceptual and perceptual habit. In the second place, even with these factors determined, similarities along the several axes are not immediately commensurate, and the degree of total resemblance will depend upon how the several factors are weighted. Normally, for example, nearness in geographical location has little to do with our judgment of resemblance among buildings but much to do with our judgment of resemblance among building lots. The assessment of total resemblance is subject to influences galore, and our representational customs are not least among these. In sum, I have sought to show that insofar as resemblance is a constant and objective relation, resemblance between a picture and what it represents does not coincide with realism: and that insofar as resemblance does coincide with realism, the criteria of resemblance vary with changes in representational practice.

32. [Ed.— . . .] a symbol system (not necessarily formal) embraces both the symbols and their interpretation, and a language is a symbol system of a particular kind. A formal system is couched in a language and has stated primitives and routes of derivation.

33. On the interaction between specific judgment and general policy, see my *Fact, Fiction, and Forecast* (2nd ed.; Indianapolis and New York; The Bobbs-Merrill Co., Inc., 1965—hereinafter referred to as *FFF*), pp. 63–64. The propriety of projecting a predicate might be said to depend upon what similarities there are among the objects in question; but with equal truth, similarities among the objects might be said to depend upon what predicates are projected (cf. note 31 above, and *FFF*, pp. 82, 96–99, 119–120). Concerning the relationship between the 'language theory' of pictures outlined above and the much discussed 'picture theory' of language, see "The Way the World Is" (cited in note 4 above), pp. 55–56.

34. The specification that follows has many shortcomings, among them the absence of provision for the often three-dimensional nature of picture surfaces. But while a rough distinction between pictorial and other properties is useful here [Ed.— . . .], nothing very vital rests on its precise formulation.

On Drawing an Object *RICHARD WOLLHEIM*

'What is the criterion of the visual experience?,' Wittgenstein writes in the *Philosophical Investigations*, 'Well, what would you expect the criterion to be? The representation of "what is seen." '¹

The remark is taken from the second half of the *Investigations* where whatever structure the book possesses elsewhere is more or less abandoned, and it occurs there rather as a hint, as a suggestion, than as an articulated contribution to the philosophy of mind. In this lecture, however, I want to take up this stray thought and, without in any way systematizing it, simply see where it leads us. For I suspect that, if we follow its light, we may find that areas of thought we had believed disparate or apart prove contiguous.

2. It is at this stage worth pointing out that the question to which Wittgenstein's remarks suggests an answer is one of which we have heard surprisingly little in the philosophy of recent years: given, that is, the extreme interest that philosophers have taken in the visual experience, or in the problem of what we really see. For they have, on the whole, confined themselves to the more epistemological questions: such as whether we can ever really know for certain what we see, or whether this can be a matter only for hypothesis and belief, or whether, if this is something on which we can be certain, this is the same as saying that we couldn't be wrong or that our perceptual judgements are incorrigible. Or again, they have asked what is the relation between these judgements, between the deliverances of visual experience, that is, and all the other kinds of judgement that we claim to know, and whether it is true that, as the philosophy within which we are all supposed to fall has traditionally claimed, the latter are based exclu-

Inaugural lecture delivered in the University of London, December 1964 (London: H. K. Lewis, 1965). Copyright © University College London. Reprinted by permission of the author and University College London.

sively on the former. Or, in so far as contemporary philosophers have taken an interest in the judgement of perception itself and its correlative, the visual experience, they have wanted to know what sort of object, in the most general of senses, the judgement was *about* or the experience *of*: sense-datum, material object, appearance. But as to the question of any particular judgement or experience, and what makes that judgement true or how we decide what the experience is of, the matter has been left rather like this: that if an observer claims to see something or to see something in a certain way, then, if this could be so, that is if his judgement falls within the general specifications of what is possible, we may assume that it is so. Of course, according to some philosophers (though not to others) what the observer says may be false: but that we cannot go behind what he says is common ground to nearly all.

3. Wittgenstein's criterion is, then, an attempt to get behind the observer's words. Not (though the fragmentary character of the quotation may obscure this) in all cases: but in some. In some cases, that is, the answer to the question, What did such-and-such a man see? is directly given by how he represents what he saw or by what he would draw in response to this question. To try to go behind the representation is, in those cases, vain.

Such a criterion, I feel, fits a great deal of our experience. Consider, for instance, the way in which we often conceive of naturalistic art as a kind of exploration: a research into the world of appearances: by which is meant, of course, how things look to us. Implicit in such a conception is the view that draughtsmanship, or the techniques of representation taken more generally, afford us in certain cases a direct revelation of what we see, a revelation not mediated by any perceptual judgement.

Or, again, take a visual phenomenon already known in the Middle Ages, which modern psychology has illuminated. An object, seen obliquely or at a distance or in a poor light, can seem to us in shape, colour, size, much more as it seems to us in standard conditions than the stimulus pattern would lead us to anticipate. Various interpretations of this have been suggested, but there seems fairly general agreement on the existence of the phenomenon. When, however, we ask what is the criterion employed in determining that things do look to us in this deviant way, it turns out to be one very close to how we would represent them. Take, for instance, the experiment which is supposed to establish shape constancy.² A circle is exposed to the subject, tilted so that it is no longer at right angles to the line of vision, and the subject is then asked to select from a graded series of ovals that which corresponds most closely to what he sees: and the fact that he selects an oval divergent from the perspectival profile in the

direction of the circle is taken as conclusive evidence that this is how he sees the circle. But why should we regard the experiment in this way? Why should we not rather see it as establishing a characteristic error to which human beings are susceptible when they try to select shapes to match their perceptions? And I suspect that a large part of the reason why we think that the experiment relates to vision is because of the substantial overlap between matching and representation. The subject may, indeed, be thought of as selecting out of a pre-existent assortment a representation of what he saw, and it is obviously but a short step from the selection to the construction of a representation.³

4. However, it might be objected against this criterion that it allows of the absurd eventuality that we could come to know what our visual experience was by observing our representation of it: that when we had finished our drawing, we could look at the sheet and, by scrutinizing the configuration lying upon it, learn what we have seen—where 'what we have seen' means, of course, not what thing we have seen but how we saw whatever it was or what it looked like to us. And absurd as such a supposition may seem when the visual experience and the representation are very close together in time, to the point virtually of simultaneity, the absurdity is felt to be compounded when one occurs considerably after the other. The artist, say, goes back to his studio, and works up the sketch he made on the spot, as we know Constable did: are we to say that *then* he comes to know, or that it is *only then* that he really knows, what he saw? Put like this, the conclusion certainly sounds absurd.

Now without deciding at this stage whether this is so absurd or not, I want to consider two arguments both of which bear on this issue. One assumes that the conclusion does follow from accepting the criterion, and uses this against the criterion, and the other maintains that the conclusion does not follow, and thinks this goes some way towards vindicating the criterion.

5. And now at this juncture, when we have already effected an entry, the merest entry it is true, into the subject, and can see stretching ahead of us some of the territories we must pass through—perception, action, knowledge, representation, verisimilitude—I should like to pause and carry out a task which those well versed in the conventional structure of an inaugural lecture might have thought I was about to omit, but which those at all acquainted with the history of my Chair must have known it was inconceivable I could. And that is to pay a tribute to my predecessors. Predecessors, I say: for I could not, on such an occasion as this, unyoke the names of the two philosophers under whom I worked over a period of

fourteen years, both of whom I can regard as close friends, and from whom conjointly I derived a consciousness of how philosophy should be pursued, and why.

If I have waited till now to bring them into this lecture, it is not only because (though that *is* a reason) I preferred to introduce the names of Ayer and Hampshire in close proximity to topics with which the history of twentieth-century philosophy, when it comes to be written, will always associate them. But it is also because it seemed wanton to insert them where they so obviously do not belong, in a cold or formal paragraph, when, with just a little patience, I could place them, more fittingly, in the context of an argument.

Some of what I shall say this evening would not, will not, be found acceptable by my precedessors: but then I did not learn—or may I, just for a moment, speak here for my colleagues too, and say we did not learn? either from Professor Ayer or from Professor Hampshire the desire to agree. This was not what we learnt, because this was not what they had to teach us. What they had to teach us was a virtue which might well be called systematic irreverence. By which I mean the desire, the insistence to test for lucidity, for relevance, above all for truth, any idea that solicits our allegiance, whatever its standing, whether it originates from the tradition, or from some eminent contemporary, or from what is only too often the most seductive and irresistible of sources, ourselves: and if it is found wanting, to reject it without more ado. Philosophy can never become a mere idle or indulgent occupation as long as it incorporates this virtue. University College London is a very fitting place for its cultivation.

6. The first argument runs like this: so far from its being a possibility that we might come to know how we saw things by observing how we represent them, on the contrary we must already know how we saw them before we can represent them. Suppose our medium of representation is drawing—and I shall stick to this supposition for most of the lecture, and use the terms 'represent' and 'draw' by and large interchangeably: then, we must be able to answer the question. How do we decide whether the drawing that we do is correct or not? Unless any drawing that we choose to do counts equally as an adequate representation, then there must be something by appeal to which we assess the adequacy of what we have done. We need, in other words, a criterion, and where is this to be found but in the knowledge that we already possess of what we have seen? Put in stronger terms, the argument asserts that the idea of the representation of what we see as the criterion of what we see is a self-contradictory idea. For it in the first place assumes (by talking of representation) that there is an independent means of identifying what we see, independent that is of how we represent it, and then goes on to deny that this is so.

7. Now it is certainly true that not *any* drawing we might choose to produce of what we have seen will do.

Indeed, when we consider just the very cases that make our criterion acceptable—cases, that is, like the perceptual constancies, where there is a divergence between what we would expect to see and what we actually see —it seems likely that the drawing that is a faithful representation of our visual experiences is one that will come about only as the product of trial and error. We can imagine the observer making a few strokes, scrutinizing them, accepting them, or finding them unsatisfactory and then correcting them and so working his way forward to the finished product through erasures and *pentimenti*. In other words, in so far as it is plausible to talk of the visual experience, this representation is going to be the result of a process within which judgements of adequacy or inadequacy, of verisimilitude or distortion, will have an essential place.

But does this involve, as the argument before us would suggest, that we need have any prior knowledge of what we have seen by reference to which we make these judgements: let alone a criterion that we apply in making them?

I think that we can see that the supposition that a criterion is necessary is wrong by considering what at first might seem a rather special sort of case: one, that is, where we do employ a criterion in drawing what we have seen, but unfortunately the criterion gives us a faulty representation. The problem is then to correct what we have drawn so as to bring it into line with the visual experience. Imagine, as the traditional writers on perspective so often ask us to,⁴ a man placed in front of a landscape: between him and the scene before him is interposed a large sheet of paper, transparent but also firm enough for him to draw on without difficulty, set at right angles to the line of vision. With a pencil he starts to trace on the paper the outlines of the various objects in the landscape as they manifest themselves through the sheet of paper: when he has done this, he then proceeds, on the same principle, to block in the various silhouettes so that, within the restrictions of the medium, the sheet will bear upon it the imprint of the various lines and areas of colour as, seen through it, they showed up on it.

But if we take into account the perceptual constancies and the various phenomena that arise out of, or are enhanced by, the change of scale, such as colour-juxtaposition, it is evident that the drawing that is produced in this way, upon 'the diaphanous plain',⁵ will not be a fair representation. As soon, indeed, as the man abandons the purely mechanical part of his task and stands back and looks at what he has done, he will straightway see that it is out of drawing. Now this is the point; he will simply *see* it: and to talk of any criterion in terms of which he judges the representation

to be at fault or by reference to which he corrects it, seems here totally gratuitous. The man corrects the drawing by seeing that it is wrong.

But surely the process of correcting the drawing is not essentially different from the process of constructing it; and so, if the former can be conducted without the aid of a criterion, it must be that the latter could have been too. We may need to imagine that the drawing was done with the aid of a criterion in order to see how it could then be corrected without one. But once we see how it could be corrected without one, we also see that a criterion was not needed for the drawing to be done.

8. Of course if a man draws what he has seen, there is something that is prior to his doing the drawing and which is also that on the basis of which he does the drawing. And that is the visual experience itself. If the visual experience had not been as it was, the man would not have drawn as he did nor would he have corrected what he did draw as he did.

That is indubitable. But the fact that the visual experience can be in this way operative after it has passed should not lead us into the view that it somehow persists in the form of a lingering image, which we then try to reproduce when we set ourselves to represent what we have seen. For there is no reason either in logic or in experience⁶ to believe in the existence of such an image. We do not need it in order to explain the facts of the case, nor do we have any independent evidence for its existence in our actual consciousness. It seems a pure invention conjured into being to bridge the gap between one event—our seeing as we do—and another event, when what we have seen asserts its efficacy.

9. And yet this last phrase—'asserts its efficacy'—seems to bring us back to the view that something must have happened at the time of the visual experience which allows us, or influences us, to draw as we do. And if it is crude to identify this enabling power with the creation of an image which endures, then a more sophisticated view of the matter might be to think of this as the establishment in the mind of a disposition. And the natural name for such a disposition would be 'knowledge.' When we have the visual experience, we *eo ipso* know what we have seen, and this is why we are able, at a later point in time, to represent it. And this in turn is why it is absurd to think that by looking at what we have drawn, we could come to know what we have seen. For it is this knowledge that guides the drawing.

Now there is little to be said against talking of a disposition in this context: precisely because in talking of it, we are really saying so little. It is hard to feel that we are in fact doing more than simply redescribe the facts we start off with. Nor is there even perhaps so much to be said against thinking of this disposition as knowledge: if, that is, we recognize one

important point. And that is that we can be conscious to widely differing degrees of what knowledge we possess. So that, for instance, when some dispositional form of knowledge about what we have done or felt or experienced becomes actualized, the shock or surprise can be so great for us that it seems perfectly appropriate for us to describe the situation as one in which we *come to know* such-and-such a fact about ourselves: that we wished someone dead, that we desired a certain person, that we helped only in order to dominate. If, however, we wantonly refuse to admit this, if we insist that we have equally ready access to anything that we truly know, then we must also abandon thinking of the disposition that we have anyhow so gratuitously postulated, as a form or mode of knowledge.

10. However, it might now be maintained-and this is the second argument that I want to consider-that, even if we accept the contention that the representation (or let us say, more specifically, the drawing) of what is seen is the criterion of the visual experience, and do not insist (as the last argument would) that we must have prior knowledge of what we have seen before we can draw it, we still do not have to embrace the conclusion, which seems to some so objectionable, that we could ever come to know what we have seen by looking at our drawing of it. For we would have to accept this only if it were true that we could come to know what we have drawn by looking at our drawing. But this (the argument runs) is impossible. In the case of someone else's drawing, I can, indeed must, obtain my knowledge in this way. But in my own case, when it is I who draw, it is not open to me to come to know by observation what I have done. No more indeed than (which is much the same thing) I could predict what I will draw, and then check my prediction by looking at the drawing I actually produce.

Or rather there *might be* cases where something like this happened cases of automatic drawing, or working under drugs or in hallucinated states. But they would not be central cases, and moreover they almost certainly would not be amongst those cases which did anything to suggest that representation is a good criterion of the visual experience. For, if we drew in this way, our depiction of what we saw would not be, in the full sense of the word, an action of ours: it would be something that just happened, rather than something we did. And that in which it issued, the drawing, would have to be relegated more to the status of a 'symptom,'⁷ of the visual experience: just as, in the case of Perdita, blushing was a symptom of what she saw.

11. This argument is, of course, grounded in a certain view of human action, properly so called, of which we have come to hear so much recently that we might call it an orthodoxy of the day. The general form of this view

is that action, or what is sometimes more narrowly identified as voluntary or intentional action, can be marked off, or is differentiated, by some epistemic property that it possesses. An action, on one variant of this view, is something whose nature is known by the agent, or more neutrally by the 'doer,' without observation: it being, of course, a necessary but not a sufficient condition of action that it should be known of in this way, for the same thing is also true (it is said) of the disposition of one's limbs.⁸

On another variant of this view, an action is not something that the agent can predict: where to predict means to come to know in advance by inductive or observational means. The agent can possess knowledge of his future actions, but this knowledge will be of a non-inductive kind and is most succinctly expressed in an assertion of the form 'I intend to do such-and-such a thing.⁹

12. However, it would be as well explicitly from the start to distinguish the question whether we could come to know what we have drawn by observation, from two other issues with which, largely for verbal reasons, it might get confused. The first is whether we could come to know by observation what we have done a drawing of, in the sense of what precise thing we have drawn-to which I am sure that the answer is that (except in very irregular circumstances) we certainly could not. However, I shall not spend any time on this question, for it would lead us on to rather deeper issues, of which it is indeed the mere epistemological shadow, such as, What is it for a drawing to have an object?, or, What is the link that ties a representation to that which it represents? These issues have come to interest philosophers in recent years, since they provide such excellent examples of intentionality. But here I mention them only en passant: and then only because of the unfortunate ambiguity of the phrase 'what we have drawn': for besides meaning 'what sort of drawing we have done,' as it has with us so far, this phrase can also mean 'what we have done a drawing of,' so that 'coming to know what we have drawn' can, from this latter meaning, derive a secondary usage equivalent to 'coming to know what we have done a drawing of.' But I hope it is apparent that none of my argument either refers to, or derives its authority from, anything that is true in or of this usage.

13. The second issue with which we ought not to confuse the question before us is whether we need to use our eyes in order to draw. For it is certainly true that to many an activity the use of the eyes is essential or intrinsic. We need them in order to perform it. Consider, for instance, driving a car: or reading: or aiming a gun: or threading a needle. But it would obviously be wrong to say that we find out by observation that we are driving, or reading, or aiming a gun, or threading a needle. For in such

cases the use of the eyes is not primarily cognitive: either as to the mere performance of the activity (i.e. that we are doing it), or, for that matter, as to any subsidiary or ancillary piece of information. In reading, for instance, we do not use our eyes in order to find what words are before us, which we then proceed to read: we read, rather, with our eyes.

What we need to distinguish, then, is the necessity of the eyes for the performance of some activity and the necessity of them for knowledge of that activity. For instance, I have seen it argued that a man could not come to know by observation what he was writing, since, though he might, while writing, keep his eyes open, as an aid, 'the essential thing he does, namely to write such-and-such, is done without the eyes.'10 But while I am convinced that the conclusion here is true, that we could not use our eyes to find out that, or what, we had written, this does not follow from the equally true premiss that we do not need our eyes in order to write. For there could, after all, be activities for the doing of which the eyes were inessential: but where we could not know that we had done whatever it was. save by observation. Conjuring-tricks might be an example. Equally, there could be cases where the eyes were essential for the performance, yet it would not follow that we had, or even could, come to know what we had done by observation. We could not, for instance, after we had read a paragraph, look back over it to find out what we had read: and if there are moments of great torpor, in which we are tempted to say that this is what we are doing, we use the phrase to call in doubt that we have been reading at all. To return then to the main argument, my point is that if someone were to claim, as one well might, that we could not draw without the use of the eyes, or that we must use the eyes in order to draw, this would not establish that we could use the eyes in order to come to know what we had drawn.

14. However, though it would be wrong to argue in this way, I am nevertheless convinced that the conclusion is true and that we could use our eyes in order to come to know what we have drawn.

There are, of course, cases where we draw and the drawing we might say flows out of us, and what appears on the sheet is exactly what all the while we had expected to appear there. It is, indeed, in cases such as these that we are tempted to conceive, quite erroneously as we have seen, of the act of representation, given that the actual object is not there, as the reproduction of some inner image: for, however unplausible such a conception may turn out to be under analysis, it does at least go some way to accounting for the feel of inevitability and familiarity that accompanies the drawing.

But there are other cases where the process is stickier: where there is no such smooth interlocking of anticipation and performance: and where after the drawing has been done, the draughtsman has to make a separate act of accepting it as his own, as corresponding to his wishes or designs. In such cases there may eventually arise feelings of familiarity which attach themselves to the drawing, but in contrast to the earlier kind of case, here it will be familiarity breaking through some initial cloud of surprise or suspicion.

Now, I want to maintain two things. First of all, it is more likely to be the second than the first kind of case that will provide us with instances in which it is plausible to think of a representation of what we have seen as a criterion of the visual experience. What I said initially on the occasion of introducing my criterion will, I hope, have sufficed to make this point fairly evident. Secondly, though just now I talked of the latter kind of case as primarily one where after we have completed the drawing, and only then, do we come to see that it is right, I think that on many occasions, when the drawing is complete, what we also do is to come to know what we have drawn. Indeed, I suspect that with many activities the distinction between these two kinds of discovery or revelation is far from sharp; perhaps, in particular, with activities the performance of which is not readily verbalized. Take, for instance, the case of someone trying to reproduce a noise that he had heard in the night. Who will claim that he can distinguish, as the noise comes out of his mouth, between, on the one hand, recognizing that the noise is right and, on the other hand, finding out what noise he has made? But even suppose the distinction to be sharp, and moreover sharp in the case of drawing: then I still want to maintain that in many cases where someone experiences uncertainty while drawing, or surprise afterwards, the uncertainty and the surprise will relate as much to what he is drawing or has drawn, as to its rightness as a representation. In other words, it would be erroneous to think of all cases of the second kind on the analogy of a man doing a crossword puzzle and trying out a certain word, to see if it will fit: in many cases, the perception of the fit is simultaneous with the perception of what is being tried out, and the analogy (to be appropriate) should require that the word forms itself or comes into being for us only as it falls into place in the puzzle.

15. Must we then conclude that in many cases the act of drawing what we have seen is not a true action of ours at all? And that, so far from being entitled to infer from the intentionality of representation to the fact that we cannot come to know what we have drawn by observation, we ought rather to argue contrapositively: that is to say, from the evident fact that we *can* come to know what we have drawn by observation to the non-intentionality of representation?

But perhaps we need not go so far. For even the adherents of the view that every intentional action that we do is known by us without observation have conceded that there will always also be certain descriptions of our actions that we do not know to be true of them or that we know to be true of them only by observation.¹¹ Similarly the adherents of the view that we have a non-inductive knowledge of our future actions allow that there will always also be certain descriptions of these actions under which we can in an ordinary inductive fashion predict that they will come about.¹² So for instance, a man might be building a wall intentionally and know that he was building a wall, but not know that he was depriving his neighbour of a cherished view. A man might intend to track his enemy all afternoon and know that he was going to do this non-inductively, but might also be in a position to predict, on the basis of a knowledge of his enemy's habits, that around three o'clock he would find himself walking in front of the church of St. Stephen.

Mightn't we then have here a possible let-out: in that we could say that the act of representing what we have seen is intentional, since even if we don't know directly what we are doing under one description, there is another description under which we do know what we are doing? Even if we don't know that we are drawing two figures the same size, or don't know this until after we've finished, we do at any rate know that we are drawing two figures. Isn't that good enough? And the answer of course is that it isn't. For those who allow that, though for any intentional action there must be one description under which we know immediately what we are doing, there could also be others under which we don't, insist in the same breath that the action is intentional only under the former description and that it is unintentional under the latter. In other words, their view is that the intentionality or otherwise of an action is relative to the description under which we subsume it. Applied to our example, this gives the conclusion that the drawing of two figures would be intentional but the drawing of two figures the same size would not be.

• 16. I hope I have already indicated how undesirable I should find such a conclusion, and why. The point is that it is only in so far as an action is intentional that it can be regarded as the criterion of an experience. Otherwise it can at best be a symptom of that experience. Now the distinction here, criterion or symptom, might be thought to be a purely verbal matter, since either way round, the representation could still be (to use a neutral term) the index of what I have seen. That is true. But if the representation of what we see were to make good its claim to be a symptom, then there would have to be shown to be something like a series of causal connections holding between, on the one hand, specific visual experiences and, on the other hand, specific configurations. To believe in such connections would be a pretty strenuous exercise of the mind. Accordingly, the only plausible way in which representation and visual experience can be linked is one according to which the former is the criterion of the latter, which in turn means that the former must be fully intentional, which is just what looks threatened at the moment.

I want to maintain, however, that this threat can be grossly exaggerated. For we do wrong to adopt as a universal principle the idea that if a man does a certain action and there is a description under which he knows directly that he is doing it and another under which he doesn't, then though the second description is also true of it, it is only under the first description that the action is intentional. It may well be true that in the case where a man builds a wall which obscures his neighbour's view and he knows directly that he is building a wall but only, say, afterwards that he has obscured the view, then the building of the wall was intentional but the obscuring of the view not. But the argument could easily be extrapolated invalidly. For, I want to maintain, there are cases where the description under which the action is known directly and the description under which it isn't are so related that intentionality transmits itself from the action described in the one way to the action described in the other. For instance-and I suggest this without prejudicing that there might be other ways in which the two descriptions are related with the same resultwhen one description refers to the following of a rule and the other to the carrying out of a particular instance of that rule.

17. Suppose that I decide to count aloud, starting with the number 2 and proceeding in accordance with a simple progression: say, one expressed by the instruction. 'Add 7.' Now it is not hard to imagine that though I was able to do this with great fluency, I could not say beforehand, short of sitting down with paper and pencil and calculating, what number I would come out with at, for example, the eighth place. It was, indeed, only when I heard the number actually issue from my mouth, which it did (we are to assume) quite correctly, that I even knew what number I was saying. But surely there is nothing in all this that could conceivably give us reason to say that, whereas counting in accordance with the progression was something I *did* intentionally, coming out with the number 51 was something that merely happened. On the contrary, what seems right to say here, and anything else absurd, is that if the counting in general was intentional, then so also *must* have been the coming out with this particular number.

An older way of characterizing intentional actions, which is at any rate plausible, is to say that they are actions that can be commanded.¹³ Now we might regard our embarking on the process of counting in this particu-

lar way as the acceptance of a command that we give to ourselves. But if this is so, would it not be odd to say that all the various steps that follow on, or are dependent from, our acceptance of the command, that is all the various steps that conjointly make up the carrying out of the command, lack intentionality? Particularly, when it looks as though the only reason for saying that these actions do lack intentionality is just that they constitute the execution of the command.

There could, of course, be a situation in which it was plausible to argue from the existence of a command somewhere in the air to the non-intentionality of whatever put it into effect. This would be where the penalties for disobeying the command were so crushing, or where the command itself or the issuing of it was so peremptory that we became like automata in its grip. However, in the case of a command that we give to ourselves it is difficult to see how, outside pathological states, the first of these conditions could be realized, and not easy to see how the second could be. The second could be, I suppose, if, say we were in a situation in which we had to give ourselves, or find, someone else who would give us, another command before we could be released from the original one.¹⁴

Now, my contention is that drawing a certain configuration can stand in the same relation to drawing what we have seen as coming out with the number 51 does to counting according to the relevant progression: so that if we know directly that we are drawing what we have seen, then we can regard the drawing of the particular configuration as an intentional action, even if we only learn afterwards by observation what configuration we have drawn. Where what we draw is in compliance with the instruction, 'Draw what you see,' then we can regard the drawing we do as something we do.

18. Before leaving this problem I should like to touch upon another and more traditional treatment of it:¹⁵ according to which intentionality has nothing at all to do with any epistemic property that an action possesses, but is determined by the relation in which the action, or, more neutrally, the behaviour, stands to some mental antecedent. For the action now divides itself into two constituents: an intention, which occurs in the mind, and a piece of behaviour, which occurs in the world. The intention originates uniquely with the agent, but the behaviour depends for its realization upon external as well as internal factors: and it is when, and only when, the world is so co-operative as to allow the behaviour to accord fully with the intention, that intentionality transmits itself from the intention to the behaviour. The match between behaviour and intention, being so dependent on factors outside the agent's control, is something that he can come to know of only by observation. Of his intention, on the other hand, he has direct knowledge. And it is this fact—that the agent can have direct knowledge of that which bestows intentionality upon his action that accounts for whatever measure of plausibility accrues to the otherwise false epistemic theory, viz. that whether an action is intentional depends on whether the agent knows of it directly.

But this approach too is not without its difficulties: the most notorious of which is to find anything, any kind of occurrence that is, in our mental life that can lay claim to being the invariable antecedent of intentional action. However, there is another difficulty that I prefer to emphasize this evening, partly because it relates to an important restriction upon our criterion, which I have not so far had occasion to mention.

The present approach obviously requires that we are able in all cases to assign a determinate content to a man's intentions-for otherwise we could not say whether his actions were intentional, since we could not say whether or to what degree they realized these intentions. But take a fairly complex activity, like drawing a landscape with figures, and take a man who can do it and one who can't. Now are we to say that the two men have the same intentions, or different intentions? If we say that they have different intentions, then we have to hold something like that the competent man intends to draw the scene accurately, whereas the incompetent man intends to draw it inaccurately; or that, to be more specific, the competent man intends to draw two figures the same size, whereas the incompetent man intends to draw them different sizes: which is obviously absurd. If, however, we say that the intentions of the two men are the same, this looks more plausible, but it also has its difficulties. For amongst other things, it makes the failure of the incompetent man quite peculiarly hard to understand. For if his failure is specifically a failure to realize his intention, then it looks as though either he is particularly unfortunate, in that the world is very persistent in its refusal to co-operate with him, or else he is unbelievably incompetent, in that he cannot even draw two figures the same size. Now, of course, we need to exclude the man who cannot, say, draw, from the application of our criterion: for it cannot be right to take his representation as the criterion of his visual experience. But the approach we are considering seems unable to account adequately for this exclusion: since the reasons it suggests for it are either far too weak or far too strong, making the man into a victim, on the one hand, or an imbecile, on the other.

19. But now it might be asked, How can I talk of a drawing that I do as the criterion of what I see, when a drawing is so very unlike a visual experience? When, for instance, a drawing is bound to be full of contours, whereas except in the limiting case where what I am looking at happens itself to be a drawing—what I see lacks contours?

Now before I embark on this problem, which is, I think, both interesting and difficult, I should like parenthetically to mention one way out of it, which is inviting, but which it would, I feel, be wrong to take. For (it might be said) the difficulties I refer to are not really intrinsic to representation as such. They arise specifically out of the particular medium I have invoked, that of drawing, and they do not raise any general issues about how we can represent what we see. Since the issue here is a philosophical or conceptual one, I am entitled to assume an ideal method of representation, and, if I am to make any progress, I must begin by saying: Let us suppose that we take a sheet of paper and that we breathe on it, and that as we breathe on it there is left behind a perfect imprint of everything that we see as we see it, i.e. a complete representation of our visual experience.

The appeal to such magical procedures is not uncommon in contemporary philosophy. 'Imagine', it might be said, 'that we were watching our own funeral', or 'Imagine that we just directly knew what other people were feeling'. Now, doubtless such invitations have considerable pedagogic value, in persuading us to ignore some contingent features of a situation in favour of the essential phenomenon. But they also have their dangers, in that this magical way of thinking is not always confined to the procedures envisaged, but can so easily leak out and infect the results that these procedures are supposed to bring about, and turn them into something of a mystery. Is it so clear what it would be for our funeral to pass our eyes, or for us to be directly cognizant of our neighbour's jealousy?

20. But once we reject the notion of an ideal mode of representation, and content ourselves with the existent and admittedly imperfect modes, how can we avoid the objection that arose a moment ago, that we cannot hope to find amongst these modes adequate criteria of our visual experiences, since any drawing is bound to contain contours, whereas there are no contours to be found in the visual field?

Now if someone at this stage were to retort that my example was badly chosen, in that the visual field does or sometimes does contain contours and the extent to which we experience contour in perceiving real objects is an experimental, not an *a priori*, issue, I should regard this retort as at once misguided and yet also illuminating, if indirectly, on the point I am trying to make. For what this retort assumes is that contours in the sense in which they occur in drawings and contours in the sense in which they have been postulated of our perception of objects are one and the same thing. Yet they evidently aren't. For what we are alleged or asserted to see objects as having might alternatively be expressed by talking of 'edges': edges perhaps marked, or articulated for us, by some kind of separationor boundary-mechanism, such as a sharp gradation of colour, or a brightness difference, or a halo or corona around the object, but nevertheless edges. But no one could maintain that drawings contain edges: within, that is, the edges of the sheet. And now perhaps we can see—and this is what I meant by saying that the retort was illuminating—just why my example of contours as something that differentiates drawings from visual experiences was well chosen. For I wanted something that differentiates them essentially. And that is what contours do. For contours in the sense in which they belong to drawings can belong only to two-dimensional surfaces: which is why they belong to drawings, and possibly to other forms of representation, and why they do not belong to visual experiences.

21. Yet it cannot be right to think of it as a mere coincidence that we should use the same word to refer both to the lines in a drawing and to the edges of perceived objects. 'Contour' is not in this context a homonym. There is a reason for this double usage, and the reason surely is this: that though the contours in a drawing aren't themselves edges, when we look at a drawing as a representation, we see the contours as edges.

But implicit in this explanation is, I feel, a way of meeting the more general objection that is holding us up: namely, that a drawing couldn't be the criterion of a visual experience, because drawings and visual experiences are so very unalike. For in making this judgement of dissimilarity, the objector is presumably contrasting visual experiences with twodimensional configurations of lines and strokes. Now to do so might seem in order, since this is certainly what drawings are. But though this is what they are, this is not the only way in which they can be seen. They can also be seen as representations. Now my suggestion is that in so far as we see a drawing as a representation, instead of as a configuration of lines and strokes, the incongruity between what we draw and what we see disappears. Or, to put the matter the other way round, it is only when we think of our drawing as a flat configuration that we can talk of the unalikeness or dissimilarity of the thing we draw and the thing we see. This is not, of course, to say that we do not distinguish between good and bad representations, where good and bad mean more or less like. But it is significant that in such cases we never make any appeal to the general or pervasive dissimilarity that, according to the argument we have been considering, is supposed to hold between what we represent and how we represent it. Indeed it has even been argued¹⁶ that a good representation, or a representation that is 'revealing', requires an alien or resistent medium through which it is then 'filtered'.

22. But now I must pause and consider this new phrase, which has apparently been so useful and ask, What is it to see something as a representation? A question that I rather dread, because I have so little con-

structive to say in answer to it. I shall begin with a view that has of recent years been canvassed with great brilliance but which I am convinced is fundamentally wrong, and that is that to see something as a representation of a lion or a bowl of fruit is to be disposed to some degree or other, though probably never totally, to take it for a lion or a bowl of fruit: the degree to which we are so disposed being an index of its verisimilitude or goodness as a representation.¹⁷ That representation is a kind of partial or inhibited illusion, working only for one sense or from one point of view, and that to see something as a representation is to enter into this illusion so far as is practicable, is a view that has obvious attractions: even if only because it offers to explain a very puzzling phenomenon in terms of one that is easy and accessible.

Yet it is, I am convinced, misguided. For, in the first place, it does not fit our experience. We have only to think of the undoubted cases of illusion and *trompe l'oeil* that do exist, and compare what we experience in front of them with what we experience in front of an ordinary work of representation, to be immediately and overwhelmingly struck by the difference between the two situations. Just one instance of this: to enter into an illusion (as opposed to seeing through it) depends by and large on a subversion of our ordinary beliefs; whereas to look at something as a representation seems not to necessitate either denial or erroneous belief *vis-à-vis* reality.

And this connects with the second objection I have to the equation of representation with illusion. And that is that it tends to falsify—or perhaps it springs from a false conception of—the relation between seeing something as a representation and seeing it as a configuration. For though there certainly are these two different ways of seeing the same thing—sheet, canvas, mural—there is no reason to think of them as incompatible ways. Indeed, does not a great deal of the pleasure, of the depth that is attributed to the visual arts, come from our ability at once to attend to the texture, the line, the composition of a work and to see it as depicting for us a lion, a bowl of fruit, a prince and his cortège? Yet on the view we are considering it should be as difficult to look at a work in these two ways simultaneously as it is at once to experience a *trompe l'oeil* and to admire the brushstrokes that go to its making.

It is surely no coincidence that the author of *Art and Illusion*—if I may refer in this impersonal way to my former colleague, to whose thinking on these subjects I am so deeply, so transparently indebted—it is no coincidence, I say, that the author of *Art and Illusion* should assimilate what he calls the 'canvas or nature' dichotomy, which corresponds to what I have talked of as the difference between seeing something as a configuration and seeing it as a representation, to the kind of ambiguities of vision typified in the diagrams that decorate textbooks of perception: the reversible staircase, the Necker cube, or, Gombrich's own example, the duck-rabbit figure.¹⁸

For with such figures, we can see them sometimes one way, sometimes the other, but never both ways simultaneously. We can see the duck-rabbit figure sometimes as a rabbit, sometimes as a duck, but never as both.

23. The rejection of the idea that representation is a kind of partial or inhibited illusion might well lead us to the view, which can be regarded as its diametric opposite, that representation is a kind of code or convention. On this view, to see a drawing as a representation of something is no longer to take it, or to be disposed to take it, for that thing: it is rather to understand that thing by it. Now this view not merely avoids the grossness of assimilating all works of representation to *trompe l'oeil*, it has the added advantage that it can allow for the way in which we are able simultaneously to take in, or admire, a drawing as a configuration and as a representation. For when we turn to other cases which are indubitably those of a code or convention, there seems to be no difficulty over any analogous bifurcation of interest. Can we not attend at once to the typography of a book and to what the book says? Do we have to deflect our attention from the beauty of the script to appreciate the melancholy of the poetry it conveys?

But this view of representation has its defects too. For we could imagine a painting of a landscape in which, say, the colours were reversed so that every object—tree, river, rocks—was depicted in the complementary of its real colour: or we could imagine, could we not?, an even more radical reconstruction of the scene, in which it was first fragmented into various sections and these sections were then totally rearranged without respect for the look of the landscape, according to a formula? And in both cases it seems as though there is nothing in the present view that could relieve us from classifying such pictures as representations. Yet ordinarily we should not be willing to concede that this is what they were, since it is only by means of an inference, or as the result of a 'derivation',¹⁹ that we are able to go from the drawing to what it is said to depict. There is no longer any question of seeing the latter in the former. We have now not a picture that we look at, but a puzzle that we unravel.

A good way, I suggest, of bringing out the typical defects of each of the two theories I have been considering would be via two phrases that are used—interchangeably it seems—to characterize our perception of drawings, paintings, etc. For if we are looking at a drawing, say, of a lion and looking at it as a representation, then this fact can be conveyed by saying that we see it as a lion:²⁰ alternatively, it can be conveyed by saying that we see it as the representation of a lion. Now though (as I say) these two phrases can be used in this context interchangeably, each, when concentrated on exclusively, gives rise to characteristic misunderstandings of its own: and my suggestion is that the error of the illusionistic theory of rep-

resentation might be expressed by saying that the theory leans too heavily on the first of these phrases, in that it brings seeing a lion in a drawing too close to seeing a lion in the jungle, whereas the conventionalist theory leans too heavily on the second phrase, in that it over-emphasizes the difference between a lion and a representation of a lion, even to the point of suggesting that quite distinct visual experiences attach to the seeing of each.

24. Students entering the studio of Hans Hofmann, the father of New York painting, were told as their first assignment to put a black brushstroke on a white canvas, and then to stand back and observe how the black was on the white.²¹ Now what these boys had certainly done was to place some black paint on a white canvas, but it was not this—though it was something contingently dependent on this—that they were asked to observe, when they were asked to observe that one thing was on another.

For, in the first place, in the sense in which the black paint is on the white canvas, it follows as a consequence that the white canvas is behind or underneath the black paint. If the paint were rubbed off, the white canvas would be revealed. But there is no analogous supposition that the young painters were required to entertain when they were invited to see the black on the white. They could accompany their perception with, for instance, fantasies about there being a yellow patch behind the black, or there being another black patch behind it, or there being a deep orifice behind it, and they would still have accepted their teacher's invitation.

Secondly, in the sense in which the black paint is on the white canvas, this follows as a consequence from the fact that the black paint has been applied to the canvas. But what the young painters were asked to observe stands in no such connection to the contact of brush and canvas. The putting of paint on canvas is a necessary but it is not a sufficient condition for our seeing one colour on another: even when the first colour is that of the paint and the second that of the canvas. For we could imagine a case in which the paint was put on very thin and the edges of the stroke carefully indented, and the effect might then be as of a cut or slice across the canvas, opening on to darkness. In this case, if this is what Hofmann had asked his students to do, he could then have asked them to observe how the black was behind the white. In other words, if black paint is applied to white canvas, the paint must be *on* the canvas: but of the black we need only say that it *could* be on the white, for it could also be *behind* the white and it could presumably also be *level with* the white.

In other words, there are two distinct dimensions here along which 'on', 'level with', and 'behind' are values: a physical dimension and what we might call a pictorial dimension. It is along the first that the paint is on the canvas, it is along the second that the black is (or, at any rate, is when Hofmann's students did what he wanted them to do) on the white.

Now I have used the word 'pictorial' here, and used it deliberately and in preference to another word, which entered my mind briefly, as it may have yours: that is, the word 'visual'. I rejected this word, because it might tend to obscure one very important point: and that is, that not merely can we see the black on, level with, behind the white, as the case may be, but we can also see the black paint on the white canvas. The physical fact is also something visible. Indeed, that we can see it is just what I have been endeavouring to draw your attention to, whenever I talked of seeing a drawing, painting, etc. as a configuration.

25. Which brings me to the one general point of a positive kind that I have to make about representation: and that is, that to see something as a representation is intrinsically bound up with, and even in its highest reaches is merely an elaboration or extension of, the way in which when the black paint is applied to white canvas, we can see the black on the white, or behind the white, or level with it.

Now there are two objections that could be raised at this stage, both designed to show that my view of representation is much too liberal: in that it will let in far more than is acceptable on intuitive grounds. The first takes as its point d'appui the figure-ground hypothesis of Gestalt psychology. For according to this hypothesis, our very capacity to discriminate any element in the visual field depends upon our power to see it on something else. Accordingly, it would be wrong to use this power to explicate what it is to see something as a representation or to think that we could define the seeing of representations in terms of the power. Now, whatever may be the proper application of the figure-ground hypothesis to the perception of three-dimensional objects, I am sure that, in the case of the perception of configurations (to which, for some reason or other, it is usually applied), all that the hypothesis relevantly asserts is that, in so far as we are able to discriminate a visual element, we see it as opposed to, or in contrast to, or over against, something else. In other words, for an element to be figural is a far more general characteristic than for it to be pictorially on something else or, indeed, than for it to be at any specific point along the pictorial dimension: and we should not be misled over this by the contingent fact that, in most cases where the figure is contrasted with the ground, it is so by means of being localized in front of it. It is, after all, significant that the figure-ground relation has been asserted to hold in cases where the 'on' relation could not hold or could hold only metaphorically, e.g. within the domain of auditory elements. What I have called the generality of the figural characteristic has even encouraged some thinkers

to regard the figure-ground hypothesis itself as purely tautological, in that all it does is to define the property of being an identifiable object.²²

The second objection that I want to consider is one that superficially is more empirical in that it takes as its starting-point specific examples: things like diagrams, arabesques, doodles, which are cases where we see one thing on another, and which surely are not representational. We see one line cross over another, we see one edge of the cube stick out in front of another, we see the key-pattern on the course along which it runs. I agree: but then I do not see why we should not regard these as cases where we see something as a representation. Indeed, the only reason I can think of for not doing so is a prejudice which, if we had not been cured of by our early lessons in geometry, we should have been by our experience of the pictorial art of the last twenty years: that is, the crude identification of the representational with the figurative. For, of course, we cannot see the diagram of a cube, or a grid-like doodle, or the ornament on a frieze as something figurative. But this doesn't mean that we cannot see them as representational. Indeed I want to claim that just this is what we generally do: we generally see each of those diagrams or details as the representation of whatever it is of which the lines that constitute it are the projection on to a plane surface. That this is so becomes apparent when we realize that, along-side the way in which we generally look at them, there is another way, which we seldom employ but always could, and which could appropriately be described as looking at them as configurations.

That this is true even for the simplest case can be brought out by considering something which might at first brush be thought to be minimally representational: a straight line drawn in pencil across a white sheet of paper. For what are we usually aware of in such a case? Is it not something stretched out, and in front of, and across, something else? And isn't being aware of this seeing the line as a representation? Which stands in contrast to what we could do if we were merely to attend to the pencil mark as it lies on the page: *on* the page, in the sense that rub it off, you have the page underneath it. Indeed the real difficulty in a case like this, after we have concentrated on it a while, becomes not so much to understand how we can see the line as a representation but even to make sense of the suggestion that we can see it in any other way, i.e. as a configuration.

26. But now it might be asked whether my argument has not come full circle, and whether the account I offer of representation is in any way distinguishable from that in terms of illusion which I rejected a short while back. I am sure that it is.²³

For in the first place, my account allows for the fact which the illusionistic account does not, that we can see a picture simultaneously as a configuration and as a representation. For there is no general reason why we should not at one and the same moment see one element in a picture as physically on and, say, pictorially behind another: whereas we cannot, at one and the same moment, see a picture as configuration and as *trompe l'oeil*. There may be some cases where we cannot, in fact, see a drawing or painting along these two dimensions without a deliberate switch of set or attention, which must take place over time, but such an inability is always going to be grounded in the particular conditions or occasion.

Secondly, illusion (as we have seen) always involves some subversion of belief. But seeing one thing on another, in the sense that I claim is relevant to representation, has no such epistemic consequences or presuppositions.

Indeed the real difficulty concerning the distinction between my account and the illusionistic account of representation is not so much to find the grounds of the difference, as to bring the grounds together or to assign them their respective weight. For I have made the distinction, you will observe, partly by reference to a difference in experience, partly by reference to a difference in belief. But how do the experience and the belief connect? Could we imagine the experience of illusion totally divorced from the correlative belief? Or is the belief here just a peculiarly vivid kind of experience, or does it still retain, even if in a phantom or attenuated mode, links with action?

27. I end on a question which I have neither the means nor the time to answer. But I have no doubt that the answer if it came could only take us a little further along the path we have been pursuing.

For, though I have, I know, presented nothing this evening that even resembles a demonstrative proof, I nevertheless like to think that the various arguments and considerations I have been advancing do possess a unity over and above that of having been compressed by me into a single lecture.

For all are calculated to disturb a certain picture of the mind, still in circulation, which can only lead to error or vulgarity wherever it asserts itself: in philosophy, in art, in our efforts towards self-knowledge. According to this picture, the thoughts, passions, beliefs, perceptions, sensations, actions that constitute a human biography, form a hierarchy, in which the orders are comparatively distinct, and to each of which attaches its own appropriate degree of certainty. A truer picture seems to be one on which it is only by means of matching perceptions against actions, passions against beliefs, characteristic modes of concealment against characteristic modes of expression, that we can slowly, painstakingly, painfully build up any sort of conception of the human individual that is worth the name of knowledge.

Notes

1. Was ist das Kriterium des Scherlebnisses?—Was soll das Kriterium sein? Die Darstellung dessen, "was gesehen wird," Ludwig Wittgenstein, *Philosophical Investigations* (Oxford, 1959), p. 198. I have amended the translation.

2. R. H. Thouless, "Phenomenal Regression to the 'Real' Object," I-II, Brit. J. Psychol., XXI (1930–1931), 339–359; XXII (1931–1932), 1–30.

3. It is interesting to observe that Thouless originally employed as his criterion what he calls 'the drawing method,' and only later substituted, for reasons presumably of convenience, 'the matching method.'

4. E.g. L. B. Alberti, *Della Pittura* (1435–1436), Lib. II; Leonardo, *Libro di Pittura*, Parte secunda, 118; *La Perspective Pratique*, by Un Religieux de la Compagnie de Jésus (Paris, 1640), Tr. II, Pract. xciii. There are four woodcuts by Dürer (Panofsky, pp. 361–364) showing a similar mechanism in operation.

5. The phrase is Berkeley's: Theory of Vision Vindicated (1733), Sec. 55.

6. Cf. 'Il n'est pas besoin d'avoir une profonde expérience du dessin pour avoir remarqué que l'on saisit quelquefois mieux la ressemblance quand on travaille de souvenir. Mais je ne croirai pas plus celui qui dit voir à volonté son modèle absent comme s'il était présent, que je ne crois l'enfant qui s'enfuit en disant qu'il a vu le diable et ses cornes' (Alain, Système des Beaux Arts [Paris, 1963], p. 289.

7. For the distinction between criterion and symptom see L. Wittgenstein, Blue and Brown Books (Oxford, 1958), pp. 24-25.

8. E.g. G. E. M. Anscombe, Intention (Oxford, 1957), para. 8; P. F. Strawson, Individuals (London, 1959), ch. 3; A. I. Melden, Free Action (London, 1961), ch. 4; O'Shaughnessy, "Observation and the Will," Journal of Philosophy, LX (1963), 367-392.

9. H. L. A. Hart and S. Hampshire, "Decision, Intention and Certainty," *Mind*, LXVII (1958), 1–12; Stuart Hampshire, *Thought and Action* (London, 1959), chs. 2–3; D. M. MacKay, "On the Logical Indeterminacy of a Free Choice," *Mind*, LXIX (1960), 31–40.

10. G. E. M. Anscombe, op. cit., para. 29.

11. G. E. M. Anscombe, op. cit., para. 6.

12. Stuart Hampshire, loc. cit.

13. E.g. Erasmus, *De Libero Arbitrio Diatribe* (1524), II a 1, II a 5–8, II a 13–b 8.

14. That we have no choice but to obey commands that we 'genuinely' give ourselves is a curious lapse in the moral psychology of our day. What makes it even less comprehensible is its occurrence in the thought of otherwise 'liber-tarian' philosophers: e.g. R. M. Hare, *The Language of Morals* (London. 1952), pp. 18–20.

15. E.g. Richard Price, A Review of the Principal Questions in Morals (1758), ch. 8; Jeremy Bentham, Introduction to the Principles of Morals and Legislation (1789), chs. 7-9; James Mill, Analysis of the Phenomena of the Human Mind (1829), ch. 25; William James, Principles of Psychology (London, 1890), I, 253 (à propos the 'intention of saying a thing').

16. Stuart Hampshire, Feeling and Expression (London, 1961), pp. 14–15. 17. E. H. Gombrich, Art and Illusion (2nd ed.; London, 1962), chs. 7–9, e.g. pp. 172–176, 233–236, 256. Of course Gombrich combines his thesis with a very complex account of what constitutes illusion, in which great emphasis is placed on the role of projection: but as the discussion of Shadow Antiqua (*ibid.*, pp. 175–176) clearly brings out, for him illusion certainly involves false belief.

18. Op. cit., pp. 24, 236-238.

19. L. Wittgenstein, Blue and Brown Books, p. 129.

20. Wittgenstein seems to suggest that it would be quite erroneous for us to talk of seeing a drawing of e.g. a lion 'as a lion' unless we were aware of something else which the drawing could be seen as a representation of. So, for instance, imagining himself to be in the position of someone who was aware only of the rabbit-aspect of the duck-rabbit figure, he writes: 'It would have made as little sense for me to say "Now I am seeing it as . . ." as to say at the sight of a knife and fork "Now I am seeing this as a knife and fork" (*Philosophical Investigations*, p. 195). But surely the 'seeing-as' terminology would be in place here, just because there is another way in which Wittgenstein can see the drawing, i.e. as a configuration, even though there is not something else of which he can see it as a representation. This fact seems to be concealed by Wittgenstein's introduction of the clumsy phrase 'picture-object,' which he uses to cover the configuration, the representation, and the object represented.

21. I am indebted for this piece of information to Mr. Larry Rivers.

22. David Hamlyn, *The Psychology of Perception* (London, 1957), pp. 55–57. 23. The distinction on which I insist is in many ways similar to that made between 'tridimensionalité' and 'réalité' by A. Michotte, "L'énigme psychologique de la perception dans le dessin linéaire," *Bull. Acad. Belg.* (*Cl. lettres*), 5e série, Vol. XXXIV (1948). See also Margaret Phemister, "An Experimental Contribution to the Problem of Apparent Reality," *Quart. J. Exp. Psychol.*, III (1951), 1–18.

14. Depiction, Vision, and Convention PATRICK MAYNARD

I. Pictures as "Graphic Symbols"

Some recent uses of symbol and language metaphors for the pictorial arts (witness titles like "The Visual Dialogue,"¹ "The Grammar of Drawing,"² and remarks such as "The relationship between the painting and what it represents is symbolic," under other titles³) have had the good intention of restoring appreciation for representation itself—largely through efforts to rescue the concepts of representation from the competing model of "the imitation of appearances." This paper attempts to identify, consolidate, and assess some main lines of argument for this approach, but only from the restricted standpoint of their bearing upon the old and continuing business of capturing the appearances of the natural world.

Language metaphors are of course not new to language about the arts. But where in the heyday of artist-expression theories those metaphors had a flavor of aesthetic "pragmatics," their appeal today suits a taste for art's syntax and semantics. For a parallel in theory to the recent post-painterly cooling on the topics of art as the artist's action and self-realization we may compare the relative places accorded representation and expression in the earlier "linguistic" doctrines of Croce and Collingwood with those in the theories of Gombrich and Goodman. "Expression," after all, was only one of several terms figuring in disputes about the "modern art" movement at the beginning of the century, but it became the focus for much of the subsequent theorizing: a peculiar situation, since a crisis of representation lay near the heart of the revolution. Possibly the assumption was that we already understood depiction (which, as everyone knew, artists had been doing all along), and that our efforts should be spent explaining expression (which, supposedly, was what artists had really been doing all

From American Philosophical Quarterly, IX (1972), 243–250. Reprinted by permission of the author and American Philosophical Quarterly. along), and nonfigurative design (which some were beginning to do for the first time).

Many of course knew differently, and sensed misconceptions about the nature of representation on all sides of the controversy. Thus Meyer Schapiro had observed in 1937 how "in regarding representation as a facsimile of nature, the abstract artist has taken over the error of vulgar nineteenth century criticism. . . . If the older taste said, how exactly like the object, how beautiful!—the modern abstractionist says, how exactly like the object, how ugly!"⁴ Latterly, the correction has been made by use of a symbol or language theory of representation. Writing about the modernist controversy some years after Schapiro, Leo Steinberg makes this case against the imitation view:

The encroaching archaism of old photographs is only the latest instance of an endless succession in which every new mode of naturerepresentation eventually resigns its claim to co-identity with natural appearance. And if appearances are thus unstable in the human eye, their representation in art is not a matter of mechanical reproduction but of progressive revelation. . . . "Technical capacity in the imitation of nature" simply does not exist. What does exist is the skill of reproducing handy graphic symbols for natural appearances, of rendering familiar facts by set professional conventions.⁵

Where imitation becomes a boring technical feat it is not as imitation of nature but rather as imitation of other pictures.

I count three points in this on the topics of imitation, vision, and convention which have since received extensive elaboration. First, there is the principle that a picture could not give an imitation of *the* appearance of something since there is no such favored appearance. And in the "symbol" terminology there is a second, implicit, point that a picture does not yield even an imitation of *an* appearance of its subject,⁶ since it is rather what various writers have termed "a symbolic cipher" for it, its "translation," or "structural equivalent in a given medium." (Some have urged further that a picture stands as such a symbol only for those who are acquainted with its style and medium "language.") Finally, in the remark that new kinds of "graphic symbols" reveal new appearances to us, there is the view that a cause of the instability of natural appearances is the instability of the representational conventions themselves.

Let us begin with the first of these observations. Everyone already knew that a given thing will have different appearances at different times, from different points of view, to different observers. What the principle asserts beyond this is that ideas about what we might call a representative or typical appearance of a thing may vary widely. Given a group of photographs

Depiction, Vision, and Convention

of a house or a friend we are usually able to sort among them for good likeness. Yet if any of those images presents what can be called an imitation of an appearance, they all do, and since it is therefore the appearances themselves which are being graded for correctness, something besides close imitation of an appearance must be involved in the criteria. The missing standard in this story often turns out to be a background of beliefs, expectations, classifications, and attitudes about the items portrayed. That background will also include one's familiarity with other representations; art's "imitation" of nature rests on our construal of nature, and at least part of that is conditioned by art's own legacy of images.

I think that this simple observation has important consequences for our understanding of representation, but neither a differentiation of representation from imitation nor a symbol theory of depiction is among them. For all that has so far been said about representation applies equally well to imitation. Given an object and an order to replicate it closely we shall be as much limited by our beliefs and construals concerning it as by our skills and the availability of materials. For granting the impossibility of emulating in our copy all of the properties of the original, our actual ideas of a fair or close imitation are as much riddled with cognitive and pragmatic factors as that of a good representational likeness was said to be. Emulation of archetype in scale, weight, and strength would likely count toward close imitation of a fabric or an article of furniture; emulation with regard to such properties as color, texture, odor, age, etc., will be essential, important, or irrelevant to a close copy, depending upon the kind of thing copied and the use to which the replica is to be put. Thus the familiar observation that the artist intelligently selects among aspects and characteristics of his subject-matter, rather than "slavishly imitating" it, fails to distinguish either art from nonart or representation from imitation or copying. And although such artifacts may be products of, and evidence for, symbolusing activities of their makers, nothing so far indicates that the artifacts have themselves a symbol-like function.

II. "Imitating Appearances": Super-Pictures

In praise of Masaccio, Vasari wrote: "He recognized that painting is naught else but the imitation of things as they are."⁷ The second antiimitationist principle denied that faithful pictures could be said to yield even imitations of things as they *appear* under prescribed conditions. In a sympathetic effort to understand the idea of a pictorial imitation of something in even *an* appearance, I shall introduce the idea of "super-depiction."

A super-picture of something would be, roughly speaking, a picture of it which, when viewed under some set of objective and subjective conditions, is indistinguishable to all from the thing itself, as viewed under some (possibly different) set of conditions. There would be many difficul-

ties confronting efforts to refine this notion sufficiently for use, even in a relativized version: "P is for S a super-picture of $X \dots$ " For instance, a super-picture of X must be super as an X-representation, so qualifications would have to be framed to exclude as super-depictional cases like that of a picture of a table which looks just like a table when placed face-side down on four table legs, or a portrait of a man which, when viewed in the dark, is indistinguishable from that man (as viewed in the dark). And of course qualifications on the "conditions of observation" would have to exclude subjective conditions (hypnosis, drugged states) on which any picture would be indistinguishable from its subject and all depictions would be super. I believe that the super-picture has served as an ideal for some theories of perspective and of picture-perception.8 My question is whether this ideal-even if it were shown coherent by a precise specification-could explain our usual sense of terms like "realistic," "naturalistic," "convincing," etc., and whether its use might show that these notions are somehow related to the idea of imitating an appearance.

Pictures that we see every day in books, magazines, television screens, etc., are not super-pictures of what they represent. Pictures representing sunlit scenes are printed in low tones of black and white; objects are indicated in lines on what are obviously flat, limited, surfaces; closeups of human features fill a theater screen two hundred feet away. Yet we familiarly judge such representations to be more or less faithful or convincing. to be more or less lifelike, realistic, naturalistic. What could these judgments have to do with the imitation of an appearance? The answer might seem to be expressed in the following procedure: For each motif we imagine a super-picture, and then rank nonsuper-pictures of various styles, sorts, and conventions as they more or less closely approach this ideal of imitation. The super-picture perfectly reproduces an appearance, and ordinary pictures tend toward realism or lifelikeness as they approach super-depiction.

Now for different sets of conditions for observing the chosen subject there will be different sorts of super-pictures of it, and (as previously remarked) we would not in fact count all such pictures as equally faithful or lifelike depictions of the subject, since we would not count all such appearances as equal regarding it. We might then attempt to specify a single ideal by altering the description of the subject so as to incorporate part of the conditions of observation, and thereby to avoid the issue of a multiplicity of appearances: "Fuji—as seen through a window of this hut on a clear morning," "Henry—as he appears through a 33mm lense," etc.

The idea would again be that of ranking nonsuper-pictures for faithfulness by deciding which yield relatively closer imitations of an appearance, where "is a closer imitation" is defined as "more closely resembles the appropriate super-pictorial imitation." But of course for every chosen view there will be innumerable possible pictures of different sorts which resem-

Depiction, Vision, and Convention

ble its selected super-picture in innumerably different ways. And the *respects* of resemblance which we select as most important will determine for us which kinds of pictures more closely match the ideal. Thus even within the restricted frame of "*an* appearance" of a thing there is unclarity about the notion of that appearance which is to be approximated pictorially.

Besides, the resemblance clause of the criterion was not supposed to apply to points of resemblance between nonsuper-picture and superpicture which the latter also bears to its indistinguishable natural archetype. Otherwise, interposition of the superpictorial ideal would be unnecessary: we might as well speak forthrightly of points and degrees of resemblance between nonsuper-picture and subject-matter. Resemblance to the ideal picture, then, was rather to be in terms of those pictorial characteristics and devices which produced the super-depictive effect: emulation in size, perspective system, pigment distribution, for example. Yet such emulation of a super-picture would give no guarantee of faithfulness for what is depicted. In fact-as the checkered history of debates about perspective teaches us-it will often be necessary to depart from emulation of a superpicture in certain pictorial features to bring off just some effect in our ordinary picture which we admired in the super-picture. (Thus while linear perspective may win on optical grounds for a certain sort of super-picture, we may wish, in our easel-sized nonsuper-picture, to bend parallel lines with a "synthetic perspective" to recapture the panoramic effect of the large super-picture otherwise lost in the smaller format.)9

To sum up: In admitting the possibility of super-depiction I allow faithful representation by imitation of appearances. What the foregoing denies is that the notion of imitation as indistinguishability provides even the beginning of a *general* explication of what is involved in the capturing of appearances in pictures. Now a mimetic theorist may at this point object to the use of the limiting perfect case of imitation: After all, to know what imitation leather is we need no notion of a perfect imitation leather. He may therefore still wish to explain statements of the form

P is a perceptually faithful depiction of (an) X

by something of the form

P depicts (an) X as possessing, and closely *imitates* (an) X in, perceptually significant aspects of its appearance,

which yields to our arguments about faithfulness while still getting imitation into the formula.

I believe that it is at this point that many writers deploy a principle like the second in Steinberg's account to remind us that aspects of appearance must be "translated" into pictorial terms and not copied. Unfortunately, their message is often obscured by carelessness about cases. Hermann von Helmholtz, for example, once remarked how because of physical limitations in his medium "the artist cannot transcribe Nature; he must translate her";¹⁰ but many of Helmholtz's own examples of "translation" amount only to adjustments in the physical stimulus designed to reproduce the "subjective impressions"¹¹ we would be getting from nature: We color our picture-mountains blue since we cannot rely on the scattering of light to produce this effect as in nature, etc. Such "translation" is not an alternative to imitation. I believe that those who speak of representational "signs," "symbols," "structural equivalents in a medium," etc., usually have the rather different point in view, that a representational style or convention can itself act as a sort of medium or perceptual context upon which pictorial appearances are causally dependent.

We all know how physical context may affect the appearance of a color or a shape: How could style or system have a like influence? It would not suffice to say that style factors may be causally effective in conveying effects. A red figure on a green ground may look different from a red figure on a purple ground, and use of green with red may be a defining characteristic of your style. But although it could then be said that stylistic features determine the appearance of red in your pictures, knowledge of your style is not itself a perceptual context, since acquaintance with it is unnecessary for getting the optical effect in question.

To determine when style and knowledge of style acts as perceptual context we might observe the effect which misclassification as to style or medium has upon the appearance of a representation—and, thereby upon its fidelity. Fred may closely resemble Harry by being like him in perceptually significant ways, and Fred's snapshot of Harry may also be said closely to resemble Harry, but the kinds of resemblance are different, for Fred resembles Harry as a man resembles a man, and Fred's picture of Harry resembles Harry as a (sort of) photograph resembles a man. The photograph might not be thought to resemble Harry even slightly if it were mounted on a man's neck, so as to be seen as a part of his body. We might expect then that the size, flatness, gloss, and color would so interfere with the overall resemblance that a poor photograph would come out no worse as a likeness. Such is an extreme case of the effects of misclassification upon pictorial appearance and resemblance; less bizarre cases have been described elsewhere in enlightening ways.¹²

A revision of imitationist accounts of good pictorial likeness in view of the preceding considerations may run to something like the following:

P depicts (an) X as possessing, and either imitates X in or yields "symbols" or medium equivalents for, perceptually significant aspects of its appearance.

Depiction, Vision, and Convention

Possibly this is no less than what "the imitation of appearances" meant all along. Further assessment of the imitation model or metaphor would require then more careful analysis of the concept of imitation than its critics have so far afforded it. But I proceed now to a different question.

III. Realism as Vividness

What is the legacy of considerations like those preceding for our everyday notions of realistic, lifelike, naturalistic, or convincing depiction? Proponents of "language" theories of depiction have not agreed as to the answer. Having himself authored a forceful and influential version of that theory, Ernst Gombrich had occasion to complain in the second edition of *Art and Illusion* about a "group of readers [who] have sought support from this book for the . . . view, according to which the demand for fidelity to nature must always be meaningless, since everybody sees nature differently."¹³ Now by his efforts as a historian (e.g. in *The Story of Art*¹⁴ and *Norm and Form*)¹⁵ Gombrich, like others, has made a large stake in what he calls the "objectivity" of notions of realism or fidelity of representation. Thus we find him in *Art and Illusion* attempting to explain the history of the conquest of appearances from style to style in Western art, and grappling unsuccessfully with formulae designed to protect these ideas from his own best insights about the conventionality of vision and depiction.

Many would believe with Gombrich that there is more lifelikeness in a Vandyke portrait of Charles I than in an image of William in the Bayeux Tapestry, more truth to appearances in a photographic advertisement for a piece of electronic equipment than in a diagram for one, more naturalism in the Pergamon altar relief than in an early archaic kouros statue, more realism in a film sequence of a running horse than in a four-year-old's drawing of one, etc. Could such judgments tell of more than their authors' style prejudices? By a strategy which would further exploit rather than diminish the language metaphor for methods of representation, I shall argue that they can.

The relativist answer has had forceful expression. According to Paul Feyerabend, "realism of representation is an impossible doctrine" which "assumes that there is only one correct way of translating occurrences in the . . . world into situations portrayed in an altogether different medium."¹⁶ In his recent *Languages of Art* Nelson Goodman holds that "realism is relative," that " 'naturalism' is a matter of habit"¹⁷ which reduces to the relative ease in interpretation of representational symbols, having earlier argued that

Each way of painting represents a different way of seeing; each makes its own selection, its own emphasis. . . What we regard as the most realistic pictures are merely pictures of the sort that most of us, unfortunately, are brought up on.¹⁸

Before sketching a case for an objective concept of pictorial realism or naturalism which I believe is adequate to the needs of an art historian such as Gombrich. I wish to make some preliminary remarks about crosscultural arguments concerning ways of seeing. First, beginning with a familiar culture (our own), we shall find that neither ease at interpretation, absence of a sense of distortion, nor effect upon our nonpictorial seeing suffices for realism. We "read" cartoon drawings (like Miss Peach and *Peanuts*) with at least the ease—and through as much habituation as we do drawings by Ingres or Signorelli, and without a sense of grotesqueness in distortion. Perhaps then realism is a (relative) property of what is in some sense a standard method of representation or reportage and a preferred way of perceiving, rather than simply an accustomed one.¹⁹ But today's newspaper contains several sorts of representations. each familiar and standard to its own function. And although we may decline to select the one "best" of these, we might allow that they are not all equal in realism. What is wanted then is further explanation of what we mean here by "realism," "naturalism," etc. For the historian like Gombrich who would describe and explain characteristics, changes, and contrasts in styles by these terms, we need an account of them, free from appeals to suspect notions such as "literal likeness" or "imitation of appearance," but showing them fit for objective use.

Secondly, it seems an exaggeration to suppose that where the style is unfamiliar learning to "read" a picture will always affect one's seeing of nature. Sometimes a representational method resolutely avoids resemblance and interest in appearances. And even when there is such interest, learning to look at small or flat pictures, upside-down pictures, wide-angle photographs with marginal distortions, or at shiny daguerrotypes, need involve no change in one's nonpictorial seeing. It may involve, as earlier argued, an effort at seeing the new kind of image as an image of that type, rather than of some more familiar type, before accommodation breeds invisibility of certain stylistically invariant features which are counted irrelevant to resemblance. But whether increased fluency with the unfamiliar sort of image issues in some change in our way of perceiving will depend upon the particular case. Examples of misconstruing or stumbling about with an unfamiliar style may therefore not always be what the relativist supposes, and the mere fact that another culture would have rejected as distorted the pictures we choose as most faithful does not by itself show that its accustomed way of picturing reflects a distinct way of seeing. The analogy of accustoming one's ear to an unfamiliar accent, or of learning to read upside-down pages, may sometimes serve better than the model of learning a new language.

These remarks read the "seeing" in "ways of seeing" in a very literal way, and it may be urged that the realistic picture is not necessarily (but

Depiction, Vision, and Convention

only for some cultures) the one which captures appearances: Rather, it is the one in which the subject seems most *real*. And for diverse theoretical reasons—if you are a Byzantine, a Moslem, or a Neoplasticist—appearances may be a poor key to your reality. I take this observation as limiting or describing, rather than as discrediting, the present task. Waiving the topic of other equally defensible uses of terms such as "realistic," "naturalistic," etc., the question is simply how well we can fare when we ask, with Gombrich, for the meaning of such expressions, interpreted in the sense of the rendering of perceptual likeness or of the capturing of appearances.

Gombrich's own reply is ambiguous between pictorial illusionism and fullness of information content, but neither alternative is acceptable.20 The fact that a drawing by Eakins is more realistic than is a Greek geometric-figure vase does not mean that anyone is at all likely to be fooled by the Eakins. And from the fact that a picture represents a house as possessing many perceptual properties it by no means follows that the image looks much like a house. Yet I do not think that the notion of realism or naturalism in depiction reduces simply to that of good overall or physiognomic resemblance. The recent caution about the "real" in "realism" suggests to me that lack of distortion and good or significant likeness are no more sufficient for realism than is habituation. The fact that my picture is a poor likeness of Henry does not mean that it is an unrealistic picture, for we might still wish to call it a realistic picture of a man, or a naturalistic and convincing rendering of movement, space, or texture. And while we might not wish to characterize a surrealist landscape such as Dali's "Agnostic Symbol" simply by the label "realistic," surrealist images often derive their force from their realism. from the fact that their very distortions are made perceptually undeniable in their vividness.

Our criteria for realism, then, seem to favor sensorily vivid representation of a particular sort of characteristic, for any subject-matter. There is a difference between representing something as possessing a property and managing to convey, represent, or express those properties (such as brightness, hue, weight) or effects (movement, sparkle of light, etc.) themselves. In the latter case we speak of capturing, conveying, or rendering a quality or effect, or of giving a vivid sense of it. A like distinction obtains between resources of verbal descriptions—between vivid description and mere description-as. One question we can ask of a verbal description concerns the accuracy and inaccuracy of its attributions; another—parallel to the one about pictures—concerns the vividness of the description, whether it merely attributes characteristics or gives a vivid sense of them, so as to make the described situations seem real. Neither question concerns merely the ease with which we can read the description.

I shall call a pictorial device a *realism device* if it yields a vivid sensory equivalent, or gives a vivid sense of, a physical property or effect. Here I

take into account both the manner and the object of representation or expression. Any such device gives us the sense of seeing, touching, feeling, hearing, etc., the objects, characteristics, or events represented. While whatever is conveyed in this way is thereby represented and conceived in a sensual manner, the thing conveyed need not itself be physical or perceivable: Consider, for example, the things expressed or represented with sensory impact by Gothic stained-glass or by a Rothko canvas. There is more involved in being a person than in being a physical existent, and characteristics which a person has as a person and not simply as a physical existent can be represented vividly. But for realism in representation we usually emphasize the expression of those characteristics which a person has as a physical existent: weight, texture, volume, movement, etc. The Western tradition in realism has favored rendering of these "tactile" characteristics as counting toward a sense of the material presence of the subject portrayed, but it would be possible to emphasize vivid conveying of auditory or chemical-sense characteristics as well.

There are many familiar realism devices as here defined. Motion pictures create a powerful sensation of motion by stroboscopic and other devices used on a succession of images; stereoscopes produce a sense of space through the use of two slightly differing images viewed by separate eyes at once, etc. Less powerfully, but not less interestingly, devices such as perspective distortion and diminution, overlap, shadow modelling, aerial perspective, etc., are used to create a sense of spatial depth. It is here rather than in its uniquely corresponding to "the way we actually see the world around us" or even in its being "the best possible approximation" to appearances—as some have claimed²¹—that a perspective system such as the classic "linear" method wins realism for a picture. With those who argue for the absolute advantage in realism of that perspective system over a frontal isometric system, or a nonperspectival system, we can say that perspective distortion and diminution are, with respect to realism, more than "conventional" devices. It would not then be necessary to introduce questions of the appearance of the nonpictorial world or of the indistinguishability of picture and motif to make this claim for artificial perspective. Nevertheless, it is to be expected that in their efforts at realistic effects, picture-makers will investigate nature to discover the cues for perception of space, weight, motion, etc., that they can exploit in their own creations. In this way artists discovered facts about optics and the psychology of perception which hold for nonpictorial perceiving.

A picture may then be described as a realistic or naturalistic picture of something in those respects or to that degree in which the picture possesses realism devices which convey strong sensations of those physical properties which it depicts the subject as possessing. And a pictorial style

Depiction, Vision, and Convention

or convention is realistic to the extent that, or in those ways in which, it is characterized by such devices.

By supplementing this account with other criteria for realism,²² we should be able to reconstruct the family of concepts of realism, naturalism, or convincingness which are familiarly used in discussions of the interest or lack of interest in the capturing of appearances in the history of art. To describe episodes of realism in art as marking renewals of interest in natural appearances would seem unavoidable, though to put them forward as periods of "the imitating of appearances" is a mistake. Consistent with a relativistic view of resemblance we may observe that there have been particular periods in the history of image-making where special interest was taken in ways of giving vivid impressions of sensible aspects of the world. Thus (it is often held) the Greeks discovered means for rendering space and motion, the Renaissance Italians discovered these effects and others (including Berenson's "tactile," "visceral," and "respirational" ones). And, on the present account, a Northern painter or a modern "magic realist" is called a realist not because he provides information about just what can be seen of an object from a given vantage point, but rather because he gives us so much detail and in such a way as to convey a keen sense of surface textures.

IV. Objectivity

Gombrich had wanted to secure a measure of neutrality and objectivity for descriptive terms such as "realistic." The vividness account of realism in depiction would allow objectivity in comparisons of the degrees and respects of naturalism or realism in children's drawings, Middle Kingdom Egyptian paintings, stick-figure drawings, blueprints, various sorts of photographs, etc., without having to argue for the literalist's "innocent eye" or privileged ways of perceiving. Such judgments get objective sense because, far from being bound by one's own habits or preferences, their responsible utterance presupposes acquaintance with the styles or conventions described. On this account we cannot tell about realism in a picture unless we can tell what sensory effects it would have. And we cannot tell this until we have grown sufficiently accustomed to a style that it can disclose its power to us, or until we have indirect evidence of what powers that style had for those who were fluent with it. Thus responsible comparisons for realism between representational systems presupposes either one's own fluency with them or evidence about the people who were fluent with them.

This approach makes much of the authority of indigenous construals, while previous arguments here had urged tolerance regarding the diverse possible ways of perceiving nature in terms of representations of it. Why should we now speak of preferred ways of perceiving the *representations* themselves? The question is whether I am not overtaxing the linguistic metaphor for representation. Certainly, if we are to comment on the nuances of a sentence in an Ananda dialect we must either be ourselves fluent with that dialect or else rely upon the reports and behavior of those who are. But can we assume that representational systems are like descriptive ones in this respect?

The answer is that we can consistently speak of preferred ways of interpreting representations, so long as we remember that things are preferred for certain purposes, and that there are different possible purposes. The question, "How shall I look at this picture?" is a practical one, and it yields different answers depending upon our varying needs and interests. Suppose that my interest is simply in getting more enjoyment from a picture: The best counsel might then be for me to see the picture in whatever way it comes out best for me then or later. Toward this end I might go to a critic or a historian for guidance, to have pointed out to me what I enjoy perceiving but would not have noticed on my own, or to hear those anecdotes about the picture's history which make my present experience of it or my later thought about it more rewarding. No preference need be given in such cases to the original intention of the work. There are times when one may remark truthfully, "I liked it better before you explained it to me," and it is possible that a certain work will come off better for a given person, with certain interests and abilities, perceiving the work under certain conditions, if he does not attempt to approximate someone else's experiences. The fickleness of fashion regarding these abilities, interests, and conditions is attested to by the variety of responses over the years to incidents like the cleaning and brightening of favored works by "old masters."

But for the scholar who uses a society's legacy of images as evidence for judgments about that culture's beliefs, attitudes, perceptions, and doings, the situation is different. Correctness of interpretation becomes a meaningful and important idea here, and accordingly, insularity or prejudice of perception becomes a vice-largely because it leads to error. In these contexts, and with these purposes, the scholar's judgments about pictorial realism or naturalism are typically related to remarks about socioeconomic, political, scientific, religious, and aesthetic matters. And in principle there is no more theoretical problem of objectivity concerning the question how convincingly something is conveyed in a picture than there is about the questions of what is represented there and what that thing is represented as being. I would be inclined here to appeal to facts about a picture's representational "conventions," but the fact is that there are no rules prescribing such conventions.²³ For conveying and expressing, as for representing-as, the "conventions" exist only in the greater or lesser agreement in the responses of those numbered among the fluent. Here the

Depiction, Vision, and Convention

art historian finds, as for verbal languages and other cultural entities, communities with debatable and shifting borders which only approximate unanimities of response.

Notes

1. Nathan Knobler, The Visual Dialogue (New York, 1967).

2. Colin Hayes, The Grammar of Drawing for Artists and Designers (New York, 1969).

3. Frederick Gore, *Painting: Some Basic Principles* (London and New York, 1965), p. 36.

4. "Nature of Abstract Act," Marxist Quarterly, I (1937), p. 86.

5. "The Eye Is a Part of the Mind," *Partisan Review*, XX (1953); reprinted in S. Langer ed., *Reflections on Art* (Galaxy Book edition, New York, 1961): see p. 247.

6. These two points are distinguished by Nelson Goodman in his review of Ernst Gombrich's *Art and Illusion*, in *The Journal of Philosophy*, LXII, (1960), p. 59.

7. On Wölfflin's translation of the passage in Vasari's Vite in Classic Art, tr. by P. and L. Murray (London, 1952, p. 4.

8. Cp. James Gibson's notion of "fidelity": "A faithful picture is a delimited surface processed in such a way that it reflects (or transmits) a sheaf of light-rays to a given point which is the same as would be the sheaf of rays from the original to that point," with "indistinguishability" as the limiting case ("A Theory of Pictorial Perception," *Audio-Visual Communications Review*, II [1954], p. 14).

9. For discussion see G. ten Doesschate, *Perspective* (Nieuwkoop, 1964); D. Gioseffi, "Optical Concepts," *Encyclopedia of World Art* (New York, London, Toronto, 1967), X, col. 766–769; J. White, *The Birth and Rebirth of Pictorial Space*, 2nd ed. (London, 1967). Maurice Pirenne's recent *Optics, Painting, and Photography* (London, 1970)—esp. pp. 93nl, 148f, 165–183—supersedes his earlier writings on the subject of perspective. Pirenne's discussion there of "subsidiary awareness" of the picture surface is of special importance to this issue.

10. "On the Relation of Optics to Painting," tr. by E. Atkinson, in *Popular Scientific Lectures*, M. Kline, ed., (Dover publications edition, 1962), p. 285.

11. Ibid., p. 278.

12. K. Walton, "Categories of Art," *The Philosophical Reviéw*, LXXIX (1970); R. Arnheim, *Art and Visual Perception* (Berkeley and Los Angeles, 1954), pp. 161–165; E. Gombrich, "Expression and Communication," in *Meditations on a Hobby Horse* (London, 1963).

13. Art and Illusion, 2nd (rev.) ed. (New York, 1961), p. xii.

14. (London, 1950), esp. the treatment of Greek art, Renaissance art, and Cézanne.

15. (London, 1966), esp. the title essay, with its notes.

16. "Problems of Empiricism," in *Beyond the Edge of Certainty*, ed. by R. Colodny (Englewood Cliffs, 1965), p. 221.

17. (Indianapolis and New York, 1968), pp. 36f, 231. The present essay, restricted as it is to the topic of perceptual fidelity in representation, avoids the wider issues involved in Goodman's general and impressive case for pictures as symbols.

18. "The Way the World Is," The Review of Metaphysics, XIV (1960), p. 52.

19. See Languages of Art, p. 37f.

20. See Art and Illusion, pp. xiif, 99, 276, 299, and Goodman's criticisms in his review of Gombrich, p. 599.

21. See Pirenne's defense of linear perspective in "The Scientific Basis of Leonardo da Vinci's Theory of Perspective," *British Journal for the Philosophy of Science*, III (1952), p. 183.

22. Resemblance or lack of distortion is usually a factor. Besides this, existence of things of the sort depicted is sometimes a requirement, as in Courbet's remark, "Show me an angel and I will paint one."

23. See E. Panofsky's discussion of the difficulty involved in defending the seemingly correct remark that van der Weyden's "Three Magi" represents the Infant as making an apparitional appearance: *Studies in Iconology* (Oxford, 1939), pp. 9f.

Bibliography to Part Five

The problem of representation has been focused, in recent years, by the appearance of E. H. Gombrich's views about pictorial representation and Nelson Goodman's general theory of representation and the referential functions of art. Particularly relevant are:

E. H. Gombrich, Art and Illusion (London, 1962, 2nd ed.), Chapters 7-9;

E. H. Gombrich, "Meditations on a Hobby Horse," in Meditations on a Hobby Horse and Other Essays on the Theory of Art (London, 1963).

Among the livelier discussions bearing on the issue of representation, the following may be mentioned:

- Max Black, "How Do Pictures Represent?," in E. H. Gombrich, Julian Hochberg and Max Black, Art, Perception and Reality (Baltimore, 1972);
- B. Falk, "Portraits and Persons," Proceedings of the Aristotelian Society, LXXI (1974–1975), 181–200;
- E. H. Gombrich, "The 'What' and the 'How': Perspective Representation and the Phenomenal World," in Richard Rudner and Israel Scheffler (eds.), *Logic & Art* (Indianapolis, 1972);
- Göran Hermerén, Representation and Meaning in the Visual Arts (Lund, 1969);
- Julian Hochberg, "The Representation of Things and People," in E. H. Gombrich, Julian Hochberg and Max Black, Art, Perception and Reality (Baltimore, 1972);
- David Novitz, Pictures and Their Use in Communication ('s-Gravenhage, 1977);
- L. R. Rogers, "Representation and Schemata," British Journal of Aesthetics, V (1965), 159-178;

Richard Rudner, "On Seeing What We Shall See," in Richard Rudner and Israel Scheffler (eds.), Logic & Art (Indianapolis, 1972);

Roger Squires, "Depicting," Philosophy, XLIV (1969), 193-204;

Robert H. Thouless, "Phenomenal Regression to the Real Object," British Journal of Psychology, XXI (1930–1931), 339–359; XXII (1931–1932), 1–30;

Representation in Art

- Kendall L. Walton, "Pictures and Make-Believe," *Philosophical Review*, LXXXII (1973), 283-319;
- Marx W. Wartofsky, "Pictures, Representation, and the Understanding," in Richard Rudner and Israel Scheffler (eds.), Logic & Art (Indianapolis, 1972);
- Richard Wollheim, "Reflections on Art and Illusion," in On Art and the Mind (London, 1973).

Representation in music was, formerly, the center of the controversy. Discussion often focused on:

Eduard Hanslick, *The Beautiful in Music*, trans. Gustav Cohen (Indianapolis, 1957).

See also:

V. A. Howard, "On Musical Expression," British Journal of Aesthetics, XI (1970), 268-280;

Leonard B. Meyer, Emotion and Meaning in Music (Chicago, 1956);

Leonard B. Meyer, Music, The Arts and Ideas (Chicago, 1967).

Part Six The Intentional Fallacy and Expressive Qualities

Representational art raises the general question of the relevance of an artist's intention in the appreciation of art (see Part Two). It is of course possible to construe representation, as Goodman does, in logical or functional terms. But it may be reasonably argued that, whatever the puzzles generated, the question is ultimately one of intentional considerations—though not necessarily psychological ones.

The issue of the Intentional Fallacy, therefore, is a special, rather heavily debated, version of more general puzzles regarding what may be critically eligible or relevant (that is, short of true or false, or correct or incorrect) in describing and interpreting works of art and peforming particular works. Characteristically, we ask whether, say, James Joyce intended Finnegan's Wake to be construed this way or that, or whether Stanislavski's production of The Cherry Orchard accords with Chekhov's intentions. The questions are quite familiar. But one may puzzle over the critical eligibility of these very questions. Is it "aesthetically" relevant to inquire regarding the artist's intention? As soon as the question is put in this form, we see that the issue depends on the ease with which we may decide what the aesthetic point of view in criticism is (see Parts One and Two). Are we faced with a finding or a ruling? If a finding, how are we to judge conflicting opinions here? If a ruling, what is the force of the term 'fallacy'? We notice that critics, in their practice, sometimes appeal to the artist's intention. What then is the logical status of a judgment that such appeals are inadmissible? And how may the artist's intention be determined: through autobiographical materials? through psychoanalysis? through cultural conventions? through the properties of the work of art itself? And will the answer be quite general for all the arts? For example, will adjustments be advisable when we possess a composer's musical notation?

The issue of the Fallacy is tangentially related to that of the artist's expression, since one variant of the view that the artist expresses himself is

The Intentional Fallacy and Expressive Qualities

to hold that to understand a work one must, or at least on occasion one may have to, know the artist's intention. Sometimes the relationship is reversed and one insists that the merit of a work is to be judged solely or chiefly on whether the artist's intention has been fulfilled-either, on internal grounds, in the work actually produced or, as in the performing arts, in accord with a notation. More directly, the issue of the Fallacy presupposes some fairly clean-cut conception of what "the work of art" is (see Parts Three and Four). Otherwise, we should have difficulty determining the relevance or irrelevance of critical comments-whether intentionally oriented, psychoanalytically oriented, oriented in terms of cultural history or in accord with frankly partisan convictions (e.g., Marxist, Roman Catholic). So the issue of the Fallacy spreads inevitably to that of the general relationship of critical interpretations to the work of art. If we ask ourselves how we define the boundaries of a poem, what are the implications of a changing tradition of dramatic and musical performance, we are at once placed at the center of the difficulties. If a psychoanalytically oriented interpretation of Hamlet be eligible, why not one that accords with Shakespeare's autobiographical remains? And if we may at times restrict dramatic and musical performances in terms of period style, why not in terms of the artist's intention? May we perhaps judge with equal ease, in the context of appreciation, that some particular performance is both ingenious and not in accord with the artist's original conception? And what are the differences, with regard to appreciation itself, between two such remarks as these? What in fact is properly meant by 'the artist's intention'?

All of these questions have been focused memorably by the appearance of Wimsatt and Beardsley's essay (1954). The essay has attracted considerable attention and a very large part of the professionally relevant literature since its appearance is explicitly concerned to defend or criticize its views. A number of questions may be usefully sorted, here. For one thing, Wimsatt and Beardsley construe 'intentional' not only in psychological terms but also in terms of an artist's conscious plan. In effect, what they are concerned about is what, broadly speaking, is central to so-called autobiographical considerations. Many who have criticized them are inclined to think that the "intentional" aspects of a work-even aspects bearing on the artist's "plan"-may be discerned in the work itself. Now, it is not clear whether Wimsatt and Beardsley would be entirely opposed to reference to such features-presumably not-though it is also not clear whether so-called intentionalists have ever meant to rely on biographical considerations somehow not manifest or confirmed at all in some actual work. Again, along these lines, it is not entirely obvious how, as in the performing arts, reference to the artist's plan-mediated by a notation,

possibly by biographical information—can be altogether avoided. Granting this, counterpart moves seem possible to the other arts.

Sometimes, Wimsatt and Beardsley understand the Fallacy to be what might be termed the Romantic Fallacy, that an artist is, at the moment of creation, expressing himself or his age. But this invites us to consider that some of the features of given works of art may well be expressive in either of these two senses, as well as to concede that to construe them thus need not rest on independent evidence of a plan in the artist's mind. Criticism of the one thesis seems not to be tantamount to criticism of the other. Again, they do not sort out with complete success puzzles connected with the problem of allusiveness and meaning. If, for example, as both Wimsatt and Beardsley on separate occasions have maintained, meanings depend on usage and usage includes the author's usage (even if idiosyncratic), then it is difficult to see how to free the objective specification of meaning altogether from intentional factors, however they may be attenuated. This bears in an important way on Wimsatt and Beardsley's would-be distinction between "internal and external evidence" and, more generally, on the theory of the nature of a work of art (see Part Four). More recently, Beardsley in particular-in fact, a number of theorists of literature-has been attracted to a speech-act model. But such a model is incapable of being developed along non-intentionalistic lines. And the intentional factors involved cannot be freed altogether from contextual and psychological considerations.

Among the most vigorous and detailed criticisms of Wimsatt and Beardsley's position is a paper by Frank Cioffi (1963–1964), which stresses, among other things, that the relation of intention to interpretation is unpredictable and variable (hence cannot be ruled out as a general policy) and that art (Cioffi confined himself to the literary arts) is such that our appreciation of it is affected by the artist's relation to his own work. These appear to be quite sensible observations, though their force against Wimsatt and Beardsley depends in part on how we construe the latter's distinction between internal and external evidence—which is not entirely explicit.

More recently, Guy Sircello (1972) has identified a range of attributes properly ascribed to works of art that may reasonably be expressed as well in terms of the artist's intentions. These are interesting because they spring to mind in the most natural way, cannot properly be ascribed to particular works without attention to something like a plan in the artist's mind or psychological intention or intentional state, and because their possession by works of art confirms distinctive aspects of the nature of artworks as such (see Parts One and Two). They may be characterized as expressive properties, though this is not to say that all expressive qualities are properly formulable in terms of the artist's intentional states. The conflation of

The Intentional Fallacy and Expressive Qualities

the two themes is the central feature of the Romantic theory of art: Wimsatt and Beardsley are right in supposing that it cannot be an adequate theory of art; the question is whether they rightly claim that it has no application at all. The principal feature of Sircello's account, however, is that, although these properties may be ascribed to works of art, they cannot be detected by attention to the work of art itself—in any sense in which it is frequently claimed that works of art are directly perceivable (see Part One). On the other hand, Alan Tormey (1971) argues persuasively that expressive qualities need not, and cannot all, be dependent on the actual intentional states of artists. He provides, therefore, for a set of predicates (e.g., *tenderness, sadness, anguish, nostalgia*) which designate expressive properties in works of art because when applied to human persons they designate intentional states.

The question remains whether works of art actually have such properties or whether they may validly be attributed to them for some other reason. There is a strong tendency to hold that such attributions are, somehow, metaphorical. Both Goodman and Beardsley have been inclined to construe them thus. But the justifiability of that view depends ultimately on the theory of the ontology of art (see Part Four), because to hold that a work of art could not literally possess an expressive property or that the expressive property it does possess must depend on a metaphoric application of a predicate that designates what may be literally ascribed to human beings favors certain theories of the nature of artworks over others.

The Intentional Fallacy

W. K. WIMSATT, JR.

and MONROE C. BEARDSLEY

"He owns with toil he wrote the following scenes; But, if they're naught, ne'er spare him for his pains: Damn him the more; have no commiseration For dullness on mature deliberation."

> William Congreve Prologue to The Way of the World

I

The claim of the author's "intention" upon the critic's judgment has been challenged in a number of recent discussions, notably in the debate entitled The Personal Heresy, between Professors Lewis and Tillyard. But it seems doubtful if this claim and most of its romantic corollaries are as yet subject to any widespread questioning. The present writers, in a short article entitled "Intention" for a Dictionary1 of literary criticism, raised the issue but were unable to pursue its implications at any length. We argued that the design or intention of the author is neither available nor desirable as a standard for judging the success of a work of literary art, and it seems to us that this is a principle which goes deep into some differences in the history of critical attitudes. It is a principle which accepted or rejected points to the polar opposites of classical "imitation" and romantic expression. It entails many specific truths about inspiration, authenticity, biography, literary history and scholarship, and about some trends of contemporary poetry, especially its allusiveness. There is hardly a problem of literary criticism in which the critic's approach will not be qualified by his view of "intention."

From *The Verbal Icon*, by W. K. Wimsatt, Jr. (Lexington: University of Kentucky Press, 1954), Chapter I. Reprinted by permission of the authors and the University of Kentucky Press.

15.

"Intention," as we shall use the term, corresponds to *what he intended* in a formula which more or less explicitly has had wide acceptance. "In order to judge the poet's performance, we must know *what he intended*." Intention is design or plan in the author's mind. Intention has obvious affinities for the author's attitude toward his work, the way he felt, what made him write.

We begin our discussion with a series of propositions summarized and abstracted to a degree where they seem to us axiomatic.

1. A poem does not come into existence by accident. The words of a poem, as Professor Stoll has remarked, come out of a head, not out of a hat. Yet to insist on the designing intellect as a *cause* of a poem is not to grant the design or intention as a *standard* by which the critic is to judge the worth of the poet's performance.

2. One must ask how a critic expects to get an answer to the question about intention. How is he to find out what the poet tried to do? If the poet succeeded in doing it, then the poem itself shows what he was trying to do. And if the poet did not succeed, then the poem is not adequate evidence, and the critic must go outside the poem—for evidence of an intention that did not become effective in the poem. "Only one *caveat* must be borne in mind," says an eminent intentionalist² in a moment when his theory repudiates itself; "the poet's aim must be judged at the moment of the creative act, that is to say, by the art of the poem itself."

3. Judging a poem is like judging a pudding or a machine. One demands that it work. It is only because an artifact works that we infer the intention of an artificer. "A poem should not mean but be." A poem can be only through its meaning—since its medium is words—yet it is, simply is, in the sense that we have no excuse for inquiring what part is intended or meant. Poetry is a feat of style by which a complex of meaning is handled all at once. Poetry succeeds because all or most of what is said or implied is relevant; what is irrelevant has been excluded, like lumps from pudding and "bugs" from machinery. In this respect poetry differs from practical messages, which are successful if and only if we correctly infer the intention. They are more abstract than poetry.

4. The meaning of a poem may certainly be a personal one, in the sense that a poem expresses a personality or state of soul rather than a physical object like an apple. But even a short lyric poem is dramatic, the response of a speaker (no matter how abstractly conceived) to a situation (no matter how universalized). We ought to impute the thoughts and attitudes of the poem immediately to the dramatic *speaker*, and if to the author at all, only by an act of biographical inference.

5. There is a sense in which an author, by revision, may better achieve his original intention. But it is a very abstract sense. He intended to write

The Intentional Fallacy

a better work, or a better work of a certain kind, and now has done it. But it follows that his former concrete intention was not his intention. "He's the man we were in search of, that's true," says Hardy's rustic constable, "and yet he's not the man we were in search of. For the man we were in search of was not the man we wanted."

"Is not a critic," asks Professor Stoll, "a judge, who does not explore his own consciousness, but determines the author's meaning or intention, as if the poem were a will, a contract, or the constitution? The poem is not the critic's own." He has accurately diagnosed two forms of irresponsibility, one of which he prefers. Our view is yet different. The poem is not the critic's own and not the author's (it is detached from the author at birth and goes about the world beyond his power to intend about it or control it). The poem belongs to the public. It is embodied in language, the peculiar possession of the public, and it is about the human being, an object of public knowledge. What is said about the poem is subject to the same scrutiny as any statement in linguistics or in the general science of psychology.

A critic of our Dictionary article, Ananda K. Coomaraswamy, has argued³ that there are two kinds of inquiry about a work of art: (1) whether the artist achieved his intentions; (2) whether the work of art "ought ever to have been undertaken at all" and so "whether it is worth preserving." Number (2), Coomaraswamy maintains, is not "criticism of any work of art qua work of art," but is rather moral criticism; number (1) is artistic criticism. But we maintain that (2) need not be moral criticism: that there is another way of deciding whether works of art are worth preserving and whether, in a sense, they "ought" to have been undertaken, and this is the way of objective criticism of works of art as such, the way which enables us to distinguish between a skillful murder and a skillful poem. A skillful murder is an example which Coomaraswamv uses, and in his system the difference between the murder and the poem is simply a "moral" one, not an "artistic" one, since each if carried out according to plan is "artistically" successful. We maintain that (2) is an inquiry of more worth than (1), and since (2) and not (1) is capable of distinguishing poetry from murder, the name "artistic criticism" is properly given to (2).

II

It is not so much a historical statement as a definition to say that the intentional fallacy is a romantic one. When a rhetorician of the first century A.D. writes: "Sublimity is the echo of a great soul," or when he tells us that "Homer enters into the sublime actions of his heroes" and "shares the full inspiration of the combat," we shall not be surprised to find this rhetorician considered as a distant harbinger of romanticism and greeted in the warmest terms by Saintsbury. One may wish to argue whether Longinus should be called romantic, but there can hardly be a doubt that in one important way he is.

Goethe's three questions for "constructive criticism" are "What did the author set out to do? Was his plan reasonable and sensible, and how far did he succeed in carrying it out?" If one leaves out the middle question, one has in effect the system of Croce—the culmination and crowning philosophic expression of romanticism. The beautiful is the successful intuition-expression, and the ugly is the unsuccessful; the intuition or private part of art is *the* aesthetic fact, and the medium or public part is not the subject of aesthetic at all.

The Madonna of Cimabue is still in the Church of Santa Maria Novella; but does she speak to the visitor of to-day as to the Florentines of the thirteenth century?

Historical interpretation labors . . . to reintegrate in us the psychological conditions which have changed in the course of history. It . . . enables us to see a work of art (a physical object) as its *author* saw it in the moment of production.⁴

The first italics are Croce's, the second ours. The upshot of Croce's system is an ambiguous emphasis on history. With such passages as a point of departure a critic may write a nice analysis of the meaning or "spirit" of a play by Shakespeare or Corneille—a process that involves close historical study but remains aesthetic criticism—or he may, with equal plausibility, produce an essay in sociology, biography, or other kinds of non-aesthetic history.

III

I went to the poets; tragic, dithyrambic, and all sorts. . . . I took them some of the most elaborate passages in their own writings, and asked what was the meaning of them. . . . Will you believe me? . . . there is hardly a person present who would not have talked better about their poetry than they did themselves. Then I knew that not by wisdom do poets write poetry, but by a sort of genius and inspiration.

That reiterated mistrust of the poets which we hear from Socrates may have been part of a rigorously ascetic view in which we hardly wish to participate, yet Plato's Socrates saw a truth about the poetic mind which the world no longer commonly sees—so much criticism, and that the most inspirational and most affectionately remembered, has proceeded from the poets themselves.

The Intentional Fallacy

Certainly the poets have had something to say that the critic and professor could not say; their message has been more exciting: that poetry should come as naturally as leaves to a tree, that poetry is the lava of the imagination, or that it is emotion recollected in tranquillity. But it is necessary that we realize the character and authority of such testimony. There is only a fine shade of difference between such expressions and a kind of earnest advice that authors often give. Thus Edward Young, Carlyle, Walter Pater:

I know two golden rules from *ethics*, which are no less golden in *Composition*, than in life. 1. *Know thyself*; 2dly, *Reverence thyself*.

This is the grand secret for finding readers and retaining them: let him who would move and convince others, be first moved and convinced himself. Horace's rule, *Si vis me flere*, is applicable in a wider sense than the literal one. To every poet, to every writer, we might say: Be true, if you would be believed.

Truth! there can be no merit, no craft at all, without that. And further, all beauty is in the long run only *fineness* of truth, or what we call expression, the finer accommodation of speech to that vision within.

And Housman's little handbook to the poetic mind yields this illustration:

Having drunk a pint of beer at luncheon—beer is a sedative to the brain, and my afternoons are the least intellectual portion of my life —I would go out for a walk of two or three hours. As I went along, thinking of nothing in particular, only looking at things around me and following the progress of the seasons, there would flow into my mind, with sudden and unaccountable emotion, sometimes a line or two of verse, sometimes a whole stanza at once.

This is the logical terminus of the series already quoted. Here is a confession of how poems were written which would do as a definition of poetry just as well as "emotion recollected in tranquillity"—and which the young poet might equally well take to heart as a practical rule. Drink a pint of beer, relax, go walking, think on nothing in particular, look at things, surrender yourself to yourself, search for the truth in your own soul, listen to the sound of your own inside voice, discover and express the *vraie vérité*.

It is probably true that all this is excellent advice for poets. The young imagination fired by Wordsworth and Carlyle is probably closer to the verge of producing a poem than the mind of the student who has been sobered by Aristotle or Richards. The art of inspiring poets, or at least of inciting something like poetry in young persons, has probably gone further in our day than ever before. Books of creative writing such as those issued from the Lincoln School are interesting evidence of what a child can do.⁵ All this, however, would appear to belong to an art separate from criticism —to a psychological discipline, a system of self-development, a yoga, which the young poet perhaps does well to notice, but which is something different from the public art of evaluating poems.

Coleridge and Arnold were better critics than most poets have been, and if the critical tendency dried up the poetry in Arnold and perhaps in Coleridge, it is not inconsistent with our argument, which is that judgment of poems is different from the art of producing them. Coleridge has given us the classic "anodyne" story, and tells what he can about the genesis of a poem which he calls a "psychological curiosity," but his definitions of poetry and of the poetic quality "imagination" are to be found elsewhere and in quite other terms.

It would be convenient if the passwords of the intentional school, "sincerity," "fidelity," "spontaneity," "authenticity," "genuineness," "originality," could be equated with terms such as "integrity," "relevance," "unity," "function," "maturity," "subtlety," "adequacy," and other more precise terms of evaluation—in short, if "expression" always meant aesthetic achievement. But this is not so.

"Aesthetic" art, says Professor Curt Ducasse, an ingenious theorist of expression, is the conscious objectification of feelings, in which an intrinsic part is the critical moment. The artist corrects the objectification when it is not adequate. But this may mean that the earlier attempt was not successful in objectifying the self, or "it may also mean that it was a successful objectification of a self which, when it confronted us clearly, we disowned and repudiated in favor of another."⁶ What is the standard by which we disown or accept the self? Professor Ducasse does not say. Whatever it may be, however, this standard is an element in the definition of art which will not reduce to terms of objectification. The evaluation of the work of art remains public; the work is measured against something outside the author.

IV

There is criticism of poetry and there is author psychology, which when applied to the present or future takes the form of inspirational promotion; but author psychology can be historical too, and then we have literary biography, a legitimate and attractive study in itself, one approach, as Professor Tillyard would argue, to personality, the poem being only a parallel approach. Certainly it need not be with a derogatory purpose that one points out personal studies, as distinct from poetic studies, in the realm

The Intentional Fallacy

of literary scholarship. Yet there is danger of confusing personal and poetic studies; and there is the fault of writing the personal as if it were poetic.

There is a difference between internal and external evidence for the meaning of a poem. And the paradox is only verbal and superficial that what is (1) internal is also public: it is discovered through the semantics and syntax of a poem, through our habitual knowledge of the language, through grammars, dictionaries, and all the literature which is the source of dictionaries, in general through all that makes a language and culture; while what is (2) external is private or idiosyncratic; not a part of the work as a linguistic fact: it consists of revelations (in journals, for example, or letters or reported conversations) about how or why the poet wrote the poem-to what lady, while sitting on what lawn, or at the death of what friend or brother. There is (3) an intermediate kind of evidence about the character of the author or about private or semiprivate meanings attached to words or topics by the author or by a coterie of which he is a member. The meaning of words is the history of words, and the biography of an author, his use of a word, and the associations which the word had for him, are part of the word's history and meaning.7 But the three types of evidence, especially (2) and (3), shade into one another so subtly that it is not always easy to draw a line between examples, and hence arises the difficulty for criticism. The use of biographical evidence need not involve intentionalism, because while it may be evidence of what the author intended, it may also be evidence of the meaning of his words and the dramatic character of his utterance. On the other hand, it may not be all this. And a critic who is concerned with evidence of type (1) and moderately with that of type (3) will in the long run produce a different sort of comment from that of the critic who is concerned with (2) and with (3) where it shades into (2).

The whole glittering parade of Professor Lowes' Road to Xanadu, for instance, runs along the border between types (2) and (3) or boldly traverses the romantic region of (2). "'Kubla Khan'" says Professor Lowes, "is the fabric of a vision, but every image that rose up in its weaving had passed that way before. And it would seem that there is nothing haphazard or fortuitious in their return." This is not quite clear—not even when Professor Lowes explains that there were clusters of associations, like hooked atoms, which were drawn into complex relation with other clusters in the deep well of Coleridge's memory, and which then coalesced and issued forth as poems. If there was nothing "haphazard or fortuitous" in the way the images returned to the surface, that may mean (1) that Coleridge could not produce what he did not have, that he was limited in his creation by what he had read or otherwise experienced, or (2) that having received certain clusters of associations, he was bound to return them in just the way he did, and that the value of the poem may be described in terms of the experiences on which he had to draw. The latter pair of propositions (a sort of Hartleyan associationism which Coleridge himself repudiated in the *Biographia*) may not be assented to. There were certainly other combinations, other poems, worse or better, that might have been written by men who had read Bartram and Purchas and Bruce and Milton. And this will be true no matter how many times we are able to add to the brilliant complex of Coleridge's reading. In certain flourishes (such as the sentence we have quoted) and in chapter headings like "The Shaping Spirit," "The Magical Synthesis," "Imagination Creatrix," it may be that Professor Lowes pretends to say more about the actual poems than he does. There is a certain deceptive variation in these fancy chapter titles; one expects to pass on to a new stage in the argument, and one finds more and more sources, more and more about "the streamy nature of association."⁸

"Wohin der Weg?" quotes Professor Lowes for the motto of his book. "Kein Weg! Ins Unbretretene." Precisely because the way is unbetreten. we should say, it leads away from the poem. Bartram's Travels contains a good deal of the history of certain words and of certain romantic Floridian conceptions that appear in "Kubla Khan." And a good deal of that history has passed and was then passing into the very stuff of our language. Perhaps a person who has read Bartram appreciates the poem more than one who has not. Or, by looking up the vocabulary of "Kubla Khan" in the Oxford English Dictionary, or by reading some of the other books there quoted, a person may know the poem better. But it would seem to pertain little to the poem to know that Coleridge had read Bartram. There is a gross body of life, of sensory and mental experience, which lies behind and in some sense causes every poem, but can never be and need not be known in the verbal and hence intellectual composition which is the poem. For all the objects of our manifold experience, for every unity, there is an action of the mind which cuts off roots, melts away context-or indeed we should never have objects or ideas or anything to talk about.

It is probable that there is nothing in Professor Lowes' vast book which could detract from anyone's appreciation of either *The Ancient Mariner* or "Kubla Khan." We next present a case where preoccupation with evidence of type (3) has gone so far as to distort a critic's view of a poem (yet a case not so obvious as those that abound in our critical journals). In a well-known poem by John Donne appears this guatrain:

> Moving of th'earth brings harmes and feares, Men reckon what it did and meant, But trepidation of the spheares,

Though greater farre, is innocent.

The Intentional Fallacy

A recent critic in an elaborate treatment of Donne's learning has written of this quatrain as follows:

He touches the emotional pulse of the situation by a skillful allusion to the new and the old astronomy. . . . Of the new astronomy, the "moving of the earth" is the most radical principle; of the old, the "trepidation of the spheares" is the motion of the greatest complexity. . . . The poet must exhort his love to quietness and calm upon his departure; and for this purpose the figure based upon the latter motion (trepidation), long absorbed into the traditional astronomy, fittingly suggests the tension of the moment without arousing the "harmes and feares" implicit in the figure of the moving earth.⁹

The argument is plausible and rests on a well substantiated thesis that Donne was deeply interested in the new astronomy and its repercussions in the theological realm. In various works Donne shows his familiarity with Kepler's *De Stella Nova*, with Galileo's *Siderius Nuncius*, with William Gilbert's *De Magnete*, and with Clavius' commentary on the *De Sphaera* of Sacrobosco. He refers to the new science in his Sermon at Paul's Cross and in a letter to Sir Henry Goodyer. In *The First Anniversary* he says the "new philosophy calls all in doubt." In the *Elegy* on *Prince Henry* he says that the "least moving of the center" makes "the world to shake."

It is difficult to answer argument like this, and impossible to answer it with evidence of like nature. There is no reason why Donne might not have written a stanza in which the two kinds of celestial motion stood for two sorts of emotion at parting. And if we become full of astronomical ideas and see Donne only against the background of the new science, we may believe that he did. But the text itself remains to be dealt with, the analyzable vehicle of a complicated metaphor. And one may observe: (1) that the movement of the earth according to the Copernician theory is a celestial motion, smooth and regular, and while it might cause religious or philosophic fears, it could not be associated with the crudity and earthiness of the kind of commotion which the speaker in the poem wishes to discourage; (2) that there is another moving of the earth, an earthquake, which has just these qualities and is to be associated with the tear-floods and sigh-tempests of the second stanza of the poem; (3) that "trepidation" is an appropriate opposite of earthquake, because each is a shaking or vibratory motion; and "trepidation of the spheares" is "greater farre" than an earthquake, but not much greater (if two such motions can be compared as to greatness) than the annual motion of the earth; (4) that reckoning what it "did and meant" shows that the event has passed, like an earthquake, not like the incessant celestial movement of the earth. Perhaps

The Intentional Fallacy and Expressive Qualities

a knowledge of Donne's interest in the new science may add another shade of meaning, an overtone to the stanza in question, though to say even this runs against the words. To make the geocentric and heliocentric antithesis the core of the metaphor is to disregard the English language, to prefer private evidence to public, external to internal.

V

If the distinction between kinds of evidence has implications for the historical critic, it has them no less for the contemporary poet and his critic. Or, since every rule for a poet is but another side of a judgment by a critic, and since the past is the realm of the scholar and critic, and the future and present that of the poet and the critical leaders of taste, we may say that the problems arising in literary scholarship from the intentional fallacy are matched by others which arise in the world of progressive experiment.

The question of "allusiveness," for example, as acutely posed by the poetry of Eliot, is certainly one where a false judgment is likely to involve the intentional fallacy. The frequency and depth of literary allusion in the poetry of Eliot and others has driven so many in pursuit of full meanings to the *Golden Bough* and the Elizabethan drama that it has become a kind of commonplace to suppose that we do not know what a poet means unless we have traced him in his reading—a supposition redolent with intentional implications. The stand taken by F. O. Matthiessen is a sound one and partially forestalls the difficulty.

If one reads these lines with an attentive ear and is sensitive to their sudden shifts in movement, the contrast between the actual Thames and the idealized vision of it during an age before it flowed through a megalopolis is sharply conveyed by that movement itself, whether or not one recognizes the refrain to be from Spenser.

Eliot's allusions work when we know them—and to a great extent when we do not know them—through their suggestive power.

But sometimes we find allusions supported by notes, and it is a nice question whether the notes function more as guides to send us where we may be educated, or more as indications in themselves about the character of the allusions. "Nearly everything of importance . . . that is apposite to an appreciation of 'The Waste Land,' " writes Matthiessen of Miss Weston's book, "has been incorporated into the structure of the poem itself, or into Eliot's Notes." And with such an admission it may begin to appear that it would not much matter if Eliot invented his sources (as Sir Walter Scott invented chapter epigraphs from "old plays" and "anonymous" authors, or as Coleridge wrote marginal glosses for *The Ancient Mariner*). Allu-

The Intentional Fallacy

sions to Dante, Webster, Marvell, or Baudelaire doubtless gain something because these writers existed, but it is doubtful whether the same can be said for an allusion to an obscure Elizabethan:

The sound of horns and motors, which shall bring Sweeney to Mrs. Porter in the spring.

"Cf. Day, Parliament of Bees": says Eliot,

When of a sudden, listening, you shall hear, A noise of horns and hunting, which shall bring Actaeon to Diana in the spring, Where all shall see her naked skin.

The irony is completed by the quotation itself; had Eliot, as is quite conceivable, composed these lines to furnish his own background, there would be no loss of validity. The conviction may grow as one reads Eliot's next note: "I do not know the origin of the ballad from which these lines are taken: it was reported to me from Sydney, Australia." The important word in this note—on Mrs. Porter and her daughter who washed their feet in soda water-is "ballad." And if one should feel from the lines themselves their "ballad" quality, there would be little need for the note. Ultimately, the inquiry must focus on the integrity of such notes as parts of the poem, for where they constitute special information about the meaning of phrases in the poem, they ought to be subject to the same scrutiny as any of the other words in which it is written. Matthiessen believes the notes were the price Eliot "had to pay in order to avoid what he would have considered muffling the energy of his poem by extended connecting links in the text itself." But it may be questioned whether the notes and the need for them are not equally muffling. F. W. Bateson has plausibly argued that Tennyson's "The Sailor Boy" would be better if half the stanzas were omitted, and the best versions of ballads like "Sir Patrick Spens" owe their power to the very audacity with which the minstrel has taken for granted the story upon which he comments. What then if a poet finds he cannot take so much for granted in a more recondite context and rather than write informatively, supplies notes? It can be said in favor of this plan that at least the notes do not pretend to be dramatic, as they would if written in verse. On the other hand, the notes may look like unassimilated material lying loose beside the poem, necessary for the meaning of the verbal symbol, but not integrated, so that the symbol stands incomplete.

We mean to suggest by the above analysis that whereas notes tend to seem to justify themselves as external indexes to the author's *intention*, yet they ought to be judged like any other parts of a composition (verbal

The Intentional Fallacy and Expressive Qualities

arrangement special to a particular context), and when so judged their reality as parts of the poem, or their imaginative integration with the rest of the poem, may come into question. Matthiessen, for instance, sees that Eliot's titles for poems and his epigraphs are informative apparatus, like the notes. But while he is worried by some of the notes and thinks that Eliot "appears to be mocking himself for writing the note at the same time that he wants to convey something by it," Matthiessen believes that the "device" of epigraphs "is not at all open to the objection of not being sufficiently structural." "The *intention*," he says, "is to enable the poet to secure a condensed expression in the poem itself." "In each case the epigraph *is designed* to form an integral part of the effect of the poem." And Eliot himself, in his notes, has justified his poetic practice in terms of intention.

The Hanged Man, a member of the traditional pack, fits my purpose in two ways: because he is associated in my mind with the Hanged God of Frazer, and because I associate him with the hooded figure in the passage of the disciples to Emmaus in Part V The man with Three Staves (an authentic member of the Tarot pack) I associate, quite arbitrarily, with the Fisher King himself.

And perhaps he is to be taken more seriously here, when off guard in a note, than when in his Norton Lectures he comments on the difficulty of saying what a poem means and adds playfully that he thinks of prefixing to a second edition of *Ash Wednesday* some lines from *Don Juan*:

I don't pretend that I quite understand My own meaning when I would be *very* fine; But the fact is that I have nothing planned Unless it were to be a moment merry.

If Eliot and other contemporary poets have any characteristic fault, it may be in *planning* too much.

Allusiveness in poetry is one of several critical issues by which we have illustrated the more abstract issue of intentionalism, but it may be for today the most important illustration. As a poetic practice allusiveness would appear to be in some recent poems an extreme corollary of the romantic intentionalist assumption, and as a critical issue it challenges and brings to light in a special way the basic premise of intentionalism. The following instance from the poetry of Eliot may serve to epitomize the practical implications of what we have been saying. In Eliot's "Love Song of J. Alfred Prufrock," toward the end, occurs the line: "I have heard the mermaids singing, each to each," and this bears a certain resemblance to a line in a

The Intentional Fallacy

Song by John Donne, "Teach me to heare Mermaides singing," so that for the reader acquainted to a certain degree with Donne's poetry, the critical question arises: Is Eliot's line an allusion to Donne's? Is Prufrock thinking about Donne? Is Eliot thinking about Donne? We suggest that there are two radically different ways of looking for an answer to this question. There is (1) the way of poetic analysis and exegesis, which inquires whether it makes any sense if Eliot-Prufrock is thinking about Donne. In an earlier part of the poem, when Prufrock asks, "Would it have been worth while, . . . To have squeezed the universe into a ball," his words take half their sadness and irony from certain energetic and passionate lines of Marvell's "To His Coy Mistress." But the exegetical inquirer may wonder whether mermaids considered as "strange sights" (to hear them is in Donne's poem analogous to getting with child a mandrake root) have much to do with Prufrock's mermaids, which seem to be symbols of romance and dynamism, and which incidentally have literary authentication, if they need it, in a line of a sonnet by Gérard de Nerval. This method of inquiry may lead to the conclusion that the given resemblance between Eliot and Donne is without significance and is better not thought of, or the method may have the disadvantage of providing no certain conclusion. Nevertheless, we submit that this is the true and objective way of criticism, as contrasted to what the very uncertainty of exegesis might tempt a second kind of critic to undertake: (2) the way of biographical or genetic inquiry, in which, taking advantage of the fact that Eliot is still alive, and in the spirit of a man who would settle a bet, the critic writes to Eliot and asks him what he meant, or if he had Donne in mind. We shall not here weigh the probabilities-whether Eliot would answer that he meant nothing at all, had nothing at all in mind-a sufficiently good answer to such a question-or in an unguarded moment might furnish a clear and, within its limit, irrefutable answer. Our point is that such an answer to such an inquiry would have nothing to do with the poem "Prufrock"; it would not be a critical inquiry. Critical inquiries, unlike bets, are not settled in this way. Critical inquiries are not settled by consulting the oracle.

Notes

1. Dictionary of World Literature, Joseph T. Shipley, ed. (New York, 1942), 326–329.

2. J. E. Spingarn, "The New Criticism," in *Criticism in America* (New York, 1924), pp. 24-25.

3. Ananda K. Coomaraswamy, "Intention," in American Bookman, I (1944), 41–48.

4. It is true that Croce himself in his Ariosto, Shakespeare and Corneille (London, 1920), Ch. 7, "The Practical Personality and the Poetical Personality," and in his Defence of Poetry (Oxford, 1934), p. 24, and elsewhere, early and late, has delivered telling attacks on emotive geneticism, but the main drive of the Aesthetic is surely toward a kind of cognitive intentionalism.

5. See Hughes Mearns, Creative Youth (Garden City, 1925), esp. pp. 27–29. The technique of inspiring poems has apparently been outdone more recently by the study of inspiration in successful poets and other artists. See, for instance, Rosamond E. M. Harding, An Anatomy of Inspiration (Cambridge, 1940); Julius Portnoy, A Psychology of Art Creation (Philadelphia, 1942); Rudolf Arnheim and others, Poets at Work (New York, 1947); Phyllis Bartlett, Poems in Porcess (New York, 1951); Brewer Ghiselin, ed., The Creative Process: A Symposium (Berkeley and Los Angeles, 1952).

6. Curt Ducasse, The Philosophy of Art (New York, 1929), p. 116.

7. And the history of words *after* a poem is written may contribute meanings which if relevant to the original pattern should not be ruled out by a scruple about intention.

8. Chs. 8, "The Pattern," and 16, "The Known and Familiar Landscape," will be found of most help to the student of the poem.

9. Charles M. Coffin, John Donne and the New Philosophy (New York, 1927), 97–98.

Intention and Interpretation in Criticism

FRANK CIOFFI

If we adapt Wittgenstein's characterisation of philosophy: "putting into order our notions as to what can be said about the world," we have a programme for aesthetics: "putting into order our notions as to what can be said about works of art."

One of the tasks of such a programme would be to elucidate the relation in which biographical data about an author, particularly of the kind loosely known as knowledge of his intentions, stand to those issues we call matters of interpretation. *I.e.*, the relation between questions like these:

Whether it is Goethe who is referred to in the first line of the first canto of *In Memoriam*.

Whether it is the poet who is speaking in the concluding lines of Ode on a Grecian Urn.

Whether Pope is 'screaming with malignant fury' in his character of Sporus.

Whether Hamlet in his famous soliloquy is contemplating suicide or assassination.

Whether Milton's Satan in his speech in Book IV beginning 'League with thee I seek' may be wholly or partly sincere.

Whether the governess who tells the story in James' *Turn of the Screw*, is a neurotic case of sex-repression and the ghosts not real ghosts but hallucinations.

Whether Wordsworth's Ode: Intimations of Immortality is 'a conscious farewell to his art, a dirge sung over his departing powers' or is a 'dedication to new powers'; and whether the 'timely utterance' referred to in that poem is My Heart Leaps Up or Resolution and Independence.

Whether we are meant to reflect that Othello becomes jealous very quickly on very little provocation.

From Proceedings of the Aristotelian Society, n.s., LXIV (1963–1964), 85–106. Copyright © 1964 The Aristotelian Society. Reprinted by courtesy of the Editor of The Aristotelian Society.

Whether the Moses of Michelangelo is about to hurl the tablets of the law to the ground or has just overcome an impulse to do so.

Whether Shakespeare's Sonnet 73 contains an allusion to despoilt and abandoned monasteries.

Whether the image which floats before Yeats' mind in *Among School* Children, 'hollow of cheek,' is of an old woman or of one beautiful in a *quattrocento* way.

Whether the metaphors in Othello's soliloquy which begins 'Steep me in poverty to the very lips' are deliberately inappropriate so as to suggest the disorder of Othello's mind.

Whether Ford Maddox Ford's novel *Parade's End* is a trilogy or a tetralogy.

Whether on reading the line 'in spite of that we call this Friday good' from *East Coker* we are to think of Robinson Crusoe's friend.

Whether Gertrude's marriage to Claudius was incestuous.

Whether Othello was black or brown.

Whether Pippit in Eliot's *A Cooking Egg* is young or old, of the same social status as the speaker or not and whether the connotations of the expression 'penny-world' in that poem are sordid or tender.

Whether in *The Mystery of Edwin Drood* Dickens has deepened his analysis of Victorian society to include Imperialism; and whether John Jasper in that novel is a member of the Indian sect of Thugs.

Whether we should identify with Strether in *The Ambassadors* and whether the Ververs in *The Golden Bowl* are unqualifiedly admirable.

And statements like these:

That Eliot associates the Hanged Man, a member of the traditional tarot pack, with the Hanged God of Frazer and with the hooded figure in the passage of the disciples to Emmaus.

That Hopkins said: The Sonnet on Purcell means this: 1–4 I hope Purcell is not damned for being a protestant because I love his genius, etc., etc. 'Low lays him' means 'lays him low,' 'listed is enlisted' etc., etc.

That Wordsworth wrote *Resolution and Independence* while engaged on the first part of the Immortality Ode.

That Henry James in 1895 had his faith in himself shaken by the failure of his plays.

That Donne's Valediction: Forbidding Mourning was addressed to his wife.

That James was conversant enough with English ways to know that no headmaster would have expelled a boy belonging to a county family without grave reasons.

That A. E. Housman vehemently repudiated the view that his poem 1887 contained a gibe at the Queen.

That Swift was philanthropic and well-loved by his friends.

Intention and Interpretation in Criticism

That Maude Gonne was an old woman when Yeats wrote Among School Children.

That Keats in his letters uses the word 'beauty' to mean something much more subtle than is ordinarily meant by it.

That Eliot meant the lines 'to Carthage then I came, burning, burning, burning . . .' to evoke the presence of St. Augustine and the Buddha, of Western and Eastern Ascetism.

That Abraham Cowley had had very little to do with women.

That ruined monasteries were a not uncommon sight in 1685.

That Henry James meant his later novels to illustrate his father's metaphysical system.

That Conrad in *The Arrow of Gold* has an unrealistic and sentimentalised portrait of a woman.

That Wordsworth nowhere in his work uses the word 'glory' to refer to his creative powers.

That Eliot told someone that Richards in his account of A Cooking Egg was 'barking up the wrong tree.'

That Tennyson shortly before his death told an American gentleman that he was referring to Goethe when he wrote 'of him who sings to one clear harp in divers tones.'

That there were no industrial mills when Blake wrote "Jerusalem."

That in the book of Genesis Moses shattered the tablets of the law.

That Dickens wrote a letter at the time of the Sepoy mutiny advocating the extermination of the Indian people.

In this paper I have assembled and invented examples of arguments which use biographical claims to resolve questions of interpretation and confronted them with a meta-critical dogma to the effect that there exists an operation variously known as analysing or explicating or appealing to the text and that criticism should confine itself to this, in particular eschewing biographical enquiries.

By now any of you who are at all interested in this topic must have had the phrase 'the intentional fallacy' occur to you. This phrase owes its currency to a widely anthologised and often-alluded to paper of that title by two Americans, Wimsatt and Beardsley. I want now to try to bring what they say in it into relation with the issue I have raised.

1.

The first statement of their thesis runs: ". . . the design or intention of the author is neither available nor desirable as a standard for judging the success of a literary work of art." These words don't really mean what they say. They don't mean that an artist may have intended to create a masterpiece but for all that have failed to do so; for the authors go on to say of their thesis that it entails "many specific truths about inspiration,

authenticity, biography, literary history and scholarship," etc., and none of these specific truths follows from the truism that knowledge of an artist's intentions cannot provide us with criteria for judging of his success. The charitable conviction that they mean more than this is borne out by a later statement of the thesis; this time to the effect that it is a thesis about the *meaning* of a work of art that they are concerned to advance: that certain ways of establishing this meaning are legitimate whereas others are not. So, presumably, what they intended to say is: "the design or intention of an author is neither available nor desirable as a standard for judging the meaning of a literary work of art." But no argument can profitably be conducted in these terms. For if a discrepancy should come to light between a reader's interpretation of a work and the interpretation of the author or his contemporaries, no way of determining which of these could be properly described as *the* meaning of the work could be produced.

What an author meant, by a poem, say, what his contemporaries took him to mean, what the common reader makes of it and what makes the best poem of it are usually concomitant and allow us to speak of the meaning without equivocation. If when confronted by instances in which this concomitance breaks down we appeal to only one of the ordinarily coincident features as if we had a settled convention behind us, the question becomes intractable. If the question is expressed instead as "How should this poem be read?" it at least becomes clearer what the issues are. So the thesis becomes, "The design or intention of an author is neither available nor desirable as a standard for judging how a work of literature should be read." But does any criticism of literature consist of the provision of standards by which you may judge how the work should be read? One of the pieces of criticism which the authors have provided in their paper as an illustration of how it should be done concerns Eliot's The Love Song of J. Alfred Prufrock. They say that when Prufrock asks, "would it have been worth while . . . to have squeezed the universe into a ball," "his words take half their sadness and irony from certain energetic and passionate lines of Marvell's To His Coy Mistress." This may be true and it may be helpful but nothing in it answers to the description of providing a standard by which the work may be read. What they have done or have tried to do is to produce in the reader a more adequate response to Eliot's lines by reminding him of Marvell's. If we bring their thesis in line with their practice it becomes: "The design or intention of the author is neither available nor desirable as a means of influencing a reader's response to a literary work." But since they give as an example of what they consider as irrelevant to criticism the fact that Coleridge read Purchas, Bartram, Milton and Bruce and this is not a fact about either his design or his intention it is obvious that they mean something rather wider than this, something which

Intention and Interpretation in Criticism

the expression 'biographical data' would be a closer approximation to. This gives us "biographical data about an author, particularly concerning his artistic intentions, is not desirable [I omit available as probably being just a sign of nervousness] as a means of influencing a reader's response to a literary work."

What any general thesis about the relevance of intention to interpretation overlooks is the heterogeneity of the contexts in which questions of interpretation arise. This heterogeneity makes it impossible to give a general answer to the question of what the relevance of intention to interpretation is. There are cases in which we have an interpretation which satisfies us but which we feel depends on certain facts being the case. It may involve an allusion and we may wish to be reassured that the author was in a position to make the allusion. In this case biographical facts act as a kind of sieve which exclude certain possibilities. Then there is the case where we are puzzled, perhaps by an allusion we don't understand, perhaps by syntax, and reference to the author's intention, though it does not guarantee a favourable response, may at least relieve this perplexity and make one possible. There are cases in which we suspect irony but the text is equivocal, and cases where we aren't sure what view the author wishes us to take of the situation he places before us. Then there are the most interesting cases, those in which the text seems unmistakably to call for a certain interpretation and this is found satisfying, but in which we learn with surprise that it has been explicitly repudiated by the author. Even within the same kind of context the author's intention will vary in relevance depending on the kind of question involved; whether it concerns the meaning of a word or the tone of a passage, the view to be taken of a character or a situation or the general moral of an entire work.

Why did Wimsatt and Beardsley think they had a general answer to the question of deciding what the response to a work of literature should be? This is what they say: "There is a difference between internal and external evidence for the meaning of a poem. And the paradox is only verbal and superficial that what is (1) internal is also public. It is discovered through the semantics and syntax of a poem, through our habitual knowledge of the language, through grammars, dictionaries and all the literature which is a source of dictionaries, in general through all that makes a language and culture; while what is (2) external is private or idiosyncratic; not a part of the work as a linguistic fact; it consists of revelations (in journals, for example, or letters, or reported conversations) about how or why the poet wrote the poem—to what lady, while sitting on what lawn, or at the death of what friend or brother. There is (3) an intermediate kind of evidence about the character of the author or about private or semi-private meanings attached to words or topics by an author or by a coterie of which he is a member. The meanings of words is the history of words, and the biography of an author, his use of a word, and the associations which the word had for him are part of the word's history and meaning. But the three types of evidence, especially (2) and (3), shade into one another so subtly that it is not always easy to draw a line between examples, and hence arises the difficulty for criticism."

It is not clear from this account what the authors mean to exclude as illicit sources of interpretive data. Once the author's character and the private associations a word may have for him are admitted among these, along with all that makes a language and a culture, what is there left to commit fallacies with? Were it not that their illustrations give a much clearer impression of their attitude than their attempts at explicit formulation of it do, and show it to be much more restrictive, they could be suspected of advancing one of those enchanted theses which possess the magical power of transforming themselves into truisms at the touch of a counterexample. They say of a line in Eliot's The Love Song of J. Alfred Prufrock: "I have heard the mermaids singing each to each" that it bears some resemblance to a line of Donne's: "Teach me to heare Mermaids singing" so that the question arises whether Eliot's line contains an allusion to Donne's. They go on to say that there are two radically different ways of answering this question. The way of poetic exegesis and the way of biographical enquiry, and the latter would not be a critical enquiry and would have nothing to do with the poem. The method of poetic exegesis consists of asking whether it would make any sense if Donne's mermaids were being alluded to. The biographical approach would be to ask Eliot what he thought at the time he wrote it, whether he had Donne's mermaids in mind. The answer to this question would be critically irrelevant. It is not surprising that their example bears them out since it was hand-chosen, as it were. To expose its tendentiousness we need only take an example in which it was felt that a literary allusion would enhance the value of the lines. Let us take their own example of Marvell's To His Cov Mistress. familiarity with which they maintain enhances the value of certain lines of Eliot's. If we take the case of someone not familiar with Marvell's To His Coy Mistress, then the biographical claim that Eliot alludes to it in Prufrock would enhance its value for them. If on the other hand they merely applied the test of poetic exegesis and incorporated the allusion to Marvell's To His Coy Mistress into the poem without knowing whether Eliot was alluding to it, it is doubtful whether their appreciation would survive the discovery that he was not. If a critical remark is one which has the power to modify our apprehension of a work, then biographical remarks can be critical. They can serve the eliminative function of showing that certain interpretations of a work are based on mistaken beliefs about the author's state of knowledge.

Intention and Interpretation in Criticism

2.

We can illustrate this eliminative function of biographical data by taking the very case on which Wimsatt and Beardsley based their arguments as to its irrelevance. They quote a quatrain from John Donne's *A Valediction: Forbidding Mourning*:

> Moving of the earth brings harmes and fears, Men reckon what it did and meant, But trepidation of the spheares, Though greater farre, is innocent.

They then go on to criticise an interpretation of this quatrain which basing itself on the biographical fact that Donne was intensely interested in the new astronomy and its theological repercussions sees in the phrase 'Moving of the earth' an allusion to the recently discovered rotation of the earth round the sun. Wimsatt and Beardsley show the unlikelihood of this, not by disputing the well-authenticated facts concerning Donne's interest in astronomy, which would be to use a biographical method, but through an analysis of the text. They maintain that whereas the fear which is produced by the rotation of the earth is a metaphysical, intellectual one, the fear which Donne is attempting to discourage is of the emotional kind which an earthquake is more likely to produce and that this accords better with the 'tear-floods' and 'sigh-tempests' of the poem's second stanza than the earth's rotation. Let us concede that the authors have made it very plausible that Donne was alluding not to the heliocentric theory of the earth's rotation but to earthquakes. The gratuitousness of the conclusion which they draw from this becomes apparent if we ask the following question: have they established that Donne was not referring to the rotation of the earth as conclusively as the fact that Donne was ignorant of the heliocentric theory would establish it? Wouldn't this external fact outweight all their internal ones?

At this point someone who finds my question unrhetorical is thinking to himself 'dark satanic mills.' It is true that the knowledge that the poem that prefaces Blake's *Milton* is not an expression of the Fabian sentiments it has been traditionally taken as has not caused the traditional interpretation to be abandoned. I suggest that what we have in this case is something in the nature of a spontaneous adaptation of Blake's poem. It is unlike what we ordinarily consider an adaptation in not being conscious (initially at any rate) and not involving any physical change in the work adapted. Does the fact that this was possible in the case of Blake's lyric reflect adversely on it as poem? Does the fact that the melody of *God Save the Queen* could be fitted with new words and become the national anthem of a republican nation reflect on it? The combination of resolution and

exaltation which characterise Blake's poem carries over into its adaptation; it functions like a melody. We should see cases like that of "Jerusalem" as continuous with more obvious cases of adaptation. When Pistol tells French audiences that his "rendezvous is quite cut off," his Doll lies dying of Maladie of *Naples*. Does anything follow as to the relevance or irrelevance of an author's intentions? Then neither does it in the case of Jerusalem. It would only follow if the discovery that a work was an adaptation made no difference. There is one sort of literature in which adaptation is a matter of indifference: jokes. Wilkes becomes Disraeli and Disraeli becomes Birkenhead. The two Jews become two Irishmen or two Chinese. But then, we speak of the author of a poem but not of the author of a joke. I am saying: we don't stand in the same relation to Blake's lyric after changing our conviction as to what he meant to convey as we did before. If the case were one in which the discrepancy between the author's interpretation and the reader's were one as to the very emotions expressed and not just the accompanying imagery our attitude would be very different. Frank Harris read A. E. Housman's poem 1887 as an anti-imperialist gibe and the expression 'God Save the Queen' which recurs in it as a sarcastic jeer until Housman revealed otherwise. Thereafter he naturally found it difficult to do so in spite of his conviction both as to the superiority of his interpretation and its greater consonance with Housman's general outlook. ("How was I to know that someone steeped in a savage disgust of life could take pleasure in outcheapening Kipling at his cheapest?")

The following examples should make it clear how inept Wimsatt's and Beardsley's characterisation of the rôle of biographical data in critical discourse is. An example which seems to support their account is Leavis' reaction to John Middleton Murry's attempt to give the word 'beauty' in the concluding couplet of Keat's *Ode on a Grecian Urn* a less limiting sense based on the use Keats made of the word in his letters. "To show from the letters that 'beauty' became for Keats a very subtle and embracing concept and that in his use the term takes on meanings that it could not possibly have for the unintiated is gratuitous and irrelevant. However, his use of the word may have developed as he matured, 'beauty' is the term he used and in calling what seemed to him the supreme thing in life 'beauty' he expresses a given bent—the bent everywhere manifest in the quality of his verse, in its loveliness . . . and that beauty in the *Ode on a Grecian Urn* expresses this bent is plain, that it should as the essence of the poem, and there is nothing in the poem to suggest otherwise."

This may sound as if a general principle akin to Wimsatt's and Beardsley's is being employed, but that this is not so Leavis' practice elsewhere shows. For example, "Hopkins' *Henry Purcell* is a curious special case, there can be few readers who have not found it strangely expressive and few who could have elucidated it without extraneous help. It is not inde-

Intention and Interpretation in Criticism

pendent of the explanatory note by Hopkins that Bridges prints. Yet when one approaches it with the note fresh in mind, the intended meaning seems to be sufficiently in the poem to allay at any rate the dissatisfaction caused by baffled understanding." We must not be misled by the expression "a curious special case." Leavis' dealings with The Waste Land make it clear that the only question which arises in connexion with notes or other extraneous aids to understanding is not one of their legitimacy but of their efficacy. For example, Leavis says of The Waste Land that it "sometimes depends on external support in ways that can hardly be justified . . . for instance, the end of the third section 'The Fire Sermon.' . . . No amount of reading of the Confessions or Buddhism in Translation will give these few words power to evoke the kind of presence that seems necessary to the poem." Of another passage he writes: "it leaves too much to Miss Weston; repeated recourse to Ritual and Romance will not invest it with the virtues it would assume." On the other hand, of Eliot's note on Tiresias, Leavis remarks, "if Mr. Eliot's readers have a right to a grievance, it is that he has not given this note more salience." 'Power to evoke,' 'Invest with Virtues,' these are not the idioms in which the probative value of statements is weighed.

Wimsatt and Beardsley are aware of the problem posed them by Eliot's notes to The Waste Land and make the suggestion that the notes should be considered as part of the poem. They thus become internal evidence, and may be consulted with a good conscience. Does it follow that since the effectiveness of certain lines in Prufrock depends on familiarity with Marvell's Coy Mistress, Marvell's poem should be considered part of Eliot's, or does this not follow because whereas we are expected to be familiar with Marvell's poem, familiarity with the contents of Eliot's notes is not expected of us? Then is this what the distinction between external and internal evidence comes to; the difference between what we can and can't be expected to know?, and how is it decided what we can be expected to know? Leavis has said of Quinton Anderson's book on Henry James, "thanks to the light shed by Mr Anderson, we can see in the peculiar impressiveness of Mrs Lowder of the Wings of the Dove a triumph of morality art." Is Mr Anderson's book also to be considered part of James' Wings of the Dove then?

No amount of tinkering can save Wimsatt and Beardsley's distinction between internal and external evidence. It isn't just that it's made in the wrong place, but that it is misconceived from the start. A reader's response to a work will vary with what he knows; one of the things which he knows and with which his responses will vary is what the author had in mind, or what he intended. The distinction between what different people know of an author before reading his work or what the same person knows on successive occasions can't be a logical one. When is a remark a critical remark about the poem and when a biographical one about the author? The difficulty in obeying the injunction to ignore the biographical facts and cultivate the critical ones is that you can't know which is which until after you have read the work in the light of them.

The assumption which stultifies their exposition is the conception of critical argument as the production and evaluation of evidence. They say that there are two kinds of evidence: that provided by poetic exegesis and that provided by biographical enquiry. But the examples they give of poetic exegesis seem not to be evidence but conclusions or judgments. For example, that the lines from *Prufrock* take half their sadness and irony from lines in a poem of Marvell's, or that the mermaids in *Prufrock* derive no benefit from a reminiscence of the mermaids in Donne. We could construe these statements as evidence, only by taking them as biographical statements about Wimsatt and Beardsley, but so taken they would stand in the same relation to critical judgment as biographical statements about Eliot. If a critical remark fails to confirm or consolidate or transform a reader's interpretation of a work it will then become for him just evidence of something or other, perhaps the critic's obtuseness. Biographical remarks are no more prone to this fate than any others.

3

In the sixth stanza of Yeats' Among School Children there occur the lines:

Plato thought nature but a spume that plays Upon a ghostly paradigm of things; Solider Aristotle played the taws Upon the bottom of a king of kings.

Many editions give the first word of the third line 'solider' as 'soldier.' This is due to a compositor's error, a transposition of two letters which went unnoticed because by a fluke instead of producing gibberish, it produced the English word 'soldier.'

The American critic Delmore Schwartz was thus led to advance his well-known interpretation to the effect that the expression 'soldier Aristotle' alludes to a legend that Aristotle accompanied Alexander on his military expedition to India. Since there is obviously a contrast intended between the unworldliness of Plato and the down-to-earthness of Aristotle, Schwartz' military interpretation accords well with the rest of the poem. But in spite of this, now that we know of the error wouldn't we insist on the restoration of the lines as Yeats wrote them and regard the view that there is a military allusion in the lines as a mistake? It might be objected that this is not to the point because the case here is one of a discrepancy between what the author

Intention and Interpretation in Criticism

wrote and what we made of it and not between what he *meant* and what we made of it.

But can this distinction be upheld? Can't we imagine cases where the words were homophones? In such a case the only distinction between what an author wrote and a mistaken reading would be what he meant. In fact, we needn't imagine such a case. Hopkins' note on his poem *Henry Purcell* provides us with one: "One thing disquiets me: I *meant* 'fair fall' to mean 'fair (fortune be) fall': it has since struck me that perhaps 'fair' is an adjective proper and in the predicate and can only be used in cases like 'fair fall the day,' that is 'may the day fall, turn out fair.' My lines will yield a sense that way indeed, but I never meant it so." Is the possible meaning mentioned but rejected by Hopkins any more tenable than, 'soldier Aristotle'?

There is thus no doubt that there are cases in which knowledge of an author's avowed intention in respect of his work exercises a coercive influence on our apprehension of it. The question now arises: When doesn't it? My answer is, "When the issue is of a complexity comparable to that which would cause us to discount his avowed intention in respect of something not a work of literature." To put it another way, we tend to think that there are cases where we over-ride the author's intention and persist in an interpretation which he has rejected but what we are really doing could less misleadingly be described as favouring one criterion of intention as against another. If we establish the existence of a discrepancy between the interpretation we give to a work of art, and that of the author, we haven't shown that the work has a meaning independent of what the author intends because what the author intends will now be the interpretation given to the work by us and his own statement as to its meaning an aberration. The notion of the author's intention is logically tied to the interpretation we give to his work. It's not just that our language works this way; but that our minds do. Confronted with a choice between saying that an effect so complex could have come about by accident and that the author was mistaken we would opt for the latter. The work will be considered more conclusive evidence of his intention than his own statements. The colour flows back.

Edmund Wilson's dealings with Henry James' *The Turn of the Screw* brings this out clearly. *The Turn of the Screw* was generally considered a superior ghost story until Wilson popularised the view that the ghosts were figments of the narrator's imagination and the work a study in thwarted anglo-saxon spinsterdom. He thought he had discovered that the text was skillfully ambiguous so as never unequivocally to imply the ghosts' objective existence. He was able to interpret some passages in James' preface to the book to similar effect. The publication of James' notebooks some years later, however, made it clear that James' conscious intention was to produce a ghost story. At the same time Wilson came to admit that the text itself

was not completely reconcilable with his thesis that the ghosts were hallucinatory. Nevertheless, Wilson continued to insist that it was not a straightforward ghost story, but a study in the neurotic effects of repressed sexuality. His arguments for this provide an excellent example of what I have called the colour flowing back. Instead of simply enjoying a gratuitous effect for its own sake, Wilson convinces himself on the basis of certain biographical facts about James that at the time the book was written, his faith in himself had been shaken and that "in *The Turn of the Screw*, not merely is the governess self-deceived, but that James is self-deceived about her. The doubt that some readers feel as to the soundness of the governess' story are the reflection of doubts communicated unconsciously by James himself."

The real interest of this kind of example is that it brings out quite clearly what otherwise is not so apparent; that there is an implicit biographical reference in our response to literature. It is, if you like, part of our concept of literature. It is only when it is missing that we notice that it was always there.

I want now to deal with some notorious ostensible counter-examples. This is the fifth stanza of Yeats' *Among School Children*:

> What young mother a shape upon her lap Honey of generation had betrayed, And that must sleep, shriek, struggle to escape As recollection or the drug decide, Would think her son, did she but see that shape With sixty or more winters on its head, Compensation for the pang of his birth, Or the uncertainty of his setting forth?

There is an accompanying note to this poem which indicates that the phrase "honey of generation" is taken from an essay of Porphyry's and that Yeats has arbitrarily used it to refer to "the drug that destroys the recollection of pre-natal freedom." It is then, the shape upon the mother's lap, the child, which has been betrayed by being born. John Wain has put forward a reading according to which it is the mother who has been betrayed, and "honey of generation" is an allusion to the sexual pleasure which accompanies conception, and the desire for which has betrayed her. Doesn't this example show the irrelevance of intention? Not necessarily. It could be interpreted as a case where we take the poem as better evidence of what the poet intended than his own explicit remarks on the subject. To persist in an interpretation in spite of an author's explicit disavowal of it is not necessarily to show an indifference to the author's intention. For we may feel that he was mistaken as to what his intention was. A case which

Intention and Interpretation in Criticism

comes to mind is Goldsmith's withdrawal of the gloss he offered on the word "slow" in the first line of his poem, *The Traveller*, "Remote unfriended, melancholy, *slow*." Goldsmith said it meant "tardiness of locomotion" until contradicted by Johnson. "No sir. You do not mean tardiness of locomotion. You mean that sluggishness of mind that comes upon a man in solitude."

Though it might be true, as Wimsatt and Beardsley say, that critical enquiries are not settled like bets, neither may questions of intention. I can't resort here to the argument I used in the case of Donne's Valediction and ask you to imagine what your attitude to Wain's interpretation would be if you were convinced that Yeats was ignorant of the fact on which it is based, since this fact, that sexual pleasure is an incentive to procreation, is not such as can be overlooked. Nevertheless, I want to maintain that we don't, if we accept Wain's interpretation, think it an accident that it should be possible to read the text as he does, but we feel that the ambiguity which makes it possible was the result of a connection in Yeats' mind between the expression "honey of generation" and sexual pleasure. (In fact this can be demonstrated.)

In order to convince you that an implicit biographical influence is at work even in Wain's interpretation, I want you to imagine the case altered in some important respects. Imagine that the reading according to which it is the mother who is betrayed, was also that of Yeats, and that there was no footnote referring to Porphyry's essay, of which Yeats was completely ignorant, but that a reader familiar with it and sharing its views on prenatal existence, insisted on taking the expression "honey of generation" as an allusion to the drug which destroys the recollection of pre-natal freedom and, therefore, to the infant and not the mother as betrayed. Wouldn't our attitude to this interpretation be quite different from our attitude to Wain's? Wouldn't we feel it perverse? And since it can't be the text which makes it perverse but only the facts about Yeats as we have imagined them, doesn't our implicit biographical or intentionalistic approach to literature emerge quite clearly here? Of course, there are cases where the pleasure we take in literature doesn't depend on this implicit biographical reference. Literature, as Wittgenstein probably said, is a motley. Nursery rhymes come to mind as the most notable example. But in general we do make such a reference. Eliot's attitude towards a line of Cyril Tourneur's illustrates this reluctance to take pleasure in what is accidental and unintended. The line is: "The poor benefit of a bewildering minute," which is given as "The poor benefit of a bewitching minute" in the texts both of Churton Collins and of Nicoll who mention no alternative reading. Eliot comments: "it is a pity if they be right for 'bewildering' is much the richer word here." It has been argued that if the folio text of Henry V was right and Theobald's lovely guess wrong so that Shakespeare made the dying Falstaff allude to

The Intentional Fallacy and Expressive Qualities

a painting rather than babble of green fields most of us would persist in reading the traditional and incorrect version. We probably would but it would worry us; and if "a babbled of green fields" wasn't even Theobald's guess but a transcriber's or printer's unthinking error, it would worry us even more. The suspicion that a poetic effect is an artefact is fatal to the enjoyment which literature characteristically offers. If the faces on Mount Rushmore were the effect of the action of wind and rain, our relation to them would be very different.

IV

In the course of their criticism of the interpretation of Donne's poem which saw in it an allusion to the rotation of the earth round the sun Wimsatt and Beardsley remark, "But the text itself remains to be dealt with . . ."!

Where understanding fails, says Goethe, there immediately comes a word to take its place. In the case the word is "text." Let us appeal to the text. But what is the text? These critics talk of the text of a poem as if it had an outline as neat and definite as the page on which it is printed. If you remind yourself of how questions about what is 'in the text' are settled you will see that they involve a great deal which is not 'in the text'. Though there are many occasions on which we can make the distinction in an immediately intelligible and non-tendentious way, where an interpretative issue has already arisen, the use of a distinction between internal, licit considerations, and external, illicit ones is just a form of question-begging.

What are we to say of attempts to support an interpretation by citing other works of the author? For example, Leavis on Conrad's *Heart of Darkness*; "If any reader of that tale felt that the irony permitted a doubt regarding Conrad's attitude towards the Intended, the presentment of Rita (in *The Arrow of Gold*) should settle it." Isn't this illicit? Isn't the common authorship of several works a biographical fact?

What of the use of previous drafts of a work for critical purposes? Leavis in commenting on Hopkins' *Spelt from Sybil's Leaves* is able to enforce his point that "Hopkins' positives waver and change places and he is left in terrible doubt by showing that in a previous draft of the poem the wordorder in the phrase 'black, white; right, wrong' was conventionally symmetrical 'black, white; wrong, right'." The only doubt which might arise in connexion with Leavis' point is whether the word-order may have been altered to avoid a rhyme, but this is equally intentionalistic.

Marius Bewley supports his interpretation of James' *The Turn of the Screw* by pointing out that when James collected his stories for the definitive edition he put it in the same volume as one called *The Liar*.

Even if the anti-intentionalist thesis were qualified to accommodate all these there would still be a fundamental objection to it.

Intention and Interpretation in Criticism

You must all have had the experience while reading of having the words suddenly undergo a radical transformation as you realised you had missed the end of a quotation, say, and mistaken the speaker. The more familiar the speakers the greater the transformation when you realised your mistake. Doesn't this illustrate the importance of implicit biographical assumptions in interpreting what we read? Here's an illustration: In Rudyard Kipling's *Loot* occur the lines:

> An' if you treat a nigger to a dose of cleanin'-rod 'E's like to show you everything he owns.

Hugh Kingsmill has quoted these lines as an example of Kipling's brutality and even Kipling's biographer Edward Shanks is embarrassed by them. Edmund Wilson, on the other hand, in his well-known essay on Kipling, says this about them: "Kipling was interested in the soldier for his own sake, and made some effort to present his life as it seemed to the soldier himself. The poem called *Loot*, for example, which appears to celebrate a reprehensible practice is in reality perfectly legitimate because it simply describes one of the features of the soldier's experience in India. There is no moral one way or the other." T. S. Eliot takes a similar line in his introduction to his selection of Kipling's verse.

How is this issue to be decided? By an appeal to the text? Isn't it rather our sense of Kipling which will determine the side we come down on? A sense built up not only from the other tales but from his autobiography and other sources as well? Don't these throw a 'field of force' round the work? If it had been written by someone else wouldn't this make a difference to our apprehension of it? Isn't this like the case described by Wittgenstein in the *Philosophical Investigations*? "I see a picture which represents a smiling face. What do I do if I take the smile now as a kind one, now as a malicious one? Don't I often imagine it with a spatial and temporal context which is one either of kindness or of malice? Thus I might supply the picture with the fancy that the smiler was smiling down at a child at play, or again on the suffering of an enemy."

The difference of opinion between F. R. Leavis and Marius Bewley over James' *What Masie Knew* is an excellent illustration of an interpretation depending on 'the fiction I surround it with'. Unfortunately it is too long to quote, but the gist of it is that Bewley finds the atmosphere of the book one of horror and its theme the meaning and significance of evil, whereas Leavis can detect no horror and sees it as an extraordinarily highspirited comedy reminiscent of the early part of David Copperfield. Bewley in attempting to locate the source of their difference says that it has its "origin in areas not readily open to literary-critical persuasion" and "that the way one senses the presence of evil and horror in the novel may be due to one's conception of them outside the novel."

There is one aspect of our response to a work of literature to which biographical data seem to have particular relevance and that is our conviction as to an author's sincerity. It is certain that there are cases where biographical considerations are genuinely relevant and equally certain that there are cases where they are intrusions which we feel we ought not to allow to condition our response. But it is difficult to know where the line should be drawn. I suppose that we would all consider Beethoven's inability to get on with Scott's *Kenilworth* because "This man writes for money" as eccentric, though the decline in Trollope's reputation which followed his revelation as to his methods of composition and his business-like attitude towards his writing in his autobiography, show it is not rare. Perhaps these responses should be considered more as moral gestures, like refusing to hear Gieseking perform, rather than as aesthetic responses.

A good example of a response which is genuinely critical but which we would all consider misplaced is Johnson's criticism of Abraham Cowley's *The Mistress*: "But the basis of all excellence is truth: he that professes love ought to feel its power. Petrarch was a real lover and Laura doubtless deserved his tenderness. Of Cowley we are told by Barnes, who had means enough of information, that whatever he may talk of his own inflammability, and the variety of characters by which his heart was divided, he in reality was in love but once, and then never had resolution to tell his passion!

"This consideration cannot but abate in some measure the reader's esteem for the work. . . ."

Another, perhaps slightly less conclusive example is provided by Johnson's remarks on Cowley's poem on the death of Hervey" . . . but when he wishes to make us weep he forgets to weep himself, and diverts his sorrow by imagining how his crown of bays, if he had it would crackle in the fire. It is the odd fate of this thought to be the worse for being true. The bay leaf crackles remarkably as it burns, as therefore this property was not assigned to it by chance, the mind must be thought sufficiently at ease that could attend to such minuteness of physiology." It might be argued that Johnson has indicated a source of dissatisfaction in the poem, the bay leaves image. But it is what this enabled him to infer about something outside the poem concerning Cowley which abated his esteem. If he could have been convinced that Cowley was ignorant of the propensity of bay leaves to crackle remarkably and the felicity of his image therefore fortuitous, Johnson would presumably have liked the poem better. But it would be a mistake to think Johnson simply absurd here. Suppose that the poem in question were Bishop King's Exequy and the biographical fact that he was never married and therefore never bereaved. Some of us would decide

Intention and Interpretation in Criticism

it didn't matter, some that it did and some would oscillate. This is an example of the more general dilemma which arises when an empirical concomitance on which we habitually depend and so regular that it has influenced the build of our concepts, disintegrates. Van Meegeren's *Disciples at Emmaus*, the poems of Ern Malley, Macpherson's *Ossian*, Chatterton's *Rowley*, all point the same moral.

D. W. Harding raised a related issue in a vivid form some years ago. He wrote: "We think of it (a work of art) as being a human product, as implicitly sanctioning and developing interests and ideals and attitudes of our own. That being so it does become disconcerting to find that for the author it satisfied certain impulses which we ourselves are glad not to possess, or which if we do possess we think better left unsatisfied. The same thing goes on in social intercourse of a simpler kind than literature. We enjoy the bon mot with which our friend disposes of a charlatan, but if we know that he is incidentally working off irrelevant spite against either the charlatan or the world in general the flavour of the remark is spoilt. The bon mot is as good as ever regarded as something impersonal, but as a human product it no longer gives us pure satisfaction-an element of distaste or regret comes in and makes our state of mind more complex. Many people find this more complex attitude extremely difficult to maintain . . . especially because in most actual cases the neurotic flaw can be detected in the work itself." But once in possession of biographical data it is difficult to be sure what is "in the work itself." Leavis has suggested it is a pity much is known of Pope's life since the expression of spite, envy, venom and malice so often found in his work is a consequence of the distorting effect of this knowledge.

What I have called "putting a field of force round a work," surrounding it with a web of associations, may be effective even when it doesn't deserve to be. But this kind of suggestibility is a risk all critical remarks run and not merely biographical ones. Would anyone have found the last few lines of Bishop King's *Exequy* productive of an effect of terror if Eliot had not said so? And would Eliot himself if he had not first come across them in Poe's *The Assignation*? It is the fact that we can speak of criticism which is effective but mistaken which makes the analogy with argument so tempting for there too we speak of conclusions seeming to follow but not following; so it seems that we can have specious criticism in the same sense in which we have specious argument. But this is an illusion. You don't show that a response to a work of literature is inadequate or inappropriate in the way that you show that the conclusion of an argument has been wrongly drawn.

Wittgenstein has some remarks in Part Two of the *Investigations*, which shed light on the nature of the intractability which characterises so much critical argument and makes its prevalence less surprising. His remarks

The Intentional Fallacy and Expressive Qualities

though concerned with the question of the genuineness of an expression of feeling have a more general application. He contrasts our judgments about sincerity with those about colour. "I am sure, *sure* that he is pretending: but some third person is not. Can I always convince him? And if not, is there some error in his reasoning or observations?" Though there are those whose judgment is better in such matters and rules for determining this, these do not form a system and only experienced people can apply them. There are consequences which distinguish correct from incorrect judgment, but these are of a diffuse kind and like the rules incapable of general formulation. ". . . only in scattered cases can one arrive at a correct and fruitful judgment." It is not surprising, then, that "the game often ends with one person relishing what another does not."

Conclusion

What I have been saying is this: a conviction that a poet stands in a certain relation to his words conditions our response to them. That this should be so seems to me part of the physiognomy of literature (as Wittgenstein might have put it). We are not ordinarily aware of this as these convictions tend to be held in solution in 'the work itself.' It is only in exceptional circumstance that we crystallise them out as explicit beliefs and become aware of the role they play. Why should anyone wish to deny this? Because it is then only a step to the production of phantasy-theses like Wimsatt's and Beardsley's, "What is said about a poem is subject to the same scrutiny as any statement in linguistics or in the general science of psychology."

This in its turn has its source in the determination to tidy up the activity of reading and to reduce what it involves to a neat logically homogenous set of considerations such as guarantee a readily communicable rationale. The idea of a work of literature as 'a linguistic fact' or an 'integrated symbol' is comparable to the notions of 'a concept' in philosophy or 'behaviour' in psychology in being the manifestation of an irresistible demand for discrete, coherent and enduring objects of investigation. But, "Literature is a motley."

GUY SIRCELLO

Romantic ideas about mind and its relation to art did not receive their clearest expression until the twentieth century. Then philosophers like Croce, Collingwood, Cassirer, Dewey, and Langer tried to spell out exactly how it is that art can be expressive. But to many other twentieth-century philosophers, especially to those working in the various "analytical" styles whose intellectual ancestry was anything but Romantic, those philosophical discussions of expression in art were puzzling. This puzzlement can best be seen in the work of Monroe Beardsley and O. K. Bouwsma, philosophers who represent two distinct strains in recent analytical philosophy.

I think it is fair to understand the puzzlement of both Beardsley and Bouwsma in the following way. We understand relatively well what it is for a *person* to express such things as feelings, emotions, attitudes, moods, etc. But if we say that sonatas, poems, or paintings also express those sorts of things either we are saying something patently false or we are saying something true in an uninformative, misleading, and therefore pointless way. For to say of works of art that they express those sorts of things seems to imply that they are very much like persons. Therefore, unless we believe that philosophers who think of art as expression believe the unbelievable, that is, that art has feelings, attitudes, and moods and can express them, we must believe that such philosophers are trying, however inadequately, to come to grips with genuine truths about art.

Furthermore, there is such an obvious disparity between the nature of art and the thesis that art can express the same sorts of things that people do that we cannot understand that thesis as simply a clumsy and inept way of stating some truths about art. We must understand it, rather, as a kind

[&]quot;Expressive Properties of Art," in Guy Sircello, Mind & Art: An Essay on The Varieties of Expression (copyright © 1972 by Princeton University Press): pp. 16-46. Reprinted by permission of Princeton University Press.

of *theoretical* statement, that is, as a deliberately contrived and elaborated way of construing some simple facts about art. Both Beardsley and Bouwsma thus speak of the "Expression *Theory*" of art.

What are the facts which the Expression Theory is meant to interpret? Although Beardsley and Bouwsma differ slightly in the way they put the point, they agree that works of art have "anthropomorphic" properties. That is, we may often properly characterize works of art as, for example, gay, sad, witty, pompous, austere, aloof, impersonal, sentimental, etc. A "theory" of art as expression, therefore, can say no more than that art works have properties designated by the same words which designate feelings, emotions, attitudes, moods, and personal characteristics of human beings.

The nature of these properties has not been probed very deeply by analytical critics of the Expression Theory. Beardsley calls them "qualities." Bouwsma prefers to call them "characters," pointing out their affinity with the "characters" of a number of things like sounds, words, numerals, and faces. In case this suggestion is unhelpful, Bouwsma further invites us to conceive the relation of the "character" to the art work in terms of the relation of redness to the apple in a red apple. At this point he is exactly in line with Beardsley, who mentions a red rose instead of a red apple.¹

The Bouwsma-Beardsley position on the question of expression in art is currently rather widely accepted. Indeed, John Hospers, writing in the Encyclopedia of Philosophy has, in effect, canonized the view.² Accordingly, I shall refer to it henceforth as the Canonical Position. Now despite the fact that it has illuminated the concept of expression in art, the Canonical Position is false in some respects and inadequate in others. In this chapter and the next two I shall argue (1) that attributions of "characters," or "anthropomorphic qualities," to works of art come in a number of different varieties, (2) that the simple thing-property relation is not an adequate model for understanding any of those varieties, (3) that there are far better reasons for calling art "expressive" than are allowed by the Canonical interpretation of Expression Theory, (4) that the presence of "anthropomorphic qualities" in works of art is not the only fact about art which makes it expressive, and (5) that the features of art which make it expressive have precise parallels in non-artistic areas of culture such as philosophy, historiography and science.

The Canonical Position has two incorrect presuppositions. The first is that works of art are very much like such natural objects as roses and apples as well as, I suppose, such natural quasi- and non-objects as hills, brooks, winds, and skies. The second is that the anthropomorphic predicates of art are not essentially different from simple color terms like "red" and "yellow." No one has seriously argued, as far as I know, that any art work is

just like some natural "object." Everyone admits that there are basic differences between art and nature, most of them related to the fact that art is made by human beings and natural things are not. What the first presupposition of the Canonical Position amounts to, therefore, is that as far as the anthropomorphic predicates are concerned works of art are not different from natural objects.³

It is fairly easy to show that this presupposition is false by the following strategy. Anthropomorphic predicates are applied to natural things in virtue of certain non-anthropomorphic properties of those things. Of course these properties vary, depending on the particular predicate as well as on the thing to which it applied. Hills, for example, may be austere in virtue of their color, their vegetation (or lack of it), or their contours; an ocean may be angry in virtue of the droop and shape of its branches. With respect to a number of art works to which anthropomorphic predicates are applied, I shall inquire what it is about those works in virtue of which the predicates are applicable. This strategy will yield categorial features of art which do not belong to natural things.

(1) Like most of Raphael's Madonna paintings, the one called *La Belle Jardinière* can be described as calm and serene. It is fairly clear what there is about this painting which makes it calm and serene: the regular composition based on an equilateral triangle, the gentle and loving expressions on the faces of the Mother, the Child, and the infant John the Baptist, the placid landscape, the delicate trees, the soft blue of the sky, the gentle ripples in the Mother's garments blown by a slight breeze, and, finally, the equanimity and quiet with which the artist views his subject and records the details of the scene.

(2) We might reasonably describe Hans Hofmann's *The Golden Wall* as an aggressive abstract painting. But in this painting there is no representational content in the usual sense and therefore nothing aggressive is depicted. What is aggressive is the color scheme, which is predominantly red and yellow. Blue and green are also used as contrasting colors, but even these colors, especially the blue, are made to look aggressive because of their intensity. Furthermore, by the way they are juxtaposed, the patches of color are made to appear as though they were rushing out towards the observer and even as though they were competing with one another in this rush towards the observer.

(3) We might say of Poussin's *The Rape of the Sabine Women* (either version, but especially the one in the Metropolitan Museum of Art in New York City) that it is calm and aloof. Yet it is quite clear that the depicted scene is *not* calm and that no one in it, with the possible exception of Romulus, who is directing the attack, is aloof. It is rather, as we say, that Poussin calmly observes the scene and paints it in an aloof, detached way.

The Intentional Fallacy and Expressive Qualities

(4) Breughel's painting called *Wedding Dance in the Open Air* can be aptly if superficially described as gay and happy. In this case however it is surely the occasion and the activities of the depicted peasants which are happy. Perhaps the prominent red used throughout the painting can be called "gay." The faces of the peasants however are neither happy nor gay. They are bland, stupid, and even brutal. It is this fact which makes the painting ironic rather than gay or happy. Yet there is certainly nothing about a peasant wedding, the dull peasants, or their heavy dance which is ironic. The irony lies in the fact that the painter "views," "observes," or depicts the happy scene ironically.

(5) John Milton's "L'Allegro" is not only "about" high spirits, but it is surely a high-spirited, i.e. gay and joyful, poem. The gaiety and joy are evident in several ways. First, the scenes and images are gay and joyful: Zephir playing with Aurora, maids and youths dancing and dallying, the poet himself living a life of "unreproved" pleasure with Mirth. Second, the diction and rhythms are light-hearted: "Haste thee nymphs and bring with thee / Jest and youthful Jollity, / Quips and Cranks, and wanton Wiles, / Nods, and Becks and Wreathed Smiles."

(6) Another sort of example entirely is William Wordsworth's sentimental poem "We Are Seven." This poem is quite obviously not *about* sentimentality. It purports simply to record the conversation between the poet and a child. Neither the child nor the poet (that is, the "character" in the poem), moreover, is sentimental. The child matter-of-factly reports her firm conviction there are still seven members of her family despite the fact that two of them are dead. The poet is trying, in a rather obtuse and hard-headed sort of way, to get her to admit that there are only five. But the little girl is made to win the point by having the last word in the poem. She is thus made to seem "right" even though no explicit authorization is given to her point of view. By presenting the little girl's case so sympathetically, Wordsworth (the poet who wrote the poem, not the "character" in the poem) treats the attitude of the little girl, as well as the death of her siblings, sentimentally.

(7) The case of "The Dungeon" by Coleridge is different again. At least the first half of this poem is angry. But it is not about anger or angry persons. It is a diatribe in verse (and certainly not a poor poem on that account) against the cruelty, injustice, and wasteful ineffectiveness of prisons.

(8) T. S. Eliot's "The Lovesong of J. Alfred Prufrock" can, with considerable justice, be called a compassionate poem. In this case it is quite clear that the compassion exists in the way in which the character Prufrock is portrayed as a gentle and sensitive, if weak, victim of ugly and sordid surroundings.

(9) Suppose that we say that the second movement of Beethoven's "Eroica" symphony is sad with a dignified and noble sadness character-

istic of Beethoven. In this case the sadness is in the slowness of the tempo, and the special quality of the sadness comes from the stateliness of the march rhythm, from the use of "heavy" instruments like horns and tympani and from the sheer length of the movement.

(10) A somewhat different case is presented by Mozart's music for Papageno, which is gay, carefree, light-headed and light-hearted like Papageno himself. What differentiates this case from (9), of course, is that the Mozart music is intended to suit a certain kind of character, whereas the Beethoven has no clear and explicit "representational" content. Despite this difference, however, the "anthropomorphic qualities" of the Mozart music are, like those of the Beethoven, audible in properties of the sound: in the simple harmonies, tripping rhythms, and lilting melodies of Papageno songs.

(11) A slightly different case from either (9) or (10) is that presented by the first movement of Vivaldi's "Spring" Concerto. The first lilting, happy theme represents the joyful advent of spring. This is followed by the gentle music of the winds and waters of spring. Next, this pleasantness is interrupted by the angry music representing a thunder shower, after which the happy, gentle music returns. In this music the "programmatic" content is clear and explicit because we know the poetry from which Vivaldi composed the music.

(12) Quite different from the three cases immediately preceding is the witty Grandfather theme from Prokoviev's *Peter and the Wolf*. Grandfather's music, played by a bassoon, is large, lumbering, and pompous like Grandfather himself. But what makes it witty is that it portrays a dignified old man as just a bit ridiculous. Through the music Prokoviev pokes gentle fun at the old man, fun which is well-motivated by the story itself. For in the end Peter turns out to be more than equal to the danger which Grandfather has ordered him to avoid.

(13) Finally, there is music like the utterly impersonal and detached music of John Cage, exemplified in *Variations II* played by David Tudor on (with) the piano. But where can we locate the "qualities" of impersonality and detachment in Cage's music? They do not seem to be "properties" of the sounds and sound-sequences in the way that gaiety is a property of Papageno's music or sadness is a property of Beethoven's. Indeed, we feel that these "anthropomorphic qualities" of Cage's music depend on the very fact that the sounds themselves are completely lacking in "human" properties. They are as characterless as any of a thousand random noises we hear every day. In fact, *Variations II* does have the apparent randomness and disorganization of mere noise. But we would not be inclined to call *any* random sequences of noises "impersonal" and "detached," even if they sounded very much like the sounds of *Variations II*. The predicates "impersonal" and "detached" are not applied to Cage's music simply in virtue

The Intentional Fallacy and Expressive Qualities

of some features of its sounds. These "qualities" of *Variations II* arise rather from the fact that the composer presents what sounds like mere noise as music. Cage offers this "noise" for us to attend to and concentrate upon. Moreover, he offers it to us without "comment," and with no intention that it evoke, represent, or suggest anything beyond itself. That is to say, Cage offers these noise-like sounds in a totally uninvolved, detached, impersonal way, seeking in no way to touch our emotional life.

From the preceding examples we can see that there are some respects in which anthropomorphic predicates are applied to works of art in virtue of features of those works which they share or could share with some natural things. In the Raphael it is the composition of the painting which accounts in part for the "calm" of the painting. But "composition" here refers simply to the configuration of lines and shapes, which sorts of features can of course be shared by natural objects. Similarly, the aggressiveness of Hofmann's painting is due to its colors and their arrangement. In the Beethoven and Mozart examples the anthropomorphic qualities are traceable to features of sound which can be present in natural phenomena. The ocean crashing on the shore, a twig tapping against a windowpane, the gurgle of a stream-all of these can have "tempi," "rhythms," and even "tone color." Natural "melodies" are present in the rustle of trees and the howl of winds as well as in the songs of birds. Even the anthropomorphic qualities of verbal art can be like properties of natural things. For, as the example of "L'Allegro" shows, such qualities can be attributed to poetry at least partly in virtue of the tempo and rhythm of its verses.

Some of the above examples of anthropomorphic qualities applied to art, however, show that such qualities sometimes belong to works of art in virtue of what those works represent, describe, depict, or portray. Thus the calm and serenity of the Raphael is due in part to the countryside, the sky, the garments, and the faces depicted; the gaiety of the Breughel comes from the gaiety of the depicted scene, and the high spirits of Milton's poem are due to the gay, happy scenes and images described and presented. In cases of this sort, neither paintings nor poems are comparable to natural things with respect to the way they bear their anthropomorphic qualities. And the situation is similar with respect to all other forms of representational art, whether prose fiction, drama, ballet, opera, or sculpture. Only architecture and music are generally incapable of bearing anthropomorphic qualities in this way. This is true, moreover, even for music with a sort of representational content such as the Mozart music mentioned in (10) above. For it is not due to the fact that Mozart's songs are written for a gay, lighthearted character that they are properly described as gay and lighthearted. It is rather that the songs suit Papageno precisely in virtue of the gaiety and lightheartedness of their "sound" and are thereby capable of portraying him musically.

There is a second way in which anthropomorphic predicates may be applied to art works which is unlike the ways in which such predicates apply to natural things. In the discussion of (1) through (13) above we discovered the following:

(a) La Belle Jardinière is calm and serene partly because Raphael views his subject calmly and quietly.

(b) The Rape of the Sabine Women is aloof and detached because Poussin calmly observes the violent scene and paints it in an aloof, detached way.

(c) Wedding Dance in the Open Air is an ironic painting because Breughel *treats* the gaiety of the wedding scene ironically.

(d) "We Are Seven" is a sentimental poem because Wordsworth treats his subject matter sentimentally.

(e) "The Dungeon" is an angry poem because in it the poet angrily *inveighs* against the institution of imprisonment.

(f) "The Lovesong of J. Alfred Prufrock" is a compassionate poem because the poet compassionately *portrays* the plight of his "hero."

(g) Prokoviev's Grandfather theme is witty because the composer wittily *comments* on the character in his ballet.

(h) Cage's Variations II is impersonal because the composer presents his noise-like sounds in an impersonal, uninvolved way.

I have italicized the verbs in the above in order to point up the fact that the respective anthropomorphic predicate is applied to the work of art in virtue of what the artist does in that work. In order to have a convenient way of referring to this class of anthropomorphic predicates, I shall henceforth refer to what verbs of the sort italicized above designate as "artistic acts." I do not intend this bit of nomenclature to have any metaphysical import. That is, I do not mean that the viewings, observings, paintings, presentings, portrayings, and treatings covered by the term "artistic acts" all belong to a category properly called "acts." Nor do I mean that all activities properly called "artistic" are covered by my term "artistic act." As shall come out later, many artistic activities are neither identical with, constituents of, nor constituted by "artistic acts." Furthermore, I do not want to suggest that "artistic acts" have anything more in common than what I have already pointed out and what I shall go on to specify. To do a complete metaphysics of artistic acts might be an interesting philosophical job but one which would distract me from my main purpose [here].

What the preceding discussion has shown is that the view of art presupposed by the Canonical Position ignores complexities in works of art which are essential in understanding how they can bear anthropomorphic predicates. Even more significant is the discovery that anthropomorphic predicates apply to art works in virtue of "artistic acts" in these works. For, as I shall argue presently at length, it is precisely this feature of art works which enables them to be *expressions* and which thereby shows that the Canonical Position has missed a great deal of truth in classical Expression Theory.

As far as I know, no adherent of the Canonical Position, with one exception to be noted below, has recognized the existence of what I call "artistic acts," much less seen their relevance to expression in art. But it is not difficult to anticipate the first defensive move a proponent of the Canonical Position would likely make against the threat posed by "artistic acts." It would go somewhat as follows. What the "discovery" of "artistic acts" shows is merely that not all applications of anthropomorphic predicates to art works attribute qualities to those works. They merely *seem* to do so because of their grammatical form. But in fact statements of this sort say nothing at all about the art work; they describe the artist. After all, "artistic acts" are acts of the artists, and they cannot possibly be acts of (i.e. performed by) the art works themselves.

However superficially plausible this objection is, it can be shown to have little force. First, the objection presupposes a false dichotomy: a statement must be descriptive either of a work of art or of its artist. On the contrary, there seems to be no reason why when we talk in the above examples of the painting's aloofness, the poem's sentimentality, etc., we cannot be talking both about the painting or poem and about how Poussin painted or how Wordsworth treated his subject. And it is in fact the case that we are talking about both. The best proof of this is that the grounds for the truth of the descriptions of artistic acts in (a) through (g) above can come from the art work in question. One knows by looking at Poussin's painting that he has painted the scene in an aloof, detached way. The cold light, the statuesque poses, the painstaking linearity are all visible in the work. Similarly, we recognize by reading Wordsworth's poem that he treats his subject sentimentally. That is just what it is to give the child, who believes that the dead are present among the living, the advantage over the matter-of-fact adult. We can also recognize the impersonality of Variations II by listening to its neutral, noise-like sounds. A test for statements describing art in anthropomorphic terms is always and quite naturally a scrutiny of the art, even when the terms are applied in virtue of "artistic acts."

Moreover it is not as if this sort of attention to the work of art were merely a second-best way of testing such statements. One does not look, listen, or read in order to *infer* something about the aloof way Poussin painted, the compassionate way Eliot portrayed his hero, etc. We must not

imagine that had we actually been with the artist at work, we could *really*, i.e. immediately and indubitably, have seen his aloofness, compassion, sentimentality, etc. How absurd to think that when Poussin's way of painting is described as aloof, what is meant is that Poussin arched his eyebrows slightly, maintained an impassive expression on his face, and moved his arms slowly and deliberately while he painted the picture. Or that because Eliot portrays Prufrock compassionately, he penned the manuscript of his poem with tears in his eyes. Not only would such facts not be needed to support statements about Poussin's aloofness or Eliot's compassion, but they are totally irrelevant to such statements. For even if we knew the way Poussin looked and moved when he was painting the Sabine picture or the way Eliot's face looked when he penned "Prufrock," we could not infer that the painting and poem were, respectively, aloof and compassionate in the ways we are discussing.

The foregoing considerations do not mean that the "artistic acts" in question are not truly acts of the artists, that is, are not truly something which the artists have done. Nor do they imply that these artistic acts are phantom acts, airy nothings existing mysteriously in works of art and disembodied from any agents.⁴ They simply mean that these acts are not identifiable or describable independently of the works "in" which they are done. Probably nothing makes this point clearer than the fact that descriptions of artistic acts of this sort can be known to be true even when little or nothing is known about the author, much less what he looked like and what his behavior was like at the precise time that he was making his art. It can be truly said, for example, that Homer describes with some sentimentality the meeting of the returned Odysseus and aged dog Argos. And yet it would be absurd to say that the truth of that statement waits upon some detailed knowledge about Homer, even the existence of whom is a matter of considerable dispute.

Artistic acts are peculiar in that descriptions of them are at once and necessarily descriptions of art works. They are in this way distinguishable from other sorts of acts of artists which contribute to the production of works of art, e.g. looking at the canvas, chiseling marble, penning words, applying paint, revising a manuscript, thinking to oneself, etc. But artistic acts, for all their peculiarity, are not entirely alone in the universe; there are other sorts of things which people do which are analogous to artistic acts in significant ways. Note the following: A person may scowl angrily, and thereby have an angry scowl on his face; he may smile sadly and thereby have a sad smile on his face; he may gesture impatiently and thus make an impatient gesture; he may shout defiantly and produce thereby a defiant shout; he may pout sullenly and a sullen pout will appear on his face; his eyes may gleam happily and there will be a happy gleam in his eyes; he may tug at his forelock shyly or give a shy tug at this forelock.

The Intentional Fallacy and Expressive Qualities

What is interesting about these clauses is that they show how an anthropomorphic term can be applied either adverbially to "acts" or adjectivally to "things" without a difference in the sense of the term or of the sentences in which it is used. This sort of shift in the grammatical category of a term is clearly analogous to what is possible with respect to those anthropomorphic predicates applied to works of art in virtue of their artistic acts. Thus one may, without change of meaning, say either that Eliot's "Prufrock" is a compassionate poem or that Eliot portrays Prufrock compassionately in his poem; that Poussin paints his violent scene in an aloof, detached way or that the Sabine picture is an aloof, detached painting.⁵

This grammatical shift is possible in both sorts of cases because of the inseparability of the "act" and the "thing." One does not *infer* from a smile on a person's face that he is smiling any more than one *infers* that Eliot portrayed Prufrock compassionately from his compassionate poem, and for analogous reasons. The "acts" of smiling, pouting, shouting, tugging are not even describable without also and at once describing the smile, pout, shout, or tug. Smiling, after all, is not an act which produces or results in a smile so that something could interfere to prevent the smiling from bringing off the smile. "Smiling" and "smile," we are inclined to say, are simply two grammatically different ways of referring to the same "thing."⁶

Now the parallel I want to point out is not between smile-smiling, poutpouting, tug-tugging, on the one hand, and poem-portraying, picture-(act of) painting, music-presenting, on the other. For clearly Poussin's Sabine painting is more than (is not simply identical with) Poussin's aloof way of painting the violent scene; Eliot's poem is more than his compassionate way of portraying its title character; Cage's music is more than his impersonal presentation of noise-like sounds. When we have described these artistic acts we have not by any means completely described the respective art works. The analogy rather is between smile-smiling and portravalportraying, presentation-presenting, treatment-treating, view-viewing, etc. Therefore, when we designate artistic acts by a noun term, those acts seem to be "parts" or "moments" of the works of art to which they pertain. We may then more properly understand the way in which an anthropomorphic adjective applies to an art work in virtue of such a "part" in something like the way in which a person's whole face is called sad in virtue merely of his sad smile or his sad gaze, or in which a person's behavior is generally angry in virtue (merely) of his quick movements and angry tone of voice. In these cases, too, it is not as if the terms "sad" and "angry" completely described the face or the behavior or even all parts and aspects of the face and behavior even though they can generally characterize the face and the behavior.

The foregoing comparison points out that not only is it the case that anthropomorphic predicates do not always apply to art works the way predicates, anthropomorphic or not, apply to natural objects, but that sometimes anthropomorphic predicates apply to works of art rather like the way that they apply to verbal, gestural, and facial *expressions*. For sad smiles are characteristic expressions of sadness in a person; angry scowls, of anger; shy tugs at forelocks, of diffidence; sullen pouts, of petulance. And this is an all-important point which the Canonical Position has missed in its interpretation of the Expression Theory of Art. Had proponents of the Canonical Position pursued their inquiry into anthropomorphic predicates further, they would have been forced to question whether such predicates apply to art in the way they apply to objects or in the way they apply to common human expressions.

Instead of pursuing this line of questioning, however, they were misled by the noun-adjective form of their favorite example—sad music—into their object-quality interpretation of Expression Theory, an interpretation which of course makes that "theory" seem very far removed indeed from the "facts" which were alleged to have motivated it. Small wonder that Beardsley's final judgment on Expression Theory is that it "renders itself obsolete" after it has reminded us that anthropomorphic predicates may reasonably be applied to art works. Even O. K. Bouwsma, who of all the proponents of the Canonical Position comes closest to the point I am maintaining, was not able to see quite where his comparison between sad music and sad faces leads. For instead of making a transition from sad faces to sad *expressions* on faces, he takes the (rather longer) way from sad faces to red apples.

There is more to the comparison between artistic acts and facial, vocal, and gestural expressions than the formal or grammatical similarities just noted. Even more important are the parallels between the "significance" of things like sad smiles and angry scowls and the "significance" of aloofness or irony in paintings, sentimentality or compassion in poems, and impersonality or wittiness in music. For there are parallels between what facial, gestural and vocal expressions, on the one hand, and artistic acts, on the other, can tell us about the persons responsible for them. In order to draw out these parallels explicitly I shall use the cases of an angry scowl and a compassionate portrayal in the mode of Eliot's "Prufrock."

First, it is obvious that an angry scowl on a person's face might well mean that the person is angry. It might be more than simply an expression of anger; it might be an expression of *his* anger. Now it should need very little argument to show that a compassionate poem like "Prufrock" might be an expression of the poet's own compassion. He might be a person with a generally sympathetic and pitying attitude towards modern man and his situation. In that case, a poem like "Prufrock," at least a poem with "Prufrock's" kind of compassion, is precisely what one could expect from the poet, just as one could expect an angry man to scowl angrily. But just as we cannot reasonably expect that *every* time a person is angry he scowls angrily, we cannot expect that every man who is a poet and who has compassion towards his fellows will produce poetry with the compassion of "Prufrock." If a man can keep his anger from showing in his face, a poet can, with whatever greater difficulties and whatever more interesting implications for himself and his poetry, keep his compassion from showing in his poetry.

Moreover, just as there is no necessity that a man's anger show in his face, there is no necessity that an angry scowl betoken anger in the scowler. There is a looseness of connection between anger and angry expressions which is matched by a looseness between compassion and compassionate poems. One reason that a man might have an angry scowl on his face is that he is *affecting* anger, for any of a number of reasons. Now although the range of reasons for affecting compassion in his poetry might be different from the range of reasons for affecting anger in his face, it is nevertheless possible that a corpus of poetry with "Prufrock's" sort of compassion might betoken nothing more than an affectation of compassion. This might be the case if, for example, the poet is extremely "hard" and sarcastic but thinks of these traits as defects. He might then quite deliberately write "compassionate" poetry in order to mask his true self and present himself to the world as the man he believes he should be.

On the other hand, both angry scowls and compassionate poetry might be the result simply of a desire to imitate. Children especially will often imitate expressions on people's faces, but even adults sometimes have occasion to imitate such expressions, e.g. in relating an anecdote. A poet might write poems with Eliot's sort of compassion in them in imitation of Eliot's early attitude. This imitation might be executed by a clever teacher in order to show more vividly than by merely pointing them out the means Eliot used to convey his special sympathy in "Prufrock." Or Eliot might be imitated because his techniques and style, together with the attitudes they imply, have become fashionable among serious poets or because these attitudes strike a responsive chord among serious poets. The latter sorts of imitation are rather like the imitations which a child might make of a person whom he regards as a model. It is not unusual for a girl who admires a female teacher, say, to practice smiling in that teacher's kind, gentle way or for a very young boy at play to "get angry" in the same way he has seen his father get angry.

A poet might write poems with the compassion of "Prufrock," not because he is either affecting or imitating the attitude of that poem, but because he is *practicing* writing poetry in different styles and different

"moods." This may be just something like a technical exercise for him, or it may be part of a search for a characteristic attitude or stance which seems to be truly "his own." He thus "tries on" a number of different poetic "masks," so to speak, to see how they fit him. In a similar way, an adolescent girl grimacing before her mirror might "try on" various facial expressions to see how they "look on her" and to discover which is her "best," or perhaps her most characteristic face: innocent, sullen, sultry, haughty, or even angry.

Finally, an angry scowl on a face might be there when the person is portraying an angry person on the stage. There is a similar sort of situation in which compassionate poetry might be written not as betokening a characteristic of the poem's real author but as betokening the traits of a *character* in a play or novel who is *represented* as having written the poem. No actual examples of such a character come immediately to mind; but we surely have no trouble imagining a master of stylistic imitation writing a novelized account of modern literature in which he exhibits examples of the "Prufrock"-like poetry of an Eliot-like figure.

What I have argued so far is not that all art is expression, nor even that all art works with artistic acts anthropomorphically qualified are expressions. My argument shows only that artistic acts in works of art are remarkably like common facial, vocal, and gestural expressions. It also demonstrates that precisely in virtue of their artistic acts and of the similarity they bear to common kinds of expressions, works of art may serve as expressions of those feelings, emotions, attitudes, moods, and/or personal characteristics of their creators which are designated by the anthropomorphic predicates applicable to the art works themselves. And it thereby demonstrates that one presupposition of the Canonical Position is clearly wrong: namely, that art works, insofar as they allow of anthropomorphic predicates, are essentially like natural things untouched by man.

But the second presupposition of the Canonical Position, to wit, that anthropomorphic predicates of art are like simple color words, is also false. It is false with respect to all of the three ways, distinguished earlier, that anthropomorphic predicates can be applied to works of art. And it is *a fortiori* false with respect to those predicates which are applied to art in two or three ways at once, as most of them are. The falsity of the presupposition can be brought out in an interesting way by showing how the three ways of applying anthropomorphic predicates to art bear a certain resemblance to color attributions which are rather unlike simply calling a (clearly) red rose red or an (indubitably) green hill green.

Suppose that a sign painter is painting a sign in three colors: yellow, red, and blue. Since the sign is large, he is required to move his equipment several times during the job. Suppose that he employs an assistant to attend

to this business. Now we can imagine that the painter will have occasion to give directions to his assistant. He might say, "Bring me the red bucket, but leave the blue and yellow ones there, since I'll need them on that side later." Now if we suppose that the color of all the paint containers is black, when the painter calls for the "red bucket," he must mean "the bucket of red paint," and would surely be so understood by his assistant. In the context the phrase "red bucket" only *appears* to have the same grammatical form as "red rose." I suggest that to the extent that a painting or other representational work of art is called "gay" or "sad" solely in virtue of its subject matter or parts thereof, the latter terms function *more* like "red" in "red bucket" than in "red rose."

It is a common opinion that "sad" in "sad smile" and "gay" in "gay laughter" function metaphorically.7 There may well be a use of "metaphor" such that the opinion is true. Whether there is such a use will not be determined until there exists a thorough philosophical study of metaphor; and I do not intend to offer one here. But even if it turns out to be true that such uses of anthropomorphic words are metaphorical, it cannot be very useful simply to say it. For such uses appear not to be metaphorical at all. After all, it is not as if calling a smile sad were representing the smile as, as it were, feeling sad, acting sad, weeping and dragging its feet. To see a smile's sadness is not to discern the tenuous and subtle "likeness" between the smile and a sad person. It is much more straightforward to think that a smile is sad because it is a smile *characteristic* of a sad person who smiles; that laughter is gay because such laughter is *characteristic* laughter of persons who are gay. In this respect "sad smile" is rather like "six-yearold behavior" or "Slavic cheekbones." These phrases do not indirectly point to unexpected similarities between a sort of behavior and six-yearold children or between cheekbones and persons. They designate, respectively, behavior which is characteristic of six-year-old children and cheekbones characteristic of Slavs. And there is no inclination at all to call these phrases "metaphorical."

Yet to say that a sad smile is a smile characteristic of sad people is not to deny what the Canonical Position affirms, namely, that "sad" designates a "property" or "character" of the smile. Surely there is something about the smile which marks it as sad: its droopiness, its weakness, its wanness. But the term "sad" still has a different import from "droopy," "weak," or "wan" when applied to smiles, even though all the latter terms are also characteristic smiles of sad persons. The difference is that the term "sad" *explicitly* relates the character of the smile to sadness of persons. A comparable sort of color term might be "cherry red." "Cherry red" is like the term "bright red with bluish undertones" in that they both designate roughly the same shade of red, which is characteristic of cherries. But the

former term is unlike the latter in that it *explicitly* relates the color to cherries.

It might seem that the Canonical Position would be correct in its interpretation of anthropomorphic terms as they apply to those features of works of art which they can share with natural things. For the term "sad" applied to the second movement of the "Eroica" and to a weeping willow must surely denote some properties of the music and of the tree. And they do: drooping branches in the tree; slow rhythm and "heavy" sound in the Beethoven. But "sad" differs from "drooping," "slow," and "heavy" as in the preceding case; it immediately relates the properties of the sounds and the branches to properties of other things which are sad. In these cases "sad" does function metaphorically, harboring, as it were, a comparison within itself. To find an analogy among color words, this use of "sad" is like "reddish." Like "reddish," which quite self-consciously does not denote true redness, "sad" in "sad tree" does not denote true sadness but only a kind of likeness of it. This use of "sad" is also arguably analogous to the use of "red" in "His face turned red with shame." But whether "sad tree" and "sad rhythm" are closer to "reddish clay" or to "red face" is, if determinable at all, unimportant for my point. For "reddish clay" and "red face" are equally unlike "red rose" and "red apple" when the latter refer to a full-blown American Beauty and a ripe Washington Delicious.

In this section I have argued that anthropomorphic terms, when applied to art, are more like "red" in "red bucket (of paint)," "cherry red" in "cherry red silk," or "reddish" in "reddish clay" than like "red" in "red rose." But, in truth, anthropomorphic predicates of art are not very much like any of these. The reason is that what all anthropomorphic predicates ultimately relate to are human emotions, feelings, attitudes, moods, and personal traits, none of which are very much at all like colors. But there is point in drawing out the comparison between anthropomorphic predicates and color-terms more complicated than "red" in "red rose." The point is that "red" as applied to bucket, "cherry red," and "reddish" are all in some way relational terms in ways that "red" said of a rose is not. "Red bucket" means "bucket of red paint"; "cherry red" means "the red characteristic of cherries"; and "reddish" means "of a color rather like red." Had proponents of the Canonical Position troubled to refine their comparison between anthropomorphic predicates and color predicates, they might have been forced to recognize the relational aspects of the former. Eventually they might have been led to see that anthropomorphic terms finally relate to various forms of the "inner lives" of human beings. And that is where Expression Theory begins. The Canonical model of the red rose (or apple) ultimately fails to help us understand how anthropomorphic predicates apply to art because such predicates are not very much like

simple quality-words and what they apply to are not very much like natural objects.

In spite of all the above arguments, the Canonical Position is not left utterly defenseless. Although it is the notion of "artistic acts" which is most threatening to the Canonical Position, proponents of that position have been almost totally unaware of this threat. Not totally unaware, however. There is a brief passage in Monroe Beardsley's book *Aesthetics: Problems in the Philosophy of Criticism* in which he mentions an artist's "treatment" and "handling," two examples of what I have called "artistic acts." Beardsley does not relate them, however, to the analysis of anthropomorphic terms. He discusses them under the rubric "misleading idioms," and he suggests that all talk about art concerning "handling" and "treatment" not only can be but should be translated into talk which makes no mention of these sorts of acts.⁸

These are meager clues, but from them it is possible to excogitate an objection to my notion of "artistic arts" which a defender of the Canonical Position might raise. We should first note a remark which Beardsley makes elsewhere in his book when he is concluding his interpretation of Expression Theory. He states that all remarks about the expressiveness of an art work can be "translated" into statements about the anthropomorphic qualities either of the subject matter or of the "design," i.e., roughly the properties which the work could share with natural things.9 A defense against the notion of "artistic acts" might thus run as follows: Any statement which describes an artistic act anthropomorphically can be "translated" into a statement which describes features of the work of art other than its artistic acts. So stated, however, the defense is ambiguous; it has two plausible and interesting interpretations. First, it might mean that any anthropomorphic description of an artistic act in a work can be replaced, without loss of meaning, by a description of the subject matter and/or design of the work in terms of the same anthropomorphic predicate. Or it might mean that there are descriptions, of whatever sort, of the subject matter and/or design of a work which, given any true anthropomorphic description of an artistic act in that work, entail that description.

The first interpretation of the objection is easily shown to be false. All that is required is that some examples of art be adduced in which anthropomorphic predicates are applicable with some plausibility to an "artistic act" but which are in no other way plausibly attributable to the work. Let us look again at the works of Poussin, Eliot, and Prokoviev discussed earlier in this chapter.

In the Poussin painting of the rape of the Sabines there is nothing about the violent subject matter which could be called "aloof." Certainly the attackers and the attacked are not aloof. Romulus, the general in charge,

is a relatively *calm* surveyor of the melee, but he cannot be called aloof, partly because we cannot see him well enough to tell what his attitude is. "Aloof" does not apply with regard to the formal elements of the Poussin painting either. It is difficult even to imagine what "aloof" lines, masses, colors, or an "aloof" arrangement thereof might be. The light in the painting is rather cold, and that feature does indeed contribute to the aloofness of the work. "Cold light" is not, however, the same as "aloof light," which does not even appear to be a sensible combination of words.

A similar analysis is possible with respect to Eliot's "Prufrock." If we consider first the "material" elements of the poem—its rhythm, meter, sound qualities, etc.—we realize that "compassionate" simply cannot apply to those features meaningfully. Moreover, there is nothing about the subject matter of "Prufrock" which is compassionate. Certainly Prufrock himself is not compassionate; he is simply confused, a victim of his own fears and anxieties, and of the meanness and triviality of his routinized life and soulless companions.

Finally, the wittiness of Prokoviev's Grandfather theme cannot be supposed to be a "property" of the music the way its comic qualities are. The music is amusing, or comic, because the wheeziness of the bassoon is funny and because the melody imitates the "structure" of a funny movement (one *must* move in an amusing way to that melody). Moreover, although Grandfather himself is funny, he is definitely not witty. What is comical, amusing, or funny is not always witty. To be witty is generally to make, say, or do something comical, amusing, or funny "on purpose." That is why Prokoviev's musical *portrayal* of a comical grandfather is witty. Similar analyses of the Breughel painting, the Wordsworth poem and the Cage music mentioned previously could obviously be carried out. But the point, I take it, is already sufficiently well made.

The second interpretation of the hypothetical attack on the importance of artistic acts borrows any initial plausibility it possesses from the fact that anthropomorphic descriptions of artistic acts can be "explained" or "justified" in terms which neither mention artistic acts nor use any of the terms which describe them. For example, one might point out the irony in the Breughel painting discussed above by noting the combination of the gay scene and the dull faces of its participants. Or one might justify the "aloofness" he sees in the Poussin by remarking on the cold light, clear lines, and statuesque poses in a scene of violence and turmoil. And in discussing the impersonality of *Variations II* it is necessary to mention that the Cage work sounds like accidentally produced noise, which is senseless and emotionally neutral, but that this noise-like sound is to all *other* appearances music, i.e. it is scored, it is performed on a musical instrument, it is even reproduced on recordings. From these facts about the way in which anthropomorphic descriptions are justified, it might seem plausible that the statements which figure in the justification *entail* the original description. But such is not the case, as the following will show.

It has been suggested that the reason that Breughel's peasant faces are dull and stupid-looking is that the painter was simply unable to paint faces which were happy. Whether the suggestion is true or well supported by the evidence is not an issue here. What is important is that were there any reason for believing Breughel to have been incompetent in that way, then there might be (not necessarily "would be") that much less reason for believing that there is irony in Breughel's Wedding Dance. That is because Breughel's incompetence and Breughel's irony can in this case function as mutually exclusive ways of accounting for a "discrepancy" in the picture. Of course, there are ways of admitting both the incompetence and the irony. It is possible to suppose, for example, that Breughel used his particular incompetence in making an ironic "statement" about peasant existence. Such a supposition would imply that Breughel was aware of his limitation and made use of it in his work. However, were it known that the only reason for the discrepancy in the painting was Breughel's incompetence, the "irony" would disappear. It makes no difference, incidentally, that such a thing could probably never be known. I am making a logical point regarding the way an attribution of a certain sort to an "artistic act" relates to other aspects of a painting like the Breughel. In short, certain facts about the painting's subject matter do indeed "ground" the attribution but by no means logically entail that attribution. And that is so for the good reason that the same facts about the subject matter are consistent with a supposition about Breughel which might be incompatible with the description of the painting as ironic.

A similar point can be illustrated in Poussin's Sabine painting. In that work there is a discrepancy between the violent scene, on the one hand, and the "still," clear figures, on the other. Two persons might agree about the character of the figures and the character of the depicted scene, however, and yet disagree whether these facts entail that Poussin painted the rape of the Sabines in an aloof, reserved way. One viewer might think simply that the work is incoherent, that Poussin's coldly classical means are not suited to the end he had in mind, namely, to depict the violence of the event. In this quite reasonable view, the discrepancy makes the painting "fall apart" rather than "add up" to an aloof and reserved point of view. Here then are two incompatible descriptions of a work which are equally well grounded on facts which allegedly "entail" one of the descriptions. I am mindful that it might be objected that there are other features of the Sabine painting than the ones mentioned which preclude the judgment of "incoherence" and necessitate the judgment of "aloofness." The best I can say is that there seem to me to be no such additional features

contributing to the "aloofness" of the painting and that the burden of proof is upon those who disagree.¹⁰

Finally, let us suppose that a devoted listener of traditional Western music scoffs at the description of Cage's Variations II as "impersonal music." He insists that it is nothing but what it sounds like-meaningless noise. He charges that Cage is a fraud whose "music" is a gigantic hoax, a put-on, and that Cage is laughing up his sleeve at those who take him seriously, perform his "scores," record the performances, and listen gravely to his nonsense. He has, the traditional listener says, read some of Cage's "ideological" material relating to his "music" but he has noted how laden with irony it is. To him that shows that Cage is not to be taken seriously because he does not take himself seriously. Now such a doubter does not disagree with the description of Variations II which is used to justify calling it "impersonal." The disagreement concerns rather the way we are to assess John Cage. Are we to judge him to be a responsible and serious, albeit radically innovative, composer of music or not? It is only when Cage's seriousness is assumed that the term "impersonality" applies to his music. Otherwise, the aforementioned justification for calling it impersonal is equally justification for calling it nonsense.

What the above three cases demonstrate is that a true anthropomorphic description of an artistic act might presuppose conditions having nothing necessarily to do with the way the formal elements and/or subject matter are describable. The conditions mentioned are (1) the competence of the artist, (2) the coherence of the work, (3) the seriousness of the artist. But there are surely other examples which would bring light to other conditions of this sort. With sufficient ingenuity one could likely discover and/or construct examples of art in which anthropomorphic descriptions of artistic acts would or would not be applicable depending upon how one assessed the artist with respect to, say, his maturity, his sanity, his self-consciousness, his sensitivity, or his intelligence.

Now it is probably too rigid to regard "competence," "coherence," "seriousness," "maturity," "sanity," and the rest as denoting necessary conditions for the legitimate description of all artistic arts. It is probably not true that the artist *must* be serious, competent, sane, etc., and that the work *must* be coherent in order for any anthropomorphic description (of an artistic act) to apply to any work. What these terms should be taken as denoting are "parameters" according to which an artist or a work can be measured in whatever respect is relevant in a particular case. To do so would be to admit that there is probably not a single set of particular conditions of these sorts presupposed in *all* descriptions of artistic acts. Naming these parameters simply points out the *sorts* of considerations which *might* be relevant in particular descriptions of artistic acts, leaving it an open question which of these parameters are relevant, and to what degree, in particular cases.

In any event, what the recognition of such parameters means is that any attempt to save the Canonical Position by "eliminating" descriptions of artistic acts in favor of "logically equivalent" descriptions of formal elements and/or represented subject matter is doomed to fail. For the description of artistic acts in anthropomorphic terms does presuppose something about the artist which cannot be known *simply* by attending to his art. A similar point holds with respect to common expressions. The look of a sullen pout on a person's face does not mean that the person is pouting sullenly if we discover that the look results from the natural lay of his face. And thus it is that no description simply of the configuration of the person's face can *entail* the statement that the person is pouting sullenly.

But it is equally true that the assertion that a person is pouting sullenly is incompatible with the claim that the person's face has the same configuration as it does when he is not pouting sullenly. The sullen pout *must* make a difference visible on the face. Analogously, for an anthropomorphic predicate of an artistic act to be applicable to a work of art there *must* be *some* features of the material elements and/or the subject of the work which *justify* the attribution of the term, even though they do not *entail* that attribution. One thing, however, is never presupposed or implied when an anthropomorphic predicate is truly applied to a work, namely, that the predicate is truly applicable to the *artist*. In this, too, works of art are like expressions.

Notes

1. Cf. Monroe Beardsley, *Aesthetics: Problems in the Philosophy of Criticism* (New York: Harcourt, Brace, 1958), pp. 321–332; and O. K. Bouwsma, "The Expression Theory of Art," in *Philosophical Analysis*, ed. Max Black (Ithaca: Cornell University Press, 1950), pp. 75–101.

2. The Encyclopedia of Philosophy, ed. Paul Edwards (New York: Macmillan and The Free Press, 1967), I, 47.

3. I hope it is clear that throughout this discussion the emphasis is on "natural," not on "object." But I will, for convenience, use the terms "object" and "thing" to cover non-objects and non-things as well.

4. Nor are they "virtual," i.e. unreal, acts, as I have maintained in another place. Cf. my "Perceptual Acts and Pictorial Art: A Defense of Expression Theory," *Journal of Philosophy*, LXII (1965), 669–677. Giving these acts a separate and unusual metaphysical status not only complicates the universe needlessly, it is unfaithful to the commonsense facts of the situation. There are no good reasons to deny what our ways of talking implicitly affirm, namely, that "artistic acts," perceptual and otherwise, are "acts" of the artist.

5. Of course it is true that sometimes when anthropomorphic terms are predicated of art works, they apply to subject matters and to "material" aspects of the work such as lines, colors, sounds, masses, etc., as well as to "artistic acts." My point above is only that anthropomorphic adjectives may be applied to a work only in virtue of an artistic act, in which case it is, without change of meaning, immediately applicable in adverbial form to that act.

6. It is no objection to this assertion that in virtue of the natural lay of their faces some people have perpetual "smiles," "smirks," "pouts," etc., on their faces even when they do not smile, smirk, or pout. Of course, a "smile" of this sort is different from a smile; that is what the scare quotes signify. But even though a person with such a "smile" on his face is not thereby smiling, he is, significantly, "smiling."

7. Nelson Goodman's recent theory of expression seems to depend rather heavily on the opinion that such uses of anthropomorphis predicates are metaphorical. As far as I can tell, however, Goodman merely asserts and does not argue for this opinion. Nor does he offer anything more than the briefest sketch of a theory of metaphor, which could be used to support his assertion. See his *Languages of Art: An Approach to a Theory of Symbols* (Indianapolis: Bobbs-Merrill, 1968), pp. 50–51, 80–95.

8. Beardsley, Aesthetics, pp. 80 ff.

9. Ibid., p. 332.

10. These statements commit me to the position that a positive judgment about the Poussin cannot be deduced from any descriptions of the painting of the sort which "ground" its aloofness. For arguments in favor of this general position see my "Subjectivity and Justification in Aesthetic Judgments," *Journal of Aesthetics and Art Criticism*, XXVII (1968), 3–12.

Art and Expression: A Critique

ALAN TORMEY

1. If the analysis developed in preceding chapters is correct in its general outlines, it should be possible to derive from it a number of implications bearing on the adequacy of attempts to understand art as a form of expression.

The history of the philosophy of art could, without excessive distortion, be written as a study of the significance of a handful of concepts. The successive displacement of 'imitation' by 'representation,' and of 'representation' by 'expression,' for example, marks one of the more revealing developments in the literature of aesthetics; and it would be only a slight exaggeration to claim that from the close of the eighteenth century to the present 'expression' and its cognates have dominated both aesthetic theorizing and the critical appraisal of the arts. One purpose of this chapter will be to explore the claim that works of art or the activities of the artist can best be understood as a form of expression.

2. Let us first consider some of the contentions of philosophers who have advanced expression theories of art. It has generally been recognized that some distinction must be made at the outset between the process and the product of art: we must distinguish between the artist's activity in constructing a work of art and the outcome of that activity, the work itself, It matters, that is, whether 'expression' is predicated of the process, the product, or both. Many, including Dewey, Reid, Ducasse, Santayana, and Collingwood,¹ have been explicit about this distinction, and have advocated predicating 'expression' of both process and product. These writers are committed to maintaining that there is a noncontingent and specifiable

From "Art and Expression: A Critique," in Alan Tormey, *The Concept of Expression: A Study in Philosophical Psychology and Aesthetics* (copyright © 1971 by Princeton University Press): pp. 97–106 and 122–124. Reprinted by permission of Princeton University Press.

Art and Expression

relation between the artist's activity and the work of art. More precisely, they are committed to the position that the artist, in creating the work, is expressing something,² which is then to be found "embodied," "infused," or "objectified" in the work itself. For such theorists, the "central problem of the aesthetic attitude" is "how a feeling can be got into an object"³ or, alternately, how the artist in expressing his feelings embodies them in the art work.

Common to all theories of this type are two assumptions: (1) that an artist, in creating a work of art, is invariably engaged in expressing something; and (2) that the expressive qualities of the art work are the direct consequence of this act of expression. I shall argue that there is no reason to accept these assumptions; but first we must consider a logically prior contention which is almost universally accepted by Expression theorists. This contention is that aesthetic, or artistic expression is something quite different from the symptomatic behavioral display of inner states.⁴ Vincent Tomas summarizes this view in these words:

... behavior which is merely symptomatic of a feeling, such as blushing when one is embarrassed or swearing when one is angry, is not artistic expression of feeling. Collingwood says it is just a "betrayal" of feeling. Dewey says it is "just a boiling over" of a feeling, and Ducasse says it is "a merely impulsive blowing off of emotional steam." As Hospers says, "A person may give vent to grief without expressing grief." Unlike merely giving vent to or betraying a feeling, artistic expression consists in the deliberate creation of something which "embodies" or "objectifies" the feeling.⁵

The corollary is that "embodying" or "objectifying" a feeling is equivalent to (artistically) expressing it. It is important to notice that these distinctions have been made in the interest of sustaining some favored version of the Expression theory; and since the appropriation of 'expression' for this purpose involves a significant departure from ordinary usage, we may reasonably demand some justification for this procedure.

On this point Dewey is the most thorough and articulate, and I shall confine my criticism to his version of the argument. Dewey writes that:

Not all outgoing activity is of the nature of expression. At one extreme, there are storms of passion that break through barriers and that sweep away whatever intervenes between a person and something he would destroy. There is activity, but not, from the standpoint of the one acting, expression. An onlooker may say "What a magnificent expression of rage!" But the enraged being is only raging, quite a different matter from *expressing* rage. Or, again, some spectator may say "How that man is expressing his own dominant character in what he is doing or saying." But the last thing the man in question is thinking of is to express his character; he is only giving way to a fit of passion.⁶

Dewey is concerned to protect us from the "error" which has invaded aesthetic theory ". . . that the mere giving way to an impulsion, native or habitual, constitutes expression."⁷ He adds that "emotional discharge is a necessary but not a sufficient condition of expression" on the grounds that: "While there is no expression, unless there is urge from within outwards, the welling up must be clarified and ordered by taking into itself the values of prior experiences before it can be an act of expression."⁸ There can be no expression without inner agitation then, but the mere discharging of inner impulsions is insufficient to constitute an expression. ". . . to express is to stay by, to carry forward in development, to work out to completion";⁹ and, "Where there is . . . no shaping of materials in the interest of embodying excitement, there is no expression."¹⁰

Dewey offers these remarks as evidence for the adequacy of the Expression theory, whereas they follow in fact only if one has already assumed its truth. They are thinly disguised stipulations and not, as Dewey would have it, independently discoverable truths about expression. The circularity of this procedure can best be seen in his refusal to admit anything as an expression which does not result in the production of an object or state of affairs that embodies some aesthetically valuable quality.¹¹ But there are more serious objections. Dewey clearly wants to confine 'expression' to activities which are intentionally or voluntarily undertaken. (It must be an expression "from the standpoint of the one acting"; the involuntary venting of rage is ruled out with the comment that "the last thing the man in question is thinking of is to express his character; he is only giving way to a fit of passion.") But there is an existing distinction, and one which we would normally employ here, between voluntary and involuntary expression.¹² Dewey offers us no reason for abandoning this in favor of his stipulative restriction, other than an implicit appeal to the very theory which requires the sacrifice, and we are entitled to a more compelling argument before adopting this way of speaking.¹³

One reason for Dewey's insistence on this restriction is obvious. Many activities and behavioral patterns that are called 'expressions' are irrelevant to the production of aesthetically interesting objects. Most Expression theorists agree that the artist is engaged in doing something quite different from the man who merely vents his rage or airs his opinions—that he is doing something which bears little resemblance to commonly recognized varieties of expressive behavior. But the fact that the artist *is* doing something something something something to suggest not that he alone is expressive.

Art and Expression

ing while others are not, but that the aesthetically relevant activity of the artist may not be an expression at all. Rather than being shown in creative activity the real meaning of 'expression,' we are offered a stipulation which would undermine most of the paradigmatic examples of expressive behavior in the interests of promoting a debatable theory.

The upshot of this is that, if "aesthetic expression" as a process is not to be understood in relation to pre-analytic notions of expressive behavior, then it must be understood in relation to something else—the something else here being the aesthetic qualities of the created product, the work of art.

In turning to the expressive qualities of the object we are not leaving behind the act of expression, for even if we center attention on the properties of the work itself ("the object that is expressive, that says something to us" 14) Dewey reminds us that "isolation of the act of expressing from the expressiveness possessed by the object leads to the notion that expression is merely a process of discharging personal emotion";¹⁵ and that, "Expression as personal act and as objective result are organically con*nected* with each other [italics added]."¹⁶ But it is just here that Expression theories fail to convince, for the nature of this supposed connection is far from obvious, and no adequate analysis has yet been offered by anyone committed to this view. The argument for such a connection is usually established somewhat in the following way: aesthetic objects, including works of art, are said to possess certain perceptible physiognomic or "expressive" qualities such as 'sadness,' 'gaiety,' 'longing'; and where these are qualities of intentionally structured objects it is reasonable to assume that their presence is the intended consequence of the productive activity of the artist. But the Expression theorist is not content with this; he will go on to assert that, since the aesthetically relevant qualities of the object are expressive qualities, the productive activity must have been an act of expression and, moreover, an act of expressing just those feeling states whose analogues are predicated of the object. The situation can be represented more schematically in the following way:

(E-T) If art object O has expressive quality Q, then there was a prior activity C of the artist A such that in doing C, A expressed his F for X by imparting Q to O (where F is a feeling state and Q is the qualitative analogue of F).

The *E*-*T* represents a core-theory which I believe to be shared e.g. by Dewey, Ducasse, Collingwood, Carritt, Gotshalk, Santayana, Tolstoy, and Véron, whatever their further differences might be.¹⁷ I shall argue that the *E*-*T* contains an error traceable to the tendency to treat all of the cognate forms of 'expression' as terms whose logical behavior is simi-

lar. The particular mistake here arises from assuming that the existence of *expressive qualities* in a work of art implies a prior act of *expression*.

Now, to say that an object has a particular expressive quality is to say something, first of all, about the object. (Even those who argue that 'the music is sad' can be translated as 'the music makes me feel sad' or '... has a disposition to make me, or others, feel sad' will agree that their accounts are only plausible on the assumption that the object has some properties which are at least causally relevant to the induced feeling). But the Expression theorist is committed to the further assumption of a necessary link between the qualities of the art work and certain states of the artist. Critics of this theory have been quick to observe that this would commit us to treating all art works as autobiographical revelations. Moreover, it would entail that descriptions of the expressive qualities of an art work were falsifiable in a peculiar way. If it turned out that Mahler had experienced no state of mind remotely resembling despair or resignation during the period of the composition of Das Lied von der Erde, the Expression theorist would be obliged to conclude that we were mistaken in saying that the final movement (Der Abschied) of that work was expressive of despair or resignation; and this seems hardly plausible, since it implies that statements ostensibly about the music itself are in fact statements about the composer.¹⁸ If works of art were expressions, in the way that behavior and language are expressions of states of a person, that is precisely what we would say. Normal imputations of expression are falsifiable, and the assertion that a person's behavior constitutes an expression of something is defeated when it can be shown that the imputed inference is unwarranted.¹⁹ But statements about the expressive qualities of an art work remain, irresolutely, statements about the work, and any revision or rejection of such statements can be supported only by referring to the work itself. 'That's a sad piece of music' is countered not by objections such as, 'No, he wasn't' or 'He was just pretending' (referring to the composer), but by remarking 'You haven't listened carefully' or 'You must listen again; there are almost no minor progressions and the tempo is allegro moderato.'

Descriptions attributing expressive qualities to works of art then are not subject to falsification through the discovery of any truths about the inner life of the artist. An Expression theorist could of course grasp the other horn, arguing that the presence of quality Q in O is *sufficient* evidence of the occurrence of state S in A, such that A felt F for X. But in ruling out the possibility of independent and conflicting evidence of the artist's feeling states, the Expression theorist secures his position by the simple expedient of making it analytically true; and no one, to my knowledge, has wished to claim that the E-T is an empty, though indisputable truth.

That a theory of art-as-expression which entails these difficulties should have been embraced so widely is due in part to a misunderstanding of the

Art and Expression

logic of 'expression' and 'expressive.' I would argue that statements attributing expressive (or physiognomic) properties to works of art should be construed as statements about the works themselves;²⁰ and that the presence of expressive properties does not entail the occurrence of a prior *act* of expression. Misunderstanding of this latter point has contributed greatly to the uncritical acceptance of the E-T.

3. 'Expressive,' despite its grammatical relation to 'expression,' does not always play the logical role that one might expect. There are occasions on which the substitution of one term for the other is semantically harmless. 'His gesture was an expression of impatience' may in some contexts be replaced without noticeable alteration in meaning by 'His gesture was expressive of impatience.' But there are other contexts in which 'expression' and 'expressive' are significantly disparate. The remark that 'Livia has a very expressive face' does not entail that Livia is especially adept at expressing her inner states, nor does it entail that she is blessed with an unusually large repertoire of moods and feelings which she displays in a continuous kaleidoscope of facial configurations.

To make this clear I shall need to appeal to another distinction, developed in an earlier chapter,²¹ between the two syntactic forms, ' ϕ expression' (A) and 'expression of ϕ ' (B). That distinction was intended to establish that instances of B are inference-warranting while instances of A are descriptive, and that A and B are logically independent in the sense that no statement containing an instance of A (or B) entails another statement containing an instance of B (or A). (A cruel expression in a human face does not automatically entitle us to infer that cruelty is being expressed.)

Now, the assertion that a person has an expressive face is not equivalent to the assertion that he is expressing, or is disposed to express, his inner states through a set of facial configurations; or rather the equivalence is not guaranteed. The difficulty is that 'expressive' is systematically ambiguous. It may be an alternate reading of 'is an expression of \ldots ' or it may be understood as a one-place predicate with no inferential overtones. Which of these meanings it has in a particular instance will depend upon what substitutions we are willing to make and what further questions we are prepared to admit. If, for example, the question 'expressive of what?' is blocked, we can conclude that 'expressive' is not functioning here in a variant of syntactic form B. 'X is expressive' does not entail that there is an inner state S such that S is being expressed, any more than the appearance of a cruel expression in a face entails that cruelty is being expressed.

The statement that 'X is expressive' then may be logically complete, and to say of a person's gesture or face that it is *expressive* is not invariably to legitimize the question 'expressive of what?' In such cases we may say that 'expressive' is used intransitively. Still, we would not call a face

The Intentional Fallacy and Expressive Qualities

(intransitively) expressive unless it displayed considerable mobility. A face that perpetually wore the *same* expression would not be expressive, and appreciation of this point should contribute to an understanding of the intransitive (I) sense of 'expressive.' A face is expressive (I) when it displays a wide range of expressions (A). Thus the successive appearance of sad, peevish, sneering, and puzzled expressions on the face of a child may lead us to say that he has an expressive face without committing us to a set of implications about the inner state of the child.

The meaning of 'expressive' (I) is not exhausted, however, through correlation with indefinitely extended sets of expressions (A). A face may be expressive merely in virtue of its mobility or its range of perceptible configurations, even though it presents no recognizable expressions (A)for which there are established names. To this extent, 'expressive' (I) is dispositional. It refers to the disposition of a face (or a body) to assume a variety of plastic configurations regardless of whether any momentary aspect of the face is describable as an expression (A) or not; and since it is clear that we have neither names nor definite descriptions for many of the geometrical patterns the human face and body can assume, the domain of 'expressive' (I) is both wider and less precise than 'expression' (A). It may refer at times simply to the capacity or disposition of a person to move or use his body in varied and perceptually interesting ways.²² But whatever the correct analysis of 'expressive' (I), the fact remains that its use imposes no inferential commitments, and we may use it, just as we use 'expression' (A) to refer to certain gualities of persons and objects without implying the existence of some correlated act of expression.

4. It may be objected that all this, at best, discloses some interesting features of the use of 'expression' and 'expressive' in ordinary language which, from the standpoint of the Expression theorist, are entirely irrelevant. On the contrary, I believe these distinctions are crucial for an understanding of the very art form to which Expression theorists have made most frequent appeal. The point I want to develop here is that the language used by composers and performers of music is at variance with the conception of musical activity derivable from the E-T. This is not merely an instance of the naïveté of artists in contrast with the ability of philosophers to provide reflective analyses of a complex enterprise. It is rather that 'expressive' has a particular and quasi-technical meaning within the language used by musicians—a meaning which is logically similar to the intransitive sense of 'expressive,' which is clearly distinguishable from 'expression' (B), and whose use does not therefore commit us to any version of the E-T.

There are numerous passages in the music of the Romantic period (and later) which are marked *espressivo* ("expressively" or "with expression"). Now this is a particular instruction for the performance of the indicated

Art and Expression

passage or phrase, and as such it can be compared with the instructions agitato, grazioso, dolce, leggiero, secco, stürmisch, schwer, and pesante. All of these are indications to the performer that the passage is to be played in a certain manner, and to play espressivo is merely to play in one manner rather than another. It is not to play well rather than badly, or to play with, rather than without some particular feeling, nor is it to succeed rather than fail to communicate the composer's intentions, feelings, or ideas. All of these misconceptions are the result of a category mistake. One does not play agitato or pesant and espressivo; the choice must come from among alternatives all of which are logically similar members of a single category.²³ Moreover, to play espressivo is not to be engaged in expressing anything, any more than to play leggiero is to express lightness. (Nor, similarly does the composition of an expressive work entail that the composer be expressing anything.) Failure to realize this has led some adherents of the Expression theory into associating an expressive musical performance with some presumed act of expression on the part of the performer, the composer, or both, and thence with some particular feeling state which is attributable to them.²⁴

It would follow from the E-T that we might always be mistaken in thinking that a performer had played a phrase expressively, since the correctness of this belief would depend on the truth of some psychological statement about the performer's inner states. But *espressivo* (expressively) is an adverbial characterization of a *manner* of performance, and the suggestion that follows from the E-T, that an expressive performance *must* be linked noncontingently to some particular inner state of the performer, is untenable.

It might be objected at this point that both the Expression theorist and I have misconceived the role of 'expressive,' for in critical usage 'expressive' may characterize entire performances or personal styles of performance (one might argue that Oistrakh's performance of the Sibelius *Violin Concerto* was more expressive than Heifetz's, or that generally, *A*'s playing was more expressive than *B*'s). 'Expressive' is still intransitive in this role, but it resists reduction to specific occurrences of passages played *espressive*.²⁵ And it is this usage which may lead to the suggestion that 'expressive' has a primarily *evaluative* function in critical discourse. 'Expressive' does not, on this view, license inferences nor label particular or even general features of the object to be assessed, rather it does the assessing. Thus, calling a performance expressive would be to approve, applaud, or commend, not to detect, notice, or describe.

But there are two related and, I think, decisive objections to this suggestion. For even where 'expressive' is used to characterize a style or an entire performance and cannot be explicated by reference to particular occurrences of *espressivo* passages, the possibility remains that the expressiveness may be misplaced. There are omnipresent opportunities for misplaced expressiveness in musical performances, and we should find something peculiarly offensive in an expressive performance of Stravinsky's *L'Histoire du Soldat* or Bartok's *Allegro Barbaro*. Appropriate and effective performances of such works require the absence, or perhaps even the deliberate suppression of expressiveness. Similarly, austere performances of austere works are not *bad* performances; and to call performances of such works expressive may well be to condemn them. If 'expressive' were primarily an evaluative device, the notion of misplaced expressiveness would be self-contradictory, or at best paradoxical. Similar remarks apply to works as well as performances, and describing a particular work as nonexpressive is not equivalent to condemning it, nor is it prima facie evidence of its lack of artistic worth.

The second error results from failure to notice the first. Whether 'expressive' may be correctly *used* to praise a performance is a function of whether an expressive performance is appropriate to the work being performed. Where it *is* appropriate, and the performance commensurately expressive, *calling* it so may also serve to commend it. But this does no more to show that 'expressive' is an essentially evaluative predicate of our critical language than commending figs for their sweetness shows that 'sweet' is an essentially evaluative predicate of our culinary language. That we prefer expressive to nonexpressive performances of Rachmaninoff and Chopin implies that we regard expressiveness as required for an appropriate reading of the Romantic architecture of their works; it does not imply that 'expressive' is an essential of 'good.'

We shall gain a better view of the issue, I think, if we consider how we might teach someone to play expressively or, conversely, how we might teach someone to recognize an expressive performance. If a student asks: 'What must I do to play this passage expressively?' we cannot give him a rule to follow such as: 'You must always play such passages in this way. . . .' Of course we can give him a rule of sorts—'To play expressively you must vary the dynamics of the phrase; you must stress some notes more than others, and you must not play with rhythmic rigidity'-but we cannot give him a precise rule specifying which notes to stress or where and how to vary the dynamics. There are no paradigmatic examples of expressive playing from which a universal rule could be extracted and applied to other phrases. No phrase can be played expressively without some deviation from literal note values, without some modulations in the dynamic level, but the choice of where and how is not rule-governed.²⁶ The student who merely follows our second-order rule and plays the passage with rhythmic freedom and some dynamic modulation may produce a grotesquely unmusical and inexpressive result.

Art and Expression

The problem is analogous to teaching someone to recognize an expressively played passage. There are no rules that will help here either. (If someone had no idea what to listen for, we might say: 'It happens when the pianist closes his eyes' or 'Watch for him to sway from the waist' and so on.) It may be thought that the difficulty here is much the same as that of showing the face in the cloud to someone whose aspect-blindness allows him to perceive only the cloud. There is an analogous kind of expressiondeafness, but the analogy is only partial, and it is apt to mislead. Expression-deafness is closer to aspect-blindness than to color-blindness. There is no way to teach a color-blind person to see the normal range of colors, but we may succeed in getting someone to see the face in the cloud or the 'aspects' of the duck-rabbit figure; and we may succeed, analogously, in teaching someone to recognize an expressive performance. But the analogy cannot be stretched to a perfect fit. Recognition of the expressiveness in Grumiaux's performance of the Debussy Sonata for Violin and Piano presupposes that we are able to discriminate among a number of qualities that are predicable of musical performances. To hear a performance as expressive is also to hear that it is not dry, strained, heavy, agitated, or hollow. The identification presupposes, in other words, that we are conversant with a highly complex set of predicates and with their logical relations to one another. Recognition of the duck in the duck-rabbit figure, on the other hand, seems not to presuppose any comparably complex discriminatory abilities. Ducks and duck-like shapes may be recognizable even to those whose acquaintance with the zoological world is limited to ducks. But talk of expressive performances or works can occur meaningfully only within a developed language of musical criticism, and it implies an ability to discriminate and select from among a number of logically similar predicates.

There is no possibility that someone should learn to use 'expressive' correctly and yet be unable correctly to apply any other aesthetic predicate, as one might learn to use 'duck' correctly without at the same time being able to correctly apply other zoological predicates. (Seeing the figure as a duck is more closely analogous to hearing the sounds as music than to hearing the music as expressive.)

Aesthetic predicates are not learned independently of one another in some discursive or ostensive fashion. They acquire significance for us only in relation to one another as we become reflective and articulate participants in the art world.²⁷

Despite the popularity of aspect and "seeing-as" models in recent discussions of aesthetic perception, considerations such as this seriously impair the attempt to explain our perception of aesthetic qualities by analogy with the perception of aspects, or as instances of "seeing-as."²⁸ Aspect perception has been a useful model in freeing us from the temptation to think of aesthetic objects as ontologically peculiar and distinct from, say, the material objects we hang on our walls; but it is misleading when it suggests that seeing, or hearing, an art work as *expressive* (or garish, or sentimental) is no different from spotting the face in the cloud or the duck in the figure.

5. The Expression theorist of course may object that he is not concerned so much with the language of musicians or critics as with the possibility of giving a theoretical description of the art which would enable us to grasp certain aesthetically relevant features of the processes of creating, performing, and attending to musical compositions. We must, I think, admit that there is a sense in which it would be correct to say that a piece of music may be an expression (B); the account I have given in the preceding chapters leaves open this possibility. But this admission concedes nothing to the E-T, for the only sense in which 'expression' (B) is admissible here is inconsistent with the E-T.

The admission amounts to this: Aside from certain occurrences of nonverbal behavior and linguistic utterances there is a class of things we may call indirect or secondary expressions. The manner of a woman's dress, the way she wears her hair, or the arrangement of her room may "express" some aspect of her character. My handwriting, my preferences in literature, my style at poker, and my choice of friends may likewise reveal something of my inner states and dispositions. It is legitimate to speak of these as expressions (B) where they satisfy the conditions of being evidential or inference-warranting, and lead, correctly, to the attribution of an intentional state.²⁹ It is clear that this is often the case, that we do make such inferences, and that the conditions for expression are satisfied here as well as in cases of direct or primary expression in language and behavior.

And if my style of playing poker expresses my temerity or my avarice, why should not my style of painting landscapes express something of me as well? Or my style of playing the flute? The conditions of a warranted inference to an intentional state may be as well met by art as by action; and there are impressive examples in the literature of psychoanalysis of the use of art works to unlock the psychic labyrinths of the artist.³⁰ It is this sense in which I concede that an art work may be an expression of something: it may contribute material leading to a correct inference to an intentional state of the artist. But I contend that this does nothing to support the *E*-*T*, and further, that it does nothing to distinguish art from any other product of human activity.

We should recall that the E-T entails that the (successful) artist, by his creative activity, imparts a quality to the work which is *descriptively analogous* to the feeling state expressed by him (sadness-'sadness') and ought therefore to be recognizable as the embodiment of his feeling with-

Art and Expression

out assistance from extra-perceptual sources of knowledge. But, far from being clear that this is always the case with successful works of art, it would seem in some instances to be impossible. It will be best to illustrate this point with an example. Carl Nielsen completed his Sixth Symphony during the years 1924–25, and it was during this period of the composer's life that "he was harassed by ill health and depression, puzzled by the notoriety enjoyed by what seemed to him to be musical nihilism, and upset over the seeming failure of his own work to take hold beyond the borders of his native land. . . . It is not unreasonable to suppose that this is the source of some of the exasperation that manifests itself particularly in the second and final movements of the Sixth Symphony."³¹ (The second movement is referred to later as ". . . a bitter commentary on the musical modernism of the 1920's.")

Now the second movement of the Nielsen symphony is marked Humoresque, and the prevailing impression left by the music itself is that of lighthearted buffoonery. It may not be unreasonable as the program notes suggest, to conclude that Nielson was venting exasperation, bitterness, or disappointment here, but it is difficult to see how such an inference could have been suggested by attending to the qualities of the music alone. The music does not sound exasperated or disappointed, nor can I see how any piece of music *could* have these as perceptible qualities. The movement sounds humorous, and there is an obvious reference to Prokofiev's Peter and the Wolf; but the suggestion that Nielsen was manifesting exasperation or commenting bitterly on musical modernism in this piece can have arisen only with the acquisition of some extra-musical information about the composer's life. If the critic now wants to maintain that the Sixth Symphony is an expression of Nielsen's bitterness and disappointment, we may agree that this is at least a plausible inference given the truth of the biographical data. But we must also point out that this has little to do with the aesthetically relevant expressive qualities of the music itself. This is something of a paradox for the E-T. In order for the Nielsen symphony to be an expression of the composer's bitterness and disappointment (i.e., to be a secondary expression) it must have certain perceptible qualities which, together with the biographical data, will yield an inference. But the qualities of the music here are not, and cannot be analogues of the intentional state of the composer. The music is humorous, the composer is disappointed. And he cannot inject his bitterness and disappointment into the music in the way that is required by the E-T. There is no sense in which the music is disappointed. Even if we suppose it to be true that Nielsen was disappointed, exasperated, or bitter, and that the critic's inferences are correct, there is nothing in this to establish the presence of a noncontingent relation between the perceptible qualities of the music and any particular state of mind of the composer. Such linkages are contingent, and dependent in every case on the possession of some extra-musical knowledge of the composer's life. In itself, humor in a piece of music no more guarantees the presence of bitterness than it invariably betrays a carefree state of mind. Paralleling the distinction between syntactic forms A and B, the expressive qualities of a work of art are logically independent of the psychological states of the artist, and humor (or sadness) in a madrigal is neither necessary nor sufficient for amusement (or despair) in a Monteverdi.

Thus, even where we speak of a piece of music as an expression (B) of some state of mind, this use fails to meet the requirements of the *E*-*T*. There is no direct, noncontingent relation between qualities of the work and states of the artist as the *E*-*T* supposes (*F* and *Q* are not related in the required way). The relation is contingent and mediated by extramusical considerations, including in some instances appeal to psychological theories. Secondly, it is often *impossible* to impart a feeling quality to a work which will perceptually reflect the artist's feeling state (e.g. disappointment). And, finally, the presence of an expressive quality in a work of art is never sufficient to guarantee the presence of an analogous feeling state in the artist. What the music "expresses" is logically independent of what, if anything, the composer expresses.³²

It follows from this that statements of the form, 'The music expresses ϕ ,' or 'The music is expressive of ϕ ' must, if we are to understand them as making relevant remarks about the music and not as making elliptical remarks about the composer, be interpreted as intensionally equivalent to syntactic form A; that is, they are to be understood as propositions containing 'expression' or 'expressive' as syntactic parts of a one-place predicate denoting some perceptible quality, aspect, or gestalt of the work itself. Moreover, 'The music expresses ϕ ' cannot be interpreted as an instance of the use of 'expression' (B) since it would make no sense to ask for the intentional object of the music. The sadness of the music is not sadness over or about anything.³³ I am not claiming that everyone who uses these constructions does in fact understand them to have this meaning, but I am contending that this is the only interpretation which is both coherent and which preserves the aesthetic relevance of such assertions.

6. To recapitulate, neither playing expressively nor composing "expressive" music entails that one *be* expressing anything.³⁴ They require only that the product of the relevant activity have certain phenomenal properties that can be characterized as noninferentially expressive. And once we have shed the tendency to look behind the expressive qualities in an art object for some correlated act of expression we shall be closer to a correct understanding of the relation of the artist to his work; or rather, we shall be relieved at least of a persistent misunderstanding of the relation. Musi-

Art and Expression

cians, and artists generally, do not "express" themselves in their work in any sense that is intelligible, consistent, and aesthetically relevant. This is not to say that there is no relation between the artist's activity and the resultant expressive qualities of the work, but rather to argue that it must be something other than that envisaged by the E-T. It would be less misleading, if a little archaic, to say simply that the relation is one of making or creating. The artist is not expressing something which is then infused into the work by alchemical transformation; he is making an expressive object. What he does to accomplish this remains, of course, as complex and mystifying as before, and I have nothing to add to the numerous attempts to explain the "creative process" except to argue that, whatever it may be, it is not identical with some act or process of expression.

One aspiration of aesthetics has always been to demonstrate that the creation of art works is a unique and exalted form of human activity. Even those like Dewey who have been determined to narrow the gap between art and ordinary experience reflect the urge to find something extraordinary in art. To conclude that the traditional concept of art-as-expression fails to realize this aim is not to abandon the conviction that there is something singular in the creative process; it is only to abandon a theory which fails to do justice to that conviction, and to reveal the need to give it more trenchant and persuasive formulation.

The theory that art is an or *the* expression of the human spirit is either trivial or false; for the sense in which art is an expression of a state of mind or character of the artist does not establish a relevant distinction between art and any other form of human activity, and the attempt to utilize the concept of expression to distinguish artistic or creative activity from more mundane affairs leads only to incoherence and absurdity. If there is a residue of truth in the E-T, it is that works of art often have expressive qualities. But so do natural objects, and there is nothing in this to compel us to the conclusion entailed by the E-T. The only way that we can interpret the notion of art-as-expression which is both coherent and aesthetically relevant is to construe statements referring to works of art and containing some cognate form of 'expression' as references to certain properties of the works themselves . . .

Notes

1. [Ed.—note omitted.]

2. There is a range of values for the variable here; 'feeling,' 'attitude,' 'idea,' 'mood,' and 'outlook' have all been suggested at some time, but 'feeling' is the favored substitution.

3. Bernard Bosanquet, Three Lectures on Aesthetic (London: Macmillan, 1915), p. 74.

4. [Ed.—note omitted.]

5. "The Concept of Expression in Art," *Philosophy Looks at the Arts* [Ed. first edition], ed. Joseph Margolis (New York: Scribner's, 1962), p. 31. The quotations are taken from Collingwood, *The Principles of Art*; Dewey, *Art as Experience*; Ducasse, *Art, the Critics, and You*; and Hospers, *Meaning and Truth in the Arts.*

6. Art as Experience, p. 61.

7. Loc. cit.

8. Loc. cit.

9. Ibid., p. 62.

10. Loc. cit.

11. Chs. 4 and 5 of Art as Experience.

12. [Ed.—note omitted.]

13. Dewey makes more of this than most Expression theorists, but even those, like Ducasse, who admit the use of 'expression' to decribe involuntary revelations of inner states have argued the *aesthetic* expression is something quite distinct, and not to be confused with the former.

14. Dewey, Art as Experience, p. 82.

15. Loc. cit.

16. Loc. cit.

17. Harold Osborne has summarized the Expression theory in a somewhat different manner: "The underlying theory is, in its baldest form, that the artist lives through a certain experience; he then makes an artifact which in some way embodies that experience; and through appreciative contemplation of this artifact other men are able to duplicate in their own minds the experience of the artist. What is conveyed to them is . . . an experience of their own as similar as possible to the artist's experience in all its aspects . . ." (*Aesthetics and Criticism* [London: Routledge and Kegan Paul, 1955], p. 143). My formulation is constructed to call attention to the Expression theorist's view of the relation between the activity of the artist and the expressive qualities of the work. . . .

18. If it is objected that the composer is expressing some *remembered* or unconscious feelings of this sort, we can strengthen the example by supposing it to be false that the composer had ever experienced, consciously or otherwise, the feeling corresponding to the feeling-quality attributed to the music. The logical point remains untouched in any case.

19. [Ed.—note omitted.]

20. [Ed.—note omitted.]

21. [Ed.—note omitted.]

22. Notice e.g. that we can refer to the movements of a Thai dancer performing a *Lakon* as expressive even though we may have no idea what the movements "mean" and no precise language in which to describe them.

23. Many of the commonly encountered instructions for performance are incompatible, though of course this is not true of all. Leggiero and animoso are clearly compatible, and the opening bars of Debussy's Prélude à 'L'Après-Midi D'Un Faune' are marked doux et espressif; but the indication 'secco, espressivo' would be contradictory, and contradictory in the same way that in-

Art and Expression

compatible imperatives are contradictory—the performer could not simultaneously carry out both instructions.

24. When the difficulty of naming particular feeling states becomes apparent, the Expression theorist may resort to the sui generis category of "aesthetic emotions."

25. There is a strong analogy between the intransitively expressive performance and the intransitively expressive face.

26. See Frank Sibley, "Aesthetic Concepts," *Philosophical Review*, LXVIII (1959), 421–450, for a cogent discussion of the general question of rule-governed and sufficient conditions in aesthetic discourse.

27. See also Arthur C. Danto, "The Artworld," Journal of Philosophy, LXI (1964), 571-584.

28. See e.g. B. R. Tilghman, "Aesthetic Perception and the Problem of the 'Aesthetic Object," *Mind*, LXXV (1966), 351-368; Virgil C. Aldrich, *Philosophy of Art* (Englewood Cliffs: Prentice-Hall, 1963). A recent illustration of some of the limitations of aspect-perception models in aesthetics may be found in Peter Kivy, "Aesthetic Aspects and Aesthetic Qualities," *Journal of Philosophy*, LXV (1968), 85-93. The *locus classicus* for discussions of the problem is Wittgenstein, *Philosophical Investigations*, Part II.

29. [Ed.—note omitted.]

30. Freud's study of Leonardo is perhaps the best known of such attempts; but Jung has made more consistent use of art works in his routine analytic practice. Cf. particularly *Symbols of Transformation*, tr. R. F. C. Hull, Bollingen Series XX:5 (New York: Pantheon, 1956).

31. Quoted from the notes to *Music of the North*, Vol. VIII: Carl Nielsen, Symphony No. 6, "Sinfonia Semplice," Mercury Classics Recordings, MG 10137.

32. Many of these points may be extended beyond music, though I am not concerned to argue here for the applicability of all of these remarks to the other arts. Freud's analysis of Leonardo, for example, makes use of certain features of the paintings (the similarity of facial expression in the *Gioconda* and the *Madonna and Child with St. Anne*; the incompleteness of many of the canvases, etc.); yet none of Freud's analytic inferences are based on qualities of the paintings alone. They are rooted in his interpretation of the available biographical material. I would suggest, though I cannot pursue it here, that inferences from works of art *alone*—whether from music, fiction, or architecture—to the character of the artist are generally suspect.

33. Much has been made of the difference between "real" feelings and "aesthetic" feelings; between, for instance, life-sadness and music-sadness, and I would suggest that at least the promise of an explanation lies in the fact that intentional objects are present in the former and absent from the latter.

34. There is a trivial sense in which these activities may always be an expression of something—an expression of the desire to get the phrase right, for instance—but such expressions are irrelevant to the E-T for reasons given above.

Bibliography to Part Six

Most current discussions of the artist's intentions and their bearing on the content of a work of art are still focused on William Wimsatt and Monroe Beardsley's original paper. Among the earlier papers of interest are:

- Henry Aiken, "The Aesthetic Relevance of Artists' Intentions," Journal of Philosophy, LII (1955), 742-753;
- Leslie Fiedler, "Archetype and Signature: A Study of the Relationship Between Biography and Poetry," Sewanee Review, LX (1952), 253-273;
- Isabel Hungerland, "The Concept of Intention in Art Criticism," Journal of Philosophy, LII (1955), 733-742;
- Richard Kuhns, "Criticism and the Problem of Intention," Journal of Philosophy, LVII (1960), 5-23;
- Erwin Panofsky, "The History of Art as a Humanistic Discipline," in T. M. Greene (ed.), *The Meaning of the Humanities* (Princeton, 1940);
- Theodore Redpath, "Some Problems of Modern Aesthetics," in C. A. Mace (ed.), British Philosophy in the Mid-Century (London, 1957);
- Eliseo Vivas, "Mr. Wimsatt on the Theory of Literature," Comparative Literature, VII (1955), 344-361.

The most prominent survey of the general question of intention, outside the narrow domain of aesthetics, is provided in:

G. E. M. Anscombe, Intention (Oxford, 1957).

The literature on intentions has mushroomed since that time, and more recent discussions reflect the newer currents in this larger topic. Among the more interesting recent discussions of the problem of intention in the criticism of the arts are:

Sidney Gendin, "The Artist's Intentions," Journal of Aesthetics and Art Criticism, XXIII (1964), 193-196;

Genre, I (July, 1968): Symposium on E. D. Hirsch's views;

Göran Hermerén, "Intention and Interpretation in Literary Criticism," New Literary History, VII (1975-76), 57-82;

Bibliography

- E. D. Hirsch, Jr., Validity in Interpretation (New Haven, 1967);
- E. D. Hirsch, Jr., The Aims of Interpretation (Chicago, 1976);
- J. Kemp, "The Work of Art and the Artist's Intentions," British Journal of Aesthetics, IV (1964), 150-151;
- Berel Lang, "The Intentional Fallacy Revisited," British Journal of Aesthetics, XIV (1974), 306-314;
- Colin Lyas, "Personal Qualities and the Intentional Fallacy," in Royal Institute of Philosophy Lectures (1971-1972), Vol. VI (London, 1973);
- Joseph Margolis, review of Validity in Interpretation, Shakespeare Studies, IV (1970), 407-414;
- David Newton-de Molina (ed.), On Literary Intention (Edinburgh, 1976);
- Stein H. Olsen, "Authorial Intention," British Journal of Aesthetics, XIII (1973);
- Richard E. Palmer, Hermeneutics: Interpretation Theory in Schleiermacher, Dilthey, Heidegger, and Gadamer (Evanston, 1969);
- Anthony Savile, "The Place of Intention in the Concept of Art," Proceedings of the Aristotelian Society, LXIX (1968-1969), 101-124;
- William Wimsatt, Jr., "Genesis: A Fallacy Revisited," in P. Demetz et al. (eds.), The Discipline of Criticism (New Haven, 1968).

The problem of intention, particularly with respect to literary works but also in general for art as such, has been complicated by recent appeals to the speechact model of language and the counterpart theory of art as utterance. The speech-act model itself is closely associated with the following:

- J. L. Austin, How To Do Things with Words (Oxford, 1962);
- H. P. Grice, "Meaning," Philosophical Review, LXVI (1957), 377-388;
- John Searle, "What is a Speech Act?," in Max Black (ed.), Philosophy in America (Ithaca, 1965).
- Its best-known application, in philosophical aesthetics, to literature is to be found in:
 - Monroe C. Beardsley, *The Possibility of Criticism* (Detroit, 1970), though this entails a kind of intentionalism. Other recent efforts to apply the notion to literature include:
 - Richard Ohmann, "Speech Acts and the Definition of Literature," *Philosophy* and Rhetoric, IV (1971), 1–19;
 - Richard Ohmann, "Speech, Literature and the Space Between," *New Literary History*, V (1974), 37–63;
 - Mary Louise Pratt, Toward A Speech Act Theory of Literary Discourse (Bloomington, 1977).

See also:

Umberto Eco, A Theory of Semiotics (Bloomington, 1976),

for a somewhat confused generalization of the communicative model entailed.

The most sustained current discussions of expression and expressive qualities may be found in:

Guy Sircello, Mind & Art (Princeton, 1972);

Alan Tormey, The Concept of Expression (Princeton, 1971).

Other earlier, well-known discussions of expression include:

- Rudolf Arnheim, "The Gestalt Theory of Expression," *Philosophical Review*, LVI (1949), 156–171;
- Rudolf Arnheim, "The Priority of Expression," Journal of Aesthetics and Art Criticism, VIII (1949), 106–109;
- John Benson, "Emotion and Expression," *Philosophical Review*, LXXVI (1967), 335–357;
- Otto Baensch, "Art and Feeling," in Susanne K. Langer (ed.), Reflections on Art (Baltimore, 1958);
- O. K. Bouwsma, "The Expression Theory of Art," reprinted in William Elton (ed.), *Aesthetics and Language* (Oxford, 1954);
- Karl Britton, "Feelings and their Expression," *Philosophy*, XXXII (1957), 97–111;
- John Hospers, "The Concept of Artistic Expression," reprinted (revised) in Morris Weitz (ed.), *Problems in Aesthetics* (New York, 1959);
- Susanne K. Langer, Feeling and Form (New York, 1953), Chapter 3;

Susanne K. Langer, Problems of Art (New York, 1957);

- Douglas Morgan, "The Concept of Expression in Art," in Science, Language, and Human Rights (Philadelphia, 1952);
- Vincent Tomas, "The Concept of Expression in Art," in Science, Language, and Human Rights (Philadelphia, 1952);

Other more recent statements include:

John Hospers (ed.), Artistic Expression (New York, 1971);

- George F. Todd, "Expression without Feeling," Journal of Aesthetics and Art Criticism, XXX (1972);
- Richard Wollheim, "On Expression and Expressionism," *Revue Internationale de Philosophie*, XVIII (1964), 270–289;
- Richard Wollheim, "Expression," in Royal Institute of Philosophy Lectures (1966–67), Vol. 1.

The classic target of most earlier discussions is found in:

Benedetto Croce, *Aesthetic*, trans. Douglas Ainslie (London, 1922, 2nd ed.). Also of interest in this regard are:

- R. G. Collingwood, *The Principles of Art* (Oxford, 1938), Chapters 6–7, 9; Alan Donagan, "The Croce-Collingwood Theory of Art," *Philosophy*, XXXIII (1958), 162–167;
- John Hospers, "The Croce-Collingwood Theory of Art," *Philosophy*, XXXI (1956), 3–20;
- Milton Nahm, "The Philosophy of Aesthetic Expression; The Crocean Hypothesis," Journal of Aesthetics and Art Criticism, XIII (1955), 458-468.

364

Part Seven The Objectivity of Criticism

The most strategic question to raise about a theory of criticism is, What is the author's theory of the nature of a work of art? Alternative views of the fundamental nature of art force us to adopt alternative views about the objectivity and possible truth of particular critical claims and judgments; and insistence that interpretive and evaluation judgments can or cannot be straightforwardly true or false draws in its wake a suitably congruent conception of what it is to be a work of art. Thus, theorists who construe works of art as, or on the model of, standard physical objects are inclined to construe interpretive judgments as hardly more than a difficult species of description; and those who treat works of art as rather complex entities of a cultural sort will be more hospitable to the view that the work of interpretation may not be restricted to discovering or "unearthing" properties somehow merely hidden in an artwork. Correspondingly, those theorists who claim that works of art are, in some sense, fully perceptually accessible may, if they think that works of art have inherent value, actually hold that evaluative judgments are equally true or false; and those who believe that values cannot inhere in objects like discriminable properties or who believe that appraisals of value depend on considerations going well beyond perceivable qualities will be disposed to concede the joint defensibility of competing evaluations—if any can be objectively defended at all.

Objectivity in criticism begins to appear, therefore, as a complex and controversial matter. On the simplest view, objective judgments are true because they conform in the appropriate way to the actual properties that works of art possess. On a more generous view, judgments are objectively true because, although they ascribe properties or values that cannot all be supposed to inhere independently in artworks themselves, they conform to what are taken to be the correct canons for such ascriptions. On a more extreme view, critical judgments can be defended on the basis of canons of relevance or of certain minimal constraints of objectivity—for instance, as exhibiting congruence with what are admitted to be the objectively describable properties of particular works—but not in a way that would exclude all otherwise incompatible judgments. Here, we are obliged to retreat from the severe and exclusive alternatives of truth and falsity to such weaker values as plausibility or reasonableness; but, if we wish, we may still speak of objectivity, the objectivity with which, say, plausible interpretations or reasonable appraisals may be made.

Obviously, what is at stake is the rejection or acceptance of some form of relativism in interpretation, evaluation, and appreciation. Some hold that relativism is basically incoherent, since it would require that a given judgment must be both true and false. But this is a mistake if, as suggested, we may temper our conception of objectivity by retreating from a model of truth and falsity to a weaker set of values such as plausibility. If, reflecting on the practice of criticism, we are persuaded that greater conceptual flexibility must be admitted than the simpler version of objectivity would allow, we must be prepared to make corresponding adjustments both in our theory of critical judgments and in our theory of the nature of art. Or if, theorizing about art itself, we are led to the view that we cannot in principle preclude the validity of otherwise incompatible claims or the legitimacy of alternative ways of responding to particular works, then we must be prepared to make adjustments both in our theory of the function of criticism and of the logic of judgments.

The extreme alternatives with respect to the entire range of criticismadhering still to some conception of objectivity-are dialectically represented in the theories of Monroe Beardsley (1970) and Joseph Margolis (1976). Throughout his career, focused principally in his influential book Aesthetics: Problems in the Philosophy of Criticism (1958), Beardsley has been identified with the most uncompromising version of objectivity in judgment. This has for example entailed a strenuous rejection of the authority or relevance of an author's or artist's intention (see Part Six), on the grounds that the work of art is a self-contained object accessible in some perceptually fair sense to the objective appreciation of competent agents (see Parts One and Four). Beardsley has pursued this theme in great detail through all of its ramifications in the domain of aesthetics. He has, therefore, provided us with a fully fashioned theory of art and criticism committed to the seemingly neutral thesis that the central judgments of aesthetic concern-the description, interpretation, evaluation of art-are simply true or false. Margolis has attempted to construct an alternative account of comparable range (Art and Philosophy [1978]): he assigns a metaphysical complexity to art, in virtue of which the kind of objectivity Beardsley would sustain cannot be defended; and he construes the actual work of critics and of the appreciative efforts of amateurs of art as requir-

The Objectivity of Criticism

ing and supporting the defensibility of claims and judgments that would be contradictory on the model of truth and falsity.

Still, the positing of critical judgments by persons of some authority and the responses of others of some sensibility suggest a further complication: appreciation does not appear to be compelled by arguments however fairly managed. Sometimes, the issue has been pursued in terms of an emotivist theory of values, so that no reasons-taken simply as reasons rather than as influencing causes-could lead one to a certain judgment. Sometimes, the issue is more convincingly viewed in terms of the difference between value judgments or verdicts and appreciative responses. Arnold Isenberg, in a relatively early paper (1949), had pursued the latter distinction in an influential way. The issue in fact lends itself to several divergent thesesthat are not quite clearly sorted by Isenberg himself: one stresses that the logic or critical arguments cannot be taken to govern the critically informed responses of an aesthetically engaged agent; another stresses that when he makes a critical judgment or verdict about a work of art, an informed agent is actually responding for quite particular reasons, in a context in which there are no pertinent arguments of a logically compelling form. The second thesis is, in fact, closer to Isenberg's view, though the first provides a viable alternative. One might also insist on a difference between arguments leading to entailed conclusions and arguments, as in appreciative and verdictive settings, that favor certain conclusions, not by strict entailment and not by any usual inductive canon (see Part Two).

Actually, value judgments are ubiquitous in aesthetics. In a sense, one thinks of the analysis of these as the aesthetician's most distinctive concern. The discussion of recent years still shows the marked influence of Immanuel Kant's neat and exclusive division of moral and aesthetic judgments (see Part One) and of G. E. Moore's exposure of the so-called Naturalistic Fallacy. Nevertheless, to some extent, the Kantian emphasis loses its force as it becomes clear that moral judgments may well be appreciative and not, as such, concerned to direct anyone's conduct and that aesthetic judgments (as in the criticism of a work in progress) may well be intended to direct another's efforts and, in doing so, come to construe these efforts as the solving of a practical problem. Also, the force of Moore's criticism declines as philosophers attempt (as they do) to treat evaluation in terms of certain distinctive uses sentences are put to rather than in terms of the qualities that may be found in things. Isenberg's analysis has a somewhat Kantian-like quality in the sense that the logical distinction of critical judgments is to be marked out, but it goes substantially beyond Kant's observations in the sense both that the relevant considerations cannot be squared with a Kantian scheme of things and that something of the actual reasoning that lies behind a critical judgment is developed. If one were to look for a related thesis elsewhere in the literature of aesthetics, perhaps the most useful comparison that recommends itself is to Frank Sibley's well-known paper (see Part Two). There is also a certain Moorian quality to Isenberg's account, except that the particular features of a work that the critic sorts out are not, apparently, actual bits of goodness or beauty spotted so to say, but rather features that, for a given critic, enlist his preference or an expression of his (informed) taste. Comparison with Santayana suggests itself. Complications regarding validity obviously abound.

Value-laden remarks range themselves in an extensive spectrum. There are comments that merely express our taste; there are comments that express our appreciation; there are comments that appraise and rank and grade works of art; there are commendations and recommendations that we make. We may expect, therefore, that there will be no simple, comprehensive theory of evaluation that will hold for the variety of remarks we are to account for.

We may, however, simplify certain of the principal distinctions in the following way. Let us admit that, sometimes, remarks that assign some value to a work of art are merely expressions of one's own particular taste, that is, of one's own likes and dislikes. These are, surely, idiosyncratic, at best matters of fact, and call for no justification (though taste may itself be evaluated). Let us admit, further, that some remarks are appreciative, that is, assign some value to a work of art for relevant reasons. One's taste will not be mentioned here: the reasons one supplies to another will not include mention of one's own likes and dislikes (though these will be expected to be in accord with the remarks made). Another may confirm that the reasons given do mention features that can be noticed in the work and that reasons of the sort given are pertinent to appreciation. But since taste is involved, no one else is bound to appreciate the work for the same reasons and in the same way. Hence, one may be called on to defend or make plausible and clear his own appreciative attitude toward a given work, but he cannot be called on to show that his appreciation is true or correct; his appreciative remarks cannot be disputed beyond its measure of plausibility, except in the uninteresting sense that he may have contradicted himself or made an error regarding some quality of the work in question. Finally, we may admit that works of art may be evaluated. that is, judged to have this or that sort of merit on grounds that do not concern one's own likes and dislikes (whatever they may be). And these judgments may be open to dispute.

To concede these possibilities, however, is to concede the need that Isenberg's account imposes on us to pursue the distinctions he himself alludes to. And to concede that is to return us to the dialectical alternatives posed by Beardsley's and Margolis's claims. I. C. Jarvie (1967) has, for one, vigorously pressed the need for distinguishing response and judg-

The Objectivity of Criticism

ment in criticism. In doing so, he has attended in an exploratory way to the difficulty of locating the objectivity of criticism, to the realistic sense in which argument appears to break down in the context of aesthetic dispute, to the need for avoiding subjectivism. His useful suggestion is that the objectivity of criticism lies in the nature of institutions rather than in formulable rules. But he tends somewhat to assimilate relativism to subjectivism and he does not say precisely how appeal to institutions can preclude a form of relativism.

19. The Testability of an Interpretation MONROE C. BEARDSLEY

Surely there are many literary works of which it can be said that they are understood better by some readers than by others. It is that fact that makes interpretation possible and (sometimes) desirable.

For if A understands *Sordello* better than B does, he may be able to help B understand what he understands but B does not. No doubt there are many ways in which A might do this. One is by reading the poem aloud in a manner that reflects his understanding of it. Another is by telling B what the work means; and any such statement, or set of statements, used to report discovered meaning in a literary text I shall call a "literary interpretation" or (for brevity in the present context) "interpretation."

Common usage among critics and literary theorists seems to sanction this broad definition of the term, and I resign myself to it here, though I hold out hope for distinguishing "interpretation" in a narrower sense from two other operations of literary exegesis.1 I would prefer to reserve the term "interpretation" for exposing what I call the "themes" and "theses" of a literary work; the term "explication" for exposing the marginal or implicit meanings of words, phrases, and sentences (metaphors, for instance); and the term "elucidation" for exposing implied features of the world of the work (inferred motivations and character traits, for instance). On this occasion I shall conform to general practice by considering all three critical operations as acts of interpretation, and the sentences produced by these operations as interpretation-statements. Explication is evidently the most basic; since we can hardly be sure we know what is going on in a poem, much less what it symbolizes or says about the world, until we understand the interrelationships of meaning at the level of verbal texture.

Reprinted from Monroe C. Beardsley, *The Possibility of Criticism* (Detroit: Wayne State University Press, 1970), by permission of the author and Wayne State University Press.

1

One of the main and recurrent themes of this volume might be called the vindication of critical rationality. Put less pretentiously, my thesis (or one of them) is that the processes of criticism, when they are performed well, have much reasonableness in them. The deliberations the critic goes through in his characteristic commerce with literary texts are rational deliberations, in important part; and the conclusions he reaches through them are (or can be) reasonable conclusions, in that reasons can be given to support their claims to truth.

Even if these generalizations have an appearance of acceptability when cast in abstract form, they may well become dubitable when applied to particular sorts of critical statement. That is what we have to find out. It must be acknowledged that the issues are complex and debatable.

For one thing, some critical theorists have recently emphasized the element of creativity in interpretation. By comparing literary interpretation with the performing artist's interpretation of score or script (which is a vital cooperation with the composer or dramatist in perfecting an actual aesthetic object), they have suggested that the literary interpreter, too, has a certain leeway, and does not merely "report" on "discovered meaning," as I said earlier, but puts something of his own into the work; so that different critics may produce different but equally legitimate interpretations, like two sopranos or two ingenues working from the same notations. I find myself rather severe with this line of thought. There is plenty of room for creativity in literary interpretation, if that means thinking of new ways of reading the work, if it means exercising sensitivity and imagination. But the moment the critic begins to use the work as an occasion for promoting his own ideas, he has abandoned the task of interpretation. Yet can we really draw a line here? That is the question.

The literary interpreter can be likened to practitioners of many other trades—not only to the singer and dancer but to the coal-miner, the hunter, the pilgrim, and the rapist. Each of these similitudes casts light on aspects of his work, but none is perfectly just. For his results, unlike theirs, issue in the form of statements. He claims to supply information we lack. And such a claim, when it could be challenged, calls for the support of reasons. The critic cannot avoid, in some way, *arguing*.²

Nevertheless, the view persists—and even grows—that there is something peculiar about interpretation-statements that gives them a distinct logical status and makes them undeserving of the adjectives that we apply to ordinary claims to provide information. Consider, for example, Stuart Hampshire's remark in a symposium on interpretation a few years ago:

If correctness is taken to imply finality, then I see no reason to accept this as the right epithet of praise for a critical interpretation. Some interpretations are impossible, absurd, unplausible, far-fetched, strained, inappropriate, and the object does not permit many of the interpretations that have been suggested. But the epithet of praise is more likely to be "illuminating," "plausible," even "original," also "interesting." "True interpretation" is an unusual form of words in the context of crticism. "Correct interpretation" does sometimes occur in these contexts; but it isn't standard and even less is it universal.³

That interpretations may be original and interesting, I would not wish to deny, though I would consider such praise faint enough to qualify as ironic condemnation. (If all you can say of my interpretation of a poem is that it is "interesting," I somehow do not feel I have convinced you.) It may be that we are not usually given to saying things like "Your interpretation is true," though "Your interpretation is false" strikes me as a little more familiar. Certainly interpretations are "right" or "wrong," and there are *mis*interpretations. Moreover, the statements that are given as interpretations ("This poem has such-and-such a meaning") can be called true or false without embarrassment at the idiom. Indeed, if they could not be true or false, I do not see how they could be illuminating or plausible. Hampshire objects to the phrase "correct interpretation" because it implies some rule of procedure to which the interpretative act conforms. I agree that the implication is there; I think it belongs there.

Hampshire's conditional at the beginning of the quotation "If correctness is taken to imply finality" brings out another reason why he thinks that interpretations are not true or false, strictly speaking: "it is typical of works of art that they should normally be susceptible of some interpretation and not susceptible of just one interpretation."⁴ It is typical of the practice of criticism, especially in our own time (when the incentives to come up with novel interpretations, and the rewards of doing so, are great), that works of art are subjected to constant reinterpretation. But Hampshire's implication is that there can be no way of choosing among multiple interpretations, and no ground for regarding any particular one as most acceptable or exclusively acceptable. I do not agree. However, this question has been discussed more extensively by Joseph Margolis, to whose views I now turn.⁵

Margolis says that an interpretation can be "reasonable," but not "simply true or false."⁶ I find this position puzzling. For I do not see how an interpretation could be reasonable unless reasons can be given to show its superiority to some alternatives; and I do not see how the reasons could count unless they are reasons for thinking it true. But Margolis's main thesis is that

The philosophically most interesting feature of critical interpretation is its tolerance of alternative and seemingly contrary hypotheses. . . .

Given the goal of interpretation, we do not understand that an admissible account necessarily precludes all others incompatible with it.⁷

Margolis points me out as one of those who has espoused the old-fashioned view that if two proposed interpretations of an aesthetic object are logically incompatible, then at least one of them must be rejected. It is, he says, a mistake to think that "there is some ideal object of criticism toward which all relevant experiences of a given work converge. . . . If we simply examine the practice of critics, I think we shall find no warrant at all for the claim."

My own examination of the practice of critics has led me to question this sweeping statement. I find the critic Samuel Hynes, for example, contrasting the opinions of Clark Emery and Hugh Kenner on the *Cantos* and adding: "Obviously they cannot both be right; if the passage describes an earthly paradise, then it cannot be a perversion of nature."⁸ I find E. D. Hirsch remarking: "No doubt Coleridge understood *Hamlet* rather differently from Professor Kittredge. The fact is reflected in their disparate interpretations. . . . Both of them would have agreed that at least one of them must be wrong."⁹ I find Frank Kermode commenting in a similar vein on the line between "liberty" and "license" in interpretation.¹⁰

We do not discover, according to Margolis's view, that interpretations are true or false, but only that they are "plausible"-and though two incompatible statements cannot both be true, they can both be plausible. But plausibility is at least an appearance of truth based upon some relevant evidence, and any statement that is plausible must be in principle capable of being shown to be true or false. Margolis does not deal with any of the sorts of real-life dispute over interpretation that exercise critics most-for example, Wordsworth's Lucy poem, discussed [earlier]. It seems that when he is talking about interpretations, he has in mind a Freudian or Marxist or Christian "interpretation." This is bringing to bear upon the work an "admissible myth,"11 or looking at the work through the eyes of some such grand system. If that is the kind of thing that is in question, then I have no quarrel with his principle of tolerance. The story of "Jack and the Beanstalk," for example, can no doubt be taken as Freudian symbolism, as a Marxist fable, or as Christian allegory. I emphasize the phrase "can be taken as." It is true that "readings" such as these need not exclude each other. But the reason is surely that they do not bring out of the work something that lies momentarily hidden in it; they are rather ways of using the work to illustrate a pre-existent system of thought. Though they are sometimes called "interpretations" (since this word is extremely obliging). they merit a distinct label, like superimpositions.

The issue between Margolis and myself, then, can be stated in this way: he holds that all interpretations have what he calls a "logical weakness," i.e., they tolerate each other even when they are incompatible. In contra-

The Objectivity of Criticism

diction to this view, I hold that there are a great many interpretations that obey what might be called the principle of "the Intolerability of Incompatibles," i.e., if two of them are logically incompatible, they cannot both be true. Indeed, I hold that *all* of the literary interpretations that deserve the name obey this principle. But of course I do not wish to deny that there are cases of ambiguity where *no* interpretation can be established over its rivals; nor do I wish to deny that there are many cases where we cannot be sure that we have the correct interpretation.

2

Interpretations come in various sizes as well as shapes: some apply to individual words, phrases, or sentences, and thus concern what I call "local meanings" of the text; others purport to say what is meant by the work as a whole or some large part of it, and I shall call the meanings they claim to establish "regional meanings." The regional meanings (when they call for interpretation) evidently depend on the local ones. Consider once again the Lucy poem, and the question whether there is a hint of pantheism in its second stanza.

The poem is not explicitly pantheistic like, for example, the "Lines Composed a Few Miles above Tintern Abbey":

And I have felt

A presence that disturbs me with the joy Of elevated thoughts; a sense sublime Of something far more deeply interfused, Whose dwelling is the light of setting suns, And the round ocean and the living air, And the blue sky, and in the mind of man: A motion and a spirit, that impels All thinking things, all objects of all thought, And rolls through all things.

(It is interesting to note how "rolls" and "things" are used in this passage.) If there is pantheism in "A Slumber Did My Spirit Seal," it must be brought into the poem indirectly, either by the connotations of the words or by the suggestions (that is, the non-logical implications) of the syntax. Let us examine one problem of each type.

First, what I call "suggestion." The words "rocks" and "stones" and "trees" are placed in parallel syntactical situations, and this suggests, quite definitely, that the objects they denote are similar in some important respect. But a suggestion that two different things are similar can go in either direction, and we have to decide between them. Melvin Rader, in his recent book on Wordsworth's philosophy, says that Wordsworth (tak-

ing him as the speaker in this poem) "evidently felt that Lucy in her grave was wholly assimilated to inorganic things."¹² But is this evident? She is assimilated to rocks and stones and trees—but trees are certainly not inorganic things. Rader seems to take the parallelism as suggesting that the trees (and a fortiori the dead Lucy) are like rocks and stones, blind passive victims of external mechanical forces. But one could take the comparison the other way and come out with the opposite interpretation: by putting the word "trees" at the end, the speaker gives it emphasis; therefore, he is really suggesting that rocks and stones (and a fortiori the dead Lucy) are like trees in having an inner life of their own.

Thus we can bring the issue to a fairly sharp decision point. If the speaker is suggesting that Lucy and trees are like rocks and stones, we have a hint of mechanistic materialism. If he is suggesting that rocks and stones and Lucy are like trees, then we have a hint of pantheism (or at least animism).

Consider next a connotation problem. The speaker says that the dead Lucy has no force, no motion, and no sense-awareness-but then he savs that she does have a motion, after all, since she lies near the surface of the earth and thus participates fully in its rotation. She is "rolled round in earth's diurnal course." The question is, How much can we legitimately find in the meaning of "rolled" here? Now the available repertoire of connotations for the word "rolled" is certainly quite rich. We can open up some of them by thinking of kinds of motion that we would strictly describe as "rolling"-that of the billiard ball, the snowball on the hill, the hoop propelled by a child. By exploring these familiar contexts for the term in its literal standard uses, we remind ourselves of the various forms of motion that can be classified as rolling. And by contrasting these forms of motion, we inventory the potential connotations of the term. There are steady boring motions, ungainly decelerating motions (the wagon rolling to a stop), scary accelerating motions (the car rolling downhill), etc. But what about the present context? Here what must strike us forcibly is the way the other words in this line qualify and specify the motion that Lucy has: it is a regular motion, with a constant rate; it is a comparatively slow and gentle motion, since one revolution takes twenty-four hours; it is an orderly motion, since it follows a simple circular path.

In none of these respects is it terrifying or demeaning; if anything, it is comforting and elevating. If we accept these connotations, the poem contains a hint of pantheism, or at least animism.

If these little exercises in close reading have a point, then, interpreting this poem is not a matter of willfully superimposing some precast intellectual scheme upon it. There really is something in the poem that we are trying to dig out, though it is elusive. And if we do come up with a decision, the interpretation-statement in which we express it will be subject to that fine principle of the Intolerability of Incompatibles. (If the poem is pantheistic, it is *not* non-pantheistic.)

In this discussion, I have strewn a number of ifs in my wake, and now is the time to convert them into categorical assertions. I have been giving a very simple model of a process of interpretation, showing how, if we can decide on the local meanings (connotations and suggestions), we can support the regional interpretations (such as that a poem is pantheistic). My defense of literary interpretation, then, has to go back to the basic premises and to the basic problem, which is the problem of meaning itself.

The issue we must now confront is precisely whether we ought to call these connotations and suggestions meanings at all—strictly speaking. It will no doubt be agreed that the word "rolled" does have a meaning, which the dictionary will supply: it applies to rotary motions of macroscopic objects, let us say, but not to other sorts of motion. To talk this way is indeed to talk about the meaning of a word, and such talk can be tested by empirical (that is, lexicographical) inquiry. But when it comes to the connotations of the word, are we on the same safe ground? When we say, for example, that the word can hint at a fearsome sort of motion or a gentle motion, at monotonous repetition or at steadiness and order—where do we get these ideas? The dictionary does not report them, and we are not obliged to take them into account when we ordinarily use the word in speaking of wheels, balls, hoops, etc.

Perhaps these connotations should not be considered part of meaning, strictly speaking, at all, but rather as psychological associations that individual readers may or may not be inclined to have when they read the word. In that case, no one could be told that he has to have these associations, or ought to have them, or that he has failed to understand the poem if he does not have them. The interpreter, according to that view, could only report his own associations, which might or might not chance to correspond with others'; and if another interpreter reported opposed associations, all we could ask is that he be equally sincere. Such reports would no longer be incompatible; nor would they give information about the meaning of the poem.

A consistent defender of this skeptical view of interpretation will no doubt extend his position to cover suggestions as well. Suppose one critic reports that Wordsworth's line about rocks and stones and trees suggests to him that the first two are as alive as the third, and another reports that it suggests to him that the third is as dead as the first two. Again both reports may be sincere, and therefore incorrigible, confessions of psychological response. But, according to the skeptic, the critics are not talking about anything that can be called the meaning of the poem; and so again their interpretations cannot be regarded as testable or as interpresonally valid.

If connotations and suggestions are not a part of meaning but something psychological and personal, then the alleged regional meanings that depend on them must be equally subjective and relative. It follows that the statement that Wordsworth's poem is pantheistic has the same status as the statements I have called "superimpositions." The interpreter is simply showing one way of taking the poem, and he cannot exclude others.

The question is, then, Are the connotations and the suggestions in poetry really part of the poem's meaning? To answer this question, we shall have to consider the nature of meaning.

3

I propose to bring to bear upon our present problem a most interesting and persuasive account of meaning that has been worked out by William Alston and the late J. L. Austin, following out Ludwig Wittgenstein's original insights into language.13 This account begins with the concept of a certain sort of verbal action, one that essentially requires the use of units of language, namely sentences or (in special cases) utterances that are understood to be substitutes for sentences. It has not so far been possible to give a satisfactory general characterization of these linguistic acts; the most helpful clue to recognizing them is that suggested by Austin. He distinguished between acts that we perform in using sentences (these he called "illocutionary acts") and acts that we perform by using sentences (these he called "perlocutionary acts"). In using language, we may assert, argue, ask, order, promise, beg, appraise, implore, advise, consent, etc. By means of such acts, we may achieve certain effects upon other people: we may convince, inspire, enroll, please, enrage, inform, deceive, etc. In general, these results can also be obtained in other ways than by using language, but when they are obtained by means of language, then the languageuser is performing a perlocutionary act. An illocutionary act may be intended to produce effects: for example, you argue to convince; you command to influence conduct. But whether or not you succeed in convincing, you have still argued, if you have used certain sentences in certain ways; and a command that is not obeyed is still a command.

The basic Wittgensteinian insight was that using language is a form of activity that is guided by rules—it was for this reason that he frequently used the analogy of playing games, and spoke of "language-games." Alson's proposal is that the difference between one type of illocutionary act and another is a matter of the rules that we tacitly submit ourselves to in choosing the appropriate form of expression. For example, suppose I want to tell someone to do something. I can say, "I command you to do it" or "I advise you to do it" (there are numerous alternatives, of course). The difference lies in what I implicitly "represent" to be the case in using these

expressions.¹⁴ When I command I claim to be in a position of authority over the person I am speaking to; but I can advise without claiming authority.

Now I can, of course, command or advise without saying "I command" or "I advise." I may choose a form of words that, by some convention, represents the speaker as being, or as not being, in a position of authority —as certain forms of written discourse constitute military orders, or the prescription blank purports to be the issuance of a physician. If I simply say, "Send in your resignation," and this utterance by itself would be, under the circumstances, ambiguous, I can provide a context that makes it a command or a piece of advice. Suppose I say to someone, "Send in your resignation." He might ask whether I have any authority over him; and if I admit that I have none, then I am admitting that I was not commanding. Or, to put the matter another way, if I should say to him, "I know I have no authority over you, but I command you to send in your resignation," I would be talking a kind of nonsense.

By exploring the conditions that are represented as holding in performing a particular sort of illocutionary act, we can characterize each type of act and distinguish one type from another. Some of these sets of conditions are complicated and subtle, and require much careful analysis. For example, when I promise someone to do something, what are the represented conditions? Some of them can easily be stated:

In promising Y to do A, X represents

- (1) that A is an action by X,
- (2) that A is within X's power,
- (3) that A is a future action,
- (4) that Y wants X to do A,
- (5) that X intends to do A.

There are others. Notice again that the act of promising does not depend on its results; even if X does not keep his word, he has still made the promise. But other elements of the illocutionary act are essential to its nature: X cannot promise (strictly speaking) that someone else will do something (he can promise that he will make the other person do it, though); X cannot promise today to do something yesterday. Such promises are void. It is true that in one sense X can promise to do something he knows he cannot do, or does not intend to do (then his promise is insincere), but to promise seriously is to make a commitment to sincerity.

We are to think of these conditions as so many rules that are tacitly recognized by the speech community in which these illocutionary acts are performed. When a sentence in a particular language can be used to perform a certain illocutionary act—when, that is, its use is understood as involv-

ing the speaker's representing certain conditions to hold—then it may be said to have a certain "illocutionary-act potential." This illocutionary-act potential of a sentence is what Alston identifies as its *meaning*. And further he proposes to say that when two sentences have the same illocutionaryact potential, then they have the same meaning.

It seems clear that we can speak of the meanings of sentences in this way, but ordinarily it is more common to speak of the meanings of words. Alston explains this notion ingeniously by pointing out that the words that appear in sentences make their distinctive contribution to the meanings of those sentences.

Thus it would seem plausible to think of two words as having the same meaning if and only if they make the same contribution to the illocutionary-act potentials of the sentences in which they occur; and whether or not they do can be tested by determining whether replacing one with the other would bring about any change in the illocutionary-act potentials of the sentences in which the replacements are carried out.¹⁵

Thus the meaning of a particular word or phrase is *its* (indirect) illocutionary-act potential. Not that a word or phrase can (normally) be used to perform an illocutionary act, but that it contributes in a distinctive way to the illocutionary-act potentials of sentences. The meaning of "milk" is its capacity to play a role in acts of describing milk, buying milk, explaining how to milk a cow, etc. And to say that a word has several meanings is to say that its total (indirect) illocutionary-act potential includes the capacity to make various distinct contributions to the illocutionary-act potentials of sentences in which it may occur.

All this is, of course, a mere sketch. Numerous complications are required for a fully developed theory of meaning. And there may be difficulties. But let us assume for the present that the theory is basically right— —that when we are concerned with meaning, we are concerned with illocutionary-act potential. Then we must see whether this account offers help in resolving the issue stated earlier, whether the connotations of words and the suggestions of sentences are part of their meaning.

Consider suggestion first. Compare:

- (1) He took the pill and became ill.
- (2) He became ill and took the pill.

Now I hope it will be agreed that there is something that can be said by both of these sentences; there is an illocutionary-act potential that they share. Moreover, each suggest something that the other does not: (1) suggests that the illness came after, and as a consequence of, the pill-taking; (2) suggests that the pill-taking came after, and as a remedy for, the illness. Is this difference in suggestion a difference in illocutionary-act potential—and therefore a difference in meaning? It seems to me that it is.

Now it is not clear just how illocutionary acts are to be divided and counted, or when we have one rather than two. But if we say that there is one illocutionary act performed in both (1) and (2), since in both cases the speaker represents that two actions were performed by a single person, then we must say that there is another illocutionary act performed in (1) and still another performed in (2)—for in (1) the speaker represents a certain temporal and causal order and in (2) its reverse. There is no doubt a further difference between what is stated and what is suggested by each sentence, but I think this is a difference in the force or intensity of the illocutionary act.

The notion that illocutionary acts can be performed with various degrees of force may be surprising, but it is not, I think, paradoxical. Take, for example, acts of engaging to do something. We can imagine a whole spectrum of these acts, ranging from the most solemn covenants, signed in blood, through promises and contracts, down to the most half-hearted, casual sort of commitment in which you can hardly be sure that a commitment has been made at all (as when someone says, in a tone carrying absolutely no conviction, that he reckons he will help you paint the house). Assertion can be made firmly and decidedly, or it can trail off into a mere insinuation or hesitant suggestion. Now when we have a sentence that is used to state one thing and to suggest another thing, there is a great difference in the force of the two simultaneous illocutionary acts. One is the primary illocutionary act; the other is secondary. This relationship is reversed in the case of irony, where the suggested ironic meaning is in fact put forth more intensely than the stated meaning. It might be said that the less intense the illocutionary act, the less responsibility the speaker assumes for its requisite conditions. But the main point I am concerned with here is that what is suggested by a sentence has a claim to be considered part of the illocutionary-act potential of the sentence.

Alston does not discuss suggestion, but he does discuss connotations (which he calls "associations"), and his conclusion is that they are not a part of meaning. He offers as his example some lines of Keats and a paraphrase of them:

Keats: "O, for a draught of vintage! that hath been

Cooled a long age in the deep-delved earth!"

Alston: "O, for a drink of wine that has been reduced in temperature over a long period in ground with deep furrows in it!"¹⁶

Alston concedes that the word "earth" has many special associations that are lacking in the word "ground," but he says,

I cannot see that in saying "It came from the earth" I am taking responsibility for any conditions over and above those for which I am taking responsibility in saying "It came out of the ground."¹⁷

And so, by his account of meaning, Alston concludes that the difference between "ground" and "earth" is not a difference of meaning.

Now there are two questions here that ought to be kept separate. First, do "earth" and "ground" differ in meaning? Second, do they have different meanings in this context?

As to the first question, if the meaning of each word is its total illocutionary-act potential, then there is no doubt that the words have different meanings. For there are many illocutionary acts performable with the help of one that will clearly fail if the other is substituted. I can not conceive that Paul Tillich could have called his deity "the earth of being"; and we will not get the right picture if we substitute "earth" in the description of a house having a good deal of ground around it. On the other hand, "ground" will not do for "earth" in the phrase "earth-mother" (Alston's example) or in the phrase "salt of the earth."

The second question is whether earth and ground have different meanings, or only different associations, in the particular context of Alston's examples. Let us formulate part of the texts as imperatives:

- (1) Bring me a draft of vintage that hath been cooled in the earth.
- (2) Bring me a drink of wine that has been reduced in temperature in the ground.

I do not deny that both can be used to perform the same illocutionary act of ordering wine from the waiter. As far as that particular act is concerned, one will do as well as the other—provided the waiter is literate enough to understand all the words. If there is a difference of meaning embedded in the connotations of the different words, it will have to be because there is also a difference in *other* illocutionary acts simultaneously performed with these sentences.

To make clear the kind of difference I have in mind, I will introduce another example in which connotations are not involved. Compare:

- (1) Bring me my slippers.
- (2) Bring me my favorite slippers, which are such a comfort to me.

There is a particular illocutionary act which both of these sentences can be used to perform, under identical circumstances; and the nature of this act can be analyzed in terms of the represented conditions: for example, that there is one and only one pair of slippers singled out by the context; that the speaker does not already have them on; that the speaker wants them; that the hearer is in a position to bring them; etc. But obviously they do not have the same meaning, for the second one purveys information totally lacking from the first. A second illocutionary act is added in the second case: the act of praising the slippers on the ground that they comfort the speaker. The second case is a compound illocutionary act, though the syntax makes the ordering primary, the praising secondary.

This difference between the two slipper orders is like the difference between the two wine orders. I have to concede that the latter difference is somewhat more subtle. Keats's speaker does not use a set formula, like "Vintage is the most!" or "When you're out of vintage, you're out of wine." He relies on the connotations of "draft," "vintage," "cooled," and "earth." But he says something (though in a sense parenthetically) about the delicious flavor of the wine he wants, about the care required for its production, and about the satisfaction that drinking it is expected to give. He represents something to be the case. To ask for "vintage" is to ask for an old wine, but it is not to ask for any old wine. In short, the wine is praised in Keats's lines, but not in Alston's: a secondary illocutionary act is performed, as well as the primary one.¹⁸

4

The possibility of criticism depends not only on the existence of a text, an object susceptible of independent study, but also on the availability of a kind of method or principled procedure, by which proposed interpretations can be tested and can be shown to succeed or fail as attempts to make textual meanings explicit. I have not tried to set forth a whole interpretive procedure, and I have ignored many problems that must be tackled in working out and defending such a procedure. I have concentrated on one problem, which, though by no means the whole story, is (in my view) very basic: what sort of evidence can be appealed to in testing an interpretation? I have tried to answer this question, to show that public semantic facts, the connotations and suggestions in poems, are the stubborn data with which the interpreter must come to terms, even in his most elaborate, imaginative, and daring proposals.

Without such data to rely on, the interpretive process is in danger of degenerating into idle fancy or arbitrary invention. It is well known that when we come to a poem with an idea in mind of what it may be about to add up to, what we find in it will be much affected by our mental set. If we can pick and choose among the potential meanings of the work and arrange them to suit our mood, we can often spin out remarkable "read-

ings." There is plenty of evidence to show what the ingenuity of critics can do when no semantic holds are barred. But I am arguing that there are some features of the poem's meaning that are antecedent to, and independent of, the entertaining of an interpretive hypothesis; and this makes it possible to check such hypotheses against reality, instead of letting them become self-confirming through circular reasoning.

If we make the distinction between regional interpretations of the work as a whole, or some large segment of it, and the more localized facts that support them, then we can formulate the interpretation problem as that of connecting macro-meanings with micro-meanings. In order to accept a proposed macro-meaning, we must be able to see it as emerging from the micro-meanings, as growing out of them and yet as making a whole that is more than the sum of the parts. Thus interpreting a poem is not like arranging a sack of children's blocks in a deliberately selected and imposed order. Nor is it like decoding a message bit by bit with the help of an appropriate code book. It is more like putting a jigsaw puzzle together, or tracing out contours on a badly stained old parchment map. But it can be done better or worse; and the results can be judged by reason.

In trying to resolve the problem I originally set for myself, I seem to have done something else. I have unexpectedly turned up a new answer to an old question. And though the answer may at first appear odd, it will, I think, prove more attractive on reflection. What is a poem? A poem is an imitation of a compound illocutionary act.

We have seen that even a single sentence may be used in performing two or more illocutionary acts, of rather different types, together. The speaker in a lyric poem may plead, threaten, cajole, deplore, reminisce, and pronounce a curse in sequence or almost simultaneously. Even in the Lucy poem, small as it is, the speaker compares two life-situations, praises Lucy, and expresses a mixture of resignation and regret. But the whole poem can be thought of as a single act, made up of several: the compound illocutionary act of its fictional speaker. Richard Wilbur has shown very clearly¹⁹ how the shape of Robert Burns's poem "O My Luve's Like a Red, Red Rose" is defined by a series of illocutionary acts, such as praising, assuring, bidding farewell, promising, but with a rising curve of emotion in a single "thought or mood, which is developed to full intensity."²⁰

It is surprising, and even unsettling, to find oneself reviving the term "imitation" after all its years of enforced retirement from most aesthetic circles. One of the problems in applying this concept to poems has been the difficulty of saying what it is that is imitated. The doctrine of illocutionary acts gives us a solution of this problem. The so-called "poetic use of language" is not a real use, but a make-believe use. A poem can, of course, be used in performing an illocutionary act—it may, for example, be enclosed in a box of candy or accompanied by a letter endorsing its

sentiments. But the writing of a poem, as such, is not an illocutionary act; it is the creation of a fictional character performing a fictional illocutionary act.

But will this description really apply to all poems? The most serious counterexamples are didactic poems of various sorts—for example, *De rerum natura*.²¹ Surely, it might be said, Lucretius in this poem is not merely imitating a series of illocutionary acts, but actually performing them, for he means to marshal actual facts and arguments, to preserve the memory of his master Epicurus, and to bring to mankind final liberation from the fear of death.

One way of meeting this objection would be to restrict the original generalization to lyric poems, setting aside the *Essay on Man, Paradise Lost*, and *English Bards and Scotch Reviewers*. I choose the bolder alternative of holding that even didactic poems are not to be taken as the verbal residues of real illocutionary acts. What makes them didactic is not, I think, that they are arguments rather than "expressions of emotion" (whatever that may be), but that they *imitate* arguments rather than pleadings, laments, or cries of joy.

Part of my reason for this view has been well stated by Paul Fussell, Jr.:

Meter, one of the primary correlatives of meaning in a poem, can "mean" in at least three ways. First, all meter, by distinguishing rhythmic from ordinary statement, objectifies that statement and impels it in the direction of a significant formality and even ritualism. The ritual "frame" in which meter encloses experience is like the artificial border of a painting: like a picture frame, meter reminds the apprehender unremittingly that he is not experiencing the real object of the "imitation" (in the Aristotelian sense) but is experiencing instead that object transmuted into symbolic form.²²

It does not matter how sincerely the poet believes his doctrines, or how fondly he hopes to persuade others. If he goes about making speeches, writing letters, and distributing textbooks, then he is indeed arguing. But if he embodies his doctrines in a discourse that flaunts its poetic form (in sound and in meaning) and directs attention to itself as an object of rewarding scrutiny, then—so to speak—the illocutionary fuse is drawn. His utterance relinquishes its illocutionary force for aesthetic status, and takes on the character of being an appearance or a show of living language use. Of course, those of us who are interested in the history of philosophy can *read* Lucretius as a philosopher—can extract what he says about atoms and the void—and place these passages in other contexts where they can function as real arguments and can be judged as such. And because of this, there is perhaps no great harm in referring to these passages as argu-

ments, even as they stand in *De rerum natura*—just as we speak of characters in a novel as disputing, even though we are aware that since the characters are nonexistent people, no real disputing is taking place.

To characterize poems in the way I have proposed is to give a genus, not the differentia. Not all imitations of illocutionary acts are poems: for example, to mimic what someone has said, to tell a joke, to say something for the purpose of testing a public address system. What makes a discourse a literary work (roughly speaking) is its exploitation to a high degree of the illocutionary-act potential of its verbal ingredients—or, in more usual terminology, its richness and complexity of meaning. And what makes a literary work a poem is the degree to which it condenses that complexity of meaning into compact, intense utterance.

It may seem that we have taken a very long way around to this final and familiar formula: that poems are distinguished by their complexity of meaning. But this commonplace ought to take on added significance from the route by which we reached it. For we see that the poem's complexity is not accidental or adventitious but a natural development of what it essentially is: the complex imitation of a compound illocutionary act.

Notes

1. See my Aesthetics, pp. 129-130, 242-247, 401-403.

2. I say this notwithstanding the dogmatic denial of it by Frank Cioffi in "Intention and Interpretation in Criticism": "You don't show that a response to a work of literature is inadequate or inappropriate in the way that you show that the conclusion of an argument has been wrongly drawn" (p. 105). But it seems to me the literary interpreter is not concerned with the adequacy of our "response" to the work but only with the adequacy of our *understanding* of the work. It is true that a proposed interpretation often does not need to be argued, because we can see at once how it fits. But if we are hesitant about accepting it, we can always ask for a display of reasons—i.e., an argument.

3. Hampshire, in Sidney Hook, ed., Art and Philosophy, p. 108.

4. Hampshire.

5. See Margolis, *The Language of Art and Art Criticism* (Wayne State University Press, 1965), pt. III; and also his comments in Hook, ed., *Art and Philosophy*, pp. 265–268.

6. Language of Art, p. 76.

7. Ibid., pp. 91-92.

8. Hynes, "Whitman, Pound, and the Prose Tradition," in *The Presence of Walt Whitman*, English Institute Papers (Columbia University Press, 1962), pp. 129–130.

9. Hirsch, p. 137.

10. The New York Review of Books, September 24, 1964, apropos of Jan Kott's Shakespeare.

11. Margolis, Language of Art, p. 93.

12. Wordsworth: A Philosophical Approach (Oxford: Clarendon Press, 1967), p. 172.

13. See William Alston, *Philosophy of Language* (Englewood Cliffs, N.J.: Prentice-Hall, 1964); J.L. Austin, *How to Do Things with Words* (Harvard University Press, 1962).

14. Alston speaks of "taking responsibility" for certain conditions in performing a particular illocutionary act; I prefer the term "represent," which has been suggested and used by Elizabeth Beardsley; see "A Plea for Deserts," *American Philosophical Quarterly* 6 (January 1969): 33-42.

15. Alston, p. 37.

16. Ibid., p. 45.

17. Ibid., p. 46.

18. Another way of analyzing the difference would perhaps be more congenial to Alston's view, though I think it would be oversimplified: we could say that in asking for "vintage . . . cooled in the earth" rather than "wine . . . reduced in temperature in the ground," he represents that what he desires is wine of high quality, and if this condition is taken to concern the attitude of the speaker, it would be assigned by Alston to the "emotive meaning" of the term (see Alston, pp. 47–48).

19. See "Explaining the Obvious," in "Speaking of Books" column of The New York Times Book Review, March 17, 1968.

20. One interesting use that can be made of this concept of a poem is to bring out the basic differences, sometimes called "rhetorical," between different kinds of poetry. English Augustan poetry, for example, gets its character largely from the preponderance of certain closely related kinds of pretended illocutionary act: asserting, denying, judging, contrasting, arguing, etc.; see William K. Wimsatt, "The Augustan Mode in English Poetry," *ELH: A Journal of English Literary History* 20 (March 1953): 1–14.

21. I want to thank Joseph Margolis for bringing this counterexample and counterargument to my attention.

22. Poetic Meter and Poetic Form (New York: Random House, 1965), p. 14. A closely similar view has been well defended by Seymour Chatman: "Meter, then, is the sign of a certain kind of discourse. . . . It is one of the 'variety of well-understood conventions by which the fictional use of language is signalled'" (A Theory of Meter [The Hague: Mouton, 1965], p. 221).

JOSEPH MARGOLIS

There seems to be a simple way to refute relativism. Construe it as a conservative thesis: that, for some set of judgments, it is not the case that no judgments can in principle be valid (skepticism) or that judgments can be validly defended on one principle only (what Richard Henson has recently termed "universalism").¹ Assign truth-values, then, to judgments on relativistic grounds and assume that, in relevantly significant disputes, the correct assignment of incompatible truth-values depends on the use of competing (relativistic) "principles." There is no need to attempt to individuate such principles. The point of the exercise is that, on the hypothesis, relativism leads to contradiction, since judgments would then be able to be validly shown to be both true and false.

The argument is impeccable but indecisive—for an elementary reason. Grant only that a putatively relativistic set of judgments lacks truth-values (true and false) but takes values of other sorts or takes "truth-values" other than true and false. For example, if judgments are said to be probable (on the evidence) rather than true, then it is quite possible that judgments otherwise incompatible—as true or false—are equiprobable (on the evidence).² This is not to say that considerations of probability entail relativism; but it is also not to deny that they could be construed relativistically. In any case, the refutation of relativism fails so far forth if there is a set of judgments that relativism claims for its own, to which not truth and falsity but values that, interpreted on the model of truth-assignments, would lead to contradiction do not therefore thus do so. It is of course also possible to hold that judgments are relativized in the sense that every validating "principle" is said to subtend its own sector of judgments and that no two principles have intersecting sectors.³ But, although this is a possible

Reprinted from The Journal of Aesthetics and Art Criticism, XXXV (1976), 37-46, by permission of the author and the Journal.

strategy, it is quite uninteresting, since what we want to consider are the prospects of a *robust* relativism, that is, a relativism that admits some range of *competing* claims, claims for which there are at least minimal grounds justifying the joint application of competing principles—hence, that admits not only incompatible judgments relative to any particular principle but also what may be called "incongruent" judgments, judgments that construed in terms of truth and falsity would be incompatible *and* that involve the use of predicates jointly accessible to competing principles. The weaker form of relativism is uninteresting whether truth itself is thought to be relativized to a particular language⁴ or whether a restricted range of judgments is thought to be defensible only in terms of some particular convention or "implicit agreement."⁵

Still, the distinction between the two sorts of relativism suggests some necessary constraints that a viable and robust relativism would entail: (1) the rejection of skepticism and universalism for a given set of judgments; (2) the provision that such a set of judgments takes values other than truth and falsity and includes incongruent judgments; (3) the rejection of cognitivism (entailed by [(2)], in any case-that is, the rejection of the view that, for the properties ascribed in the judgments in question, we possess a matching cognitive faculty [perception for instance] the normal exercise of which enables us to make veridical discriminations of their presence or absence);⁶ (4) the admission of the joint relevance of competing principles in validating the ascriptions or appraisals in question (entailed by [(2)], in any case-that is, the admission of some theory explaining such tolerance).7 On reflection, these four conditions appear to be sufficient as well as necessary for the provision of a robust relativism. They are, in any case, jointly compatible and, together, they undercut what may fairly be taken to be the least specialized attack on relativism that could be mounted. I shall take a theory to be relativistic, therefore, if it meets our four conditions-which, on the analysis sketched, is equivalent to the first two. It is important and useful to note that no constraints at all are placed on the kinds of judgment that may be construed relativistically, for instance, as between judgments that are and are not value judgments.

Having said this much, let me proceed, first, polemically, to provide grounds for thinking that, in the context of aesthetics or of the aesthetic appreciation of the arts, there are at least three distinct ranges of judgment that may be strongly defended as tolerating or even requiring a relativistic construction; and secondly, more affirmatively but very briefly, to sketch a theory in virtue of which those findings may be sustained. In the first portion of the argument, then, I shall try to show that, for each of the three domains to be marked out, well-known arguments (at least implicitly) opposed to a relativistic construction are inherently indecisive. In the second portion of the argument, then, I shall try to say what it is about the

nature of art and judgment that sustains a relativistic thesis. It should be said at once, however, that it is no part of my thesis that all judgments (taken collectively) may be defensibly construed as behaving relativistically-which of course would involve construing truth relativistically. That would be tantamount to retreating to a radical version of the weaker sense of relativism; and, in any case, I am persuaded that such a view is incoherent. So it may be insisted that a further condition (5) should be appended, namely, that relativistic sets of judgments presuppose some range of non-relativistic judgments, or that relativistic judgments are dependent on there being some viable range of non-relativistic judgments. But I take (5) to be entailed by (1). In any case, the provision precludes the possible embarrassment of conceding that we may wish to hold it true that relativistic judgments ("incongruent" in the sense supplied) do have the values (other than true and false) that they are said to have. It may also be claimed that genuinely relativistic theories should be distinguished sharply from theories that merely admit that the validity of any range of judgments is relative to the supporting evidence or supporting considerations on which that is said to depend. So a further condition (6) may be required, namely, that a set of judgments is relativistic if their validation is determined by considerations bearing on the individual sensibilities of anyone who relevantly judges. (This may in fact be the fair sense of the relativistic interpretation of Protagoras' dictum.) But, the thesis to which (6) is contrasted is itself tautological; and, also, (6) appears to be entailed by (2). Still, (6) is essential, since it is surely with regard to varying personal sensibilities that we anticipate the relevant specimens to arise; and (6) precludes mere expressions of differing preference, since the expression of a preference is not as such a judgment.

Turn, now, to our specimens.

Frank Sibley, in a well-known series of papers, has argued that a particularly important set of aesthetic properties are not in any positive way "condition-governed" and that their discrimination requires the exercise of taste or perceptiveness. As he puts it,

We say that a novel has a great number of characters and deals with life in a manufacturing town; that a painting uses pale colors, predominantly blues and greens, and has kneeling figures in the foreground; that the theme in a fugue is inverted at such a point and that there is a stretto in the close; that the action of a play takes place in the span of one day and that there is a reconciliation scene in the fifth act. Such remarks may be made by, and such features pointed out to, anyone with normal eyes, ears, and intelligence. On the other hand, we also say that a poem is tightly-knit or deeply moving; that a picture lacks balance, or has a certain serenity and repose, or that the grouping of the figures sets up an exciting tension; or that the characters in a novel never really come to life, or that a certain episode strikes a false note. It would be neutral enough to say that the making of such judgments as these requires the exercise of taste, perceptiveness, or sensitivity, of aesthetic discrimination or appreciation; one would *not* say this of my first group. Accordingly, when a word or expression is such that taste or perceptiveness is required in order to apply it, I shall call it an *aesthetic* term or expression, and I shall, correspondingly, speak of *aesthetic* concepts or *taste* concepts.⁸

About these, Sibley claims, "there are no non-aesthetic features which serve in *any* circumstances as logically *sufficient* conditions for applying aesthetic terms. Aesthetic or taste concepts are not in *this* respect conditiongoverned at all."⁹ Of course, Sibley clearly means to hold that the discrimination involved is, in some sense, perceptual or perception-like—informed by taste or perceptiveness—*and* that the capacity in question is not to be understood in terms of any form of intuitionism.¹⁰

It is, admittedly, not clear whether Sibley can escape intuitionism; and it is entirely reasonable to claim that some of the concepts that Sibley regards as aesthetic are condition-governed and that some that he regards as non-aesthetic (and that are also condition-governed) are, on a perfectly reasonable usage, actually aesthetic or aesthetically important-for instance, the discrimination of the fugal form and its complications and the discrimination of musical unity.¹¹ The central question remains, what of those uses of aesthetic terms that are not condition-governed, in Sibley's sense? Can these be reasonably construed as objectively discerned in the work in question? Here, Sibley himself concedes the possibility that ascriptions of the sort he has in mind ("graceful," "dainty," "moving," "plaintive," "balanced," "lacking in unity," and the like-what he sometimes calls "tertiary or Gestalt properties, among others") may merely be "apt rather than true."12 Sibley himself opts for the objectivity of such qualities on the basis of considerations that quite clearly fail to exclude a decisive alternative. He notices that simple qualities like color admit of "ultimate proof" (that is, proof that they are present) only in the way in which that proof is "tied to an overlap of agreement in sorting, distinguishing and much else which links people present and past; . . . where different sets of people agree amongst themselves thus (e.g., groups of similarly colorblind people), it is reference to the set with the most detailed discrimination that we treat as conclusive."13

His argument continues in the following way:

When I say the only ultimate test or proof, I mean that, since colors are simple properties in the sense that no other visible feature makes something the color it is, one cannot appeal to other features of an

object in virtue of possessing which, by some rule of meaning, it can be said to be red or blue, as one can with such properties as triangular, etc. With colors there is no such intermediate appeal; only directly an appeal to agreement. But *if* there are aesthetic properties—the supposition under investigation—they will, despite dissimilarities, be like colors in this respect. For though, unlike colors, they will be dependent on other properties of things, they cannot, since they are not entailed by the properties responsible for them, be ascribed by virtue of the presence of other properties and some rule of meaning. Hence a proof will again make no intermediate appeal to other properties of the thing, but directly to agreement.¹⁴

Sibley adds that "this agreement is not easy to describe. Not any agreement will do; the fact that some of us, here and now, make identical discriminations need not settle the color of things."15 This shows reasonably clearly that Sibley thinks that the "perception" of aesthetic or tertiary qualities is not dissimilar in an essential regard from the perception of colors: the agreement involved is an agreement about perceived (though dependent) qualities. And so, in effect, Sibley subscribes to some form of cognitivism (if not intuitionism): he must reject our condition (3)—hence, relativism. But that's just it. What Sibley needs is a theory of perception and perceptual qualities that would justify construing the qualities in question as perceptual qualities and not merely as qualities such that, in a sense that conforms to the enormous variability of such judgments, it would be apt but not true to say that this poem or sculpture "has" it. In an earlier paper, Sibley says quite explicitly that "aesthetics deals with a kind of perception," and appeals to the case of the color-blind man to clarify the nature of defective aesthetic perception.¹⁶ On the other hand, in spite of his insistence that "some aesthetic judgments may be characterized as right, wrong, true, false, undeniable," he actually favors the alternative theory at times, conceding that, even for his own cases, "for some range of judgments we prefer terms like 'reasonable,' 'admissible,' 'understandable' or 'eccentric' to 'right' and 'wrong.' "17

Sibley also has considerable difficulty in explaining how to select the aesthetic "elite" whose discrimination is relatively reliable simply because he fails to supply a theory of the requisite perception in terms of which to account for and to correct the discrimination of any would-be aesthetic percipient. But the absence of such a theory places his advocacy of cognitivism in doubt, since, for *any* claim that putatively relies on the exercise of a cognitive faculty (perceptual for instance), a theoretical basis must be provided for distinguishing between what actually *is* the case and what only *seems* to be so.¹⁸ This condition must be satisfied whether the properties in question are said to be simple or complex. Sibley's admission, however, of what it may be *apt* but not true to say is incompatible with

his particular claims of aesthetic objectivity, since judgments of what may be apt but not true to say cannot preclude incongruence (in the sense supplied). His concession, in short, precludes the application of the requisite "is"/"seems" contrast, where the concession has force; and where he would deny its force, he lacks the requisite theory. Hence, Sibley's position is subject to a complex dilemma: either (a) his aesthetic concepts are condition-governed (since dependent) and thus enter inferentially into judgments that are straightforwardly true or false; or else (b) they are not condition-governed (though dependent) and, since they enter into judgments that are straightforwardly true or false, Sibley is committed to some sort of intuitionism; or else (c) they are not condition-governed (though dependent) and enter into judgments that can be apt or inapt or the like but not true or false.

It is, I think, fair to say that the concepts Sibley is chiefly concerned with ("graceful," "moving," "balanced," "unified," and the like) have a definite use in judgments that depend on the individual sensibilities of different persons. He himself concedes the point, which is tantamount to conceding a relativistic thesis. Some of his opponents (Peter Kivy, for instance)¹⁹ wish to show that these concepts are used in an ordinary condition-governed way, but they have not shown (and it is difficult to imagine how they could possibly show) that such concepts are never, or are not even characteristically, used in a way that is either not condition-governed (in Sibley's sense) or if condition-governed not governed in such a way as to lead to judgments that are straightforwardly true or false. Let it suffice, then, that judgments that Sibley says involve taste or perceptiveness or sensibility-ranging over much of what is typically noted in appreciative discourse, without directly involving (but not necessarily excluding) evaluative distinctions²⁰-may be construed, and may even need to be construed, relativistically.

The other two quarrels I wish to pick are drawn from Monroe Beardsley's relatively recent book, *The Possibility of Criticism*.²¹ Again, I mean to argue in each case primarily on the basis of internal evidence.

In speaking about a critic's judgments (he confines himself here to judgments of literature), Beardsley has the following straightforward view to present:

What is the point of making a literary judgment and arguing for it? My answer to this question—which I shall defend here—is simple and old-fashioned. It is to inform someone how good a literary work is. But philosophers are rightly suspicious of this so-called "informing," if it merely evokes verbal agreement but brings no further satisfaction to the hearer. . . . [Still] there is a proximate end in judging —namely, to provide information about value. . . .²²

Judgments of course call for supporting reasons. Beardsley claims that the reasons a critic supplies in order to justify his judgment conform to the "ordinary' sense" of reasons; that is, they "have a bearing on the *truth* of the judgments." He adds that "the relevance of such reasons presupposes that the judgments can be true or false"; but he concedes in the very same context, noting that this runs contrary to his own view about criticism, that "there might be reasons for making a certain judgment that are not reasons for saying it is true, if it should be the case that judgments cannot be true or false."²³ So Beardsley in effect concedes our condition (2) or at least an essential part of it. He even concludes as a result: "So our first question is whether in fact critical judgments have a truth-value—i.e., are either true of false"²⁴—which, under the circumstances, we must understand to mean, whether all relevant judgments are either true or false.

But he never does show that they are. He does mention P. H. Nowell-Smith's account purporting to show that even so-called verdictives (in J. L. Austin's sense), estimates for instance, though not usually said to be true or false, nevertheless "surely involve a claim to truth, which may be allowed or disallowed."25 But he considers no other possibilities. His principal effort is actually directed against an argument of Michael Scriven's, which purports to show that critical reasoning is impossible, in the sense that justifying or explaining reasons are impossible to supply in the way required to support ascriptions of truth.26 Scriven's argument, as Beardsley summarizes it, holds that "it must be possible for us to know that the reason is true, and also to know that it is a reason for the conclusion, before knowing that the conclusion is true" (the so-called "independence requirement").27 Beardsley seems to take it that the refutation of Scriven's thesis entails his own favored view-that critical judgments (in particular, estimates, as he puts it, of "the greatest amount of artistic goodness that [e.g.,] the poem allows of actualizing in any one encounter with it") have truth-value. "This," he says, "I am convinced, is what the critic estimates."28 Again, his argument against Scriven runs as follows:

But *if*, as I claim, these judgments are estimates, then some reasons *must* be used by the critics in arriving at them, and *therefore* there must be some basic features of literary works that are always merits or defects...²⁹

But this begs the question with which Beardsley originally began. For, *if* justification or explanatory reasons may be provided for utterances (judg-ments) that lack truth-value, then it cannot be shown that if judgments include estimates and if estimates call for supporting reasons, then all judgments have truth-value. Some estimates may and some may not, in the sense given; and some critical judgments may not behave in the way

Beardsley claims estimates do. Also, it is difficult to see how, unless by some sort of cognitivism or the weaker version of relativism, judgments of the kind mentioned above ("concerning the greatest amount of artistic goodness," etc.) could possibly be said to be straightforwardly true or false. In fact, what Scriven's argument tends to show, as a by-benefit, is that a significant range of critical value judgments, though they call for supporting reasons, rest on consideration that actually preclude the ascription of the value true; for, as Scriven says, agreement about how some valuational condition must be satisfied often (Scriven apparently thinks, always) "does not exceed the degree of our initial agreement about the merit of the work of art."30 I take this to accord with what I have elsewhere termed "appreciative judgments," that is, judgments that call for pertinent justifying or explanatory reasons but that, depending as they do on personal taste, cannot be binding on another, cannot be simply true, cannot be said to support the relevant distinction between a work's actually having the value in question or only appearing to.³¹ With respect to such judgments, I claim, we may say only that it is reasonable, extreme, eccentric, etc. to say that a work has this or that degree of merit rather than that it demonstrably has it. Hence, even such judgments conform to whatever semantic constraints obtain on the use of the predicates in question. There are, therefore, judgments (including some that Beardsley himself considers) that would support the relativistic view, and that might even require itthe view, that is, that justifying reasons may be admitted where particular judgments cannot take the value "true" (and do not, in Nowell-Smith's sense, involve a claim to truth).

The third quarrel concerns the nature of the interpretation, as opposed to the description, of a work of art; and here, I am simply responding to Beardsley's criticism of my own earlier statements on the matter.³² The issue directly concerns what may be definitely found *in* a work and what lies *outside* it. Beardsley opposes what I and others emphasize as "the element of creativity in interpretation." He says, "I find myself rather severe with this line of thought," that is, the suggestion "that the literary interpreter, too [like the performing artist] has a certain leeway, and does not merely 'report' on 'discovered meaning,' . . . but puts something of his own into the work; so that different critics may produce different but equally legitimate interpretations, like two sopranos or two ingenues working from the same notations."³³

But there are difficulties in his account. For one thing, though he subscribes to what he terms "the Principle of Independence" (that is, "that literary works exist as individuals and can be distinguished from other things"), he claims that what he terms "the Principle of Autonomy" is a postulate "that is logically complementary to the first" (that is, "that literary works are self-sufficient entities, whose properties are decisive in checking

interpretations and judgments."34 But I would maintain-and have tried to demonstrate elsewhere³⁵—that problems about the numerical identity of a work of art can be managed without any commitment respecting the demarcation between description and interpretation, the demarcation between what is in a work and what is not. Only if one held, in addition to a theory about individuating works of art, a compelling theory about the nature and properties of works of art, could one hope to sustain the socalled Principle of Autonomy-by actually providing criteria for determining putatively internal properties to be or actually not to be internal. Beardsley offers no such theory, as far as I know. But then, it follows, as a second consideration, that he may well have misdescribed the "latitudinarian" view of interpretation: interpretations (in the sense he rejects) may not be simple "superimpositions," as he says, that is, "interpretations" that are merely "ways of using the work to illustrate a pre-existent system of thought [say, in taking the story of 'Jack and the Beanstalk' as Freudian symbolism or as a Marxist fable]";36 they may actually be needed precisely because there is no sharp demarcation line between what is internal and what is external to a work of art and because what is uncertain in this respect may be important in terms of aesthetic appreciation. Thirdly, the admission of so-called superimpositions would itself be a telling concession if (as is in fact the case) Beardsley has not yet provided the requisite theory in virtue of which superimpositions and "genuine" interpretations can be logically demarcated. Fourthly, the implied admission that there is a certain latitude that holds in music and the other performing arts raises (unresolved) questions both about whether there is a clear sense, for all the arts, of the tenability of the Principles of Independence and Autonomy and about what may be the formulable (and relevant) differences between literature and the performing arts. Fifthly, Beardsley himself concedes, in a context in which he opposes an extreme view ingeniously supported by Frank Cioffi,37 that

Some things are definitely said in the poem and cannot be overlooked; others are suggested, as we find on careful reading; others are gently hinted, and whatever methods of literary interpretation we use, we can never establish them decisively as "in" or "out." Therefore whatever comes from without, but yet can be taken as an interesting extension of what is surely in, may be admissible. It merely makes a larger whole. But this concession will not justify extensive borrowings from biography.³⁸

I cannot see how this concession, generously advanced though it may be, can fail to undermine Beardsley's Principle of Autonomy. Even the question of biographical reference and of intentional interpretation surely becomes moot—which is not to say of course that critical interpretation lacks rigor altogether.

A sixth consideration concerns the nature of language itself, since Beardsley here restricts himself to literary interpretation. First of all, he rests his case on the strength of the thesis that the interpretation of "textual meaning" (as opposed to "authorial meaning"-in the sense proposed by E. D. Hirsch)³⁹ is "the proper task of the literary interpreter" and that such meaning "lies momentarily hidden" in, say, some poem, "really is something in the poem that we are trying to dig out, though it is elusive."40 But even apart from his confidence about determining textual meaning, Beardsley seems entirely prepared to concede that meanings may accrue to a literary text because of the historical conditions under which a living language is used. In his effort to contrast textual and authorial meaning, for instance, he says that "the meaning of a text can change after its author has died. . . . The OED furnishes abundant evidence that individual words and idioms acquire new meanings and lose old meanings as time passes; these changes can in turn produce changes of meaning in sentences in which the words appear." He offers a curious instance from the work of Mark Akenside, acknowledges that a certain eighteenth-century phrase "has . . . acquired a new meaning," and even speaks of "today's textual meaning of the line" (in question).41

But if he allows changing textual meanings, he cannot preclude the possibility of incompatible and non-converging literary interpretations in rendering a coherent account, unless he also maintains that there is an executive rule (unformulated) for determining which textual meaning (changing through diachronic changes in language itself) to prefer; after all, large portions of an entire text may be subject to similar changes and may therefore support plural interpretations. But secondly, in this regard, the very theory of linguistic meaning to which he subscribes-William Alston's theory of "illocutionary act potentials" (regardless of its own defensibility)⁴²—depends precisely on speakers' intentions; consequently, once again, Beardsley cannot, on his own principles, preclude the prospect of defending non-converging ("creative") literary interpretations. Finally, with regard to literature (and certainly with regard to the other arts), the critic's interpretation is not restricted, as Beardsley claims, merely to ferreting out textual meanings; it is often concerned (as even the admission of diachronic changes in meaning confirm) with plausible ways in which what may be called the artistic design (the internal coherent order of the work) may be construed.43 In fact, the case that Beardsley puts before us (introduced by Hirsch) of Cleanth Brooks's and F. W. Bateson's incompatible interpretations of Wordsworth's A Slumber Did My Spirit Seal bears this point out convincingly.⁴⁴ Unfortunately, neither interpretation, however plausible, is enitrely unproblematic. Bateson's pan-

theistic interpretation cannot be supported on the basis solely of the socalled textual meaning of the lines No motion has she now, no force, / She neither hears nor sees; / Rolled round in earth's diurnal course, / With rocks, and stones, and trees. And Brooks's interpretation (which, rightly understood, emphasizes the lover's shock—almost in a clinical sense reacting to Lucy's death and consequent inertness) is somewhat careless about textual meanings but not in a way that vitiates his interpretation. The upshot is that Wordsworth's Lucy poem, contrary to Beardsley's claim, does appear to support two different interpretations of the poem's larger meaning or design (that is, roughly the picture of the imaginative world disclosed in the poem), without even entailing different interpretations of the poem's textual meaning. There seems to be no way to preclude the possibility.

There is then no reason to deny that interpretation sometimes serves to convey a sense of virtuosity in fathoming what is hidden (but describable) in a work of art. But there is no reason to insist that interpretation functions only thus. Beardsley discounts incompatible interpretations in accord with what he calls "the principle of 'the Intolerability of Incompatibles,' i.e., if two [interpretations] are logically incompatible, they cannot both be true [and they implicitly claim to be true]." "Indeed," Beardsley says, "I hold that all of the literary interpretations that deserve the name obey the principle."45 He does not deny that there are "interpretations" that could not be jointly true and yet may be said to be plausible; but these are not true interpretations, are merely what he calls "superimpositions." And he fails to notice that falsity may be opposed to both truth and plausibility.⁴⁶ Also, he has not provided either an explicit theory of the nature of a work of art or the requisite criteria for determining what is internal and what, external to the work of art itself: consequently, he cannot in principle preclude plural and incompatible interpretations of a literary work just as he cannot in principle distinguish between superimpositions and interpretations that specify what is "momentarily hidden" in a piece of literature. Hence, he cannot preclude a relativistic conception of interpretation-which may well be not merely tolerated but required.

I have now, I hope, shown (polemically) that a relativistic conception of aesthetic appreciation, of critical judgments (of value), and of literary interpretations is viable, not unreasonable, and possibly even required by the ways in which we attend to works of art. I shall have to be extremely brief about my reasons for thinking that a relativistic account is actually required for these and related distinctions. The argument centers on two considerations. First of all, works of art are what I should call culturally emergent entities.⁴⁷ I wish to avoid here theorizing in too detailed a way about the nature of art, since our issue does not require it and since controversial details may easily deflect us from our purpose. But the most

familiar properties of art, its artifactuality, its internal purposiveness, its being assignable meanings (in various senses), forms, designs, styles, symbolic and representational functions, and the like all call for a sensitivity to cultural distinctions that cannot in any obvious way be directly accessible (unless by postulating some ad hoc intuitionism) to any cognitive faculty resembling sensory perception. But culturally freighted phenomena are notoriously open to intensional quarrels, that is, to identification under alternative descriptions; and there is no obvious way in which to show that plural, non-converging, and otherwise incompatible characterizations of cultural items can be sorted as correct or incorrect in such a way that a relativistic account would be precluded. The proliferation of intensional divergences is as close to the heart of the cultural as anything we might otherwise suggest. One has only to think of ideologies, ideals, schools of thought, traditions as well as the deep informality of the so-called rules of language and of artistic creation. This suggests why it is that the appreciation, the interpretation, and the evaluation of art should behave in accord with relativistic expectations. In particular, the relativistic theory of interpretation is sometimes resisted because one wishes to avoid the somewhat unfortunate habit of speaking of art's being inherently incomplete or defective and awaiting the interpretive critic's contribution in order actually to *finish* the work. What is initially defective or incomplete, of course, is our understanding, not the work; but the nature of the defect is such that, for conceptual reasons, we cannot be certain that what is supplied by way of interpretation is really in principle descriptively available in the work itself-on the basis of any familiar perceptual or perceptionlike model, which after all offers us the best prospect of the requisite control. One can expect, therefore, a certain conceptual congruence between the theory of art and the latitude tolerated in the practice of critical interpretation.

The second consideration concerns the nature of values themselves. I should hold (controversially, I admit) that persons like works of art are culturally emergent entities—not natural creatures like the members of *Homo sapiens*: chiefly, because the mastery of language is essential to being a person.⁴⁸ If this were granted, then the possibility of defending *any* form of cognitivism (moral, aesthetic, or any other) with respect to the values appropriate to persons or to their characteristic work is radically undermined. Consequently, the prospects of avoiding a relativistic account of values (and of value judgments), even were it possible to avoid such an account of the presumably descriptive and interpretive levels of our appreciative concern with art, is nearly nil. But noticeably with respect to values, if cognivitism is defeated,⁴⁹ then we can either retreat to the robust or weaker form of relativism or else, even further but with inevitable dissatisfaction, to a skepticism about values.

There appear to be no other promising strategies.⁵⁰

Notes

1. In an untitled and as yet unpublished book on ethical relativism.

2. Cf. C. G. Hempel, "Inductive Inconsistencies," in Aspects of Scientific Explanation (New York, 1965). Cf. also G. H. von Wright, "Remarks on the Epistemology of Subjective Probability," in Ernest Nagel et al., eds., Logic, Methodology and Philosophy of Science (Stanford University Press, 1962).

3. This is, roughly, the theme of conventionalism in values.

4. Cf. Alfred Tarski, "The Semantic Conception of Truth," *Philosophy and Phenomenological Research*, IV (1944), 341–376; cf. also W. V. Quine, *Word and Object* (Cambridge, 1960), pp. 23–24; and Donald Davidson, "Truth and Meaning," *Synthese*, III (1967), 304–322. The requirements of the coherence of interlinguistic communication entail the inadequacy of such a conception; even if ascriptions of "truth" are relativized, we require a conception of truth that is not language-relative even if what is true can only be formulated in a way that is subject to the local features of particular languages.

5. The thesis has been defended most recently by Gilbert Harman, "Moral Relativism Defended," *Philosophical Review*, LXXXIV (1975), 3–22. Harman's thesis is relativistic not merely in the trivial sense that supporting reasons are relative to considerations of some sort but because "the source of the reasons" (for doing something—Harman's concern here is with moral relativism) is one's "sincere intention to observe a certain agreement," *ibid.*, 10.

6. The argument is indifferent to the kind of property considered, though moral properties have traditionally been the principal object of concern. Cf. Joseph Margolis, "Moral Cognitivism," *Ethics*, LXXXV (1975), 136–141.

7. It's possible that one might argue that (2) signifies only that, were the relevant judgments interpreted so as to take truth and falsity as truth-values, we should be commited to a single arena of dispute; that the admission of other values does not entail the relevance of competing validating principles. But the intention here is to formulate constraints for the robust, not the weaker, version of relativism. Hence, provision must be made—even if separately, via (4)—for the joint relevance of competing principles.

8. Frank Sibley, "Aesthetic Concepts," *Philosophical Review*, LXVIII (1959), 421–450; reprinted (with extensive minor revisions) in Joseph Margolis, *Philosophy Looks at the Arts* (New York, 1962).

9. Loc. cit.

10. Cf. Frank Sibley, "Objectivity and Aesthetics," Proceedings of the Aristotelian Society, Supplementary, XLII (1968), 31-54.

11. Cf. Peter Kivy, Speaking of Art (The Hague, 1973), chs. 1-3; also Joseph Margolis, The Language of Art and Art Criticism (Detroit, 1965), ch. 8.

12. "Objectivity and Aesthetics."

13. Loc. cit.

14. Loc. cit.

15. Loc. cit.

16. Cf. Frank Sibley, "Critical Judgments of Aesthetic Value," Philosophical Review, LXXIV (1965), 135-159.

17. "Objectivity and Aesthetics."

The Objectivity of Criticism

18. Cf. Isabel Hungerland, "The Logic of Aesthetic Concepts" (Presidential Address of the Pacific Division of the American Philosophical Association, 1962, *Proceedings and Addresses of the American Philosophical Association*, XXXVI, 43–66. Hungerland's statement is, however, too extreme in that it fails to provide for condition-governed concepts.

19. Loc. cit.

20. Cf. Kivy, op. cit., p. 17.

21. Detroit, 1971.

22. Ibid., pp. 63-64.

23. Ibid., p. 71.

24. Ibid.

25. Ibid.

26. Cf. Michael Scriven, "The Objectivity of Aesthetic Evaluation," The Monist, L (1969), 159-187.

27. Beardsley, op. cit., pp. 77f.

28. Ibid., p. 75.

29. Ibid., p. 82.

30. Scriven, op. cit., p. 179.

31. Cf. Joseph Margolis, *The Language of Art and Art Criticism* (Detroit, 1965), ch. 10; and *Values and Conduct* (Oxford, 1971), ch. 1.

32. The Language of Art and Art Criticism, chs. 5-6.

33. Beardsley, op. cit., pp. 39-40.

34. Ibid., p. 16.

35. The Language of Art and Art Criticism, ch. 4.

36. Beardsley, op. cit., pp. 43-44.

37. Cf. Frank Cioffi, "Intention and Interpretation in Criticism," *Proceedings* of the Aristotelian Society, LXIV (1963–1964), 85–103. Cf. also, Stuart Hampshire, "Types of Interpretation," in Sidney Hook, ed., Art and Philosophy.

38. Beardsley, op. cit., p. 36.

39. Cf. E. D. Hirsch, Validity in Interpretation (New Haven, 1967); also Joseph Margolis, review of above, in Shakespeare Studies, II (1970), 407-414.

40. Beardsley, op. cit., pp. 32, 44, 47.

41. Ibid., pp. 19-20.

42. Cf. William Alston, *Philosophy of Language* (Englewood Cliffs, 1964); and Joseph Margolis, "Meaning, Speakers' Intentions, and Speech Acts," *Review of Metaphysics*, XIX (1973), 1007–1022.

43. Cf. The Language of Art and Art Criticism, ch. 3.

44. Cf. Cleanth Brooks, "Irony as a Principle of Structure," in M. D. Zabel, ed., *Literary Opinion in America* (New York, 1951); and F. W. Bateson, *English Poetry: A Critical Introduction* (London, 1950).

45. Beardsley, op. cit., p. 44.

46. Ibid., pp. 42-44.

47. Cf. Joseph Margolis, "Works of Art as Physically Embodied and Culturally Emergent Entities," British Journal of Aesthetics, XIV (1974), 187-196.

48. Cf. "Works of Art as Physically Embodied and Culturally Emergent Entities"; also Joseph Margolis, "Mastering a Natural Language: Rationalists vs. Empiricists," *Diogenes*, no. 84 (1973), pp. 41–57.

49. Cf. "Moral Cognitivism"; also Values and Conduct.

50. I had seen, in manuscript, Professor Annette Barnes's paper, "Half an Hour Before Breakfast," criticizing my theory of the logic of interpretive judgments (JAAC, Spring, 1976). I have taken no account of her charges here, both because the paper had not been published at the time this essay was completed (it was in fact completed before I saw her paper) and because I had attempted to answer her in detail, by letter. Suffice it to say that her charges go wrong in a number of ways: (i) I do not maintain that contradictory accounts of anything can be defended as true, either separately or jointly; only that what would, on a model of truth and falsity, be contradictory, may be jointly defended as plausible or reasonable or the like; (ii) Barnes offers a set of alternative versions of a tolerance principle for admitting diverging interpretations, that she wrongly takes to be exhaustive and therefore, to capture my own view in a multiple dilemma: not exhaustive both because several of her alternatives involve self-contradictory features (which I explicitly avoid) and because no provision is made for truth-values other than "true" and "false"; (iii) Barnes make no provision for what I term the asymmetry of truth and falsity: that, for instance, the "false" is opposed both to the "true" and the "plausible" and that considerations of plausibility do not entail the relevance of considerations of truth; (iv) my argument regarding the logic of interpretation is only applied to those entities that we call works of art; it does not presuppose any theory of the nature of a work of art, though it is compatible with an independent theory that I also support; (v) on my view, it follows that, if interpretation behaves as I claim it does, the properties ascribed to a work of art by way of interpretive criticism cannot be said to be in the work in the sense in which description would require; some of the paradoxes that Barnes attributes to my position simply fail to take account of this important point.

$A R N O L D I S E N B E R G^{1}$

That questions about meaning are provisionally separable, even if finally inseparable, from questions about validity and truth, is shown by the fact that meanings can be exchanged without the corresponding cognitive decisions. What is imparted by one person to another in an act of communication is (typically) a certain idea, thought, content, meaning, or claimnot a belief, expectation, surmise, or doubt; for the last are dependent on factors, such as the checking process, which go beyond the mere understanding of the message conveyed. And there is a host of questions which have to do with this message: its simplicity or complexity, its clarity or obscurity, its tense, its mood, its modality, and so on. Now, the theory of art criticism has, I think, been seriously hampered by a kind of headlong assault on the question of validity. We have many doctrines about the objectivity of a critical judgment but few concerning its import, or claim to objectivity, though the settlement of the first of these questions probably depends on the clarification of the second. The following remarks are for the most part restricted to meeting such questions as: What is the content of the critic's argument? What claim does he transmit to us? How does he expect us to deal with this claim?

A good point to start from is a theory of criticism, widely held in spite of its deficiencies, which divides the critical process into three parts. There is the value judgment or *verdict* (V): "This picture or poem is good..." There is a particular statement or *reason* (R): "—because it has such-and-such a quality..." And there is a general statement or *norm* (N): "—and any work which has that quality is *pro tanto* good."²

V has been construed, and will be construed here, as an expression of feeling—an utterance manifesting praise or blame. But among utterances

From *The Philosophical Review*, Volume LVIII (July, 1949), 330–344. Reprinted with the permission of the author and *The Philosophical Review*.

of that class it is distinguished by being in some sense conditional upon **R**. This is only another phrasing of the commonly noted peculiarity of aesthetic feeling: that it is "embodied" in or "attached" to an aesthetic content.

R is a statement describing the content of an art work; but not every such descriptive statement will be a case of R. The proposition, "There are just twelve flowers in that picture" (and with it nine out of ten descriptions in Crowe and Cavalcaselle), is without critical relevance; that is, without any bearing upon V. The description of a work of art is seldom attempted for its own stake. It is controlled by some purpose, some interest; and there are many interests by which it might be controlled other than that of reaching or defending a critical judgment. The qualities which are significant in relation to one purpose—dating, attribution, archaeological reconstruction, clinical diagnosis, proving or illustrating some thesis in sociology might be quite immaterial in relation to another. At the same time, we cannot be sure that there is any *kind* of statement about art, serving no matter what main interest, which cannot also act as R; or, in other words, that there is any *kind* of knowledge about art which cannot influence aesthetic appreciation.

V and R, it should be said, are often combined in sentences which are at once normative and descriptive. If we have been told that the colors of a certain painting are garish, it would be astonishing to find that they were all very pale and unsaturated; and to this extent the critical comment conveys information. On the other hand, we might find the colors bright and intense, as expected, without being thereby forced to admit that they are garish; and this reveals the component of valuation (that is, distaste) in the critic's remark. This feature of critical usage has attracted much notice and some study; but we do not discuss it here at all. We shall be concerned solely with the descriptive function of R.

Now if we ask what makes a description critically useful and relevant, the first suggestion which occurs is that it is *supported by N*. N is based upon an inductive generalization which describes a relationship between some aesthetic quality and someone's or everyone's system of aesthetic response. Notice: I do not say that N *is* an inductive generalization; for in critical evaluation N is being used not to predict or to explain anybody's reaction to a work of art but to vindicate that reaction, perhaps to someone who does not yet share it; and in this capacity N is a precept, a rule, a *generalized value statement*. But the *choice* of one norm, rather than another, when that choice is challenged, will usually be given some sort of inductive justification. We return to this question in a moment. I think we shall find that a careful analysis of N is unnecessary, because there are considerations which permit us to dismiss it altogether.

At this point it is well to remind ourselves that there is a difference between *explaining and justifying* a critical response. A psychologist who should be asked "why X likes the object y" would take X's enjoyment as a datum, a fact to be explained. And if he offers as explanation the presence in y of the quality Q, there is, explicit or latent in this causal argument, an appeal to some generalization which he has reason to think is true, such as "X likes any work which has that quality." But when we ask X as a critic "why he likes the object y," we want him to give us some reason to like it too and are not concerned with the causes of what we may so far regard as his bad taste. This distinction between genetic and normative inquiry, though it is familiar to all and acceptable to most of us, is commonly ignored in the practice of aesthetic speculation; and the chief reason for this—other than the ambiguity of the question "Why do you like this work?"—is the fact that some statements about the object will necessarily figure both in the explanation and in the critical defence of any reaction to it. Thus, if I tried to explain my feeling for the line

But musical as is Apollo's lute,

I should certainly mention "the pattern of u's and l's which reinforces the meaning with its own musical quality"; for this quality of my sensations is doubtless among the conditions of my feeling response. And the same point would be made in any effort to convince another person of the beauty of the line. The remark which gives a reason also, in this case, states a cause. But notice that, though as criticism this comment might be very effective, it is practically worthless as explanation; for we have no phonetic or psychological laws (nor any plausible "common-sense" generalizations) from which we might derive the prediction that such a pattern of u's and l's should be pleasing to me. In fact, the formulation ("pattern of u's and l's," etc.) is so vague that one could not tell just what general hypothesis it is that is being invoked or assumed; yet it is quite sharp enough for critical purposes. On the other hand, suppose that someone should fail to be "convinced" by my argument in favor of Milton's line. He might still readily admit that the quality of which I have spoken might have something to do with my pleasurable reaction, given my peculiar mentality. Thus the statement which is serving both to explain and to justify is not equally effective in the two capacities; and this brings out the difference between the two lines of argument. Coincident at the start, they diverge in the later stages. A complete explanation of any of my responses would have to include certain propositions about my nervous system, which would be irrelevant in any critical argument. And a critically relevant observation about some configuration in the art object might be useless for explaining a given experience, if only because the experience did not yet contain that configuration.3

Now is would not be strange if, among the dangers of ambiguity to which the description of art, like the rest of human speech, is exposed, there should be some which derive from the double purpose—critical and psychological—to which such description is often being put. And this is, as we shall see, the case.

The necessity for sound inductive generalizations in any attempt at aesthetic explanation is granted. We may now consider, very briefly, the parallel role in normative criticism which has been assigned to N. Let us limit our attention to those metacritical theories which *deny* a function in criticism to N. I divide these into two kinds, those which attack existing standards and those which attack the very notion of a critical standard.

(1) It is said that we know of no law which governs human tastes and preferences, no quality shared by any two works of art that makes those works attractive or repellent. The point might be debated; but it is more important to notice what it assumes. It assumes that if N were based on a sound induction, it would be (together with R) a real ground for the acceptance of V. In other words, it would be reasonable to accept V on the strength of the quality Q if it could be shown that works which possess Q tend to be pleasing. It follows that criticism is being held back by the miserable state of aesthetic science. This raises an issue too large to be canvassed here. Most of us believe that the idea of progress applies to science, does not apply to art, applies, in some unusual and not very clear sense, to philosophy. What about criticism? Are there "discoveries" and "contributions" in this branch of thought? Is it reasonable to expect better evaluations of art after a thousand years of criticism than before? The question is not a simple one: it admits of different answers on different interpretations. But I do think that some critical judgments have been and are every day being "proved" as well as in the nature of the case they ever can be proved. I think we have already numerous passages which are not to be corrected or improved upon. And if this opinion is right, then it could not be the case that the validation of critical judgments waits upon the discovery of aesthetic laws. Let us suppose even that we had some law which stated that a certain color combination, a certain melodic sequence, a certain type of dramatic hero has everywhere and always a positive emotional effect. To the extent to which this law holds, there is of course that much less disagreement in criticism; but there is no better method for resolving disagreement. We are not more fully convinced in our own judgment because we know its explanation; and we cannot hope to convince an imaginary opponent by appeal to this explanation, which by hypothesis does not hold for him.

(2) The more radical arguments against critical standards are spread out in the pages of Croce, Dewey, Richards, Prall, and the great romantic

critics before them. They need not be repeated here. In one way or another they all attempt to expose the absurdity of presuming to judge a work of art, the very excuse for whose existence lies in its difference from everything that has gone before, by its degree of resemblance to something that has gone before: and on close inspection they create at least a very strong doubt as to whether a standard of success or failure in art is either necessary or possible. But it seems to me that they fail to provide a positive interpretation of critcism. Consider the following remarks by William James on the criticism of Herbert Spencer: "In all his dealings with the art products of mankind he manifests the same curious drvness and mechanical literality of judgment. . . . Turner's painting he finds untrue in that the earth-region is habitually as bright in tone as the air-region. Moreover, Turner scatters his detail too evenly. In Greek statues the hair is falsely treated. Renaissance painting is spoiled by unreal illumination. Venetian Gothic sins by meaningless ornamentation." And so on. We should most of us agree with James that this is bad criticism. But all criticism is similar to this in that it cites, as reasons for praising or condemning a work, one or more of its qualities. If Spencer's reasons are descriptively true, how can we frame our objection to them except in some such terms as that "unreal illumination does not make a picture bad": that is, by attacking his standards? What constitutes the relevance of a reason but its correlation with a norm? It is astonishing to notice how many writers, formally commited to an opposition to legal procedure in criticism, seem to relapse into a reliance upon standards whenever they give reasons for their critical judgments. The appearance is inevitable; for as long as we have no alternative interpretation of the import and function of R, we must assume either that R is perfectly arbitrary or that it presupposes and depends on some general claim.

With these preliminaries, we can examine a passage of criticism. This is Ludwig Goldscheider on *The Burial of Count Orgaz*:

Like the contour of a violently rising and falling wave is the outline of the four illuminated figures in the foreground: steeply upwards and downwards about the grey monk on the left, in mutually inclined curves about the yellow of the two saints, and again steeply upwards and downwards about . . . the priest on the right. The depth of the wave indicates the optical centre; the double curve of the saints' yellow garments is carried by the greyish white of the shroud down still farther; in this lowest depth rests the bluish-grey armor of the knight.

This passage—which, we may suppose, was written to justify a favorable judgment on the painting—conveys to us the idea of a certain quality

which, if we believe the critic, we should expect to find in a certain painting by El Greco. And we do find it: we can verify its presence by perception. In other words, there is a quality in the picture which agrees with the quality which we "have in mind"-which we have been led to think of by the critic's language. But the same quality ("a steeply rising and falling curve," etc.) would be found in any of a hundred lines one could draw on the board in three minutes. It could not be the critic's purpose to inform us of the presence of a quality as obvious as this. It seems reasonable to suppose that the critic is thinking of another quality, no idea of which is transmitted to us by his language, which he sees and which by his use of language he gets us to see. This quality is, of course, a wavelike contour; but it is not the quality designated by the expression 'wavelike contour.' Any object which has this quality will have a wavelike contour; but it is not true that any object which has a wavelike contour will have this quality. At the same time, the expression 'wavelike contour' excludes a great many things: if anything is a wavelike contour, it is not a color, it is not a mass, it is not a straight line. Now the critic, besides imparting to us the idea of a wavelike contour, gives us directions for perceiving, and does this by means of the idea he imparts to us, which narrows down the field of possible visual orientations and guides us in the discrimination of details, the organization of parts, the grouping of discrete objects into patterns. It is as if we found both an oyster and a pearl when we had been looking for a seashell because we had been told it was valuable. It is valuable, but not because it is a seashell.

I may be stretching usage by the senses I am about to assign to certain words, but it seems that the critic's *meaning* is "filled in," "rounded out," or "completed" by the act of perception, which is performed not to judge the truth of his description but in a certain sense to *understand* it. And if *communication* is a process by which a mental content is transmitted by symbols from one person to another, then we can say that it is a function of criticism to bring about communication at the level of the senses; that is, to induce a sameness of vision, of experienced content. If this is accomplished, it may or may not be followed by agreement, or what is called "communion"—a community of feeling which expresses itself in identical value judgments.

There is a contrast, therefore, between critical communication and what I may call normal or ordinary communication. In ordinary communication, symbols tend to acquire a footing relatively independent of sense-perception. It is, of course, doubtful whether the interpretation of symbols is at any time completely unaffected by the environmental context. But there is a difference of degree between, say, an exchange of glances which, though it means "Shall we go home?" at one time and place, would mean something very different at another—between this and formal science, whose

vocabulary and syntax have relatively fixed connotations. With a passage of scientific prose before us, we may be dependent on experience for the definition of certain simple terms, as also for the confirmation of assertions; but we are not dependent on experience for the interpretation of compound expressions. If we are, this exposes semantical defects in the passageobscurity, vagueness, ambiguity, or incompleteness. (Thus: "Paranoia is marked by a profound egocentricity and deep-seated feelings of insecurity" -the kind of remark which makes every student think he has the diseaseis suitable for easy comparison of notes among clinicians, who know how to recognize the difference between paranoia and other conditions; but it does not explicitly set forth the criteria which they employ). Statements about immediate experience, made in ordinary communication, are no exception. If a theory requires that a certain flame should be blue, then we have to report whether it is or is not blue-regardless of shades or variations which may be of enormous importance aesthetically. We are bound to the letters of our words. Compare with this something like the following:

"The expression on her face was delightful."

"What was delightful about it?"

"Didn't you see that smile?"

The speaker does not mean that there is something delightful about smiles as such; but he cannot be accused of not stating his meaning clearly, because the clarity of his language must be judged in relation to his purpose, which in this case is the *evaluation* of the immediate experience; and for that purpose the reference to the smile will be sufficient if it gets people to feel that they are "talking about the same thing." There is understanding and misunderstanding at this level; there are marks by which the existence of one or the other can be known; and there are means by which misunderstanding can be eliminated. But these phenomena are not identical with those that take the same names in the study of ordinary communication.

Reading criticism, otherwise than in the presence, or with direct recollection, of the objects discussed is a blank and senseless employment—a fact which is concealed from us by the cooperation, in our reading, of many non-critical purposes for which the information offered by the critic is material and useful. There is not in all the world's criticism a single purely descriptive statement concerning which one is prepared to say beforehand, "If it is true, I shall like that work so much the better"—and *this* fact is concealed by the play of memory, which gives the critic's language a quite different, more specific, meaning than it has as ordinary communication. The point is not at all similar to that made by writers who maintain that value judgments have no objective basis because the reasons given to support them are not logically derivable from the value judgments themselves. I do not ask that R be related *logically* to V. In ethical argument you have someone say, "Yes, I would condemn that policy if it really

did cause a wave of suicides, as you maintain." Suppose that the two clauses are here only psychologically related—still, this is what you never have in criticism. The truth of R never adds the slightest weight to V, because R does not designate any quality the perception of which might induce us to assent to V. But if it is not R, or what it designates, that makes V acceptable, then R cannot possibly require the support of N. The critic is not commited to the general claim that the quality named Q is valuable because he never makes the particular claim that a work is good in virtue of the presence of Q.

But he, or his readers, can easily be misled into thinking that he has made such a claim. You have, perhaps, a conflict of opinion about the merits of a poem; and one writer defends his judgment by mentioning vowel sounds, metrical variations, consistent or inconsistent imagery. Another critic, taking this language at its face value in ordinary communication, points out that "by those standards" one would have to condemn famous passages in *Hamlet* or *Lear* and raise some admittedly bad poems to a high place. He may even attempt what he calls an "experiment" and, to show that his opponent's grounds are irrelevant, construct a travesty of the original poem in which its plot or its meter or its vowels and consonants, or whatever other qualities have been cited with approval, are held constant while the rest of the work is changed. This procedure, which takes up hundreds of the pages of our best modern critics, is a waste of time and space; for it is the critic abandoning his own function to pose as a scientist-to assume, in other words, that criticism explains experiences instead of clarifying and altering them. If he saw that the *meaning* of a word like 'assonance'-the quality which it leads our perception to discriminate in one poem or another-is in critical usage never twice the same, he would see no point in "testing" any generalization about the relationship between assonance and poetic value.

Some of the foregoing remarks will have reminded you of certain doctrines with which they were not intended to agree. The fact that criticism does not actually designate the qualities to which it somehow directs our attention has been a ground of complaint by some writers, who tell us that our present critical vocabulary is woefully inadequate.⁴ This proposition clearly looks to an eventual improvement in the language of criticism. The same point, in a stronger form and with a different moral, is familiar to readers of Bergson and Croce, who say that it is impossible by means of concepts to "grasp the essence" of the artistic fact; and this position has seemed to many people to display the ultimate futility of critical analysis. I think that by returning to the passage I quoted from Goldscheider about the painting by El Greco we can differentiate the present point of view from both of these. Imagine, then, that the painting should be projected on to a graph with intersecting co-ordinates. It would then be possible to write

complicated mathematical expressions which would enable another person who knew the system to construct for himself as close an approximation to the exact outlines of the El Greco as we might desire. Would this be an advance towards precision in criticism? Could we say that we had devised a more specific terminology for drawing and painting? I think not, for the most refined concept remains a concept; there is no vanishing point at which it becomes a percept. It is the idea of a quality, it is not the quality itself. To render a critical verdict we should still have to perceive the quality; but Goldscheider's passage already shows it to us as clearly as language can. The idea of a new and better means of communication presupposes the absence of the sensory contents we are talking about; but criticism always assumes the presence of these contents to both parties; and it is upon this assumption that the vagueness or precision of a critical statement must be judged. Any further illustration of this point will have to be rough and hasty. For the last twenty or thirty years the "correct" thing to say about the metaphysical poets has been this: They think with their senses and feel with their brains. One hardly knows how to verify such a dictum: as a psychological observation it is exceedingly obscure. But it does not follow that it is not acute criticism; for it increases our awareness of the difference between Tennyson and Donne. Many wordslike 'subtlety,' 'variety,' 'complexity,' 'intensity'-which in ordinary communication are among the vaguest in the language have been used to convey sharp critical perceptions. And many expressions which have a clear independent meaning are vague and fuzzy when taken in relation to the content of a work of art. An examination of the ways in which the language of concepts mediates between perception and perception is clearly called for, though it is far too difficult to be attempted here.

We have also just seen reason to doubt that any aesthetic quality is ultimately ineffable. 'What can be said' and 'what cannot be said' are phrases which take their meaning from the purpose for which we are speaking. The aesthetics of obscurantism, in its insistence upon the incommunicability of the art object, has never made it clear what purpose or demand is to be served by communication. If we devised a system of concepts by which a work of art could be virtually reproduced at a distance by the use of language alone, what human intention would be furthered? We saw that criticism would not be improved: in the way in which criticism strives to "grasp" the work of art, we could grasp it no better then than now. The scientific explanation of aesthetic experiences would not be accomplished by a mere change of descriptive terminology. There remains only the aesthetic motive in talking about art. Now if we set it up as a condition of communicability that our language should afford the experience which it purports to describe, we shall of course reach the conclusion that art is incommunicable. But by that criterion all reality is unintelligible and in-

effable, just as Bergson maintains. Such a demand upon thought and language is not only preposterous in that its fulfillment is logically impossible; it is also baneful, because it obscures the actual and very large influence of concepts upon the process of perception (by which, I must repeat, I mean something more than the ordinary *reference* of language to qualities of experience). Every part of the psychology of perception and attention provides us with examples of how unverbalized apperceptive reactions are engrained in the content and structure of the perceptual field. We can also learn from psychology how perception is affected by verbal cues and instructions. What remains unstudied is the play of critical comment in society at large; but we have, each of us in his own experience, instances of differential emphasis and selective grouping which have been brought about through the concepts imparted to us by the writings of critics.

I have perhaps overstressed the role of the critic as teacher, i.e., as one who affords new perceptions and with them new values. There is such a thing as discovering a community of perception and feeling which already exists; and this can be a very pleasant experience. But it often happens that there are qualities in a work of art which are, so to speak, neither perceived nor ignored but felt or endured in a manner of which Leibniz has given the classic description. Suppose it is only a feeling of monotony, a slight oppressiveness, which comes to us from the style of some writer. A critic then refers to his "piled-up clauses, endless sentences, repetitious diction." This remark shifts the focus of our attention and brings certain qualities which had been blurred and marginal into distinct consciousness. When, with a sense of illumination, we say "Yes, that's it exactly," we are really giving expression to the change which has taken place in our aesthetic apprehension. The post-critical experience is the true commentary on the precritical one. The same thing happens when, after listening to Debussy, we study the chords that can be formed on the basis of the whole-tone scale and then return to Debussy. New feelings are given which bear some resemblance to the old. There is no objection in these cases to our saying that we have been made to "understand" why we liked (or disliked) the work. But such understanding, which is the legitimate fruit of criticism, is nothing but a second moment of aesthetic experience, a retrial of experienced values. It should not be confused with the psychological study which seeks to know the cause of our feelings.

Note

In this article I have tried only to mark out the direction in which, as I believe, the exact nature of criticism should be sought. The task has been largely negative: it is necessary to correct preconceptions, obliterate false trails. There remain questions of two main kinds. Just to establish the adequacy of my analysis, there would have to be a detailed examination of critical phenomena, which present in the gross a fearful complexity. For example, I have paid almost no attention to large-scale or summary judgments—evaluations of artists, schools, or periods. One could quote brief statements about Shakespeare's qualities as a poet or Wagner's as a composer which seem to be full of insight; yet it would be hard to explain what these statements do to our "perception"—if that word can be used as a synonym for our appreciation of an artist's work as a whole.

But if the analysis is so far correct, it raises a hundred new questions. Two of these-rather, two sides of one large question-are especially important. What is the semantical relationship between the language of criticism and the qualities of the critic's or the reader's experience? I have argued that this relationship is not designation (though I do not deny that there is a relationship of designation between the critic's language and some qualities of a work of art). But neither is it denotation: the critic does not point to the qualities he has in mind. The ostensive function of language will explain the exhibition of parts or details of an art object but not the exhibition of abstract qualities; and it is the latter which is predominant in criticism. The only positive suggestion made in this paper can be restated as follows. To say that the critic "picks out" a quality in the work of art is to say that if there did exist a designation for that quality, then the designation which the critic employs would be what Morris calls an analytic implicate of that designation. (Thus, 'blue' is an analytic implicate of an expression 'H3B5S2' which designates a certain point on the color solid.) This definition is clearly not sufficient to characterize the critic's method; but, more, the antecedent of the definiens is doubtful in meaning. A study of terms like 'Rembrandt's chiaroscuro,' 'the blank verse of The Tempest,' etc., etc., would probably result in the introduction of an idea analogous to that of the proper name (or of Russell's "definite description") but with this difference, that the entity uniquely named or labelled by this type of expression is not an object but a quality.

If we put the question on the psychological plane, it reads as follows: How is it that (a) we can "know what we like" in a work of art without (b) knowing what "causes" our enjoyment? I presume that criticism enlightens us as to (a) and that (b) would be provided by a psychological explanation; also that(a) is often true when (b) is not.

Contrary to Ducasse⁵ and some other writers I cannot see that the critic has any competence as a self-psychologist, a specialist in the explanation of his own responses. There is no other field in which we admit the existence of such scientific insight, unbridled by experimental controls and unsupported by valid general theory; and I do not think we can admit it here. (For that reason I held that critical insight, which does exist, cannot be identified with scientific understanding.) The truth is that, in the present stone age of aesthetic inquiry, we have not even the vaguest idea of the

form that a "law of art appreciation" would take. Consider, "It is as a *colorist* that Titian excels"; interpret this as causal hypothesis—for example, "Titian colors give pleasure"; and overlook incidental difficulties, such as whether 'color' means tone or the hue (as opposed to the brightness and the saturation) of a tone. Superficially, this is similar to many low-grade hypotheses in psychology: "We owe the *color* of the object to the retinal rods and cones," "It is the *brightness* and not the color that infuriates a bull," "Highly *saturated* colors give pleasure to American schoolboys." But the difference is that we do not know what test conditions are marked out by our chosen proposition. Would it be relevant, as a test of its truth, to display the colors of a painting by Titian, in a series of small rectanguler areas, to a group of subjects in the laboratory? I cannot believe this to be part of what is meant by a person who affirms this hypothesis. He is committed to no such test.

Anyone with a smattering of Gestalt psychology now interposes that the colors are, of course, pleasing *in* their context, not out of it. One has some trouble in understanding how in that case one could know that it is the *colors* that are pleasing. We may believe in studying the properties of wholes; but it is hard to see what scientific formulation can be given to the idea that a quality should have a certain function (that is, a causal relationship to the responses of an observer) in one and only one whole. Yet that appears to be the case with the color scheme in any painting by Titian.

We can be relieved of these difficulties simply by admitting our ignorance and confusion; but there is no such escape when we turn to criticism. For it is as a colorist that Titian excels-this is a fairly unanimous value judgment, and we should be able to analyze its meaning. (I should not, however, want the issue to turn on this particular example. Simpler and clearer judgments could be cited.) Now when our attention is called, by a critic, to a certain quality, we respond to that quality in its context. The context is never specified, as it would have to be in any scientific theory, but always assumed. Every descriptive statement affects our perception of -and our feeling for-the work as a whole. One might say, then, that we agree with the critic if and when he gets us to like the work about as well or as badly as he does. But this is clearly not enough. For he exerts his influence always through a specific discrimination. Art criticism is analytic, discriminating. It concerns itself less with over-all values than with merits and faults in specified respects. It is the quality and not the work that is good or bad; or, if you like, the work is good or bad "on account of its qualities." Thus, we may agree with his judgment but reject the critic's grounds (I have shown that the "grounds," to which he is really appealing are not the same as those which he explicitly states or designates); and when we do this, we are saying that the qualities which he admires are not

The Objectivity of Criticism

those which we admire. But then we must know what we admire: we are somehow aware of the special attachment of our feelings to certain abstract qualities rather than to others. Without this, we could never reject a reason given for a value judgment with which we agree—we could never be dissatisfied with descriptive evaluation. There must therefore exist an analyzing, sifting, shredding process within perception which corresponds to the conceptual distinctness of our references to "strong form but weak color," "powerful images but slovenly meter," and so on.

This process is mysterious; but we can get useful hints from two quarters. Artists and art teachers are constantly "experimenting," in their own way. "Such a bright green at this point is jarring." "Shouldn't you add more detail to the large space on the right?" We can compare two wholes in a single respect and mark the difference in the registration upon our feelings. Implicit comparisons of this kind, with shifting tone of feeling, are what are involved in the isolation of qualities from the work, at least in *some* critical judgments. I am afraid that as psychology, as an attempt to discover the causes of our feelings, this is primitive procedure; but as a mere analysis of what is meant by the praise and blame accorded to special qualities, it is not without value.

If, in the second place, we could discover what we mean by the difference between the "object" and the "cause" of an emotion, *outside* the field of aesthetics; if we could see both the distinction and the connection between two such judgments as "I hate his cheek" and "It is his cheek that inspires hatred in me"; if we knew what happens when a man says, "Now I know why I have always disliked him—it is his pretence of humility," there would be a valuable application to the analysis of critical judgments.

Notes

1. The author is indebted to Mr. Herbert Bohnert for assistance with this paper.

2. Cf. for instance, C. J. Ducasse, Art, the Critics, and You (p. 116): "The statement that a given work possesses a certain objective characteristic expresses at the same time a judgment of value if the characteristic is one that the judging person approves or, as the case may be, disapproves; and is thus one that he regards as conferring, respectively, positive or negative value on any object of the given kind that happens to possess it." See, further, pp. 117-120.

3. I should like to add that when we speak of "justifying" or "giving reasons" for our critical judgments, we refer to something which patently does go on in the world and which is patently different from the causal explanation of tastes and preferences. We are not begging any question as to whether the critical judgment can "really" be justified; that is, established on an objective basis. Even if there were no truth or falsity in criticism, there would still be agreement and disagreement; and there would be argument which arises out

of disagreement and attempts to resolve it. Hence, at the least there exists the purely "phenomenological" task of elucidating the import and intention of words like 'insight,' 'acumen,' 'obtuseness,' 'bad taste,' all of which have a real currency in criticism.

4. See D. W. Prall, Aesthetic Analysis, p. 201.

5. Op. cit., p. 117.

Bibliography to Part Seven

Among the earlier discussions of the objective status of criticism are:

- Monroe C. Beardsley, *Aesthetics* (New York, 1958), Chapters 10-11; Pepita Haezrahi, "Propositions in Aesthetics," *Proceedings of the Aristotelian Society*, LVII (1956-57), 177-206);
- Stuart Hampshire, "Logic and Appreciation," reprinted in William Elton (ed.), Aesthetics and Language (Oxford, 1954);
- Bernard Harrison, "Some Uses of 'Good' in Criticism," Mind, LXIX (1960), 206-222;
- Bernard C. Heyl, "Relativism Again," Journal of Aesthetics and Art Criticism, V (1946), 54-61;
- Isabel C. Hungerland, Poetic Discourse (Berkeley, 1958), Chapter 3;
- Arnold Isenberg, "Perception, Meaning, and the Subject-Matter of Art," Journal of Philosophy, XLI (1944), 561-575;
- William E. Kennick, "Does Traditional Aesthetics Rest on a Mistake?," Mind (1958), 317-334;
- Helen Knight, "The Use of 'Good' in Aesthetic Judgments," reprinted in William Elton (ed.), Aesthetics and Language (Oxford, 1954);
- Margaret Macdonald, "Some Distinctive Features of Arguments Used in Criticism of the Arts," reprinted (revised) in William Elton (ed.), Aesthetics and Language (Oxford, 1954);

Harold Osborne, Aesthetics and Criticism (London, 1955), Chapter 1;

- J. A. Passmore, "The Dreariness of Aesthetics," reprinted in William Elton (ed.), *Aesthetics and Language* (Oxford, 1954);
- Charles L. Stevenson, "Interpretation and Evaluation in Aesthetics," in Max Black (ed.), *Philosophical Analysis* (Ithaca, 1950);
- Charles L. Stevenson, "On the Reasons That Can Be Given for the Interpretation of a Poem," in Joseph Margolis (ed.), *Philosophy Looks at the Arts* (New York, 1962, 1st ed.);
- Jerome Stolnitz, "On Objective Relativity in Aesthetics," Journal of Philosophy, LVII (1960);
- Paul Ziff, "Reasons in Art Criticism," in Israel Scheffler (ed.), *Philosophy* and Education (Boston, 1958).

Particularly pertinent to the puzzles of appreciation and evaluation, though not focused on aesthetic issues, are:

- P. H. Nowell-Smith, *Ethics* (London, 1954), Chapter 12; John Wisdom, "Gods," reprinted in *Philosophy and Psycho-analysis* (Oxford, 1953).
- More recent discussions of interest include:
 - Karl Aschenbrenner, The Concepts of Criticism (Dordrecht, 1974);
 - Monroe C. Beardsley, The Possibility of Criticism (Detroit, 1970);
 - John Casey, The Language of Criticism (London, 1966);
 - Marcia Cavell, "Critical Dialogue," Journal of Philosophy, LXVII (1970), 339-351;
 - Stanley Cavell, "Aesthetic Problems of Modern Philosophy," in Max Black (ed.), *Philosophy in America* (Ithaca, 1965);
 - Donald W. Crawford, "Causes, Reasons, and Aesthetic Objectivity," American Philosophical Quarterly, VIII (1971), 266-274;
 - Denis Dutton, "Criticism and Method," British Journal of Aesthetics, XIII (1973), 232-242;
 - Denis Dutton, "Plausibility and Aesthetic Interpretation," Canadian Journal of Philosophy, VII (1977), 327-340;
 - J. N. Findlay, "The Perspicuous and the Poignant," British Journal of Aesthetics, I (1967), 3-19;
 - E. D. Hirsch, Jr., Validity in Interpretation (New Haven, 1967);
 - I. C. Jarvie, "The Objectivity of Criticism of the Arts," Ratio, IX (1967), 67-83;
 - Stefan Morawski. "On the Objectivity of Aesthetic Judgement," British Journal of Aesthetics, VI (1966), 315-328;
 - Harold Osborne, "Taste and Judgement in the Arts," Journal of Aesthetic Education, V (1971), 13-28;
 - A. G. Pleydell-Pearce, "Objectivity and Value in Judgements of Aesthetics." British Journal of Aesthetics, X (1970), 25-38;
 - Colin Radford and Sally Minogue, "The Complexity of Criticism: Its Logic and Rhetoric," Journal of Aesthetics and Art Criticism, XXXIV (1976). 411-429;
 - Theodore Redpath, "Some Problems of Modern Aesthetics," in C. A. Mace (ed.), British Philosophy in the Mid-Century (London, 1966);
 - Michael Scriven, "The Objectivity of Aesthetic Evaluation," The Monist, L (1966), 159-187;
 - F. N. Sibley, "Aesthetic and Non-Aesthetic," *Philosophical Review*, LXXIV (1965), 135–159;
 - F. N. Sibley, "Objectivity and Aesthetics," Proceedings of the Aristotelian Society, Suppl. Vol. XLII (1968), 31-54;
 - F. N. Sibley, "Particularity, Art and Evaluation," Proceedings of the Aristotelian Society, Suppl. Vol. XLVIII (1974), 1-21;
 - Guy Sircello, A New Theory of Beauty (Princeton, 1975);
 - M. A. Slote, "Rationality of Aesthetic Value Judgements," Journal of Philosophy, LXVIII (1971), 821-839;

F. G. Sparshott, The Concept of Criticism (Oxford, 1967);

Alan Tormey, "Critical Judgments," Theoria, XXXIX (1973), 35-49;
Bruce Vermazen, "Comparing Evaluations of Works of Art," Journal of Aesthetics and Art Criticism, XXXIV (1975), 7-14.

Part Eight Fiction and Metaphor

The literary arts have been of philosophical interest chiefly in terms of the puzzles generated by the concepts of fiction and metaphor. Literature, of course, raises an important challenge to conventional views about aesthetic interests and aesthetic qualities (see Part One); its admission strengthens as well the need to provide a sufficiently general account of representation (see Part Five). Also, there is developing at the present time a strong interest in providing an analysis of literary pieces in terms of a speech-act model, now that that notion has become a settled part of the professional equipment of both philosophers and linguisticians. To some extent, speech-act features have always been a consideration in theorizing about fiction and metaphor, though recent discussions are explicitly indebted to the work of J. L. Austin, H. P. Grice, and John Searle and of innumerable others who have built on their original insights.

Philosophically considered, fiction interests us chiefly in the respects in which the sentences of a story may or may not function as do statements of fact. This is not to restrict the sort of sentences that appear in a story but rather to draw attention to the logical peculiarities involved in conceding that what is being told is a story. On the face of it, then, stories are not lies or false statements. The question is, what are the properties of sentences that enter into a story, in so far merely as fiction is concerned?

Whatever the account put forward, complications of at least two distinct sorts will have to be examined. One concerns the fact that stories are based on an experience of the world, sometimes even cast as historical or biographical novels. So one sometimes declares a story to be "true" or "true to life" or some such thing and even considers that the story may refer to the things of the world. The master question here is verisimilitude; and the philosophical puzzle, in a nutshell, is to reconcile the facts about these sorts of stories with the apparently fundamental thesis that fiction, as fiction, cannot be true or false. A second set of questions arises from the fact that, sometimes, statements of fact or moral maxims and the like may be told in story form, statements and maxims that are, on independent grounds, true or false, accurate or inaccurate, defensible or indefensible. And these questions call for a distinction between the special logical features of sentences in so far as they are used to tell a story and the features of a fictional style of speaking that is bound to some ulterior use of language—a distinction, say, between *Alice in Wonderland* and Aesop's *Fables*. One comes then to consider the differences between a fictional use of sentences and a fictional style that may relate to any use of sentences, such as stating a fact or prescribing a moral rule.

Once a contrast of this sort is admitted, the study of fiction suggests interesting comparisons. What, for instance, are the differences between telling a story and speaking jokingly or ironically? For all of these clearly concern ways of waiving or reversing considerations of truth and falsity and the like. These bear, therefore, on the discrimination of a certain favored set of speech acts. What, furthermore, may one say about poetry and drama? Do these concern uses of language like the fictional use of language or are they rather styles of language that may be fitted to any otherwise legitimate use of language, like making statements or judgments or recommendations? Both because of these complexities and because speaking jokingly and speaking ironically (irony of course is actually designated a trope) seem to involve certain distinctive speech acts and certain distinctive uses of words, we are led quite naturally to the topic of metaphor.

The late Margaret Macdonald has provided, in her contribution to an Aristotelian Society's symposium on fiction (1954), a challengingly clear analysis of the distinction of fictional language. The point at stake is the reducibility of fictional language to other well-known uses of language and the propriety of viewing all admissible specimens of fiction as exhibiting whatever essential distinction is claimed for fiction as such. Macdonald is particularly concerned to explain the sense in which reference in fiction is to be understood. Her solution, roughly, is that authors of fictions, in telling their stories, create the characters of those fictions or stories; reference, therefore, can be made to the characters created, though they "exist" or "can be found" only in the stories told. This obviously raises questions about equivocating on "exists." If one cannot refer to what does not exist and if one can somehow refer to a fictional character that "exists" in a story, what are we to suppose is the nature of the world that would tolerate such an adjustment? It has become a piece of philosophical orthodoxy to maintain that one cannot refer to what does not exist: in fact, the thesis has been dubbed (it seems, by John Searle) the Axiom of Existence. But many (including Searle) have been inclined to bend the Axiom so that a

Fiction and Metaphor

theory like that of Macdonald's would be compatible with it. Others of course, as Macdonald herself observes, have simply concluded that there is no reference in fiction qua fiction (though there may be in historical novels) or to fictional characters. And still others have argued that reference is essentially a grammatical distinction having no ontic import as such, that reference to what does not exist (even, cannot exist) is not in the least impossible. Alvin Plantinga (1974) attempts to solve the puzzle of reference by admitting that names in fiction do not denote actual or possible objects, that the seemingly referential devices of fictional sentences appear in so-called "stylized sentences," (existentially quantified sentences) with respect to a story's "story line" (a general proposition telling the story), and that the author does not assert the propositions of his story. The difficulty of Plantinga's proposal lies in the fact that the denial of the author's asserting the propositions of the story does not seem to affect the question of reference (say, along the lines Macdonald concedes) and that, were the Axiom of Existence rejected, the account given would actually appear to confirm reference.

The study of metaphor, on the other hand, inevitably invites comment on the general nature of figurative language. It turns out that figures of speech are often merely ornamental, in the sense that their analysis reveals no distinctive logical features that a comprehensive philosophical account of language would wish to accommodate. Metaphor does not seem to be ornamental in this sense. It undoubtedly has important implications for a theory of meaning.

It may be easily supposed that, since one speaks of metaphor as of a particular sort of figure, that all metaphors behave in the same way essentially. This may be disputed at once in at least one important respect. It is a matter of debate whether all metaphors may be paraphrased or not. To hold that metaphors can be correctly and more or less accurately paraphrased is, in effect, to hold that figurative language reduces to literal language, that the metaphoric remainder is merely an ornament, in a philosophically uninteresting sense. On the other hand, to hold that metaphors (at least certain sorts of metaphor) cannot be paraphrased is to suggest that a special account must be given of figurative sense, that metaphor is itself philosophically interesting and would provide specimen expressions whose meaning cannot be determined in those ways appropriate to literal sense. The evidence seems to be that, particularly in poetry, non-paraphrasable metaphors abound. The question is, what is the meaning of such expressions which, if taken literally, may even appear as nonsense, and how do we decide about their meaning?

The important clue lies in the parasitic nature of metaphor. Quite obviously, it trades on the literal meanings of the words it joins together in unexpected ways. We may also notice, incidentally, that the "literal sense"

on which it trades has an enormous spread-from standard dictionary meanings to looser suggestions, associations, even private asides. The question is, how does metaphor trade on literal sense? To put the matter this way is to see at once the inadequacy (though not the irrelevance) of any talk of resemblance and similarity. Resemblance is the favorite theme among theories of metaphor, but by itself it fails to touch on the use of resemblance and similarity (possibly also the use of lack of resemblance) that distinguishes metaphor proper from literal comparison, analogy, catachresis, simile, possibly even synecdoche and metonymy (see Part Five). Metaphor is particularly troublesome both because there is no question that the invention of metaphors involves taking liberties with the meanings of expressions and because to understand the figurative sense of such inventions requires attention to speakers' intentions and the exploitation of a linguistic tradition that cannot be neatly reduced to explicit rules. The admission of metaphor, therefore, must affect profoundly the adequacy of any theory of language.

One also notices, reverting to the tropes, that the principal tropesirony, synecdoche, metonymy, and metaphor-undoubtedly will not lend themselves to a single comprehensive analysis. One has only to see that irony directly affects the primary uses of language, such as making a statement or asking a question-speech acts, in short. One sees that it need not otherwise involve any departure from the literal sense of the words it employs; that, on the other hand, metaphor is not at all directly linked with speech acts, that it is more a semantic than a syntactical matter. In this sense, it is more closely related to codes and slang (though it cannot be identified with these) than it is to telling a story, speaking jokingly or ironically, or stating a fact. Also, it may be noted, an inevitable quibble dogs all candidate theories. The distinctions between metaphor, synecdoche, and metonymy are construed in stricter and looser ways by different theorists; in fact, some examples taken to be absolutely telling against a particular account may be found rejected as ineligible by the partisans of another theory. And this calls for caution in gauging the force of all arguments pro and con.

Max Black's discussion of metaphor (1954–1955) is generally conceded to be one of the indispensable papers on the subject. Black isolates a kind of metaphor (the "interaction view") that resists paraphrase. But his reasons for holding that these cannot be paraphrased have to do more with a view of the peculiarities of cognitive discovery than with the semantic function of metaphor as such. Black's account has had considerable influence, therefore, in the development of a theory of scientific theories. There is, also, much in what Black says that bears directly on the semantic function of metaphor that deserves to be further explored. The difficulty with the interaction view is simply that once the putative cognitive discovery is

Fiction and Metaphor

assimilated by a given community, the metaphor must fade (catachresis). But it is simply not true that non-paraphrasable metaphors always involve a new intellectual discovery; nor is it true that the assimilation of whatever might be supposed to have been the cognitive achievement associated with a metaphor entails the decline of that metaphor or its paraphrasability.

The Language of Fiction MARGARET MACDONALD

I

22.

Emma Woodhouse, handsome, clever and rich, with a comfortable house and happy disposition seemed to unite some of the best blessings of existence and had lived nearly twenty-one years in the world with very little to distress or vex her.

The opening sentence of Jane Austen's novel *Emma* is a sentence from fiction. *Emma* is a work in which the author tells a story of characters, places and incidents almost all of which she has invented. I shall mean by "fiction" any similar work. For unless a work is largely, if not wholly, composed of what is invented, it will not correctly be called "fiction." One which contains nothing imaginary may be history, science, detection, biography, but not fiction. I want to ask some questions about how an author uses words and sentences in fiction. But my interest is logical, not literary. I shall not discuss the style or artistic skill of any storyteller. Mine is the duller task of trying to understand some of the logic of fictional language; to determine the logical character of its expressions. How do they resemble and differ from those in other contexts? What are they understood to convey? Are they, e.g., true or false statements? If so, of or about what are they true or false? If not, what other function do they perform? How are they connected? These are the questions I shall chiefly discuss.

First of all, "fiction" is often used ambiguously both for what is fictitious and for that by which the fictitious is expressed. Thus "fiction" is opposed to "fact" as what is imaginary to what is real. But one must emphasize that a work of fiction itself is not imaginary, fictitious or unreal. What is fictitious

From *Proceedings of the Aristotelian Society*, Supplementary Volume XXVII (1954), pp. 165–184. Reprinted by courtesy of the Editor of the Aristotelian Society. © 1954 the Aristotelian Society.

Fiction and Metaphor

does not exist. There are no dragons in the zoo. But the novels of Jane Austen do exist. The world, fortunately, contains them just as it contained Jane Austen. They occupy many bookshelves. Works of fiction, stories, novels are additions to the universe. Any unreality attaches only to their subject matter.¹

Secondly, everyone understands the expressions of fiction. Or, if they do not, the reason is technical, not logical. One may find it hard to understand some of the expressions of Gertrude Stein or Finnegan's Wake but this is due to the peculiar obscurity of their style and not to the fact they occur in works of fiction. No one who knows English could fail to understand the sentence quoted from Emma. That Emma Woodhouse was handsome. clever, and rich is understood just as easily as that Charlotte Brontë was plain, sickly and poor. Both are indicative sentences which appear to inform about their subjects. But while the sentence containing "Charlotte Brontë" expresses a true statement of which Charlotte Brontë is the subject, that containing "Emma Woodhouse," cannot work similarly, since Jane Austen's Emma did not exist and so cannot be the logical subject of any statement. "Emma Woodhouse" does not and cannot designate a girl of that name of whom Jane Austen wrote. This has puzzled philosophers.² If apparent statements about Emma Woodhouse are about no one. of what is Jane Austen writing and how is she to be understood? Perhaps a subsistent wraith in a logical limbo is her subject? This will not do; or, at least not in this form. Jane Austen is certainly "pretending" that there was a girl called Emma Woodhouse who had certain qualities and adventures. According to one view she is understood because we understand from non-fictional contexts the use of proper names and the general terms in which she describes Emma Woodhouse and her adventure. There is no Emma Woodhouse, so Jane Austen is not writing about her; rather is she writing about a number of properties, signified by the general terms she uses, and asserting that they belonged to someone. Since they did not, "Emma Woodhouse" is a pseudodesignation and the propositions are false, though significant. Readers of Emma need not, and usually do not, believe falsely that its propositions are true. A work of fiction is, or is about, "one big composite predicate" and is so understood by readers who need neither know nor believe that any subject was characterized by it. If, however, there had been, by chance, and unknown to Jane Austen, a girl called Emma Woodhouse who conformed faithfully to all the descriptions of the novel, its propositions would have been about and true of her and Jane Austen would have "accidentally" written biography and not fiction.³

This seems a somewhat strained account of a story. As Moore says,⁴ it does seem false to deny that Jane Austen wrote about Emma Woodhouse, Harriet Smith, Miss Bates, Mr. George Knightley and the rest, but is, instead, about such a peculiar object as a "composite predicate." He would,

surely, find this quite unintelligible. It is also false to say that a work of fiction may be "accidentally" history or biography. For if there were ten girls called "Emma Woodhouse" of whom all that Jane Austen wrote were true, they are not the subject of *Emma*, for Jane Austen is not telling a story of any of them, but of a subject of her own invention. Moreover, it would not only be necessary that Emma Woodhouse should have a real counterpart but that such counterparts should exist for every other element of the novel. You cannot separate Emma from Highbury, her companions and the ball at the Crown. They all belong to the story. Such a coincidence would be almost miraculous. So Moore seems to be right when he says:⁵

I think that what he (Dickens) meant by "Mr. Pickwick" and what we all understand is: "There was only one man of whom it is true both that *I am going to tell you about him* and that he was called 'Pickwick' and that, etc." In other words, he is saying from the beginning, that he has one and only one man in his mind's eye, about whom he is going to tell you a story. That he has is, of course, false; it is part of the fiction. It is this which gives unique reference to all subsequent uses of "Mr. Pickwick." And it is for this reason that Mr. Ryle's view that if, by coincidence, there happened to be a real man of whom everything related of Mr. Pickwick in the novel were true then "we could say that Dickens' propositions were true of somebody" is to be rejected . . . since Dickens was not telling us of him: and that this is what is meant by saying that it is only "by coincidence" that there happened to be such a man.

I think this can be seen to be true even in circumstances which might appear to support Ryle's view. Jane Eyre and Villette are known to contain much autobiographical material. Charlotte Brontë knew her original as Dickens did not know of a "coincidental" Mr. Pickwick. Yet Jane Eyre and Villette are still works of fiction, not biography. They are no substitute for Mrs. Gaskell's Life of Charlotte Brontë. For although she may be using the facts of her own life, Charlotte Brontë is not writing "about" herself, but "about" Jane Eyre, Helen Burns, Mr. Rochester, Lucy Snowe, Paul Emmanuel and the rest. Or, she is writing about herself in a very different sense from that in which she is writing about the subject matter of her novels.

Ryle and Moore agree, with many others, that the sentences of fiction express false statements and Moore adds, I think rightly, that, so far, at least, as these are fictional, they could not be true. But there is a more radical view for which there is also some excuse. If a storyteller tells what he knows to be false, is he not a deceiver and his works a "tissue of lies?" That storytelling is akin to, if not a form of, lying is a very common view.

The Language of Fiction

"To make up a tale," "to tell a yarn" are common euphemisms for "to tell a lie." A liar knows what is true, but deliberately says what is false. What else does the storyteller do who pretends that there was a girl called "Emma Woodhouse," etc., when she knows this is false? A liar intends to, and does, deceive a hearer. Does not a storyteller do likewise? "Poets themselves," says Hume, "though liars by profession, always endeavor to give an air of truth to their fictions."6 Hume is contrasting all other expressions as indifferently lies or fiction, with those which are true of matters of fact. Hume is quite wrong to classify all poetry with fiction, though some stories may be told in verse. But no one could correctly call, e.g., Shakespeare's Sonnets, Keats' Odes or Eliot's Four Quartets, works of fiction. Nor are they statements of fact, but their analysis is not my task here. I wish only to protest against a common tendency to consign to one dustbin all expressions which do not conform to the type of statement found in factual studies. Even though they are not factual statements, expressions in literature may be of many different logical types. It is clear, however, that for Hume storytelling is a form of lying. And, indeed, a storyteller not only says what he knows to be false but uses every device of art to induce his audience to accept his fancies. For what else are the ancient incantatory openings, "Once upon a time ...," "Not yesterday, not yesterday, but long ago ...," and their modern equivalents, but to put a spell upon an audience so that the critical faculties of its members are numbed and they willingly suspend disbelief to enter the state which Coleridge called "illusion" and likened to dreaming?7 All this is true. Everyone must sometimes be informed, instructed, exhorted by others. There are facts to learn and attitudes to adopt. However dull, these processes must be endured. But no one is obliged to attend to another's fancies. Unless, therefore, a storyteller can convince, he will not hold an audience. So, among other devices, he "endeavors to give an air of truth to his fictions." It does not follow that what he says is true, nor that he is a deceiver. One must distinguish "trying to convince" from "seeking to mislead." To convince is a merit in a work of fiction. To induce someone to accept a fiction, however, is not necessarily to seduce him into a belief that it is real. It is true that some people may be deceived by fiction. They fail to distinguish conviction from deception. Such are those who write to the B.B.C. about Mrs. Dale and the Archers as if they believe themselves to be hearing the life histories of real families in these programs. But this does not show that the B.B.C. has deliberately beguiled these innocents. Finally, a liar may be "found out" in his lie. He is then discredited and his lie is useless. Nor is he easily believed again. But it would be absurd for someone to complain that since Emma was fiction he had "found out" Jane Austen and could never trust her again. The conviction induced by a story is the result of a mutual conspiracy, freely entered into, between author and audience. A storyteller does not lie, nor is

a normal auditor deceived. Yet there are affinities between fiction and lying which excuse the comparison. Conviction, without belief or disbelief, as in art, is like, but also very different from, unwitting deception. And a liar, too, pretends but not all pretending is lying.

A fictional sentence does not, then, express a lying statement. Does it express a false statement which is not a lie? False statements are normally asserted from total or partial ignorance of the facts. Those who assert them mistakenly believe they are true. This is not true of the storyteller. Neither he nor his auditor normally believes that his statements are true. It is false that Jane Austen wrote *Pickwick Papers* but it is not nonsense to suggest that it might have been true. As already seen, however, no factual discovery can verify a fictional statement. It can then never be true. So it would seem to be necessarily false or logically impossible. But the expressions of fiction are neither self-contradictory nor nonsensical. Most of them are perfectly intelligible. Those which are not are so for reasons quite unconnected with truth and falsity. It is not because James Joyce's statements are false that they are unintelligible. For those of Jane Austen and Dickens are equally false, but not obscure.

Alternatively, it might be said that the propositions of fiction are false, but neither believed nor asserted. Their fictional character consists in the fact that they are merely proposed for consideration, like hypotheses. "Let us suppose there was a girl called Emma Woodhouse, who . . . etc." For a proposition may be entertained, but yet be false. So an author puts forward and his audience considers, but neither affirm, the false propositions of fiction.8 Now, a storyteller does invite his audience to "Imagine that ...," "Pretend that " and even "Suppose that" or "Let it be granted that. . . ." He does not often preface his story with just these remarks, but he issues a general invitation to exercise imagination. So far one may liken his attitude to that of some one proposing an hypothesis in other fields. An hypothesis, like a lie or a story, requires some invention; it is not a report of observed fact. But these suggested fictional hypotheses are also very different from all others. Non-fictional hypotheses are proposed to explain some fact or set of facts. "If the picture is by Van Dyck, then . . . "; "Suppose that malaria is transmitted by mosquitoes, then . . . " They suggest, e.g., the origin of a painting or the cause of a disease. But a story is not told to solve any such problem. Moreover, a non-fictional hypothesis must be testable or be mere speculation without explanatory value. But, obviously, nothing can count as evidence in favor of a fictional story. And what no fact can confirm none can disconfirm either. So, if a story consists of propositions entertained for consideration, the purpose of such entertainment must be for ever frustrated since they can never be asserted as true, false, probable or improbable. I conclude, therefore, that

The Language of Fiction

the expressions of fiction do not function either as propositions or hypotheses.

Nevertheless, as I have said, one can easily understand why people are tempted to identify fictional expressions with lies, falsehoods, unverifiable hypotheses. For what it is worth, the English dictionary appears to support this view. "Fiction," it says, "the act of feigning, inventing or imagining: that which is feigned, i.e., a fictitious story, fable, fabrication, falsehood." If the last four terms are intended as synonyms, this certainly suggests that all fiction is falsehood. Both rationalist and religious parents have forbidden children to read fairy stories and novels lest they be led astray into false and immoral beliefs. Yet its logical difference from these seems to show that fiction is not false, lying or hypothetical statement. It is clear that "S pretends that p" cannot entail p. This is, again, the point of saying that the truth of p must be "coincidental." When discovered, no future S (or storyteller) could pretend that p, for one cannot pretend that a proposition is true when it is, and is known to be, true. But neither, in fiction, can "S pretends that p" entail "not-p," or even "Perhaps-p." So, fictional expressions must be of a different type from statements.

An alternative is the familiar emotive answer. This is associated chiefly with the name of I. A. Richards. I can mention it only briefly. According to it, sentences in fiction, as in all non-informative contexts, express an emotional state of their author and seek to induce a similar state in his audience. A work is judged better or worse according to the amount of harmonious mental adjustment by which it was caused and which it effects. This view is difficult to estimate because of its vague use of the word "express." It tends to suggest that the expressions of fiction are disguised exclamations such as "Hurrah!" or "Alas!" Or that these could be substituted for them. This, of course, is impossible. No one could tell the story of Emma in a series of smiles, sighs, tears, shouts or the limited vocabulary which represents such emotive expressions. Most stories, one must reiterate, are told in normal English sentences which are common to fact and fiction and appropriately understood. This is, indeed, just the problem. If the expressions of Jane Austen were as easily distinguishable from factual statement as exclamation from articulate utterance no one would be puzzled. "Emotive expression" must, therefore, be compatible with understood sense.9 It is true that emotional relationships play a large part in most fiction, but so does much else. Nor need these subjects coincide with the experience of either author or audience. No story, even though told in the first person, can be completely autobiographical without ceasing to be fiction. And whether or not a work of fiction uses autobiographical material, the actual, or suspected, direct intrusion of personal feeling by the author is liable to be fatal to the work.

I opened it at chapter twelve and my eye was caught by the phrase "Anybody may blame me who likes." What were they blaming Charlotte Brontë for, I wondered? And I read how Jane Eyre used to go up on the roof when Mrs. Fairfax was making jellies and look over the fields at the distant view. And then she longed—and it was for this that they blamed her—that "then I longed for a power of vision which might overpass that limit . . . I desired more of practical experience . . . more of intercourse with my kind . . . I believed in the existence of other and more vivid kinds of goodness and what I believed in I wished to behold . . . Who blames me? Many no doubt and I shall be called discontented . . . When thus alone I not infrequently heard Grace Poole's laugh."

That is an awkward break, I thought. It is upsetting to come upon Grace Poole all of a sudden. The continuity is disturbed. One might say, I continued . . . That the woman who wrote these pages had genius . . . but if one reads them over and marks that jerk in them, that indignation, one sees . . . that her books will be deformed and twisted. (Virginia Woolf; A Room of One's Own, p. 104.)

In short, Charlotte Brontë will, or will appear to, express her own feelings too nakedly through her heroine, in order to induce a sympathetic emotional response in her readers, instead of telling her story. Someone may protest that this amounts to describing, not expressing, her emotions. But this is not ostensibly so. The passage is still a soliloquy by Jane Eyre, not an introspective report by Charlotte Brontë. Virginia Woolf is giving an interpretation of the passage, but this would not be necessary if it were a simple description of Charlotte Brontë's feelings. If her critic is right and if, nevertheless, the passage is not what is meant by an expression of the author's emotion by fiction, this cannot be because it is a straightforward description of fact. Another objection might be that this is a crude example of expression and does not prove that the task of fiction is not to express emotion. Skilful expression is impersonal, almost anonymous. One cannot tell from their works what Shakespeare or Jane Austen felt. Hence the floods of speculation by critics. One knows only too well from her novels what Charlotte Brontë felt, so she is not truly expressing, but merely venting, her emotions. But then, if one so often cannot tell whose, or even what, emotion is being expressed, what is the point of saying that all fictional expressions are emotive? Should the criterion be solely the effect on their audience? Certainly, a tale may amuse, sadden, anger, or otherwise move a hearer. But is the fact that Emma may cause one to laugh or sigh what distinguishes it as a work of fiction from a statement of fact? This must be false for much that is not fiction has the same effect. The answer to the theory is that a work of fiction, like any work of literary art,

The Language of Fiction

causes a very special emotional effect, an harmonious adjustment of impulses, a personal attitude, not otherwise obtainable. But no independent evidence of any such pervasive effect is offered, nor can I, for one, provide it from experience of reading fiction. So, if one cannot distinguish fiction from fact by the normal emotional effects which fiction sometimes causes, nor by the pervasive changes it is alleged to cause, the theory only reformulates and does not explain this distinction.

But the theory does emphasize that language has less pedestrian uses than those of the laboratory, record office, police court and daily discourse. Also, that to create and appreciate fiction requires more than intellectual qualities. Most fiction would be incomprehensive to a being without emotions. One must be able to enter imaginatively into its emotional situations though its emotions need not be felt. One need not feel jealously either to construct or understand Mr. Knightley's censorious attitude to Frank Churchill, but someone who had never felt this might find an account of it unconvincing. Authors differ, too, in what may vaguely be called "climate" or "atmosphere," which is emotional and moral as well as intellectual. The "worlds" of Jane Austen and Henry James, e.g., differ considerably from those of Emily Brontë and D. H. Lawrence. Also, much of the language of fiction is emotionally charged. For it depicts emotional situations which are part of its story. But none of these facts is positively illuminated by a theory which limits the language of fiction to the expression of an emotion transferred from author to auditor even if such a transaction were fully understood. It does not seem to be the feeling which generates them nor that which they cause which wholly differentiates the ironies of Gibbon from those of I. Compton Burnett. Nor is it either Tolstoy or ourselves in whom we are primarily interested when reading War and Peace. Rather is it the presentation of characters, actions and situations. The vast panorama of the novel shrinks into triviality as the instrument of the emotional adjustments of Tolstoy and his readers. I conclude, therefore, that the characteristic which differentiates fictional sentences from those which state facts is not that the former exclusively express anybody's emotions, though many of them have a very vital connection with emotion.

Π

When someone reports a fact he may choose the language or symbolism of his report. He may choose to use this carefully or carelessly. But there is a sense in which he cannot choose what he will say. No one could report truly that Charlotte Brontë died in 1890; that she wrote *Villette* before *Jane Eyre*; that she was tall, handsome and a celebrated London hostess. No biography of Charlotte Brontë could contain such statements and remain a biography. For what is truly said of Charlotte Brontë must be controlled by what she was and what happened to her. But Jane Austen was under no

such restraints with Emma Woodhouse. For Emma Woodhouse was her own invention. So she may have any qualities and undergo any adventures her author pleases. It is not even certain that these must be logically possible, i.e., not self-contradictory. For some stories, and not the worst, are extremely wild. There is Finnegan's Wake as well as Emma. A storyteller chooses not only the words and style but also, and I suggest with them, provides the material of a fictional story. I want to stress this fact that in fiction language is used to create. For it is this which chiefly differentiates it from factual statement. A storyteller performs; he does not-or not primarily-inform or misinform. To tell a story is to originate, not to report. Like the contents of dreams, the objects of fiction may pre-suppose, but do not compete with, those of ordinary life. Unlike those of dreams, however, they are deliberately contrived. Hence, they differ too from lunatic frenzies. A lunatic unintentionally offends against fact and logic. He intends to respect them. He thinks he is right, however wild his fancies, when he is always wrong. But a storyteller, though equally wild, is never deluded. He invents by choice, not accident.

As I have already said, most of a storyteller's words and sentences are understood to have the same meanings as the same words and grammatical forms in non-fictional contexts. For all who communicate use the same language, composed mainly of general terms. But language may be used differently to obtain different results. When a storyteller "pretends" he simulates factual description. He puts on an innocent air of informing. This is part of the pretence. But when he pretends, e.g., that there was a Becky Sharp, an adventuress, who finally came to grief, he does not inform or misinform about a real person called "Becky Sharp" or anyone else: he is creating Becky Sharp. And this is what a normal audience understands him to be doing. Of course, he does not thereby add to the population of the world. Becky Sharp is not registered at Somerest House. But this, too, is shown by language. A storyteller, like a dramatist, is not said to create persons, human beings, but characters. Characters, together with their settings and situations, are parts of a story. According to Ryle, although "it is correct to say that Charles Dickens created a story, it is wholly erroneous to speak as if Dickens created Mr. Pickwick."10 But Dickens did create Mr. Pickwick and this is not equivalent to saying, as Ryle does, that what Dickens created was a "complex predicate." No one would ever say this. But it is perfectly ordinary and proper to say that an author has created certain characters and all that is required for them to function. "In Caliban," said Dryden, "Shakespeare seems to have created a being which was not in nature."11 He was not in nature because he was part of The Tempest. To create a story is to use language to create the contents of that story. To write "about" Emma Woodhouse, Becky Sharp, Mr. Pickwick, Caliban, and the rest is to "bring about" these characters and their worlds. Human

The Language of Fiction

beings are not normally called "characters." If they are, it is by analogy with art. One might say, "I met a queer character the other day; he might have been created by Dickens." This does not show that Dickens wrote or tried to write about such a person, but that his readers now view their fellows through Dickens' works. So may one now see Constable and Cézanne pictures in natural landscapes, which would not have been seen without these artists. Characters play a rôle; human beings live a life. A character, like all else in pure fiction, is confined to its rôle in a story. Not even the longest biography exhausts what could be told of any human person, but what Jane Austen tells of Emma Woodhouse exhausts Emma Woodhouse. A character may be completely understood, but the simplest human being, if any human being is simple, is somewhere opaque to others. A character has no secrets but what are contained within five acts or between the covers of a book or the interval from supper to bedtime.¹² A story may, indeed, have a sequel, but this is a new invention, not a report of what was omitted from the original.

This may be challenged. Surely, it will be said, many characters in fiction are as complex as human beings? Do not critics still dispute about the motives of Iago and the sex of Albertine? But to say that a character is limited to what is related of it in a story does not imply that this must always be indisputably obvious. All it implies is that the only way to find out about a character is to consult the author's text. This contains all there is to discover. No one can find independent evidence which the author has missed. Not even Dr. Ernest Jones for the alleged "complexes" of Hamlet. Assuming that the text is complete and authentic, there may be different interpretations of it and thus of a character but no new evidence such as may render out of date a biography. No one will find a diary or a cache of letters from Hamlet to his mother which will throw light upon his mental state. Nor must this be forever secret in the absence of such evidence. For Hamlet is what Shakespeare tells and what we understand from the text, and nothing more.

What is true of characters is true also of other fictional elements of a story. "Barchester" does not name a geographical place. It is the setting or scene of a number of Trollope's characters. So is his magic island for Prospero and his companions. The words used to "set the scene" of a story paint as it were the backcloth to its incidents. "Scene" is a term of art, a word from the language of the theatre. One would naturally say "The scene of Archdeacon Grantley's activities is laid in Barchester," but not, unless affecting histrionics, "The scene of this Conference is laid in Oxford." It would be more normal to say "This Conference is being held in Oxford." "Scene" is used of natural situations only when they are being treated artificially. Finally, the situations and incidents of a story form its plot. They conform to a contrived sequence of beginning, middle and end -or have some modern variety of this shape. But human life and natural events do not have, or conform to, a plot. They have no contrived shape.

It is thus, then, that we talk of works of fiction and their fictional contents. They are contrivances, artefacts. A story is more like a picture or a symphony than a theory or report. Characters, e.g., might for a change, be compared with musical "themes" rather than with human flesh and blood. A composer creates a symphony, but he also creates all its several parts. So does a storyteller, but his parts are the characters, settings and incidents which constitute his story. The similarity is obscure just because the storyteller does, and must, use common speech with its general terms, so that he appears to assert propositions about an independent reality in a manner similar to that of one who does or fails to report what is true. So, philosophers conclude, since pure fiction cannot be about physical objects, it must be about wraith-like simulacra of real objects or equally attentuated "predicates." I do not, however, want to claim a special mode of existence for fictional objects as the contents of fiction. And though it is obvious that fiction writers use our common tongue I do not think that what they do is illuminated by saying that they write about predicates or properties. It is agreed that a storyteller both creates a story, a verbal construction, and the contents of that story. I want to say that these activities are inseparable. Certainly, no one could create pure fiction without also creating the contents which are its parts. One cannot separate Emma Woodhouse from Emma as one can separate Napoleon from his biography. I do not say that Emma is simply identical with the words by which she is created. Emma is a "character." As such she can, in appropriate senses, be called charming, generous, foolish, and even "lifelike." No one could sensibly use these epithets of words. Nevertheless, a character is that of which it makes no sense to talk except in terms of the story in which he or she is a character. Just as, I think, it would make no sense to say that a flock of birds was carolling "by chance" the first movement of a symphony. For birds do not observe musical conventions. What is true of characters applies to the settings and incidents of pure fiction. To the questions "Where will they be found?"; "Where do they exist?," the answer is "In such and such a story," and that is all. For they are the elements or parts of stories and this is shown by our language about them.

But the content of very little fiction is wholly fictitious. London also forms part of the setting of *Emma* as it does of many of Dickens' novels; Russia of *War and Peace* and India of *A Passage to India*. Historical persons and events also seem to invade fiction. They are indeed the very stuff of "historical" novels. Do not the sentences in which the designations or descriptions of such places, persons and incidents occur express true or false statements? It is true that these real objects and events are mentioned in such fictional expressions. Nevertheless, they certainly do not function

The Language of Fiction

wholly as in a typographical or historical record. They are still part of a story. A storyteller is not discredited as a reporter by rearranging London's squares or adding an unknown street to serve his purpose. Nor by crediting an historical personage with speeches and adventures unknown to historians. An historical novel is not judged by the same standards as a history book. Inaccuracies are condemned, if they are, not because they are bad history or geography, but because they are bad art. A story which introduces Napoleon or Cromwell but which departs wildly from historical accuracy will not have the verisimilitude which appears to be its object and will be unplausible and tedious. Or if, nevertheless, interesting will provoke the question, "But why call this character Oliver Cromwell, Lord Protector of England?" Similarly, for places. If somewhere called "London" is quite unrecognizable, its name will have no point.

So I am inclined to say that a storyteller is not making informative assertions about real persons, places and incidents even when these are mentioned in fictional sentences. But rather that these also function like purely fictional elements, with which they are always mingled in a story. Russia as the setting for the Rostovs differs from the Russia which Napoleon invaded which did not contain the Rostovs. There was a battle of Waterloo, but George Osborne was not one of its casualties, except in Thackeray's novel. Tolstoy did not create Russia, nor Thackeray the battle of Waterloo. Yet one might say that Tolstoy did create Russia-as-the-background-of the-Rostovs and that Thackeray created Waterloo-as-the-scene-of-George-Osborne's-death. One might say that the mention of realities plays a dual rôle in fiction; to refer to a real object and to contribute to the development of a story. But I cannot pursue this, except to say that this situation differs from that in which, e.g., Charlotte Brontë uses the real events of her life in Jane Eyre. For she does not mention herself nor the real places and incidents upon which her story is modelled.

I have tried to say how the expressions of fiction operate and to show that they differ both from statements and emotive expressions. I also began by asking how they are connected. It is clear that their order need not be dictated by that of any matter of fact. Nor are they always even bound by the principles of logic. Do their connections, then, follow any rule or procedure? Is there a conception by which their transitions may be described? Since a work of fiction is a creative performance, however, it may be thought senseless to ask for such rules or such a conception. Is not the creation of that which is new and original, independent of logic and existence, just that to which no rules are appropriate and no conception adequate? But the creation of a work of fiction, however remarkable, is not a miracle. Nor is its author's use of language entirely lawless and vagabond but is directed by some purpose. Certainly, no set of rules will enable anyone to write a good novel or produce a good scientific hypothesis. But a scientist employs his ingenuity to invent a hypothesis to connect certain facts and predict others. He provides an organizing concept related to the facts to be organized and governed by the probability that it provides the correct explanation. As already emphasized, the situation of the storyteller is different.

In his Preface to The Portrait of a Lady, Henry James recalls that in organizing his "ado" about Isabel Archer, having conceived the character, he asked, "And now what will she do?" and the reply came immediately, "Why, the first thing she will do will be to come to Europe." He did not have to infer, guess, or wait upon observation and evidence; he knew. He knew because he had thus decided. He so decided, no doubt, for a variety of artistic reasons; to develop his conception of a certain character in relation to others, against a particular background, in accordance with his plot. His aim was to produce a particular, perhaps a unique, story; a self-contained system having its own internal coherence. There is certainly a sense in which every work of fiction is a law unto itself. Nevertheless, I think there is a general notion which governs these constructions though its application may give very different results. This is the Aristotelian notion which is usually translated "probability" but which I prefer to call "artistic plausibility." This is not an ideal phrase but it is preferable to "probability" which suggests an evidential relation between premisses and conclusion and "possibility" which suggests a restriction to logical conceivability which might exclude some rare, strange and fantastic works. It is, moreover, a notion which applies only to what is verbal. Though some comparable notion may apply to them, one does not normally talk of "plausible" pictures, statues and symphonies, but does talk of "plausible stories." A plausible story is one which convinces; which induces acceptance. But since the plausibility is artistic plausibility, the conviction induced will not be the belief appropriate to factual statement. Nevertheless, one drawback to the notion is that it may suggest that all fiction is, or should be, realistic or naturalistic. It is true that although fiction does not consist of statements about life and natural events, yet much fiction does take lived experience as a model for its own connections. Sometimes, as with Charlotte Brontë's novels, using autobiographical material. Such stories convince by being "lifelike." But by no means all fiction is thus naturalistic. Nor is a story allegedly founded on fact necessarily fictionally convincing. To repeat the Aristotelian tag, "a convincing impossibility is better than an unconvincing possibility." There is, in fact, a range of plausible connections in fiction, varying from the purest naturalism to the wildest fantasy. If any convinces then it is justified. Much should obviously be said about who is convinced and whether he is a reliable judge, but I can do little more here than indicate the type of connection which differentiates works of fiction from descriptions of fact. It is the task of the literary critic to analyze the differ-

The Language of Fiction

ent types of plausibility, exemplified by, e.g., Emma, War and Peace, The Portrait of a Lady, Wuthering Heights, Moby Dick, Alice in Wonderland and Grimm's Fairy Stories. And though, perhaps, no rules can be given for attaining any particular type of plausibility, yet it is sometimes possible to say what does or would make a work unplausible. A mixture of elements from different plausible systems would, e.g., have this result. It is quite plausible that Alice should change her size by drinking from magic bottles, but it would be absurd that Emma Woodhouse or Fanny Price should do so. Or, to make such an incident plausible, Jane Austen's novels would need to be very different. For it would have needed explanation in quite different terms from the conventions she uses. This also applies to more important plausibilities. Emma Woodhouse could not suddenly murder Miss Bates after the ball, or develop a Russian sense of sin, without either destroying the plausibility of the novel or bringing about a complete revolution in its shape, though these incidents are in themselves more likely than that which befell Alice. But such examples raise questions about fiction and fact; art and life which I cannot now discuss.

Notes

1. Cf. also "Art and Imagination," Proc. Aris. Soc., 1952-1953, p. 219.

2. See earlier Symposium on "Imaginary Objects," Proc. Aris. Soc., Supp. Vol. XII (1933), by G. Ryle, R. B. Braithwaite and G. E. Moore.

3. Loc. cit., G. Ryle, pp. 18-43.

4. Ibid., p. 59.

5. Loc. cit., p. 68.

6. Treatise of Human Nature, Bk. I, pt. 3, sec. 10.

7. Cf. Notes on The Tempest from Lectures on Shakespeare.

8. I understood Professor Moore to hold such a view in a discussion in 1952. I do not, however, claim his authority for this version. Nor do I know if he is still of the same opinion.

9. Cf. also Empson, The Structure of Complex Words (London, 1951), ch. 1. 10. Loc. cit., p. 32.

11. Quoted by Logan Pearsall Smith, S.P.E. Tract XVII, 1924.

12. See also E. M. Forster, Aspects of the Novel, chs. 3 and 4.

Possible But Unactual Objects: On What There Isn't

ALVIN PLANTINGA

1. Predicative and Impredicative Singular Propositions

Our subject has been the venerable contention that there are or could be possible objects that do not exist—more specifically, the Classical Argument for that claim. This argument, you recall, had three essential premisses:

- (1) There are some singular negative existential propositions,
- (2) Some singular negative existentials are possibly true, and
- (3) Any world in which a singular proposition is true, is one in which *there* is such a thing as its subject, or in which its subject has being if not existence.

[Earlier] we examined objections to (1); we have found them wanting. Among the things there are we do indeed find such singular existential propositions as

(23*) Socrates exists

i.e. Socrates has the property of existing; and such singular negative existentials as

(13*) Socrates does not have the property of existing.

Furthermore, some of these singular negative existentials are indeed possible. So if we accept the Ontological Principle . . . we seem to find the original argument intact. We seem committed to the supposition that there are or could have been possible but nonexistent objects.

From Alvin Plantinga, *The Nature of Necessity* (Oxford: Clarendon Press, 1974), Chapter 8. Reprinted by permission of Oxford University Press.

Possible but Unactual Objects

But now suppose we take a closer look at singular propositions and the Ontological Principle. The former, we recall, come in two varieties: those that *predicate* a property of their subject, and those that *deny* a property of it. We may call them respectively *predicative* and *impredicative* singular propositions.

(4) Socrates was snubnosed,

for example, is a predicative singular proposition. What would be an example of an impredicative singular proposition?

(5) Socrates was not snubnosed,

we say, pleased with our alacrity. But the sentence (5) is ambiguous; it may express either

(5') Socrates was nonsnubnosed

which is really a predicative singular proposition, or

(5") It is false that Socrates was snubnosed

which is properly impredicative. There is a *de-re-de dicto* difference here; (5') predicates of Socrates the property of being nonsnubnosed, while (5'') predicates of (4) the property of being false.

Now the Ontological Principle does have a certain attractiveness and plausibility. But (as presently stated, anyway) it exploits our tendency to overlook the difference between (5') and (5''). Its plausibility, I suggest, has to do with *predicative* rather than impredicative singular propositions; with propositions like (5') rather than ones like (5''). It is plausible to say that

(6) Any world in which a *predicative* singular proposition is true, is one in which the subject of that proposition has being or existence.

Call this *The Restricted Ontological Principle*. Not only is this plausible; I think it is true. For any world in which there is a true predicative singular proposition whose subject is Socrates, let us say, is a world in which Socrates has some property or other. If such a world had been actual, Socrates would have had some property. And how could he have had a property if there simply were no such thing as Socrates at all? So (6) is true. But if we fail to note the distinction between

(5') Socrates was nonsnubnosed

and

(5") It is false that Socrates was snubnosed

we may inadvertently credit the Ontological Principle with a plausibility that properly belongs to the Restricted Ontological Principle alone. For if we fail to note that a proposition *denying* a property P of Socrates need not predicate its complement of him, we easily fall into the error of supposing that the contradictories of predicative propositions are themselves predicative. And in the presence of their error the Restricted and unrestricted Ontological Principles are equivalent. Feeling the legitimate tug of the former, we seem obliged to assert the latter, which together with the truths (1) and (2) entails that there are or could have been things that do not exist.

But once we recognize the distinction between predicative and impredicative singular propositions, we can give the Restricted Ontological Principle its due without endorsing the Classical Argument. For this distinction applies of course to singular existentials as well as to other singular propositions. We must distinguish the impredicative

(13*) Socrates does not have the property of existing

better put, perhaps, as

(13*) It is false that Socrates has the property of existing

from the predicative

(13**) Socrates has the property of nonexistence.

 (13^*) is the contradictory of (23^*) and is true in just those worlds where the latter is false. We need not conclude, however, that (13^{**}) is true in those or any other worlds; and in fact, I suggest, this proposition is true in no possible worlds whatever. If there *were* a world in which (13^{**}) is true, then certainly in that world Socrates would be but not exist. But the fact is there are no such worlds. (13^{**}) is necessarily false; and Socrates is essentially existent.

2. The Classical Argument Fails

The sentence 'Socrates does not exist,' therefore, can be used to express three quite different propositions: (13), the proposition, whatever exactly

Possible but Unactual Objects

it is, that a historian might claim to discover; (13^*) , the impredicative singular proposition; and (13^{**}) , a necessarily false proposition predicating of Socrates the property of nonexistence. Accordingly, the proper response to the Classical Argument is this. Indeed some singular negative existentials are possibly true: those that are impredicative. But once we have the distinction between predicative and impredicative singular propositions clear, we see that it is the Restricted Ontological Principle, not its unrestricted colleague, that is intuitively plausible. Given this principle and the possible truth of impredicative singular negative existentials, however, it does not follow that there are or could have been things that do not exist.

A firm grasp on the distinction between predicative and impredicative singular propositions enables us to clear up a residual anomaly attaching to (6). That principle affirms that a world in which a singular predicative proposition is true, is one in which its subject either exists or *has being*; but now we see that this second disjunct is as pointless as it is puzzling. The truth of the matter is

(7) Any world in which a singular predicative proposition is true, is one in which its subject *exists*.

Failing to note the distinction between predicative and impredicative singular propositions (and consequently assuming them all predicative) we may reason that (7) must be false as follows: clearly there are worlds where singular negative existentials are true; but by hypothesis their subjects do not *exist* in those worlds; so (7) must be false. But now we see the error of our ways: although some singular negative existentials are possibly true, none of these are predicative. So this implausible notion of being or thereisness is uncalled for; and there remains no obstacle to accepting (7)—which, after all, is both the source of the attractiveness of the Ontological Principle and the truth in it.

Accordingly, singular propositions like

(8) Socrates is wise

and

(9) Socrates is unwise

are true only in worlds where their subject exists. (8) and (9) are not true where Socrates does not exist, where Socrateity is not exemplified. If W is a world where Socrates does not exist, both (8) and (9) are false in W and their impredicative denials are both true. In worlds where he does not exist, Socrates has no properties at all, not even that of nonexistence.¹

3. Creatures of Fiction

But now we must recognize a consideration that has been clamouring for attention all along. Statements like

(10) Hamlet was unmarried

and

(11) Lear had three daughters

are obviously, we shall be told, true singular statements about Hamlet and Lear. Hence Hamlet and Lear must be objects of some kind or other and must have being of some kind or other. Now Hamlet and Lear do not in fact exist; but clearly they could have. So there must be possible worlds in which Lear and Hamlet exist; hence they are possible but unactual objects; hence there are some.

Essential to this argument is the idea that when we say 'Hamlet was unmarried' we are talking about an object named 'Hamlet' and describing it by predicating of it a property it actually has—the idea that such statements as (10) and (11) are indeed singular statements about objects named 'Hamlet' and 'Lear.' Call this 'the Descriptivist Premiss'; and suppose we examine it. Stories (taken broadly) are to be thought of as descriptions of something or other; they consist in true assertions about objects of a certain sort. Ophelia was indeed Hamlet's girl friend, just as the play has it; and when we make this assertion we are predicating that property of an object that does not exist but could have.

There are initially at least three objections to this account—three peculiar and interesting facts about fiction that the view in question does not easily accommodate. First of all, both 'Lear exists' and 'Lear does not exist' express true propositions. Although Lear does not *really* exist, he does exist *in the play*—just as certainly as he has three daughters in the play. In this regard, his status differs from that of the Grand Inquisitor in the *Brothers Karamazov*; the latter is only a character in Ivan's parable and exists neither in reality nor in the novel. On the Descriptivist Account it is easy to see that Lear does not exist; after all he is a nonexistent possible object. But how then shall we contrast his status with that of the Grand Inquisitor? Shall we say that the latter is a merely possible possible object?

Secondly, sentences such as

(12) Santa Claus wears a size ten shoe

Possible but Unactual Objects

seem to have a peculiar status. The myths and legends say nothing about the size of Santa's feet. It seems wrong, however, to say that we just do not happen to *know* whether (12) is true or false; there seems nothing *to* know here. But on the descriptivist view presumably Santa Claus (who clearly has feet) does have either a size ten foot or else a foot of some other size.

Thirdly, such statements as (10) and (11) are presumably *contingent* on the Descriptivist View. In fact Lear had just three daughters, but no doubt in other possible worlds he has maybe one son and three daughters. Now how did Shakespeare know just how many children to give him? If it is only a contingent truth that he has just three daughters, then is it not quite possible that Shakespeare made a mistake? Perhaps he had only two daughters, Goneril being the fruit of an illicit liaison between Lear's wife and Gloucester. Perhaps Shakespeare was unaware of the fact that Lear once took a trip through the Low Countries, was enamoured of a Frisian milkmaid, and became the progenitor of a long line of Calvinist clergymen.

But of course these suppositions are absurd. You and I can get Lear's properties wrong; not having read the play recently I may perhaps think that he had just one daughter; but Shakespeare could not have made that sort of mistake in creating the play. Still, does the Descriptivist View not imply that he could? If Shakespeare, in writing his play, is *describing* something, it would certainly seem plausible to suppose that he could *mis*-*describe* it, get its properties wrong. And how can the descriptivist view accommodate this fact?

Another difficulty has been emphasized by David Kaplan. According to Descriptivism, (10) and (11) express singular predicative propositions about Hamlet and Lear. If so, then 'Lear' in (11) must be functioning as a proper name—a name of a possible but unactual object. But how could it be? On the Searlean view of proper names, one who thus uses 'Lear' must be able to produce an *identifying description* of what he uses it to name. And how could he do that? He starts as follows: Lear is the possible individual who has the properties P_1, P_2, \ldots, P_n . But why does he suppose that there is just one possible individual with the Pi? If there are any possible objects that have the P_i there will be as many as you please. For take any property $P_n + 1$ such that $P_n + 1$ and its complement are both consistent with the P_i; there will be a possible object that has the P_i and also $P_{n} + 1$, and another with the P_{i} and the complement of $P_{n} + 1$. So how can he single out any one possible but unactual object? A similar fate awaits this view on the historical chain account of names. For the latter requires that a name originate in some kind of dubbing or baptism, broadly conceived. But this means that some person or persons were able to specify or identify the dubbee-perhaps ostensively, perhaps by description. And how could this be done? Clearly no possible but nonexistent individual was dubbed 'Lear' by someone who had it in full view and solemnly (or frivolously) intoned "I dub thee 'Lear.' " So it must have been by description. But then we are back to the previous problem: what was the description and what reason is there for thinking there is just *one* possible individual meeting it? As Kaplan says,

I fear that those who would so speak have adopted a form of dubbing which corresponds to the logician's existential instantiation: There is at least one cow in yonder barn. Let's call one of them 'Bossie.' Now, how much do you think she weighs? I am skeptical of such dubbings. The logician is very careful in *his* use of such names.²

Still the Descriptivist is perhaps not entirely without reply. Suppose we try to develop his reply, as much, perhaps, in the spirit of playful exercise as in that of sober inquiry. No doubt we cannot name just *one* possible object, just as it is not possible (without further ado) to name just one of the cows in Kaplan's barn. But perhaps we need not name things one at a time. Perhaps we can name *all* the cows in the barn at one fell swoop we could name them all 'Bossie.' If we felt so inclined, we could name every lion in Africa 'Frazier.' No doubt this would be a pointless procedure; still, it could be done. Now why cannot the friend of possibles do the same? He thinks there are many possible objects with the properties Shakespeare attributes to Lear. Why not suppose that when Shakespeare writes his play, he engages in a peculiar kind of dubbing? Perhaps in telling this story Shakespeare is naming every possible object that fits the specifications of the play; he is naming them all 'Lear.'

But here we meet a couple of complications. First, consider these possible objects he is naming 'Lear.' Where do they have the relevant properties? According to Descriptivism, the answer is in α , the actual world. But there are reasons for doubt; a wiser answer would be that these are the things that have those properties in some world or other. For first, a story may imply that one of its characters is unique. Suppose Frederick Manfred (formerly Feike Feikema) writes a story about someone described as the meanest man in North Dakota. Presumably the friend of possibles will not wish to commit himself to the claim that there is a possible man in North Dakota that has the property of being meaner than any other manactual or possible-in North Dakota. He may prefer to hold that for any degree of meanness you pick, there is a possible North Dakotan meaner than that. And even if there is a maximal degree of North Dakotan meanness-one such that it is not possible to be both meaner and in North Dakota-it is at best extremely unlikely that Manfred's hero displays it. On the other hand, there are (on this view) any number of possible objects

Possible but Unactual Objects

and worlds such that the former have in the latter the property of being the meanest man in North Dakota. Secondly, a story may detail certain relationships between its characters and actual objects. In H. G. Wells's *War of the Worlds* the Martians destroy New York City sometime during the first half of the twentieth century. But the fact is New York was not destroyed during that period. Not in α , that is; but in plenty of other possible worlds. So Wells's story must be about creatures that destroy New York City in some world distinct from α . Thirdly, we have already seen that some fictional characters are presented as really existing—Ivan, for example, as opposed to the Grand Inquisitor. But Ivan does not exist in α ; so the story describes him as he is in some other possible world.

A second complication: Hamlet is not the only character in *Hamlet*; there are also Ophelia, Rosencrantz, Polonius, and all the rest. So in writing the play Shakespeare is not confined to naming things 'Hamlet.' He also dubs things 'Rosencrantz,' 'Guildenstern,' 'Polonius,' and the like. (Indeed, perhaps he is naming some object both 'Rosencrantz' and 'Guildenstern'; for perhaps there is a possible object x and worlds W and W* such that x has the properties the play ascribes to Rosencrantz in W and those of Guildenstern in W*.) The play determines a complex n-place relation (n fixed by the number of its characters); and where R is this relation, the playwright gives the name 'Hamlet' to each possible object x_1 for which there are n - 1 possible objects x_2, \ldots, x_n such that there is a possible world in which x_1, x_2, \ldots, x_n stand in R.

So on this neo-Descriptivist view sentences like

(10) Hamlet was unmarried

and

(11) Lear had three daughters

express singular propositions. Indeed, each expresses an enormous multitude of such propositions: (10), for example, expresses a different singular proposition for each possible object named 'Hamlet'—one for each object that is the first member of some appropriate *n*-tuple. Now none of these propositions is true in α ; but where, then, *are* they true? Consider the possible worlds in which *R* is exemplified by an *n*-tuple of objects that do not exist in α : call these *Hamlet Worlds*. For each possible object *x* dubbed 'Hamlet' by the play, there is a class of Hamlet Worlds in which *x* exists and has the appropriate properties. Furthermore, for each such class there will be some state of affairs *S* such that *S* but no state of affairs including but distinct from *S*, obtains in each member of the class; these are *Hamlet Situations*. For each object named 'Hamlet' there is a distinct Hamlet Situation. And a sentence like (10) expresses a multitude of propositions, each true in³ at least one Hamlet situation. So propositions from fiction are not in *fact* true; when we say of such propositions as (10) that they *are* true, we are to be understood as pointing out that they are true in some Hamlet Situation.

Thus (10) expresses indefinitely many singular propositions; this embarrassment of riches is no real embarrassment, however, since each is true—that is, each is true in a Hamlet Situation. Hence for most purposes we can ignore their plurality and pretend that (10) expresses but one proposition. And now note how neatly we thus elude the three difficulties that initially beset descriptivism. First, there was the objection that both 'Hamlet exists' and 'Hamlet never really existed' seem to express true propositions. Now we see that the second expresses a bevy of propositions each true in fact, in the actual world, while the first expresses a host of propositions true in the fashion appropriate to fiction—that is, each is true in a Hamlet Situation. Secondly, there was the fact that a sentence like

(13) Hamlet wore size ten shoes

seems to have a peculiarly indeterminate status: we feel uncomfortable ascribing either truth or falsity to it. Now we see that our hesitation is justified; for while this sentence expresses a vast company of propositions, none is true or false in any Hamlet Situation. Thirdly, we asked how the Descriptivist can handle Shakespeare's apparent immunity from error in asserting what appear to be contingent propositions. But now we see that in writing the play he concurrently names objects 'Hamlet' and selects states of affairs—the very states of affairs in which the named objects have the properties with which he credits them. So it is no wonder that he cannot easily go wrong here.

Thus does neo-Descriptivism retain the descriptivist posture. But perhaps we must concede that it has about it an air of the arcane and epicyclic. And anyway a descriptivism without the claim that stories give us the sober literal truth—truth in the actual world—about possible objects is like a Platonism without the forms: emasculated, at best. More important, however, is the following point. The Descriptivist position as initially presented contained an *argument* for the claim that there are nonexistent possibles. This argument loses whatever force it may have had once the descriptivist concedes that stories do not apprise us of properties their subjects have in the actual world. For if descriptivist intuitions are satisfied by the suggestion that a story describes its characters as they are *in other possible worlds*, why not hold instead that a piece of fiction is about *n*-tuples of *actual* objects, ascribing to them properties *they* have in other worlds? If we think stories must be *about* something, why not think of them as about existent objects? No doubt there are possible worlds in which Ronald

Possible but Unactual Objects

Reagan, for example, is named 'Rip van Winkle' and has the properties depicted in Irving's story. If we are bent upon a descriptivist account we may suppose that Irving is describing Reagan as he is in these worlds (and the rest of us as we are in our Rip van Winkle worlds). For any fictional character there will be real objects and worlds such that the former have in the latter the properties credited to the fictional character. And hence we have no reason for supposing that stories about Pegasus, Lear, and the rest are about possible but unactualized objects—even if we accept the dubious supposition that they must be about objects of some kind or other.

4. Names: Their Function in Fiction

The fact, however (or so it seems to me), is that names such as 'Lear,' 'Hamlet,' 'Superman,' and the like do not (as they normally function in fiction) serve to denote any objects at all. How then *do* they function? Perhaps as follows. Someone writes a story entitled "George's Adventures": "Once upon a time," he begins, "there was a boy named George who lived in Jamestown, North Dakota. George had many splendid adventures. For example, once he was attacked by an aroused prairie dog when he inadvertently stepped on its burrow. . . ." No doubt "George's Adventures" will not win many prizes; but what, fundamentally, is the author doing in telling this story? Fundamentally, I suggest, he presents and calls our attention to a certain proposition or state of affairs. He brings it to mind for us, helps us focus our attention upon it, enables us to entertain, explore, and contemplate it, a procedure we find amusing and titillating or edifying and instructive as the case may be.

But what sort of proposition does the author present? In the simplest typical case—where, let us say, the story has only one character—a general proposition, one that could be expressed by an existentially quantified sentence whose conjuncts correspond roughly to the results of replacing 'George' in the story's sentences by the quantifier's variable. Let us call the proposition thus related to a story the story's *Story Line* and such an existentially quantified sentence expressing it a *Stylized Sentence*. The initial segment of a Stylized Sentence expressing the Story Line of "George's Adventures" will look like this:

(14) (Ex) x was named 'George' and x had many splendid adventures and....

where the succeeding conjuncts result from the story's succeeding sentences by replacing occurrences of 'George' therein by the variable 'x.' Of course the correspondence is *rough*. For example "George's Adventures" could have begun thus: "George lived in Jamestown, North Dakota. Many interesting things happened to him there; for example, one day. . . ." Here the Story Line is the same as in the previous case even though the author does not explicitly say that someone was named George. But for each fictional name in a story, I suggest, a stylized sentence expressing its Story Line will contain a quantifier and a conjunct introducing that name.

Now of course only an author wooden *in excelsis* could present the Story Line by means of a Stylized Sentence such as (13). A more accomplished storyteller employs an artful mode of presentation complete with all the cunning and pleasing embellishments of stylistic technique. So naturally he replaces subsequent occurrences of the variable by the name introduced in the first conjunct; and he will probably omit that conjunct altogether. Then (unless he is writing in German) he breaks up the result into a lot of shorter sentences and adds his other embellishments.

The essential feature of this account (tentative and incomplete as it is) is that names such as 'George' in "George's Adventures" do not serve to denote anything at all; they function substantially as stylistic variants of variables appearing in a Stylized Sentence. To ask "Who or what does 'George' denote in 'George's Adventures'?"—is to misunderstand. This name denotes nothing at all in that story. To illustrate a point or give a counterexample I might speak of a pair of philosophers, McX and Wyman,⁴ who hold peculiar views on some topic or other. Here it would be the sheerest confusion to ask for the denotation of 'McX' and 'Wyman.' It is the same in the case of serious fiction.

Of course this account requires much by way of supplementation and qualification before it can be so much as called an account; many questions remain. For example, real persons and places often turn up in fiction, as do Jamestown in "George's Adventures" and Denmark in Hamlet; then the Story Line entails the existence of these persons or objects. Sometimes real people and places are given fictitious names, as is Grand Rapids, Michigan, in Frederick Manfred's The Primitive. Sometimes the author pauses to express his own views on some appropriate subject, as Tolstoy does in War and Peace; he then briefly deserts fiction for sober assertion. Sometimes it is difficult to discern the Story Line; we may be unable to tell whether it includes the existence of a real person-Henry Kissinger, let us say-detailing his adventures in state of affairs quite different from the actual world, or whether it only includes the existence of someone similar to Kissinger. Sometimes a story appears to be inconsistent or incoherent as in some time-travel fiction and fairy stories about people who turn into teacups or pumpkins. But then what goes into the Story Line of such a story?

There are plenty of other questions about what to include in the Story Line. Whatever is entailed by what the author explicitly says? Shall we therefore suppose that all of mathematics and necessary truth generally is included in every Story Line, and that *everything* is included in the Story Line of an inconsistent story? Does the Story Line include causal laws if

Possible but Unactual Objects

the author seems to be taking them for granted but explicitly mentions none? Does it include trivial and obvious truths known to the author and his intended audience—e.g. that most people are under nine feet tall? Does it include items of misinformation—e.g. that a bilious person suffers from an excess of bile—the author shares with his audience or thinks shared by his audience? These questions all await resolution; I shall say nothing about them here.

So the peculiar talent and virtue of author of fiction is his wide-ranging and fertile imagination; he helps us explore states of affairs we should never have thought of, left to our own devices. Of course he does not *assert* the propositions that form his stock in trade; as Sir Philip Sydney puts it,

Now for the poet, he nothing affirms, and therefore never lieth. For, as I take it, to lie is to affirm that to be true which is false. . . But the poet (as I said before) never affirmeth. . . . And therefore, though he recount things not true, yet because he telleth them not for true, he lieth not—without we will say that Nathan lied in his speech before-alleged to David; which as a wicked man durst scarce say, so think I none so simple would say that Aesop lied in the tales of his beasts; for who thinks that Aesop writ it for actually true were well worthy to have his name chronicled among the beasts he writeth of.⁵

The author does not assert these propositions; he exhibits them, calls them to our attention, invites us to consider and explore them. And hence his immunity from error noted earlier on.

Of course we are not thus immune. A critic who insists that Othello was an Eskimo has fallen into egregious error, whether through excess of carelessness or sophistication. For

(15) Othello was a Moor

is true and

(16) Othello was an Eskimo

is false. The first is true (again, roughly and subject to qualification and amendment) because the appropriate Story Line entails the existence of a Moor named Othello. (16), however, is false, because the Story Line entails the existence of someone named Othello who was not an Eskimo and it does not entail the existence of anyone else named Othello. (Here I venture no necessary and sufficient conditions for truth and falsehood in fiction; I mean only to indicate a promising line of approach.) But surely there will be sentences such as

(17) Hamlet wore size 13 shoes

that are neither true nor false. The appropriate Story Line does not entail the existence of someone named Hamlet who wore size 13 shoes; but neither does it entail the existence of someone named Hamlet who did not wear size 13 shoes. So (17) is neither true nor false. Of course a careless critic writing a book on literary characters with large feet might write "Hamlet, furthermore, wore size 13 shoes, as did" Such a critic would probably be saying what is false; for very likely he would be asserting something that entails that (17) is true; and *that* is false.

As I said, this account requires much by way of development and supplementation and qualification. Here I am less interested in filling out the account than in simply sketching its basic features, thus pointing to an understanding of fiction according to which stories are about nothing at all and the names they contain denote neither actual nor possible objects.

Notes

1. [Ed.—Note omitted.]

2. "Bob and Carol and Ted and Alice," in *Approaches to Natural Language*, ed. J. Hintikka (Dordrecht: D. Reidel, 1973).

3. Recall that a proposition P is true in a state of affairs S if and only if it is impossible that S obtain and P be false; similarly P is false in S if and only if it is impossible that S obtain and P be true.

4. See W. V. Quine, "On What There is," in *From a Logical Point of View* (New York: Harper & Row, 1963), p. a.

5. Apology for Poetry. Quoted in N. Wolterstorff, "A Theory of Fiction," unpublished.

Metaphor

MAX BLACK

Metaphors are no arguments, my pretty maiden. The Fortunes of Nigel, Book 2, Chapter 2

To draw attention to a philosopher's metaphors is to belittle him—like praising a logician for his beautiful handwriting. Addiction to metaphor is held to be illicit, on the principle that whereof one can speak only metaphorically, thereof one ought not to speak at all. Yet the nature of the offense is unclear. I should like to do something to dispel the mystery that invests the topic; but since philosophers (for all their notorious interest in language) have so neglected the subject, I must get what help I can from the literary critics. They, at least, do not accept the commandments, "Thou shalt not commit metaphor," or assume that metaphor is incompatible with serious thought.

I

The questions I should like to see answered concern the "logical grammar" of "metaphor" and words having related meanings. It would be satisfactory to have convincing answers to the questions: "How do we recognize a case of metaphor?," "Are there any criteria for the detection of metaphors?," "Can metaphors be translated into literal expressions?," "Is metaphor properly regarded as a decoration upon 'plain sense'?," "What are the relations between metaphor and simile?," "In what sense, if any, is a metaphor 'creative'?," "What is the point of using a metaphor?" (Or, more briefly, "What do we *mean* by 'metaphor'?" The questions express attempts to become clearer about some uses of the word "metaphor"—or, if one prefers the material mode, to analyze the notion of metaphor.)

From Proceedings of the Aristotelian Society, LV (1954–1955), 273–294 (now with a minor correction). Reprinted by courtesy of the Editor of the Aristotelian Society. © 1955 The Aristotelian Society.

The list is not a tidy one, and several of the questions overlap in fairly obvious ways. But I hope they will sufficiently illustrate the type of inquiry that is intended.

It would be helpful to be able to start from some agreed list of "clear cases" of metaphor. Since the word "metaphor" has some intelligible uses, however vague or vacillating, it must be possible to construct such a list. Presumably, it should be easier to agree whether any given item should be included than to agree about any proposed analysis of the notion of metaphor.

Perhaps the following list of examples, chosen not altogether at random, might serve:

- 1. "The chairman ploughed through the discussion."
- 2. "A smokescreen of witnesses."
- 3. "An argumentative melody."
- 4. "Blotting-paper voices" (Henry James).
- 5. "The poor are the Negroes of Europe" (Chamfort).
- 6. "Light is but the shadow of God" (Sir Thomas Browne).
- 7. "Oh dear white children, casual as birds. Playing amid the ruined languages" (Auden).

I hope all these will be accepted as unmistakable *instances* of metaphor, whatever judgments may ultimately be made about the meaning of "metaphor." The examples are offered as clear cases of metaphor, but, with the possible exception of the first, they would be unsuitable as "paradigms." If we wanted to teach the meaning of "metaphor" to a child, we should need simpler examples like "The clouds are crying" or "The branches are fighting with one another." (Is it significant that one hits upon examples of personification?) But I have tried to include some reminders of the possible complexities that even relatively straightforward metaphors may generate.

Consider the first example—"The chairman ploughed through the discussion." An obvious point to begin with is the contrast between the word "ploughed" and the remaining words by which it is accompanied. This would be commonly expressed by saying that "ploughed" has here a metaphorical sense, while the other words have literal senses. Though we point to the whole sentence as an instance (a "clear case") of metaphor, our attention quickly narrows to a single word, whose presence is the proximate reason for the attribution. And similar remarks can be made about the next four examples in the list, the crucial words being, respectively, "smokescreen," "argumentative," "blotting-paper," and "Negroes."

(But the situation is more complicated in the last two examples of the list. In the quotation from Sir Thomas Browne, "Light" must be supposed to have a symbolic sense, and certainly to mean far more than it would in

Metaphor

the context of a text-book on optics. Here, the metaphorical sense of the expression, "the shadow of God" imposes a meaning richer than usual upon the subject of the sentence. Similar effects can be noticed in the passage from Auden [consider for instance the meaning of "white" in the first line]. I shall have to neglect such complexities in this paper.)

In general, when we speak of a relatively simple metaphor, we are referring to a sentence or another expression, in which *some* words are used metaphorically, while the remainder are used non-metaphorically. An attempt to construct an entire sentence of words that are used metaphorically results in a proverb, an allegory, or a riddle. No preliminary analysis of metaphor will satisfactorily cover even such trite examples as "In the night all cows are black." And cases of symbolism (in the sense in which Kafka's castle is a "symbol") also need separate treatment.

Π

"The chairman ploughed through the discussion." In calling this sentence a case of metaphor, we are implying that at least one word (here, the word "ploughed") is being used metaphorically in the sentence, and that at least one of the remaining words is being used literally. Let us call the word "ploughed" the *focus* of the metaphor, and the remainder of the sentence in which that word occurs the *frame*. (Are we now using metaphors—and mixed ones at that? Does it matter?) One notion that needs to be clarified is that of the "metaphorical use" of the focus of a metaphor. Among other things, it would be good to understand how the presence of one frame can result in metaphorical use of the complementary word, while the presence of a different frame for the same word fails to result in metaphor.

If the sentence about the chairman's behavior is translated word for word into any foreign language for which this is possible, we shall of course want to say that the translated sentence is a case of the *very same* metaphor. So, to call a sentence an instance of metaphor is to say something about its *meaning*, not about its orthography, its phonetic pattern, or its grammatical form.¹ (To use a well-known distinction, "metaphor" must be classified as a term belonging to "semantics" and not to "syntax"—or to any *physical* inquiry about language.)

Suppose somebody says, "I like to plough my memories regularly." Shall we say he is using the same metaphor as in the case already discussed, or not? Our answer will depend upon the degree of similarity we are prepared to affirm on comparing the two "frames" (for we have the same "focus" each time). Differences in the two frames will produce *some* differences in the interplay² between focus and frame in the two cases. Whether we regard the differences as sufficiently striking to warrant calling the sentences *two* metaphors is a matter for arbitrary decision. "Metaphor" is a loose word, at best, and we must beware of attributing to it stricter rules of usage than are actually found in practice.

So far, I have been treating "metaphor" as a predicate properly applicable to certain expressions, without attention to any occasions on which the expressions are used, or to the thoughts, acts, feelings, and intentions of speakers upon such occasions. And this is surely correct for some expressions. We recognize that to call a man a "cesspool" is to use a metaphor, without needing to know who uses the expression, or on what occasions, or with what intention. The rules of our language determine that some expressions must count as metaphors; and a speaker can no more change this than he can legislate that "cow" shall mean the same as "sheep." But we must also recognize that the established rules of language leave wide latitude for individual variation, initiative, and creation. There are indefinitely many contexts (including nearly all the interesting ones) where the meaning of a metaphorical expression has to be reconstructed from the speaker's intentions (and other clues) because the broad rules of standard usage are too general to supply the information needed. When Churchill, in a famous phrase, called Mussolini "that utensil," the tone of voice, the verbal setting, the historical background, helped to make clear what metaphor was being used. (Yet, even here, it is hard to see how the phrase "that utensil" could ever be applied to a man except as an insult. Here, as elsewhere, the general rules of usage function as limitations upon the speaker's freedom to mean whatever he pleases.) This is an example, though still a simple one, of how recognition and interpretation of a metaphor may require attention to the particular circumstances of its utterance.

It is especially noteworthy that there are, in general, no standard rules for the degree of *weight* or *emphasis* to be attached to a particular use of an expression. To know what the user of a metaphor means, we need to know how "seriously" he treats the metaphorical focus. (Would he be just as content to have some rough synonym, or would only *that* word serve? Are we to take the word lightly, attending only to its most obvious implications—or should we dwell upon its less immediate associations?) In speech we can use emphasis and phrasing as clues. But in written or printed discourse, even these rudimentary aids are absent. Yet this somewhat elusive "weight" of a (suspected or detected³) metaphor is of great practical importance in exegesis.

To take a philosophical example. Whether the expression "logical form" should be treated in a particular frame as having a metaphorical sense will depend upon the extent to which its user is taken to be conscious of some supposed analogy between arguments and other things (vases, clouds, battles, jokes) that are also said to have "form." Still more will it depend upon whether the writer wishes the analogy to be active in the minds of

Metaphor

his readers; and how much his own thought depends upon and is nourished by the supposed analogy. We must not expect the "rules of language" to be of much help in such inquiries. (There is accordingly a sense of "metaphor" that belongs to "pragmatics," rather than to "semantics"—and this sense may be the one most deserving of attention.)

Ш

Let us try the simplest possible account that can be given of the meaning of "The chairman ploughed through the discussion," to see how far it will take us. A plausible commentary (for those presumably too literal-minded to understand the original) might run somewhat as follows:

"A speaker who uses the sentence in question is taken to want to say *something* about a chairman and his behavior in some meeting. Instead of saying, plainly or *directly*, that the chairman dealt summarily with objections, or ruthlessly suppressed irrelevance, or something of the sort, the speaker chose to use a word ('ploughed') which, strictly speaking, means something else. But an intelligent hearer can easily guess what the speaker had in mind."⁴

This account treats the metaphorical expression (let us call it "M") as a substitute for some other literal expression ("L," say) which would have expressed the same meaning, had it been used instead. On this view, the meaning of M, in its metaphorical occurrence, is just the *literal* meaning of L. The metaphorical use of an expression consists, on this view, of the use of that expression in other than its proper or normal sense, in some context that allows the improper or abnormal sense to be detected and appropriately transformed. (The reasons adduced for so remarkable a performance will be discussed later.)

Any view which holds that a metaphorical expression is used in place of some equivalent *literal* expression, I shall call a *substitution view of* metaphor. (I should like this label to cover also any analysis which views the entire sentence that is the locus of the metaphor as replacing some set of literal sentences.) Until recently, one or another form of a substitution view has been accepted by most writers (usually literary critics or writers of books on rhetoric) who have had anything to say about metaphor.

To take a few examples. Whately defines a metaphor as "a word substituted for another on account of the Resemblance or Analogy between their significations."⁵ Nor is the entry in the Oxford Dictionary (to jump to modern times) much different from this: "Metaphor: The figure of speech in which a name or descriptive term is transferred to some object different from, but analogous to, that to which it is properly applicable; an instance of this, a metaphorical expression."⁶ So strongly entrenched is the view expressed by these definitions that a recent writer who is explicitly arguing for a different and more sophisticated view of metaphor, nevertheless slips into the old fashion by defining metaphor as "saying one thing and meaning another."⁷

According to a substitution view, the focus of a metaphor, the word or expression having a distinctively metaphorical use within a literal frame, is used to communicate a meaning that might have been expressed literally. The author substitutes M for L; it is the reader's task to invert the substitution, by using the literal meaning of M as a clue to the intended literal meaning of L. Understanding a metaphor is like deciphering a code or unravelling a riddle.

If we now ask why, on this view, the writer should set his reader the task of solving a puzzle, we shall be offered two types of answer. The first is that there may, in fact, be no literal equvalent, L, available in the language in question. Mathematicians spoke of the "leg" of an angle because there was no brief literal expression for a bounding line; we say "cherry lips," because there is no form of words half as convenient for saying quickly what the lips are like. Metaphor plugs the gaps in the literal vocabulary (or, at least, supplies the want of convenient abbreviations). So viewed, metaphor is a species of catachresis, which I shall define as the use of a word in some new sense in order to remedy a gap in the vocabulary. Catachresis is the putting of new senses into old words.8 But if a catachresis serves a genuine need, the new sense introduced will quickly become part of the literal sense. "Orange" may originally have been applied to the color by catachresis; but the word is now applied to the color just as "properly" (and unmetaphorically) as to the fruit. "Osculating" curves don't kiss for long, and quickly revert to a more prosaic mathematical contact. And similarly for other cases. It is the fate of catachresis to disappear when it is successful.

There are, however, many metaphors where the virtues ascribed to catachresis cannot apply, because there is, or there is supposed to be, some readily available and equally compendious literal equivalent. Thus in the somewhat unfortunate example,⁹ "Richard is a lion," which modern writers have discussed with boring insistence, the literal meaning is taken to be the same as that of the sentence, "Richard is brave."¹⁰ Here, the metaphor is not supposed to enrich the vocabulary.

When catachresis cannot be invoked, the reasons for substituting an indirect, metaphorical, expression are taken to be stylistic. We are told that the metaphorical expression may (in its literal use) refer to a more concrete object than would its literal equivalent; and this is supposed to give pleasure to the reader (the pleasure of having one's thoughts diverted from Richard to the irrelevant lion). Again, the reader is taken to enjoy problemsolving—or to delight in the author's skill at half-concealing, half-revealing

Metaphor

his meaning. Or metaphors provide a shock of "agreeable surprise"—and so on. The principle behind these "explanations" seem to be: When in doubt about some peculiarity of language, attribute its existence to the pleasure it gives a reader. A principle that has the merit of working well in default of any evidence.¹¹

Whatever the merits of such speculations about the reader's response, they agree in making metaphor a *decoration*. Except in cases where a metaphor is a catachresis that remedies some temporary imperfection of literal language, the purpose of metaphor is to entertain and divert. Its use, on this view, always constitutes a deviation from the "plain and strictly appropriate style" (Whately).¹² So, if philosophers have something more important to do than give pleasure to their readers, metaphor can have no serious place in philosophical discussion.

IV

The view that a metaphorical expression has a meaning that is some transform of its normal literal meaning is a special case of a more general view about "figurative" language. This holds that any figure of speech involving semantic change (and not merely syntactic change, like inversion of normal word order) consists in some transformation of a *literal* meaning. The author provides, not his intended meaning, m, but some function thereof, f(m); the reader's task is to apply the inverse function, f^{-1} , and so to obtain $f^{-1}(f(m))$, i.e., m, the original meaning. When different functions are used, different tropes result. Thus, in irony, the author says the *opposite* of what he means; in hyperbole, he *exaggerates* his meaning; and so on.

What, then, is the characteristic transforming function involved in metaphor? To this the answer has been made: either *analogy* or *similarity*. M is either similar or analogous in meaning to its literal equivalent L. Once the reader has detected the ground of the intended analogy or simile (with the help of the frame, or clues drawn from the wider context) he can retrace the author's path and so reach the original meaning (the meaning of L).

If a writer holds that a metaphor consists in the *presentation* of the underlying analogy or similarity, he will be taking what I shall call a *comparison view* of metaphor. When Schopenhauer called a geometrical proof a mousetrap, he was, according to such a view, *saying* (though not explicitly): "A geometrical proof is *like* a mousetrap, since both offer a delusive reward, entice their victims by degrees, lead to disagreeable surprise, etc." This is a view of metaphor as a condensed or elliptical *simile*. It will be noticed that a "comparison view" is a special case of a "substitution view." For it holds that the metaphorical statement might be replaced by an equivalent literal *comparison*.

Whately says: "The Simile or Comparison may be considered as differing in form only from a Metaphor; the resemblance being in that case *stated*, which in the Metaphor is implied."¹³ Bain says that "The metaphor is a comparison implied in the mere use of a term" and adds, "It is in the circumstance of being confined to a word, or at most to a phrase, that we are to look for the peculiarities of the metaphor—in advantages on the one hand, and its dangers and abuses on the other."¹⁴ This view of the metaphor, as condensed simile or comparison, has been very popular.

The chief difference between a substitution view (of the sort previously considered) and the special form of it that I have called a comparison view may be illustrated by the stock example of "Richard is a lion." On the first view, the sentence means approximately the same as "Richard is brave"; on the second, approximately the same as "Richard is *like* a lion (in being brave)," the added words in brackets being understood but not explicitly stated. In the second translation, as in the first, the metaphorical statement is taken to be standing in place of some *literal* equivalent. But the comparison view provides a more elaborate paraphrase, inasmuch as the original statement is interpreted as being about lions as well as about Richard.¹⁵

The main objection against a comparison view is that it suffers from a vagueness that borders upon vacuity. We are supposed to be puzzled as to how some expression (M), used metaphorically, can function in place of some literal expression (L) that is held to be an approximate synonym; and the answer offered is that what M stands for (in its literal use) is similar to what L stands for. But how informative is this? There is some temptation to think of similarities as "objectively given," so that a question of the form, "Is A like B in respect of P?" has a definite and predetermined answer. If this were so, similes might be governed by rules as strict as those controlling the statements of physics. But likeness always admits of degrees, so that a truly "objective" question would need to take some such form as "Is A more like B than like C in respect of P?"-or, perhaps, "Is A closer to B than to C on such and such a scale of degrees of P?" Yet, in proportion as we approach such forms, metaphorical statements lose their effectiveness and their point. We need the metaphors in just the cases when there can be no question as yet of the precision of scientific statement. Metaphorical statement is not a substitute for a formal comparison or any other kind of literal statement, but has its own distinctive capacities and achievements. Often we say, "X is M," evoking some imputed connection between M and an imputed L (or, rather, to an indefinite system, L_1 , $L_2, L_3 \dots$) in cases where, prior to the construction of the metaphor, we would have been hard put to it to find any literal resemblance between M and L. It would be more illuminating in some of these cases to say that the metaphor creates the similarity than to say that it formulates some similarity antecedently existing.16

V

I turn now to consider a type of analysis I shall call an *interaction view* of metaphor. This seems to me to be free from the main defects of substitution and comparison views and to offer some important insight into the uses and limitations of metaphor.¹⁷

Let us begin with the following statement: "In the simplest formulation, when we use a metaphor we have two thoughts of different things active together and supported by a single word, or phrase, whose meaning is a resultant of their interaction."¹⁸

We may discover what is here intended by applying Richards' remark to our earlier example, "The poor are the Negroes of Europe." The substitution view, at its crudest, tells us that something is being *indirectly* said about the poor of Europe. (But what? That they are an oppressed class, a standing reproach to the community's official ideals, that poverty is inherited and indelible?) The comparison view claims that the epigram *presents* some comparison between the poor and the Negroes. In opposition to both, Richards says that our "thoughts" about European poor and (American) Negroes are "active together" and "interact" to produce a meaning that is a resultant of that interaction.

I think this must mean that in the given context the focal word "Negroes" obtains a *new* meaning, which is *not* quite its meaning in literal uses, nor quite the meaning which any literal substitute would have. The new context (the "frame" of the metaphor, in my terminology) imposes *extension* of meaning upon the focal word. And I take Richards to be saying that for the metaphor to work the reader must remain aware of the extension of meaning—must attend to both the old and the new meanings together.¹⁹

But how is this extension or change of meaning brought about? At one point, Richards speaks of the "common characteristics" of the two terms (the poor and Negroes) as "the ground of the metaphor" (*op cit.*, p. 117), so that in its metaphorical use a word or expression must connote only a *selection* from the characteristics connoted in its literal uses. This, however, seems a rare lapse into the older and less sophisticated analyses he is trying to supersede.²⁰ He is on firmer ground when he says that the reader is forced to "connect" the two ideas (p. 125). In this "connection" resides the secret and the mystery of metaphor. To speak of the "interaction" of two thoughts "active together" (or, again, of their "interillumination" or "cooperation") is to *use* a metaphor emphasizing the dynamic aspects of a good reader's response to a non-trivial metaphor. I have no quarrel with the use of metaphors (if they are good ones) in talking about metaphor. But it may be as well to use several, lest we are misled by the adventitious charms of our favorites.

Let us try, for instance, to think of a metaphor as a *filter*. Consider the statement, "Man is a wolf." Here, we may say, are *two* subjects—the

principal subject, Man (or: men) and the subsidiary subject, Wolf (or: wolves). Now the metaphorical sentence in question will not convey its intended meaning to a reader sufficiently ignorant about wolves. What is needed is not so much that the reader shall know the standard dictionary meaning of "wolf"-or be able to use that word in literal senses-as that he shall know what I will call the system of associated commonplaces. Imagine some layman required to say, without taking special thought, those things he held to be true about wolves; the set of statements resulting would approximate to what I am here calling the system of commonplaces associated with the word "wolf." I am assuming that in any given culture the responses made by different persons to the test suggested would agree rather closely, and that even the occasional expert, who might have unusual knowledge of the subject, would still know "what the man in the street thinks about the matter." From the expert's standpoint, the system of commonplaces may include half-truths or downright mistakes (as when a whale is classified as a fish); but the important thing for the metaphor's effectiveness is not that the commonplaces shall be true, but that they should be readily and freely evoked. (Because this is so, a metaphor that works in one society may seem preposterous in another. Men who take wolves to be reincarnations of dead humans will give the statement "Man is a wolf" an interpretation different from the one I have been assuming.)

To put the matter in another way: Literal uses of the word "wolf" are governed by syntactical and semantical rules, violation of which produces nonsense or self-contradiction. In addition, I am suggesting, literal uses of the word normally commit the speaker to acceptance of a set of standard beliefs about wolves (current platitudes) that are the common possession of the members of some speech community. To deny any such piece of accepted commonplace (e.g., by saying that wolves are vegetarians—or easily domesticated) is to produce an effect of paradox and provoke a demand for justification. A speaker who says "wolf" is normally taken to be implying in some sense of that word that he is referring to something fierce, carnivorous, treacherous, and so on. The idea of a wolf is part of a system of ideas, not sharply delineated, and yet sufficiently definite to admit of detailed enumeration.

The effect, then, of (metaphorically) calling a man a "wolf" is to evoke the wolf-system of related commonplaces. If the man is a wolf, he preys upon other animals, is fierce, hungry, engaged in constant struggle, a scavenger, and so on. Each of these implied assertions has now to be made to fit the principal subject (the man) either in normal or in abnormal senses. If the metaphor is at all appropriate, this can be done—up to a point at least. A suitable hearer will be led by the wolf-system of implications to construct a corresponding system of implications about the principal subject. But these implications will *not* be those comprised in the

commonplaces *normally* implied by literal uses of "man." The new implications must be determined by the patterns of implications associated with literal uses of the word "wolf." Any human traits that can without undue strain be talked about in "wolf-language" will be rendered prominent, and any that cannot will be pushed into the background. The wolf-metaphor suppresses some details, emphasizes others—in short, *organizes* our view of man.

Suppose I look at the night sky through a piece of heavily smoked glass on which certain lines have been left clear. Then I shall see only the stars that can be made to lie on the lines previously prepared upon the screen, and the stars I do see will be seen as organized by the screen's structure. We can think of a metaphor as such a screen, and the system of "associated commonplaces" of the focal word as the network of lines upon the screen. We can say that the principal subject is "seen through" the metaphorical expression—or, if we prefer, that the principal subject is "projected upon" the field of the subsidiary subject. (In the latter analogy, the implication-system of the focal expression must be taken to determine the "law of projection.")

Or take another example. Suppose I am set the task of describing a battle in words drawn as largely as possible from the vocabulary of chess. These latter terms determine a system of implications which will proceed to control my description of the battle. The enforced choice of the chess vocabulary will lead some aspects of the battle to be emphasized, others to be neglected, and all to be organized in a way that would cause much more strain in other modes of description. The chess vocabulary filters and transforms: it not only selects, it brings forward aspects of the battle that might not be seen at all through another medium. (Stars that cannot be seen at all, except through telescopes.)

Nor must we neglect the shifts in attitude that regularly result from the use of metaphorical language. A wolf is (conventionally) a hateful and alarming object; so, to call a man a wolf is to imply that he too is hateful and alarming (and thus to support and reinforce dislogistic attitudes). Again, the vocabulary of chess has its primary uses in a highly artificial setting, where all expression of feeling is formally excluded: to describe a battle as if it were a game of chess is accordingly to exclude, by the choice of language, all the more emotionally disturbing aspects of warfare. (Similar by-products are not rare in philosophical uses of metaphor.)

A fairly obvious objection to the foregoing sketch of the "interaction view" is that it has to hold that some of the "associated commonplaces" themselves suffer metaphorical change of meaning in the process of transfer from the subsidiary to the principal subject. And *these* changes, if they occur, can hardly be explained by the account given. The primary metaphor, it might be said, has been analyzed into a set of subordinate meta-

phors, so the account given is either circular or leads to an infinite regress.

This might be met by denying that *all* changes of meaning in the "associated commonplaces" must be counted as metaphorical shifts. Many of them are best described as *extensions* of meaning, because they do not involve apprehended connections between two systems of concepts. I have not undertaken to explain how such extensions or shifts occur in general, and I do not think any simple account will fit all cases. (It is easy enough to mutter "analogy" but closer examination soon shows all kinds of "grounds" for shifts of meaning with context—and even no ground at all, sometimes.)

Secondly, I would not deny that a metaphor may involve a number of subordinate metaphors among its implications. But these subordinate metaphors are, I think, usually intended to be taken less "emphatically," i.e., with less stress upon *their* implications. (The implications of a metaphor are like the overtones of a musical chord; to attach too much "weight" to them is like trying to make the overtones sound as loud as the main notes —and just as pointless.) In any case, primary and subordinate metaphors will normally belong to the same field of discourse, so that they mutually reinforce one and the same system of implications. Conversely, where substantially new metaphors appear as the primary metaphor is unravelled, there is serious risk of confusion of thought (cf. the customary prohibition against "mixed metaphors").

But the preceeding account of metaphor needs correction, if it is to be reasonably adequate. Reference to "associated commonplaces" will fit the commonest cases where the author simply plays upon the stock of common knowledge (and common misinformation) presumably shared by the reader and himself. But in a poem, or a piece of sustained prose, the writer can establish a novel pattern of implications for the literal uses of the key expressions, prior to using them as vehicles for his metaphors. (An author can do much to suppress unwanted implications of the word "contract," by explicit discussion of its intended meaning, before he proceeds to develop a contract theory of sovereignty. Or a naturalist who really knows wolves may tell us so much about them that *his* description of man as a wolf diverges quite markedly from the stock uses of that figure.) Metaphors can be supported by specially constructed systems of implications, as well as by accepted commonplaces; they can be made to measure and need not be reach-me-downs.

It was a simplification, again, to speak as if the implication-system of the metaphorical expression remains unaltered by the metaphorical statement. The nature of the intended application helps to determine the character of the system to be applied (as though the stars could partly determine the character of the observation-screen by which we looked at them). If to call a man a wolf is to put him in a special light, we must not forget that the metaphor makes the wolf seem more human than he otherwise would.

I hope such complications as these can be accommodated within the outline of an "interaction view" that I have tried to present.

VI

Since I have been making so much use of example and illustration, it may be as well to state explicitly (and by way of summary) some of the chief respects in which the "interaction" view recommended differs from a "substitution" or a "comparison" view.

In the form in which I have been expounding it, the "interaction view" is committed to the following seven claims:—

(1) A metaphorical statement has *two* distinct subjects—a "principal" subject and a "subsidiary" one.²¹

(2) These subjects are often best regarded as "systems of things," rather than "things."

(3) The metaphor works by applying to the principal subject a system of "associated implications" characteristic of the subsidiary subject.

(4) These implications usually consist of "commonplaces" about the subsidiary subject, but may, in suitable cases, consist of deviant implications established *ad hoc* by the writer.

(5) The metaphor selects, emphasizes, suppresses, and organizes features of the principal subject by *implying* statements about it that normally apply to the subsidiary subject.

(6) This involves shifts in meaning of words belonging to the same family or system as the metaphorical expression; and some of these shifts, though not all, may be metaphorical transfers. (The subordinate metaphors are, however, to be read less "emphatically.")

(7) There is, in general, no simple "ground" for the necessary shifts of meaning—no blanket reason why some metaphors work and others fail.

It will be found, upon consideration, that point (1) is incompatible with the simplest forms of a "substitution view," point (7) is formally incompatible with a "comparison view"; while the remaining points elaborate reasons for regarding "comparison views" as inadequate.

But it is easy to overstate the conflicts between these three views. If we were to insist that only examples satisfying all seven of the claims listed above should be allowed to count as "genuine" metaphors, we should restrict the correct uses of the word "metaphor" to a very small number of cases. This would be to advocate a persuasive definition of "metaphor" that would tend to make all metaphors interestingly complex.²² And such a deviation from current uses of the word "metaphor" would leave us without a convenient label for the more trivial cases. Now it is in just such trivial cases that "substitution" and "comparison" views sometimes seem nearer the mark than "interaction" views. The point might be met by *classifying* metaphors as instances of substitution, comparison, or interaction. Only the last kind are of importance in philosophy.

For substitution-metaphors and comparison-metaphors can be replaced by literal translations (with possible exception for the case of catachresis) —by sacrificing some of the charm, vivacity, or wit of the original, but with no loss of *cognitive* content. But "interaction-metaphors" are not expendable. Their mode of operation requires the reader to use a system of implications (a system of "commonplaces"—or a special system established for the purpose in hand) as a means for selecting, emphasizing, and organizing relations in a different field. This use of a "subsidiary subject" to foster insight into a "principal subject" is a distinctive *intellectual* operation (though one familiar enough through our experiences of learning anything whatever), demanding simultaneous awareness of both subjects but not reducible to any *comparison* between the two.

Suppose we try to state the cognitive content of an interaction-metaphor in "plain language." Up to a point, we may succeed in stating a number of relevant relations between the two subjects (though in view of the extension of meaning accompanying the shift in the subsidiary subject's implication system, too much must not be expected of the literal paraphrase). But the set of literal statements so obtained will not have the same power to inform and enlighten as the original. For one thing, the implications, previously left for a suitable reader to educe for himself, with a nice feeling for their relative priorities and degrees of importance, are now presented explicitly as though having equal weight. The literal paraphrase inevitably says too much-and with the wrong emphasis. One of the points I most wish to stress is that the loss in such cases is a loss in cognitive content; the relevant weakness of the literal paraphrase is not that it may be tiresomely prolix or boringly explicit-or deficient in qualities of style; it fails to be a translation because it fails to give the insight that the metaphor did.

But "explication," or elaboration of the metaphor's grounds, if not regarded as an adequate cognitive substitute for the original, may be extremely valuable. A powerful metaphor will no more be harmed by such probing than a musical masterpiece by analysis of its harmonic and melodic structure. No doubt metaphors are dangerous—and perhaps especially so in philosophy. But a prohibition against their use would be a wilful and harmful restriction upon our powers of inquiry.²³

Notes

1. Any part of speech can be used metaphorically (though the results are meagre and uninteresting in the case of conjunctions); any form of verbal expression may contain a metaphorical focus.

2. Here I am using language appropriate to the "interaction view" of metaphor that is discussed later in this paper.

3. Here, I wish these words to be read with as little "weight" as possible!

4. Notice how this type of paraphrase naturally conveys some implication of *fault* on the part of the metaphor's author. There is a strong suggestion that he ought to have made up his mind as to what he really wanted to say—the metaphor is depicted as a way of glossing over unclarity and vagueness.

5. Richard Whately, *Elements of Rhetoric* (7th revised ed., London, 1846), p. 280.

6. Under "Figure" we find: "Any of the various 'forms' of expression, deviating from the normal arrangement or use of words, which are adopted in order to give beauty, variety, or force to a composition; *e.g.*, Aposiopesis, Hyperbole, Metaphor, etc." If we took this strictly we might be led to say that a transfer of a word not adopted for the sake of introducing "beauty, variety, or force" must necessarily fail to be a case of metaphor. Or will "variety" automatically cover *every* transfer? It will be noticed that the O.E.D.'s definition is no improvement upon Whately's. Where he speaks of a "word" being substituted, the O.E.D. prefers "name or descriptive term." If this is meant to restrict metaphors to nouns (and adjectives?) it is demonstrably mistaken. But, if not, what *is* "descriptive term" supposed to mean? And why has Whately's reference to "Resemblance or Analogy" been trimmed into a reference to analogy alone?

7. Owen Barfield, "Poetic Diction and Legal Fiction," in *Essays Presented* to Charles Williams (Oxford, 1947), pp. 106–127. The definition of metaphor occurs on p. 111, where metaphor is treated as a special case of what Barfield calls "turning." The whole essay deserves to be read.

8. The O.E.D. defines catachresis as: "Improper use of words; application of a term to a thing which it does not properly denote; abuse or perversion of a trope or metaphor." I wish to exclude the pejorative suggestions. There is nothing perverse or abusive in stretching old words to fit new situations. Catachresis is surely a striking case of the transformation of meaning that is constantly occurring in any living language.

9. Can we imagine anybody saying this nowadays and seriously meaning anything? I find it hard to do so. But in default of an authentic context of use, any analysis is liable to be thin, obvious and unprofitable.

10. A full discussion of this example, complete with diagrams, will be found in Gustaf Stern's *Meaning and Change of Meaning* (Göteborgs Högskolas Årsskrift, Vol. XXXVIII, [1932], part I), pp. 300 ff. Stern's account tries to show how the reader is led by the context to *select* from the connotation of "lion" the attribute (bravery) that will fit Richard the man. I take him to be defending a form of the substitution view.

11. Aristotle ascribes the use of metaphor to delight in learning; Cicero traces delight in metaphor to the enjoyment of the author's ingenuity in overpassing the immediate, or in the vivid presentation of the principal subject. For references to these and other traditional vews, see E. M. Cope, *An Introduction to Aristotle's Rhetoric* (London, 1867), "Appendix B to Book III, Ch. II: *On Metaphor*."

12. Thus Stern $(\bar{o}p. cit.)$ says of all figures of speech that "they are intended to serve the expressive and purposive functions of speech better than the 'plain

statement" (p. 296). A metaphor produces an "enhancement" (*Steigerung*) of the subject, but the factors leading to its use "involve the expressive and effective (purposive) functions of speech, not the symbolic and communicative functions" (p. 290). That is to say, metaphors may evince feelings or predispose others to act and feel in various ways—but they don't typically say anything.

13. Whately, *loc. cit.* He proceeds to draw a distinction between "Resemblance, strictly so called, i.e. *direct* resemblance between the objects themselves in question, (as when we speak of '*table*-land,' or compare great waves to *mountains*)" and "Analogy, which is the resemblance of ratios—a similarity of the relations they bear to certain other objects; as when we speak of the '*light* of reason,' or of 'revelation'; or compare a wounded and captive warrior to a stranded ship."

14. Alexander Bain, English Composition and Rhetoric (enlarged ed., London, 1887), p. 159.

15. Comparison views probably derive from Aristotle's brief statement in the *Poetics*: "Metaphor consists in giving a thing a name that belongs to something else; the transference being either from genus to species, or from species to genus, or from species to species, or on grounds of analogy" (1457b). I have no space to give Aristotle's discussion the detailed examination it deserves. An able defence of a view based on Aristotle will be found in S. J. Brown's *The World of Imagery* (London, 1927, especially pp. 67 ff).

16. Much more would need to be said in a thorough examination of the comparison view. It would be revealing, for instance, to consider the contrasting types of case in which a formal comparison is preferred to a metaphor. A comparison is often a prelude to an explicit statement of the grounds of resemblance; whereas we do not expect a metaphor to explain itself. (Cf. the difference between *comparing* a man's face with a wolf mask, by looking for points of resemblance—and seeing the human face *as* vulpine.) But no doubt the line between *some* metaphors and *some* similes is not a sharp one.

17. The best sources are the writings of I. A. Richards, especially chapter 5 ("Metaphor") and chapter 6 ("Command of Metaphor") of his *The Philosophy* of Rhetoric (Oxford, 1936). Chapters 7 and 8 of his Interpretation in Teaching (London, 1938) cover much the same ground. W. Bedell Stanford's Greek Metaphor (Oxford, 1936) defends what he calls an "integration theory" (see especially pp. 101 ff) with much learning and skill. Unfortunately, both writers have great trouble in making clear the nature of the positions they are defending. Chapter 18 of W. Empson's *The Structure of Complex Words* (London, 1951) is a useful discussion of Richards' views on metaphor.

18. The Philosophy of Rhetoric, p. 93. Richards also says that metaphor is "fundamentally a borrowing between and intercourse of *thoughts*, a transaction between contexts" (p. 94). Metaphor, he says, requires two ideas "which cooperate in an inclusive meaning" (p. 119).

19. It is this, perhaps, that leads Richards to say that "talk about the identification or fusion that a metaphor effects is nearly always misleading and pernicious" (op. cit. p. 127).

20. Usually, Richards tries to show that similarity between the two terms is at best *part* of the basis for the interaction of meanings in a metaphor.

21. This point has often been made. E.g.:—"As to metaphorical expression, that is a great excellence in style, when it is used with propriety, for it gives you two ideas for one." (Samuel Johnson, quoted by Richards, *op. cit.*, p. 93). The choice of labels for the "subjects" is troublesome. See the "Note on terminology" appended to this paper.

22. I can sympathize with Empson's contention that "The term ['metaphor'] had better correspond to what the speakers themselves feel to be a rich or suggestive or persuasive use of a word, rather than include uses like the *leg* of a table" (*The Structure of Complex Words*, p. 333). But there is the opposite danger, also, of making metaphors too important by definition, and so narrowing our view of the subject excessively.

23. (A note on terminology): For metaphors that fit a substitution or comparison view, the factors needing to be distinguished are:—(i) some word or expression E; (ii) occuring in some verbal "frame" F; so that (iii) F(E) is the metaphorical statement in question; (iv) the meaning m'(E) which E has in F(E); (v) which is the same as the literal meaning, m(X), of some literal synonym, X. A sufficient technical vocabulary would be: "metaphorical expression" (for E), "metaphorical statement" (for F(E)), "metaphorical meaning" (for m') and "literal meaning" (for m).

Where the interaction view is appropriate, the situation is more complicated. We may also need to refer (vi) to the principal subject of F(E), say P (roughly, what the statement is "really" about), (vii) the subsidiary subject, S (what F(E) would be about if read literally); (viii) the relevant system of implications, I, connected with S; and (ix) the resulting system of attributions, A, asserted of P. We must accept at least so much complexity if we agree that the meaning of E in its setting F depends upon the transformation of I into A by using language, normally applied to S, to apply to P instead.

Richards has suggested using the words "tenor" and "vehicle" for the two "thoughts" which, in his view, are "active together" (for "the two ideas that metaphor, at its simplest, gives us," op. cit., p. 96, my italics) and urges that we reserve "the word 'metaphor' for the whole double unit" (ibid.). But this picture of two ideas working upon each other is an inconvenient fiction. And it is significant that Richards himself soon lapses into speaking of "tenor" and "vehicle" as "things" (e.g. on p. 118). Richards' "vehicle" vacillates in reference between the metaphorical expression (E), the subsidiary subject (S) and the connected implication system (I). It is less clear what his "tenor" means: sometimes it stands for the principal subject (P), sometimes for implications connected with that subject (which I have not symbolized above), sometimes, in spite of Richards' own intentions, for the resulting meaning (or as we might say the "full import") of E in its context, F(E).

There is probably no hope of getting an accepted terminology so long as writers upon the subject are so much at variance with one another.

Bibliography to Part Eight

Of the earlier literature on fiction, two quite interesting symposia have appeared in the *Proceedings of the Aristotelian Society*:

"Imaginary Objects," Suppl. Vol. XII (1933), including contributions by R. B. Braithewaite, Gilbert Ryle, and G. E. Moore;

"The Language of Fiction," Suppl. Vol. XXVII (1954), including the paper

by Margaret Macdonald printed here and a contribution by Michael Scriven. The first of these symposia contains what are very nearly the only contributions of Moore and Ryle to aesthetics. A convenient resumé of the principal issues may be found in:

Monroe C. Beardsley, Aesthetics (New York, 1958), Chapters 3, 8-9.

Among discussions of the same period may be noted:

R. K. Elliott, "Poetry and Truth," Analysis, XXVII (1967), 77-85.

T. M. Greene, *The Arts and the Art of Criticism* (Princeton, 1940), Chapter 23.

Sidney Hook (ed.), Art and Philosophy (New York, 1966), Pt. III;

John Hospers, Meaning and Truth in the Arts (Chapel Hill, 1946), Chapters 5-8;

John Hospers, "Literature and Human Nature," Journal of Aesthetics and Art Criticism, XVII (1958), 45-57;

John Hospers, "Implied Truths in Literature," Journal of Aesthetics and Art Criticism, XIX (1960), 37-46;

Isabel Hungerland, "Contextual Implication," Inquiry, IV (1960), 211-258;

- Arnold Isenberg, "The Esthetic Function of Language," Journal of Philosophy, XLVI (1949), 5-20;
- Peter Mew, "Facts in Fiction," Journal of Aesthetics and Art Criticism, XXXI (1973), 329-337;

I. A. Richards, Science and Poetry (London, revised 1935);

Morris Weitz, Philosophy of the Arts (Cambridge, 1950), Chapter 8;

Morris Weitz, "Truth in Literature," Revue Internationale de Philosophie, IX (1955), 116-129;

Bibliography

Morris Weitz, Hamlet and the Philosophy of Literary Criticism (Chicago, 1964);

More recent accounts of fiction have focused on the problem of reference to non-existent entities. Pertinent accounts may be found in:

- Charles Crittenden, "Fictional Existence," American Philosophical Quarterly, III (1966), 317-321;
- Richard M. Gale, "The Fictive Use of Language," *Philosophy*, XLVI (1971), 324–340;

Joseph Margolis, Art and Philosophy (Atlantic Highlands, 1978), Chapter 12;

Thomas G. Pavel, "'Possible Worlds' in Literary Semantics," Journal of Aesthetics and Art Criticism, XXXIV (1975), 165-176;

Nicholas Wolterstorff, "Worlds of Works of Art," Journal of Aesthetics and Art Criticism, XXXV (1976), 121-132;

John Woods, The Logic of Fiction (The Hague, 1974).

Among the earlier discussions of metaphor of interest are the following:

Owen Barfield, "Poetic Diction and Legal Fiction," in Essays Presented to Charles Williams (Oxford, 1947);

Monroe C. Beardsley, Aesthetics (New York, 1958), Chapter 3;

- Cleanth Brooks, "The Heresy of Paraphrase," in *The Well Wrought Urn* (New York, 1947);
- Scott Buchanan, Poetry and Mathematics (New York, 1929);
- William Empson, The Structure of Complex Words (New York, 1951);

Martin Foss, Symbol and Metaphor in Human Experience (Princeton, 1951);

Paul Henle, "Metaphor," in Paul Henle (ed.), Language, Thought and Culture (Ann Arbor, 1958);

Isabel Hungerland, Poetic Discourse (Berkeley, 1958), Chapter 4;

I. A. Richards, The Philosophy of Rhetoric (London, 1936), Chapters 5-6;

Gustaf Stern, "Meaning and Change of Meaning," in *Götesborgs Högskolas Årsskrift*, Vol. XXXVIII, 1932: 1 (Göteborg, 1931), Chapter 9;

Andrew Ushenko, "Metaphor," Thought, XXX (1955), 421–435;

Philip Wheelwright, The Burning Fountain (Bloomington, 1954).

More recent discussions include:

- Monroe C. Beardsley, "The Metaphorical Twist," *Philosophy and Phenomeno-logical Research*, XXII (1962);
- Monroe C. Beardsley, "Metaphor," *Encyclopedia of Philosophy*, Vol. 5 (New York, 1967);
- Timothy Binkley, "On the Truth and Probity of Metaphor," Journal of Aesthetics and Art Criticism, XXXIII (1974), 171-180;
- Stanley Cavell, "Aesthetic Problems of Modern Philosophy," in Max Black (ed.), *Philosophy in America* (Ithaca, 1965);
- Ted Cohen, "Figurative Speech and Figurative Acts," *Journal of Philosophy*, LXII (1975), 669–684;
- Ted Cohen, "Notes on Metaphor," Journal of Aesthetics and Art Criticism, XXXIV (1976), 249–259;

Fiction and Metaphor

Mary Hesse, Models and Analogies in Science (London, 1963); Joseph Margolis, Art and Philosophy (Atlantic Highlands, 1978), Chapter 13; Colin M. Turbayne, The Myth of Metaphor (Columbia, 1970, rev.).

Notes on the Contributors

- Monroe C. Beardsley. Professor of Philosophy, Temple University. Author, Aesthetics from Classical Greece to the Present (1965), Aesthetics (1968), The Possibility of Criticism (1970). Co-editor, Aesthetic Inquiry: Essays on Art Criticism and the Philosophy of Art (1967).
- Timothy Binkley. Chairman of Humanities, School of Visual Arts (New York City). Author, Wittgenstein's Language (1973) and articles in aesthetics.
- Max Black. Susan Linn Sage Professor of Philosophy, Cornell University. Author, The Nature of Mathematics (1933), Language and Philosophy (1949), Models and Metaphors (1962), Margins of Precision (1970). Editor, Philosophical Analysis (1950), Philosophy in America (1965). Editor, Philosophical Review, Contemporary Philosophy Series. Director, The Society for the Humanities, Cornell University.
- Frank Cioffi. Professor of Philosophy, University of Essex. Co-editor, Explanation in the Behavioural Sciences (1970).
- Arthur Danto. Professor of Philosophy, Columbia University. Author, Analytical Philosophy of History (1965), Analytical Philosophy of Knowledge (1968), Mysticism and Morality (1972), Analytical Philosophy of Action (1973), Jean-Paul Sartre (1975). Co-editor, Journal of Philosophy.
- R. K. Elliott. Professor and Head, History and Philosophy of Education Division, University of Birmingham. Author of a number of articles in aesthetics.
- Jack Glickman. Assistant Professor of Philosophy, College at Brockport, State University of New York. Editor, Moral Philosophy (1976) and author of articles in aesthetics.
- Nelson Goodman. Professor of Philosophy, Harvard University. Author, Problems and Projects (1972), Languages of Art (2nd ed., 1976), The

Structure of Appearance (3rd ed., 1977), Fact, Fiction, and Forecast (3rd ed., 1977), Ways of Worldmaking (1978).

Arnold Isenberg. Late Professor of Philosophy, Stanford University. His collected papers have been published as Aesthetics and the Theory of Criticism (1973).

Margaret Macdonald. Late University Reader, Bedford College, Oxford University. Editor of Analysis. Editor, Philosophy and Analysis (1954).

- Joseph Margolis. Professor of Philosophy, Temple University. Author, The Language of Art and Art Criticism (1965), Psychotherapy and Morality (1966), Values and Conduct (1971), Knowledge and Existence (1973), Negativities. The Limits of Life (1975), Persons and Minds (1977), Art and Philosophy (forthcoming).
- Patrick Maynard. Associate Professor of Philosophy, University of Western Ontario. Author of articles in aesthetics.
- Alvin Plantinga. Professor of Philosophy, Calvin College. Author, The Nature of Necessity (1974).
- F. N. Sibley. Professor and Head, Department of Philosophy, University of Lancaster. Editor, *Perception* (1971) and author of numerous articles in aesthetics.
- Guy Sircello. Professor of Philosophy, University of California at Irvine. Author, Mind & Art (1972), A New Theory of Beauty (1975).
- Alan Tormey. Professor of Philosophy, University of Maryland, Baltimore County. Author, The Concept of Expression (1971).
- Kendall Walton. Associate Professor of Philosophy, University of Michigan. Author of articles in aesthetics.
- Morris Weitz. Professor of Philosophy, Brandeis University. Author, Philosophy of the Arts (1950), Philosophy in Literature (1963), Hamlet and the Philosophy of Literary Criticism (1964). Editor, Problems in Aesthetics (1959) and revised, Twentieth-Century Philosophy (1966).
- Richard Wollheim. Grote Professor of Mind and Logic and Head, Department of Philosophy, University College, University of London. Author, F. H. Bradley (1959), Art and Its Objects (1968), Sigmund Freud (1971), On Art and the Mind (1973). Editor, Freud. A Collection of Critical Essays (1974).
- Nicholas Wolterstorff. Professor of Philosophy, Calvin College. Author, On Universals (1970), Reason Within the Bounds of Religion (1976).

References to complete selections are given in italics.

Aagaard-Mogensen, Lars, 44

achievement verbs, 150-151

action, intentional, 256, 258, 259, 260-262

Adler, Renata, 21

Aeschylus, 127

- aesthetic: concepts, 64–87; experience, 5, 45–57; gratification, 11–12, 13, 16, 17, 20; interests, 1–5; and non-aesthetic qualities, 31–32, 37, 62–63, 79, 88– 114; point of view, 6–24, 117; primary marks of the, 12; theory, 121–131; value, 11–16 passim
- aesthetics, 25-44, 57; and art, 3, 25, 34-35; Baumgarten on, 28-29; and literature, 31; Sibley on, 30-31
- Akenside, Mark, 396
- Alain [Emile Chartier], 271
- Alberti, L. B., 271
- Aldrich, Virgil C., 361
- Alexander, 316
- "Allegro, L'" (Milton), 328, 330
- allusion, 302, 305, 311, 312
- Alston, William, 377, 379, 380–381, 382, 386, 396, 400
- Among School Children (Yeats), 316, 318-319
- Anderson, Quinton, 315
- Anscombe, G. E. M., 271
- Antonioni, Michelangelo, 21
- Appassionata (Beethoven), 7, 10
- appreciative judgments, 394

Aristotle, 127, 298, 316, 465, 466

- Arnheim, Rudolf, 246, 285, 306
 - Arnold, Matthew, 298
- art: Binkley on definition of, 25-44; concept of, 125, 126-128; conceptual, 4, 5, 9, 160; creativity in, 145-161; Croce-Collingwood theory of, 184; Danto on theory of, 141-142; descriptive use of, 129; evaluative use of, 130; Glickman on definition of, 157-158; as "graphic symbols," 274; identity of, 165, 166, 167, 183; as imitation, 132-133, 135, 274-275, 277-278; Imitation Theory of (IT), 133-135, 142; nature of, 165, 167; ontology of, 136-144, 165-168, 169-188, 189-212, 213-220; as open concept, 126-128; phenomenology of, 166-193; as physical object, 169-177, 179-180; and physical objects, 217-219; [Reality Theory of] (RT), 135, 136, 142; Romantic Theory of, 292; Weitz on definition of, 121-131; Weitz on theory of, 121-131; see also artworks; work of art
- artifact, 120, 129, 156, 157, 158, 214
- artist('s): intentions, 289, 290, 291-292; self-expression, 289
- "artistic acts," 331-334, 335, 337, 340-344 passim
- artistic medium, 31, 32-35, 38; Langer on, 32; Margolis on, 33-34

artworks, 37-40 passim; as culturally emergent, 218-219, 397, 398; Danto on, 136-144; embodied in physical objects, 217-219; examples of, 194-198, 201, 203, 206-208; Glickman on, 157-158; as kinds, 198, 200-202, 204-205; as particulars, 216-218; as tokens-oftypes, 218-219; Wolterstorff on, 194-210; see also art; work of art artworld, Danto on, 132-144 Ashley, Linda, 44

Auden, W. H., 24, 452

Austen, Jane, 434-437 passim

Austin, J. L., 62, 377, 419

Austin, William, 113

authorial meaning, 396

- Axiom of Existence, the, 420, 421 Ayer, A. J., 252
- Bach, C. P. E., 107
- Bach, J. S., 204
- Bain, Alexander, 458, 466
- Balzac, Honoré, 14
- Barfield, Owen, 465
- Barnes, Annette, 401
- Barnes, William, 322
- Barry, Robert, 38
- Bartlett, Phyllis, 306
- Bartok, Bela, 53, 54, 196, 198, 204, 354
- Bartram, William, 300, 310
- Bateson, F. W., 303, 396, 400
- Baudelaire, Charles, 303
- Baumgarten, Alexander Gottlieb, 28, 29, 42 Beach Art, 156, 214, 215, 216 Beardsley, Elizabeth, 386 Beardsley, Monroe C., 4, 6–24, 30, 32, 42,
- 43, 44, 57, 63, 111, 112, 161, 290–291, 292, 293–306, 309–326 passim, 340, 344, 345, 366, 368, 370–386, 392–397, 400
- Beethoven, Ludwig van, 7, 10, 18, 23, 91, 93, 98, 103, 194, 202, 207, 322, 328– 329, 330
- Bell, Clive, 3, 30, 43, 117, 122
- Belle Jardinière, La (Raphael), 327, 331
- Bentham, Jeremy, 271
- Berg, Alban, 107
- Bergson, Henri, 409, 411
- Berkeley, George, 247, 271
- Bernini, Giovanni, 175

Bewley, Marius, 320, 321 Binkley, Timothy, 4-5, 25-44 Black, Max, 422, 451-467 Blake, William, 309, 313-314 Bochner, Mel, 36 Bohnert, Herbert, 414 Bonnard, Pierre, 55 Bosanquet, Bernard, 359 Botticelli, Sandro, 135 Bottlerack (Duchamp), 157, 159, 216 Bouwsma, O. K., 50, 57, 325-326, 335, 344 Bradley, A. C., 123 Brahms, Johannes, 92, 93 Braithwaite, R. B., 437 Breughel, Pieter, 328, 330, 331, 341, 342 Bridges, Robert Seymour, 315 Brillat-Savarin, Anthelme, 155 Brillo boxes, 140-144 passim Brook, D., 160 Brooks, Cleanth, 396, 397, 400 Brown, Merle E., 57 Brown, S. J., 466 Brown, William P., 244 Browne, Sir Thomas, 452 Bruce, James, 300, 310 Bruner, Jerome, 244 Burbage, Richard, 185, 186 Burial of Count Orgaz, The (El Greco), 406-407 Burnett, I. Compton, 431 Burns, Robert, 383 Burroughs, Edgar Rice, 15 Cage, John, 206, 329-334 passim, 341, 343 camp, 19, 21 Campbell, Donald, 244 Carlyle, Thomas, 297 Carritt, E. F., 349

Cassirer, Ernst, 325

Cavell, Stanley, 23

catachresis, 456-457, 464

Chamfort, S. R. N., 452

Chatman, Seymour, 386

Chatterton, Thomas, 323

Chekhov, Anton, 289

Chopin, Frederic, 354

Ch'ing Yuan, 140

Cavalcaselle, Giovanni Batista, 403

Cézanne, Paul, 91, 93, 135, 151, 433

Churchill, Winston, 454 Cicero, 465 Cimabue, Giovanni, 296 Cioffi, Frank, 291, 307-324, 385, 395, 400 class, 181, 182 Classical Argument, the, 438, 440-441 Clavius, Christophe, 301 Coffin, Charles M., 306 cognitivism, 388, 391, 398 Cohen, Ted, 63 Coleridge, Samuel, 148, 298, 299-300, 302, 310, 328, 373, 427 Collingwood, R. G., 43, 123, 124, 152, 273, 296, 306, 325, 405, 409 Collins, Churton, 319 composing and creating, 206-208 concepts, open and closed, 126 Congreve, William, 293 Conrad, Joseph, 309, 320 Constable, John, 226, 239, 247, 249, 433 Coomaraswamy, Ananda K., 295, 305 Cope, E. M., 465 Corneille, Pierre, 296 Cornsweet, J. C. and T., 245 Courbet, Gustave, 286 Cowley, Abraham, 309, 322 creating: and composing, 207-208; contrasted with making, 154, 157, 159, 213-216; types, 155 Creative-Process Theory, 145-146, 149, 152 creativity: Glickman on, 145-161; Tomas on, 146-150 criteria of evaluation, 129-130 criteria of recognition, 128-129 critical discourse, 76-78; Hampshire on, 77, 78-79; Macdonald on, 77 criticism, 365-369; Beardsley on, 370-386; Isenberg on, 402-415; objectivity in, 365-366; relativism in, 366, 369 Croce, Benedetto, 43, 123, 124, 152, 273, 296, 306, 325, 405, 409 Cromwell, Oliver, 435 Crowe, Sir Joseph Archer, 403

Dali, Salvador, 281

- Dante Alighieri, 303
- Danto, Arthur, 44, 119, 120, 132–144, 157, 158, 159, 161, 361
- Davidson, Donald, 399
- da Vinci, Leonardo, 26, 36, 271, 286, 361

Day, John, 303

Debussy, Claude, 101, 355, 360, 411

- defeasible concepts, 70
- definition, 118–119; of art, Binkley on, 25–44; of art, Glickman on, 157–158; of art, Weitz on, 121–131; honorific, 130; real, 124
- Degas, Edgar, 69
- De Kooning, Willem, 25, 37, 38, 40, 89, 143
- de Morgan, Augustus, 246
- denotation, 226, 233-236
- depiction, 273-288
- De rerum natura (Lucretius), 384
- Descartes, René, 247
- Descriptivism, 442-446
- Dewey, John, 152, 325, 346, 347–349, 359, 360, 412, 414
- Dickens, Charles, 308, 309, 426, 428, 432, 433, 434
- Dickie, George, 11, 42–43, 44, 57, 158, 159, 161
- Donatello, 173
- Donne, John, 48, 49, 50, 54, 185, 300– 302, 305, 308, 312, 313, 316, 319, 320, 410
- Drexler, Arthur, 158
- driftwood, 129, 156, 157, 158, 214, 216, 217
- Dryden, John, 432
- Ducasse, Curt, 123, 298, 306, 346, 347, 349, 360, 412, 414
- Duchamp, Marcel, 26, 27, 28, 35-43 passim, 157, 158-160, 214, 216
- Dufy, Raoul, 135
- "Dungeon, The" (Coleridge), 328, 331
- Dürer, Albrecht, 185, 214, 217, 271

Ehrenzweig, Anton, 113

elements, 181

- El Greco, 406, 409, 410
- Eliot, T. S., 302-328 passim, 332-336 passim, 340, 341, 427
- Elliott, R. K., 5, 45-57
- Emery, Clark, 373
- Emma (Austen), 424-437 passim
- emotion, 47; expressed in music, 50-54
- Emotionalism, 121
- Empson, William, 437, 466, 467
- Epicurus, 384
- epigraph, 304

- "Erased De Kooning Drawing" (Rauschenberg), 25
- Erasmus, 271
- "Eroica" (Beethoven), 328
- essential properties, 5
- Euripides, 127
- evidence, internal and external, 299, 302, 311-312, 315-316
- examples (of art works), 194–205 passim exemplification, 120
- expression, 177, 178; Sircello on, 325-345; Tormey on, 346-361
- Expression Theory (*E-T*), 45, 46, 56, 326– 353, 356–359; Bouwsma on, 50; as Canonical Position, 326–327, 331–332, 335, 337, 338–340, 344
- expressive properties, 174, 175, 176, 177– 179, 291–292; Sircello on, 325–345; Tormey on, 346–361
- Faculty of Taste, 25, 28-29
- family resemblances, 117, 125–126 Feyerabend, Paul, 279
- fiction, 419–421; Macdonald on, 424–437; Plantinga on, 438–450 First Quartet (Bartok), 196, 198 Fodor, Jerry, 220 Ford, Ford Maddox, 308 Formalism, 121, 122–123 Forster, E. M., 437 Fountain (Duchamp), 157 4 feet 33 inches (Cage), 206 Fragonard, Jean-Honoré, 69 Frazer, Sir James, 308 Fremont-Smith, Elliot, 9
- Freud, Sigmund, 361
- Fry, Roger, 122, 135
- Fussell, Jr., Paul, 384
- Galileo, 301 games (Wittgenstein), 125–126 Gauguin, Paul, 135 Gentile, Giovanni, 45 Gerard, David, 19 *Gestalt* quality, 92–93 Ghiselin, Brewer, 306 Giacometti, Alberto, 107, 108 Gibbon, Edward, 431 Gibson, J. J., 228, 245, 246, 247 Gieseking, Walter, 322 Gilbert, William, 301

- Gill, Brendan, 22
- Gioseffi, D., 245, 285
- Glickman, Jack, 120, 213, 214, 219
- Goethe, Friedrich, 298, 307, 309, 320
- Golden Wall, The (Hofmann), 327
- Goldschieder, Ludwig, 406, 409, 410
- Goldsmith, Oliver, 318
- Gombrich, E. H., 43, 113, 223–224, 227, 228, 239, 245, 246, 265, 272, 273, 279, 280–281, 285, 286
- Goodman, Nelson, 112, 113, 120, 219, 223–224, 225–248, 273, 279, 285, 286, 289, 292, 345 Goodyer, Sir Henry, 301
- Gore, Frederick, 285
- Gorky, Maxim, 7, 22
- Gotshalk, D. W., 349
- Goya, Francisco, 55, 175
- Greek tragedy, 128
- Green, Sam, 9
- Greenberg, Clement, 41, 43
- Gregory, R. L., 244
- Grice, H. P., 247, 419 Grizzly, the, 199–200
- G11221y, the, 199–200
- Grumbles, Lloyd A., 15 Grünewald, Mathias, 175
- guernicas, 96–97, 102–105 passim

Hamlet, 132, 144 Hamlyn, David, 272 Hampshire, Stuart, 77, 78-79, 86, 252, 271, 272, 371-372, 385, 400 Harding, D. W., 323 Harding, Rosamond E. M., 306 Hardy, Thomas, 295 Hare, R. M., 271 Harman, Gilbert, 399 Harris, Frank, 314 Harrison, Andrew, 211 Hart, H. L. A., 70, 85, 271 Hayes, Colin, 285 Heart of Darkness (Conrad), 320 Hebb, D. I., 245 Heifitz, Jascha, 353 Helmholtz, H. L. F. von, 278 Hempel, C. G., 399 Henry V (Shakespeare), 319-320 Henry Purcell (Hopkins), 314-315, 317 Henson, Richard, 387 Henze, Donald, 160 Hepburn, R. W., 57

Heron, W., 245 Herskowitz, Melville J., 244, 245 Hightower, John, 10 Hindemith, Paul, 195 Hippogriff, the, 198 Hirsch, E. D., 373, 385, 396, 400 Hochberg, J. E., 245 Hochmuth, Rolf, 21 Hofmann, Hans, 267, 268, 327, 330 Hölderin, J. C. F., 49, 50 Holloway, John, 86 Homecoming (Hölderin), 49, 50 Homer, 333 Hopkins, Gerard Manley, 308, 314, 315, 317, 320 Horace, 297 Hospers, John, 23, 161, 326, 347, 360 Housman, A. E., 207, 297, 314 Hull, R. F. C., 361 Hume, David, 427 Hungerland, Isabel, 31, 43, 62, 400 Huxtable, A. L., 161 Hynes, Samuel, 375, 385

Ibsen, Henrik, 21 illocutionary acts, 377-383 passim, 396; and poems, 383-384, 385 illusion and representation, 223, 224 "independence requirement," 393 Ingarden, Roman, 166, 168 Ingres, J. A. D., 143, 280 innocent eye, 224, 227, 283 "is": of artistic identification, 137-141 passim; of composition, 217; of embodiment, 217; of identity, 217 "is"/"seems" contrast, 392 (IT) (Danto), 133-135, 142 intellectualism, 121 intention, 293-306, 307-324; artist's, 289; and interpretation, 291 "intentional," 290 Intentional Fallacy, 289, 290-291, 293-306, 309 interpretation: Beardsley on, 370-386; Cioffi on, 307-324; Margolis on, 394-398; Wollheim on, 185-188 "Intolerability of Incompatibles, The," 374, 376, 397 Intuitionism, 121, 123, 390, 391 Irving, Washington, 447

Isenberg, Arnold, 85, 86, 367, 368, 402-415 Ives, Charles, 205 Iyer, K. Bharata, 24 "Jack and the Beanstalk," 373, 395 James, Henry, 21, 307-321 passim, 431, 436, 452 James, William, 271, 406 Jane Eyre (Brontë), 430, 435 Jarvie, I. C., 368 Johns, Jasper, 135 Johnson, Samuel, 319, 322, 467 Jones, Ernest, 433 Joyce, James, 126, 170, 172, 289, 428 Kafka, Franz, 453 Kant, Immanuel, 1, 367 Kaplan, David, 443-444 Kawara, On, 36 Keats, John, 309, 314, 380, 382, 427 Kenner, Hugh, 373 Kennick, William (W. E.), 151, 152-153, 160, 161 Kepler, Johannes, 301 Kermode, Frank, 373 Kierkegaard, Soren, 57 kinds, 198, 213-214, 216; natural, 198-199; norm-, 200, 204, 209 King, Bishop, 322, 323 Kingsmill, Hugh, 321 Kipling, Rudyard, 314, 321 Kissinger, Henry, 448 Kitto, H. D. F., 131 Kittredge, George Lyman, 373 Kivy, Peter, 86 Klagende Lied, Das (Mahler), 185-186 Klee, Paul, 231, 245, 246 Klein, Yves, 100 Kleist, Heinrich von, 171 Knight, Helen, 86 Knobler, Nathan, 285 Kott, Jan, 385 "Kubla Khan" (Coleridge), 299-300 Landscape with a Huntsman (Rembrandt), 235 Lang, Olga, 23 Langer, Susanne, 30, 32, 186, 325 Lawrence, D. H., 431 Leavis, F. R., 314-323 passim

478

- Leibniz, Gottfried, 411
- Lenin, V. I., 7, 18, 21, 22
- Leslie, C. R., 247
- Lewis, C. S., 293
- L.H.O.O.Q. (Duchamp), 26-28, 36-37
- L.H.O.O.Q. Shaved (Duchamp), 26, 28, 35-36
- Lichtenstein, Roy, 135, 143
- Lied von der Erde, Das (Mahler), 350
- "Lines Composed a Few Miles Above Tintern Abbey" (Wordsworth), 374
- Lippard, Lucy, 42
- Longinus, 47, 55, 296
- Loot (Kipling), 321
- Lossky, Vladimir, 245
- "Love Song of J. Alfred Prufrock" (Eliot), 304–305, 310–316 passim, 328–341 passim
- Lowes, John Livingston, 299, 300
- Lucretius, 384
- Lucy poem (Wordsworth), 373
- Macdonald, Margaret, 76, 77, 86, 131, 211, 420-421, 424-437
- machines, as creative, 153-154
- MacKay, D. M., 271
- Macpherson, James, 323
- Mahler, Gustav, 185, 186, 350
- making: contrasted with creating, 154, 157, 159, 213–216; particulars, 155
- Malley, Ern, 323
- Manfred, Frederick, 444, 448
- Margolis, Joseph, 33, 39, 43, 44, 57, 156, 161, 167, 211, 213–224, 336, 368, 372– 373, 385, 386, 387–401
- Maritain, Jacques, 17
- Marvell, Andrew, 303, 305, 310, 312, 315, 316
- Masaccio, 175, 274
- Matthiessen, F. O., 302, 303, 304
- Maynard, Patrick, 224, 273-286
- Meager, Ruby, 57
- Mearns, Hughes, 306
- Meegeren, Hans Van, 326
- Melancholia I (Dürer), 214, 217
- Melden, A. I., 271
- meta-aesthetic questions, 118
- metaphor, 419, 420-423; Black on, 451-467
- metaphorical focus, 453-461 passim metaphorical frame, 453-457 passim
- Meyer, Ursula, 43, 44

Michelangelo Buonarroti, 34, 143, 217, 308 Michotte, A., 272 Mill, James, 271 Milton, John, 307, 310, 328, 330, 404 mimesis, 133 Mistress, The (Cowley), 322 Mona Lisa (da Vinci), 26-28, 35-37 monkeys, as creative, 153-154 Monteverdi, Claudio, 358 Moore, G. E., 367, 425-426, 437 Morgan, Douglas (D. N.), 145-146, 149, 160 Morris, Charles, 412 Mozart, Amadeus, 107, 207, 329, 330 Murry, John Middleton, 314 Mussolini, Benito, 454

names, 447-450 Napoleon, 434, 435 naturalism, 279-283 passim Naturalistic Fallacy, 367 Nerval, Gérard de, 305 Nervi, Pier Luigi, 23 Newman, Anthony, 204 Newman, Barnett, 135 Nicoll, Allerdyce, 319 Nielsen, Carl, 357, 361 Nietzsche, Friedrich, 148 nominalism, 194, 224 notes, 302-304, 315, 317 Nowell-Smith, P. H., 393, 394 Nude before a Mirror (Bonnard), 55-56 numerals, copies of, 135

Obedient unto Death (Rouault), 190, 191, 195 "objective correlative," 50 "objective pleasure," 123 object-works, 191-198 passim, 209; objects of, 191, 198 Ode on a Grecian Urn (Keats), 314 Oistrakh, David, 353 Oldenburg, Claes, 9, 136 Oldenburg's bed, 136 Ontological Principle, the, 438, 439-441 ontology of art: Danto on, 136-144; Margolis on, 213-220; Wollheim on, 169-188; Wolterstorff on, 189-212 opposites (predicates), 142-144

Opus 111 (Beethoven), 195, 202-208 passim Organicism, 121, 123, 124 Osborne, Harold, 360 O'Shaughnessy, Brian, 271 Ouspensky, Leonid, 245 Panofsky, Erwin, 246, 286 paraphrasability, 421, 423 Parker, DeWitt, 123-124, 131 Parsey, Arthur, 246 particulars, 120, 155, 181, 209, 213-215, 216 Passmore, J. A., 86 Pater, Walter, 297 Peirce, Charles Sanders, 181, 219 performance, 170, 172-173, 181, 186-207 passim performance-work, 190-198 passim perlocutionary acts, 377 persons: Danto on, 136-137; and works of art, 217 perspective, 228-232 Peter and the Wolf (Prokofiev), 329 Petrarch, 322 Phemister, Margaret, 272 philosophy as logical description, 125 physical-object hypothesis, 169-173, 179-180 Picabia, Francis, 37 Picasso, Pablo, 34, 94, 96-97, 105, 153, 154, 213, 214, 239 Pickwick, 426, 432 "piece" (of art), 25-44 Pietà (Michelangelo), 217 Pirenne, M. H., 245, 246, 285, 286 Plantinga, Alvin, 421, 438-450 Plato, 47, 117, 120, 296 Poe, Edgar Allen, 323 poems, as imitations, 383-384, 385 Pollack, Jackson, 158 Pope, Alexander, 307, 323 Porphyry, 318, 319 Portnoy, Julius, 306 Portrait of a Lady, A (James), 436 Postman (Van Gogh), 234 Potato Eaters (Van Gogh), 135 Poussin, Nicolas, 327-334 passim, 340-345 passim Prall, D. W., 405, 415

Prelude and Fugue in D minor (Bach), 204 Price, Richard, 271 Principle of Autonomy, 394-395 Principle of Independence, 394 Pritchard, R. M., 245 Prokofiev, Sergei, 329, 331, 340, 341, 357 properties and predicates, 194-198, 199-200 Protagoras, 389 Purcell, Henry, 308 Purchas, Samuel, 300, 310 Putnam, Hilary, 119, 220 Quine, W. V., 24 Rachmaninoff, Serge, 354 Rader, Melvin, 374-375 Rape of the Sabine Women, The (Poussin), 327, 331-334 passim, 340-341 Raphael, Sanzio, 143, 175, 327, 330, 427 Ratliff, F., 245 Rauschenberg, Robert, 25, 26, 37, 38, 40, 89, 136, 141 Rauschenberg's bed, 136 readymades, 158-160, 214 Reagan, Ronald, 446-447 real essences, 119 realism, 224; representational, 239-242 realism device, 281-282 Red Flag, 181-182, 185 Regan, Thomas, 24 Reid, L. A., 346 Reinhardt, Ad. 144 relativism, Margolis on, 387-401 Rembrandt van Rijn, 27, 89, 94, 104, 235, 412 Renoir, Jean, 26 representation, 224, 252-259 passim, 263-270 passim; -as, 236-237; copy theory of, 227-228, 232, 235; and denotation, 226, 233-236; and description, 238,

predicates: and properties, 194-198, 199;

cally, 195; used univocally, 195

used analogically, 195; used equivo-

239, 242–243; Goodman on, 225–248; and illusion, 223, 224; as imitation, 273–274; intentional aspect of, 224, 258–259; Maynard on, 273–286; and resemblance, 223, 225–226; Wollheim on, 249–272

representational properties, 94, 174, 224 representational realism, 224, 239-242, 279 - 283resemblance, 94-96, 223-226 passim Richard III (Shakespeare), 185-186 Richards, I. A., 188, 298, 309, 405, 429, 459, 466, 467 Richardson, Samuel, 126 Riggs, L. A., 245 Rivers, Larry, 272 Rock, Irving, 245 Rodin, Auguste, 191, 215 Romantic Fallacy, 291, 295 romanticism, 295-296 Rosenberg, Harold, 159, 161 Rosenkavalier, Der (Strauss), 170-173 passim, 181 Rothko, Mark, 282 Rouault, Georges, 54, 55, 135, 190, 191, 195 (RT) (Danto), 135, 136, 142 Rubens, Peter Paul, 26, 32 Russell, Bertrand, 412 Ryle, Gilbert, 150, 161, 224, 426, 432, 437 Sacro Bosco, Johannis de, 301 Sailing to Byzantium (Yeats), 195, 197 St. Bernard, 18, 21 St. George (Donatello), 173, 174 Saintsbury, George, 296 Salzman, Eric, 113 Santayana, George, 346, 349 Schapiro, Meyer, 18, 245, 274 Schoenberg, Arnold, 101, 106, 107, 189, 190 Schopenhauer, Arthur, 457 Schubert, Franz Peter, 93, 101 Schumann, Robert, 93 Schwartz, Delmore, 316 Scott, Geoffrey, 8, 10 Scott, Sir Walter, 302, 322 Scriven, Michael, 393-394, 400 Searle, John, 419, 420 "seeing-as," 355 Segall, Marshal H., 244 Sessions, Roger, 113 sets, 194-195, 216 Shakespeare, William, 154, 296, 308, 319, 412, 427, 432-446 passim

Shanks, Edward, 321

Sibelius, Jan, 353 Sibley, Frank (F. N.), 30, 31, 43, 62, 63, 64-87, 90, 112, 361, 368, 389-392, 399 "significant form," 123, 124 Signorelli, Luca, 280 Sircello, Guy, 291, 292, 325-345 Sixth Symphony (Nielsen), 357 "Slumber Did My Spirit Seal, A" [Lucy poem] (Wordsworth), 373, 374-377, 396-397 Smith, Logan Pearsall, 437 Socrates, 132, 133, 296 Sonntag, Susan, 19, 21, 24 Sophocles, 127 Spelt from Sybil's Leaves (Hopkins), 320 Spencer, Herbert, 406 Spingarn, J. E., 305 "Spring" Concerto (Vivaldi), 329 Stanford, W. Bedell, 466 Stanislavski, Constantin, 289 Stein, Edith, 47, 57 Stein, Gertrude, 239, 425 Steinberg, Leo, 274, 277 Stern, Gustav, 465 Story Line, 447-450 passim Story of O, The (Réage), 9 Strauss, Richard, 172 Stravinsky, Igor, 354 Strawson, P. F., 136, 209 Stylized Sentence, 447-448 Sunne Rising, The (Donne), 49, 50 superimpositions, 373, 377 super-pictures, 275-277 Swift, Jonathan, 308 Sydney, Sir Philip, 449 Szell, George, 190

Tarski, Alfred, 399 taste, 66, 71, 75, 76 Taylor, J. G., 245 Taylor, Paul, 11, 23 Tech-Bilt House No. 1, 191 ten Doesschate, G., 285 Tennyson, Alfred, Lord, 303, 309, 410 Testadura (Danto), 136, 139, 140 textual meaning, 396 Thackeray, William, 435 Theobald, Lewis, 319, 320 *Thinker, The* (Rodin), 191 Thouless, R. H., 271 Tilghman, B. R., 361

Tillich, Paul, 381 Tillyard, E. M. W., 293, 298 Tischler, Hans, 24 Titian, 144, 413 To His Cov Mistress (Marvell), 305, 312 tokens, 181 tokens-of-types, 168, 216-217, 218-219 Tolstov, Leo, 123, 349, 431, 435 Tomas, Vincent, 146-149, 152, 153, 154, 155-156, 160, 161, 347 Tompkins, Calvin, 111 Tormey, Alan, 43, 292, 346-361 Tourneur, Cyril, 319 tragedy, 127 Traveller, The (Goldsmith), 319 Trollope, Anthony, 322, 433 truth-values, 387, 388, 393 Tudor, David, 329 Turner, J. M. T., 29, 406 Turn of the Screw, The (James), 317-318, 320 types, 120, 155, 168, 181, 198, 213 types and tokens: Margolis on, 213-219; Wollheim on, 181-185 type/token distinction, 167, 216 Ulysses (Joyce), 170-173 passim, 181 Unicorn, the, 198 universals, 181, 182, 213, 218, 224 Urmson, J. O., 2-3, 23, 247 Valediction, A.: Forbidding Mourning (Donne), 313

Valéry, Paul, 188

- value judgments (V), 367–368, 402–403, 405, 408–409 Van Gogh, Vincent, 90, 135, 234
- Vasari, Giorgio, 174, 274, 285

Verklaerte Nacht (Schoenberg), 189, 190 Véron, Eugène, 349

visual experience, criteria of, 249–272 Vitruvius, 7

Vivaldi, Antonio, 329

Voluntarism, 121, 123–124

von Wright, G. H., 399

Wagner, Richard, 101, 412 Wain, John, 318, 319 Walton, Kendall L., 63, 88–114, 212, 285 Warhol, Andy, 140, 141 Warren, Austin, 211

Waste Land, The (Eliot), 315

Way of the World, The (Congreve), 293

"We Are Seven" (Wordsworth), 318, 331

Webern, Anton von, 107

Webster, John, 303

- Wedding Dance in the Open Air (Breughel), 318, 331, 342
- Weitz, Morris, 118, 121-131, 156, 161
- Wellek, René, 211
- Wells, H. G., 445
- Weston, Jesse, 302, 315
- Weyden, Roger vander, 286
- Whately, Richard, 455, 457, 458, 465, 466
- What Masie Knew (James), 321

White, John, 246, 285

Wiggins, David, 220

Wilbur, Richard, 383

- Williams, John, 24
- Wilson, Edmund, 317-318, 321
- Wimsatt, Jr., William, 112, 290-291, 292, 293-306, 309-320 passim, 324, 386
- Wisdom, John, 62, 86
- Wittgenstein, Ludwig, 2, 62, 117, 125, 131, 249, 250, 271, 272, 307, 319, 321, 323, 324, 361, 377
- Wolf, Hugo, 93
- Wölfflin, Heinrich, 111, 114, 174, 285
- Wollheim, Richard, 166–167, 169–188, 199, 211, 220, 224, 249–272
- Wolterstorff, Nicholas, 167, 189–212, 219, 450
- Woolf, Virginia, 225, 430
- Wordsworth, William, 54, 297, 307, 308, 309, 328, 331, 332, 341, 373–377 passim, 396–397
- work of art, 9, 34–35; as basic categoryterm, 117–118; conceptual, 4, 5, 9; definition of, 117–118, 119; as symbol, 120; *see also* art; artworks

Wotton, Sir Henry, 7, 23

Wright, M., 160

Yeats, William Butler, 142, 308, 309, 316, 318, 319 Young, Edward, 297

Zeuxis, 136 Ziff, Paul, 112